Cultural Politics

Cultural Politics

*Class, Gender, Race and the
Postmodern World*

Glenn Jordan and Chris Weedon

BLACKWELL
Oxford UK & Cambridge USA

First published 1995

Blackwell Publishers, the publishing imprint of
Basil Blackwell Ltd
108 Cowley Road
Oxford OX4 1JF
UK

Basil Blackwell Inc.
238 Main Street
Cambridge, Massachusetts 02142
USA

British Library Cataloguing in Publication Data

A CIP catalogue record for this book is available from the British Library.

Library of Congress Cataloging-in-Publication Data

Cultural politics: class, gender, race, and the postmodern world/Glenn Jordan and Chris Weedon.
 p. cm.
 Includes bibliographical references and index.
 ISBN 0–631–16227–5 (alk. paper). — ISBN 0–631–16228–3 (pbk.: alk. paper)
 1. Arts and society – History – 20th century. 2. Minorities in art. 3. Ethnic arts.
4. Marginality, social – History – 20th century.
I. Jordan, Glenn II. Title.
NX 180.S6W43 1994 94–4311
700'.1' 03 – dc20 CIP

Printed in Great Britain by T.J. Press Ltd., Padstow
This book is printed on acid-free paper

*To our mothers
and the memory of our fathers*

Contents

List of Plates

Preface

What has culture to do with politics – that is, with struggles to acquire, maintain or resist power? Everything, or so this book argues. Focusing on the relationships between culture, power and subjectivity, *Cultural Politics* seeks to contribute to critical cultural enquiry and liberating political practice.

The book is a collective enterprise. It could not have been written by either of us alone. Each of us brought to it our particular areas of experience and expertise, but the chapters themselves are the product of our work together.

Most research in Cultural Studies has focused on those areas excluded by the 'high' cultural and academic traditions of Literature, Art and History. Early work in Britain, for example, looked at forms of working-class culture, at youth subcultures and at popular cultural forms. Our focus is different. We look precisely at those areas that constitute the dominant 'high' culture: Literature, Art and History. Many social groups do not find themselves or their interests reflected in these traditions. Working-class people, women and people of Colour find themselves marginalized or excluded. We focus on examples of how these groups have attempted to reclaim and transform the dominant in their own interests.

Many books on culture and politics have a tendency to academicize issues. In the process the bitter experiences of structural inequality, sexism and racism – their effects on people's sense of self and their opportunities in life – are diffused. Class, gender and race become academic issues freed of passion, anger and pain. We have written a book which we hope will not allow this to happen. We have included multiple voices and perspectives, including voices of the oppressed.

Where possible we have tried to let the marginalized groups whose work we look at speak for themselves. This is particularly important where works are little known or not easily accessible, for example,

writing by Australians of Aboriginal descent. Here the cost of permission to reproduce extracts means that we have had to limit extracts more than we would otherwise have wished.

In using multiple voices our text often speaks from within dominant discourses. We do not constantly alert the reader to this by marking our own distance from voices with which we would disagree. We hope the text itself deconstructs these voices. Nor do we follow the current vogue for putting terms like race in inverted commas. We know, of course, that race is a social construction, but it is also lived as a brute fact. We want to avoid evacuating terms like race of the lived oppression of racism.

Much of the book consists of detailed case studies in the cultural politics of class, gender and race. We believe that it is important to ground more general theoretical and political arguments and we ask what we can learn from our case studies for cultural politics today.

Our book is both a political and a theoretical intervention in the broad field of Cultural Studies. We hope that it will encourage questioning and reflexivity, particularly among those so eager to espouse a postmodern rhetoric of difference without due attention to power. Power is our central concern and we see *Cultural Politics* as an attempt to use theory in the interests of change, as a contribution to an emancipatory cultural politics. We hope that many different groups of reader – from students and teachers to arts and cultural workers – will find it accessible and above all useful.

We would like to thank all those people whose ideas, comments and practical help have fed into our work. Stuart Allan, Rasheed Araeen, Catherine Belsey, Gill Boden, Steve Connor and two anonymous readers approached by Blackwell, Marco Gil-Cervantes, David Jackson, Jane Moore, Bernd Rosner and John Taylor read parts of the manuscript. Our nephew Ernest Carlton Smith, who visited us for six months during the writing of this book, not only read sections of it but found himself left to his own devices while we sat glued to our computer screens. Ollie Harrington shared his life and work with us and allowed us to reproduce one of his cartoons. Eddie Chambers and the African and Asian Visual Artists' Archive in Bristol helped with pictures. Alison Jackson gave us photos of Greenham Common. Jutta Wrase in (East) Berlin and Hannah Justice-Mills and Simon Ford of Ffotoworks in Cardiff produced prints and negatives for us. Edward Bruner, Elaine Bruner, Kimberley Smith, Joyce Jordan Smith and Marguerite Weedon helped with various information. Mark O'Neill provided useful background on the People's Palace. Michael Trickey, Mike Sweet and Sally Medlyn gave helpful interviews on arts funding. Rob Middlehurst provided us with the *Guardian* article 'Mad Dogs and Englishmen'. Yvette Phillips helped with typing. The Butetown History and Arts Project allowed us to use their Macintosh computer system. Thanks to Marco Gil-Cervantes and Neil

Sinclair for coming to the rescue when computer systems failed us. We are grateful to Andrew McNeillie of Blackwell Publishers for his patient support, to Ginny Stroud-Lewis and Thelma Gilbert for their help with picture research and permissions, and to Audrey Bamber for her excellent copy-editing. Thanks also to those who helped check the proofs: Gill Boden, David Broughton, Peter Buse, David Jackson, Anne James, Caroline Joll, Molly Maher, Yvette Phillips, Carl Plasa, Neil Sinclair and Jeff Wallace. Thanks too to Valery Rose.

This book was written in Cardiff and (East) Berlin. Our time in Berlin was made possible by a grant from the Alexander von Humboldt-Stiftung in Bonn. We are grateful for their support.

Acknowledgements

The authors and publisher wish to thank the following for permission to use material in copyright:

Allen & Unwin Pty Ltd, Australia, for material from Archie Weller, *Going Home* (1986);

Rasheed Araeen for material from 'The Other Story', Exhibition Catalogue, 'From Primitivism to Ethnic Art', *Third Text*, 1 (Autumn 1987), and 'The Other Immigrant', *Third Text*, 15 (Summer, 1991);

Longman Group UK for material from John Tosh, *The Pursuit of History* (1984);

Penguin Books Australia Ltd for material from Kevin Gilbert, *Living Black* (1978); Kevin Gilbert, 'The New True Anthem', Jack Davis, 'Aboriginal Australia' and Eva Johnson, 'A Letter to my Mother' in *Inside Black Australia*, ed. Kevin Gilbert (1988);

Patricia St Hilaire for 'A Poem for Black Women' in *Black Womantalk Poetry* (1987);

South End Press for material from bell hooks, *Black Looks* (1992);

the Charlotte Sheedy Agency on behalf of the author for material from Audre Lorde, 'Eye to Eye' in *Sister Outsider*, The Crossing Press, Freedom, California; copyright © 1984 by Audre Lorde;

Carmen Tunde for 'Bus Stop' in *Black Womantalk Poetry* (1987);

Virago Press Ltd, Henry Holt and Co., Inc. and Freemantle Arts Centre Press for material from Sally Morgan, *My Place* (1988); copyright © 1987 Sally Jane Morgan;

Jacaranda Wiley Ltd for material from Jack Davis, 'The First Born', 'Deso-

lation' and 'The Drifters' in *The First Born and Other Poems*; and from Oodgeroo of the tribe Noonuccal, Custodian of the land Minjerribah, *My People* (1970);

Every effort has been made to trace all the copyright holders, but if any have been inadvertently overlooked the publisher will be pleased to make the necessary arrangement at the first opportunity.

Part I
Mapping the Terrain

1

Introduction: What are Cultural Politics?

As we were completing the draft of this book, the XXVth Olympic Games took place in Barcelona. The Olympic Games are officially opened with the utterance of a single sentence: 'I now declare the Games of the . . . Olympiad open.' At the opening ceremony of the Barcelona Olympics, King Juan Carlos gave a bilingual rendition, beginning the official declaration in Catalonian and completing it in Spanish.

Similarly, the opening festivities of the Games included both Catalonian and Spanish music, dance and theatrical performance. Both Catalonian and Spanish flags flew. Both languages were used in announcements over the loudspeakers. No agreement could be reached, however, as to which of the two languages should be used to determine the alphabetized order in which the 170 nations competing in the Games would parade their athletes in the opening ceremony. In the end, as a compromise, the programme committee decided on French!

Beneath the glitter of the extravaganza which opened the XXVth Olympics lay a longstanding conflict. Spain, like most modern countries, consists of a number of smaller nations united together in – or dominated under – a single central state. These 'nations' or ethnic groups have their own languages, their own histories, their own cultures. There is a continual struggle between forces seeking to assimilate these peoples and their cultures into the dominant order – Catalonia into Spain, Scotland into Britain, Tartarstan into Russia, Tibet into China, Québec into Canada – and those seeking to ensure their autonomous existence.

History and culture are fundamental aspects of the fabric of everyday life. They help to give us our sense of identity, telling us who we are, where we are from and where we are going. In any society the denial or marginalization of histories and cultures other than those of the dominant group has profound implications for subjectivity and identity. Markers of

history are all around us – in the monuments that adorn our cities, in street names, in museums, in educational syllabuses.

The visitor to the reunited Berlin cannot fail to notice this. When she consults a city map or public transport guide in order to reach the main museums in East Berlin, she looks in vain for Marx–Engels Square station. Like many other stations and street names, it has been changed in an attempt to purge the city of its divided and communist past. Old monuments, for example the massive statue of Lenin on *Leninplatz* (renamed *Platz der Vereinten Nationen* – United Nations Square) have disappeared and new ones have replaced them. Entering the East Berlin *Museum für Deutsche Geschichte* (Museum of German History), the visitor finds that most of the previous exhibits have been either removed, or replaced by temporary exhibitions.

Between 1945 and 1989 two competing versions of German history had confronted each other in the museums of East and West Berlin. Today, this is no longer the case. German history has apparently become one – and it is a history which privileges West German meanings and values. For the third time in 60 years, a sizeable part of Germany finds its past silenced, its culture repudiated, its history rewritten or denied.

Whose culture shall be the official one and whose shall be subordinated? What cultures shall be regarded as worthy of display and which shall be hidden? Whose history shall be remembered and whose forgotten? What images of social life shall be projected and which shall be marginalized? What voices shall be heard and which be silenced? Who is representing whom and on what basis? THIS IS THE REALM OF CULTURAL POLITICS.

Societies contain social divisions, that is, lines of actual or potential conflict between various social groups. All known societies have contained divisions of age, gender and kinship, that is, divisions between young and old, men and women, people from one kinship group and people from another. Further, most societies maintain divisions between themselves and their neighbours. Such divisions are marked by differences in appearance, behaviour and speech. Their reproduction is largely secured through culture, that is, through belief systems, social rituals, ideologies and other modes of intersubjective thinking and acting.

Social divisions rarely divide equals: in any society some groups are more powerful and/or have higher status than others. For example, in most contemporary Western societies, it is generally the case that men exercise greater power and status than women, the wealthy than the working classes, White people than Black people, and so forth. Very often, social divisions are reflections of *social inequality*, that is, differences of wealth, power and/or status. Although many sociologists and all economic determinists tend to forget this point, relations of inequality are closely tied to questions of culture. The relative domination of various groups by other groups is partly secured and reproduced through the

practices and products of cultural institutions. Here we are thinking of examples such as language, the family, the educational system, the media, the law, and religious organizations. It is through these institutions that we learn what is right and wrong, good and bad, normal and abnormal, beautiful and ugly. It is through them that we come to accept that men are better leaders than women, that Black people are less intelligent than Whites, that rich people are rich because they have worked hard and the poor are poor because they are lazy, that the most beautiful women are those with fair skin and blue eyes, that Moslems are fanatical and 'we' are rational, that little boys should play football and little girls should play with dolls, that my clan is better than yours, that the English are cleverer than the Irish, that those who do not share our religion are going to hell . . .

Suppose that within a given society one poses the question: 'Which cultural practices and products are most valued?' The answer is most likely to be this: those of the dominant group and the past traditions with which it aligns itself. Social inequality is *legitimated* through culture. It is through intersubjective modes of thinking and acting that the relative domination of one group over another is made to appear logical, acceptable, 'natural', perhaps even prescribed by God. This is not all that culture does, but it is no small thing.

Just as group domination has its cultural dimensions, so *resistance to domination* must also be rooted in culture and experience, at least, if it is to be successful. Take, for example, the Women's Liberation Movement, or 'Third World' liberation movements. Struggles to achieve political independence or social equality have not been fights simply for formal recognition. They have also been battles to transform the nature of the educational system, to shift the pattern of control in the national media, to rewrite history, to reconstruct human beings. All revolutions – from socialist revolutions to the Women's Movement to Thatcherism – decentre, displace or deconstruct dominant cultural constructions, meanings and values. All seek to realize one aim: to transform human action and being.

The legitimation of social relations of inequality, and the struggle to transform them, are central concerns of CULTURAL POLITICS. Cultural politics fundamentally determine the meanings of social practices and, moreover, which groups and individuals have the power to define these meanings. Cultural politics are also concerned with subjectivity and identity, since culture plays a central role in constituting our sense of ourselves. Cultural struggles often reflect and/or produce deep emotional feelings – feelings of patriotism, elitism, racism, sexism, anti-racism and so on. In other words, they are necessarily connected to subjectivity. The forms of subjectivity that we inhabit play a crucial part in determining whether we accept or contest existing power relations. Moreover, for marginalized and oppressed groups, the construction of new and resist-

ant identities is a key dimension of a wider political struggle to transform society.

This book is concerned with the cultural politics of *class*, *gender* and *race*. (Other topics might have been included, such as the cultural politics of religion, nationalism or ethnicity.) Class, gender and race still profoundly determine access to wealth and social power in the Western world. The continued prevalence of these structures of inequality poses many questions for those who are interested in cultural politics. Such questions include the following:

- What has culture to do with politics, that is, with struggles to acquire, maintain or resist power?
- What role does culture play in reproducing and contesting social divisions of class, gender and race?
- What has happened to traditional class-based cultural politics?
- What are feminist, Black and anti-racist cultural politics?

These are some of the questions which this book seeks to address.

Culture: a Contested Category

Providing a single definition of 'culture' is a very tricky business indeed. 'Culture' is a contested category. Not only does the term have different meanings, it is a concept over whose meaning people are prepared to engage in serious intellectual and political battle. In his writings on the history of the concept 'culture', Raymond Williams has described four contemporary usages.

1 'a general process of intellectual, spiritual and aesthetic development'. (Williams, 1976, p. 80)

This definition of culture underlies the Liberal Humanist view discussed in chapter 2, as well as some of the early Marxist views (for example, in pre- and interwar Britain), which are discussed in chapter 3. It is the sense employed when one says, 'Ms Jones is certainly a cultured person!' or 'Jimmy's definitely got class!' It assumes that culture is something that one acquires and may have more or less of: 'She is more cultured than they are.' It assumes that 'culture' is something that is *cultivated*, that one gets more 'cultured' over time – for example, by reading the right books, attending the right schools, learning the right accent, acquiring the right tastes and so on.

The second usage of 'culture' which Williams identifies is:

2 'a particular way of life, whether of a people, a period or a group' – a way of life that is informed by a 'common spirit'. (Williams, 1976, p. 80)

Here culture is the 'property' not of individuals but of groups (or periods) – of ethnic groups, societies, subgroups. Culture, in this second sense, is in the plural. Here one talks of cultures: for example, 'The peoples and cultures of the old Soviet Union were numerous indeed.' This usage is sometimes referred to as the *anthropological conception of culture*. Actually there are many conceptions of 'culture' in anthropology, but this is certainly the predominant one.[1] Culture in this sense is *not* the primary focus of this book. The point is not that we do not find this sort of 'anthropological' conception useful, rather it is not a major concern of this particular intervention. Accordingly, when we do draw on this conception, the word 'culture' is accompanied by an adjective indicating the relevant group to which it 'belongs': for example, 'Australian Aboriginal culture' is mentioned on occasions in chapter 14.

The third usage of 'culture' identified by Raymond Williams is:

3 'the works and practices of intellectual and especially artistic activity'. (Williams, 1976, p. 80)

As Williams notes, 'This seems often now to be the most widespread use: **culture** is music, literature, painting and sculpture, theatre and film' (p. 80). It is the dominant view of culture found in a range of key cultural institutions, such as the educational system, the media, the academies, publishing, museums and galleries. It is widely used by arts funders and by many humanist intellectuals and artists. *Precisely because it is dominant, this conception of culture largely defines the space in which this book operates.* We are interested in how this definition has worked to exclude and marginalize cultural production by most women, people of Colour and the working classes. We are interested, too, in how these same groups have attempted to claim it in their own interests.

It is important to note that this High Art conception of culture, though widely used, is being increasingly contested. The central effect of this struggle is that the concept 'culture' is being ever broadened to include *popular culture* and the *mass media*, that is, mass-produced cultural forms and practices such as the press, generic fiction, cinema, fashion, radio, television and video. When we use the concept 'culture' in the sense of High Art (usage 3), or in the sense of a 'general process of intellectual, spiritual and aesthetic development' (usage 1), the word will be written with a capital 'C': 'Culture'.

The fourth conception of culture comes out of contemporary cultural studies. (Williams does not discuss this usage in the 1976 book but does in later publications.) In this conception, culture is seen as:

4 'the signifying system through which necessarily (though among other
 means) a social order is communicated, reproduced, experienced and
 explored'. (Williams, 1981, p. 13)

What does this mean? Culture, in this sense, is not a separate sphere, but
a dimension of all institutions – economic, social and political. Culture is
a set of *material* practices which constitute meanings, values and subject-
ivities. The notion of the *constitution of subjectivity* is discussed later in this
chapter as well as in the chapters on feminism and the cultural politics of
racism. Here, we simply note that usage 4 takes two main forms. In its
weaker dialectical form, it suggests that as human beings create culture so
culture creates them. In its strong version, a version which comes out of
structuralist and poststructuralist theory, culture determines subjectivity.

Culture: a Contested Space

Culture is not only a contested concept, it is also a contested space.
Culture consists of material practices which require a certain level of
resources for their realization. Books may be written by putting pen to
paper, though nowadays writers are more likely to use word processors,
but in order to be widely read they must be published and distributed.
Publishing houses, distribution companies, bookshops and libraries form
part of the infrastructure of writing as a form of cultural politics.
 In Britain, the 1970s and 1980s saw the establishment of successful
community projects concerned with producing and distributing working-
class writing and people's history. These projects, examples of which are
discussed in chapter 5, insist on control over the whole process of writing,
publishing and distributing texts. Similarly, as we point out in our chap-
ters on feminist cultural politics (chapters 6, 7 and 8), the Women's
Movement recognized the need to control publication and distribution of
feminist literature, and feminists set up women's presses and women's
bookshops. Control of the means of cultural production and distribution
is also the – as yet unrealized – aspiration of the Australian Aboriginal
writers whose work we discuss in chapter 14.
 Yet there is more still to the cultural politics of literature. Which texts
are bought and read and which are taken up by educational institutions
depends in part on reviews and reception. Here the institutions of literary
and cultural criticism play a crucial role. They, too, are a contested space,
since the values and interests that govern these institutions determine
what is judged as valuable. This was recognized by the left-wing, cultural
journal *Left Review* in the 1930s (chapter 3), as well as by the feminist
cultural activists of the last 20 years (chapters 6 to 8). Access to publishing

relies on particular levels of education and writing skills. In the 1930s, *Left Review* attempted to improve the skills of working-class writers. This was also a major concern of worker-writer circles in the German Democratic Republic (chapter 4) and community publishing projects in Britain in the postwar period (chapter 5). Not surprisingly, it is a feature of feminist cultural politics as well. Recognizing the structural disadvantage that many women suffer, feminists have set up women's writing groups to encourage women to write.

Writing and publishing are clearly a contested space but they are not alone. Similar arguments can be made about other forms of cultural production, such as the visual arts and film. For example, in chapter 6 we look briefly at the area of feminist film-making and in chapters 11, 12 and 13 we discuss cultural struggles around postcolonial art in Britain.

In general, it is fair to say that the spaces that marginalized groups have to negotiate are often very complex. Complicated skills and other resources are required. *Access* to the institutions which control resources and validate cultural products is one key strand of the oppositional cultural politics that we discuss in this book. The other, more radical aspiration is *control* of the institutions which govern the publication, display, distribution and reception of cultural products and practices.

As we argue in detail in chapter 2, cultural institutions in Britain are structured according to a dominant, Liberal Humanist discourse of Culture, which they help to reproduce. Liberal humanism privileges The Individual over social factors or determinants. Art is the product of individual talent and represents an expression of the better aspects of human nature. This view of Culture helps determine both what counts as art and how artists should be. Its effects can be seen in the constitution of cultural traditions as well as in the practice of funding bodies. It determines what is taught in schools and in institutions of higher and further education. It profoundly effects what is widely performed and exhibited in public spaces. It influences who has access to and feels part of this Culture.

The dominant, Liberal Humanist tradition has tended to limit 'Culture' to a selective body of literary and artistic texts, particularly those said to embody 'universal truths and values' and to express a fixed and recognizable 'human nature'. The texts which have become part of the 'great' traditions of art and literature are not only regarded as transcending politics, but also tend to be physically removed from the arena of day-to-day social and political life in libraries, art galleries and museums. These institutions themselves have come to signify the 'non-political' status of 'Culture'.

Who are the great composers, the great figures in the history of music? Bach, Beethoven, Handel, Mozart, Chopin, Lizst, Strauss, Tchaikovsky,

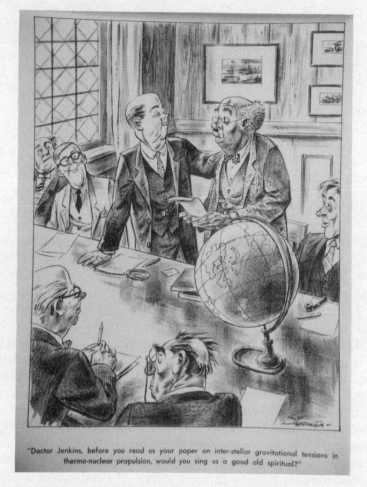

"Doctor Jenkins, before you read us your paper on inter-stellar gravitational tensions in thermo-nuclear propulsion, would you sing us a good old spiritual?"

Plate 1.1 Who are the Great Thinkers?, Oliver Harrington, 1949.
Reproduced by kind permission of the artist. Photograph: Jutta Wrase.

Debussy, Stravinsky, Bartok, Mahler, Schoenberg, Dvorak, Shostakovich, Webern, Copland, Cage. . . .

Who are the great painters, the great figures in modern art? Monet, Renoir, Cézanne, Rodin, Moreau, van Gogh, Munch, Picasso, Braque, Matisse, Kandinsky, Duchamp, Lissitzky, Mondrian, Dali, Magritte, Dix, Klee, Moore, Pollock, Warhol. . . .

Who are the great writers, those most gifted with the pen? Sophocles, Chaucer, Dante, Shakespeare, Goethe, Schiller, Cervantes, Milton, Dickens, Tolstoy, Dostoevsky, Joyce, Yeats, Pushkin, Austen, Eliot, James, Woolf, the Brontës, Beckett, Pinter, Brecht, Grass, Gide, Sartre, Camus, Steinbeck, Lorca, Marquez. . . .

Who are the great philosophers and thinkers? Socrates, Plato, Aristotle,

Aquinas, Bacon, Hobbes, Descartes, Spinoza, Kant, Hegel, Schopenhauer, Nietzsche, Locke, Berkeley, Hume, Rousseau, Vico, Marx, Freud, Kierkegaard, Comte, Mill, Russell, Moore, Wittgenstein, Dewey, Chomsky, Husserl, Heidegger, Sartre, Merleau-Ponty, Adorno, Marcuse, Habermas, Lacan, Foucault, Althusser, Bahktin, Derrida, Rorty. . . .

It is obvious, isn't it? It is White people – mostly White men, actually – who have made the important contributions to civilization and culture. Of course, non-White people have made contributions here and there – Aboriginal rock painting, Eastern philosophy, soul music. And, of course, women have made the odd contribution, such as the fiction of Virginia Woolf or Alice Walker. But surely these achievements do not compare with those of Michelangelo, Socrates, Beethoven or Shakespeare?[2]

The institutions which construct and reproduce cultural traditions and the national heritage work with gendered and racially inflected criteria of skill, crafts(wo)manship and exceptional talent or genius. These are defined by excluding what is seen as 'Other' – for example, popular culture, much work by women, the work of Black and Asian writers and artists, and the so-called 'primitive' art of non-Western cultures. These institutions practice processes of inclusion and exclusion which tend to reflect broader social power relations. They privilege White, middle-class and male interests.[3] *This book looks at responses from the margins to these exclusions.*

Power

In this book we make a scandalous claim: *everything* in social and cultural life is fundamentally to do with *power*. Power is at the centre of cultural politics. It is integral to culture. *All signifying practices – that is, all practices that have meaning – involve relations of power.* They *subject* us in the sense that they offer us particular subject positions and modes of subjectivity. But these subject positions are not all the same. The power relations inherent in a particular signifying practice may be in a state of equilibrium, but more often they involve relations of domination and subordination. We are either active subjects who take up positions from which we can exercise power within a particular social practice, or we are subjected to the definitions of others. The racist discourses discussed in Part IV, for example, allot the power to define Black people to White subjects. White people and institutions do this defining in ways that deny the value of Black people and of their work.

Power enables some individuals and groups to realize for themselves particular possibilities which it denies others. In the area of cultural practice, these include:

1	Spanish Morocco	7	Togoland (Ger.)	13 It. Somaliland
2	Gambia (Br.)	8	Spanish Guinea	14 Mozambique
3	Portuguese Guinea	9	Eritrea (It.)	15 Southern Rhodesia
4	Sierra Leone (Br.)	10	Fr. Somaliland	16 Swaziland (Br.)
5	Liberia	11	Br. Somaliland	17 Nyasaland (Br.)
6	Gold Coast	12	Uganda	

Fig 1.1 The pattern of alien rule in Africa, 1914

- the means to represent oneself and one's interests;
- the means to get one's work published, displayed and distributed;
- the means to define oneself, for example, what it means to be a person of Colour, a woman or working class;
- the means to define meanings and to shape social values.

Each of these areas is integrally related to broader questions of power. These include:

- the power to name;
- the power to represent common sense;
- the power to create 'official versions';
- the power to represent the legitimate social world.

The *power to name*, for example, is central to colonialism. Not only did colonial powers rename countries and peoples, in the process they redrew boundaries, often arbitrarily, leaving a legacy which blights 'Third World' countries to this day (see figure 1.1). The colonial legacy has fed a racist labelling of groups in which people become 'Pakis', 'lazy niggers', 'patriots' or 'the criminal element among us'. (Often such labels are opposed by those so named: these names do not imply consent.)

The *power to represent common sense* implies the power to embody and articulate 'our' basic notions and values. These include, for example, what is right or wrong, good or bad, proper or improper, beautiful or ugly. Perhaps the major achievement of Thatcherism in Britain was the way in which it took over the space of common sense, thereby naturalizing individualism at the expense of the social.

The *power to create official versions*, that is to give authoritative accounts of things, is largely a property of institutions, but it affects all areas of individual and social life. It includes, for example, government statements and surveys, police and media reports, as well as academic narratives of history and ethnography. In racist and sexist societies, what counts as authoritative is an ongoing site of struggle.

The *power to legitimate the social world* implies the power to speak on behalf of respectable, decent society. It is closely allied to the power to represent common sense. In their presidential campaigns, for example, both Nixon and Reagan claimed to represent a 'silent majority' of White, middle-class, God-fearing people who were being ignored, except when being taxed to support the lay-abouts, the Blacks, the welfare cheats, the disloyal, and so on.

In each case, what is at issue is the power to define what things mean. How meanings are defined largely determines who has access to wealth and the social resources that are necessary for a decent life.

Conflicting Discourses: Contested Meanings

Social power manifests itself in *competing discourses*. Discourses are more than ways of giving meaning to the world, they imply forms of social organization and social practices which structure institutions and constitute individuals as thinking, feeling and acting subjects. In this book, we are using the term 'discourse' in the way that it was developed in the later writings of Michel Foucault.[4] Here it signifies forms of knowledge, ways of constituting the meaning of the world, which take a material form, have an institutional location and play a key role in the constitution of individuals as subjects.

This can be seen clearly in our case study of cultural politics in the German Democratic Republic (GDR) in chapter 4. The GDR was a state which set out to realize Marxist–Leninist theory in the social institutions and practices of everyday life. It aimed to transform not only ownership of the means of production (factories, raw materials and so on), but also social institutions and individual subjectivities.

The GDR attempted, for example, to redefine the meaning and practice of 'democracy'. In the Federal Republic of Germany, as in the rest of the Western world, 'democracy' is defined in terms of a liberal pluralism which seeks its legitimation in the rights of the individual to choose between parties at the ballot box. It is a concept of democracy which mostly fails to acknowledge how such structural inequalities as class, gender and race affect democratic structures.[5]

In the German Democratic Republic, 'democracy' signified a system of representation and government in which the policies of the ruling Socialist Unity Party were said to represent the interests of *all* citizens. The basis of this claim was public (that is, state) ownership of the means of production, the abolition of antagonistic class relations and the representation in parliament of all significant social groups, for example, workers, farmers, intellectuals, small business people, women and youth. However, it also assumed the legitimacy of the leading role of the Communist Party in determining what was good for society as a whole. This leading role was guaranteed by Marxist–Leninist theory itself. The full weight of the state cultural apparatuses were invoked in the struggle to convince people of the truth and superior morality of this version of democracy and to encourage people to become committed socialists.

Conflicting discourses of democracy in Eastern and Western Europe were part of political systems which constituted individual subjectivity in particular ways. They defined the meaning of citizenship, freedom and political choice for the individual through the ways in which they organized civil, political and cultural life. Cultural politics were central to

the attempts in Eastern Europe to construct meanings and social values alternative to those of Western capitalism. Since the unification of East and West Germany, much emphasis has been placed by politicians and the media on denying the validity of any claim to democratic status for the institutions and practices of the GDR, which is regularly described as a 'dictatorship'. At the same time, however, many East Germans are now questioning whether Western forms of democracy can actually represent their interests.

Subjectivity and Identity

In the United States of America, generations of children and young people have begun each school day by standing, with hands on their hearts, reciting:

> I pledge allegiance to the flag
> Of the United States of America
> And to the Republic
> For which it stands
> One nation under God
> Indivisible
> With liberty and justice for all.

This apparently harmless ritual goes to the very heart of the question of cultural politics and subjectivity. It recruits children to a particular ideology of what 'America' stands for and what it represents. They become active and apparently willing participants within a discourse that *subjects* them, virtually forcing them to endorse meanings which in many cases conflict with their own experience of American life. Some Black children have their own last line: 'with liberty and justice for *none*'.

The Pledge of Allegiance is part of a discourse of Americanness; one transmitted, in this case, through educational institutions, where it is reinforced by lessons in history and social studies. Discourses can only be effective if they are able to constitute individuals as *subjects*, defined positively or negatively in relation to the norms which they privilege.

Whereas *identity* implies a conscious sense of self, *subjectivity* encompasses unconscious and subconscious dimensions of the self, and implies contradictions, process and change. As we discuss in more detail in chapter 2, common-sense views of subjectivity in the West tend to reiterate certain humanist assumptions: for example, that we are unique, rational individuals born with a human potential which, given the right environment, we can realize through education and personal develop-

ment. We learn about the world through experience and this experience is expressed in language – or so the humanist argument goes. This unproblematic relationship between the individual, experience and language allows little scope for theorizing contradictions either in our sense of ourselves or in the meaning of our experience. Even though social constructions of subjectivity, such as masculinity and femininity, are often contradictory, we are none the less assumed to be whole and coherent subjects with a unified sense of identity.

In order to constitute individuals as subjects, discourses require a material base in social institutions and practices. A wide range of institutions help construct our sense of national identity. In the case of 'Britishness', they include education, the press and television (whether news, drama or documentary), the pageantry of monarchy and the heritage industry. 'Britishness' is never one thing. It is a plural signifier which often carries competing and even contradictory meanings and emotions. None the less, some meanings and emotions are more powerful than others. For example, the dominant construction of 'Britishness' as White has serious implications for those Britons who are excluded or marginalized by it. Not only do dominant constructions of Britishness render non-White Britons invisible, their exclusion becomes the basis for widespread social discrimination on the basis of race.[6]

The degree to which particular meanings are able to affect social practices varies according to how far they are institutionalized and internalized. Racism, for example, affects not only the self-concepts of people of Colour and White people, but also the practice of institutions such as the police and the courts, the schools and the press. Given the institutionalized status of racist discourse and imagery, anti-racist training has made little impact on, for example, police practice. Institutions organize and govern individuals by defining them as particular types of subject – such as school child, prisoner, mental patient, mother or welfare recipient; or teacher, father, 'professional' or 'authority'. Often these subjects are gendered as well as racially and ethnically specific. Any individual will, at different times, live a range of subject positions which are located within relations of class, race and gender.

Institutions define forms of subjectivity, offering particular meanings, social values, emotions, modes of pleasure and conscious and unconscious identity as natural, inevitable or desirable. This can be seen in the construction of both individual and collective identities. *Individual identity* is the target of legal and political practices which constitute us, among other things, as rational autonomous citizens, voters and taxpayers. *Collective identities* may be constituted through membership, chosen or imposed, of a particular organization such as nation, school, football club, army, Women's Institute or prison. It may also be formed by and in resistance to oppressive power relations. This is the case, for example,

with racism, which is examined in detail in Part IV. White racist societies do not give people of Colour a choice in their collective definition as 'Black'.

While racism, sexism and classism impose particular types of collective identity on individuals, resistance is possible. Subject positions that are grounded in alternative meanings of race, gender and class, developed outside dominant institutions, can also be powerful. They act as *sites of resistance* to hegemonic definitions of what people are or should be. Much of the power of extra-parliamentary political movements, such as Women's Liberation, Black Liberation, the Peace Movement and the Green Movement, lies in the alternative forms of subjectivity which they provide. Feminism, for example, offers a range of different ways of being a woman. What they all share is a rejection of patriarchal definitions of femaleness. Black liberation movements, for example, the Black Power Movement in the United States, offer positive forms of Black identity which draw their strength variously from positive images of cultural difference, liberal discourse and Black nationalism. Forms of Black nationalism, in particular, have considerable appeal among Black people because they offer alternative, positive versions of Black history, culture and subjectivity.

As we point out in chapter 2, resistance to racism, sexism and class hegemony has often taken the form of denying difference, whilst emphasizing shared humanity. Women's and abolitionist movements in the nineteenth century, for example, invested considerable political energy in asserting 'sameness'. Activists claimed that all women and people of Colour were equally human, that is, as rational, moral and responsible as (White) men and that they would be their equals if they were given the same opportunities.[7] Inevitably, such political strategies, which rested on liberal notions of the 'human', were later rejected as inadequate by Black liberation movements and by many socialists and feminists. This is because they fail to challenge the material basis of the oppositions between women and men, rich and poor, and Black and White. That is, they do not challenge those social practices which construct and reproduce conscious and subconscious, rational and irrational dimensions of class oppression, racism and sexism.

'Culture' has a powerful role to play in shaping subjectivity and identity because it addresses much more than our rational selves. It helps to constitute the emotions, the subconscious and unconscious dimensions of the individual. Assuming the position of a thinking, speaking, signifying subject involves attributing meaning to experience and opting for one mode of subjectivity amongst others available. The degree to which individuals can 'choose' forms of identity is circumscribed by social power relations. In racist societies, for example, the subject positions open to Black people are often those defined by White institutions and it tends to

be extremely difficult to escape hegemonic definitions of what it means to be 'Black'.

Yet culture is an important site of resistance. Visual art, literature, film, history writing and other cultural practices can offer the possibility of new forms of identity in which 'female' or 'Black' or 'working class' gain new and positive meanings. Forms of subjectivity that resist oppressive definitions are an important prerequisite for broader political struggle.

The Postmodern Challenge

For some years now, *postmodernism* has been at the centre of debates about culture and politics.[8] What does *postmodernism* question?

Postmodernism puts into question some of the most basic assumptions and beliefs which have, up until now, been fundamental to cultural politics both in the West and in 'socialist' countries such as the GDR. These assumptions include the belief in automatic progress based on rational planning, education and legislation, the existence of universal standards and values, and the possibility of 'true' knowledge of the world. The theoretical rationale of much postmodernist thought can be found in poststructuralist modes of social and cultural analysis and its concerns are echoed in postmodern cultural practices.[9]

Poststructuralist theorists have suggested that knowledge is always partial – in a double sense: that is, knowledge is both incomplete and necessarily connected with interests. It exists in many competing forms which represent conflicting groups and interests. Poststructuralism and postmodernism hold that knowledge should be judged not by reference to truth claims but, rather, in relation to its social effectivity – in other words, its effects in the world.

Postmodern thinking has questioned the authority of traditional guarantees of meaning – such as religion, science, nature and experience. In the struggle over meanings and social power, interest groups often attempt to establish their own legitimacy and hegemony by asserting that particular meanings are true, inevitable or unchangeable. This is the case, for example, with the Liberal Humanist cultural politics discussed in chapter 2. Different social groups appeal to general theories or *meta-narratives* which claim to offer true accounts of the world. Such theories can be found in science, religion, philosophy and social theory. They include, for example, the Enlightenment conception of human progress, which is fundamental to Liberal Humanist cultural politics, Marxist theories of history and revolution, radical feminist theories of patriarchy, Black nationalist theories of race and culture, and theories that emphasize the primacy of experience and common sense. *A crucial question in cultural*

politics is whether effective intervention that is aimed at transforming social relations must, of necessity, appeal to general theories.

The challenge of postmodern thinking has profound implications for cultural politics. Until recently, Liberal Humanism and Marxism were the major theories that grounded cultural politics in Western societies. Examples of such cultural politics are discussed in chapters 2 to 4. In the 'postmodern' world, the certainties that they provided have been put into question. Liberal and Marxist perspectives, with their specific assumptions and truth claims, have come to be seen as competing versions of reality. Like other perspectives, such as feminism or Black nationalism, they have particular implications for how societies are organized.

The Book

In this book, we are concerned with culture as a key site in the political struggle to reproduce and transform power relations. Cultural politics focus on struggle over meanings, values, forms of subjectivity and identity. We continue Part I with a discussion, in chapter 2, of dominant cultural assumptions and practices in the West. Taking Britain as an example, we argue that the dominant cultural institutions are, overwhelmingly, Liberal Humanist, sexist, racist and Eurocentric. In particular, we argue that the Liberal Humanist tradition both shapes conceptions of culture and determines the nature of education, arts funding and cultural provision. It also influences how we are taught to read, what we are taught to read for and why. We look at the assumptions which underpin Liberal Humanist cultural policy. We take, as examples, the development of Liberal Humanist cultural and educational theory in Britain between 1860 and 1945, and postwar Liberal Humanist funding policy. We examine some of the arguments advanced by critics of Liberal Humanism and ask what kind of space Liberal Humanism offers for cultural political struggle.

In Parts II, III and IV, we look at responses to dominant images, narratives and other practices from the margins. We concentrate on those areas defined as important by the dominant cultural institutions: HISTORY, LITERATURE and VISUAL ART, and we examine responses to them which privilege power relations of class, gender and race.

Part II is concerned with questions of culture and class. Chapter 3 focuses on art and literature as weapons in class struggle in Britain up to the Second World War. Here we look at the competing conceptions of the role of culture in the British socialist tradition: for some it was the key to individual development, for others it played a central role in the struggle

for socialism. The chapter offers a detailed case study of the debates about culture and class and the promotion of working-class and socialist writing in the radical monthly journal *Left Review* (1934–8). We close the chapter with a consideration of the nature of socialist cultural politics up to 1939, setting an agenda against which to examine developments in the postwar period.

In chapter 4, we turn to Marxist–Leninist approaches to culture and class after 1945. The chapter takes the example of cultural politics in the German Democratic Republic where Marxist–Leninist cultural and political theory moved from its interwar position on the margins to centre stage. We ask: What was the official role of culture? What was the relationship between the individual and culture? How did socialist realist aesthetics function in theory and practice? We look at cultural provision, amateur art, culture as a site of resistance and assess the strengths and weaknesses of cultural policy.

Chapter 5 is about history as cultural politics. The first part of the chapter, a dialogue with historians, poses questions such as these: What is History? How is the past a site of cultural struggle? Can History be democratized? The remainder of the chapter looks at history *for* the working class and then turns to 'history from below'. We focus on the objectives and struggles of two community-based projects: Centreprise in Hackney, East London, and the Butetown History & Arts Centre based in the old docks community – Tiger Bay – in Cardiff.

In Part III, we look at feminist cultural politics. Chapter 6 offers an overview of recent developments in feminist thinking about culture and politics. We look at examples of feminist cultural initiatives – film and video and Women's Studies – and at the recent shift away from forms of feminism founded on liberal humanist, Marxist or radical feminist certainties to a concern with differences between women. The chapter considers the current debate about feminism and postmodernism and then looks in some detail at Black and 'Third World' feminist perspectives and their implications for feminist cultural politics.

In chapters 7 and 8, we look at recent women's fiction as a site of feminist cultural politics. We analyse examples of feminist fiction by Black, Asian and White women writers in Britain and the USA. We look at how they address questions of sexism and racism and ask: What is the relationship between modes of writing and the politics of subjectivity?

In Part IV, we consider the cultural politics of race. Chapter 9 looks at classical racism and its legacy. We ask: How does racism create its subjects? We look at the claims that racist discourse makes about Black and Asian female and male bodies, about character and intellect. We bring together classic examples of racism from the last four hundred years with examples of contemporary practices and representations. We

ask: What does racist discourse have to say about the culture and history of Europe's Others? We consider the meaning and status of race in current postmodern thinking which claims to celebrate difference.

Chapters 10, 11, 12 and 13 are detailed studies of the cultural politics of racism as it affects the art world. We look at hidden and marginalized histories of encounters between the West and its Others. What concerns us is how dominant cultural institutions have conceptualized 'Art' and 'The Artist' and, in particular, how they have used these categories as a basis for drawing boundaries and reproducing relations of power.

In chapter 10 we ask: How has modern Western art related to art and culture from the non-White world? Through case studies, we explore how artistic products, aesthetic principles and cultural values from Africa, the Pacific and Native America – from so-called 'primitive' and 'tribal' societies of the 'Third World' – have been received and valued within the Euro-American art world.

In chapter 11, through a series of reflective dialogues, we examine in more detail the racial politics of the European avant-garde in twentieth-century art.

Chapter 12 asks: How has modern Western art related to non-White artists? That is, to what extent and in what ways have the cultural politics of race structured the relations between the modernist art establishment and Artists of Colour? We look at examples of the lives and works of postwar Artists of Colour in Britain. Utilizing a series of biographical narratives, primarily from the exhibition catalogue *The Other Story* (Araeen, 1989) and the journal *Third Text*, we raise profound questions about the politics of race in an officially liberal and cosmopolitan environment.

Chapter 13 focuses on debates, primarily involving Artists and Critics of Colour, in *Third Text*. Drawing on certain insights from Michel Foucault about knowledge and power, it asks: What is 'Ethnic Art'? How is it positioned within the cultural politics of race?

In chapter 14 we looks in some length at the case of Australian Aboriginal writing. We ask: What are its themes? What questions does it pose about the role of history, identity and fiction in the struggle against racism and for dignity? We offer detailed readings of texts by three authors, Archie Weller, Sally Morgan and Colin Johnson, and consider the broader cultural political questions facing writers and artists of Aboriginal descent.

Part V contains the concluding chapter, 'The Postmodern Challenge/Challenging Postmodernism: A Cultural Politics for Today'. We ask: What are the important questions and issues which emerge from the various case studies in Parts I to IV? We ask: What are the central issues raised by postmodernism? We further ask: How do the two sets of issues and questions relate to one another? What light can postmodern theory

and practice throw on the cultural politics of class, gender and race? Where is it inadequate or even dangerous?

While *Cultural Politics* is not primarily another book about postmodernism, we attempt to take seriously issues raised by postmodern theory and practice and to offer a critical perspective on the relationship between postmodernism and cultural politics of class, gender and race.

2

Liberals and Humanists, Cosmopolitans and Eurocentrics: on the Development of Cultural Policy in Britain

What are the dominant cultural and political discourses of the modern era in the West? Surely the answer is LIBERALISM and HUMANISM. They have helped shape political, social and cultural institutions in Western societies and in many other parts of the world.[1]

Over the past 150 years, but especially since the Second World War, Liberal Humanist cultural values have come to dominate the most important cultural institutions in Britain: schools, the academies, museums, galleries, the BBC, the practice of arts funding bodies. They have determined what counts as valuable culture and, generally speaking, who has access to the means of cultural production, distribution and legitimation.

Liberal philosophy is characterized by a belief in the inalienable rights of the individual to realize him- or herself to the full. *Humanism* is characterized by the belief in an essential human nature and in the power of reason to bring about human progress. Both Western forms of democracy and capitalist economic and social relations rely on liberal concepts of the sovereign, rational individual and on the related concept of 'free will'.[2] Humanism, which in various forms has a long history, dating back to the early Renaissance, has over the past few centuries been closely interconnected with the development of liberalism, which is a more recent philosophy. Together these world-views have given rise to a powerful theory

in which Culture plays a privileged role in the development of The
Individual.

 In this chapter, we look at Liberal Humanist ideas about the Individual
and Culture, and at the types of cultural politics which Liberal Humanist
thinking has produced. Examples are taken from pre- and postwar Britain
and include education and current arts funding. We ask what kind of
space Liberal Humanism offers those on the margins of the dominant
culture to realize their own cultural needs.

From Matthew Arnold to Cultural Diversity

Below are two quotations. Both are OFFICIAL VOICES, strategic interven-
tions spoken from positions of power. Both concern fundamental issues,
issues of the role of Culture, the arts and education in society. The first
passage, written in the 1860s, is from *Culture and Anarchy*, a polemical text
by the English cultural critic (and inspector of schools) Matthew Arnold.
The second, written some 125 years later, is from a policy document
drawn up by the National Arts and Media Strategy Monitoring Group.
The Group – consisting of nominees from the Arts Council of Great
Britain, the British Film Institute, the Craft Council, the Regional Arts
Associations and local government – was given the task of drawing up a
national arts strategy for Britain in the 1990s. Read these passages care-
fully. These are not useless statements from Ivory Tower intellectuals.
Rather, they are important interventions in cultural politics, attempts to
substantially influence cultural policies and practices. Here is Matthew
Arnold speaking:

> Culture seeks to do away with classes; to make the best that has been
> thought and known in the world current everywhere; to make all men live
> in an atmosphere of sweetness and light, where they may use ideas, as it uses
> them itself, freely – nourished and not bound by them.
> This is the social idea; and the men of culture are the true apostles of
> equality. The great men of culture are those who have had a passion for
> diffusing, for making prevail, for carrying from one end of society to the
> other, the best knowledge, the best ideas of their time. (Arnold, 1875 (1st
> edn 1869), p. 44)

Here is our second Voice of Power – that of key players in dominant
cultural institutions in contemporary Britain:

> Education through the arts fosters creativity in areas beyond the arts, culti-
> vates the imagination and develops manipulative skills and critical judge-
> ment. . . . We believe that a civilised society is one which values the arts and

artists, which encourages people of all ages to develop their creative talents and potential either to make their careers in the arts or for their personal development and pleasure, and which provides continuing opportunities to understand and enjoy the arts. (National Arts and Media Strategy Monitoring Group, 1992, pp. 75–6)

Towards Cultural Democracy

What do the voices in these two passages have to say? Let us note, first, that they are expressions of a DEMOCRATIZING ATTITUDE. That is, both statements take up positions that push towards CULTURAL DEMOCRACY.

Take Matthew Arnold. In nineteenth-century Britain, Utilitarianism, the ideology of the rising bourgeoisie, was, as you Cultured readers will know, a major force in intellectual and social life. One of the main arguments of the Utilitarians was that the purpose of education is to train people to carry out specific tasks in society

A VOICE: This sounds familiar, like Britain under the Thatcherites

Matthew Arnold was wholly opposed to such a view. He argued that Culture brings ENLIGHTENMENT, an enlightenment which *transcends social divisions* such as class (or religion, ethnicity, race or gender).

Culture, for Arnold, is far more important than wealth. Listen as he comments disparagingly on the Cultural deprivation of the new rich, the nineteenth-century capitalist-utilitarians:

Culture says: 'Consider these people then, their way of life, their habits, their manners, the very tone of their voice; look at them [these Uncultured capitalists] attentively; observe the literature they read, the things which give them pleasure, the words which come forth out of their mouths, the thoughts which make the furniture of their minds; would any amount of wealth be worth having [if as a consequence] one was to become just like these people . . . ?' (Matthew Arnold, *The Two Paths*, 1887, pp. 129–31; quoted in Williams, 1961, p. 125)

AN ARNOLDIAN VOICE: I'd rather have Culture than silver or gold.
SOME CYNIC'S RESPONSE: You can't eat Culture, nor does it pay your bills

The idea that Culture is the path to Enlightenment and Self-realization is central to what has come to be known in recent years as the LIBERAL HUMANIST TRADITION. People everywhere share a common (more or less developed) *human nature*. Culture, Arnold and other liberal humanists maintain, offers all individuals the means to realize this human nature to the full by developing their intellectual and moral life.

Only the Best Will Do

Simply the best,
Better than all the rest . . .
— Tina Turner

How does this wondrous self-development occur? Through liberal educa-
tion and the arts.

Culture transmits the *best* ideas and values of a particular age – ideas
and values that transcend social and cultural differences. Through the
medium of EDUCATION, Liberal Humanist cultural policy makes these
ideas and values accessible. The task of education is to make available to
the population at large 'the best that has been thought and known'. The
task is to develop 'cultivated minds' and 'cultivated tastes'. The standard
for the human mind and spirit is PERFECTION. Listen to John Henry New-
man, who was to Matthew Arnold as John the Baptist was to Christ:

> There is a physical beauty and a moral: there is a beauty of person, there is a
> beauty of our moral being, which is natural virtue; and in like manner there
> is a beauty, there is a perfection, of the intellect. There is an ideal perfection
> in these various subject-matters, towards which individual instances are
> seen to rise, and which are the standards for all instances whatever. (J. H.
> Newman, *On the Scope and Nature of University Education*, 1852, pp. 197–8;
> quoted in Williams, 1961, p. 121)

'Beauty, . . . morality, . . . virtue , . . . intellect, . . . perfection, . . . (univer-
sal) standards' – here in a nutshell are virtually all of the values of the
West's well-established dominant cultural institutions. Think of the BBC,
Oxford University, Harvard, London's Museum of Mankind, New York's
Museum of Modern Art, the Tate Gallery, the Louvre . . .

Thanks to the benevolent institutions of Western colonialism, neo-
colonialism and cultural imperialism, the potential for this enlightenment
and perfection is not simply limited to individuals within Western so-
cieties. It is available to all the world's peoples.

THE SLAVE: For all of your goodness, Master, we are truly grateful . . .

Not Cultures but Culture (with a Capital 'C')

The cultural politics we have been discussing is LIBERAL in its insistence
on the rights and potential of all individuals to benefit from Culture,

whatever their class, gender or social background, and HUMANIST in its belief in the power of Culture to bring enlightenment and, with it, human progress.

It is also COSMOPOLITAN in its outlook: its concern is only for the best ideas and values, regardless of their place or culture or origin.

Or so it would appear.

Actually, despite its altruistic, enlightened rhetoric, Liberal Humanism is quintessentially EUROCENTRIC. All of Arnold's 'great men' and 'great ideas', all of his 'sweetness' and 'light', are Western European. Indeed, this is what one virtually always finds when one probes beneath the cosmopolitan rhetoric of Western liberal intellectual and cultural life.

> TRUTH: While proclaiming to be Universal, Western civilized 'Man' and European cultural values are privileged.
> A VOICE: We are being conned – again. This is a cultural politics of deception . . .

That is why Arnold and the (traditional) Liberal Humanists talk of Culture (capitalized and in the singular), never of cultures.

By the time the passage from the *National Arts and Media Strategy* was being written (the early 1990s), the world had changed considerably. One consequence of this is that notions of a monolithic 'Western Culture', 'English Culture', 'British Culture' and so on have been massively contested. And, in many corners at least, they are no longer part of the received wisdom. Here is the National Arts and Media Strategy Monitoring Group reminding their peers – other members of the official Cultural Establishment – of the new line on the question of Culture:

> The United Kingdom is made up not of a single culture, but of a multiplicity of cultures, cultural groups and interests . . . part of the individual's sense of identity arises from the groups to which they belong. 'British culture' is neither a single concept nor a set of neat packages labelled 'youth culture', 'women's culture' and so on: it is a kaleidoscope, constantly shifting and richly diverse. (National Arts and Media Strategy Monitoring Group, 1992, p. 55)

In recent years, dominant cultural institutions have taken up the language of *diversity* and *plurality*. Many intelligent Liberal Humanists have started talking about cultures (small 'c' and plural), rather than Culture – though, one suspects, not without a degree of regret.

Since the late 1960s, in the USA, Britain, Australia, Canada, France and many other Western countries, the elitism, ethnocentricity and racism of dominant cultural traditions have been repeatedly challenged – at the levels of policy and institutional practices. In the 1980s and 1990s,

'CULTURAL DIVERSITY' has become a key concept in cultural policy, tending
– certainly in Britain – to replace 'multiculturalism' in the policy state-
ments of arts policy-makers and funders. Of the two terms, cultural
diversity is perhaps potentially a more progressive concept. It does not
necessarily link culture to sexual origin, race or ethnicity, and thereby
avoids the danger of ghettoization lurking in some versions of 'multicul-
turalism' and 'ethnic arts'.

Continuities, Shifts and Tensions

One of the most interesting features about the passage initially quoted
from the *National Arts and Media Strategy* is that, although it is all about
Culture, the word itself does not appear. The concept of 'culture', even
with a small 'c', is a hotly contested terrain.

In addition to the shift to a rhetoric of plurality, there is sometimes an
abandonment of the term. But does this mean that the old notions – which
yielded elitist, sexist and Eurocentric cultural policies and practices –
have been abandoned? Suppose, for example, one asks: Given the new
rhetoric of the Arts Council of Great Britain, has there been a fundamental
shift in terms of which arts and cultural organizations receive the most
money?

We shall pursue this question, and related ones, later in this chapter.
First, we must consider other dimensions of the politics of Liberal Hu-
manism.

Freedom and Control

Preamble to the American Declaration of Independence

*We hold these truths to be self-evident, that all men are created equal, that
they are endowed by their Creator with certain inalienable Rights, that among
these are Life, Liberty and the pursuit of Happiness.*
 — Signed Thomas Jefferson & Co., 4 July 1776

*I think I have somewhere related how M. Michelet said to me of the people
of France, that it was 'a nation of barbarians civilised by the conscription'.
He meant that through their military service the idea of public duty and
discipline was brought to the mind of the masses, in other respects so raw
and uncultivated. Our masses are quite as raw and uncultivated as the
French.*
 — Matthew Arnold, *Culture and Anarchy*, 1875, p. 52

Reason, the Individual and Struggles for Freedom

Over the last few centuries, both liberalism and humanism, in their various forms, have often been forces for positive social change. Liberalism's insistence on the RIGHTS OF THE INDIVIDUAL has been a basis for the emancipation of groups initially excluded from the civil and political rights gained by men – or rather White men of the property-owning classes – in the process of the emergence of modern Western states. Today, it is still the intellectual basis for a wide range of social and cultural practices which constitute individuals as apparently free, autonomous and rational subjects. And, as a political and moral philosophy, it continues to offer the promise of self-determination and freedom to people who are denied civil and political rights.

Liberal Humanist discourse maintains that *all people share essential human qualities and deserve respect and the opportunity to realize their full potential.* This philosophy is an important basis for concepts of universal human rights as espoused, for example, by the United Nations and innumerable organizations and pressure groups.

But what are these 'universals'? How do we discover them? How do we ensure that they are respected?

The content of the 'universal human rights' in question are, as it turns out, mostly the product of particular historical moments in the development of Western societies. Despite the all-inclusive claims made for these rights, they have mainly functioned, historically, on behalf of quite specific bourgeois, White, male interests. They have often privileged the wealthy at the expense of the poor, 'Man' at the expense of Woman, European interests at the expense of Others.

However, they do not have to do so.

While dominant forms of humanism, both liberal and socialist, have privileged European thought and values, they have also served strategically to legitimate movements for civil rights and struggles for national liberation in non-Western countries. Consider, for example, the anti-colonialist movements of the first half of the twentieth century; consider the movements against the totalitarian state in Eastern Europe of the second half. The abandonment of any universal concept of human rights and its replacement by cultural relativism, as demanded periodically at the United Nations by various authoritarian and retrograde states (and implicitly endorsed by certain chic 'postmodernists' who have forgotten about power), would seriously undermine oppositional struggles for legitimate rights, dignity and freedom.

The last 300 years have seen a vast number of struggles by marginalized and excluded groups to gain access to the rights and dignity which Liberal Humanism offers its subjects. Indeed, it is Liberal Humanism's

very claim to represent universal values which has legitimized these struggles.

Consider struggles for civil and human rights for women. Until the early decades of the twentieth century, 'universal' rights virtually always meant rights for property-owning, White males. Most women, together with most poor people and those Others who happened to have been born without the benefit of white skin, were excluded from the rights and duties which liberalism, in its institutional forms and practices, bestowed. Women in the enlightened West, whatever their class or colour, had no vote, few rights under the law, little access to education or the professions.

> QUESTION: Why was this so?
> COMMENSENSE: The answer is as clear as it is logical. Women are inferior to men, certainly as regards rationality and grasp of ethical values.[3]

In response to this, women in the West, of various classes and colours, have long made use of Liberal Humanist arguments in their fight for civil rights and equal social status with men. From the birth of liberalism to the present day, feminists have argued that sexual difference should not determine how one is regarded as a human being.[4] Writing at the time of the French Revolution, Mary Wollstonecraft attempted to extend Thomas Paine's *Rights of Man* (Part One, 1791; Part Two, 1792) to women. She argued in *A Vindication of the Rights of Woman* (1792) that given the right opportunities, women would be as rational and capable as men. In doing so, she set the framework for much subsequent feminist activism. These arguments find an echo in Germany 80 years later when Hedwig Dohm advocated women's right to education, the vote and professional work.[5]

Similarly, over the course of the last 200 years in the USA, Black activists, engaged in the struggle for emancipation, have recurrently used Liberal Humanist language to argue for equality. Listen to the rhetoric and passion of the two speeches partially reproduced below. The first is the voice of a Black American activist, intellectual and feminist speaking in 1893. The second is the voice of America's prophet in Babylon – the Dreamer who was slain – speaking 70 years later.

Our Cause Is One, Our Rights Are Inalienable
Anna Julia Cooper, early Black American activist and feminist

We take our stand on the solidarity of humanity, the oneness of life, and the unnaturalness and injustice of all special favoritisms, whether of sex, race, country or condition. . . . The coloured woman feels that woman's cause is one and universal; and that . . . not till race, colour, sex and condition are seen as accidents, and not the substance of life; not till the universal title of humanity to life, liberty and the pursuit of happiness is conceded to be inalienable to all; not till then is woman's

lesson taught and woman's cause won – not the white woman's nor the black woman's, not the red woman's but the cause of every man and of every woman who has writhed silently under a mighty wrong.
 — Excerpt from a speech made in 1893 by Anna Julia Cooper[6]

Let Freedom Ring
Martin Luther King Jr

So I say to you, my friends, that even though we must face the difficulties of today and tomorrow, I still have a dream. It is a dream deeply rooted in the American dream: that one day this nation will rise up and live out the true meaning of its creed –

> We hold these truths to be self-evident,
> that all men are created equal.

I have a dream that one day on the red hills of Georgia, sons of former slaves and sons of former slave-owners will be able to sit down together at the table of brotherhood.

I have a dream that one day, even the state of Mississippi, a state sweltering with the heat of injustice, sweltering with the heat of oppression, will be transformed into an oasis of freedom and justice.

I have a dream my four little children will one day live in a nation where they will not be judged by the color of their skin but by the content of their character. I have a dream today! . . .

I have a dream that one day every valley shall be exalted, every hill and mountain shall be made low, the rough places shall be made plain, and the crooked places shall be made straight and the glory of the Lord will be revealed and all flesh shall see it together. . . .

With this faith we will be able to hew out of the mountain of despair a stone of hope. With this faith we will be able to transform the jangling discords of our nation into a beautiful symphony of brotherhood.

With this faith we will be able to work together, to pray together, to struggle together, to go to jail together, to stand up for freedom together, knowing that we will be free one day. This will be the day when all God's children will be able to sing with new meaning:

> My country 'tis of thee,
> Sweet land of liberty –
> Of thee I sing.
> Land where my fathers died,
> Land of the pilgrim's pride –
> From every mountain side,
> Let freedom ring.

—Excerpt from Martin Luther King Jr, 'I Have a Dream': speech at the March on Washington (in the shadow of the Lincoln Memorial), 28 August 1963

It should never be forgotten that the politics of Liberal Humanism have a progressive, liberating side. This is the lesson that Martin Luther King understood so well – and thus he turned the rhetoric of 'The Land of the Free' against its deeply engrained practices of racism and oppression.

> TRUTH: It is foolish indeed to belittle the importance in the modern world of concepts like *the dignity of the individual* and respect for *universal human rights*. To abandon such notions may well be to allow for future holocausts. Cultural relativists and naive postmodernists beware

But it does not follow that Liberal Humanism (or Socialist Humanism) is an innocent philosophy, that the application of its dictates is necessarily freedom. Liberal and Socialist Humanism have a progressive, liberating side, but this is not their only side. Liberals, socialists and humanists have been known to be colonialists, Eurocentrics and racists. Perhaps this is less anomalous than it appears.

Humanism and Eurocentrism

The Oxford literary critic Robert Young is right to point out, in his courageous book *White Mythologies: Writing, History and the West*, that:

> European thought since the Renaissance would be as unthinkable without the impact of colonialism as the history of the world since the Renaissance would be inconceivable without the effects of Europeanization. (Young, 1990, p. 119)

And that:

> Every time a literary critic claims a universal ethical, moral, or emotional instance in a piece of English literature, he or she colludes in the violence of the colonial legacy in which the European value or truth is defined as the universal one. Ibid., p. 124)

Drawing on the work of Aimé Césaire, Frantz Fanon and Jean-Paul Sartre, three of the twentieth century's most gifted and committed thinkers, Young argues that European systems of thought – crucially humanism and liberalism – have long operated 'as the effect of their colonial other' (ibid., p. 119). This reversal is encapsulated in Fanon's concise observation: 'Europe is literally the creation of the Third World' (Fanon, 1967, p. 81).

Europe's self-image has consistently been defined in opposition to a less civilized, non-European 'Other'. Furthermore, as we argue in more detail

below and in Part IV of this book, the ideology of the civilized and progressive West has served to justify some of the most exploitative and brutal practices in human history.

Today, many in Europe complain about the presence of brown-skinned 'foreigners'. They conveniently forget that the economic prosperity of the modern West would be unthinkable without the benefits of slavery and colonialism, that our way of life was largely accomplished at the expense of the 'Third World'.

This Eurocentrism has not only affected the practice of dominant Western institutions, it is intrinsic to Western political movements for human rights and liberation. For example, in their theory as well as in their practice many Western feminists employ universals drawn from liberal discourses of emancipation. Yet, as Black and 'Third World' feminists have powerfully argued, these 'universals' are often experienced negatively by groups who are not White, Western or middle class.

This is precisely because, despite the clever disguise, the content of liberal 'universals' is never universal. The 'Humanity' – or, as it has most often been put, 'the Man' – of which it speaks is always historically specific, always fractured by power relations of inclusion and exclusion based on class, gender, race, ethnicity or some other invidious distinction. Much of the struggle of marginalized groups to use Liberal Humanist terms has involved giving them a modified content.

Many have abandoned the discourse of Liberal Humanism altogether, having seen the White faces behind the non-racialist masks. It is not simply that the colonized and oppressed have improved their perceptive powers. Rather, it is that history is no longer White:

> Europe is springing leaks everywhere. What then has happened? It is simply that in the past we made history and now it is being made of us. The ratio of forces has been inverted; decolonization has begun; all that our hired soldiers can do is to delay its completion. (Sartre, 1967, p. 23)

Humanism and Racism

It is not simply that Liberal (and Socialist) Humanists are virtually always Eurocentrics. From the perspective of those who have been trampled underfoot by Western colonialism and racism, Eurocentrism is a relatively small problem. There is a larger, virtually hidden problem, and we wish to address it: liberals and humanists are implicated in slavery, racism and colonialism, in barbarous destruction of civilizations, in large-scale murder.

In his classic work, *The Wretched of the Earth* (*Les Damnés de la terre*), Frantz Fanon, the Martinican psychiatrist who joined the freedom

struggle of the Algerian people against the colonial French, has much to say about humanism. (You will probably not have encountered him in your courses at school or university. He was not an Ivory Tower scholar but a serious activist-intellectual.) What does Fanon have to say? He reminds us that the West is a place 'where they were never done talking of Man, and where they never stopped proclaiming that they were only anxious for the welfare of Man'. And then he continues: 'today we know with what sufferings humanity has paid for every one of their triumphs of the mind' (Fanon, 1967, p. 251).

We are compelled by the evidence to agree with Aimé Césaire, that other brilliant activist-scholar from Martinique, when he says in *Discourse on Colonialism* that the West, despite its self-congratulatory proclamations and other displays of self-righteousness, 'is morally, spiritually indefensible'. There was a time when the damned of the earth did not know this. But now we do: 'today the indictment is brought against' the West 'on a world scale, by tens and tens of millions . . . who, from the depths of slavery, set themselves up as judges' (Césaire, 1972, p. 10).

Perhaps Césaire and Fanon, who are Black and thus obviously prone to assume ridiculously biased positions, have overstated the case. Jean-Paul Sartre is one of the Great Thinkers – the Great White Men – in the Liberal Humanist pantheon. Let us hear what he has to say on these matters:

> liberty, equality, fraternity, love, honour, patriotism and what have you. All this did not prevent us from making speeches about dirty niggers, dirty Jews and dirty Arabs. (Sartre, 1967, p. 22)

Sartre refers to the Western discourse of liberalism and humanism as 'chatter, chatter' (ibid.).

Surely, you say, 'There is some mistake here. Such talk, the voice of racism, is wildly at odds with the best of Western thought. It has no affinity with the theory and practice of liberalism and humanism.' If this is your response, then you are either dishonest or duped. Listen again to Sartre, who, unlike many of us, was never afraid to speak truth to power:

> High-minded people, liberal or just soft-hearted, protest that they are shocked by this inconsistency; but they were either mistaken or dishonest, for with us there is nothing more consistent than a racist humanism since the European has only been able to become a man [i.e., a human] through creating slaves and monsters. (Ibid.)

It should come as no surprise that Thomas Jefferson, author of one of the greatest statements of human rights ever written, was a slave master. Slavery and colonialism have often been swept under the carpet or explained away by clever tricks of logic. Confronted with the problem of

how one could believe in universal humanism, the 'rights of men' and so on, while colonizing, enslaving, raping and murdering the native peoples of Africa, Asia and the Americas, the clever Westerner established the following logical principle:

Principle 1. *Those without white skins are not human beings.*

Where this logical principle was inadequate – for example, in the consciousness of the liberal colonialist, a second solution was proposed:

Principle 2. 'Bourgeois ideology . . . which is the proclamation of an essential equality between men, manages *to* appear logical in its own eyes *by inviting the sub-men to become human, and to take as their prototype western humanity as incarnated in the western bourgeoisie.'* (Fanon, 1967, p. 131)

To tell the truth, 'Humanism is the counterpart of racism: it is a practice of exclusion' (Sartre, 1976, p. 752). We do not claim that humanism and liberalism can be reduced to racism, that that is all they are. Our argument, based on overwhelming evidence, is positioned against the often-made assumption that racism is a phenomenon of right-wing extremists, of 'uncultured' reactionaries. We are opposed to those simplistic conceptions which assume that liberal and leftist political positions are not implicated in racism. In particular, we are arguing here that Liberal Humanism – the grounding assumptions for more than a hundred years of most dominant Western educational and cultural institutions – is an ideology which masks a history of which we have no reason to be proud: 'in the notion of the human race we found an abstract assumption of universality which served as cover for the more realistic practices' – of slavery, of colonialism, of racism, of barbarity (Sartre, 1967, p. 22).

The following words should come as no surprise: 'When I search for Man in the technique and the style of Europe' – that is to say, the West – 'I see only a succession of negations of man, and an avalanche of murders' (Fanon, 1967, p. 252).

Because Fanon knows that, whatever their merits, Western humanism and liberalism are ultimately fraudulent, he advises men and women of Colour to seek their salvation elsewhere:

Come, then, comrades; it would be as well to decide at once to change our ways Let us waste no time in sterile litanies and nauseating mimicry. Leave this Europe where they are never done talking of Man, yet murder men wherever they find them, at the corner of every one of their own streets, in all the corners of the globe. For centuries they have stifled almost the whole of humanity in the name of a so-called spiritual experience. Look at them today swaying between atomic and spiritual disintegration

> So, my brothers [and sisters], how is it that we do not understand that we
> have better things to do than follow that same Europe? . . .
> Come, then, comrades, the European game has finally ended; we must find
> something different. (Fanon, 1967, p. 251)

Culture as Control

But let us return to Liberal Humanism in the West and its cultural politics.
'My theory is at least as much about control as it is about self-realisation
and freedom. Because of some of the rhetoric I use, you and many others
have been duped. For that I am grateful.' That is what Matthew Arnold
told us the other day, as we were working through the material for this
chapter.

Unlike so many intellectuals today, Matthew Arnold was serious. His
book, *Culture and Anarchy*, is explicitly about politics. Subtitled 'An Essay
in Political and Social Criticism', the book is about the relation of Culture
(and the State) to social unrest and social cohesion. Arnold's central thesis
is this: provide the working classes with CULTURE or there will be ANARCHY
or even social(ist) REVOLUTION.

He acquired some of his best ideas from his famous father, Dr Thomas
Arnold, headmaster of the prestigious Rugby School for Boys. Here is the
father writing in the 1830s: 'I call the great evil of England [that] unhappy
situation in which the poor and the rich stand towards each other.' And
again: 'Education, in the common sense of the word, is required by a
people before poverty has made havoc among them' (quoted in Williams,
1961, p. 123).

Matthew Arnold, like his father, feared the poor and working classes, the
great masses of society. He feared them as a threat to the social and political
order. Part of his fear had to do with the fact that, in the mid-1800s, the class
he referred to as 'our playful giant' was getting out of control:

> For a long time, as I have said, the strong feudal habits of subordination and
> deference continued to tell upon the working class. The modern spirit has
> now almost entirely dissolved those habits, and the anarchical tendency of
> our worship of freedom in and for itself . . . is becoming very manifest. More
> and more, . . . this and that man, and this and that body of men, all over the
> country, are beginning to assert and put in practice an Englishman's right to
> do what he likes; his right to march where he likes, meet where he likes,
> enter where he likes, hoot as he likes, threaten as he likes, smash as he likes.
> *All this, I say, tends to anarchy.* (Arnold, 1875, pp. 53–4; emphasis added)

He adds that those who think that 'a few transient outbreaks of rowdyism
signify nothing' are terribly, and dangerously, naive (Arnold, 1875, p. 54).

Let us be absolutely clear, Arnold's greatest fears are class specific. In a
remarkable passage he says that 'every Englishman doing as he likes' was
'convenient enough so long as there were only the Barbarians and the
Philistines' – that is to say, the aristocracy and the bourgeoisie – 'doing

what they liked'. But 'now that the Populace wants to do what it likes too', things are 'getting inconvenient, and productive of anarchy' (ibid., p. 118).

AN ARNOLDIAN VOICE: Things were much better under feudalism. Then, the labouring class had discipline and respect for authority.

Arnold's solution? More power to the State and more Culture. His position, as Raymond Williams points out, is essentially that of Edmund Burke: 'He who gave our nature to be perfected by our virtue willed also the necessary means of its perfection: He willed therefore the State' (from Burke, *Reflections on the French Revolution*; quoted in Raymond Williams, 1961, p. 129). Now, Arnold is well aware that a position that relies on the power of the State is inconsistent with the official stance of the good liberal, but he is certain that there is no choice. He quotes the Frenchman, M. Renan:

'A Liberal believes in liberty, and liberty signifies the non-intervention of the State. *But such an ideal is still a long way off from us, and the very means to remove it to an indefinite distance would be precisely the State's withdrawing its action too soon'.* (Arnold, 1875, p. 127; original emphasis)

Arnold emphasizes that a strong State is particularly important in the spheres of culture and education.

Liberal Humanist Cultural Politics I: Transcending Class and Creating Social Harmony, 1860–1945

The problems which have to be solved, if deprivation and alienation are to be overcome, have been identified – namely teaching a command of the English language, a broad education in the humanities designed to help the various ethnic groups (including the 'host community') to understand each other's background and culture, and the basic training in the skills necessary to obtain work in the technological economy of the modern world. . . . (Scarman Report on the Brixton Disorders, 1981, p. 9)

Is this Matthew Arnold again? No, it is the British judge, Lord Scarman, writing more than 100 years later in the 1980s, after 'race riots' had occured in several English cities, including the Brixton area of London.

In Britain, the importance of Culture in creating SOCIAL COHESION and a sense of NATIONAL IDENTITY have been key themes of Liberal Humanist thought since the mid-nineteenth century. Much of the relevant debate has focused on education. Since at least the 1860s, there have been lively discussions about the most appropriate forms of education for a modern and increasingly secular society.

In the nineteenth century, various interest groups argued for a rethinking of traditional, liberal education as practised in the universities and public schools. The traditional education was one founded on the study of classical languages and literature. It was regarded by its proponents as both intellectually rigorous and character-forming. But its critics argued that it was too narrow a basis for mass education and, moreover, was often ill-taught, since students rarely progressed beyond the tedium of classical language learning.

What, then, should replace it? As an alternative, critics proposed the study of ENGLISH LITERATURE. This was seen as a more realistic vehicle for realizing the goals of a liberal education throughout all strata of society.[7] Liberal Humanists argued for new versions of liberal education with a passion which was motivated by their belief that Culture could create shared ethical values and combat class-based social unrest.

For Matthew Arnold literature was the key to a COMMON CULTURE. Arnold wrote from his experience as an elementary school inspector, where he had routinely noted the social effects of an education system that worked to exclude the majority of pupils from anything more than the instrumental acquisition of basic skills. In Arnold's view, utilitarian education did not work, even on its own terms, because it did not instil pupils with a consensual morality.

Arnold argued in *Culture and Anarchy* that POETRY could replace what passed for religion and philosophy. Here he was drawing on romantic theories of the moral superiority of the artist. He proposed a curriculum that would privilege literature as the source of true values and extend Culture to all classes. This, he argued, would allay social unrest and the cultural and moral crises that accompanied it. The tendency within Arnold's writing to privilege literature, and in particular poetry, was to become a key aspect of Liberal Humanist cultural and educational theory and practice in Britain.[8]

Over the following decades, appeals would be made for a recognition of the role of Culture, and English literature in particular, in the creation of shared values which could ensure social cohesion. Even today this view is strongly held by many educationalists and others, from judges to government ministers – as the quotation from the Scarman Report on the Brixton Riots cited at the beginning of this section illustrates.

Ironically, in 1990s Britain, thanks to the legacy of Thatcherism, this longstanding conception of Culture and a Liberal Education is threatened by a national curriculum that privileges basic literacy, numeracy, technology and business.

> TRUTH: We are not yet back to the reign of those Uncultured Utilitarians against whom Matthew Arnold fought so hard. But we appear to be on that road.

Culture for the Working Class

On Hearing an Opera for the First Time

I came, a unit of the toiling mob
 And heard the voice of gods in music speak
 Through simple peasant folk. I saw how weak
Humanity becomes 'neath Passion's robe;
My pulses thrilled, my heart beat throb on throb
 As Tragedy, in silence, stole to seek
 A part within the play – then all was bleak –
The Comedy had ended with a sob.
I gasped, and swayed, and shook as wave on wave
 Tossed me and drove me o'er Emotion's sea.
Fearing that naught from tears my heart could save,
 Yet glad with sailor's zest when winds blow free.
I cried aloud at each ecstatic bound:
Lord God; but this is magic wrought in sound!
 – James Welsh, a Scottish coalminer,
 Songs of a Miner, 1917, pp. 123–4

A VOICE: That must have been one fantastic opera . . .

In 1871 compulsory elementary schooling was introduced into Britain, increasing working-class access to education. In addition to this, the rapid growth and consolidation of the organized labour movement from the 1880s onwards focused the attention of both liberal and socialist thinkers on working-class access to Culture. Influential Liberal Humanist writers saw a shared, common Culture as an antidote to class tensions. Representatives of the labour movement regarded access to Culture as a basic right. They argued that working-class exclusion from Culture was a source of spiritual and intellectual impoverishment. The trade unions, socialist political parties and adult education organizations of the day, in particular the Workers' Educational Association (founded 1903) and the Plebs League (founded 1908), all shared a belief in the importance of 'Culture' in the intellectual, ethical and emotional development of the individual.

Following Arnold, literature, in particular, was believed to have a special role to play in the process of transmitting 'Culture' to all sectors of society. This idea can be found across the spectrum of thinking on culture and class up to the end of the Second World War and it informed postwar educational practice in Britain. The Newbolt Report on *The Teaching of English in England* (1921), which, among other things, surveyed the practice of English teaching over the previous decades, allocated to literature the leading role in the intellectual and moral education of both children

and adults. But it had to be literature 'properly taught'. Similar ideas were echoed in George Sampson's *English for the English* (1921), in articles in the Workers' Educational Association monthly, *The Highway*, and in the popular adult education text book, sponsored by the WEA, *How to Read Literature* (Wilkinson, 1927). As the Newbolt Report argued:

> The primary aim of education in literature, so far as adult students are concerned, should not be the acquisition of information but the cultivation of imagination. The test of its success is not that adult students should be able to talk fluently or even intelligently about literary history, but that they should have been penetrated by the power of some great writer, should have made something of him at least a part of themselves, and should have acquired insensibly an inner standard of excellence. (Newbolt, 1921, p. 274)

This standard of excellence was moral as well as aesthetic, an idea which was also supported by writers within the labour socialist tradition. It implied engagement with a quite specific canon of literary texts, a canon that was accepted by people with various political views – including liberals, labour socialists and Marxists. Here is the Labour Party leader Ramsay MacDonald speaking:

> I want an education that will change yourselves. Economics and industrial history will not do that. They will make you aggressive, they will make you formidable opponents; that, of course, I welcome. I want however to see a type of mind among the working classes which is far more massive than that.
>
> We need a type of democratic aristocrat who will rise like a great forest tree and meet the aggression of the other classes – their flattery, their baits, their allurements – by the bigness of his personality. . . . In any event know something of your literature and go to the best of it. Try to understand why it is 'best'. If you cannot appreciate Milton, be assured the fault is yours. If you prefer Shelley to him, find out what is the matter with you. If you yawn over Scott and get lively with Dickens, know you need something to cure you.
> (J. Ramsay MacDonald, in *The Highway*, 12(4), (1920) p. 56)

British society at this time was riven by deep class divisions. In this context, the democratic assumption that – given education – the established cultural tradition was something accessible and relevant to all, was immensely powerful and appealing. Working-class students were anxious to 'better themselves'. And although their experience when confronted with the 'Great Tradition' of literature may, at times, have been one of alienation, literature classes remained popular. Both working-class fiction and autobiographies from the first half of the twentieth century suggest that literature was highly valued for personal as well as political reasons.

Bettering Myself:
Testimony of a Working-class Student

I am a worker – a trade unionist, and for years a W.E.A. student with an ardent desire to learn. Three years ago I felt the need for advancing my education, and being interested in Literature, I attended my first W.E.A. class, the subject of which was 'The Modern Novel'. As I had read all the books of Edgar Wallace, Ethel M. Dell and Rafael Sabatini, I felt a very superior person, a person who could hold his own in a discussion. After two hours of hearing a lecturer, who took for granted that each member of the class was well versed in Virginia Woolf, Aldous Huxley and D.H. Lawrence, I left the room dazed. Vague references to Freud and Behaviourism ran riot in my brain in bewildering confusion. The revelation of my colossal ignorance so stunned me that I did not even know how or where to begin. Moreover, the discussion afterwards gave me such a feeling of humiliation that I daren't even ask the lecturer for advice. My first impulse was to stop going to the classes, but curiosity conquered me; so for the first year I became an interested but dumb student. By making mistakes in written work, I began to learn and I continue to learn in the same way. 'But', you may ask, 'Why don't you help swell the ranks of the class by introducing new members?' This is my answer. 'Because I do not want them to experience what I experienced. I do not want to choke them by bringing them into an environment of middle class.'[9]

Culture by the Working Class?

Thus the working classes became active *consumers* of (bourgeois) Culture. But what of cultural *production* by working-class people themselves?

Until 1945, the main cultural political struggle remained one of popular access to High Culture. Calls for autonomous, class-conscious, working-class cultural production were rare. They tended to come from outside the British context. They surfaced in debates about the Soviet *Proletcult* movement in the early 1920s and in *Left Review* after the foundation of a British section of the Moscow-based International Federation of Proletarian and Revolutionary Writers in 1934. Both these movements are discussed in chapter 3.

Culture in the Arnoldian sense was seen as the basis on which all classes could come together and acquire common understandings and values. But it was only the best examples of Western Culture which could promote such values. The important issue was to bring working-class people to Culture rather than to encourage them to produce art and literature for themselves. This project was, as we have suggested, closely related to questions of social control and the desire to pre-empt class struggle or as Arnold put it 'anarchy'.

For the most part, British Marxists and socialists did not question Culture as defined by the Liberal Humanists. They valued the works of the literary and artistic canons without subjecting them or the construction of these traditions to rigorous ideological analysis.

The social democratic Workers' Educational Association had an agenda which was in many ways very similar to that of mainstream Liberal Humanist thinking. The WEA regarded Culture as something that should be readily available to all people by right. It was necessary to the moral, intellectual and spiritual development of all individuals. It could equip working-class people with the knowledge, skill, moral qualities and understanding necessary for them to play a full role as citizens in the democratic process. Once they were fully involved in this process, they would be able to fight for the badly needed social changes which might improve the living conditions of working people.

For Marxists, Culture was the product of class societies and reflected the social relations of the societies within which it was produced. Like Marx himself (who grew up in Trier, in the shadow of Roman ruins), many Marxists had a high regard for Culture. They were concerned that all people should have access to the literature, art and education that had become the province of the middle classes. This is not to say that the Marxist agenda was exactly the same as that of the liberals and labour socialists: being proper revolutionaries, the Marxists held that working-class people should learn how to read bourgeois Culture differently – as a reflection of class society and the process of history. Read in this way, art and literature could help working-class people to understand capitalist social relations and the mechanisms of social and revolutionary change. Producing alternative cultural traditions – before the revolution . . . – was not a priority.

All this said, working-class readers did, in practice, amend the canon and add texts which they found more relevant to the social conditions of their own lives. In doing so, they began to occupy the Liberal Humanist space and make it work for themselves.

This strategy would become a major feature of radical cultural politics in the postwar period.

Liberal Humanist Cultural Politics II:
The Postwar Period

The arts and culture are at the core of citizenship; they are central to the individual in society and to community and national life. The challenge is to ensure that the arts thrive, that artists, producers, participants, audiences and the study of the arts flourish. This can only happen through a strong

partnership between the public and private sectors. (National Arts and Media Strategy Monitoring Group, 1992, p. i)

The term 'the arts' includes, but is not limited to, music (instrumental and vocal), dance, drama, folk art, creative writing, architecture and allied fields, painting, sculpture, photography, graphic and craft arts, industrial design, costume and fashion design, motion pictures, television, radio, tape and sound recording, the arts related to the presentation, performance, execution, and exhibition of such major art forms, and the study and application of the arts to the human environment. . . . The endorsement of this liberal definition signals our adoption of a broader cultural role than in the past – and one which is not necessarily limited to areas in which we have a major financial stake. (Ibid., pp. 8–9)

Postwar Britain has witnessed the realization of many different aspects of Liberal Humanist cultural policy. Expansion in education at all levels has been accompanied by a privileging of English literature in the schools as representative national Culture. Study of the literary canon has been complemented in recent years by the development of media studies. Arguably, this was a response to postwar expansion in the media, a development which has made the media key sites, alongside education, for instilling common beliefs and values. The arguments used by teachers and educationalists in favour of media studies are often similar to those advanced by F. R. Leavis in relation to popular culture in the interwar period. They argue that it is important to develop an aesthetic sensitivity and the ability to discriminate between good and bad tastes.[10]

Today, ordinary people have much greater access to elite cultural forms. A number of factors have meant that Culture has become more accessible. In addition to expansion in education, these include the establishment of substantial state subsidies to the arts. Further factors are the availability of the new media, for example, videos and CDs, increased leisure, and a rise in disposable income. The National Arts and Media Strategy Monitoring Group, whose report on participation in cultural activities in Britain in 1992 we quoted above, point out that:

- In 1990, there were more than 26 million seats sold for theatrical performances (including opera and dance) in the United Kingdom.
- In 1989, total sales of fiction in the UK were worth £3 billion. The number of books rose by more than a third during the 1980s.
- Annual cinema admissions in the UK now total around 100 million, having nearly doubled since 1984.
- Annual spending on films, film processing and photography equipment in the UK is now more than £1 billion.
- Every year, there are around 12 million visits to national art museums and galleries in England alone.

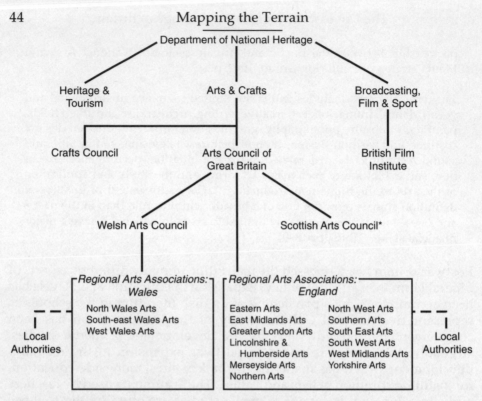

*There are no Regional Arts Associations in Scotland

Fig. 2.1 Arts funding structure in Great Britain

- Three million people regularly take part in one or more of the textile crafts, nearly 1.8 million in amateur music and drama and a similar number in painting and drawing.
- In 1990, spending on CDs, tapes and records totalled £1.7 billion. (National Arts and Media Strategy Monitoring Group, 1992, p. 6)

Educationalists and cultural policy-makers alike continue to regard Culture as a key to personal development, whatever the class, gender or ethnic background of the individuals concerned. A 'common culture' is also still seen as an important basis for social cohesion.

The Case of Arts Funding

In the postwar period, Liberal Humanist cultural policy has found clear expression in the area of arts funding. In industrialized societies like Britain, where people have an enhanced degree of access to a variety of means of representation, the actual and potential range of different cultural forms is constantly expanding. How and by whom they are valued is an important question since it has significant implications for access to the funding that can support both production and distribution. Funding

is perhaps the area in which the strengths and limitations of Liberal Humanist cultural policy are most pronounced. Significantly, while Liberal Humanist assumptions inform the composition, objectives and practice of government funding bodies, they are currently under siege. A lack of financial resources has led to increasing pressure from government to make the arts pay.

How are the arts funded? The culture industry – popular entertainment, the arts, museums, heritage centres and so forth – is funded by a mixture of public and private money. In the British private sector, giants such as Mecca and Granada run cinemas, bingo and bowling clubs. London, at least, can support commercial theatre. But for the most part, the arts – whether mainstream, experimental or community – require substantial public and private subsidy.

In Britain, state arts funding is administered by various government-appointed institutions, the most important of which are the Arts Council of Great Britain, the Craft Council, the British Film Institute and the Regional Arts Boards. These four institutions receive their funding from the Department of National Heritage (formerly the Office of Arts and Libraries) which is also responsible for the museum sector. The Arts Council of Great Britain, in turn, funds the Scottish Arts Council, the Welsh Arts Council and the work of the Arts Council in England (see figure 2.1). The Regional Arts Associations are concerned to a much greater degree with community arts.[11]

In looking at these funding organizations, we are interested in the values that characterize the practice of the funding institutions which shape the cultural landscape of contemporary Britain. We address a key set of questions:

- How are funding bodies constituted?
- What is their brief?
- How do they define 'culture'?
- Whose social interests do they serve?

To answer these questions, we consulted the various organizations' own publications and talked to some of their funding officers. We also drew on our own experiences with arts organizations in South Wales.

Arts funding bodies in Britain subscribe to a view of 'culture' which sees it as a force for good and a necessary dimension of any society. However, the range of activities that come within the working definition of 'culture' for any particular funding body varies. While they all exclude mass popular culture from their respective definitions, different degrees of importance are given to 'HIGH ART' and 'COMMUNITY ARTS'. Whereas the funding of High Art forms, such as opera, Western classical music and modern Western art, aims to make them more accessible to what are relatively small audiences, 'community' arts seek to promote the active

involvement of ordinary people in cultural production, consumption and validation.

In what follows, we look at the work of the Arts Council of Great Britain and the Regional Arts Boards, taking one region, South-east Wales, as an example. This region (which includes Cardiff, some of the South Wales valleys and some rural areas) is currently serviced by the Welsh Arts Council (WAC) and the South-east Wales Arts Association. The Welsh Arts Council defines its terms of reference in recognizably Liberal Humanist language and is primarily concerned with 'high' art forms. The South-east Wales Arts Association, on the other hand, has much less money but a wider conception of cultural practice and audience, much of which lies in the community arts sector.

The practice of the Arts Council, whether we look at the Arts Council of Great Britain or at its Welsh subcommittee, shows an institution – founded on Liberal Humanist principles – which is currently attempting to adapt to a new climate. In this new climate, *'cultural diversity'* has gained repectability, government funding is being increasingly restricted and the arts are coming to be seen as a *business*.

The Arts Council of Great Britain was founded by Royal Charter in 1946. It grew out of the wartime Council for the Encouragement of Music and Arts (founded in 1940). Raymond Williams, who served on the Council, tells of its origins as an institution concerned initially with 'fine arts'. It redefined its object in 1967 as 'the arts' but what this means in practice is an ongoing site of struggle (Williams, 1989b, pp. 141–50).

The Council's brief – in the classical Liberal Humanist tradition – is the extension of access to culture. Its stated objectives are:

1 to develop and improve the knowledge, understanding and practice of the arts;
2 to increase the accessibility of the arts to the public throughout Great Britain;
3 to advise and co-operate with the departments of the Government, local authorities; and other bodies on any matters concerned whether directly or indirectly with the foregoing objects.

Members of the Arts Council are appointed by the Minister for the Arts. They are selected as highly respected *individuals*. They are not thought to represent particular social interests or to exclude others – a view which reflects the Liberal Humanist belief in the sovereignty of The Individual. Members are thought to have no vested interests – a view which reflects the Liberal Humanist faith in the judgement of The Great and The Good. On this point, here is Kenneth Robinson, then Chairman (*sic*) of the Arts Council of Great Britain offering his considered view in 1982 on the issue of whether Council Members have vested interests: they 'have no motiva-

tion whatever other than to try and reach decisions which are in the best interests of the furtherance of the arts collectively in this country' (quoted in Hewison, 1987, p. 110). They are, as we all know, the politically neutral bearers of the best cultural values, able to discriminate between the excellent, the good and the mediocre.

> QUESTION: So, who are the members of the Council? This group of people who, unlike the rest of us, have no interests other than excellence and fairness?
> ANSWER: In 1990–1 of the 19 members about 50 per cent were businessmen, three were media professionals, one was a writer, another was an actor and three were professors. Four of the 19 (21 per cent) were women, and one of these women was Black. Almost all them were products of an elite education, with more than half having attended Oxford or Cambridge.

> A VOICE: Let there be no doubt, our future is in good hands!

The Arts Council is not directly accountable to any elected body. Although funded by central government, it claims independent status and the Minister for the Arts is not answerable for it in Parliament. Both in its general policy and day-to-day practice, the Arts Council is called upon to exercise standards of judgement in assessing cultural value which have profound implications for arts provision throughout Britain. In the process, standards of value are often assumed to be self-evident and objective. Robert Hewison is undoubtedly right when he argues, in his book *The Heritage Industry*, that the effect of this practice is that:

> The Council is able to follow its own principles of 'quality' and 'standards' without having to define what they are. Instead of conducting an open debate, they are free to work with a number of assumed generalities which in practice have the effect that 'quality' simply means that which the Arts Council chooses to support. (Hewison, 1987, p. 110)

Yet while the Arts Council does indeed define its own priorities, it is not a totally conservative, unreflective institution. Indeed, the work that has gone into producing an arts and media strategy for the 1990s suggests that questions of quality and standards are being more clearly defined than was previously the case. The question is whether arts funding is changing along with changes in the rhetoric of arts funding bodies. We shall come back to this question.

The Arts Council's annual reports show that it chooses to support professional companies and individuals producing 'high' art forms such as opera, Western classical music, painting, drama and poetry. It has less money for new developments, new audiences or non-mainstream production companies. Despite the lack of public debate about what should be funded, Arts Council funding practice is a site of cultural political

struggle which can result in innovation. Arts officers, clients and the lay members of funding panels do not all share the same ideas, nor are they immune to more general social trends. Like all liberal institutions, the Arts Council can at times operate in the interests of change.

It is, for example, aware of criticisms of its practice and is currently attempting to diversify its range of clients to include more work by British Afro-Caribbean and Asian visual and performing artists. 1989 finally saw the first major exhibition of Afro-Caribbean and Asian visual arts, *The Other Story*, at the Arts Council's Hayward Gallery in London. This project was first suggested to the Arts Council by Rasheed Araeen more than ten years earlier.[12] There is, of course, a big difference between acknowledging a problem and actually remedying it. It is striking, for example, that the 1990–1 ACGB Annual Report includes a relatively large proportion of photographs of Black arts projects when such projects actually form a very small part of the Arts Council's funding programme. Each section of the report – dance, drama, film, video and broadcasting, music, literature and the visual arts – as well as the reports on touring, multi-arts, personnel and training, and planning and development, highlights Afro-Caribbean and Asian clients. The planning and development department stresses that it is continuing to 'implement and monitor the report *Towards Cultural Diversity*, while also contributing to the development of diverse black arts initiatives' (ACGB Annual Report, 1990–1, p. 30). It also describes how it is implementing mechanisms to monitor its clients' records on 'the employment of women, people with disabilities and people from cultural minorities' (ibid.). This official commitment to cultural diversity has at the very least created a basis from which Afro-Caribbean and Asian artists can demand a larger slice of the funding cake.

Whose Culture? Funding the Arts in Wales

The arts help individuals and society as a whole to be more creative – in ways which go way beyond the arts themselves. We believe that the development of cultural identity is a basic human need, alongside those for shelter, food and social relations (National Arts and Media Strategy Monitoring Group, 1992, p. 10)

We shall respect and promote all forms of cultural diversity in the arts. (Ibid., p. v)

Whose culture should be supported by the arts funding bodies? This is a contested issue throughout Britain, particularly in Scotland and in English cities with large Afro-Caribbean and Asian communities. In Wales,

the situation is accentuated by the history of English cultural dominance and the subordinate status of the Welsh language. Besides the usual, if often unacknowledged, questions of class and gender, Arts policy and funding has of necessity to address the central question of WELSHNESS in a country where a large percentage of the population is non-Welsh-speaking. Moreover, in South Wales there are both substantial ethnic minorities and long-established multi-ethnic communities in which people of mixed descent have a Welsh identity. This occurs in the face of hegemonic constructions of Welshness that are ethnically White and tied both to the Welsh language and to traditional cultural forms such as those represented at the annual National Eisteddfod.[13] Moreover, as both Welsh and English are officially recognized languages, Welsh and English culture find themselves in competition for limited funds.

The Welsh Arts Council (WAC) is officially a subcommittee of the Arts Council of Great Britain. It will be an independent body as of 1 April 1994 and directly accountable to the Secretary of State for Wales. The Minister for the Arts, with the approval of the Secretary of State for Wales, appoints two people from Wales to the Arts Council of Great Britain. One of these is appointed Chair of the Welsh Arts Council, the other usually Vice-Chair. The other 18 members are appointed by the Arts Council of Great Britain. As in the case of the ACGB, they include a range of people from industry, education, the arts and public life. The various committees of the Welsh Arts Council – art, craft, dance, drama, film, literature, music, the Regional Committee and the Inter-Arts Committee – are composed of both Council and co-opted members. The latter are explicitly said to be there in a personal capacity, not directly representing any particular organization.

Like the Arts Council of Great Britain, the Welsh Arts Council has a tendency to privilege established mainstream arts companies such as the Welsh National Opera Company and the Welsh Symphony Orchestra. In 1990–1 the WAC had a budget of about £11 million: between them the WNO and the WSO accounted for about 20 per cent of Council spending. Other funding was spread across other musical initiatives, festivals, dance, drama, art film, literature, regional work and inter-arts. Film and video received the smallest grant, £150,000.

Commenting on the meaning of 'Welsh' in the title 'Welsh Arts Council', the former Director, Tom Owen, suggested in 1988 that it signified a concern with Welsh-language arts and general arts provision throughout Wales. It was unclear, however, whether Wales was 'a cultural entity, without necessary reference to the Welsh language' (WAC Annual Report, 1988, p. 3). *Whereas in England the Arts Council is more easily able to operate as if it were dealing with an obvious cultural entity, the co-existence of Welsh and English language culture in Wales makes this more difficult.*

It is undoubtedly the case that those English-language cultural prac-
tices supported by the Welsh Arts Council rarely address the cultural
needs and interests of the majority of people living in Wales. This is
due, among other things, to the class-based nature of British Culture.
Yet the same point would be true of the work of the Arts Council in
England and Scotland. In practice, the cultural forms supported by the
WAC are very like those supported by the Arts Council in England and
Scotland, with the addition of a measure of Welsh language drama and
publishing.

> A VOICE : *The Arts Council must establish a new framework for artistic assessment,
> one which recognises the values of other cultures. All cultures have their own
> standards of evaluation and appreciation, and they reflect the best that can possibly
> be achieved by human creative ability.* (Owusu, 1986, p. 74)

Criticisms of the narrow, non-representative nature of the cultural
forms which the Arts Council routinely funds have provoked a new
commitment to enhancing 'cultural diversity'. 'Multiculturalism' has
been a live issue in education and in cultural policy for some years.
Multicultural policy encourages schools to teach all children about the
culture and traditions of the different ethnic groups which make up
British society.[14] It encourages arts funders to include the culture of ethnic
minorities in their programmes. It is a policy that implies a respect for
cultural difference which should challenge the privilege of the dominant
culture. We discuss it in more detail in chapter 12.

The more recent term 'cultural diversity' has become an important
theme in recent ACGB reports and it is central to the National Arts and
Media Strategy for the 1990s. This promises 'prominent rather than token-
ist representation of the many cultures in Britain in the staffing and
programmes of visual arts, institutions, galleries, art schools and funding
system' (National Arts and Media Strategy Monitoring Group, 1992, pp.
41–2). It remains to be seen whether this 'cultural diversity' will really
allow cultural difference to flourish or whether it will continue to include
Black art, theatre, dance, and so on, on old terms, either assimilating them
to traditional, White, liberal cultural values or, more often, defining them
as 'ethnic arts'.

The problems inherent in trying to develop a multiculturalism that
really *decentres* traditional cultural values can be seen clearly in Wales.
Here multiculturalism is a more openly contested issue due to the posi-
tion and aspirations of Welsh-language activists. In its policy statement
on 'Arts in a Multicultural Society' adopted in June 1989, the Welsh Arts
Council distinguishes between Welsh culture both linked to and separate
from the Welsh language, as well as multiculturalism and ethnic minority
arts. The statement stresses the importance of support for the Welsh

language. This is seen as 'an inherent duty, not related of necessity to a wish to further a multicultural policy'. Multicultural policy, on the other hand, is described as 'intended primarily to deal with smaller immigrant cultures'. Indeed, whereas awareness of cultural difference produced by the Welsh language 'should create a more sympathetic approach in Wales to non-Welsh cultures', multicultural policy 'should be tempered, however, by the deeply felt aversion of many Welsh speakers to any link with policies intended to deal with the multiracial nature of British society'.[15]

This highlights a central problem faced by those anxious to develop a multicultural Britain: the wish to promote cultural diversity finds itself in conflict with a competing desire to maintain the privileged status of the 'indigenous' cultures. Under these circumstances, multiculturalism means at best inclusion on the terms laid down by the indigenous cultures. Thus, for example, the WAC recognizes that it should, 'as in the area of Welsh language activity, be prepared to find that support of work from or for small numbers is more expensive' and particularly 'be prepared to find that distinctions between amateur and professional arts can be disregarded, *without abandoning established tests of quality*'. It seeks to maintain *'the established standards applied to applicants'* (our emphasis). These established standards and tests of quality are informed by traditional criteria of value. Moreover, the Welsh Arts Council has adopted what it calls 'a pragmatic, reactive policy' to ethnic minorities. This places the onus on ethnic minorities – as is the case with other groups and interests – to initiate contact with the Council; and it seeks to maintain 'the established standards applied to applicants'. While some groups have indeed benefited from this policy, it remains to be seen whether it will significantly change the representation of ethnic minorities in funding programmes or establish a viable multiculturalism which is not at the same time a containment and domestication.

Community Arts

If the Arts Council of Great Britain, the Welsh Arts Council and the Scottish Arts Council are primarily concerned with established companies and High Art forms, the Regional Arts Associations (which become Regional Arts Boards in April 1994) have a wider brief. At issue here are two competing conceptions of 'culture' – of what it is, of who produces it, and of what its status is in relation to communities, groups and society. The South-east Wales Arts Association (SEWAA), like its sister organizations throughout Britain, seeks to promote the role of the arts in tourism, economic development, education, employment and

entertainment. In doing so it aims to create 'a network of professional partnerships with County and District and Community councils, local voluntary groups, the business community, arts workers, the Welsh Arts Council, health authorities and other government agencies' (SEWAA Annual Report, 1988–9, Introduction).

The Association sponsors or offers financial guarantees in visual art, craft, film, literature, dance, drama, music and community arts and arts centres. Its budget is however very small: £563, 323 in 1988–9, £600, 735 in 1989–90 and £658, 938 in 1990–1. Much of its work is concentrated in the Community Arts sector where it sees its role as 'demystifying the arts' and making them 'a normal part of everyday life' (Chairman's Introduction to the 1990–1 Annual Report). In addition to arts centres and professional companies, the Association sponsors community arts organizations and festivals, artists-in-residence (for example, in schools and hospitals), theatre in education projects and work with disabled groups. Much of its time and resources are spent setting up arts funding packages involving local government and other sponsors. The commitment of Regional Arts Associations in Britain to community arts has forced a rethinking of traditional notions of value which has led to a tendency to assess cultural practices according to their own stated aims and objectives.

A Shift in Rhetoric: But Who Gets the Money?

We have seen that there has been a fundamental shift in the rhetoric of official cultural policy: the Voice of Cultural Power now talks of plurality, diversity and access. But does this mean that the old institutional practices – elitist, sexist and Eurocentric – have been abandoned? Does it mean that, given the new rhetoric of the Arts Council of Great Britain, there has been a fundamental shift in how much money various categories of arts and cultural organisations receive?

> TRUTH: As my mother used to say, 'Don't be taken in by what people say. You watch what they do.'

Do opera, drama, classical music and ballet now receive less while photography, puppetry and film receive more? And how are non-White Britons faring under the new order?

To answer this question we are drawing on figures from the 1990–1 Annual Report of the Arts Council of Great Britain. The patterns it reveals, however, could be obtained from any other recent report of the Council (see table 2.1).

Table 2.1 What does Britain's Arts Council fund?

In the 1990–1 financial year, the Arts Council of Great Britain spent £165 million on the arts (excluding the Council's administrative costs). Here is a partial breakdown of expenditure (grants and guarantees).

1 Grants to Various Art Forms	
Drama & Mime	£31.8 million
Music	£28.4 million
Dance	£15.1 million
Visual Arts	£ 3.0 million
Film, Video, Broadcasting	£ 1.6 million
Literature	£ 0.95 million
	£80.6 million
2 Grants to Arts Centres/Multi-discip. Arts	£12.1 million
3 Touring: Grants & Guarantees, Publicity, Fees	£ 8.6 million
4 Grants to Other Statuatory Arts Funders	
a. Scottish Arts Council	£17.5 million
b. Welsh Arts Council	£10.6 million
c. Regional Arts Associations	£33.4 million
	£61.5 million
5 Other Categories of Grants and Guarantees	
a. Training	£620,000
b. Marketing Initiatives	£330,000
c. Planning and Development	£685,000
d. International initiatives Fund	£250,000
	£ 1.9 million
Grand Total	**£165 million**

Source : Arts Council of Great Britain *46th Annual Report and Accounts* (London: ACGB, 1991).

Looking at this list of figures it is clear that drama, music and dance get most of the money. The Arts Council uses six basic categories in its funding practice: drama, music, visual arts, literature, and film and media arts. Of the £81 million that went to all six categories, all but £15 million went to drama, music and dance. It is traditional art forms that are privileged. New and emerging art forms – in particular film, video and media arts – are clearly the poor step-children. Within these budgets, a small number of elite, 'highbrow', national institutions take a hugh amount of the overall total. The budgets for dance, drama and music show the following:

Dance. The Royal Opera House received £7.9 million of the £15 million allocated by the ACGB to dance theatres and companies. The

English National Ballet received £2.8 million. Thus, between them, these two London-based companies received nearly 70 per cent of the total (68 per cent to be precise) of the grants allocated by the ACGB to dance.

Drama. Of the £32 million allocated for drama, £15 million or 47 per cent went to two 'highbrow' national theatres: the Royal National Theatre (£8.95 million) and the Royal Shakespeare Theatre (£6.05 million).

Music. Of the £28.5 million allocated for music, £16.1 million or 56.5 per cent went to two 'highbrow' clients: the English National Opera (£9.1 million) and the Royal Opera House (£7.0 million).

As you may have noted, the Royal Opera House received a large slice of both the dance and the music budgets, accounting for £15 million from the Arts Council's public subsidies for the arts. At the other end of the spectrum, community-based arts and popular participation are far down the list of priorities.

A Threat to Liberal Humanist Values?
The Increased Role of the Private Sector

The eighties have seen major changes in the way the arts are perceived, run and funded. The language of the arts world has had to absorb a dictionary of business-speak. New relationships have had to be made with, initially, strange beings. New jobs have been developed requiring a different kind of creative ability.

The nineties will see further change. The arts have a new context within the cultural and leisure industries. It is a context which a growing number of local authorities have readily perceived as they look to the arts as a vital element in economic and social regeneration, and the arts look increasingly to economic development units for partnerships . . . Southern Arts no longer sees itself as just another funding body but as a development and investment agency negotiating contracts with clients who in turn must promise to deliver certain goods – quality products to targeted audiences who come back for more. (*The Arts Business*, Spring 1989, p. 3)

Most cultural forms and practices – television, cinema, music, dance, theatre, visual arts – rely on a degree of public and private subsidy. In the climate of the 1990s, publicly subsidized arts in Britain are having to look to increased commercial sponsorship to achieve their targets. In Wales, for example, private-sector funding of the arts had climbed by 1990–1 to nearly £2 million. In general, government funding of the arts is increasingly being linked to commercial sponsorship. In the process, the interests of business sponsors are becoming more important in determining

the cultural products to which the public have access. They can influence directly which cultural values are widely reproduced – and can increasingly determine whether arts organizations will survive or die. This is a development that is, in some cases, threatening the principles of Liberal Humanist cultural policy.

Business sponsorship of the arts throughout Britain has increased sharply over the past few years due, to a large extent, to the efforts of the Association for Business Sponsorship of the Arts (ABSA) which was founded in 1976. At that time £600,000 was spent annually by commercial enterprises on the arts. By 1986 the total was estimated at between £25 and £30 million (Hewison, 1987, p. 123). This increase was helped by the 1984 government Business Sponsorship Initiative Scheme (BSIS), which is administered by the ABSA. According to the scheme, new business sponsors had their sponsorship matched £1 for £1 by government, while established sponsors attract £1 for every £3 they spend. The initial allocation by the government in 1984 was £1 million, and between 1984 and 1989 £7 million has attracted over 700 business sponsors. The BSIS budget for 1988–9 was £3 million.[16]

Business sponsorship of the arts tends to focus on mainstream High Art. In 'Positive Stroking: Making the Right Business Links', a discussion of arts sponsorship in the Spring 1989 edition of *The Arts Business*, Judy Grahame of the London Philharmonic Orchestra described why companies sponsor classical music:

> For hardheaded business reasons; it's a very upmarket public relations exercise and they get substantial commercial returns from it – although these can't be quantified in the way that sports sponsorship can. The main reason is that they feel it enhances their image – if they associate with quality, their customers will associate them with that quality. And music has one advantage over the theatre in that there are no language barriers for foreign clients. (p. 9)

The increased emphasis on making money has implications for what sort of cultural practices are sponsored. This is particularly true where commercial sponsorship is concerned. Business sponsors sometimes play an active role in determining programmes. In the same article, Lucy Stout of the National Theatre expressed concern at 'a new danger of designer sponsorship – an event devised between business and sponsorship consultancy which is then "sold" to the arts organisation' (p. 11). Since these types of arrangement are in addition to the programme drawn up by the company concerned, they pose a threat to a company's freedom to chose its own programme. 'More businesses are deciding what they want to do – the arts company must take it or leave it' (p. 11). In such cases the government's idea of a partnership between business and arts companies is not realized and liberal cultural values are compromised. Arts companies are already wary of the danger of sponsors influencing

programming choices since this is seen as a threat to new or less mainstream productions. Criteria of excellence, some argue, are replaced by marketing criteria. *The issue becomes: what sells?* Commercial sponsorship is seen by many arts workers as potentially damaging to the artistic freedom of companies.

On the other hand, the need to attract larger audiences can mean that arts companies, galleries and museums are forced to pay more attention to how they might present work in ways that are accessible to wider audiences. This may require attention to the class, gender and ethnic interests addressed in particular productions and exhibitions.

On Liberal Humanist Cultural Politics: Reflections

The Appeal of Liberal Humanism

Liberal Humanism has many attractive features. It places *the individual* at the centre of history, telling us that we have a unique yet shared human nature which is essentially rational. Human history – which is implicitly the history of the West – tends to be seen by Liberal Humanists as a history of progress and enlightenment based on education and rational planning. Liberal Humanism offers its (White) subjects the status of belonging to the most developed and progressive cultures on earth. It remains the basis of much of the work undertaken by development agencies and the United Nations and more recently it has come to be seen as the singular answer to the problems of Eastern Europe. It has been used to justify capitalist social relations in the West and their extension, via colonialism and postcolonial cultural and economic developments, to other societies. Both colonialism and postcolonialism are broadly seen as the extension of civilization and progress to the 'Third World'. Yet, as we shall see in subsequent chapters, the equation between Western capitalism and progress has been questioned, in particular by 'Third World' activists and writers.

At the centre of Liberal Humanist thinking is the *rational, free individual* who uses language and other forms of signifying practice to express his or her view of the world. This view is the product of education and experience. Given equality of opportunity, each individual will, Liberal Humanists assume, find 'his or her own level' and develop his or her 'individual qualities' or 'aptitudes'. This theory relies on a view of the world in which subjectivity is sovereign, the source rather than the effect of language. Language is a transparent tool for reflecting or expressing the world and our experience of it. Liberal Humanism relies on an abso-

lute division between the individual as speaking subject and the 'external reality' of the world. Different individuals have different levels of ability to perceive and express reality, and among the most gifted interpreters of human experience are artists and writers. The power of art, literature and the aesthetic experience derives from its direct address to the subjectivity and essential humaness of the individual, a process in which social differences become unimportant. Social inequalities produced by class, sexism and racism are only important in liberal humanist thinking in so far as they deny particular individuals equality of opportunity to develop themselves via education and Culture.

Access to Culture has long been the key focus of Liberal Humanist cultural politics. The Culture in question tends to be traditional culture as defined by the dominant cultural institutions – the academies, education, museums, galleries and the critical establishment – although the liberal tradition has a great capacity for assimilating cultural production by marginal groups. Dominant cultural traditions consist largely of the work of White, male Europeans and people of European descent. In their claims to universality, they reduce or deny the values of other forms of culture – that of women, non-White and non-European artists and writers, a point explored in detail in chapter 6 and in Part IV.

In defining valuable Culture, the Liberal Humanist tradition privileges particular values in complex ways. The values which critics, curators and arts funders tend to endorse and reproduce are those already enshrined in established traditions, for example, modernism in the visual arts or opera and Western classical music rather than jazz, folk or popular traditions. Where the liberal tradition includes work that does not come under these headings, it tends to be incorporated into specific separate spaces, for example, women's writing or film, Black and ethnic arts. The effect of this form of incorporation, though often unintended, is to perpetuate deeply ingrained notions of cultural difference which are ultimately sexist and racist and which privilege White, male, Eurocentric norms, relegating everything else to a secondary order of value. Thus, as we argue in detail in chapter 11, the current concern of funding bodies with 'ethnic arts' often works to keep Artists of Colour in a place outside mainstream modern art.

The current emphasis within liberal humanism on diversity belies the RELATIONS OF INEQUALITY on which much diversity is based. This is not only a question of Liberal Humanism's implicit and traditional hierarchy of values. It affects who has access to the means of cultural production. Liberal Humanists, unlike Marxists and feminists, do not regard economic, social or cultural differences as determining the nature of subjectivity itself. In practice, this has often proved to be a positive aspect of Liberal Humanism, since it has enabled groups, particularly White women and women and men of Colour, to redefine themselves in the face

of hegemonic discourses which locate their inferiority in biological difference.

Yet the power relations that structure both the individual's social position, and the forms of subjectivity that she or he occupies, often remain invisible within Liberal Humanist frameworks. Forms of oppression based on social class or physical difference, especially sexism and racism, can easily persist within Liberal Humanist practices since they tend to concentrate on individuality defined as a conscious, rational identity. They have very little to say – indeed, they are virtually always silent – on issues of structural power relations.

This silencing of other interests has not remained unchallenged.

Defining Culture

Valuable Culture – the Culture that Liberal Humanist voices privilege as the expression of the highest achievements of (Western) civilization – is defined and reproduced by a range of cultural institutions. These include museums, galleries, libraries and archives. They further include funding bodies, the academies, educational institutions and their critical, historical and educational journals. Publishing and the heritage industry, too, play an important role in the process of selecting, preserving and reproducing cultural traditions. Access to the means of cultural production, distribution and validation is crucial if a writer or artist is to stand any chance of having his or her work taken seriously. Arts funding bodies exercise a good deal of power in this area.

The process of producing and maintaining cultural traditions involves a massive financial and intellectual investment. Control of both the material resources with which to create and reproduce traditions and of the institutions where dominant ideas about cultural value and history are defined are central sites of cultural politics. If we look at the development of Western cultural traditions, we find that there is a direct correlation between the White, male, middle-class groups who have controlled these institutions for centuries and the composition of dominant cultural traditions.

The emphasis in Liberal Humanist thinking on universal human nature and universal value has produced a set of cultural traditions which consist of works from a variety of historical moments and European cultures. These have been brought together to form traditions in which literary texts from Aeschylus to James Joyce, and visual arts from all ages, are seen as expressing universal human values and progress.

Aesthetically, twentieth-century culture – particularly in the visual arts – has been shaped by the hegemony of modernism. This has meant a

privileging of forms that break with realism and endorse an apparent cosmopolitanism in which, as we argue in chapter 10, elements from African, Oceanic and other 'Third World' art forms are incorporated by White artists on their own terms. Moreover, the modernist tradition has excluded the work of many women and Black and Asian artists.[17] Modernism's distance from realism and from popular culture has meant that its accessibility is often limited to an elite, educated audience.

Meanwhile the art and literature of working-class writers, most women and many Black and Asian artists and writers is excluded by critics from High Art. Much of this work is realist. Yet, as we show in detail in chapter 11, even modernist work by Artists of Colour has been relegated to a secondary league of quality. Moreover, art and literature from non-European cultures has often been defined by Western critics as intrinsically more 'primitive'.[18] Liberal Humanist Culture assumes that whilst human nature is essentially the same everywhere, some cultures are more developed than others. In privileging values that are bourgeois, Western, White and male, it implies that it is cultural difference based on *under*-development that makes non-White societies different and European culture an intrinsically civilizing force. This Eurocentric aspect of Liberal Humanist thought and practice often has racist implications.

Value and Tradition

Concepts of value determine which cultural texts and practices become part of the dominant cultural traditions. As such they determine what is readily available to different audiences, accessible in schools, universities, libraries, theatres, museums and galleries. As we have argued in this chapter, Liberal Humanist criteria of value tend to reinforce existing traditions. Liberal Humanist cultural traditions have, however, demonstrated a remarkable ability to incorporate – some would say domesticate – challenges from the margins. New texts may be included on the basis of established norms of quality and value. In this process, cultural difference and alternative values are often negated or assimilated into the mainstream. Mainstream critics are adept at producing apparently definitive readings of texts which deny difference. Those few women writers whose work has been accepted as part of the 'Great Tradition' of English literature tend to be read in this way. Mainstream critics have had little or nothing to say about those aspects of texts which have subsequently become, for example, the focus of feminist criticism. Similarly, dominant cultural institutions have shown little inclination to rethink either concepts of value or the social interests represented by High Culture.

While fixed notions of value remain central to Liberal Humanist thinking, they are being challenged by the more plural cultural values implicit in feminist and Black criticism and in multiculturalism. As we argue in more detail in chapter 6, feminist cultural critics have shown that the selection of cultural traditions and the meanings and values which they support are male-defined. As such they promote views of the world which, far from being objectively 'true', represent male interests, silencing or marginalizing women's lives, experiences, achievements and values. Similarly, we argue in chapters 11, 12 and 13, Artists of Colour are now challenging the values and standards of the British art establishment, showing them to be ethnocentric and racist.

Feminist responses to the male-defined, middle-class, White, heterosexist nature of the Liberal Humanist cultural tradition have been varied. Feminist critics have fought to include more work by women in the literary, artistic and musical canons. They have created parallel traditions of cultural production by women. Many women writers and artists, however, wish to see their work valued by the mainstream irrespective of the gender or race of the producer.

Similarly, Black and Asian critics and cultural activists, both female and male, have shown how Liberal Humanism assumes White Eurocentric cultural norms. These norms have often been defined against cultural 'Others' whose art is implicitly seen as 'primitive'. While some artists and writers fight for inclusion in the mainstream, others are actively promoting Black theatre, visual arts, music and writing, as well as Black cultural criticism.

Black and Asian responses to exclusion and devaluation are complex. The tensions between different definitions of Black art can be seen, for example, in the anthology edited by Kwesi Owusu, *Storms of the Heart* (1988), a collection of articles on Black arts and culture. Despite its eclecticism, it gives a good sense of the range of activities of Afro-Caribbean and Asian artists and cultural workers in Britain and of the problems that they face. *Storms of the Heart* works with a definition of 'Black art' which encompasses all work by Afro-Caribbean and Asian artists. It includes both political works aimed at questioning racism and colonialism and works by Black artists which seek to cultivate traditional cultural forms. The question of what constitutes 'Black art' remains controversial, as does the position of Afro-Caribbean and Asian cultural workers in relation to the mainstream. Many are concerned that Britain should develop a truly *multicultural* perspective in which minority cultures would be regarded as equally important and valuable as 'White culture'. Most believe that the cultural and ethnic background of visual and performing artists and writers should be unimportant in the evaluation of cultural products. All contest racist conflations of race and culture.

Pressure from marginalized individuals and groups has resulted in

localized shifts in liberal humanist concepts of value. The struggle by feminist, Black and Asian cultural producers and critics for inclusion of their work has led to selected examples of feminist and Black cultural production finding their way into the public eye and on to educational syllabuses. However, as we show in chapter 11, a fierce debate continues, particularly in the visual arts, about the basis on which such texts are included, whether as token representatives of cultural 'Otherness', or as great works in their own right. At issue here is the relevance of gender, race and ethnicity to concepts of value. The recent shift in White liberal practice from the exclusion of the work of Black artists to its marginalized inclusion within a separate narrow category of 'ethnic art' is a key problem for many Afro-Caribbean and Asian artists and cultural workers. It is not just a question of creating a space for Afro-Caribbean and Asian cultural practices, but also of seeking to transform dominant White assumptions and practices.

While Black arts are attracting public subsidy in some regions, notably metropolitan centres with high Afro-Caribbean and Asian populations, the amounts of funding are small when compared with that spent on mainstream arts. Moreover, funding often comes from sources other than arts budgets. For example, The Cave, a Black Arts Centre in Birmingham which opened in 1983, was purchased with Urban Aid money and owes its viability to a grant from the West Midlands Probation Service. This points both to the continuing belief in the importance of the arts in combating social unrest and to the unwillingness of the custodians of High Art to redirect money to other sectors.

Once the assumption that established cultural traditions and values are obvious and neutral has been successfully challenged, their representative nature is put into question. A cultural politics that acknowledges difference is possible from within the liberal framework. It is, however, made difficult by Liberal Humanism's tendency to insist on traditional, male-defined, Eurocentric norms of value. This can be seen in both the academic study of literature and the arts, and in patterns of funding.

In education attention to other cultural practices, such as those by most women and Black writers and artists, have been hard fought for, yet they remain on the margins. In the study and provision of 'culture', by far the majority of public funding is allocated to traditional cultural forms and institutions. Democratizing initiatives, which seek to expand definitions and access to culture, tend to be seen by mainstream critics, the academies and funding bodies as not only *different*, but as intrinsically *less valuable*.

Liberal Humanist thinking suggests that culture has a crucial role to play in shaping individual perceptions and values. It can help to determine the sort of society in which we live. If this is true, then the structure and composition of cultural institutions are crucial. These institutions

determine what counts as good and what is funded. They can influence whether the multi-ethnic nature of contemporary Britain enriches social and cultural life or becomes a bitterly divisive factor. Exclusive, traditional, Eurocentric notions of value are one problem area. Another is the increasing influence of market forces on the arts. It is becoming ever more important to look at such questions as: What is funded? Whose voices and interests are represented in cultural production? And to what extent is cultural difference allowed to flourish?

Liberal Humanist thinking insists that cultural value is not tied to economic returns. Its criteria of value are often conservative, in the sense that they are formed by and tend to reproduce cultural norms which have developed within a narrow, ethnocentric, White male cultural tradition. Yet they do not have to be so. The recent, painfully slow recognition given to Afro-Caribbean and Asian arts shows that it is possible to diversify criteria of value. More problematic is the inclusion of 'Others' – Artists and Writers of Colour and women within the dominant. Moreover, the cultivation of cultural difference can easily leave the centre intact. The essential task of decentring those hegemonic values which have characterized Liberal Humanist cultural politics for the last 150 years faces difficult problems.

Liberal Humanist thinking and cultural policy can be viewed as relatively inert vessels. On the one hand they require vigorous action on the part of marginalized groups if these are to obtain access to the means of cultural production. Liberal Humanism's claims to universal values are a major obstacle to change. So, too, is its refusal to acknowledge and contest the all-pervasive effects of class, gender and race on definitions of culture and access to it. On the other hand, Liberal Humanism rejects, at least in theory, discrimination on the base of class, gender, race and ethnicity and creates a basis from which to fight such discriminations. Strategically it is useful for cultural activists who are interested in social change to have an apparently 'depoliticized' space (which is always actually political) whose content becomes the subject of cultural political struggle. Potentially, Liberal Humanist cultural policy allows for plurality and difference. However, it cannot be taken on its own terms. It must be read critically and used strategically.

Claiming a Space

In the opening chapter of this book, we insisted that culture plays a central role in the legitimation of social relations of inequality and in the struggle to transform them. Following on from this, this chapter has looked at aspects of the dominant cultural institutions which play a part

in defining, reproducing and legitimating 'valuable' culture. It is clear that educational institutions, the media, heritage institutions, theatres, monuments and galleries, together with their funders and their critics and historians, are primary gate-keepers. They decide what Culture is. They define its social role.

> A VOICE: Who are we? We are they who determine criteria of value and construct histories. We are they who decide whether your cultural initiative shall live or die.

From its inception, Liberal Humanist cultural theory has insisted that 'Great Art' transcends the barriers created by different social, cultural and political interests. It is able to speak to everyone and to create shared beliefs and values. These ideas remain central to contemporary Liberal Humanist cultural policy. That the 'Great Art' in question has tended to be that of middle-class White men has only recently become an issue within institutions. Groups who find their culture excluded from schools, universities, theatres, concert halls, museums or galleries are increasingly questioning the view that *dominant* cultural traditions have *universal* appeal. As several of our case studies in this book show, they are making their voices heard and insisting on the importance of cultural practices in the process of self-definition and liberation.

The wide-ranging critique by women and people of Colour of the *exclusive, selective* nature of the established cultural traditions and their inability to speak for and to people who are not White, male or middle-class has provoked two main forms of liberal response. On the one hand, the cultural production of marginalized groups has been dismissed as not good enough to be included in mainstream cultural traditions. Much non-male and non-White writing and visual art has been excluded from the literary and artistic canons and has little or no place in the influential cultural institutions where it might directly challenge hegemonic values. This is rarely seen as a problem by these institutions. *The idea that art and literature transcend political interests legitimates the practice of defining the culture of particular social groups as representative of the nation as a whole.*

On the other hand, liberal humanist teachers, writers and critics have at times sought to extend the canon. In the 1930s, when interest in working-class fiction reached a high point, a relatively large number of novels by industrial workers were published by commercial publishing houses. The critical establishment responded by appropriating a small number of texts as 'modern classics'. Mainstream critical writing from this period shows how these texts were read by critics for their depictions of 'fate' and the 'human condition'. This interpretation enabled the incorporation of working-class novels within a dominant tradition which stressed an unchanging human nature.[19]

For many readers, however, the novels in question remained powerful forms of social criticism which made a strong case for social change and as such challenged the belief in the non-political nature of art. As we discuss in more detail in chapters 3, 7 and 8, fiction played an important role in raising the consciousness of working-class women and men in Britain from the nineteenth century onwards and more recently it has become important in the struggles of Black British, Asian and White women for new forms of subjectivity. These new modes of femininity are defined in opposition to those which White, male society offers women.

Yet to a large extent these texts offer an alternative which has left the dominant intact. They are published by specialist publishers such as the Women's Press and Onlywoman Press and distributed through women's and alternative bookshops. Critics tend to categorize them as 'women's writing', a term that still suggests lesser value – and this is how they appear in reviews and in education syllabuses. In spite of this, market forces have ensured that, increasingly, feminist fiction is making the shelves of mainstream bookshops. None the less, its position in relation to hegemonic traditions remains problematic.

Similarly, Black (that is, Afro-Caribbean and Asian) artists and performers are claiming a space in both the 'high' and community arts sectors. Yet most often they still find themselves contained within separate categories of 'ethnic arts'. At issue here are questions of value.

Conclusion

What are we to make of all of this? That Liberal Humanism is a double-edged sword – a politics of freedom and a mechanism of control, a rhetoric transcending social divisions and a policy upholding the elite, an ideology of universalism and a practice of Eurocentrism.

That is why it is so popular – why so many people, with so many different interests, have found it so useful.

Part II
The Cultural Politics of Class

———

University life is the breeding ground of reaction. It incites by its very nature towards breaking away from working class aspirations and cleaving on to the ideas of the class above. The knowledge that is to be of any service to the Labour Movement is not to be gained in that quarter. The problem of the workshop, the mine and the factory is not to be solved in the University. All the latter can do for the Labour Leader is to intellectually enslave him ... and confuse the working class movement. So long as we have the present economic system, just so long will it reflect itself in an educational institution like Oxford University. It is the place where men are taught to govern, it is the ruling class who control it, it is they who decide what shall be taught, and as the interests of these people are in direct antagonism to the interests of the workers, it is sheer folly for the latter to think that any good can come by sending any of their numbers there

— The Plebs' Magazine, 1909

Art is not for decorating the apartments of the bourgeoisie, it is a weapon for the fight.

— Pablo Picasso, 1945

3

Writing as a Weapon in Class Struggle: Radical Cultural Politics in Britain to the Second World War

On becoming prime minister of Britain in 1991, John Major pledged his commitment to building a 'classless' society. This pledge was made in the context of 12 years of radical Thatcherite Conservatism which had done much to widen the economic and social gap between rich and poor. In the 1990s, after the fall of 'socialism' in Eastern Europe, class remains a key political issue.

> **Class** n. **1.** *any set of persons or things grouped together, or graded or differentiated from others especially by quality.* **2a.** *a division or order of society.* **b.** *a caste system, a system of social classes.* (*The Concise Oxford Dictionary*, 8th edn, 1990, p. 207)

Until relatively recently, oppositional cultural politics in Britain and much of the Western world centred primarily on class. In the media, political and academic writing, class is a much-debated issue. It is used in a variety of ways to signify social, economic, cultural and educational differences. Varying conceptions of class determine how the nature and causes of these differences are understood; yet 'class' almost always signifies inequality. Inequalities may be understood as natural and inevitable, or as social and changeable. Either way class remains a highly politicized concept.

Ideas about class are fundamental to common sense as well as social and political theory. Common sense identifies class with particular ways of speaking, behaving and living to which individuals are born or naturally

suited. In Britain, popular notions of 'organic' working-class life are a mainstay of television soap operas and are arguably as strong as common-sense assumptions about the natural 'class' of the aristocracy.

Common-sense notions of class focus on its cultural dimension, for example, how people speak, dress, decorate their homes or spend their leisure time. Such understandings of class tend to ignore the ways in which it is firmly grounded in economic and educational relations of *difference* and *inequality*. Recently, moves towards cultural diversity, which we discussed in chapter 2, have helped promote the idea that all forms of culture – including forms of working-class culture – are valuable. This new liberalism, however, masks the structural relations of inequality on which class rests. It is Marxist theories of class which have defined class in more radical ways and produced critiques of the relation between social class and power. Marxism – in its various forms – has promoted cultural politics aimed at transforming class inequality.

The last 150 years have seen a rich range of cultural political initiatives rooted in the various organizations of the labour movement and the left-wing intelligentsia. In this chapter we look at an example of cultural politics in Britain that developed around working-class and socialist fiction between the turn of the century and 1939. We begin with a brief history of socialist ideas about the role of Culture in individual development and political education and examine in detail the cultural politics pursued by the monthly magazine *Left Review*.

Culture and Class in the British Labour Movement up to 1939

Labour

Born to the throng and the rod,
With only the dreams of sublime,
Where life like a storm-shod god
Ramps down the halls of time;
Bright gleam the stars in the sky,
Sweet is the wind on the moor,
Grovel I must and pass by
To die 'mid the slime and the hoar

. . .

Robbed of the laurels of life,
Robbed of the power to enjoy,
Robbed of the world, save its strife,
Robbed of desire to employ
Ideals and efforts and dreams,
Tastes that are almost divine,

Giving the poet his themes,
Ah! – what a heritage mine –
(James Welsh, *Songs of a
Miner*, 1917, pp. 72–3)

The development in the latter half of the nineteenth century of a broad-based labour movement in Britain brought with it demands for working-class access to education and Culture.[1] In chapter 2, we suggested that cultural political debate and practice in this period focused mainly on the exclusion of working-class women and men from 'Culture' as it was understood and practised by the educated middle classes. While little positive value was ascribed to popular working-class culture, labour movement organizations offered alternatives. Involvement in political parties and trade unions, educational organizations and the Co-operative Movement consolidated a positive sense of class belonging as well as opposition to the very existence of class within society. It also encouraged working-class poetry, fiction and drama.[2]

The labour movement in Britain from the late nineteenth to the mid-twentieth century consisted of many different groups and factions. Within the movement, class was understood by some as an economic relation, by others as a social category. At its most radical, class was seen as a political force which would bring about the end of capitalism. Ideas about class and politics drew on theories as different as ethical social-ism and economistic Marxism. Yet the virtual exclusion of working-class women and men from anything more than a largely utilitarian elementary education led to a privileging of *access* to education and middle-class cultural traditions as the key site of cultural political struggle until 1945.

In the previous chapter we argued that class – like gender and race – is virtually invisible in Liberal Humanist cultural theory. Liberalism's focus on the sovereign, rational individual leaves little space for considerations of class inequalities, even though these have long been the hidden agenda of Liberal Humanist educational and cultural policy. From the 1840s onwards, Marxism marked a major challenge to liberal conceptions of the Individual and Culture, and it profoundly influenced socialist thinking in Britain.

QUESTION: What did Marxism question?
ANSWER: The assumptions about truth, universal values and human nature that underpin Liberal Humanism. It displaced the sovereign, rational individual from the centre of society and history.

The Marxist alternative to Liberal Humanism offered a general theory of history and society – an alternative metanarrative – with its own founding assumptions. These included:

1 The assumption that the mode of production (for example, feudalism, capitalism or socialism) determines the structure of society.[3]
2 The assumption that capitalism is a mode of production founded on an antagonistic relation between two key classes: capital and labour (the owners of the means of production and the working class).
3 The assumption that class struggle is the motive force of history.

In Marxist theory all individuals are seen as social beings whose identity and consciousness are fundamentally an effect of social relations, which are, in turn, class relations.

> A VOICE: 'Life is not determined by consciousness, but consciousness by life.... Language is as old as consciousness, language *is* practical consciousness that exists also for other men, and for that reason alone it exists for me personally as well.... Consciousness is therefore from the very beginning a social product, and remains so as long as men exist at all'. (Karl Marx, *The German Ideology*, 1846/1970, pp. 47, 51)

For Marxists, language and experience are *social* phenomena. Language does not have a singular meaning, nor is experience sovereign. Both are plural and can be interpreted in many different ways. Instead of giving access to truth about the world, they reflect conflicting class interests. And these class interests are defined by the relation of individuals to the mode of production.

Marxist conceptions of class have varied over the last 150 years. In economistic Marxism, class is an objectively determined economic force in an inevitable historical process that will lead to socialism and communism. Non-economistic Marxisms stress individual agency and the subjective dimensions of class struggle.[4] Cultural politics have been more important in Marxist politics which privilege individual agency. The forms of humanist Marxism that influenced cultural politics in Britain in the late nineteenth and twentieth centuries, for example, stressed the unfulfilled, alienated nature of working-class life under capitalist social relations.

Early Marxist writings, such as the *Economic and Philosophical Manuscripts of 1844* (Marx, 1970a), argue that capitalist social relations alienate human beings from their true nature which lies in socialized productive work. This form of Marxism, in which certain aspects of behaviour, including particular forms of cultural production, are defined as essentially human, found an echo in a long humanist Marxist tradition of writing on culture which extends down to the present day. 'Capitalist production is hostile to certain aspects of intellectual production, such as art and poetry' (Karl Marx, *Theories of Surplus Value*, 1861–2).

In Britain, H.M. Hyndman and William Morris, writing in 1884, described how the division of labour within the factories led to long hours

of alienated, unskilled, repetitive work which could offer no satisfaction or self-fulfilment. This capitalist world was contrasted with a romantic image of precapitalist societies in which art was seen as the spontaneous product of the common people:

> This system [capitalism] with its unavoidable consequence that the greater and (commercially) more important part of the wares it produces are made for the consumption of poor and degraded people without leisure or taste where with to discern beauty, without money or labour to pay for the excellence of workmanship – this system makes labour so repulsive and burdensome that art, in the long run, is impossible under it ... Thus the capitalist system threatens to dry up the very spring of all art, that is, of the external beauty of life, and to reduce the world to a state of barbarism. (Hyndman and Morris, 1884, pp. 37–8)

Capitalism, Hyndman and Morris argue, produces both a degraded working class and a society in which art and literature have become the province of a small middle-class elite.

The assumption that, in precapitalist societies, art and literature were organically rooted in the daily lives of ordinary people, had a powerful appeal. It presupposed that everyone needed art and literature in order to become fully human and should have right of access to them. In excluding ordinary people from the production and consumption of culture, class was seen as a negative force which threatened its very future.

'Culture' and Individual Development

> *Life was one long round of sordidness and poverty, meanness and degradation from the cradle to the grave, and the only little glimpses of forgetfulness came, according to temperament, in books, games or drink.*
>
> *Sydney was amazed at the libraries some of them possessed. He was also filled with despair sometimes at the great want of anything higher than would minister to their animal appetites.*
>
> *Life ought not to be the mean, sordid, degrading thing that it was for them. Life ought to mean beauty, art, music, literature. Life should be wisdom, comfort and happiness.*
>
> —James Welsh, coalminer and later MP, *The Morlocks*, 1924, p. 45

TRUTH: Culture with a big 'C' is central to individual development.

Marxists, labour socialists and Liberal Humanists alike accepted this idea in the first half of the twentieth century, though their precise understandings of individual development varied. Whereas the liberal wing of

the establishment saw familiarity with the arts and literature as important antidotes to class-based social unrest, social democratic organizations such as the Workers' Educational Association argued that Culture was central to the self-development of the individual. For this reason access to Culture became a key aspect of adult education.[5] To be working-class and to be without education and Culture was to lack the prerequisites for a fully human life which would take the individual beyond barriers of class.

In contrast to the liberals, labour socialists and Marxists argued that art and literature were powerful educational tools which could help produce a working class able to fight for its own interests. Their aim was not to transcend class at the cultural level, but to create positive forms of working-class identity from which to fight for social changes which would bring about the end of class. In the words of the Plebs' League's motto, the task was to 'Educate to Organize'.

Until 1939 adult education was a key site of debate about Culture and class. The different organizations concerned with working-class education saw access to the established cultural traditions as a major goal. Foremost among them were the WEA, the Marxist Plebs' League, which later became the National Council of Labour Colleges (NCLC) and the education section of the Communist Party. The WEA, which worked predominantly within the Liberal Humanist tradition, saw its role as providing access via education to largely pregiven cultural canons. More socialist-minded members argued for the inclusion on syllabuses of books of particular interest to working-class readers.[6] For the Plebs' League and for the Communist Party, the key task was to offer an alternative to the 'impartial education' offered by University Extension classes and the Workers' Educational Association. 'Impartial' Liberal Humanist education, they argued, would undermine the labour movement.

QUESTION: What is the relationship between class and education?
ANSWER: 'Wherever there are two economic classes, there are two sets of economic interests, and that cleavage extends throughout the superstructure of society. Just as there is no neutrality in the industrial field, no impartiality in politics, neither is there any such thing as non-partisan education. The worker is either robbed or not robbed; Labout is either paid or unpaid. To ask the worker to be neutral is both insulating and absurd. The 'impartial education' idea has its source in a very partial quarter, and so long as the control of education comes from that quarter, the working class movement will be poisoned and drained'. (*The Plebs' Magazine*, 1(4), (1909), 63)

What were the implications of this position for the study of Culture? It implied developing new critical modes of reading which would enable working-class readers to understand Culture in its historical and class context.

What were the major strands in the cultural politics of class on the left up to 1939? There were two main emphases. One stressed Culture's emancipatory role: it could further individual development and understanding of capitalist social relations. The other stressed the importance of working-class involvement in cultural production. These were not mutually exclusive ideas and, often, left-wing intellectuals supported both positions. Since existing canons of art and literature largely excluded or marginalized working-class perspectives and experience, clearly working-class writers, poets and dramatists should be encouraged to give voice to them.

The idea of working-class writing was already on the cultural political agenda. From the 1880s onwards, readers, left-wing critics and publishers had shown an interest in working-class writing and theatre. There already existed a long tradition of proletarian poetry and the late nineteenth and early twentieth centuries saw the publication of a number of working-class novels, the most famous of which was undoubtedly *The Ragged Trousered Philanthropists* (Robert Tressell, 1914).

It was in the period between the First and Second World Wars, however, that working-class writing came into its own. A substantial number of novels and poems by industrial workers were published. In 1927, for example, the coalminer F.C. Boden, who later wrote several novels, published his first anthology of poems with the mainstream publisher J.M. Dent. *Pithead Poems* had an introduction by the influential literary critic Sir Arthur Quiller-Couch. He explained how the manuscript had been given to him by Guy Pocock of Dent's. The poems were lyrical with regular rhymed metre. They included love poetry, poems on the loss of youth and on the First World War. They drew widely on imagery taken from nature as well as New Testament themes and images. Often they depicted an idealized picture of the natural world unaffected by industrialization. Although titled *Pithead Poems*, they hardly referenced the social conditions of work and family life in a mining community. Frederic Boden would take up these themes in his second anthology *Out of the Coalfields – Further Poems* (1929) and in his novels. His early poems, which were typical of much of the working-class poetry which had been published since the turn of the century, were marked by the desire to escape the world of everyday life. This escape would be via poetry and the arts. Poetry, he wrote, improved the quality of inner life.

> And in the lodgings where I bide
> The folk will sit the evening thro'
> Snuffling by the bright fireside
> Of things the neighbours say and do
> . . .
> But there I have a little room
> Where I may flee from such poor fare

And tho' no fire will light the gloom
Yet I have all the singers there.
(Boden, 1927, p. 2)

Working-class writing was included in several journals. These included *The Highway*, published by the WEA from 1908 onwards; the *Plebs' Magazine*, published by the Plebs' League from 1909;[7] and *Left Review* (1934–8), published by the British Section of the Writers' International.[8] What did working-class authors write about? While much poetry drew on traditional themes such as nature and love, some poems and most novels were about everyday life. Ideologically they were rooted in the immediate social and cultural politics of the day, reflecting the various forms of ethical socialist, labourist and Marxist thinking in circulation. Moreover, they offered to a wider readership depictions of the conditions under which working-class men and women had to struggle on a day-to-day basis. In this way they helped to make a strong moral case for social change.[9]

Proletarian Culture and the Struggle for Socialism

What were the key cultural issues for Marxists between the two World Wars?

1 the role of culture in the struggle for socialism;
2 the development of an historical materialist approach to culture;
3 the development of a class-conscious working-class Culture.

In the wake of the revolution in Russia in 1917, ideas about radical working-class culture in Britain were significantly influenced by developments in the Soviet Union. Soviet debates on class and culture sharpened perceptions on the European left and helped the development of Marxist critical practice. The short-lived *Proletcult* movement, founded in the Soviet Union in 1917, stressed the importance of independent political struggle at the cultural level and urged direct working-class participation in the production and consumption of culture.

In *Proletcult* theory the focus of the revolutionary cultural movement was twofold. It was to promote in workers an appreciative but critical awareness of the great works of the past. This would enable them to use the cultural heritage for their own purposes. It should also support the development of a revolutionary proletarian culture. Valerian Poliansk, Chairman of the Central Committee of the All Russian Council of Prole-

tarian Culture, defined the goals of revolutionary cultural politics as follows:

> First it must enable the proletariat to become acquainted with the cultural heritage of the old world. Hitherto, political and economic conditions denied the workers access to that precious inheritance. The proletariat must accept the cultural attainments of previous generations not like an obedient schoolboy, but critically, refashioning them in the forge of its own class consciousness.
>
> Secondly the problem is one of cultural creative work, i.e. the reorganisation of science and art – poetry, painting, sculpture, music, drama etc. – on the new proletarian, communist foundations. The proletariat must continue the work begun by Marx, extending it to all realms of knowledge and art. (*Plebs*, 13(1), (1921), 4)

These ideas fired the imagination of the left throughout Western Europe. In Britain they encouraged debate about the role of art and literature in the struggle for socialism and about the need for a proletarian culture.

But what was class-conscious working-class culture? In the British labour movement ideas varied. For many, it was enough if a text portrayed working-class experience. Indeed, this was the main unifying feature of working-class writing. For example, the coalmining novels of James Welsh, Harold Heslop, Frederic Boden and Lewis Jones all dealt with the day-to-day life of mining communities, though from very different ideological perspectives. For orthodox Marxists, however, particularly during the late 1920s and early 1930s, the overt ideological perspective of the text was all important. Debates at the Second International Conference of the Writers' International, held in Charkov (in the Ukraine, then part of the Soviet Union) in November 1930, clearly illustrate this point. Here it was argued that 'true' working-class culture must necessarily support Comintern ideas. Works that did not fit this definition of class-conscious literature were classed as 'revisionist.'

One of those in attendance at the conference was Harold Heslop, a non-communist working-class writer from the Durham coalfield. Heslop wrote several moving novels of mining life. Yet at the Charkov meeting he criticized both his own social democratic tendencies and the 'revisionism' of his fellow British working-class writers. Speaking of James Welsh's *The Morlocks*, a novel that depicts political unrest in the Scottish coalfields, Heslop dismissed it as 'counter revolutionary', calling it 'the first novel of the social fascist in England' (*Literature of World Revolution*, 1931, p. 226). The Charkov conference marked a high point of sectarian thinking in radical cultural politics, which gave way in the early 1930s to a United Front strategy. The emphasis in Marxist and socialist cultural politics shifted from a purist notion of class consciousness to an emphasis on alliances between socialist and liberal writers, artists and activists.

This did not, however, solve the question of what constituted a progressive class-conscious culture, a question which would remain central to debates in Britain until the Second World War.

In Britain, the 1930s saw the development of an extensive, class-based, oppositional cultural politics. This was linked to two broader political developments. Many of the most committed cultural activists were self-identified Marxists and communists. Hence the importance of the Comintern's abandoning of its 'class against class' strategy which had insisted on a single exclusive ideological and political perspective hostile to the rest of the left. The second key factor was the spread of fascism in Europe. This provoked a move to engage liberal intellectuals in the development of a United Front. In this new climate, several journals linked to the Writers' International contributed to debate on culture and class. They also promoted the development of Marxist criticism and working-class writing. These publications included *Literature of World Revolution*, the Moscow-based journal founded in 1931, which became *International Literature* in 1932 and was published until 1945; *Storm – Stories of the Struggle*, a radical Marxist magazine committed to the development of socialist fiction as a tool in the struggle for socialism, which published four issues in 1933; *Viewpoint – A Critical Review*, the immediate forerunner of the *Left Review*, two issues of which appeared in 1934; and *Left Review* (1934–8).

These journals, of which *Left Review* was by far the most significant, debated important issues. Among them were the social role of the writer and artist and the relationship between culture, class and society. As the organ of the British Section of the Writers' International, *Left Review* had its equivalents in many Western countries, for example, *New Masses* in the USA, and the *Linkskurve* in Germany.

Debates on Culture and Class in *Left Review*

Left Review appeared at a time when Marxist conceptions of class and revolution still had a popular appeal within the labour movement and among middle-class, socialist intellectuals. It was published by the British Section of the Writers' International. This organization drew its membership from two key constituencies: left and liberal working-class intellectuals and left and liberal middle-class intellectuals. The dominant perspective in *Left Review* was Marxist, yet the magazine also included many contributions by liberal writers. It began with capital of £27 and retailed at sixpence (an annual subscription cost seven shillings).[10] Editorial control was in the hands of middle-class, socialist, literary intellectuals. Only distributors were paid. By the end of its first nine months, *Left Review* had a print run of 3500 copies, selling 3000 by subscription and

through bookshops such as W.H. Smith & Sons. One-third of its reader-
ship was estimated to be working-class.

What did *Left Review* write about? First and foremost, *Left Review* dis-
cussed the political role of the writer and artist and the relationship
between culture and society. Secondly, it offered space to new socialist
writers and positively encouraged amateur, working-class writers. Third-
ly, it offered a comprehensive review of recent publications. These in-
cluded: poetry; novels; and books on socialism, world politics, fascism,
imperialism, the Soviet Union, Marxist aesthetics and economic theory.
Furthermore it published eye-witness accounts and documentary mater-
ial on working-class poverty, political struggles (including the anti-
Mosley – that is, anti-fascist – campaigns), and the Spanish Civil War. It
commented on political events and social trends from Marxist perspec-
tives in an attempt to uncover what it saw as 'underlying determinants'
and to mobilize not-yet-committed readers. It published the work of
committed, socialist writers from abroad and surveyed literature and
culture in countries such as India, China and the Soviet Union.

The *Review* was a source of information about cultural political events
on the left, from the International Association of Writers for the Defence
of Culture to information on British groups and activities.[11] These in-
cluded: radical theatre, for example, the Unity, Group and Left theatres;
the Workers' Film Movement; the Left Book Club and its study groups
and summer schools; the Marx House with its workers' library; and
left-wing workers' educational facilities. A typical issue of *Left Review*
contained articles on current political issues, literary theory and criticism,
two or three pieces of working-class fiction or reportage and two or three
poems. A third to a half of the journal consisted of review articles.

Debating the Interwar Cultural Crisis

During its first six months, *Left Review* conducted a lively and at times
polarized debate on the politics of culture and class. The Writers' Interna-
tional diagnosed the contemporary world as suffering from economic,
moral and spiritual crisis produced by the structural contradictions with-
in capitalism. Contemporary literature was regarded as one of several
indicators of this crisis of culture. The key question was what were its
implications for writers and artists.

The terms of the debate were set by Edgell Rickword in the first issue of
Left Review. The article, 'Straws for the Wary: Antecedents to Fascism',
offered a comprehensive overview of the deepening postwar cultural
crisis, which, Rickword argued, would lead to fascism if not successfully
contested. His analysis identified contemporary culture as marked by an

extreme individualism which was linked to a search for a secure ideo-
logical framework. This was expressed as 'a desire for order or even for a
revelation', and the fixed values which would go with it (*Left Review*, 1(1),
(1934), 19). Since Matthew Arnold, writing in the 1860s, these values had,
Rickword argued, been located in High Culture which was still seen by
many as the locus of universal truth. The urge to recapture this stability
was spurred on by the current, massive expansion in the popular culture
industry. This had led to the popularization and commercialization of
cultural values through increased commercial publishing and film. Popu-
lar culture was, Rickword argued, a source of false consciousness that
was of little aesthetic value.[12]

In effect, art, literature and theatre had become clearly recognizable as
commodities and had been demystified in the process. This demystifica-
tion was experienced by many artists, writers and critics as a betrayal of
'true' Culture. It produced a fear of the effects of mass culture which
affected both the left and the right during the 1930s. The most common
response to this 'threat' of mass culture, seen clearly in the influential
work of F.R. Leavis, was the desire to rescue the 'true' cultural values
embodied in high Culture.[13] Alternatively, many contributors to *Left
Review* argued for a new conception of literature which would dissolve
the distinctions between High Culture and mass culture.

Marxist Certainty, Liberal Fears

For Rickword and many other contributors to *Left Review* the answer to
the crisis was obvious – commitment to historical materialism, and an
active fight for socialism. Fascism was, after all, the logical conclusion of
the crisis of capitalism. Yet answers were much less clear-cut for many
liberal supporters of the United Front. Their problem was that they felt
equally threatened by fascism and the possibility of a Marxist 'dictator-
ship of the proletariat'. They held to the Liberal Humanist principle that
art transcends politics, and felt their liberty threatened by socialism.

This fear is apparent in an article on tendencies in modern literature by
Stephen Spender. In 'Writers and Manifestos' Spender argued that mod-
ern literature should deal with 'moral or widely political subjects' rather
than the isolated individual psyche (*Left Review*, 1(5), (1935)). Yet, he was
worried by what he saw as the Marxist threat to the freedom of the
individual, arguing for socialist writing which would stress universal
'human values', rather than social and historical forces.

> The socialist artist is concerned with realising in his work the ideas of a
> classless society: that is to say, applying those ideas to the life around him,

and giving them their reality. He is concerned with a change of heart. . . . It also follows that the writer is primarily interested in man, and not in systems, not even good economic systems. Systems are rigid, and they must always be forced externally, by external criticism, to change. In that sense art, because it insists on human values, is a criticism of life. (*Left Review*, 1(5), (1935) 146).

In Spender's view, the task of the socialist writer was to show what a classless society could be like, and to convert people to it. Implicit in this was the assumption that social change could come about through a moral conversion, a 'change of heart'. Spender's liberal position had much in common with ethical socialism and with Christianity. It disregarded the force of political and ideological power structures and thereby avoided the need for any form of real confrontation.

Liberal fears tended to be defined against the most authoritarian versions of Marxist cultural politics. For the left-liberal poet Stephen Spender, Max Eastman's critical account of Soviet cultural policy in *Artists in Uniform* (1934) served as an excellent foil. It included an account of the activities of the Russian Association of Proletarian Writers, whose principles were typical of Marxist–Leninist thinking about cultural politics:

1 Art is a class weapon.
2 Artists are to abandon 'individualism' and the fear of strict 'discipline' as petty bourgeois attitudes.
3 Artistic creation is to be systematized, organized, 'collectivized' and carried out according to the plans of a central staff, like any other soldierly work.
4 This is to be done under the careful and firm guidance of the Communist Party.
5 Artists and writers of the rest of the world are to learn how to make proletarian art by studying the experience of the Soviet Union.
6 Every proletarian artist must be a dialectical materialist. The method of creative art is the method of dialectical materialism.
7 Proletarian literature is not necessarily created by the proletariat, it can also be created by writers from the petty bourgeoisie; and one of the chief duties of the proletarian writer is to help these non-proletarian writers to 'overcome their petty bourgeois character and accept the viewpoint of the proletariat'. (*Left Review*, 1(5), (1935), 148)

This policy reflected the Marxist–Leninist belief in the leading role of the party in determining both socialist policy and acceptable ideological work. Commenting on this, Spender wrote:

It is evident that the aim of this manifesto is to convert art into an instrument that can be used for party purposes. It is not the business of the artist to

observe but to conform. He must not be a two-edged instrument which
might turn against the party. It is his business to go where he is sent and to
observe what he is told. (Ibid., 149)

It was not, first and foremost, the importance of this attitude to Culture
in the Soviet Union which worried Spender; rather, he noted similar
attitudes among the left in Britain. As an example, he quoted Alec
Brown's article in *Left Review*, vol. 1, no. 3, which was, he said, typical of
the 'great many communists' in Britain, who looked on art 'purely as a
party instrument' and who were hostile to the liberal intelligentsia.

United Front or 'Real' Revolutionaries?

In the article in question Alec Brown had taken up the issues of popular
consciousness and the political consciousness of writers. He advocated an
explicit privileging of a working-class audience. Working-class readers
should be provided with a constructive revolutionary literature in cheap
paperback editions. Brown proposed that writers should have much more
direct contact with workers and that they needed a permanent propa-
ganda committee to work towards the 'proletarianization' of outlook
among bourgeois writers. This radical programme, strongly workerist in
tendency, was both abhorrent to liberals like Spender and incompatible
with the more conciliatory tone of the United Front.
 The 'bourgeois mentality' was one of Brown's key concerns. He advo-
cated the importance of a strong sense of ideology which was class-based
and exclusive. Brown rejected all existing High Culture and literary the-
ory. It was, he argued, 'bourgeois' and could therefore only serve to
uphold existing power relations. What was needed was:

> During the initial period of our magazine . . . to carry on rigorous con-
> temptuous criticism of all highbrowism, intellectualism, abstract rationalism
> and similar dilettanteisms; in short, a constant goading question to be there,
> the single minded question (the Marxist Question): 'Are we an organisation
> of revolutionary writers or are we not?' (*Left Review*, 1(3), (1934), 76)

Brown called for the 'proletarianization' of language. This would involve
a move back to spoken English. He suggested possible campaign slogans
such as 'Literary English from Caxton to us is an official jargon of the
ruling class: written English begins with us'. Another was 'We are revolu-
tionary working class writers; we have got to make use of the living
language of our class'. A third slogan was 'Allusive writing is clique
writing: we are not a clique'.

While naive in its formulation, this plea for radical action addressed the question of accessibility and the class-based nature of the literary tradition in a way that much writing in *Left Review* failed to do. It abandoned any notion of the neutrality of language and cultural products. It reiterated the marked discursive break with prevalent, older humanist approaches to language and class, a break which had also been a feature of *Proletcult* theory after the First World War.

Furthermore, Brown urged writers to take advantage of 'the middle-class search for serious literature', that 'crisis of ideas' which had its economic roots in the 'capitalist expansion of the "culture" market' (*Left Review*, 1(3), (1934), 76). Socialist writers should attempt to win over the middle class to their cause. Unlike Spender, however, Brown had no doubts that a purely intellectual, moral conversion was of limited value. He expressed his reservations in terms likely seriously to offend and worry liberal supporters:

> But while we do this, and assist the more intelligent and honest members of the class over to our side, we must never fail to maintain Robespierrian suspicion, we must never forget that the present distaste for fascism and love of 'democracy' among them is with most of them merely a result of the fact that the usual petty middle class, comfort-loving squeamishness is more than generally marked in the leading imperialist country, and incidentally makes these folk, except in rare cases, the most unreliable and weak-kneed allies. (Ibid., 77)

The claim that liberal intellectuals were 'unreliable and weak-kneed allies' attracted little support from readers of *Left Review*. Most felt that this was not a helpful approach to building a United Front. Many argued for a politically pragmatic approach which did not privilege Marxist analyses. The determining factor in evaluating theory should be whether it served to develop a United Front. It should attract those bourgeois writers who were anti-war but, as yet, did not see their opinion as counting. These writers often had large circulations:

> A writer's usefulness depends on his [*sic*] influence: that is to say on the size and enthusiasm of his public, or in the case of writers' writers, on his ability to set scores of other pens writing. In either case any lasting influence depends on his power to express the inarticulate feelings and forces that make for change. . . . The writer's job is . . . that of gaining a first hand knowledge of such opposition in terms of people: learning to talk 'as a living man to living men'. This process will develop very often . . . towards marxist understanding. Often it will halt short clear of analysis. But a book, a play, a poem which expresses the stage we have reached in England at this moment, in the human opposition to the system's annihilating conclusions, could be itself a blow struck against the plans for war. (*Left Review*, 1 (2), (1934), 16)

T.H. Wintringham, the editor of the *Left Review*, took up the issue of art as a class weapon and the fear that this instilled in liberal intellectuals. Rejecting party control of cultural production, he argued that the liberal conception of freedom failed to recognize the reality of social determination which the writer could not escape:

> Art is a class weapon? Yes, of course it is. On that I hope to write later. But to recognise that fact is not the same as trying to 'convert art into a party instrument'. I hope we shall have some purely party art in Britain, fully and consciously communist, even before our revolution. But meanwhile, the Communist Party does not feel that it is its duty to insist that Mr Spender should write about Vienna, Day Lewis about the class war, or Auden about Karl Marx. When these things happen, it tries to show that there is a reason for them happening, and that the writer who 'insists that one should write as one chooses and about what one wishes' is certainly not 'a traitor to the cause of world socialism', but hasn't yet got clear in his head how the process by which world socialism is coming does, without any 'commands', affect his work. (*Left Review*, 1(5), (1935), 159)

This perspective sought to escape the binary opposition between art and propaganda in which the two categories were radically different from one another. It was an opposition set up by liberal writers in their attempt to hold on to the Liberal Humanist conception of the transcendency and universality of Culture. For them, the universal truths and essential human values with which Culture was concerned could not be historically relative, nor could they be subject to political and ideological forces. To make them so would be to make art subject to class interests and thereby confuse it with propaganda.

Socialist Writing – Working-class Writing

What did it mean to be a committed writer?
What should socialist and working-class writing be like?

These two related questions provoked much debate in *Left Review*. Answers ranged from liberal attempts to separate art and propaganda, to the abandoning of any distinction between the two. Central to the question of propaganda and literature was *form*. If literature and propaganda were distinct forms of writing, the distinguishing formal properties of the two needed to be identified. While the question of literary form was raised implicitly in all literary critical articles and reviews, it was most explicitly discussed in the various critiques of contemporary literature and in the debates on what should be expected of socialist and working-class writing.

Marxist contributors to *Left Review* saw form as integrally related to the ideological perspective of the writer. Following Soviet theory of *socialist realism*, they argued that a socialist use of form demanded realism rather than modernism, caricature or satire. Socialist realism was an aesthetic designed to produce art and literature which would play a positive role in the construction of socialism.[14] It required that writers write from a Marxist perspective drawing on direct experience of society.

> QUESTION: What were the effects of failure to write from a Marxist perspective?
> ANSWER: The realism of the text suffered.

Attachment to liberalism and middle-class values was said to affect the writer's ability to portray the working class. It was for this reason that *Left Review* judged Spender's *Vienna* to be less successful than it might have been. The quality of his poetry reflected Spender's inability to commit himself fully to the interests of the working class and his lack of direct experience of working-class men and women:

> When the literary historian of ten years hence looks back, he will see a group of poets – sometimes called the 'New Country Group' who began to be prominent during the crisis of 1929 onwards, and who wrote as revolutionaries. He will see *Vienna* and another book as the first expression of actual contact between this group and the working class revolution. And he will note in *Vienna* that there is a remoteness, a coldness of image (as in the lines on the unemployed, for instance), that weakens the texture of the verse and the whole structure of the poem. This he will, I think, attribute to the fact that Mr Spender, when writing this, his most considerable poem, was still unable to associate himself with the living stuff of the revolution, though he could express the monumental greatness of the dead men who had fought and been 'defeated'. The roots of this inability lie, I think, in a difficulty as to the relation between art and propaganda: the revolution seems to threaten a loss of liberty. (*Left Review*, 1(5), (1935), 158)

Social realism was regarded as the only progressive form for working-class writing. Novels and poetry were well received by *Left Review* when they advanced a socialist perspective and suggested positive ways forward. When they used other techniques, for example, satire, they were judged less successful. The novel *His Worship the Mayor* (1934) by Walter Greenwood, a working-class writer who wrote a number of popular novels including the subsequent Penguin 'modern classic' *Love on the Dole* (1933), was attacked for its use of satire and its negative political implications. *Left Review* criticized *His Worship the Mayor* for failing to create 'unforgettable irony and pathos out of the circumstances with which the novel is concerned' and frittering away its material in satire. Moreover, 'the novel lacks ultimate direction, and its most serious fault is the

complete absence of any suggestion of a solution to the state of vulgar bigotry and exploitation on the one hand and the unrelieved want on the other' (*Left Review*, 1(2), (1934), 46). A Marxist perspective combined with realism could provide a way forward.

The most common criticism of working-class writing in *Left Review* was of the appropriateness of form to content. Socialist ideas should, it was argued, emerge 'organically' from the interaction of individual and society. Yet often they seemed to be superimposed on the characters. For this reason they rang hollow and dogmatic and could be read only as propaganda:

> The approach of the text book and the newspaper article should obviously be direct, that of the novel or play indirect: the latter have to give insight into the causes of events imaginatively through the reaction of society and the individual upon one another. The tendency of much proletarian art is to use individuals as lay figures expressive of political ideas, instead of depicting them as living agents and instruments of political forces. (*Left Review*, 1(4), (1935), 129)

This emergent Marxist criticism proposed a new conception of literature in which revolutionary ideas and art were not incompatible. It was a conception founded on the belief that the revolutionary writer required *technical skill*, *theory* and *experience* of what she or he was writing about. Marxism, critics argued, was the source from which the theory must be derived.

Left Review and the Development of Working-class Writing

> Theoretical advance is one of the conditions of literary advance. Another condition is knowledge of the ordinary world of people and of things, the world of work, the world of everyday economic struggle . . . We are appealing to all who are looking for a vital expression of revolutionary work. If you want to get a notion of how men can change the world by understanding it and conquering their own past: come and look. If you want to see how men are changing themselves as part of the process of world change: read. If you want to take part in the creation of the literature of the classless future and to help to prepare the ground for the masterpieces in which that future will live before it has come true: write. (*Left Review*, 1(9), (1935), 364–5)

In its founding statement, the British Section of the Writers' International urged all writers to join the association 'who, if members of the working class, desire to express in their work more effectively than in the past, the

struggle of their class' (*Left Review*, 1(1), (1934), 38). Moreover, it affirmed its commitment to the development of socialist, proletarian writing. By 1934, when this statement was made, working-class writing and documentation of working-class life had already become fashionable in Britain. *The Plebs* and the *Highway*, among other journals, had been giving some space to the issue on a sporadic basis since they were founded. Several working-class writers had become successful and were widely read. Fictional, autobiographical and sociological accounts of working-class life were being published by the mainstream publishing houses and working-class life had become a subject for theatre and the cinema.

How did *Left Review* see the development of working-class, socialist and proletarian literature? Positions ranged from Alec Brown's support for a new radical popular culture to arguments for the practice of literature to be limited to professionals who had proven their worth as writers. The Scottish writer Lewis Grassic Gibbon was the main representative of this latter position. He argued that the Writers' International should consist of 'only those who have done work of a definite and recognised literary value (from a revolutionary point of view)'. It would consist of professional journalists, novelists, historians and the like, who would have to prove their right to admittance (*Left Review*, 1(5), (1935), 179). Other contributors argued that the development of appropriate theory was more important, while the editors of the magazine pursued a policy of encouraging practice by regularly publishing working-class fiction, poetry and reportage of working-class life.

Alec Brown was not alone in urging the need for a revolutionary popular fiction which would attract a working-class readership. The cultural crisis which *Left Review* saw itself as addressing also affected the working class. There was a strong need 'to win the majority of workers from the purely escape [that is, escapist] novel of adventure and from the detective Both of these', it was argued, were 'products of cultural decay equally with more pretentious productions' (J.M. Hay, *Left Review*, 1(6), (1935), 221).

The recognition of the need for a socialist literature, attractive to working-class readers, which could replace conventional popular fiction raised the question of who was to write such books. The Marxist insistence on direct experience coupled with a revolutionary socialist perspective implied the need for socialist, working-class writers. For the most part, contributors to *Left Review* supported this. Grassic Gibbon's insistence on professionalism begged the question of how revolutionary 'literary value' was to be recognized and by whom. It also ignored the material difficulties faced by working-class writers.

Other objections to the policy of encouraging working-class writing focused on the relationship of theory to the practice of writing. Douglas Garman, for example, argued that proletarian writing required a theoretical framework. Merely publishing writing because it had a 'vaguely

revolutionary content' and without regard to its theoretical and ideological position, was, he suggested, a waste of space, which could be better devoted to literary criticism and theory. Without vigorous theoretical debate 'proletarian literature is likely to remain a sickly hanger-on of capitalist culture, undistinguished by any more profound change than that its typical hero will be one of the "toiling masses" rather than one of the "pampered bourgeoisie" ' (*Left Review*, 1(5), (1935), 181). Garman did not take the revolutionary nature of realism for granted. Rather, he argued that new revolutionary forms and content must be developed. However, this position had little effect on *Left Review*'s competitions or on published extracts and reviews of working-class writing.

The Promotion of Working-class Writing

> *Remember that it is the heart of this whole business to make the reader feel as if he or she were actually there.*
> —*Left Review*, 1(3), (1934), 74

Left Review published regular extracts of realist working-class writing. It further attempted to encourage such writing through a series of competitions. These were introduced in the first issue of the magazine in the context of a discussion of language. The magazine attacked the use of what it called 'jargon' on the left, giving as examples 'mass struggle', 'task', 'deviation' and 'ideology'. It argued that these were words to which the unconvinced worker would not respond (*Left Review*, 1(1), (1934), 38). The key to this problem was literary form. In trying to put across new content, socialist writers, *Left Review* argued, required an appropriate form. New forms could be developed only by learning from the best of past and present writing. Comprehensibility should be the overriding factor.

The emphasis in the competitions was placed on practice rather than theory:

> In order that we may learn by each other's attempts and each other's criticisms, I suggest that those readers who are also writers, but may not in some particulars be satisfied with their technical skill, should join us here in discussion and in attempting particular solutions. To that end a series of exercises or competitions would, it seems to me, be useful. (*Left Review*, 1(1), (1934), 40)

Between October 1934 and April 1937, *Left Review* sponsored seven competitions. The themes included the description of an eviction, an hour or a shift at work, an encounter, a strike, a criticism competition, school

days and 'What life means to me'. With the exception of the criticism competition, entries numbered between 40 and 50. Prizes of books to the value of about ten shillings were awarded.[15]

The formal expectations of the organizers were made clear in the guidelines to the competitions. While no explicit literary or aesthetic criteria were offered, a task was set which would promote realist fiction. Competition number three, 'An Encounter', for example, focused on characterization: 'The writer meets someone, takes part in talk at work, home and in a pub and gets a strong impression of the person he is talking to. He thinks of all the things in the other man or woman that have made them that person and no other' (*Left Review*, 1(6), (1935), 220). Literature should, *Left Review* argued, offer a reflection of social conditions which was 'worth preserving'. However, writers should also concern themselves with the forces moulding these social conditions and the possibilities of change. The questions around which entries were to be organized explicitly encouraged socialist realism.

After each competition *Left Review* published several entries which had been selected as the best, together with comments and encouragement. These comments, often paternalist in tone, were not critically precise about stylistic detail. Yet they implicitly urged realist principles of writing. Writing, they suggested, should be judged by its effect on the reader. This effect should be of an emotional nature, rather than provoking a conscious analytical response.

Left Review claimed considerable success for its competitions, referring to letters of appreciation from novelists, enthusiastic readers and publishers. Apart from competitions, the magazine published regular short stories and extracts from longer prose pieces by working-class writers. The themes of the stories could be described as social criticism and their style, too, was realist. *Left Review* also printed calls from publishers for working-class writing. For example, it advertised a competition sponsored by the Gollancz publishing house for the best genuinely proletarian novel by a British writer. And it published a note from the working-class writer James Hanley on behalf of Methuen, calling for manuscripts. Its own special issue on working-class writing, however, which was announced in October 1936, never materialized.

In addition to these forms of support, *Left Review* reviewed some published working-class novels. However, given the number of texts which appeared in the 1930s, coverage was very limited. Moreover, the reviews were not very detailed or literary in their content. Texts discussed included, for example, Walter Greenwood's *His Worship the Mayor* (1934), Ralph Bates's *Lean Men* (1934), Harold Heslop's *Last Cage Down* (1935), Leslie Halward's *To Tea on Sunday* (1936) and Lewis Jones's *Cwmardy* (1937). All were judged according to the criteria of social realism. Most were highly recommended for their 'truth to life'.

A Radical Cultural Politics Based on Certainty?

Debate on the politics of Culture in *Left Review* produced a set of defined positions on the nature of literature, the role of the writer, art and propaganda and literary form. It offered frameworks for both middle- and working-class writers. *Left Review* advocated the view that art and literature in every society are linked to the economic forces governing that society and have an important ideological role to play. This was not just true of High Art, but also of mass culture. Mass popular fiction was seen as both trivial and distracting, but no less political for that. It acted as an opiate, distracting attention from the real causes of social concern. It was therefore important to produce a radical alternative to mass popular culture.

> TRUTH: Writers and artists are politically involved whether they realize it or not. Their work will advocate social values that may be progressive or reactionary. They will always be implicated in power relations.

In the 1930s, Marxist intellectuals believed that artists and writers could take a decision to support or oppose the course of history, to help speed the coming of socialism or delay it. They could contest or support, actively or by default, the immediate threat of fascism. Writers and artists needed to be made aware of their political role and were urged to take an active part in shaping things. In their practice they needed to combat individualism and develop a socialist perspective. This would involve a redefinition of the freedom of the artist.

> QUESTION: What made it possible for liberal and Marxist writers to co-operate in the 1930s?
> ANSWER: A common threat from outside, in this case fascism. It is arguable that the dominance of *realism*, as the preferred form for progressive modern writing, was also a basis on which both liberal and socialist writers could come together. Realism was widely claimed to be 'true to life'. As a concept, it was open to articulation within a range of theories of literature, signifying something different in each of hem. Only within each specific context was it apparent whether this 'truth to life' was produced by 'neutral objectivity', as liberal writers would have it, or by the 'true' and necessarily political perspective of historical materialism, as many socialists argued.

The relative coherence of radical cultural politics in the 1930s relied on an acceptance by key activists of Marxist theory of class and revolution. Marxist assumptions about the meaning of class and the political role of culture provided left-wing writers and cultural activists with a political

programme for action. The Marxist belief in the possibility of objective knowledge produced through historical materialist theory found its aesthetic articulation in socialist realism.

Yet as *Left Review* illustrates, the 1930s produced a broader United Front between Marxists and liberals. While the tension between the two groups was never resolved, they were unified in their opposition to the growing hegemony of fascism in Europe. In this respect they prefigure much subsequent cultural political struggle. It is much easier to unite disparate interest groups *against* something than *for* particular ends.

Left Review can be seen as a move towards the development of a greater degree of cultural democracy in Britain. It was important for many reasons. Its editors believed firmly in the importance of culture to all sectors of society. They attempted both to make existing High Culture accessible and to develop new perspectives which would make it politically relevant to working-class people. The *Review* encouraged and publicized grass-roots cultural activity and although it advocated socialist realism, did not make either ideology or aesthetic purity into a dogma, as happened in the East European socialist countries in the postwar period. *Left Review* furthered left-wing cultural theory and criticism, emphasizing the relationship between culture, class interests and the reproduction of social power relations of dominance and subordination. The belief of interwar Marxists in an inevitable historical process which would lead to socialism and communism – a process that intellectuals and artists could help or hinder but not prevent – created the conditions for a reasonable degree of liberalism where art and literature were concerned. This did not mean that the tension between different positions disappeared. Some Marxist critics argued passionately for the primacy of theory and historical materialist perspectives. Others encouraged working-class participation without paying too much attention to content beyond a fundamental belief in the progressive nature of realism as a form which could make a strong political and moral case for socialism.

The postwar period, to which we turn in chapter 5, has seen the undermining of the apparent certainties on which radical cultural politics of class in the interwar period were based. Traditionally, the labour movement appealed to 'class' as if it were something obvious, identifiable and certain, the source of positive forms of identity. In the contemporary, 'postmodern' world such appeals have become unconvincing. In recent years both practical politics and thinking about class have changed. The last three decades have seen a widespread rejection of traditional forms of class identity and the hegemony of new, apparently 'classless' forms of culture. Ideas of a classless society have become central to Conservative political rhetoric, popular culture, the leisure industries and the expansion of consumerism. At the same time, Britain, like many Western countries, has witnessed an increase in oppositional cultural politics around

other issues such as race, gender, sexual orientation, nuclear weapons and the environment.

In the interwar period, class functioned as a positive and empowering force on the left. For many, to identify as working-class was to occupy a subject position at the forefront of the struggle for change, a position from which to contest dominant meanings, institutions and social practices. Relatively few people in Britain today identify with traditional versions of class politics. Few people positively identify themselves as 'working-class'. None the less, class, as a way of conceptualizing social relations of inequality, still has an important role to play in the struggle to achieve a less divided and oppressive society. While we may work with conceptions of class that insist on the centrality of economic inequality, we cannot assume that people will see themselves and their position in society in these terms. The question which we need to ask is how class interests can be articulated in ways that engage people and motivate them to work for social change.

But before we turn to Britain in the postwar period, we want to look at an example of postwar cultural politics in Eastern Europe. Here the Marxist ideas which inspired intellectuals in Western Europe in the 1930s became the basis of centralized state cultural policy. Attempts were made to overcome the class-based nature of High Culture and the divisions between intellectuals and manual workers. Culture was officially seen as an important dimension of the life of all individuals, but it also had a precise political role. This was to serve the interests of the working class and to aid the development of a truly socialist society. In chapter 4 we look in some detail at this experiment in Marxist cultural politics, taking the example of the German Democratic Republic.

4

Marxist Cultural Politics in Eastern Europe: The Case of the German Democratic Republic

When we speak about culture and cultural tasks in a developed socialist society, we do not mean some narrow limited area. It is a question of the totality of living conditions, of material and spiritual values, ideas and knowledge, through the appropriation of which people, in community with each other, ripen into capable, educated and convinced builders of socialism, into true socialist personalities.

— Kurt Hager, Member of the *Politburo* and Secretary of the Central Committee of the SED, 1982, p. 11[1]

In the new East European socialist states founded after 1945, Marxism moved from its interwar place on the margins of the dominant culture to centre stage. What were the effects of this for cultural policy and practice in countries concerned? In this chapter we look at Marxist cultural politics in the German Democratic Republic (GDR). As elsewhere in Eastern Europe and the socialist world, the Marxism in question was a form of Marxism–Leninism modelled on developments in the Soviet Union. It set both the parameters and informed the day-to-day forms of cultural political practice.

After 1945, with the division of Europe and the onset of the Cold War, cultural politics came to play a new role in both Eastern and Western Europe. In the West, communism was very soon portrayed as the main threat to 'our way of life'. In stark media campaigns, it was associated

with lack of freedom, denial of individual rights, a low standard of living and ideological brainwashing. The West's former wartime ally, the Soviet Union, which, until the invasion of Hungary in 1956, was seen by many on the West European left as a model socialist state, came to equal evil incarnate.

In Eastern Europe, where a range of new socialist Soviet satellite states emerged, postwar reconstruction involved the establishment of new social and political structures. The populations of these countries had to be won over to the cause of socialism. Central to this process was a discrediting of capitalist norms and values and, in the late 1940s and 1950s, much effort was invested in linking fascism, imperialism and the capitalist economic system. The claim to occupy the moral high ground would remain a key dimension of East European cultural politics and would indeed play an important role in popular disillusionment with the system.

Nowhere in Europe was the cultural and political situation more polarized in 1945 than in Germany. After 12 years of National Socialism, the country was defeated and divided into zones of occupation. In the Western zones the encroaching Cold War led the occupying powers to opt for a rapid rebuilding of Germany and its integration into a liberal democratic capitalist Western Europe. Out of the Soviet Occupied Zone there emerged a new socialist state which became the German Democratic Republic in 1949. It lasted for 40 years until the events of 1989 precipitated unification with the Federal Republic.

Es hat die Not ein Ende	[There'll be an end to need
Wenn IHR *die Zeit bestimmt*	If YOU control the age
Und in die eignen Hände	And into their own hands
Das Volk sein Schicksal nimmt	The people take their fate
Wenn Arbeiter und Bauern	If workers and peasants
Kommen überein	Unite
Wird es nicht lange mehr dauern	It won't be long
Und es wird Friede sein	And there'll be peace]

— Johannes R. Becher, *Volkes eigen*
(Belonging to the People), 1948–50

During the early years of the GDR, anti-fascism and the need to secure a lasting peace were key themes in cultural politics. The other major theme was the need to win the population over to the idea of a different Germany, organized on socialist principles. In popular songs, films, new fiction and theatre, ordinary people were encouraged to see themselves as active and important agents in the construction of a better society. In this work of reconstruction the people and the communist Socialist Unity Party (*Sozialistische Einheitspartei Deutschland*: SED) were depicted as

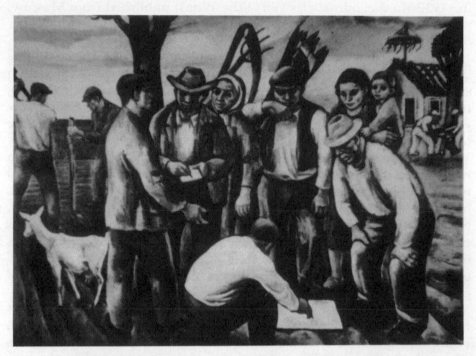

Plate 4.1 Landaufteilung, Arno Mohr, oil on canvas, 1949.
Photograph: Jutta Wrase.

partners. Look for example at plate 4.1. This is a reproduction of a classi-
cally socialist realist painting *Landaufteilung* (Distribution of Land) by
Arno Mohr from 1949. It shows a party official in the process of distribut-
ing land to landless farm workers and refugees from former German
territories east of the Oder–Neisse border with Poland.

Socialist cultural politics were not entirely new to Germany in 1945. In
addition to Soviet models, the GDR drew upon ideas developed in the
interwar Weimar Republic and consolidated for many activists, artists and
writers by the experience of imprisonment and exile. Between 1918 and
1933, Germany had had a well developed and extensive radical cultural
politics rooted in organizations belonging to the Social Democratic and
Communist Parties (SPD and KPD). It included workers' theatre, the
Federation of Revolutionary and Proletarian Writers, the Workers' Film
Movement and a wide range of amateur groups in all areas of literature
and the arts.[2] The radical middle-class intelligentsia was also strong and
there was widespread debate on issues of culture and class.

Many of the state officials who set about implementing and policing
Marxist–Leninist ideas in the GDR after 1945 had had experience of
Weimar cultural politics and of anti-fascist struggles conducted in exile.

Moreover debates about socialist culture had continued in exile during the 1930s in the journal *Das Wort* (The Word) published from Moscow, where the well-known exchanges between Brecht and Lukács over socialist realism were published.[3]

From its very beginnings as the Soviet Occupied Zone, the new state laid great importance on cultural political work. Faced with a population steeped in Nazi ideology, the German communists and social democrats, returning from exile, set out to win the people over to socialism. How was this to be done? Priorities were education, cultural provision and the restructuring of the worlds of work and community life.

Initially socialist intellectuals in the GDR hoped to establish a 'German road to socialism', an idea soon lost with the increasing centralization of the new state, organized on the Soviet Stalinist model. From the start, however, 'culture' was seen as central to political and social education. Nazi culture, which had been the sole diet of the people for the previous twelve years, was to be replaced by a new *socialist national culture*. This involved the construction of new traditions comprising 'progressive' bourgeois culture, socialist culture from abroad, German 'proletarian' culture and a new contemporary socialist German culture.

Nazi institutions were replaced by socialist ones. Emphasis was laid (as it had been under the Nazis) on the *collective* rather than the individual. Political parties were founded which were said to represent the interests of particular groups within society such as farmers and small businesses. Organizations were set up for youth, workers, women, artists, writers and cultural workers. Priority was given to ensuring that all individuals were involved in collective organizations in education, the workplace and during leisure hours. In each of these organizations, from the Free German Youth (*Freie Deutsche Jugend* (FDJ)) to the Trade Unions (*Der Freie Deutsche Gewerkschaftsbund* (FDGB)), the Socialist Unity Party played a leading role. The State took over industrial plants, land was redistributed to small farmers and subsequently collectivized. Education, the law, the army and other important social institutions were reformed, as were the structures of the workplace. An infrastructure for both professional and amateur cultural activities was gradually set up and extended to all parts of the Republic.

Auferstanden aus Ruinen und der Zukunft zugewandt,
laß uns dir zum Guten dienen, Deutschland, einig Vaterland.
Alte Not gilt es zu zwingen, und wir zwingen sie vereint,
Und es wird uns doch gelingen, daß die Sonne schön wie nie über Deutschland
 scheint

[Arisen from ruins, turned towards the future,
let us serve you well, Germany, united fatherland.

We must conquer all need, and we'll conquer it together
And we'll yet succeed in making the sun shine as never before over Germany]
(National Anthem, J. R. Becher and Hans Eisler, 1949).

From 1945 onwards the explicit aims of cultural politics in the GDR were to develop socialist consciousness and values in the population and to motivate them to work energetically to construct a thriving socialist economy. In the early years there was a good deal of enthusiastic support for a new socialist Germany, particularly among younger people. This was channelled and strengthened by the various organizations to which people were encouraged to belong, in particular by the Free German Youth Movement and the trade unions.

The new State offered real prospects of education to people previously excluded because of their class background, and socialism promised equality and justice for all. This was reflected in the enthusiastic endorsement of the new system found in the work of writers and artists in the 1940s and 1950s.

Writer and poet Johannes R. Becher (1891–1958), for example, had made a name for himself in the Weimar Republic as a founder of the Federation of Proletarian Revolutionary Writers and editor of *Die Linkskurve*. He had spent the Nazi period in the Soviet Union. In the GDR he was president of the *Deutsche Akademie der Künste* (German Academy of Arts) from 1953 to 1956, and Minister of Culture from 1954 to 1958. He wrote poetry, folksongs and prose which caught the naive spirit of the time, including the GDR national anthem.[4] Anna Seghers, another important writer of the early years, who first made her name as a radical writer in the Weimar Republic and then in exile, wrote exemplary socialist realist stories which showed how the new social relations at work could win sceptics over to socialism.[5] Younger writers were urged to produce socialist realist texts, set in factories, shipyards and on collective farms, which would motivate workers to greater productivity, thereby expediting the construction of socialism.[6] In film and the visual arts, too, stress was laid on positive images of ordinary people working to construct a new Germany. Look once again, for example, at plate 4.1.

Culture and the Individual

The key target of cultural political work was the *individual*. She/he was to be transformed into what cultural theorists called the 'all-round developed socialist personality' (*allseitig entwickelte sozialistische Persön-lichkeit*).[7] This new type of individual would realize that self-fulfilment

lay in collective engagement in society and she or he would work hard to construct socialism. How then, was, this idea realized in cultural practice?

The stress on collectivism was central to the reorganization of the structures of work and leisure. In the workplace, workers were organized into *brigades*, teams of workers who worked as collectives. In order to achieve recognition, a brigade had to fulfil various criteria. It could only do this if everyone played their part in the collective effort. Brigades took part in what was called 'socialist competition', competing against one another in an effort to increase productivity. They received bonuses if they exceeded the planned level of productivity and took part in social, cultural and sporting activities in their free time. A whole range of awards were introduced to recognize individual and collective effort. Best workers of the month were regularly featured on public notice boards in factories and best factories in the national press.

The East German State paid a great deal of attention to the organization of cultural life. In towns and villages, cultural centres were provided to house professional and amateur art, literature and music. Amateur art was encouraged in an attempt to develop what was called the 'productive use of leisure time'. The trade unions, in particular, played an important role in creating an infrastructure for workers' theatre, writing, art and music groups. The idea of the 'all-round developed socialist personality' implied the participation of everyone in culture and the arts. Practical attempts were made to overcome traditional divisions in the consumption of culture. Thus a percentage of theatre, opera and concert tickets, all of which were heavily subsidized, were reserved for particular social groups. These included young people, members of the armed forces and industrial and agricultural workers. There were positive incentives for these groups to use the tickets. For example, 'socialist competition' in the factories, which was rewarded with bonus payments, included a cultural dimension. Workers had a material incentive to attend cultural events.

Yet the committed socialist personality who would work hard to construct socialism largely eluded the best efforts of cultural functionaries. The emphasis on collectivity and on the development of the all-round developed personality stressed socialist values, while ignoring much of the reality of GDR life. The celebration of the working class in official rhetoric was accompanied by a degree of centralization and top-down planning which effectively disempowered ordinary people, eventually alienating them from the system that was supposed to serve them. Moreover, important areas of people's experience found little echo in official cultural politics. Women, for example, were told that Western feminism was an epiphenomenon of decadent capitalist society. Access to education and the workplace were seen in classical Marxist terms as the keys to emancipation. Western conceptions of patriarchy, particularly in

interpersonal relations, did not fit the official picture of life in the GDR. Yet the reality of women's lives was largely one of an untransformed double burden. This issue remained submerged for a long time but eventually surfaced in fiction in the 1970s.

Similarly, the GDR claimed to have done away with racism. Like sexism, racism was understood by the State to be an epiphenomenon of capitalism. The all too crude base–superstructure model of society, endorsed by the State, suggested that the abolition of capitalist relations of production equalled the abolition of the necessary material basis for racism. Official cultural politics stressed friendship between different peoples. This was, for example, a key feature of children's books. Some writing by foreign Writers of Colour was also published, in part to promote positive attitudes to other cultures, and in part to emphasize the exploitative nature of Western capitalism and imperialism. Meanwhile internal policy attempted to keep overseas students and foreign workers from Africa and Asia separate from the GDR population. In consequence long-ingrained racist attitudes and assumptions, inherited from the Nazi period and before, were not directly confronted. Where racism surfaced it was written off as an effect of Western propaganda.

Policing Culture

The State in the GDR was not only concerned with the material provision of culture but also with its forms and content. In the context of the Cold War and the never-ending stream of anti-socialist propaganda broadcast from West Germany, the new State quickly developed a siege mentality which sought to protect its population from all kind of Western ideas whether from within or without its borders. The Berlin Wall, for example, was officially known as the 'anti-fascist wall of protection' (*antifaschistische Schutzmauer*). Artists and writers were officially seen as a privileged group who owed their position to the working class. Compared with their counterparts in the West, they enjoyed an unparalleled degree of economic security via state subsidies. The State argued that it was the working class who created the wealth that could support cultural production. For this reason, artists and writers were morally and politically obliged to serve the interests of the working class. Under Marxism–Leninism, however, the interests of the working class were not defined at a grass-roots level but by party functionaries who did not have to submit them to the test of Western-style elections. The State thus claimed the moral high ground even where censorship was concerned. It introduced strict and effective forms of policing which ensured that only work that was considered 'constructively critical' saw the light of day. These measures

included the vetting of publications by the Ministry of Culture, the restriction of the print runs of controversial texts and the criminalization of publications not officially approved. They also included the imprisonment or deportation to West Germany of artists and writers who were considered too critical, and the rule that professional artists and writers must belong to the appropriate organizations such as the Writers' Union. These organizations excluded people thought not to be politically sound.

The development of an oppositional underground culture in the GDR was effectively prohibited by criminalization and lack of materials. Few people had access to duplicators, few people had telephones. Even as technology changed, there were no photocopiers or computers available to ordinary people. Such photocopiers as were owned by universities or the State news agency were kept more or less firmly under lock and key. In the 1980s, when unofficial opposition to the State increased markedly, the protestant Evangelical (Lutheran) Church opened its doors to a wide range of groups whose interests were marginalized or suppressed by state organizations. They ranged from a variety of women's groups, gay and lesbian organizations to environmental and peace groups. In offering the only place where people could meet legally, the Church played an important role in supporting a more critical culture. Yet the potential of oppositional groups was severely limited by the State ban on publishing, duplicating and distributing material which had not been vetted by the censors.

Library provision in the GDR was good. In addition to town libraries many factories had their own facilities. People were encouraged to read and they did read widely, but their reading diet was carefully policed. One of the main features of bookshops, for example, all of which were State-run, was the predictability of what might be found on the shelves. Non-controversial authors would be available in large numbers, controversial ones were difficult to find. Often one had to have a personal relationship with bookshop staff to obtain works by critical GDR writers such as Christa Wolf or Christoph Hein.

Publications from abroad were screened and most did not see the light of day. It was an offence to bring Western publications into the country. English-language books, for example, were selectively reprinted by the GDR Seven Seas Press. Original imprints were not imported. Even the one English-language newspaper that was not banned, the communist *Daily Worker*, later the *Morning Star*, was not distributed when its views did not tally with those of the Central Committee of the Socialist Unity Party. A number of important Western works of theory and scholarship were held by universities but they were kept locked in the *Giftkammer* (poison cabinet) and special permission was required by those wanting to read them.

The one major and decisive gap in State control of the cultural appa-

ratuses was the availability of West German television and radio. In the 1950s and 1960s, ideological campaigns were waged to persuade people not to tune in to Western broadcasts. Eventually these were abandoned as unsuccessful and programme scheduling was used to attract audiences away from particular Western programmes. None the less the West German media offered a constant flow of images of wealth and success that created expectations which the GDR could not meet.

Socialist Realism

What, then, should the people be reading and watching? In the 1950s and 1960s, the debate about desirable socialist cultural forms was heavily influenced by Soviet SOCIALIST REALISM. This found theoretical expression in the work of Georg Lukács (1963 and 1972). Lukács consolidated a socialist realist theory of art and literature which, as we pointed out in the previous chapter, was first developed in the Soviet Union in the 1930s. It linked aesthetic form directly to socio-economic factors. Form could be either progressive, as in the case of realism, or reactionary, as in the case of modernism. For example, while the ideological perspective of presocialist, realist writers was bourgeois, Lukács argued that their work contained within it the contradictions of a class society and as such could give insight into class struggle as a motor for social change. It was thus an important tool in socialist education. Modernist art and literature, on the other hand, were read by Lukács as a product of the crisis of advanced capitalist societies which produced a fragmentation of the bourgeois world view and a crisis of subjectivity. This crisis of subjectivity, which modernism manifests, was seen as reactionary in its political implications since it neither produced insight into history and society nor affirmed a unified active progressive class subject committed to social change. As such it could only distract working-class readers from the task of transforming capitalist social relations and constructing socialism.[8]

The object of socialist realist art and literature was to transform the consciousness of the individual viewer or reader through identification with an ideal hero or heroine who successfully overcame the ideological and material problems confronting the construction of socialism. Most often these heroes were industrial workers who also found themselves celebrated in large numbers of paintings and statues in public places (see plate 4.2). A typical example of socialist realism, Herbert Otto's *Zum Beispiel Josef* (For Example Josef, 1970) which was subsequently made into a film, tells the story of how a brigade of shipyard workers manage to reintegrate the anti-social Josef into GDR society. Josef, brought up in a Catholic orphanage during the war, later joins the French Foreign Legion

and eventually becomes a seaman. All his anti-social traits have their origins in his experience of capitalist societies. The process of reintegration into a socialist society and the change in Josef's attitudes and personality are slow and difficult but the persistence of Josef's fellow workers eventually triumphs. Sub-themes in the novel and film concentrate on the problems of socialist production in the shipyard.

The policy of representing ordinary working people in literature, theatre, film and public art was part of a cultural politics which sought to transform traditional criteria of who was a suitable subject of art and of public sculptures and monuments. If working-class heroes were the central figures of much socialist realist literature, film and theatre, they also found a place in public sculpture. Whereas previously only the 'great and good' – powerful statesmen and military heroes – were cast in bronze and stone, in the GDR, Marx, Engels, (until the mid-1950s) Stalin, Lenin, Thälmann and other heroes of the revolution were joined by representatives of the working class. Plate 4.2 shows sculptures of industrial workers which form the centrepiece of the shopping precinct in the East Berlin high-rise residential district of Marzahn. Since the unification of Germany, all the previously State-owned shops in this precinct have been taken over by the large West German chain Kaufhof which now forms the unlikely backdrop to socialist realist sculpture.

Why was the working class seen as so important? At the centre of GDR cultural politics lay a particular view of the historical role of the working class. The GDR shared a Marxist–Leninist theory of progressive historical development with the rest of Eastern Europe and the Soviet Union. Socialism was seen as an inevitable historical phase in the transition from capitalism to communism. The working class was the motor force behind this transformation but it was a working class whose interests were defined by the Communist Party. It was the role of the Party and of the committed art and literature which it endorsed to enable the working class to recognize these interests.

Socialist realism was central to this aim. As a theory, socialist realism was based on the assumption that revolutionary socialist subjectivity meant a unified, class identity, defined by the Party. This could be formed by identification with fictional characters, in this case ideal, working-class, socialist heroes (rarely heroines) who showed the reader or audience the way to socialism. In order to produce such culture, artists and writers required an historical materialist view of history and society (which tallied with that of the Party) and direct experience of the social relations of everyday life.

Even in the 1950s, when socialist realism was most powerful, it did not remain unchallenged. Its main opponent was Bertolt Brecht, who was offered his own theatre on his return to Berlin from exile in Sweden and the USA. His international status and foreign passport ensured him a

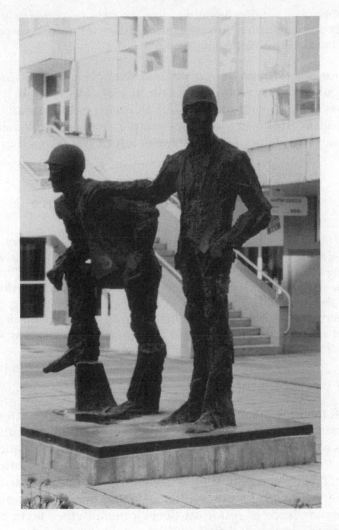

Plate 4.2 Statue of Industrial Workers, shopping precinct in Marzahn, East Berlin.
Photograph: Glenn Jordan.

greater degree of artistic freedom than was usual. Brecht rejected the
contention that empathy with a realist working-class hero could bring
about a change in consciousness. While a measure of empathy between
audience and characters was important in art, this empathy needed to be
undermined in ways that would produce conscious, rational critique.
Brecht also contested the idea that a particular set of fixed formal criteria
could constitute socialist art. He argued that aesthetic form was historical
and that it changed. Classical realism, on which socialist realism was
based, was a product of the nineteenth century. The modern age required
modern techniques:

> If we want a truly popular literature, alive and fighting, completely gripped by reality and completely gripping reality, then we must keep pace with reality's headlong development. (Brecht, 1964, p. 112)

Brecht continued to wage an oppositional struggle against an increasingly dogmatic cultural policy until his death in 1956. His work helped ensure that theatre, at least, continued to offer alternatives to a narrowly defined socialist realism. This is evident, for example, in the controversial work of Volker Braun and Heiner Müller, some of which was banned in the GDR.

Creating a New National Culture

> *What other than the literature of the German Democratic Republic can, in the name of all the German people, take upon itself the social and national task of working to ensure worthy successors to the masterworks of classical literature and the most important works of realism from the last century? Successors in which the representation of our new life, its problems, struggles and conflicts, the representation of the questions affecting the destiny of all German people lead to a coming together of socialist and national aspects to form a new conception of the national literature of our age?*
> — Alexander Abusch, 1956, in Abusch, 1975, p. 134[9]

In the GDR the idea of an inevitable historical development from capitalism to socialism informed the reconstruction of cultural traditions after 1945. Texts of the eighteenth-century German Enlightenment and Classical traditions, for example, Lessing, Goethe and Schiller, were prioritized in publishing, theatre and education. They were celebrated as expressions of progressive, bourgeois values, written at a time when the middle classes were the motor force of historical development. Other texts, integral to Western canons, particularly modernist texts, were reread as reactionary expressions of disabling bourgeois decadence and withdrawn from circulation. The work of Kafka was perhaps the most famous example of this.[10]

In the GDR, modernism was replaced by traditions of critical realism and working-class writing. Critical realism referred to the work of pre-socialist, bourgeois writers from the nineteenth and early twentieth centuries whose realist writing was read as depicting the shortcomings as well as the strengths of bourgeois society, for example, Tolstoy, Balzac, Heinrich and Thomas Mann. The new tradition of working-class writing drew mainly on writers active in the Federation of Revolutionary and Proletarian Writers in the Weimar Republic.[11] Both these traditions were gradually complemented by the development of a socialist realist culture within the GDR.

Guidelines for cultural production were laid down by the Central Committee of the Socialist Unity Party. The 1950s saw attempts to enforce a narrow conception of socialist realism together with a campaign against all non-socialist realist art which was given the blanket term 'formalist'. While it was cultural policy-makers and cultural critics who insisted on a narrow definition of socialist art, there was also a grass-roots commitment among writers and artists to produce a socialist culture which would break down the old bourgeois cultural divisions. Many aspired to create a culture that would address a new, working-class audience and aid the construction of socialism.

Practical cultural political initiatives which were aimed at bridging the gulf between mental and manual labour were implemented. These included, for example, the *Bitterfelder Weg*, which was initiated in 1959. The publishing house which was responsible for new GDR literature, *Mitteldeutscher Verlag*, organized a conference at Bitterfeld in 1959. This conference produced a policy which had a profound effect on professional writers and artists. Provisions were made for them to gain first-hand experience of industrial and agricultural production by spending months working with industrial brigades and on collective farms. It resulted in a spate of novels and plays that dealt directly with the problems in the factories and in the countryside.[12]

Amateur Art

The *Bitterfelder Weg* also played an important role in promoting amateur literature and art in the GDR. In addition to its guidelines which it laid down for professional writers, it developed policies which encouraged the development of workers' literary, musical and artistic circles. The Bitterfeld initiative *Greif zu Feder, Kumpel, die sozialistische Nationalkultur braucht dich!* (Take up a pen, mate, the socialist national culture needs you!) resulted in the establishment of numerous amateur worker writers' circles. Within ten years, 250 such circles had been founded together with 230 writers' groups for school students. These circles were led by professional writers. They met regularly and at each meeting the group would discuss each others' work. They also undertook exercises aimed at improving technical skills. For example, they would go out together, observe something and all attempt to describe it. The group would then discuss the results of the exercise. Many groups published anthologies of their work.[13]

Similar developments occurred in the areas of workers' cabaret, choirs, art and sculpture circles. The products of workers' art circles were included in national exhibitions of GDR art. Often circles were located in industrial plants where members performed for the rest of the workforce.

They held readings, exhibitions and cabaret performances. Other groups were neighbourhood-based. The expansion of amateur arts was encouraged by the introduction of regular national Workers' Arts Festivals, supported by the trade unions.

Trade union and youth movement involvement in amateur art guaranteed the provision of the necessary basic materials and access to publication. However, it also ensured a significant degree of ideological policing which meant that amateur art would not become a site for the articulation of discontent or of a radical oppositional cultural politics, even though industrial workers were in a particularly good position to see the shortcomings of the system. For most people involved, these amateur cultural organizations remained an important leisure-time activity. For a few, however, they were a stepping-stone to becoming professional writers and artists.

Cultural Politics and the Broader Political Climate

Cultural politics in the GDR were never static. They were affected by broader political developments. Censorship was at its most rigorous during the 1950s and early 1960s, the height of the Cold War. During this period socialist realist criteria and the campaign against non-realist art and literature were most strictly adhered to. Equally strong was the crusade against Western culture. Rock music and jeans became symbols of Western imperialism and decadence. In a discussion that brought together Samuel Beckett's play *Endgame* and rock and roll, the much respected critic Alexander Abusch wrote in 1957: 'Both are epiphenomena of the cultural decay of imperialism – in the ideological battle between the two social systems the imperialists are trying to infiltrate both into our German Democratic Republic and other socialist countries' (Abusch, 1976, p. 160).[14] This comment is typical of the period and clearly demonstrates the way in which the GDR interpreted all Western culture as a weapon against the socialist system. The appeal of much Western culture, in particular pop music and fashion, was one that the GDR state was not able to contest successfully. Eventually policy-makers learned to dissociate this culture from imperialism and allow it to be seen as a legitimate expression of socialist youth.

The narrowly restrictive cultural policy of the 1950s and early 1960s was not successful either in motivating the workforce or in achieving popular appeal. This can be explained by the inadequacy of the socialist realist theory of culture and of subjectivity on which it was based. At the time, however, the Ministry of Culture chose to see decadent Western cultural influences as the main obstacle to socialist realist cultural policy and responded to its own failures by increasing censorship.

After the building of the Berlin Wall in August 1961, both the political and economic situation in the GDR stabilized to the point where strict criteria of socialist realism and the war against 'formalism' could gradually give way under pressure from artists, writers and critics to the more liberal concept of 'constructive criticism'. Cultural products and practices came to be seen as acceptable as long as they did not seek to put the system itself into question. Once literature and the theatre became more critical, they aroused widescale interest among the GDR public. For example, the publication and reception of Christa Wolf's first novel *Der geteilte Himmel* (Divided Heaven, 1963) provoked a lively and polarized debate about socialist literature.

The novel tells the story of a couple whose love for one another comes into conflict with their politics and their commitment to the GDR. With the building of the Wall in 1961, Manfred opts for a life in the West. His fiancée, Rita, stays in the GDR but suffers a nervous breakdown caused by their separation. Party critics argued that the book failed because it did not show the process of Manfred's successful integration into GDR ways of thinking. The depiction of love in the novel was also attacked as not conforming to socialist conceptions of love. Had it done so, critics argued, Manfred would not have left but would have been transformed by his love into a committed socialist. Characterization in the novel was criticized for its too negative depiction of party members, its too positive depiction of the petty bourgeoisie and its lack of sufficiently strong, positive typical characters. This negative onslaught in newspapers and journals provoked more liberal critics and writers to come to the defence of the novel and in doing so they helped expand the criteria of what might count as socialist art.

In the course of the 1960s and early 1970s, as a narrow conception of socialist realism gave way to different modes of representation, literature, theatre and, to a lesser extent, the cinema became areas in which it was possible to explore the unspoken problems of GDR society. Important texts included Christa Wolf's *Nachdenken über Christa T* (*The Quest for Christa T*, 1982, first published 1968) which advocated a break with the stereotypical socialist personality advocated by official cultural politics. In this novel Christa Wolf emphasized the uniqueness of people and the importance of individual life separate from social expectations.

Controversial issues addressed by writers ranged from the shortcomings of socialism through the problems of youth to the position of women. Ulrich Plenzdorf's highly controversial stage play and short prose text *Die neuen Leiden des jungen W* (The New Sorrows of Young W, 1972), for example, dealt with the problems of a young apprentice, Edgar Wibeau, who drops out of GDR society and cultivates an alternative lifestyle in which jeans and Western pop music are paramount. In the debate that followed the première of the stage play, it was attacked by, among others,

Erich Honecker and Kurt Hager, for its atypicality and negative representation of aspects of GDR society. Its advocates, however, saw in it an authentic depiction of the thoughts and feelings of working-class youth in the GDR.

Another controversial text, Maxie Wander's collection of interviews with women, *Guten Morgen, du Schöne* (Good Morning, Lovely, 1978), played an important role in the more general movement to break with narrow definitions of the socialist personality. In these interviews, women of all ages and from all walks of life talk about their lives and problems in the family, sexually and at work. Issues that had been taboo or dismissed as bourgeois concerns, particularly sexism, now found a legitimate expression and helped liberate women from the confines of the official version of what they were supposed to be in a socialist society.

Liberalization in the implementation of cultural policy in the GDR was repeatedly followed by conservative backlashes and intensified censorship. Yet the rigours of censorship created a situation in which controversial texts were taken seriously by both general readers and party critics. People learned to read between the lines and to value fictional texts in a way that was radically different from readers in Western Europe. Moreover, the uncritical, propagandist nature of the press and other news media in the GDR, where censorship remained tight throughout the 40 years of the State's existence, had a profound effect on the status of literature, theatre and cinema. These media offered greater scope for critical engagements with the system. Fiction became the most important site of social and political criticism.

What was considered constructive and what negative became a site of constant cultural political struggle which was influenced by events both within and beyond the borders of the GDR. Many artists and writers worked at the margins of what was considered acceptable, trying constantly to extend the boundaries of what counted as 'constructive criticism' and extending the aesthetic repertoire beyond socialist realism. As a result, some found themselves excluded from the official cultural organizations which gave them legitimate professional status. Others, such as Sarah Kirsch, went into voluntary exile in West Germany and others again, such as Wolf Biermann, found themselves exiled from the GDR by the State itself.

The Effects of Cultural Policy

The development of art which is closely linked with the struggles and victories of the working class and all working people ranks among the great successes in the development of the GDR. A great number of GDR art works have

*become the constant companions of many people and they have often in-
fluenced their commitment and active engagement for socialism. Many books,
television plays, musical works and pictures have become part of our everyday
life. They make us reflect upon important questions about the socialist pres-
ent, they enrich our lives and help shape a creative attitude to life. Their effects
are realized again and again in many ways. They range from violent debates
about particular works of art to cautious and apparently invisible influences
on individuals.*

*The immense social importance of socialist art bears witness to the fact that
the arts are a vital phenomenon for socialism, essential and irreplacable for the
intellectual life of our society. This fact is the expression of an historically new
social function of art, which is integrally related to the struggle of the working
class. In socialist art the relative independence of art from the process of social
life, which is characteristic of bourgeois society, has been overcome. It is a
conscious partner in the construction of socialism, increasing its respon-
sibility in the construction of a new social order in the GDR. This social
function is characteristic of the art of all socialist countries and the cause of
its dynamic development.*

— Hannelore Gärtner, *Die Künste in der Deutschen
Demokratischen Republik* (The Arts in the GDR), 1979, p. 12[15]

In the first two decade of the GDR, when postwar reconstruction was at
the top of the social and political agenda, the new structures of work and
communal life offered many people a positive way forward.[16] In all areas
of cultural and social life, emphasis was placed on both individual and
collective responsibility for the construction of a socialist State which
would be qualitatively better and morally superior to capitalism. Ideo-
logical stress was laid on anti-fascism and people were encouraged to see
themselves as different both from the Nazis and the West Germans. West
Germany was depicted by the East German State as perpetuating fascist
ideas and practices.

As the phase of reconstruction (*Aufbauphase*) was replaced by a period
of consolidation, and with the change of leadership from Ulbricht to
Honecker, it became clear that the GDR could never match the West
German 'economic miracle'. None the less, the standard of living rose
steadily and the GDR became the most successful economy in the Eastern
bloc. Moreover it guaranteed its citizens work, housing, free education
and health care.

The cultural forms and practices which had been introduced to encour-
age productivity, a new national identity and socialist attitudes and
values remained intact. However, their limited success in engaging
people's subjectivity diminished further. Throughout the 1970s and
1980s, the GDR press, for example, *Neues Deutschland*, the central organ of
the Socialist Unity Party, continued to print eulogizing articles on the

achievements of industrial and agricultural workers even though economic and technical problems affecting production had become widely apparent. Discrepancies between official versions and actual achievements became a source of cynical amusement for ordinary people. Official propaganda continued to stress socialist achievement and moral superiority in a world where it was clear that the GDR was not realizing its promise. Even though it was the most successful East European economy, it could not meet the material expectations of its people.

How did cultural policy deal with this fundamental problem? Did it meet the cultural expectations of the people? The history of the arts in the GDR, published in 1979, and quoted above, stresses the achievements of GDR cultural policy. These included a wide-ranging infrastructure which made the arts accessible to ordinary people and the active encouragement of participation in the arts. The arts, it claimed, were closely linked to the struggles and victories of the working class. This was, to say the least, exaggerated. The official cultural organizations remained trapped in a soon-outdated Marxist–Leninist rhetoric of class struggle and the construction of socialism. This bore little relation to people's experience of life in the GDR. The very real strength and appeal of the arts, in particular literature, did not lie in their endorsement of the party line. Although many such works existed and were always available on the shelves of the bookshops, it was the critical, controversial works which appealed to people. Indeed, critical literature, theatre and film found a large audience. Critical texts were often difficult to obtain since they were published in small print-runs, a factor which made many people all the more determined to read them.

Dissatisfaction with the development of the GDR grew from the 1970s onwards, as ordinary people realized ever more clearly the increasing gulf that existed between what was being achieved in the workplace and the economy more generally and what was claimed by managers, politicians and the media. The cynicism that set in would gradually feed a radical discontent with the system. It led to an increasing gap between intellectuals, who still believed in socialism and wanted to improve the system, and the mass of the population, who by 1989 came to want little more than a better standard of living, the 'D Mark' and the freedom to travel.

When it came to the changes of 1989, intellectuals and the broad mass of the population were united in their rejection of the existing system but not in their hopes for the future. Intellectuals wanted a 'third way', that is, neither a continuation of the old GDR nor assimilation into the Federal Republic; the majority of the population, however, wanted the wealth and 'freedom' that West Germany seemed to offer. It was popular demand for change rather than intellectual critiques of the system which prevailed. This demand was expressed in the mass emigration via Hungary in the summer of 1989 which brought the political situation to a head.

In November 1989, intellectuals organized a massive demonstration in Berlin at which they called for radical reforms. But as subsequent elections were to demonstrate, they had missed the boat. The majority of the working class, whom socialism was supposed to represent, disassociated itself completely from socialist ideals. It was not only the lack of material goods and freedom to travel which produced this disillusionment. A system which had initially sought to empower ordinary people had gone badly wrong. The structural basis for this was the assumption that the Socialist Unity Party represented the interests of the people and could therefore determine how things should be. There was little space within the system for alternative ideas or practice. The ideals that had motivated people in the 1950s became hollow and critical culture tended to focus on rescuing socialism rather than on the needs and aspirations of ordinary people.

A Failed Experiment?

The founding principles and objectives of the GDR were to develop a socialist State free from class exploitation. It aimed to offer its people a good standard of living, security and fulfilled lives. While the provision of housing, education, work, healthcare and consumer goods were fundamental to a good standard of living, culture – in particular High Culture – was seen as central to the full development of the individual. The GDR made real attempts to break down class divisions in cultural production and consumption. The state assumed that the arts were important for everyone and could help form and consolidate socialist values. For this reason it went to considerable lengths to encourage working-class attendance at high cultural events. Heavily subsidized visits to concerts, opera and theatre were organized through the workplace. Artists were invited into factories to give performances and readings. The substantial subsidies given to music, theatre and opera and allocation of tickets to workers and young people made 'high' cultural events accessible to most people.

GDR cultural politics, like the ideology of the State more generally, were founded on what might be termed a 'normative humanism' imposed from above. It drew on nineteenth-century ideas about art and society, privileging realism and ideas of a unified class subject. It was neither open to modern ideas of difference and change nor to disunified subjects. It imposed inflexible social structures which were founded on the assumption that State and society were one.

While the State assumed that traditional High Culture was good for everyone, many people felt that this culture did not represent their interests. Young people in particular turned to Western youth cultures. Yet while many people were unconvinced of the benefits and appeal of

High Culture, they nevertheless – in the absence of other possibilities – took it up to some degree. Even though attendance at high cultural events was often linked to bonuses at work, the sense of solidarity which group visits to theatre and concerts produced is something that is now missed.

In the period between the opening of the Wall and the unification of Germany, when pressures on people to do what was expected of them relaxed, theatres and concert halls were relatively empty. Since unification, prices for cultural events have risen steeply and positive discrimination in the allocation of tickets has disappeared. Not only have material incentives to attend high cultural events disappeared but ticket prices are now a positive disincentive for most people.

In many ways, the provisions which the GDR State made for amateur art were admirable. Involvement in the production of literature, theatre, music and painting was experienced by many people as positive and self-fulfilling. Yet the ideological constraints exercised through the trade unions, the youth movement, publishers and cultural functionaries prevented amateur art from becoming a site of constructive criticism which might have motivated people to work to transform the system from within. It was in the area of High Art – particularly literature and theatre – that the most powerful committed critiques of the system emerged.

The GDR provided an infrastructure for the development of cultural democracy both through its subsidies of high art and support for amateur cultural production. That little cultural democracy developed was due to centralized ideological control which was seemingly motivated by the party's fear of ideas that it did not itself sanction. This fear determined both the treatment of high cultural production and of amateur art. The party tried to impose values and forms of subjectivity which often did not engage people. It failed to give them a say in what they wanted the GDR to be or to recognize the importance of taking account of what people were actually thinking. None the less, even such imposed ideas of collectivity and solidarity had their effects. To disidentify collectively with a system, as many working-class people did, produced a shared sense of identity and solidarity which people now miss.

In many ways the East German State put too much faith in the power of its own cultural politics to speak to and engage the population at large. Without a material base that could meet the demand for consumer goods, appeals to socialist ideology soon began to ring hollow, the more so given the ever-present alternative that West Germany seemed to offer. With its easy sloganizing, the East German State failed to convey convincing critiques of West German capitalism. The negative sides of capitalism, for example, unemployment and homelessness, were virtually unimaginable and people could not travel to see things for themselves. What they could see was how their standard of living and lifestyles lagged behind those of

most West Germans. Unification and the subsequent devastation of East German industry would prove equally disillusioning to the majority of East Germans.

The many positive elements in GDR cultural politics – particularly the importance given to culture as the right of every individual – were undermined, in part, by the strict ideological controls placed on cultural production. Only a small number of privileged intellectuals succeeded in criticizing the system openly, and then they often faced severe censorship problems. In deciding what was good for people, the Ministry of Culture deprived people of the right to articulate their own problems, views, hopes and aspirations. They were called upon to endorse party thinking and could not determine policy from below. This produced disillusionment. As a result, the potential for broad-based participation in culture to empower people and motivate them to take an active role in shaping a better society – one of the original objectives of socialist realist theory – was not realized. Popular disillusionment with the unrealized promises of socialist rhetoric and with the consequences of unification are captured by graffiti scrawled on the statue of Marx and Engels in the centre of East Berlin. They read 'We are guilty' and 'We'll see each other at the unemployment office.'

5

Whose History Is It? Class, Cultural Democracy and Constructions of the Past

Anyone participating in the arts or the media – whether as a Hollywood director, a Fleet Street photographer or a holiday snap shooter – is in the business of creating meaning. It is this creation of meaning which largely dictates how we see events, both past and present, and how we make decisions and, on the basis of these decisions, how we act.

Unfortunately the means of creating and disseminating these 'meanings' are not equally distributed. There is a hierarchy of power, based on the ownership and control of the means of cultural production which restricts most people to a passive receiving role – despite our so-called 'free' and 'democratic' society. Like medicine, motor cars and food, our cultural experiences come fast and highly packaged.

—Valley and Vale[1]

The postwar period has seen radical changes in the cultural politics of class. In the interwar period there was a broad-based consensus about the meaning and political relevance of such categories as 'working-class', and socialism still had wide appeal throughout Western Europe. In the decades since the Second World War this has massively declined. Relatively few people in Britain today identify with traditional versions of class politics. Few people positively identify themselves as working-class.

The point is not that structural inequality has diminished in society but that people are much less likely to conceive their identity in class terms.

As an analytical category for making sense of social divisions and certain fundamental processes of social and economic change 'CLASS' remains an extremely valuable tool. Moreover, it remains a very useful category in the struggle to achieve a less divided and oppressive society. We do not support those who think that class analysis should be abandoned – no more than we support those who think that gender, race and other invidious distinctions can be ignored so long as class is taken into account.

In chapter 3 we looked at an example of the cultural politics of class in Britain in the 1930s. These years were in many ways a unique time for left-wing cultural activists. In this period, liberal, Marxist and labour socialist intellectuals often worked together on practical cultural initiatives. Many of them drew on Marxist theory. It was also a period when the exclusion of most working-class people from secondary education and High Culture encouraged cultural political struggles to gain *access* for working-class people to both the consumption and production of Literature and Art.

In contrast to the 1930s, it is not often possible nowadays to draw direct links between postwar Marxist theory and practical, class-based cultural initiatives. In the immediate postwar years, the expansion of access to education, limited and segregated though it was, and the growth of the new media, helped to change the cultural political agenda in Britain.

Greater access to education, rising standards of living for those in work and more potential for social mobility gradually created a climate in which individual choice and effort came to be seen as primary. Structural relations of class inequality and exclusion were no longer at the forefront of cultural politics. Older labour movement forms of political identity increasingly lost much of their power and appeal and the growth of consumerism and of the leisure industries offered new and expanded forms of identity and pleasure. This general shift in the cultural political climate was something that Conservative political rhetoric of the Thatcher years was able to push to new extremes.

In consequence the postwar years have seen the gradual breakdown of explicitly class-based politics. In the 1990s neither the trade unions nor the Labour Party mobilize the rhetoric of class in quite the same way as they used to do. The British miners' strike of 1984–5, for example, which ended in defeat, was one of the last to demonstrate a popular community and class-based resistance with broad support from the labour movement. In the 1980s and 1990s, partly in response to legislation restricting trade unionism, this form of politics has tended to give way to new ways of thinking that stress INDIVIDUAL INTEREST rather than broad-based, movement-wide solidarity.

These shifts have been complemented by the new range of leisure

pursuits and popular cultural forms of expression and identification offered to working-class people. Television, the video industry and magazine publishing are just some of the industries promoting images of individual success in a society where class is either invisible or (apparently) irrelevant. From heritage parks to home and garden centres people are offered a mixture of all-round family entertainment and consumerism. This change in the cultural politics of class can perhaps be seen most spectacularly in the decline of the Labour vote and the difficulties that the Labour Party has in articulating a political programme that attracts identification on a basis other than residual labourism or an intellectual and moral commitment to socialist philosophy.

Socialist intellectuals and cultural activists still work with conceptions of class that insist on the centrality of structural economic and social inequality. Yet we cannot assume that socially disadvantaged people will see themselves and their position in society in these terms. Among the questions which we need to ask are how class interests can be articulated in ways that engage people, empower them and motivate them to work for social change.

In the postwar period cultural political initiatives around class in Britain have found their location mainly in community arts projects and in the area of municipal socialism. Projects have ranged from community publishing and video to the large scale 'people's festivals' organized in the 1980s by metropolitan authorities such as Sheffield City Council and the Greater London Council.[2] The perspectives informing community arts and municipal socialism are rarely Marxist, although they draw on notions of 'cultural democracy' which have long been part of the British liberal and socialist traditions. History has a been a central focus of many such initiatives. In this chapter we look at the cultural politics of class in relation to history.

History as Cultural Politics

All history depends ultimately upon its social purpose.
— Paul Thompson, 1978, p. 1

History and politics are fundamentally connected.
—Centre for Contemporary Cultural Studies,
Making Histories, 1982, p. 7

The past is both a stake in current struggles and an essential factor in the political relationship of forces.
— Jean Chesneaux, *Pasts and Futures*, 1978, p. 3

There is a widespread view that academic work has nothing to do with politics. The historian, the social scientist and all the rest of us highly trained researchers float above the struggles and power relations in society.

Or do we?

We would like to invite you to join us in a conversation. It is with a small group of historians who, unlike most of their colleagues, refuse to separate their work as intellectuals and scholars from issues of power and society. Our guests include Jean Chesneaux, the French radical historian widely acclaimed for his work on China and Vietnam; Catherine Hall, the British feminist historian who has done pioneering work on the middle-class family; Paul Thompson, Britain's leading oral historian; John Tosh, the British Africanist who wrote *The Pursuit of History: Aims, Methods and New Directions in the Study of Modern History*; and Alice Weedon, a relatively unknown British social historian but who has, we can assure you, often thought about the past. We were looking forward to lively contributions from Raphael Samuel, pioneer in social history and Founder-Editor of *The History Workshop* journal. Unfortunately, he is unable to be with us tonight.

This conversation privileges an ALTERNATIVE CONCEPTION OF HISTORY – as a space of domination and resistance, as an arena in which 'facts' and identities are produced and contested, as a terrain traversed by power relations and interests. That is, we shall be exploring HISTORY-AS-CULTURAL -POLITICS.

GLENN: Perhaps we can begin with this question: Why does history matter?

JOHN TOSH: 'One of the strongest bonds uniting a large grouping is its members' awareness of a common history' (Tosh, 1984, p. 3).

ALICE WEEDON: Most people have a sense of history that is both public and personal. If we learn about history through education, television, books, cinema and museums, as individuals we tend to interpret our own lives and experience in terms of our personal sense of history, beginning with our immediate family. Personal identity is necessarily rooted in past experience, family history (mediated by relatives, photos, old documents and inherited objects) and in the 'historical experience' of larger collectivities, such as the nation.

JEAN CHESNEAUX: 'History is an intellectual discipline that touches an extremely broad AUDIENCE: the millions of pupils studying their textbooks; television viewers choosing their programmes; readers of mass-circulation magazines; tourists visiting castles or cathedrals.'

For this reason, if no other, it would seem that historians would have a particularly strong relation with the general public. But this is not the case: 'The invisible doors of our universities are as hermetically sealed as those of the factories, housing projects, nuclear plants, or hospital complexes' (Chesneaux, 1978, p. 3).

CHRIS: What do historians do?

CATHERINE HALL: 'Historians construct stories, stories which necessarily have a narrative shape but in which the tensions between the teller, the tropes of the discourse, and what are understood to have been the events, are consciously worked on' (Hall, 1992, p. 1).

GLENN: So, as some of our postmodernist friends suggest, HISTORY is just another form of FICTION?

CATHERINE HALL: 'History, for me, is *not* just another fiction.'

GLENN: What kind of narrative is it then?

CATHERINE HALL: 'Historical research is always premissed on a relation between past and present, is always about investigating the past through the concerns of THE PRESENT, and always to do with INTERPRETATION. Historians attempt to interpret past realities and the meanings which they were given through language (for there is never only one real meaning, or one set of meanings), realities which can only be read textually (in the widest sense of the term), which can never be grasped in an unmediated way. The STORIES which they construct, from laborious archival work ordered by conceptual frameworks, are grounded through an attempted comprehensiveness in relation to evidence, a commitment to look at countervailing accounts, an effort to test interpretations against others, the practices of GOOD SCHOLARSHIP' (Hall, 1989, pp. 1–2).

JEAN CHESNEAUX: Catherine Hall was just speaking of the link between past and present in historical writing. She posed the issue in terms of narrative conventions and 'good scholarship'. I would like to pose it in terms of INTERESTS. My question would be: 'On which side is historical knowledge today? Whose interests are served by the dynamic relationship between the past and the present? That is a question no historian can evade' (Chesneaux, 1978, p. 12).

CHRIS: Where do the 'FACTS' of history come from? What is the nature of historical knowledge?

JOHN TOSH: 'Whereas the individual's sense of his or her past arises spontaneously, *historical knowledge has to be produced*. Society has a past which extends back far beyond the lives of the individuals who happen to comprise it at any one time. The raw materials out of which a historical consciousness can be fashioned are accordingly almost unlimited. Those elements which find a place in it represent a selection of truths which are deemed worthy of note' (Tosh, 1984, p. 2).

JEAN CHESNEAUX: 'Despite a writer's illusions about "creative freedom", every text has its roots in a given society, a given social environment or political movement' (Chesneaux, 1978, p. 7).

CHRIS: So 'facts' are not given but SELECTED and PRODUCED. . . .

> TRUTH: Whether public or personal, history is always an interpreta-
> tion of the past, constructed in the present on the basis of a
> selective range of source materials.

GLENN: This is a scandalous idea – a violation of the sacred canons of
common sense. But, for the sake of this discussion, let's assume that
you are right. My question is: What difference does it make? Why is
this observation important?

JOHN TOSH: 'WHO PRODUCES historical knowledge, and WHO VALIDATES it
for general consumption, are . . . important questions. How well the
job is done has a bearing on the cohesion of society and its capacity
for renewal and adaptation in the future. *That is why what historians
do should matter to everyone else.* Their work can be manipulated to
promote desired forms of social consciousness; it can remain con-
fined to academic circles, powerless to influence society for good or
ill; or it can become the basis for informed and critical discussion of
current issues' (Tosh, 1984, p. 2).

CHRIS: So researching and writing history is intimately connected with
POWER RELATIONS and INTERESTS.

A COMMON VOICE: Yes, on that we are all agreed . . .

JOHN TOSH: 'Clearly, then, history has a social role. Society requires a
usable past, and different conceptions of the social order produce
rival histories' (Tosh, 1984, p. 8).

GLENN: This brings me to the next question that I wish to ask: What is
the connection between HISTORY AND POLITICS?

JEAN CHESNEAUX: There are many such connections.

GLENN: Well, let me be more specific. Why are representations of the
past – in books, in anniversaries, in statues and so on – of such great
concern to kings, dictators, presidents, prime ministers and others
who wield state power? Presumably this has to do with the role of
history in social control and domination?

JEAN CHESNEAUX: 'History is one of the tools the ruling class uses to
maintain its power. The state apparatus tries to *control the past* at the
level of both political action and ideology.

The state and the power structure organize the past and build its
image in terms of their own political and ideological interests. In the
ancient Egypt of the Pharoahs, or in feudal China, time was
reckoned by the succession of dynasties that marked the periods of
history and gave substance to the society's historical consciousness.
Written by official committees of scribes or mandarins, history was

a state service that defined the power structure of the monarchy as the basis of the social order throughout historical time. This was also the structure and function of French history up to the nineteenth century' (Chesneaux, 1978, p. 16).

GLENN: So, even our conception of TIME and HISTORICAL MOVEMENT can be ideologically constructed – and in this process the HISTORIAN-IN-SERVICE-TO-STATE-POWER plays an absolutely central role.

JEAN CHESNEAUX: Yes, precisely.

GLENN: Is this the only way historians have, consciously or inadvertently, served state power?

JEAN CHESNEAUX: 'Ruling classes and governments frequently appeal to the past explicitly. TRADITION, CONTINUITY, HISTORY – all are invoked as justification for their domination' (Chesneaux, 1978, p. 16).

'All these ANNIVERSARIES and COMMEMORATIONS – one could add Churchill's funeral, the Bicentennial of Cook's arrival in Australia, the Centennial of the Meiji in the conservative Japan of 1968 – have certain features in common: the official sponsorship of an historical celebration; a mass spectacle with popular festivities; the stereotyped portrayal of a past event to fortify the ideology of the existing power structure; the occultation of the non-official aspects of the event, such as social conflicts and mass struggles' (ibid., p. 18).

CHRIS: Perhaps you could give an example, a twentieth-century example, of a political leader who was especially adept at the APPROPRIATION OF HISTORY

JEAN CHESNEAUX: 'The political power of Gaullism was based – among other things – on a skilful appropriation of the "French past", viewed as the common possession of the people. Words like permanence, continuity, tradition and heritage constantly recurred in the Gaullist historical rhetoric with the aim of strengthening the authority and prestige of the General. His "France" was an absolute, all-powerful idea demanding unlimited sacrifice and unquestioning obedience. De Gaulle was supposedly the receptacle and continuator of what he called "a certain idea of France" ' (Chesneaux, 1978, p. 17).

GLENN: I don't suppose this sort of thing ever goes on in Britain?

JOHN TOSH: 'From the political establishment's point of view, an important by-product of a national historical consensus is that it displaces other, more dangerous readings of the past. In Britain the Whig interpretation remains significant because it encourages people in the belief that British liberties are a fact of history, a closed chapter, not an agenda for change. The popular identification with the national tradition – "OUR HERITAGE" – is a powerful check on political radicalism and has been officially promoted partly for this reason. Contrary to common belief, most of the pageantry which

keeps the monarchy in the public eye is not traditional at all, but has been improvised and enlarged by deliberate policy since the death of Queen Victoria in 1901' (Tosh, 1984, p. 6).

JEAN CHESNEAUX: Historians, on the whole, are rather naive about the relation between the discipline of history and state power. 'The state power structure supervises the knowledge of the past at its source' (Chesneaux, 1978, p. 19).

GLENN: What do you mean?

JEAN CHESNEAUX: 'The great majority of "first-hand documents", so prized by historians, originate with the state or its adjuncts' (Chesneaux, 1978, p. 19).

CHRIS: Let me turn to a different but related topic, one which still concerns the relationship between history and politics. I will pose the question like this: Does knowledge of the past offer SUBVERSIVE POSSIBILITIES?

JOHN TOSH: 'To know about the past is to know that things have not always been as they are now, and by implication that they need not always remain the same in future. History can be the basis of scepticism about received ideas, which is why in totalitarian societies history-writing is not regarded as a harmless escape from the present' (Tosh, 1984, p. 5).

'The women's movement has been very conscious of the need for a usable past. For feminists this requirement is not met by studies of exceptional women like Elizabeth I who operated successfully in a man's world; the emphasis falls instead on the economic and sexual exploitation which has been the lot of most women, and on the efforts of activists to secure redress. These are the themes which, to quote from the title of a popular feminist text, have been *"hidden from history"* '[3] (ibid., p. 7).

GLENN: I want to push further this discussion of the role of HISTORY-AS-RESISTANCE – of history as a force in the development of NEW IDENTITIES and so on. I know that John Tosh, a historian concerned with developments in contemporary African societies, has done some thinking about this issue.

JOHN TOSH: 'If history has always ministered to authority, it has also been many times enlisted in the cause of DISSENT and REBELLION. In any political culture which retains some vitality *the state's appropriation of the past does not go unchallenged*. If other groups whose aspirations conflict with the approved consensus are to mobilize effectively, they too need the sanction of the past. The purpose of much labour history written by politically committed historians is to sharpen the social awareness of the workers, to confirm their com-

mitment to political action, and to reassure them that HISTORY IS 'ON THEIR SIDE' if only they will keep the faith with the heroism of their forebears. In Britain this approach is reflected in the History Workshop movement of socialist historians which began in the late 1960s; for them, the historical reconstruction of working people's experience serves as "a source of inspiration and understanding" – to use a phrase from the first editorial in the *History Workshop Journal'* (Tosh, 1984, p. 6).

GLENN: One also finds this kind of appropriation of history in the writings of nineteenth- and twentieth-century African American activist-intellectuals . . .

CHRIS: And, indeed, in the writings and proclamations of feminists.

GLENN: Another example would be the writings of contemporary Australian Aborigines Perhaps it is a feature of the cultural politics of virtually all marginalized and oppressed groups.

JOHN TOSH: 'For socially deprived groups – whether in a majority like workers and women, or in a minority like blacks in America and Britain – effective political mobilization depends on a consciousness of common experience in the past.'

> A VOICE: *'Like minority groups, women cannot afford to lack a consciousness of a collective identity, one which necessarily involves a shared awareness of the past. Without this, a social group suffers from a kind of* COLLECTIVE AMNESIA, which makes it vulnerable to the impositions of dubious stereotypes, as well as limiting prejudices about what is right and proper for it to do or not to do.'
> —Sheila Johansson, ' "Herstory" as History', 1976, p. 427

' "OPPOSITIONAL HISTORY" has the immediate effect of raising the consciousness of the group in question. In the longer term it may also lead to an adjustment in other people's historical perceptions – a recognition that women or blacks have a collective identity which merits a certain respect.

The morale of "outsider" groups in society is also enhanced by recalling earlier traditions of popular protest and revolutionary politics which can now be treated as their common property' (Tosh, 1984, p. 7).

GLENN: Yes, as a teenager in the late 1960s, I was among those who drew considerable inspiration from Black revolutionaries – David Walker, Nat Turner, Toussaint L'Ouverture, Frantz Fanon, Malcolm X and others – who had gone before.

CHRIS: Are we suggesting that 'oppositional history' is always positive? Surely, there can be real problems.

JOHN TOSH: 'As for oppositional histories, the problem here is that a view of the past which serves to raise consciousness may be less helpful as a guide to action. A great deal of history is frankly "INSPIRATIONAL" or "TRIUMPHALIST"; that is, it ROMANTICIZES THE PAST by emphasizing heroism in adversity, and in doing so may lead to faulty prescriptions for the future. Most recent labour history in Britain has tended to emphasize traditions of political radicalism and of struggle against capital; yet if it is to provide a realist historical perspective in which political strategies can be planned, labour history cannot afford to ignore the equally long tradition of working-class Toryism, still very much alive today.

 Myth-making about the past, however desirable the end it may serve, is incompatible with *learning* from the past' (Tosh, 1984, p. 17).

GLENN: This is a very crucial point – one many Black nationalists have simply missed. (I am thinking here in particular of those in what should be called the Ancient Africa School of Black nationalist thought.) This has had very unfortunate consequences. I hope to write about this some time in the near future, perhaps in a book – tentatively entitled *Racism and the Black Subject* – on which I have just begun work

JEAN CHESNEAUX: I am concerned, perhaps above all, with this question: 'What is the ROLE OF HISTORICAL KNOWLEDGE in society? Does it play in favour of, or against, the existing social order? Is it an elitist product that descends from the specialists to the "consumers" of history by way of books, television and tourism? Or is it rooted, from the outset, in a collective need, an active relationship to the past . . .?' (Chesneaux, 1978, p. 1).

CHRIS: Why should historians, or any other academic researchers, be concerned with such questions?

ALICE WEEDON: There are many reasons why we should be concerned. For example, I think we are all agreed that history plays a central role in defining both INDIVIDUAL AND GROUP IDENTITY. Dominant narratives of history construct both national identities and broader categories such as 'The West'. Moreover, DOMINANT NARRATIVES OF HISTORY tend to naturalize the social relations of the present, showing how they have evolved naturally out of the past . . .

GLENN: Perhaps we can further illuminate this point by focusing on a specific historically constructed identity – like 'BRITISHNESS'. Or perhaps 'ENGLISHNESS' . . .

CHRIS: John Tosh, I was looking at your book *The Pursuit of History* recently. As I recall, one of the arguments you make is that with the rise of literacy among the British populace in the course of the

nineteenth century history came to be seen by the ruling elites as an important and unifying force in the country's political culture.

JOHN TOSH: 'At the turn of the century Britain's imperial past was much emphasized: the migration of the British people overseas, the colonial conquests, and the provision of "civilized" government over inferior races were presented as achievements in which everyone could take pride' (Tosh, 1984, p. 5).

CHRIS: Yes, that version of what it meant to be 'British' still affects our thinking today. This STORY OF BRITAIN'S IMPERIAL PAST is one which hides the brutality and exploitation of colonialism. And it still underpins many British attitudes to other societies and cultures as well as racism at home.

JOHN TOSH: 'Alongside the imperial interpretation the older tradition of English history as "THE STORY OF OUR LIBERTY" continued as strong as ever. According to this view, all Englishmen were beneficiaries of the centuries long evolution of constitutional liberties, achieved for the most part by gradualist methods which respected the heritage of the past' (Tosh, 1984, p. 5).

GLENN: So, the first narrative is about the relationship between Britain and the rest of the world: it is a mobilization of history such that it provides an ideological account of imperialism and colonialism. The second narrative, on the other hand, masks divisions, struggles and divergent interests in British society itself; and it hides the inadequate and precarious nature of the liberties we have today.

The more fundamental point is that these two narratives have played a crucial role over the past two centuries in the construction of 'BRITISHNESS'.

JOHN TOSH: Yes, that is, more or less, the essence of my argument.

CHRIS: In dominant history writing, in television films and in museums and galleries the materials presented as history often represent a narrow and exclusive view of who makes history and whose lives and experiences are important. For a long time working-class history barely existed, though developments in social and labour history since the 1960s have done much to remedy this state of affairs.

And until very recently women, as a social group, had little or no visible history. Here feminist historians are beginning to fill this absence. Perhaps Catherine Hall could say something about how the history of women has gained visibility.

A VOICE: *In a class society history has meant the history of the rulers, and in a male dominated society the history of men.*
 —Anna Davin, 1972, p. 216; quoted in Hall, 1992, p. 6.

CATHERINE HALL: 'Feminist history as first conceptualized in the early 1970s was about the RECOVERY OF WOMEN'S HISTORY. We needed to fill out the enormous gaps in our historical knowledge which were a direct result of the male domination of historical work. How had women lived in the past, what had they experienced, what kinds of work had they done, in what patterns of family life had they been involved, what records had they made? How could we find out?' (Hall, 1992, p. 5).

GLENN: One of the particularly useful lessons from the early work done in women's and feminist history would appear to be the lesson that there is no history only histories – or, rather, no singular HER-STORY, only HERSTORIES.

CATHERINE HALL: 'The formation of autonomous black women's groups in the late 1970s, particularly the Organization of Women of African and Asian Descent, which attempted to bring together black women from a number of different backgrounds and perspectives, was a critical moment for feminism. Black feminists argued that a white, Eurocentric, Western feminism had attempted to establish itself as the only legitimate feminism, that this feminism did not speak to the experiences of black women, and that there was little recognition of the ways in which the gains of white women were made at the expense of black women' (Hall, 1992, p. 18).

CHRIS: Yes, those were heady days. One of the important interventions in that debate was made by Hazel Carby, who was a postgraduate student in the Centre for Contemporary Cultural Studies at the University of Birmingham. Hazel's article, as I'm sure you recall, was entitled 'White Women Listen!'. Did that article have any in-fluence on the cultural politics of feminist history-writing?

CATHERINE HALL: 'In 1982 Hazel Carby, in her critique of white feminist theory in Britain, was also scathing about the new forms of history. When white feminists, she argued, "write their herstory and call it the story of women but ignore our lives and deny their relation to us, that is the moment in which they are acting within the relations of racism and writing *his*story" (Carby, 1982, p. 223). Valerie Amos and Pratibha Parmar took up this emphasis on the "herstory" which had developed in Britain and the amnesia on questions of race from which it suffered . . .' (Hall, 1992, p. 18).

Some of us white feminist historians have taken such criticisms seriously. My own work shows the influence of such interventions.

ALICE WEEDON: But your work is rather more progressive than that of many of your colleagues. I think it is fair to say that in most historical narratives produced by British historians People of Colour continue

to feature as colonial subjects – if they feature at all. For example, few histories, whether written, filmed as documentary, or displayed in museums, have begun to do justice to the role of slavery in the rise of Britain as an economic and imperial power or to the affects of slavery on the colonized. While 'Black history' is beginning to make an impact as a form of alternative history, its implications for dominant history writing have still to be taken seriously by White historians.

JOHN TOSH: That is true. But I think it is also important to point out that Black people elsewhere – I am referring to the former colonies – are doing something substantial about this. Perhaps I can say a word about this.

'In today's black African states the most pressing charge laid upon historians by their wider audience has been the writing of national histories. Most African states acquired their present boundaries less than a hundred years ago, when they were laid down by European diplomats and administrators with scant regard for geographical or cultural considerations. The history which Africans were taught in schools during the colonial period was essentially a WHITE MAN'S HISTORY in which African achievements were disparaged or ignored.

Since independence history has been an important instrument in undermining the colonial psychology of dependence and inferiority Within each country the struggle for independence provides material out of which a NATIONAL IDENTIFICATION, as well as a PRIDE in African culture, can be nurtured' (Tosh, 1984, p. 4).

GLENN: Paul Thompson, you have often spoken of the role of oral history as a democratizing force in history. Perhaps you could elaborate on your position here.

PAUL THOMPSON: 'Oral history is not necessarily an instrument for change; it depends upon the spirit in which it is used. Nevertheless, oral history certainly can be a means for transforming both the content and the purpose of history' (Thompson, 1978, p. 2).

CHRIS: How so?

PAUL THOMPSON: 'It can be used to change the focus of history itself, and open up new areas of inquiry; it can break down barriers between teachers and students, between generations, between educational institutions and the world outside; and in the writing of history – whether in books, or museums, or radio and film – it can give back to people who made and experienced history, through their own words, a central place' (Thompson, 1978, p. 2).

GLENN: Does oral history have additional radical potential?

PAUL THOMPSON: 'Since the nature of most existing records is to reflect the STANDPOINT OF AUTHORITY, it is not surprising that the judgement of history has more often than not vindicated the wisdom of the

powers that be. Oral history by contrast makes a much fairer trial possible: witnesses can now also be called from the under-classes, the unprivileged, and the defeated. It provides a more realistic and fair reconstruction of the past, a CHALLENGE TO THE ESTABLISHED ACCOUNT. In so doing, oral history has radical implications for the social message of history as a whole' (Thompson, 1978, p. 5).

JOHN TOSH: 'So history is a POLITICAL BATTLEGROUND. The sanction of the past is sought by those committed to upholding authority and by those intent on subverting it, and both are assured of finding plenty of ammunition' (Tosh, 1984, p. 8).

JEAN CHESNEAUX: 'History is far too important a matter to be left to the historians!' (Chesneaux, 1978, p. 9).

CHRIS: This discussion of the politics of history has been very interesting indeed. Unfortunately, we have to bring our conversation to an end. I am hoping to do an interview later this year with the Director of the Butetown History & Arts Project here in Cardiff. BHAP is a 'people's history' project. In that interview I shall take up some of the points you have raised today. Thank you.[4]

Preserving Working-class History

In many museums Local History has given way to Social History and local people to "the Community". Do these new names reflect changes in the relationship between curators, their collections and exhibitions, and the public? Or are they just repackaging old products in trendy wrappings?
— Mark O'Neill, 1988, p. 16

In the postwar period the assertion of an increasingly 'classless society' has become central to political rhetoric and the new consumerism. Parallel to this development, older forms of working-class life, politics and experience have become the subject of both traditional and new forms of cultural activity. In the 1950s and 1960s social changes in British society produced a concern among ethnographers and social and cultural historians to document 'authentic' working-class culture before it disappeared. These cultural forms were often linked to urban industrial life and trades unionism and have subsequently found places in the heritage and museum sectors of the culture industries.

In addition to the work of historians and museum curators, the postwar period has seen the growth of community arts, publishing and video projects, often located in working-class areas, which have the explicit goal of involving working-class people in educational and cultural activities.

Working-class history has become a central focus of these projects. The motivations behind community arts and education projects are many. They include the following:

- the belief in the centrality of cultural self-expression to self-development;
- the importance of giving working-class people useful skills;
- notions of cultural democracy which seek to redistribute the means of cultural production and increase access to culture;
- the wish to record and preserve the often unwritten histories of working-class life.

This concern with working-class history has involved a re-evaluation of the social and political role of working-class cultural forms. It has enabled a move away from the interwar preoccupation with culture, class consciousness and radical social change to a focus on people's experience of working-class life. It has given value to working-class voices, insisting on the validity of oral history both in its own right and as a source along with others for professional historians. It has enabled historians to look at how working-class culture has functioned both progressively and conservatively within broader social relations.

History for the Working Class: the Glasgow People's Palace

> Come alang wi' me if you want to see
> The Palace o' the People
> Standin' alone in the red sandstone
> Wi' a big high dome and steeple.
> The place vibrates wi' the Glesga Greats
> For the workin' man they spoke
> Be you grave or gallus, take a trip to the Palace
> It belangs to the Glesga folk.[5]

In chapters 2 and 3 we discussed some of the debates and cultural initiatives from the first half of the twentieth century which were aimed at increasing working-class access to mainstream 'high' cultural production. It is clear from the material cited in chapter 2 that there were two key motivations behind liberal attempts to bring 'Culture' to the working classes. On the one hand, there was a general belief in the value of Culture *per se*. On the other, liberals placed considerable faith in the potential role of Culture in promoting shared values across classes – and thus of combating social unrest.

History, too, has often been called upon to fulfil this ideological role of creating consensus and minimizing conflict in society. In the provision of Culture for the working classes in the nineteenth and early twentieth centuries, private philanthropists, charities and municipal authorities all played a role. In providing resources in this way, they set a pattern which extends through to the present.

Origins of the People's Palace

In 1882, Sir Walter Besant published a popular utopian novel entitled *All Sorts and Conditions of Men*. It ran to many editions. Now, in this novel there is a wealthy character who

> sets about building a palace of delight and joy which provides 'absolutely free for all the same enjoyments as are purchased by the rich' – painting, music, dancing, singing. The effect of this palace was to provide joy and happiness in place of 'political wrangles'. Thus one of the characters, Radical Dick was to be transformed from a 'fierce republican' into an enthusiastic radical by dancing lessons. Singing lessons were then to change him into an 'advanced liberal', after which lessons in painting would change him into a 'mere conservative' with no political views at all. (King, 1991, p. 12)

In 1887 a 'People's Palace' was actually opened in the Mile End Road in East London. Its statement of purpose could virtually have come out of Besant's novel.

> A BESANTIAN VOICE: Why not let them have Culture? It is a small price to pay in order to rid ourselves of political strife and social unrest!

The 'Palace' in East London was financed by a mixture of business sponsorship and money from charities. How was it managed and what did it include?

> It was managed by a private trust of influential individuals including Walter Besant. The nucleus of the complex was at the Queen's Hall, a concert hall with seating for 2500 people. There were also refreshment rooms and a rotunda reading room, and a library, art gallery, music room, gymnasium, swimming baths, winter gardens and play rooms were planned over a number of years. The trustees of the project were acutely conscious that cultural and recreational facilities in London's East End were minimal in comparison to what was available in other parts of the city, and the chief purpose of the People's Palace was to 'create and scatter pleasure' in an otherwise joyless area. (King, 1991, p. 13)[6]

In 1898, this model was adopted by the municipal authorities in Glasgow when the city opened the Glasgow People's Palace.

The GLASGOW PEOPLE'S PALACE was intended as a cultural centre for the workers of the 'deprived' East End of Glasgow. Since the 1890s, however, it has developed into a museum of Glasgow life which seeks to represent the history and culture of working-class people. The People's Palace aims to be a museum with which ordinary people identify. How has it sought to achieve this aim?

Working-class life and experience are not the usual subjects of museums. In building its collections, the People's Palace faced the problem of the lack of objects through which to represent the social history of working-class people. As Mark O'Neill, the museum's Curator of Local History, argues:

> Even though vast numbers of working class people were engaged in making things, their culture was, in most respects, non-materialistic. Though poor in material terms they developed complex social institutions and values, and events and experiences in their lives as often as not were ignored by artists and photographers. (O'Neill, 1988, p. 16)

Despite this problem, the People's Palace has attempted to represent areas of history which are usually neglected by traditional museums. It has collected material from a range of social movements, for example, the Temperance Movement, the Scottish Women's Suffrage Movement, the Peace Movement, the Trade Union Movement and campaigns against unemployment, the nuclear industry and for a better environment.

What one chooses to include or exclude in the collection of a museum, library or archive ultimately involves issues of politics. The People's Palace makes decisions about collecting, cataloguing and preservation that are consistent with its politics:

> Many local museums have a collection of militaria. Instead the People's Palace has a peace collection, recovering from obscurity the long history of protest against militarism. Suffragette banners, 18th century snuff boxes, Billy Connolly's banana boots, a Margaret Thatcher teapot, a reconstructed single end, carpets for Templetons, the regalia of sectarian societies (for communities have negative as well as positive sides), sporting memorabilia, a missioner's organ, all find a place here. And it is not just a place in a magpie's nest – every object is there to represent some aspect of the city's life. (O'Neill, 1988, p. 16)

The policy behind the selection of artefacts for display in the People's Palace is governed by the will 'to represent experiences which would otherwise have no public recognition and be easily lost or excluded from the official record' (O'Neill, 1988, p. 17). The appeal of this strategy to the people of Glasgow is apparent in the increased attendance figures over the last decade. From an all-time low of 80,000 visitors in 1981, numbers had risen to 308,000 by 1987.

The People's Palace has chosen to concentrate its collections around social movements and issues. It has a policy of collecting material for the future. It is in this area that the problem of deciding what the museum should collect becomes most apparent. In an article on the problems of collecting current material for future display, former curator Elspeth King points to the difficulty of deciding just which issues are important:

> You have to decide what the issues are for your own locality. The Falklands War was not an issue for Glasgow, in the same way as it was for Southampton or London. Glasgow's war in Argentina took place in 1978, when Ally's Tartan Army was routed in the World Cup Finals. In the aftermath, we were able to acquire quite a variety of souvenirs at bargain prices for the museum collection. (King, 1985, p. 5)

King explains how the museum's horizons are restricted by finance, space, opportunity and time. This is a problem that all curators share. Yet, unlike other curators who believe in a 'process of natural selection' through which objects emerge as important after a generation or so, King believes that museums have a duty to collect in the present 'so that we leave behind something of our own time, and give our successors something to work on, if only to save them from the heartache of trying to fill great voids in the collection, or collect anew for whole decades' (King, 1985, p. 4). This policy has had profound effects on the museum's public:

> Visitor expectations of the museum have changed with the collections, and often the visitors have a better understanding of the displays than my colleagues in other museums, who expect the collections to be commensurate with the category of 'low priority local history'. Many visitors come with the knowledge that Glasgow is the industrial capital of Scotland, the place with the best football teams and the best in popular music and entertainment and if they do not, they know it by the time they leave. (King, 1985, p. 11)

The remainder of this chapter discusses cultural initiatives that involve working-class communities in efforts to represent themselves. It is about projects to collect and present history that is not simply *about* the working class but is also largely *by* and *for* them.

History by and for the Working Class: Community Publishing and Video

Haven't you ever wondered what life was like for 'ordinary' people centuries ago? Not only people in general, but perhaps your ancestors, the people that you yourself have descended from.

Haven't you ever wished that you could get a glimpse into the lives of your past relatives, and to take yourself back to those past times, and get the feel of just what people were like then, their way of life, their pleasures, joys, disappointments, fears and most important of all, their personal deep feelings and their impression of the world they lived in.

Well I had such a desire myself. Then I got to thinking: Well the aristocracy are able to trace back their ancestors, generation after generation, why shouldn't ordinary people be able to do the same? And so with these thoughts in my mind, I decided to write the accounts that you find in this book.

— Ron Barnes, 1974, p. 1

Ron Barnes, the author of *A Licence to Live: Scenes from Post-war Working Life in Hackney*, was among the first working-class authors to publish his autobiography as part of the then joint Hackney Workers' Educational Assocation/Centreprise local history project. This project was part of a broader oral history movement in Britain which aimed to democratize history, offering an alternative to elite academic history. Behind this movement was a desire to empower ordinary people by producing what Ken Warpole, co-ordinator of the group, described as 'sharable and common history from the spoken reminiscences of working-class people'. Warpole saw this as an important dimension 'to integrate with other forms of "community" politics' (Ken Warpole, quoted in Tosh, 1984, p. 177).

Centreprise is situated in Hackney, East London. It was founded in 1971 as an 'integrated educational, cultural and social centre . . . built around three ideas: a bookshop, a coffee bar and the provision of free meeting rooms' (Centreprise, 1975). Looking back from the vantage point of 1992, Centreprise comments: 'At that time Hackney, with a population of over 20,000 had no bookshop or open cultural centre. Centreprise has flourished over the years, adding to the bookshop, a Coffee Bar, Youth Project, Adult Reading Centre, Advice Centre and Publishing Project' (Centreprise, 1992).

Centreprise was launched with grants from several large foundations which fund non-statutory initiatives for a limited period in the hope that they will gain increasing statutory support. (The main source of such statutory funding is local government.)

After Centreprise's move to new premises in June 1974, the funding situation became critical. Their *Annual Report* published in December 1975 recounts the difficult process of gaining long-term funding:

We knew that we would be in serious difficulties at the start of this financial year [1975] if we could not persuade the Hackney Borough Council to shoulder a much larger portion of our running costs.

After our public deputation to them on 26th February, we realised that there was still much suspicion by many councillors as to the orthodoxy of

our aspirations, and it was then that we realised that the future of Centreprise was seriously threatened. A public appeal was launched which brought in over £1,000; an impressive and heartening response in a very short space of time.

 As it became clear that the project was really in danger of closing other funding agencies stepped up their support: City and Parochial particularly of the foundations, and the Arts Council of Great Britain and the Greater London Arts Association amongst statutory bodies.

The 1975 *Annual Report* tells how relations with the Hackney Council improved 'largely due to a lot more toleration and understanding on both sides' and the project succeeded in obtaining large-scale financial support from statutory bodies such as Hackney Borough Council and the Inner London Education Authority. This came to replace short-term support from the charitable foundations. Since the mid-1970s, Centreprise has continued to receive funding from statutory bodies such as the (since abolished) Inner London Education Authority and Greater London Council, Hackney Borough Council and Greater London Arts, as well as receiving one-off grants from a number of charities and foundations.

Community history and publishing are important parts of the Centreprise project. Centreprise began publishing working-class writing in 1972. That year the Hackney Workers' Educational Association (WEA) started a course called 'A People's Autobiography of Hackney'.

> The object of the course was to try to build up a 'collective' autobiography of Hackney, made up from tap-recorded interviews with elderly people in the borough, as well as individual pieces of writing. In the first year, the group, composed entirely of local people, collected about forty hours of tape-recorded reminiscences, from men and women involved in all kinds of jobs during the past seventy years. The topics covered included attitudes towards children, relationships with parents, jobs in the home, childhood games, school experiences, work, strikes, entertainment, politics, health and welfare, experiences of war, and many other subjects. (Arthur Newton, 1974, Introduction to *Years of Change, Autobiography of a Hackney Shoemaker*)

This project became the basis for a range of publications by local people.

 From its beginnings as a local history project, Centreprise publishing has expanded to include, alongside history, a wide range of other work by local people. Publications include: writing by young people; local autobiographies of working-class life; local history materials; writing by literacy students; Black writing (*sic*); and the poetry and stories produced in the writers' workshops.

 In its first few years (1972–5) Centreprise produced 25 titles, each of which sold between 450 and 5000 copies. Subsequently it continued to publish several titles each year and in 1992 had a list of 34 titles in print.

Centreprise is one of many community publishing projects that have sprung up in Britain since the early 1970s. These projects share the aim of giving voice to working-class experience and history. They concentrate on enabling working-class people to produce their own histories. In his introduction to *A Licence to Live*, Ron Barnes tells us how important writing the book was for him: 'My book may not be a work of art, and void of intellectual phrases; it may have a touch of self-pity about it, but there it is. To me this has been a great achievement, a thing that some years ago I would not have dreamed of doing' (Barnes, 1974, p. 2).

The Centreprise project is linked to other similar groups throughout the UK via the Federation of Worker Writers and Community Publishers – an organization that, after many years of struggle, finally received regular funding from the Arts Council of Great Britain in 1990–1.

Video in the Community

Besides the expansion of community publishing, the 1980s and 1990s have also seen the growth of community video work. This work is based in video workshops around the UK. Some workshops have a general mandate, others address themselves to specific groups such as women or the Black and Asian communities. Many focus on recording working-class history.

Like other parts of Britain, South Wales (the region where we live) has seen the flourishing of community publishing and video. Since the 1970s, the city of Cardiff has seen the growth and virtual demise of both the Chapter Video Workshop and the Black Video and Film Workshop in Wales. The Chapter Video Workshop, which is still partially in existence, made videos on a wide range of themes including life in the Welsh valleys and the miners' strike of 1984–5.

The Black Film and Video Workshop in Wales, based in the old docks community of Tiger Bay, was formed in 1984. From their origins, BFVWW had three major aims:

1 To involve Black people in all spheres of the media, film and video production in particular.
2 To produce film and video programmes in order to promote Black representation in British film and television.
3 To encourage and facilitate the use of video as a creative means of communication in Butetown and elsewhere.

Most of the BFVWW's members were male Rastas in their twenties. During its lifetime, they made a number of non-broadcast videos (most of

them on low-band UMATIC). BFVWW received funding from Channel Four, the Welsh Arts Council, South Glamorgan County Council, the South-east Wales Arts Association and the Gulbenkian Foundation.

Ten miles north of Cardiff, the women's film collective, Red Flannel – a group that had its roots in the Chapter Women's Film Group (discussed in chapter 6) – continues to make videos and television films. Among Red Flannel's early successes was *Mam* (1986), a film about the social role of the Welsh 'mam' in the South Wales valleys. It included brief interviews with a range of Welsh women and gave rise to the idea of a television series on Welsh women. In 1993 the result was a series of six portraits entitled *The Time of My Life* for BBC Wales:

> It took over five years to raise the money to make the series but we did not give up as we felt it was important to document these experiences of Welsh women before the stories were lost forever as the women became too old and frail to tell them themselves. . . . Between them, the women have over 700 years of lived experiences. The women who appear are not all well-known as we wanted to show the experience of 'ordinary' women as well as those who were prominent in public life. Some of them have overcome extraordinary circumstances within their lives, whilst others have been included because they have unique knowledge of a disappearing way of life.
>
> Despite the many books and films that have been written and made about Welsh history, very little has been documented on the lives of Welsh women – their experiences have been largely hidden from history. (From Bowyer et al., *The Time of My Life*, 1993, p. 5)

In nearby Barry, the Valley and Vale community arts project, founded in 1981, continues to produce both publications and videos on aspects of working-class life. Funded by the Welsh Arts Council, South-east Wales Arts Association, the Arts Council of Great Britain, local government and the Welsh Development Agency, Valley and Vale runs a broad community-based arts programme. In addition to producing videos and books, Valley and Vale provides workshops, stages exhibitions and performances and produces a range of marketable goods. Workshops cover video, photography, dance, drama, music, desktop publishing and design. Videos and exhibitions are hired out, T-shirts, books and posters sold locally. Valley and Vale's oral history work is currently being consolidated in a 'Living Archive Centre' in Barry.

Meanwhile in the old docks area of Cardiff, the Butetown History & Arts Project is collecting life histories, recorded on both audio and video, collecting old photos and other forms of documentation and publishing writing by people from the Butetown community.

The Butetown History & Arts Project began life as a community history project, based in the old multi-ethnic, working-class, Tiger Bay docks

district. Tiger Bay has for generations been the subject of negative images produced by the media, social research and fiction. It is also a community under threat as the docklands area of Cardiff is redeveloped.

Founded in 1987, the community history project drew on the interest of local people in representing themselves and their history in ways different from dominant representations. This led to the collecting of audio- and videotaped life histories, old photos and artefacts of working-class life. The collecting and cataloguing of material is part of a longer-term project to build an archive of the history of the community which should eventually result in a local social history museum. In the meantime the Project is publishing local life histories and photographs and working towards making television programmes. All these activities tell a different story of life in the Cardiff docklands from that found, for example, in the archives of the local newspapers or in the Industrial and Maritime Museum in Cardiff.

In the remainder of this chapter we look in detail at the Butetown History and Arts Project, at its aims and achievements, at its struggle for funding and recognition, and at the questions and problems that it raises about cultural democracy.

People's History in Tiger Bay: Butetown History & Arts Project

TRUTH: It is probably the case that more people have heard about Tiger Bay than any other community in Britain. Few areas – or myths – have proved so interesting for so long to so many observers. Few can evoke such passionate feelings. Today, this area sits in the middle of a massive docklands redevelopment scheme that will forever transform the area.

Butetown History & Arts Project is directed by G.H. Jordan, a politically radical Black American researcher and educator who has been working in Butetown since the mid-1980s. In collaboration with some local residents, he founded the Butetown History & Arts Project in 1987. The following is from an extended interview conducted with him in Autumn 1993.

Tiger Bay

CHRIS: So, tell me about Butetown . . .
GJ: Cardiff docklands has a rich and unique history. It was through the diligent labour of thousands of immigrants and their descendants

that Cardiff became, for much of the nineteenth and twentieth centuries, 'the Coal Metropolis of the World'. The expansion of Cardiff as a coal-exporting port attracted a variety of industries – heavy engineering, steelworks, ship-repairing and various other trades. It also attracted a kaleidoscope of immigrants to build and service the docks, to work aboard the ships and to otherwise service the new industrial and maritime city.

Butetown sits in the heart of Cardiff docklands. In geographical terms, Butetown is an area approximately a mile long and a quarter of a mile wide located on the southern end of Cardiff. Historically, it has been physically isolated – an 'island' bounded by (now filled-in) canals, railway tracks and the sea. Residents refer to the top (northern) half of the area as 'The Bay' or 'Tiger Bay' and the bottom part as 'The Docks'. 'The Bay' is the larger and historically more 'Coloured' of the two areas. Outsiders often refer to the whole district as 'Tiger Bay'.

GLENN: How would you describe this community? Many people refer to it as a 'Black community'. Would you agree with that?

GJ: Butetown has never been a 'Black community' – despite the impression given by a host of social scientists, journalists, politicians and so on; despite what many Black people, elsewhere in Britain, believe. The area – this little 'island' – has always been multinational and multiethnic and, since the late 1800s, it has had a significant non-White population. Among the peoples represented in Butetown over the past 150 years are the following (let me see if I can list all of them): Irish, Welsh, English, Scots, Turks, Cypriots, French, French-speaking West Indians (presumably from Martinique and/or Guadaloupe), Jamaicans, Barbadians, Trinidadians, Guyanese, British Hondurans, Panamanians, Bahamians, St Lucians, St Kittsians, Germans, Spanish, Portuguese, Cape Verdeans, Maltese, Italians, Chinese, Japanese, Malays, Indians (that is, people from what is now Pakistan, India and Bangladesh), Somalis, Yemeni, Egyptians, Jews, Poles, Estonians, Latvians, Ukranians, Norwegians, Finns, Danes, Mauritians, Sierra Leoneans, Liberians, Nigerians, Camerounians, Gambians, Ghanaians, Angolans, South Africans, North Americans and a few others (for example, one Maori and at least one Fijian).

By the early 1900s, there were some 24 consuls and 14 vice-consuls based in Cardiff. One researcher working in the area – I think it was in the 1950s – counted some 57 nationalities And there have never been more than 10,000 people living in the place.

GLENN: Are you saying that it is this very large number of nationalities and ethnic groups that make Butetown unique? Admittedly, fifty-plus nationalities in an area that is only a mile long and a quarter of a mile wide is a lot. But there are other ports in the world that also

have large numbers of nationalities – New York, San Francisco, Marseilles . . .

GJ: Yes. One could draw comparisons with Marseilles, but with very few other port communities. Let me explain.

Nearly all of the immigrants to Cardiff docklands were male – and virtually all of them settled in the Butetown area. Once there, they met and often married women from the South Wales valleys and other parts of the British Isles. Today, most of Butetown's residents (and former residents) are of 'mixed' ethnic heritage. It is *very* common to find families from the area that are Muslim and Christian and Black and White: indeed, such families are far more common than ones that are only one race or only one religion. One well-known family is of West Indian, West European and Chinese origin; the origins of another are Somali (Sunni Muslim) and Russian Jewish. Nobody who is from Butetown finds this 'odd': it is only outsiders who do.

CHRIS: It is sometimes said that Tiger Bay is a mecca of racial harmony. Is it?

GJ: Calling it a 'mecca' is a little strong. I would put it this way: This is a genuinely *cosmopolitan* community, inordinately rich in culture – and, crucially, in cross-cultural and inter-racial understanding. It is surely one of the most successful examples of tolerance of difference and understanding others. The area's reputation on this front is well-merited.

CHRIS: So, you would suggest that other communities could learn a great deal from this?

GJ: Not just communities, but regions and countries as well. The social history of Butetown provides us with valuable lessons about how to live with others – with people of different skin colours, beliefs and ways of life – in an atmosphere of tolerance, respect and harmony.

There is a great need in this world for multi-cultural education. And materials based on the Butetown experience could make a very valuable contribution to this effort.

Ignorance breeds intolerance and ethnocentrism, if not racism. Take Bosnia. Or former East Germany – where you have recently been living. Or that great 'melting pot' on the other side of the Atlantic – where I used to live, before I saw the light.

. . . And the Politics of Representation

CHRIS: We want to talk with you about the myth of Tiger Bay. The area has a very 'colourful' reputation in the popular imagination.

GJ: Yes. Images and stories about Butetown – or rather Tiger Bay – are deeply engraved in popular consciousness. Indeed, the origin of the name 'Tiger Bay' is itself shrouded in mystery. Some of these images and stories are *negative*: the area has been portrayed/constructed as dirty, violent, diseased and immoral. Others are *romantic*: the area has been portrayed/constructed as exotic and a mecca of 'racial harmony'.

The best way to talk about this is to look at some examples. Here are some photocopies of a nine-part series of featured articles which appeared in the *South Wales Echo* (the popular daily newspaper) between 18 September and 2 October 1970. As you can see, the articles are written by Herbert Williams, who has written a number of colourful feature articles drawing on local history. For the benefit of the tape recorder, let me read some of the headlines from this series:

> *THE LEGEND OF TIGER BAY (PART ONE)*
> *PUB BRAWLS, PIMPS AND OPIUM DENS . . .*
> *BUT FOR MANY IT WAS UTOPIA*
>
> *THE LEGEND OF TIGER BAY (PART TWO)*
> *THE HUMAN TIGERS WHO LAY IN WAIT FOR SEAMEN*
>
> *THE LEGEND OF TIGER BAY (PART THREE)*
> *OUT COME THE KNIVES AS THE TONG WAR FLARES*
>
> . . .
>
> *THE LEGEND OF TIGER BAY (PART NINE)*
> *THE GHOST IN THE COBBLER'S COFFIN*

Now, I don't know Herbert Williams. And I have no reason to doubt that he is a very nice man. The point I wish to make is this: 'The Legend of Tiger Bay' series – rich in sensationalism, negative stereotypes and romanticism – is typical of 150 years of discourse and imagery about the area that one finds in local newspapers, novels, short stories, radio programmes, theatrical productions, songs, television programmes and films.

The local press are particularly guilty of reproducing such imagery.[7] People from the area itself find it offensive. And they have good reason to do so.

CHRIS: Perhaps the stereotyped representations of which you speak are what has most attracted the scores of journalists, social researchers, photographers, novelists, film-makers and others.

GJ: Yes, such imagery is undoubtedly what has attracted all those (unwanted) 'Outsiders' who have come to study – to observe, to gaze upon, to represent – this community.

There have been, literally, thousands of newspaper articles (of which hundreds are feature articles). There have also been about ten novels and collections of short stories, a dozen or so television programmes, perhaps a few dozen radio programmes, hundreds of undergraduate projects and dissertations, a few dozen masters and doctoral theses, several plays and a feature film.[8]

CHRIS: So, ultimately, it is impossible to separate Tiger Bay from stories about it. Tiger Bay is a textual phenomenon – a set of related images and discourses – as much as it is a physical and social one.

GJ: Yes, I would agree with that formulation – so long as it does not involve assumptions derived from philosophical idealism.

CHRIS: How is the work of the Butetown History & Arts Project positioned in the context of this history of representations?

GJ: The Project seeks, firstly, to engage critically with dominant representations of the area – to expose their foundations and effects, to deconstruct them. As you know, we are currently working on a film for television, with the assistance of funding from the British Film Institute, which does exactly that. The television programme will be about images of racial and cultural difference, and will make use of a lot of the 'Tiger Bay' materials.

Secondly, we seek to provide a space within which those voices – the voices of ordinary people of Butetown – that have been historically marginalized and/or excluded in all those representations by 'Outsiders' can be heard. This move, an exercise in *cultural democracy*, is one which I regard as absolutely fundamental.

The Project's Origins and Aims

CHRIS: So, we've come to the Butetown History & Arts Project. Tell me more about it.

GJ: BUTETOWN HISTORY & ARTS PROJECT involves community history, multicultural education, visual arts, desktop publishing, media production and training. The Project is a unique, innovative scheme, involving local people with professional researchers, artists and media workers in collaborative ventures. Our work has a certain urgency about it, as the Butetown community – Britain's most famous multi-ethnic community – sits in the middle of the docklands area of Cardiff, an area that is currently being massively redeveloped.

CHRIS: Yes. Perhaps we can talk more later about the Cardiff docklands redevelopment scheme – and how the work of your organization fits (or does not fit) within it. But first I want to focus on the Project.

GJ: Okay.

CHRIS: How did Butetown History & Arts Project begin?

GJ: The basic idea began in the summer of 1984, when I first visited Cardiff. Iain Tweedale, a young postgraduate researcher in urban geography, and I began engaging in some serious, reflective discussions about the politics of field research. These discussions included a number of residents of the area. (Some of my own discussions with residents about these issues were recorded on audiotape.)

I think it is fair to say that we were both committed to avoiding what the French historian Jean Chesneaux refers to, in a useful little book called *Pasts and Futures – or What Is History For?* [1978], as *intellectualism, apolitical objectivism* and *professionalism*. I think of these as the THREE SINS.

GLENN: So, what are the 'sins' of intellectualism and apolitical objectivism?

GJ: If Iain and I had viewed our research efforts in Butetown as simply worthwhile ends in themselves, regardless of the social context in which they were being conducted and the social uses to which they might be put, that would have been the SIN OF INTELLECTUALISM.

Had we assumed that we – THE 'SOCIAL SCIENTISTS' – could stand outside of the historical and social context, that we were simply pursuing the 'truth' about society, that the accumulation of knowledge has nothing to do with relations of power, then we would have been committing the SIN OF APOLITICAL OBJECTIVISM.

We, like Marx and Foucault, were certain of this truth: that it is impossible to draw a line between history and politics, between knowledge and power.

CHRIS: You had a third sin as well.

GJ: Yes, the SIN OF PROFESSIONALISM.

> A VOICE: Many historians live in a state of complacent professionalism. History is their 'trade', their 'field'. They are specialists and respected as such. The press and even more television, have familiarized the general public with their position as privileged experts on the past. (Jean Chesneaux, 1978, p. 10)

Had we assumed that the purpose of our research was simply to acquire academic qualifications – we were both pursuing doctoral degrees at the time – or professional know-how, we would have been committing this third sin.

The points I want to make are these. Firstly, we refused, from the very beginning, to separate *historical and social knowledge* from issues of *power* and *social practice*. Secondly, from quite early on, we (especially I) envisaged our work as involving collaboration with local

people. I was involved in genuinely *collaborative ethnography* within a few weeks of arriving in the area.

GLENN: So, from the very beginning the Project had a kind of moral compulsion?

GJ: Yes, that's right. With the encouragement of friends and colleagues in Butetown, Iain and I decided to, as they say, 'give something back'. The initial idea was one of developing a Butetown Community Archive.

We thought it not only intellectually important but morally right for there to be a community-based research project that would systematically explore the rich tapestry of life in Butetown. It was soon decided that this project would foreground the experiences and oral recollections of long-term Butetown residents.

CHRIS: Why?

GJ: For the following reasons, among others:

1 The docklands area of Cardiff has played a crucial role in the maritime and industrial history of Wales, and this history should surely be preserved. Many people – ordinary working-class people, many of them immigrants and minorities – suffered and died helping to make this city great. It is both sensible and right that they should be remembered. Future generations should be able to learn about their experiences and struggles, not just about the history of the coal merchants and the Lords of Bute.

2 The Butetown community is unique – certainly in Wales and in Britain, if not in the world. It contains Wales's most prominent cosmopolitan community, and formerly contained Britain's most famous Sailor-Town. Butetown instantly reminds us of the multinational and multi-ethnic character of British society. It also foregrounds Britain's long history as a seafaring nation.

As I said earlier in this interview, in a world torn about by ethnic and racial divisions, the social history of Butetown provides us with valuable lessons about how to live together in a hetereogenous society.

3 Much that has been written, and said, about Butetown consists of romantic and negative stereotypes. While many of these accounts are 'colourful' and 'good fiction' – they sell newspapers and books – residents and former residents of the area usually find them monotonous and offensive. Those of us involved in the initial stages of the Project felt from the very beginning that, in such a context, it is right that residents and former residents should be able to recover their history. We sought to develop mechanisms whereby their voices would no longer be marginalized and excluded but brought to centre-stage.

Finally, we could not but be aware that many of Butetown's old-timers were dying. We felt compelled to get a move on – to systemati-

cally record oral recollections of life in Butetown (and at sea) before more long and rich memories were lost forever.

CHRIS: You mentioned someone called Iain Tweedale a few moments ago. Doesn't he work for the Welsh Development Agency?

GJ: Yes, but in those days he was a postgraduate student, with an interest in radical community politics. I haven't seen him for a few years, but I personally hold him in high regard. I think one or two of the misguided 'community leaders' eventually ran him out of Butetown. Perhaps being White, middle-class and male, without the experience of having lived for years in a 'Coloured' community, proved to be his downfall. But I knew him very well at the time, and know that his motivations were honourable.

Anyway, in 1986–7, Iain offered a community education course on 'The History of Butetown'. That course, held in a small room in the Butetown Community Centre, went for a couple of months and was videotaped by the Black Film and Video Workshop. It was in that course (after a series of lectures by Iain on the economic and social history of the area) that we first began recorded interviews with old-timers from Butetown. Those first interviews, conducted in the summer of 1987, were on video – on low-band UMATIC.

By the end of 1987, I and some local residents had formed an informal association called the Butetown Community History Project. A couple of years later, we changed our name to Butetown History & Arts Project – to emphasize that we are also involved in visual and media arts.

CHRIS: When did the Project formally begin? When was your first public event?

GJ: Our first public event was in February 1988. We began a year-long community education course called 'The Way We Were: Life Histories from Tiger Bay'. That course was followed by another one: 'Women's Lives in Old Butetown'. As it turned out, a group of us – a core group consisting mostly of residents and former residents of Butetown – met weekly for more than three years in the Butetown Community Centre.

The residents and former residents who were part of our core group in the early years include Marcia Barry, Olwen Watkins, Robert Johnson, Vera Johnson, Rita Delpeche, Molly Maher, Shelagh Maher, Nino Abdi, Dorothy Bell, Tony Degabriel, Carlos Depass, Gerald Ernest and Mr Carey. Jack Sullivan, the local painter, was also a regular member of our group.

The make-up of the group reflected the cosmopolitan character of Butetown. One night Jack counted some 20 or so ethnic groups represented in our midst. The ethnic background of most members of the group included two or three – sometimes four – different

nationalities. Marcia's background, for example, is Malay, Nepalese, French and Welsh. Olwen's is Filipino, Afro-Caribbean and Irish. Nino's is Somali, Mauritian and Welsh.

CHRIS: So the Project has always been multi-ethnic and multiracial?

GJ: Yes – like Butetown. And this is surely one of our strengths.

Oral History and Cultural Democracy

Most history has been written 'from above', from the perspective of the powerful, privileged few. In re-writing history 'from below', oral history can create a more accurate and authentic picture of the past. It can give back to people a sense of the historical significance of their own lives and make the practice of history more exciting and available to all.
 — Stephen Humphries, *Oral History*, 1984, p. x

CHRIS: I can't help but notice all those audiotapes over there.

GJ: Those?

CHRIS: Yes.

GJ: Those are blank tapes, for use in making copies. Our original recorded tapes are safely stored away.

CHRIS: Would you describe Butetown History & Arts Project as primarily an oral history project?

GJ: I would describe it as a people's history project that makes considerable use of oral history, together with community education and visual arts.

CHRIS: Tell me about the Project's collection of recorded life histories.

GJ: We have been involved in the collection of in-depth life-history interview material since 1987. Over the past few years, the Project has collected some 500 hours of in-depth audiotaped life-histories and 20 hours of videotaped life-stories. In summer 1991 we began transcribing this material but, as this is tedious work (for most people), we have not got very far. We hope to significantly speed up the processes of cataloguing, transcribing and analysis with the assistance of a multiyear research grant. During the next few years we hope to organize all of the transcribed material on to our Macintosh computer system – so it can be easily accessed, edited and otherwise used.

GLENN: What are you hoping to do with the recordings themselves, with the large number of recorded interviews that you have?

GJ: The recordings and transcriptions will form a unique archive of tremendous long-term value. The recordings themselves, made accessible by transcribing and cataloguing, will be used in radio, tele-

vision and non-broadcast media programmes, as well as in exhibitions. Some of the materials have already been used in courses and workshops we run, and in a television programme on oral history. We hope to use some of this material in primary and secondary schools as well.

CHRIS: One need only glance at all the tapes here to see that you rely a great deal on oral history. Why are you so insistent upon privileging the spoken word?

GJ: This is an important question, and I would like to answer it properly. Let me begin by making a few brief observations about history and research.

In their attempts to interpret or analyse the past, historians have traditionally relied on three basic types of evidence. They usually rely mostly on *written materials*, such as government reports, census returns, letters, diaries and newspapers, and on *archaeological evi-*

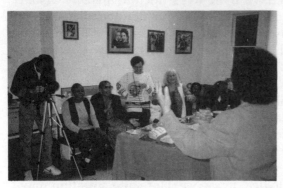

Plate 5.1 Butetown History & Arts Project at Work, Cardiff, Wales.
Top left: interviewing Mr Thabit Messin, the UK's oldest Yemeni immigrant, at opening of 'Photographs of Old Butetown', permanent exhibition in office of Fullemploy Wales, Cardiff docklands, July 1989. *Top right:* BHAP stall at Butetown Carnival, August 1993. *Bottom:* launch of *Old Cardiff Winds: Songs from Tiger Bay and Far Beyond,* the Project's second book, in BHAP office, May 1993.
Photographs: Mark Woodyatt, Marco Gil-Cervantes and Glenn Jordan.

dence – ruins, statues, carvings, coins, tools, etc. Some also use *visual evidence* – newsreels, drawings, paintings, photographs and so on.

Recently, a number of historians, especially certain social historians, have come to take *oral evidence* – verbal accounts of first-hand experience recalled retrospectively – more seriously. In particular, there has been an increase in the number of persons, professionals and amateurs, involved in work in *oral history*. Although I am not a professional historian – as you know, I was trained as a social and cultural anthropologist – I see myself, and the Project, as part of this movement.

In actual fact, the staff and volunteers of Butetown History & Arts Project are collecting a *range* of historical materials – including hundreds of *written* documents. However, it is fair to say that we privilege oral testimony.

GLENN: Along with photographs . . .

GJ: Yes, that's right. I'll come back to the matter of photographs in a bit. Let me say a little more about why we privilege recorded oral testimony, as this bears directly upon some serious issues about which I, together with many of those with whom I work, feel rather strongly.

The first thing that must be said is this. Despite their preoccupation with 'method', 'evidence' and so on, there is generally a very serious class bias inherent in the materials historians traditionally use.

Consider written materials. Now, it is patently obvious that the poor create and/or keep few written records. And they deposit even fewer with archivists.

Regarding visual materials, it is clearly the case that few working-class people can afford to have their lives documented by visual artists, photographers, cinematographers or video-technicians. Indeed, until very recently most working-class families did not even own a camera. It is true that things are changing now – with the invention and widespread availability of good compact cameras, hand-held camcorders and so on. However, this technology, which greatly increases the possibilities of cultural democracy, has only very recently become available. Also, it is still the case – and it will continue to be so for the foreseeable future – that the middle and upper classes make greater use of such tools than working-class and poor people.

Finally, consider archaeological evidence. Here, the situation may well be worst of all. Let me make an obvious point – or rather a point that should be obvious, but seems often to be overlooked. It is that the castles, estates and other property of the rich, because they are usually made with stronger and more durable materials, literally tend to last longer in the ground than the modest dwellings and belongings of the working class and the poor.

Thus, when dealing with the usual documents and artefacts, it is extremely difficult for the historian to avoid class bias in research and interpretation. It is not a question so much of the historian's own individual biases, but of structural biases in the evidence upon which she or he draws.

In general, it is only with oral history that ordinary people can be guaranteed an equal footing with elites. What I want to say here has already been said by others. If you don't mind, I would like to read here a passage from *Listening to History*, a book written by Trevor Lummis, a former student and now a colleague of Paul Thompson:

> Preservation is a prerequisite for entering the historical record. By preserving memories oral history redresses the balance of experience against artefacts, and although it records the experience of all, *it is especially valuable in preserving the history of those whose material possessions have been meagre, contemporary and transitory*. They have not kept their past in their houses or pockets, but in their heads. It is a method which can place on record anyone's historical experience: its limitation is that of living memory. For these reasons it is a major transformation of the historical record and through that, of historical practice. It has made history more democratic both in terms of those who record it and those whose experience is recorded. (Lummis, 1987, p. 154; emphasis added).

GLENN: Okay, so you use oral history because it offers the ordinary people the possibility of being included in the historical record. Are there other reasons why you use it?

GJ: Yes, I suppose there are.

Oral history brings STATUS and DIGNITY to people who are usually denied this. I am speaking here of 'under-privileged', marginalized and excluded groups – the poor, the 'ethnic minorities', the elderly. I've spent a lot of my life around people who are older than me, and I developed, probably as a child, now that I think about it, a special fondness for old people. Now, in modern Western societies, societies which are obsessed with youth, the elderly are often disregarded. In oral history, it is their voices that count most.

Also, oral history is to a community as memory is to an individual. It helps a community to recover its sense of IDENTITY. It helps community members and former members to orientate themselves in time and space (which is why reminiscence therapy often has such remarkable effects on the elderly). This is perhaps especially true in areas like Butetown where the physical environment, and, relatedly, the social environment, has radically changed over the years. If the street where your house used to be no longer exists, if the com-

munity life you once knew is gone, memories – especially oral recollections and photographs – become extremely important.

There are also other reasons why I like oral history. These reasons have to do with politics and morality. Perhaps we can talk more about this later. Just let me say here that by providing us with first-hand accounts of life in different situations and environments, oral history helps us to better understand our fellow human beings who may live in a culture or subculture that is different from the one we inhabit. In a world fragmented by social and cultural divisions, this sort of liberal education is of paramount importance.

CHRIS: Who is the audience for oral and community-based history?

GJ: I had intended to say something about this earlier. Your question, as I interpret it, bears directly on issues of cultural access and equality.

It is worth noting, from the very beginning, that oral and community-based work DEMYSTIFIES HISTORY. The past that oral history preserves is rich and interesting – or rather, it is very likely to be so. Rather than some historian's account of other people's lives, what is preserved is people's own accounts of their lives via vernacular speech, dialects, diverse languages and oral traditions. This sort of history, especially when combined with pertinent visual materials, can be intrinsically interesting. Many people who would never read a history book will listen to people talk about their lives. Also, many people who read local history books – with their first-hand accounts, pictures of community life and so on – would never read other kinds of non-fiction books.

GLENN: It is often said that oral history lends itself well to project work and to endeavours involving co-operation between professional researchers and lay researchers. It is also often said that with a little training, anyone can become involved in collecting, analysing and presenting oral history. This is one of the central claims made, for example, by Paul Thompson in *The Voice of the Past*. Based on your experience with the Butetown History & Arts Project, would you agree with this?

GJ: This is tricky

Now, let me say straightaway that I would mostly agree with this claim. Ordinary people from ordinary communities – the unemployed, old-age pensioners, single parents, school children, etc. – can and do make real contributions to oral history work. Indeed, as researchers, editors, authors, producers – as active participants in the recovery of their own history – they often make far greater contributions to oral history work than any of us so-called professionals.

It is true that the skills required to do good oral and community

history are not those monopolized by 'professionals'. But it does not follow that 'anyone can do oral history'.

Take Bob, for example. Now, as you know, he has worked with the Project since its inception, and his contributions have been invaluable. He has done as much for the Project as any of us. However, he is hopeless at doing oral history interviewing. You remember the weekly Seamen's Discussion Group which he was leading a few months ago? Well, what he basically did was to ensure that he matched or bettered any story that anyone else in the group told. He would literally talk over them!

Now, it's not as if he hasn't been instructed in the proper techniques of oral history – listening carefully, not interrupting and so on. The problem is that he prefers talking to listening.

He's very good at collecting old photographs and documents and at helping us secure meaningful and lasting ties with the community. But, after working with him for a number of years, I must say that I doubt that he will ever become a great interviewer.

I mention this particular case beause he is someone you know. I could have given others.

Before you go on to your next question. Let me add this: I suspect that females are better at oral history interviewing than males. The last thing you need in this field is a BIG EGO. And males tend too often to have this problem.

CHRIS: Yes, I know. I've worked with some of them over the years.

Oral History and Morality

GLENN: I think the picture you have painted of oral history may be a bit rosy. Is there anything you do *not* like about it?

GJ: Yes, in a sense, there is. The problem has to do with the interpersonal relationships – the social bonds – that develop between me and people I interview. I am thinking here, in particular, of people who I have interviewed over a number of visits.

It must not be forgotten that oral history, perhaps uniquely, involves *entering into the lives of other people*. This can be, as Paul Thompson and others have said, a deep and moving human experience. But it also potentially raises certain MORAL PROBLEMS. And it is this question – the matter of oral history fieldwork and morality – that I wish to address, briefly.

Let me tell you a story. A few years ago, nearly every Wednesday for six months or so, I and Marcia Barry, another member the Project, did oral history interviews with Mr Thabit Messin. Mr Messin, a

retired seaman, was born in the Yemen but he'd been in Cardiff since before anybody still alive can remember. He was approximately 104 years old. (His exact year of birth was in dispute, but he was certainly closer to 105 than to 100.)

Anyway, we visited him weekly and collected his life story – some 70 hours on audiotape! We also videotaped him. Now, it became obvious after a while that Mr Messin really enjoyed our visits – which raised the question of what would happen when we left. Didn't we have a moral obligation to keep coming by to see him, at least every few weeks or so? I think we did. This, then, is one important moral problem: what obligations do you have to people after you have interviewed them, after you have captured their life on tape?

This problem is serious, especially when one remembers that old people are often lonely and sometimes neglected.

There is a second, less obvious problem that I wish also to mention. I said a moment ago that it became obvious that Mr Messin enjoyed our visits. Well, I soon discovered that something else was happening. By our coming and asking him questions about his life, Mr Messin's memory was substantially improving. He began to remember and talk about events and people in his life that he had long forgotten. One day when we visited, he told us that the previous night a person he had not seen in perhaps 80 years had been standing by the door. (That is, they had come to him in a dream.) I felt disturbed by this. I felt that I had unleashed something that neither I nor he could control. I asked him if remembering all of these things from the past that he had long forgotten made him feel bad. He said the opposite was true – that he was pleased to be remembering his old life so well.

But it does not always work out like this. Sometimes, you lead people to think about things that are disturbing. Once, for example, I was asking an elderly lady about games that children used to play. I mentioned 'bogies' (makeshift wheeled carriages in which children used to roll down the streets). She started weeping. I didn't know what had happened. It turned out that her son had been killed while riding a bogie.

Entering people's lives is usually rewarding – for both parties involved – but it can also get one into moral difficulties.

I did not say earlier that Mr Messin died a year or two after we stopped interviewing him. I wasn't told of his death until after the funeral. I didn't even know he was in the hospital. I would have gone to see him. I would have spent hours by his bedside. But I didn't know

I will always feel horrible about that.

What Does the Project Do?

CHRIS: This discussion about oral history and the morality and poli-
tics of research is very interesting. It seems you have come to
think deeply about some of these issues, because they were so close
to you.

GJ: I don't think I have discovered many answers, but I do think I have
encountered, and reflected on, many of the questions.

GLENN: If we could, I would like to move to another topic – to focus
more specifically on the ongoing work of the Project.

CHRIS: So, what are the Project's goals and objectives?

GJ: The goals of the Butetown History and Arts Project are the follow-
ing:

- to ensure that the social history of Butetown, one of Britain's most
famous communities, is carefully collected and preserved for
posterity;
- to collect and preserve this history with the active involvement of
residents and former residents of Butetown community;
- to creatively use visual arts and media arts to produce materials,
exhibitions and programmes that are interesting and accessible to
a broad audience;
- to develop an effective marketing strategy for our publications
and other products;
- to contribute to multicultural and multiracial awareness;
- to help people from inner-city Cardiff acquire education and
training that will allow them to participate meaningfully in the
new economic order;
- to facilitate positive interaction, based on understanding and re-
spect, between the old and new communities of Cardiff dock-
lands – through courses, exhibitions, publications and other
activities.

GLENN: These general aims are laudable enough, but what specifically
do you do? What are the Project's *specific* objectives and how much
progress have you made towards them?

You said earlier that PEOPLE'S HISTORY is the backbone of the Pro-
ject . . .

GJ: Yes, it is fair to say that the 'backbone' of our work consists in
collecting, preserving, copying and utilizing oral histories, old
photographs and other documents.

CHRIS: What sorts of other documents?

GJ: Old newspaper articles, letters, diaries, seamen's discharge books,

birth certificates, death certificates, passports, boarding house ledgers, etc.

CHRIS: How much material are you hoping to collect?

GJ: We expect to keep collecting for many years to come, because what we are doing is very important. Obviously, the amount we are able to do is contingent upon resources – financial and human.

We do, of course, have specific targets . . .

CHRIS: What are they?

GJ: Over the next five years or so the Project intends to:

- collect, reproduce and catalogue approximately 5000 old photographs;
- collect and catalogue about 1500 hours of audiotaped oral recollections from Butetown's older residents and former residents, including 150 life histories;
- produce a few hundred hours of broadcast-quality videotaped oral history recollections;
- assemble an indexed collection of several thousand newspaper articles;
- assemble a collection of old documents and artefacts – seamen's discharge papers, passports, immigration cards, ration books, boarding house ledgers, etc.;
- develop a small library of pertinent books, reports, theses, etc.;
- obtain copies of all the radio broadcasts, television programmes and old film footage on the area.

These materials will form part of a BAY PEOPLE'S ARCHIVE – an invaluable resource that will be utilized for educational and artistic purposes for generations to come.

CHRIS: So, the Project's long-term aim is to have a local history archive?

GJ: We anticipate that several permanent institutions will evolve out of the Project. These will include a Bay People's History Society, Tiger Bay Publications, Tiger Bay Media Productions and, eventually, a Bay People's Museum.

The big long-term aim is the BAY PEOPLE'S MUSEUM, which would include the Bay People's Archives, together with exhibition halls, a café and pub, activities for children and so on. We have thought in some detail about this. I think you even saw a sketch of a floor plan.

But we have put our 'big plans' on the back burner for a while, until we have more permanent structures in place.

CHRIS: How do you go about collecting materials? I mean, where do you get them and how?

GJ: We get most of our material from residents and former residents of Butetown and from people whose families have other connections to the area. Let me give you an example or two.

There used to be a place in Butetown, before the 1960s' redevelopment, called the Rainbow Club. It had arts and cultural facilities for young people. Now, a couple of months ago, the Project got a visit from a man we did not know. He told us that his good friend Mr Capener, who used to run the Rainbow Club, had died the day before and that he had come to donate pictures of activities in the Club to the Project. He gave us a few hundred photographs for the archives – just like that!

We have been given a few hundred photographs on two other occasions. Usually, we get documents and articles in ones and twos – as on the night when Vera Johnson came dancing into one of our class sessions wearing a World War Two gas mask which they used to have in the bomb shelters in Butetown.

What we mostly get are old photographs, which we copy and return. Sometimes we ask people if we can borrow old documents – seamen's discharge books, passports, marriage certificates, etc. – to copy for our archives. They almost always agree. Most of the things we get come through personal contacts.

CHRIS: I understand that people often contact the Project, and you personally, for information regarding the history of the area. Who contacts you? And what do they want?

GJ: They are usually journalists, media researchers or students. Sometimes we help them; sometimes we don't.

I usually help students, although sometimes reluctantly – since I resent the University of Wales at Cardiff using Butetown as a social research laboratory. We do not always help journalists, television producers and other such professionals.

GLENN: Why?

GJ: Because they usually want something for nothing! Let me give you a couple of fast examples.

A week or so ago, I was contacted by a journalist who was doing a feature article on Butetown for *Wales on Sunday* [newspaper]. After phoning me several times, he eventually reached me. He began by explaining that he was doing an article and then saying something like: 'Butetown has been a multi-ethnic community for a long time, hasn't it?' The tone of his voice indicated that he didn't know. I said, 'If you don't know that much, you got an awful lot of research to do. . . .' I got rid of him.

My second example involves a local television company that was doing some programmes on Cardiff and the sea. One day, after they had already started shooting, they asked me did I know any

seamen. They didn't know any! I said that I did and introduced them to some.

On perhaps a half dozen occasions over the past few years, local television production companies have approached us about pictures. The conversation usually goes something like this:

'We understand you have a lot of pictures of the old Tiger Bay community.'

'Yes,' I say – and proceed to show them some.

'Can we use some of them?'

'Are we talking co-production?' I ask. The conversation usually ends there, unless they are prepared to cut a proper financial and/or co-production deal.

I'm sick and tired of White, middle-class professionals seeking to exploit the Project.

CHRIS: I can understand your feeling. This is bizarre . . .

GJ: Yes, but sadly true.

CHRIS: Let me move to another topic. You were speaking earlier about all the materials the Project collects. Presumably, some use is being made of these materials as they are being collected?

GJ: Yes. Some of the materials we are assembling have been used in articles, books, exhibitions and television programmes. We hope to utilize them in a wide range of products, including the following:

photo exhibitions
multi-media exhibitions
occasional papers and booklets
prints, postcards, calendars and posters
videotaped programmes for use in schools
oral history and photo-history books
programmes for television
tape-slide programmes
radio programmes
other items.

We are particularly keen to get our materials into the schools. An emphasis on people's lives, families and communities brings history alive for the student. It enriches the educational curriculum – and it can be used at any level, from primary school to adult education and university. Moreover, in a world torn by ethnic, religious and racial divisions, surely it is not a bad thing for young people to learn tolerance and inter-racial understanding. The history of Butetown, as I have said, provides extremely valuable lessons here.

Community Education

CHRIS: Besides collecting, cataloguing and preserving materials on everyday life in old Butetown, the Project has, I understand, attempted to develop a strong programme of community-based education and training. What have you done in the area of community education? How successful have your efforts been?

GJ: Well, however one assesses our work, we cannot be criticized for not having a go! You yourself taught a course for us a few years ago on Black Women and Feminism. That course was one of our success stories. Not all of them have been

We have offered a number of community-based courses since 1988. The original intent was to develop a kind of a kind of 'people's university' – with a regular programme of courses in the following areas: HISTORY (especially 'people's history'/oral history), VISUAL ARTS, MEDIA STUDIES and MULTICULTURAL EDUCATION. Some of the courses we have offered are the following: 'People's History', 'The Making of Multicultural Britain', 'Basic Photography', 'Drawing, Painting and Collage', 'Pottery', 'Creative Writing', 'Introduction to African History', 'Understanding Islam', 'Black Women and Feminism', 'Introduction to Computers' and 'Computer Graphics and Desktop Publishing'. We have also offered some Saturday art courses for children – in photography, drawing/painting and pottery. Eventually we hope to offer courses for young people in video production and computer art. To date our courses have been offered in collaboration with the South Glamorgan Community Education Service and the Department of Extra-Mural Studies at the University of Wales, College of Cardiff.

The idea was to develop a programme of courses that would be innovative and that would facilitate community participation in ongoing Project work. This is another reason why we placed so much emphasis on oral history. Oral history work provides an excellent context in which to teach and develop a variety of skills. It involves research skills, administrative skills, clerical skills and, depending on the specific nature of the project, a range of technical skills – in audio-recording, word-processing, photography, video-recording, editing, desktop publishing and so forth. Our community education and skills development programme have attempted to take full advantage of this fact.

CHRIS: We can talk more about skills development later. I believe that this relates crucially to your aims in terms of cultural democracy.

GJ: Yes . . .

CHRIS: But first I must ask you this: How successful have the Project's community education courses been?

GJ: As I think you know, our courses have not been exactly a raving success. Most of them have been cancelled due to lack of attendance.

CHRIS: Why haven't the courses done better?

GJ: I suppose if I really knew the answer to this, I would have used that knowledge to solve the problem. I do, however, have some thoughts about why this road has been difficult.

One of the most basic, fundamental problems was that, as in many working-class communities, there was no well-established tradition of attending classes. The local Community Education Service had dismally failed this area. When we started our first course in Butetown, there was not a single community education course going. We were it! Now, in a community like this, I think that is a serious indictment of the local authorities – and of the community leadership.

Also – and this is related – for many working-class people in Britain, school was not a positive experience. Thus, if what you are doing looks like 'school', you are likely to fail. The issues here are primarily to do with the class character of British education.

When we first began our community education initiatives in Butetown, I didn't know much about class in Britain. I probably still don't know very much about it; this is a complicated matter, you know . . .

Anyway, I think that one of the mistakes we made – and I think I am primarily responsible for this one – was to give insufficient attention to fun, to PLEASURE. Those of us who were organizing the courses, especially the Project Director, didn't spend enough time thinking about how to make the sessions not only educational but very enjoyable. This failure is related to my having spent so many years in university environments.

It is probably also the case that we had too-high expectations, that we tried to develop too quickly. For example, at one point we introduced more than a dozen new courses at a time. In retrospect, it seems obvious that we should have built the courses one by one. It is certainly the case that we should never have tried to introduce more than two or three new courses at a time. This is especially true given the fact that the Project lacked a proper infrastructure – paid staff, annually recurrent funding and so on.

There were and perhaps will always be problems having to do with internal community politics. A few years ago, precisely when the Project was engaged in our most ambitious efforts in the area of community education, some people actually campaigned to have people *not* attend our courses. The immediate trigger to this very

unfortunate episode was this: I broke off a relationship I was in with a woman whose family was from the Butetown area . . .

GLENN: It's a funny old world.

CHRIS: I don't think you had finished giving your list of reasons for why the community education courses did not take off as well as you had hoped.

GJ: Yes. It is a long list, but I'm seriously trying to analyse properly the Project's initiatives, so that we are more successful in future. There are only a few more points that I wish to make.

The first one has to do with access. Now, our courses were held in the middle of the Butetown community – literally in the middle. None the less, we should probably have done even more to make the courses accessible. I am thinking in particular of the fact that most of our courses were held at night. We could undoubtedly have involved more older people, especially older women, in our oral history courses if we had held them during the day.

Similarly, we could have taken some of our courses to Loudoun House or Nelson House – that is, to one or both of the high-rise tower-blocks in which many of the residents live. That way, people could have attended courses without even leaving the building.

It is more possible to do courses in the flats now than it used to be. They have recently been renovated, and there are now nice lounges in which people can meet. As a result of this, we have started running a weekly reminiscence group in Nelson House – the high-rise, one-bedroom flats which are mostly populated by older single people. That group meets in the day.

Incidentally, one or two people have suggested that one of our mistakes was to offer courses free of charge. Anybody with common sense knows that if something is good, it has to cost money!

Interests, Power and Cultural Democracy

What is the meaning of all this activity and whose interests does it serve?
— Jean Chesneaux, *Pasts and Futures*, 1978, p. 14

CHRIS: You are a professional researcher, trained in the academy, yet committed to cultural democracy. Butetown History & Arts Project is located in a working-class community. How, given this starting-point, has the Project been organized so as to ensure democratic control and grass-roots involvement? And how do you cope with different levels of education and skills?

GJ: Let me say something first about the way the Project began – in terms of its structure and decision-making processes.

Our origins lie, as I think I said before, in weekly meetings in the Butetown Community Centre. Now, these meetings went on every Tuesday evening for three years. The sessions combined a course – 'Life Histories from Tiger Bay', 'Women's Lives in Old Butetown' – with business. That is, we talked routinely about what the Project was doing, and about what we should be doing. *It was in those meetings, and related discussions with participants that the Project's basic agenda was set.* It was there that we decided on the basic goals and objectives of the Project.

Some people who were part of our core group did not like us talking about 'business' during our Tuesday evening sessions – since anyone could come, since they weren't 'proper', formal meetings and so on – but I insisted on this. I felt that it was a crucial component of our grass-roots cultural democracy. For what it's worth, I still think I was right.

I always viewed the Project as a collective, mostly grass-roots initiative. And I think most of our core group saw it in those terms as well.

CHRIS: You said that carefully. Your tone would seem to suggest that some of them did *not* see it that way.

GJ: Yes. I think there has always been at least some tension between whether it was MY PROJECT or THEIR PROJECT. It is true that, despite my intentions, I seem clearly to have emerged as, in some sense at least, THE LEADER. I said from the very beginning that I would not be there forever ˙ – that I would work with them to get the Project going properly and then I would take a back seat. In the first class session, for example, I said that I expected to work with them for three years.

I also initially called myself *Co*-director. The idea was for me to be in charge with another person from the community as my structural co-equal. That fell through when we didn't get proper funding. However, she is still involved with the Project.

The idea was for me and other 'outsiders' with professional skills to work with local colleagues and assistants, transferring skills and confidence to them so as to eventually make ourselves expendable. I have stuck to that policy – although, unfortunately, we haven't managed to develop local talent as quickly as I had hoped. In any event, I plan to resign as Project Director within the next twelve months or so. My successor, if I have anything to do with it, will be a person from the local community. Or perhaps it will be a collective leadership of some sort.

CHRIS: So, have your ideas about running a community project democratically been modified by your experience? I know from my own involvement in collective projects – in left politics, in the women's

movement and at the Centre for Contemporary Cultural Studies at Birmingham – that a whole range of factors can affect the degree to which one can realize these sort of ideals.

GJ: Yes, in addition to the expectations of some members of the group that I would actively lead the Project, there were serious questions of levels of commitment – particularly the amount of time people were able or willing to give to the tedious day-to-day running of the Project and to securing funding. There was also the question of how we were perceived from the outside. Funders, in particular, want to deal with one responsible representative. In the event, the fact that I was willing to put in many more hours than other members of the Project and to ensure that things got done, inadvertently reinforced my 'leadership' role.

Gradually, I came to realize that, in a situation where everyone was working on a voluntary basis with different levels of commitment, grassroots involvement could not always be fully realized in all areas of our day to day practice. I still believe, however, that a commitment to GRASS-ROOTS CULTURAL DEMOCRACY should govern the ways in which those most involved in the day-to-day work of the Project relate to the rest of the group. And I don't think this should be left to chance: it is a question of setting up and maintaining proper structures to ensure accountability and collective input.

CHRIS: You said that the Project has already collected some 500 hours of audiotaped interviews. Now, that is a lot! How have you collected so much material? Has it been easy?

GJ: Funnily enough, it hasn't been particularly difficult to collect the material. The hard part is properly cataloguing, storing and analysing it.

Perhaps the reason we have found it relatively easy to collect materials has something to do with the way in which we have worked. Whatever our failures, Butetown History & Arts Project is a genuinely community-based project – and this has profound implications for the nature of our work and how it is received.

Incidentally, when I do oral history interviews with someone I virtually always include a local person from our group with me. They are centrally involved in arranging and conducting the interviews. Hopefully, within the next few years the Project will have a couple of very well trained researchers from the local community.

One member of our group, whose children are now grown up, has recently received a BA degree in history from Cardiff University. Another member has been working on a social science degree through the Open University for the last five years or so. She should be finished soon. A couple of others who are involved with the

Project are also doing courses – in photography, women's studies and media studies.

GLENN: This is something about which the Project can justifiably be proud.

GJ: Yes, I agree.

CHRIS: If you don't mind, I would like to ask another question about structures and cultural democracy: Is Butetown History & Arts Project a charity?

GJ: In legal terms, we are an unincorporated association – a loosely connected group with a constitution and officers. But we are in the process of evolving a more formal structure. We are currently drafting Memoranda and Articles of Association so that we can become a company limited by guarantee with charitable status.

CHRIS: Now, it is easy to see how an association or a society can practice grass-roots democracy. I would have thought this would be more difficult with a company.

GJ: Yes and no. Some unincorporated institutions have unelected trustees – the Great-and-Good – who are ultimately responsible for the running of the organizations. Trusts are undemocratic institutions: one might even call them 'feudal'. We did not wish to have any structures in which people could wield power without being democratically accountable.

On the other hand, we do wish, out of necessity, to have structures that will allow us to enter into proper contracts with other institutions, to get appropriate tax allowances and so on. Thus, like a number of other groups with similar aims, we will be a not-for-profit-company with charitable status.

GLENN: Who will be members of the company?

GJ: There will be an inexpensive membership fee and local people will be encouraged to join the company and to exercise their votes. There is a provision mandating that a substantial proportion of the board members – I think it is a minimum of 50 per cent – must be people from the local community. A third of the board will be elected each year, and there is a provision stating that one cannot hold a given office for more than three years in a row. The idea is to combine stability with genuine democracy.

As you know, our current Steering Committee consists of (1) four or five people from the Butetown community who have shown particular interest in the Project; (2) a couple of Project volunteers; (3) the director of another local arts organization, (4) a couple of scholars (me, you and one other); and (5) two or three people who know something about how to manage money. I suspect the annually elected board that is to govern the new structure will tend to have a similar composition.

CHRIS: What will the new organization be called?

GJ: Butetown History & Arts Project Ltd. Or possibly Butetown History & Arts *Centre* Ltd. If we go for the latter model, we could come to include other groups within our centre – at least we could eventually when we get more space.

Staffing and Facilities

CHRIS: What sort of staffing does the Butetown History & Arts Project have?

GJ: We have nine people working as volunteers. (This number has been fairly constant for the last year or so.) Three of them come in one day per week. The others come in more often, some of them four or five days. Until I took a full-time lecturing job, a few months ago, I used to work more than a forty-hour week at the Project.

The volunteer staff include Clerical and Research Assistants, a Visual Arts Development Worker, a Finance and Marketing Officer, a Historian, a Media and Training Officer, a Research Officer and, when he shows up, a Photographer.[9]

Molly Maher and Marco Gil-Cervantes, our Historian and our Finance and Marketing Officer, have, since I have left, become Joint Co-directors. They are both from working-class communities in Cardiff. Molly's family has been in Butetown for several generations; Marco was born in Spain but has lived in Cardiff since he was three or four. They hold weekly meetings with the rest of the volunteers to plan and monitor the Project's initiatives.

My job is now research officer. I have no responsibilities for the overall running of the Project. My responsibility is to oversee our research, especially the oral history work.

GLENN: What sort of office-space do you have? And what equipment?

GJ: Our office is located in the heart of Cardiff docklands – at 5 Dock Chambers, Bute Street, a beautifully restored Victorian building consisting of about 10,000 square feet of office space. The building is owned by an old Cardiff shipping family, and was occupied for most of its life by shipping companies. We have about 900 square feet of space, located on the ground floor in the front of the building. The space includes a large room with lovely natural lighting – some of it from skylights (ceiling windows). This room is used as a multipurpose space – for work, meetings, classes and exhibitions. We are hoping, within the next several years, to perhaps turn the entire space that we currently occupy into exhibition space – a gallery featuring local history exhibitions and contemporary art. Our work

space would go elsewhere. We have been here since March 1992 and have a five-year lease.

CHRIS: I want to ask you about equipment as well, but perhaps that can wait until I have asked you about funding.

GJ: Okay.

Funding

CHRIS: How is Butetown History & Arts Project funded?

GJ: Over the past five years or so, we have received financial assistance from Cardiff City Council, the Welsh Arts Council, Marks & Spencer, Cardiff Bay Development Corporation, the County of South Glamorgan, the British Film Institute, South-east Wales Arts Association and other sources. 'Other sources' includes me and my partner. Aside from lost wages, the Project has cost us a few thousand pounds.

CHRIS: What sort of money has the Project been given?

GJ: At first, we were lucky to get a few thousand pounds a year. Since 1990 or 1991 we have been receiving between £25,000 and £30,000 a year. I have a copy of our annual report for 1 April 1991 to 31 March 1992 here. I can give you more exact figures if you would like.

GLENN: Yes, that would be helpful.

GJ: Okay. In the 1991–2 financial year, the Butetown History & Arts Project received the following grants and income:

1	Cardiff City Council: grant to assist with opening and developing our new office (i.e., rent, rates, insurance and maintenance) and to provide some clerical assistance	£7,500
2	Cardiff City Council: grant for photographic component of our work – primarily wages	£6,000
3	Cardiff Bay Development Corporation: grant for capital – equipment, furnishing, decorating	£10,000
4	Welsh Arts Council, Film, Video and Television Department: development grant for video work	£5,997
5	Welsh Arts Council, Film, Video and Television Department: training grant	£500
6	Welsh Arts Council Finance Department: grant for running costs	£2,747

7	South-east Wales Arts Association – grant for visual arts development	£500
8	Other income	£543
	Total	£33,787

Now, in terms of funding, the 1991–2 financial year has been our most successful year to date. The money we got that year took a lot of effort. Some of it had been promised for the previous financial year, but somehow got held over. (I later learned that this is sometimes done deliberately to decrease the amount of money statutory bodies have to dispense.) We would never have received that funding package if it hadn't been for two women in positions of power at Cardiff City Council. One of them is now the Leader of the Council, the other was a top administrator in the Chief Executive's Office. We will be eternally grateful to them.

GLENN: I want to ask you about the structure and mechanics of funding. Let me start by asking you about capital versus 'revenue' funding – that is, about one-off versus recurrent funding. I noticed that Cardiff Bay Development Corporation gave you a *capital* grant for £10,000. What were the restrictions on that grant?

GJ: The restrictions were that the grant had to be used to furnish and equip our office. It was not to be used for wages or activities.

We used it to purchase a Macintosh desktop publishing system, a used photocopier, a phone system, some transcribing machines, two audio-recorders, some 35mm cameras, a video machine with a large monitor, a slide projector, some chairs, a couple of filing cabinets and a few other items.

That money was very helpful. By obtaining some discounts from local merchants and some free furniture from Marks & Spencer, we put it to good use.

GLENN: But did you really *need* all of that equipment? Couldn't the money have been better spent on something else – like buying some clerical help?

GJ: Look, if you are awarded a grant, you can't simply turn around and spend the money on whatever you choose. You are legally obliged to spend the money on those things for which it has been awarded.

Yes, it possibly is true that we could have made better use of that £10,000 if we had been free to do with it as we chose. But that simply was not an option, nor could it be.

Most of the money Cardiff Bay Development Corporation has, has

been given to them by the Welsh Office for capital expenditure. In turn, most of the money they give out is also in that category.

CHRIS: Why hasn't the Project received more money? Surely there are lots of well-funded projects around that are far less deserving?

GJ: I think there are a number of reasons why we have not received more money. I have occasionally thought about this issue over the years, as you might expect. Here is what I think.

The main reason we have not done better is simple: bad timing! If we had started, say, three to five years earlier, I have no doubt that we would have attracted proper, recurrent funding years ago. By an unfortunate accident of history, the Project began in the middle of one of the worst economic depressions of the century. By 1990 or so, local government and most other statutory funding bodies in Britain were beginning really to feel the crunch. Since then, as you know, things have got worse.

Funding bodies like the City Council, County Council, Welsh Arts Council and South-east Wales Arts have been struggling to keep their commitments to the clients they've funded for years. Often, they – especially the local authorities – have had to drop their long-term clients, or severely reduce the amount of funding that they received. For us to be asking for new money in such a climate is very tricky indeed.

GLENN: You said there were a number of reasons why, in your opinion, the Project has not received a greater amount of funding. You have given one reason so far . . .

GJ: Yes, but it is the main one.

Some of the reasons have, I think, to do with me. For example, as I am not from this culture, I was sometimes fooled by British politeness. That is, I used to make the mistake of confusing politeness with commitment.

I also made another cultural error – an error which has to do with the local political culture. In retrospect, it is obvious that I was too serious about working through detailed proposals for what we wanted to do. I would clearly have done better to jot down a few ideas on the back of an envelope and scheduled myself a series of appointments with the power brokers. But even if I had done that, I may still not have succeeded.

CHRIS: Why?

GJ: Because I don't drink. Drinking is crucial in politics! An awful lot of important political decisions in this city are made over pints of beer There is a culture to Labour Party politics in which discussing things over a pint in the local pub or community centre is central. This appears to the voter as something that brings their politicians closer to them – it is just something that working men do. Actually it

is an important and exclusive ritual during which key decisions are arrived at. While one might assume that such decisions would be made by the City and County Councils and at meetings of funding bodies, I gradually discovered that these more often function as occasions for rubber-stamping decisions made elsewhere – in local pubs, etc. As Foucault suggests, power is not centred in the formal institutions of the state but is dispersed in a wide range of social practices.

CHRIS: So, the core problem was bad timing coupled with cultural misunderstandings and a dislike of drink?

GJ: I think there were other factors as well . . .

I thought the people from Cardiff Bay Development Corporation and the local authorities who are involved in the Cardiff docklands redevelopment had, on the whole, more intelligence and vision than most of them do. For example, it should be obvious to anyone thinking about attracting tourists to Cardiff docklands that a Tiger Bay Museum would be a major plus.

I had also counted on more active support from people in the community, including its representatives – not just lip-service and occasional assistance.

A FRIEND: I noticed that you haven't said anything about racism. Perhaps you haven't got more money because you're Black.

GJ: Because I'm Black? Or because the Project is?

FRIEND: Both.

GJ: Well, as you know, the Project isn't 'Black' but multi-ethnic . . .

FRIEND: Same difference . . .

GJ: Yes, perhaps I have been avoiding the issue of race and racism as it relates to funding. This is difficult terrain – a bit of a minefield. But let me see if I can manage to negotiate my way through it.

I must say straight away that I think it is too simple to say that the funders are racists and that explains it all. There are complex issues here – most of which, in my view, do not have specifically to do with race *per se*.

South Wales is anything but a stronghold of political conservatives – that is to say, of people who vote for and/or identify with the British Conservative Party. The area, as you know, has a long history of socialist and radical politics. Many of the people who run local government regard themselves as good socialists and anti-racists. Paul Robeson remains a hero here – much more so than in the United States. Also . . .

FRIEND: Sorry to interrupt, but you seem to be suggesting that good socialists cannot be good racists. I know a few who have combined the two roles rather well, not only in Eastern Europe but in Britain and Cardiff as well.

GJ: Yes, I do as well. Allow me to continue.

FRIEND: Proceed.

GJ: As I was saying, South Wales has a long tradition of socialist and radical politics. Local authorities are largely controlled by the Labour Party. The arts establishment in Wales is largely controlled by Labour Party supporters and people with some – usually mild – tendencies towards Welsh nationalism.

The rhetoric and style they employ is deceptive. They do not come on like elitists or people who are politically reactionary or unconcerned. On the contrary, they look and talk, for the most part, like 'one of the people'. Now, there lies a problem – certainly for me.

Coming from America and unused to White politicians who treat Black people as human beings and who speak with a rhetoric of socialism and comradeship, I was seduced by them. When they professed interest and support, I generally expected them to deliver the goods. I gradually and painfully discovered that they are what they are: POLITICIANS. The decisions they make are not based primarily on moral considerations but on the basis of political interests.

The allocation of funds by local government to community organizations is essentially governed by two considerations: *securing votes* and *avoiding local political protest or social unrest*. That is, politicians here, probably like everywhere else, mostly want to stay in office and avoid major difficulties: they cut deals to help them do so. They respond to groups with recognized voting power, and to groups which pose some sort of threat, for example, Rastas in the 1980s (after riots in some British cities) and now the newly arriving Somali refugees.

'Race' or ethnicity is sometimes a factor in funding decisions, but only when some group is seen as a pressing 'social problem' which might threaten future votes for the party in power.

What is going on here is what they refer to in America as maintaining the political machine. As we should know from Eastern Europe under communism, machines can be run by 'good socialists' as well as good capitalists.

Publishing, Marketing and the People's Voice

GJ: While we were talking about funding, I should have added that Butetown History & Arts Project is beginning to make money through marketing and sales. In particular, we are very pleased with our books.

CHRIS: Yes, I was going to ask you about how the publications are coming along. I know that the Project recently published its third book (in summer 1993)

GJ: It looks as though this book, *The Tiger Bay Story*, by Butetown's own Neil Sinclair, may prove to be very successful, perhaps selling 5000 or more copies. We were very pleased to see that it was one of the best-selling books in Cardiff for the first few months after it was published. In Waterstone's bookshop *The Tiger Bay Story* was number one on their best-selling books list for a few weeks: we were beating *Jurassic Park* and the *Queen and I*. We took a photograph of that list

I should also mention that we have had prominent window displays in both Waterstone's and Lear's. And we have successfully sold books at conferences in London and other UK cities.

GLENN: But how much money exactly are the publications bringing in?

GJ: It is a bit early to say precisely, since the real question is not how much they are 'bringing in' each month but how much after we have recovered all of our production costs.

Anyway, I anticipate that, from financial year 1994–5, we will be able to make at least £5000 to £10,000 per year from publications. The trick is to get a sponsor to cover the actual production costs. If that is done, whatever we sell is profit – profit that can be used to keep the Project going.

CHRIS: What plans for publications does the Project have?

GJ: I am editing a series of *Life Stories from Tiger Bay*, books of biography and community history by people who lived in old Butetown. Neil's book was the first in this series. We plan to publish three others within the next twelve months. One of them is virtually ready to go to press. We are waiting until we have sponsorship to cover the printing and initial marketing costs.

Publication of life-history interview material will take various forms. Some of it will be combined with photographs to make photo-history books on various themes – like *Butetown at War* or *The Pubs of Old Butetown* or *Rugby in the Bay*.

We are currently negotiating a book for Cardiff Bay Business Forum. They want a glossy 'coffee-table' photo-history book that could be given to new businesses that move into Cardiff docklands and could be given by businesses to their employees as Christmas presents. A few years ago, we would have been reluctant to take on such a job. These days, we do not bite the hand that feeds: we are less ideologically pure than we used to be.

We live in the real world. We have no choice – if we are to ensure our survival. Also, we don't see any reason why we should not be developing mutually beneficial relationships with the businesses

that are in and will be moving to Cardiff docklands. For example, we would welcome commissions to do permanent or rotating exhibitions of photographs of old Cardiff docklands for the foyers and meeting rooms of local companies.

GLENN: Do you only publish books?

GJ: Thus far we have only published books – two community histories and one songbook. But we will also be publishing postcards, greeting cards, posters, prints, tee shirts and so on.

CHRIS: Earlier, you talked a lot about giving the people back their voice – about ensuring that their versions of the past enter the historical record and so on. Now, I want to ask you a serious question about all of this: What happens when the people actually speak?

When local people write or tell their life histories, when they are being interviewed on camera or are involved with decision-making in the video edit suite, do they produce new, alternative representations of themselves? Or do they simply recycle all the romantic and negative stereotypes that have been produced by the dominant culture? Is the 'Tiger Bay' they produce through images and discourse substantially different from that produced by 'Outsiders'?

GJ: That is a very good question. I have occasionally thought about this issue, though, I admit, never systematically.

GLENN: Surely, it is something you should think about – assuming you don't have some naive, romantic notion about the VOICE OF THE WORKING CLASS; assuming you don't automatically think that if the people speak, they will speak the truth or at least challenge dominant images and discourse.

GJ: Am I going to be allowed to try and answer Chris's question?

GLENN: Sorry . . .

GJ: Let me begin by saying that I am not doing research in order to discover TRUTH. *I am trying to advance knowledge and understanding and to empower people.* Thus, I am not obsessed with the issue of whether what people are telling me is right or wrong.

I said I am not *obsessed* with this issue. However, I am a rigorous researcher and I try to get well-informed answers. This is one of the reasons why we generally do long interviews – on average, seven to ten hours per person. We ask a lot of questions, we probe, we explore topics in detail, we return to issues that have not been addressed and so on. A lot of interviewers tend to get simple pat answers – nostalgic answers. For the most part, I do not; we do not. I think this is true for a number of reasons, including the fact that we have already done a lot of research on the area, and thus can ask informed questions and follow them with specific follow-up questions.

So, I don't think our oral history tapes are filled with predictable

and stereotyped answers – because of the nature of the dialogue through which they are produced.

CHRIS: Yes, but what about books local people write or videotapes they edit?

GJ: In those cases, you are more likely to get romantic, 'good ole days' kinds of constructions. There are a couple of examples of this. I will mention one of them.

A few years ago, when we were engaged in negotiations with Channel 4 [TV], the Project decided to make a pilot programme of videotaped interviews with old-timers. After talking to a few people, I decided that I would have no involvement with the editing of the tape – that local people would sit in the edit suite and tell the editor what they wanted included and excluded.

When I saw what they had produced from the seven hours of interview material I was rather surprised. They had edited it in such way as to produce a tame, romantic picture. I thought it was so much in the 'how-we-all-used-to-get-on-in-the-good-ole-times' idiom that I went back on my decision and worked with the editor and a couple of local people to re-edit the last quarter or third of the tape.

CHRIS: How do you intend to structure the books with life history materials? How will they be edited?

GJ: The actual language people use will be edited very little indeed. The voices you hear will be theirs.

What we will do is to organize the material into topics and into narrative sequences.

Where the books include more than one interviewee, there will be multiple perspectives. We will not edit the texts so that all the voices from the community say exactly the same thing.

I said earlier that I don't believe the purpose of social science research is to come up with 'truth'. I do believe however that some accounts are better than others. And I believe that books that include more than one viewpoint are preferable to those that do not. I rather like MULTIVOCAL TEXTS – serious ones.

GLENN: Is your primary objective to produce publications or to build an archive?

GJ: That is an important question, which bears directly on the conversation we have just been having.

Our *primary* objective is to create an archive, involving oral and visual materials, that can be used for generations to come.

Now, it is very important, given that goal, that we ensure that we collect and preserve a plurality of voices – including different opinions. When in future someone comes to use the Bay People's Archive, say, to write a book, they will have different kinds of

evidence – different voices plus photographs, footage and written documents – on which to draw. They can submit the evidence to whatever rigorous tests they choose.

We want to leave the options open.

The Project and the Redevelopment

CHRIS: You said earlier that the Butetown History & Arts Project has something to do with the urban regeneration that is currently going on in Cardiff. Could you elaborate?

GJ: The Cardiff docklands redevelopment scheme began in the late 1980s and is to continue until 2005 or so. By then, 2700 acres of Cardiff – the city's docklands heartland – will have been radically transformed. The scheme, spearheaded by the Cardiff Bay Development Corporation, is said to involve around £250 million in public expenditure and perhaps more than £1000 million – more than $1.5 billion – in private investment. It is totally restructuring the economic and social character of south Cardiff. Ten years from now, the place will probably be unrecognizable.

As stated in various official brochures and reports, the goal of the Cardiff Bay Development Corporation is – I have memorized this line – 'to establish Cardiff internationally as a superlative maritime city, which will stand comparison with any similar city in the world, enhancing the image and well-being of Cardiff and of Wales as a whole'. Cardiff – the Welsh Capital – is to be put 'on the world tourism map'. The Cardiff of the future is to be as significant as it was in the days when the city was 'the Coal Metropolis of the World'. Large billboards proclaim the Cardiff docklands redevelopment scheme to be 'The Most Exciting in Europe'. I even saw one of these signs the other day when I got off the train at Paddington Station in London.

As you know, the scheme will result in a huge artificial lake (at considerable cost to the taxpayer), new link roads, a marina with facilities for boats and yachts, up-market office spaces, warehouses converted into luxury apartment buildings, new middle-class housing, a waterfront opera house and so on.

Now, in the middle of the massive area targeted for redevelopment sit several working-class communities – Butetown, Splott, Adamstown, Grangetown – dating from the nineteenth century. Butetown – the area locals refer to as 'Tiger Bay' and The Docks – sits squarely in the middle of it all.

The whole thing raises some *serious* questions: Will the Cardiff

docklands redevelopment scheme enhance the well-being of the communities that have historically lived in Cardiff's docklands? What will be their place – their economic, political and social position – in The New Cardiff?

CHRIS: How would *you* answer these questions?

GJ: I suppose I should have anticipated that you might ask me that.

Now, I actually happen to be of the view that, all things considered, the development will probably prove to be of considerable value to the overall economy of Cardiff and South Wales. However, it is not likely to be of particular benefit to the long-established working-class communities that are located in the area. I am not saying that this is the *inevitable* outcome – historical processes do not have inevitable conclusions – but that it is the *most likely* one.

Take Butetown. Now official representatives of Cardiff Bay Development Corporation have repeatedly said that there are no plans to get rid of the area. And, indeed, it would certainly appear to be the case that there are no specific plans to do so: for example, all the drawings published of the future Cardiff docklands show Butetown still sitting there . . .

GLENN: Do you believe them?

GJ: Me, personally?

GLENN: Yes.

GJ: I do and I don't.

Let's put it this way. I'm less suspicious of the intentions of local politicians, developers and planners than most people who live in the Butetown area are. My view, and here I am wearing my social scientist hat, is that personal intentions and motivations are not what is particularly important. This requires a bit of explanation.

Social processes are not determined by intentions alone. Whatever the *intentions* of the politicians, developers and planners involved in the redevelopment – many of them may undoubtedly intend Butetown to get its fair share – the primary beneficiaries of such schemes tend overwhelmingly to be the middle and upper classes, often at the expense of working-class communities. Anyone who claims otherwise is either lying or stupid.

There is a mass of evidence from Britain, the United States and elsewhere suggesting that the poor rarely gain from docklands redevelopment schemes. Often the biggest losers are working-class people living in long-established dockland communities located in the area. Whether those originating the schemes intend it to work out this way is almost totally irrelevant.

Let me give an example. When I first came here in 1984, there was talk by local Labour Party councillors and certain other public officials that the new houses to be built in 'Atlantic Wharf' were to be

sold at a price that local people could afford. A specific price was frequently mentioned: £23,000. Now when I came back in 1987, some of the houses in Atlantic Wharf had been built. They were selling for £47,000 and more. And many of them were being bought by corporations and property speculators – often based in London! As you know, that section of the development is nearly finished now, and you can count on your fingers the number of people from local working-class communities who have been able to even *rent* a flat there.

Now, it's possible that those who were quoting the £23,000 figure a few years ago were simply trying to get the public to go along with the scheme. That is, it is possible that they were simply being cynical and lying, as politicians often do. But it is also possible that they simply had a naive understanding of how the market works in such situations. Not everybody involved in the redevelopment is particularly bright, you know.

My point is that it doesn't particularly matter what their specific intentions were. The issue is to properly understand economic and social processes – and, in light of that understanding, to put in place proper structures and safeguards so that local people are not victimized.

CHRIS: What do most people in Butetown think of Cardiff Bay Development Corporation and their redevelopment scheme?

GJ: Most people in Butetown fear their community will be turned into a YUPPIE-LAND.[10] They may or may not be right: history will be the judge of that.

The point is that a real threat to the existence of this unique, multicultural community exists. Hence, the need for documenting the area's history has a certain urgency.

CHRIS: Indeed. But what has this got to do in specific terms with the relationship of Butetown History & Arts Project to the goals and strategies of the docklands redevelopment?

GJ: The Cardiff Bay Development Corporation, local authorities, private financial interests and various others are working to ensure that TOURISM plays a central role in the economic and social life of the regenerated city. The New Cardiff – high-profile capital city, leisure centre, financial centre and 'Gateway to Wales' – is to attract visitors from far and wide.

Now, to be a successful tourist centre a city must have AN IMAGE and HISTORY – archaeological ruins, artistic treasures, beautiful old buildings, sites of important events, birthplaces of legendary personalities, 'places of infamy', etc. In the coming years, a 'history' of Cardiff will be packaged and marketed.

Now as it turns out, for the last 150 years, the main thing most

people have known about Cardiff is that it is the city in which Tiger Bay is located. To the extent that Cardiff has a rich history, it is largely the history of its docklands area.

As we in the Butetown History & Arts Project see it, it is especially important to recover this history, given the anticipated development of a full-blown tourist industry. That tourist trade will necessarily focus on, and popularize, the history and culture (hopefully, cultures) of Wales. Tourists should be able to learn about Wales's most famous community – to purchase books and other materials about its history, to see exhibitions foregrounding its development and importance. And these materials and exhibitions should not be the sort of mythological rubbish – romantic and negative constructions – that has traditionally passed as the truth about life in Butetown. On the contrary, they should be of the highest quality.

It is clearly the case that stories and images of Tiger Bay are the most engaging and marketable aspects of the city's history.

CHRIS: Are you saying that the purpose of the Butetown History & Arts Project is to sell – literally sell – the history of Tiger Bay to tourists? This is tricky business. I must say that I'm somewhat surprised that someone with your political background would fall for this. Is this really the sort of thing we are struggling for – to sell Tiger Bay mugs, plates, cards and tee-shirts?

GJ: I never said that the politics here are not tricky. Let me try to explain the Project's position on this point – a position that is, I will tell you, precisely my own.

Political activists and academics sometimes do not live in the real world. I always try to. So, let me say straightaway that there is *no question* that the 'history of Tiger Bay' will be packaged and sold to tourists in the new, regenerated Cardiff. This packaging will include books, videos but also mugs, tee-shirts, postcards and so on. The only question is: WHOSE HISTORY WILL IT BE? That is to say, from what perspectives will these images and stories be presented? And secondly: WHO WILL BENEFIT? That is to say, who will gain money and power from the marketing of this history?

The brute fact of the matter is that if people from the community and people who share its interests do not collect, preserve, publish and exhibit Tiger Bay's past, someone else will – and we can be sure, gauging from the past 150 years, that what they will produce will be more 'colourful' romantic and negative stereotypes. In the real world, Butetown History & Arts Project has no choice but to be involved in tourism.

In any event, we do not regard this as intrinsically a bad thing. What's so wrong with providing educational materials for the general public, including tourists?

Purist politics are usually dumb politics – certainly, ineffective politics . . .

CHRIS: Let me ask you another question. You mentioned earlier that the Project is often contacted by journalists, researchers and television producers regarding the history and social composition of the area. Have you ever been contacted by Cardiff Bay Development Corporation in your capacity as an expert?

GJ: No. They seem to prefer to spend tens of thousands of pounds on consultants who know nothing about the area – and the advice they offer tends to reflect their lack of in-depth knowledge. Now, this is not exactly the best way to use the taxpayers' money . . .

I suppose I should say that there is another dimension to all of this that bothers me. It has to do with the politics of race . . .

CHRIS: What exactly are you saying?

GJ: I am saying that White people in positions of power have a long history of marginalizing and ignoring the contributions of Black professionals. Like most other educated Black people, I am offended somewhat by this.

Biography and the Politics of Research

CHRIS: Presumably anyone listening to this tape will have heard your North American accent by now. It's a long way from California to Cardiff. How did you end up here?

GJ: I've been living here in Cardiff since January 1987, when I came on an eighteen-month doctoral research grant to do fieldwork for a PhD in anthropology. I was following in the footsteps of my mentor, Professor St Clair Drake (former Director of African & Afro-American Studies at Stanford University), who 40 years earlier had done research in Tiger Bay for *his* PhD in anthropology.[11]

CHRIS: Why are you still here?

GJ: I have, as they say, 'GONE NATIVE'! I have no plans to return to the United States to live – certainly not in the foreseeable future.

I came to Britain, and thence to Tiger Bay, for the first time for a two-month research visit in the summer of 1984. When I came, I only knew one person in the whole of Britain – our good friend Professor Stuart Hall. I now know hundreds . . .

GLENN: You must like it here.

GJ: Yes, I certainly like Cardiff and Wales. Cardiff is the least racist place I have ever lived. I have never lived in England.

GLENN: You aren't saying there is no racism in Cardiff?

GJ: I didn't say that, nor would I ever. What I said is that it is far, far

less racist than the United States. What amazes me is that few Americans – and I include here Black Americans – actually realize how horribly race conscious and racist the United States is. America, in my view, is a sick society. I am very glad to be away from it.

That's enough about me! I thought this interview was about the Project.

CHRIS: I just heard that you have resigned as Director of the Butetown History & Arts Project.

GJ: Yes. I have recently accepted a job in Treforest as a full-time lecturer in the School of Humanities. Also, as you know, I got married a year or two ago – to you! Given my new commitments, together with the fact that my health is not very good, I decided to pack it in. But I will continue to work with the Project, especially in relation to the research and publishing aspects of our work.

Also, I promised from the very beginning that I would turn over the leadership of the Project to local people. I have fulfilled that promise. And, incidently, the Project is doing very well. They don't need me to succeed.

CHRIS: You seem to regard that as a tribute of some sort.

GJ: I do indeed.

On Words and Theft: Whose Story Is It?

GJ: Just a minute. I have a question before we end this interview.

CHRIS: Yes?

GJ: What do you intend to do with this tape?

CHRIS: I thought my colleague told you. We want to use this interview with you in a book we are doing on *Cultural Politics*.

GJ: You didn't exactly ask my permission . . .

GLENN: Sorry.

GJ: I hope I will be seeing some of the royalties, especially if this *Cultural Politics* book turns out to be a best-seller.

Part III
The Cultural Politics of Gender

On Art, Politics and the Women's Movement

The relevant debates which have emerged within the women's movement concern the efficacy and function of art within a political movement. Is it valid and how is it useful? To whom should it be addressed? Where should it be displayed? How should it be made and about what topics? There has also evolved within the women's art community a debate at a more specific level about the relation of feminist art practices, notable in their multiplicity, to the dominant modes of art. Should we intervene in the main institutions or disassociate ourselves and build alternative bases? Should we work in the public or commercial sector? What kinds of work should we produce? Should we use traditional art forms or traditional domestic and feminine materials, or neither, but seek out the overlooked indices of forgotten subgroups in the expanded notion of culture? Should we use theoretical material or the personal voice?

— Griselda Pollock, 1982

6

Feminism and the Cultural Politics of Gender

The weather on the day of the demonstration – 6 March 1971 – was unbeliev-
ably cold with sudden bursts of snow, but a massive crowd of women, men and
children gathered at Speaker's Corner. Down Oxford Street we went with
floats and badges and placards listing the finally agreed four demands: 'Equal
Pay Now; Equal Education and Job Opportunities; Free 24-hour Nurseries,
Free Contraception and Abortion on Demand'. All the way there were chants:
'Out of the office; Out of the home; Out from under; Women unite!' The
Women's Street Theatre Group, with grotesquely made-up faces, danced the
whole way to the music of an Eddie Cantor song: 'Keep young and beautiful;
it's your duty to be beautiful; keep young and beautiful, if you want to be
loved'.

—The first national women's demonstration since the
suffragettes, held in London in March 1971, as
described by a participant in Rowe, 1982, pp. 563–4

Feminism as a political movement has a long and varied history. There
have been moments when feminist activism has been strong and
widely visible – the 1790s, the 1840s, the turn of the nineteenth century
and the years since 1968. At other times, it has gone largely unnoticed,
even though many women continued to work for changes in the social
conditions which determined their lives. Feminist politics have always
been a response to women's actual position in society. Over the last 200
years women have campaigned against exclusion from education, the
professions, property rights and suffrage. They have fought against
prostitution, low pay and domestic violence. They have fought for contra-
ception and abortion.

Sexism as Cultural Politics

Gender: Nature or Culture?

Women's position in society is integrally related to cultural assumptions about gender. Writing in 1904, G. Stanley Hall, founder and first president of the American Psychological Association summed up much contemporary thinking about women as follows:

> Our modern knowledge of woman represents her as having characteristic differences from man in every organ and tissue. . . . Her whole soul, conscious and unconscious, is best conceived as a magnificent organ of heredity, and to its laws all her psychic activities, if unperverted, are true. . . . She works by intuition and feeling; fear, anger, pity, love, and most of the emotions have a wider range and greater intensity. If she abandons her natural naiveté and takes up the burden of guiding and accounting for her life by consciousness, she is likely to lose more than she gains. . . . Secondary, tertiary, and quarternary sex qualities are developed far beyond her ken or that of science, in a way that the latter is only beginning to glimpse. . . . We shall never know the true key to her nature until we understand how the nest and the cradle are larger wombs; the home a larger nest; the tribe, state, church and school, larger homes. (Quoted in Lee and Sussman Stewart, 1976, p. 372)

Stanley Hall sees woman as essentially different from men. Her very 'soul' is geared to procreation. Both her biological and psychological constitutions fit her exclusively for the roles of wife and mother. She is guided by emotion rather than reason. Too much reason is detrimental to her, and her sexuality is a great unknown which science has hardly begun to understand.

Such definitions of woman and 'woman's nature' can be found in a wide range of social practices, from religion and the law to philosophy and science. They are particularly abundant in sociobiology and psychology. In each case, 'man's nature' is the unspoken norm against which women are defined as different.

For centuries, conservative ideas about the 'nature of woman' were used to exclude women from many areas of social life. While the type of ideas voiced by Stanley Hall at the end of the nineteenth century have been challenged to some extent successfully over the last hundred years, the power relations of dominance and subordination which they legitimated have in many cases remained intact. It is these relations that feminists call PATRIARCHAL.

The features attributed to particular groups of women are often class- and race-specific. During North American slavery, for example, the White

wives of slave owners tended to be seen by White men as naturally sexually passive and in need of protection from an aggressive Black male sexuality. Meanwhile, Black slave women were raped, sexually abused and blamed for their 'promiscuity'. In nineteenth- and early twentieth-century Britain, working-class women were often regarded as naturally more promiscuous than their middle-class sisters. Their sexuality became a matter of public concern and state policing.[1]

For centuries women were assumed to have an instinctive tendency towards domesticity and motherhood. In the 1790s, Mary Wollstonecraft began a feminist tradition of arguing against biological theories of women's nature.[2] Feminists who write within this tradition insist that women and men share a common *human* nature. They argue that domesticity and motherhood are learned roles and that femininity and masculinity are effects of *culture* rather than *nature*. Moreover, the meanings ascribed to nature are always culturally produced. Appeals to nature – in this case 'women's nature' – as something fixed and unchangeable are most often used to justify unequal relations between the sexes. Where power is at stake, as in sexual politics, definitions of the 'nature' of men and women will be a constant site of struggle.

Poles Apart

What is desirable is that we should broaden our concepts of what the sex roles are so as to make room for more kinds of women and more kinds of men Girls with the conservative attitude towards woman's place in the world seem to be somewhat happier and better adjusted than those with the liberal attitudes. As many writers on the subject have pointed out, the progress of science and the removal from the home of many kinds of work which were once carried on there makes the restriction of women's activities to home and family increasingly inappropriate. The wide range of abilities in both sexes makes it appear that sex typing of occupations is not appropriate either. But the attitudes *that both men and women have grown up with fit these practices better than they do the actual economic and psychological facts, and too great a deviation from the accepted attitude makes for maladjustment. There lies our problem.*

— Leona E. Tyler (1947), in Lee and Sussman Stewart, 1976, pp. 407–8

'Natural' or 'normal' femininity and masculinity are defined in all areas of social life. Our identities as girls and boys, women and men are formed in and through our involvement in social practices, from the family and schooling to culture, sport and the leisure industries. Cultural practices such as the media, marketing, the cinema, sport, literature, art and popular culture construct forms of subjectivity which are mostly gendered.

This gendering suggests that certain qualities are appropriate to women and others to men.

Look at the following table of masculine and feminine qualities taken from an appraisal of sex-role stereotypes conducted in 1972:

Feminine Pole is More Desirable

Feminine	Masculine
Doesn't use harsh language at all	Uses very harsh language
Very talkative	Not at all talkative
Very tactful	Very blunt
Very gentle	Very rough
Very aware of feelings of others	Not at all aware of feelings of others
Very religious	Not at all religious
Very interested in own appearance	Not at all interested in own appearance
Very neat in habits	Very sloppy in habits
Very quiet	Very loud
Very strong need for security	Very little need for security
Enjoys art and literature	Does not enjoy art and literature at all
Easily expresses tender feelings	Does not express tender feelings at all

Masculine Pole is More Desirable

Feminine	Masculine
Not at all aggressive	Very aggressive
Not at all independent	Very independent
Very emotional	Not at all emotional
Does not hide emotions at all	Almost always hides emotions
Very subjective	Very objective
Very easily influenced	Not at all easily influenced
Very submissive	Very dominant
Dislikes maths and science very much	Likes maths and science very much
Very excitable in a minor crisis	Not at all excitable in a minor crisis
Very passive	Very active
Not at all competitive	Very competitive
Very illogical	Very logical
Very home oriented	Very worldly
Not at all skilled in business	Very skilled in business
Very sneaky	Very direct

Does not know the way of the world	Knows the way of the world
Feelings easily hurt	Feelings not easily hurt
Not at all adventurous	Very adventurous
Has difficulty making decisions	Can make decisions easily
Cries very easily	Never cries
Almost never acts as a leader	Almost always acts as a leader
Not at all self-confident	Very self-confident
Very uncomfortable about being aggressive	Not at all uncomfortable about being aggressive
Not at all ambitious	Very ambitious
Unable to separate feelings from ideas	Easily able to separate feelings from ideas
Very dependent	Not at all dependent
Very conceited about appearance	Never conceited about appearance
Thinks women are always superior to men	Thinks men are always superior to women
Does not talk freely about sex with men	Talks freely about sex with men

(*Source:* Broverman *et al.*, 1972, p. 63)

Common sense tells us that women are intuitive, emotional, dependent, irrational, passive and weak. They are destined for caring roles. Men are rational, aggressive, independent and strong. They are born leaders. Strong women such as Mrs Thatcher – or weak men – are not quite normal. Ideas about women, in common sense, 'science' and popular culture often include contradictory features. Women are at once the sexually passive virgins of romance and much sexology, and the sexually voracious vamps of pornography and prostitution. Assumptions about gender help determine the sort of role women and men play in society. The effect of gender stereotyping has been to restrict women to areas where they have fewer material resources and less power to define either their own lives or the shape that society should take.

The Feminist Response

In Britain, the contemporary women's movement began in the late 1960s. Its formal existence was marked by the foundation of the London Women's Liberation Workshop, which was a network of small groups with an information service.

Women's Liberation Workshop

believes that women in our society are oppressed. We are economically oppressed: in jobs we do full work for half pay, in the home we do unpaid work full time. We are commercially exploited by advertisements, television and press; legally we often have only the status of children. We are brought up to feel inadequate, educated to narrower horizons than men. This is our specific oppression as women. It is as women that we are, therefore, organising.

— *Workshop Manifesto,* in Rowe, 1982, p. 574

The movement defined its priorities in the early 1970s in the form of a series of demands which became the focus of political and cultural campaigns. They included:

- equal pay
- equal access to education
- free contraception and abortion
- adequate childcare facilities
- the right of women to define their sexuality for themselves and an end to discrimination against lesbians
- an end to domestic and sexual violence.

The 1980s saw the further diversification of feminist politics. The women's peace and environmental movements gave rise to new forms of political action, and the class, racial and ethnic base of feminist cultural workers and activists began to broaden to include more women of Colour and working-class women.

Since 1968, feminist cultural politics have taken many forms. Some have made the headlines, such as demonstrations at the Miss World competitions, attacks on sex shops, abortion campaigns and the Greenham peace camps. Others have attracted much less media attention but have made steady inroads into publishing, education, the performing and visual arts. Writing in 1982, after more than a decade of highly visible feminist activism, Michèle Barratt commented:

Cultural politics are crucially important to feminism because they involve struggles over *meaning.* The contemporary Women's Liberation Movement has, by and large, rejected the possibility that our oppression is caused by either naturally given sex differences or economic factors alone. We have asserted the importance of consciousness, ideology, imagery and symbolism for our battles. Definitions of femininity and masculinity, as well as the social meanings of family life and the sexual division of labour, are constructed on this ground. Feminism has politicized everyday life – culture in the anthropological sense of the lived practices of a society – to an unparal-

leled degree. Feminism has also politicized the various forms of artistic and imaginative expression that are more popularly known as culture, reassessing and transforming film, literature, the theatre and so on. (Barrett, 1982, p. 37)

An important feature of feminist cultural politics has been the development of new forms of protest. The women's peace camps at Greenham Common Air Base, for example, attracted support from women of all ages and from all over the country. Many of them were new to political protest. Peace groups produced hundreds of beautifully handcrafted banners and organized marches for peace in the tradition of the anti-nuclear movement. The massive demonstrations of the early 1980s included symbolic actions like decorating the perimeter fence of the air base with flowers, ribbons, toys, children's paintings and poems (plate 6.1).

Feminisms: Theory and Cultural Politics of a Plural Movement

Feminism is a plural movement. In the early 1970s, a predominantly White, middle-class movement began by questioning the White male subjects of liberalism and Marxism. At the same time lesbians challenged heterosexism. More recently, particularly during the 1980s, Black and 'Third World' feminisms have raised the issues of racism and colonialism, challenging the narrow, Eurocentric perspectives of Western women's movements.[3]

Feminist projects vary. Some attempt to expose, challenge and transform the patriarchal, racist and heterosexist aspects of existing social practices. Others seek to develop alternative theories on which to base social life. These theories offer new forms of identity, for example, those underpinning radical feminism, ecological feminism and some Afrocentric Black feminist writing.[4]

Feminist cultural politics can be divided into five broad-ranging perspectives: liberal, woman-centred, Marxist, postmodern, and Black and 'Third World' forms of feminism. While these categories are in no sense hard and fast – many feminists pursue forms of cultural politics which lend themselves in different ways to more than one perspective – they are none the less helpful analytical tools. Political and theoretical assumptions affect both the ways in which women see hegemonic culture and the objectives of feminist cultural politics.

LIBERAL FEMINIST CULTURAL POLITICS stress the importance of equality of opportunity. They emphasize women as individual writers, artists or critics, whose work should be valued irrespective of gender or race.

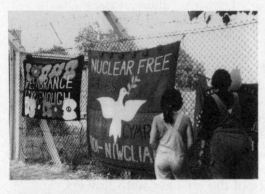
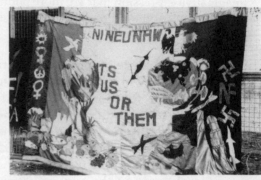
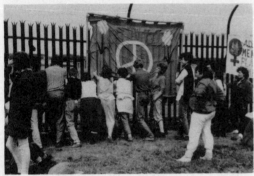
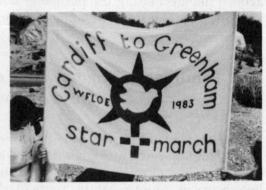

Plate 6.1 Women's Peace Movement Protest at Greenham Common Air Base, 1984.
Photographs: Alison Jackson; banners: Thalia Campbell.

Liberal feminism tends to disregard women's difference from men. Focusing on difference in cultural analysis raises the question of the status of this difference: should it be understood as natural or as socially constructed? Liberalism, with its concentration on the individual, prefers to assume equality between women and men.

In contrast to liberal feminism, WOMAN-CENTRED CULTURAL POLITICS focus on the work of women from a perspective that privileges female difference. Their objectives include establishing alternative traditions of women's cultural production and rewriting women's history from both Black and White feminist perspectives. Influential examples of woman-centred critical writing include the work of Elaine Showalter and Alice Walker. Showalter introduced the term *gynocriticism* to describe her woman-centred focus.[5] Walker uses the term *womanist* to distinguish her woman-centred approach from that of White feminists who have ignored the question of racism and the work of Black women.[6]

Woman-centred feminist cultural politics find their strongest expression in *radical feminism*. Radical feminism developed the tendency to view

women's creativity as something different from male culture to the point where there could be no overlap between the two cultures. It took a path that initially involved eluding patriarchy by having nothing to do with men and it has developed, particularly in the USA, into a social movement based on the celebration of difference and the assertion of women's natural superiority to men.

Differences in women's cultural practice do not have to be understood as signs of *essential* differences between the sexes. Marxist, postmodern, Black and Third World feminist cultural politics work with the assumption that gender is cultural.

In MARXIST FEMINIST analysis, economic social relations are central to understanding the history of gender identities and relations. Marxist feminists have explained gender difference in terms of its usefulness to capitalism.[7] They have argued, for example, that capitalism has an interest in maintaining gender identities and relations which guarantee a low-paid expendable female workforce in manufacturing and service industries, a largely feminized and low-paid public sector, and an unpaid workforce to care for children, the elderly and disabled in their own homes. They have further argued that this benefits men since it gives them privileged access to better-paid jobs, public life and leisure outside work.

POSTMODERN forms of feminism, most of which draw on poststructuralist theory, argue that neither gender nor race have naturally fixed meaning. Furthermore, they cannot be understood simply in terms of their usefulness to capitalism. In poststructuralist analysis, culture offers us a broad spectrum of possible modes of femininity and masculinity. As individuals we combine various elements from the range of available modes of subjectivity. These are structured by power relations – most prominently, those of class, gender and race. The elements which make up an individual's gender identity may be contradictory in themselves but appropriate in different contexts. None of these elements is in itself naturally female or male. Both femininity and masculinity are culturally constructed.

In abandoning any fixed idea of femaleness and femininity for which feminists might strive, postmodern feminists have a complex relationship to cultural politics. Femininity and masculinity become permanent sites of a political struggle over meanings which have real effects for individuals. They determine the forms of subjectivity and social relations open to us as women and men. The taking up of positions becomes a matter of strategy. Thus, postmodern forms of feminist cultural practice are not so much concerned with creating different, 'authentic' forms of female expression as with showing how all social practices and modes of representation construct gendered subject positions and modes of subjectivity which involve power relations and have material effects.

BLACK AND 'THIRD WORLD' FEMINIST CULTURAL POLITICS insist on the centrality of racism and colonialism to understanding gender relations. As

such they emphasize cultural and historical specificity, challenging the Eurocentric tendency of much feminism to privilege Western norms as universal. They call for a recognition of difference which acknowledges and challenges the oppressive power relations that constitute differences in a racist and (post-)colonial world.

Key Issues in Feminist Cultural Politics

The Invisibility of Women

The starting point for much feminist cultural politics after 1968 was the invisibility of women. Women's lives and experience were absent from most history writing, sociological studies and the literary and artistic canons. Women artists rarely featured in exhibitions whether historical or contemporary; women writers and critics were marginalized or read as honorary men.

The need to redress these absences united feminists of all political persuasions. Women working in education and in cultural production pointed to the under-representation of women's work in mainstream culture. Many male critics and historians justified this absence by declaring women's work inferior. In response to this feminists have pointed to the exclusion of women from the institutions which define cultural value and construct literary and artistic traditions. They have questioned the 'universal' status of the concepts of value used by male critics. They have argued that the Western literary and artistic traditions privilege White male cultural production.

The practical response of feminists has been to call for policies that give women equal representation and opportunity in all cultural institutions. They have set up alternatives to the mainstream: research projects, Women's Studies courses and exhibitions which focus on women's work. They have argued for the inclusion of more work by women in education, in exhibitions and the academies. In particular, they have fought for greater access for women to the means of cultural production and a larger share of arts funding.

The Need for 'Herstories'

By God, if women had but written stories
Like those the clergy keep in oratories,

More had been written of man's wickedness
Than all the sons of Adam could redress.
— Geoffrey Chaucer, *The Wife of*
*Bath's Tale, c.*1386, trans. Nevill
Coghill, 1951, p. 295

To be without history is to be trapped in a present where oppressive social relations appear natural and inevitable. Knowledge of history is knowledge that things have changed and do change. Nothing is inevitable. History is one key area where, until recently, women were virtually invisible. Our own histories of struggle against oppressive gender relations were lost.

History has tended to focus on the public sphere and on the actions of 'great White men'. Even the development of labour history and social history failed to pay due attention to women's lives and their various social roles. Women were seen as wives and mothers and the family belonged to the private sphere which was somehow assumed to be outside history or incidental to it.

Feminist history writing of the last 25 years has attempted to change the meaning of history. This has involved a massive amount of primary research: a work of recovery of lost histories, often hindered by the lack of source materials. Sheila Rowbotham's *Hidden From History* (1973) was a pioneering work in this area. Since then women's history has become a serious and varied area of historical research. Feminist history writing has challenged the public–private divide and reinstated the importance of those areas usually seen as 'private' such as the family and gender relations. This work of recovery and transformation has helped to denaturalize contemporary ideas about gender, showing how it has always been a contested area.

A VOICE: 'We started from the premise that women had always been involved in the production of art, but that the historians of our culture were reluctant to admit it. Our research revealed that it was in fact only in the twentieth century, with the establishment of art history as a widely-taught institutionalised academic discipline, that women artists were systematically obliterated from the record. There is, however, considerable literature on women artists prior to this century and a certain amount of reference to women in modern art criticism. But this literature consistently employed a particular cluster of terms and evaluations which we labelled the "feminine stereotype". What was suggested unquestioningly was that all that women have produced bears witness to a single, sex-derived attribute – femininity. This attribution of a pervasive and irrepressible femininity then justified a complacent judgement on women's innate inferiority in the arts.'
— Griselda Pollock, 1987b, p. 206

The recovery of lost materials and traditions and the transformation of the founding assumptions within disciplines are central to feminist work not only in history but throughout the humanities and social sciences. A major answer to the invisibility of women as producers of culture has been to rewrite the histories which exclude them. Feminist scholars and women's film and art groups have begun to recover lost texts by women. Women's publishing houses are reprinting work by women writers and artists. This work of recovery is a prerequisite for the broader feminist demand that women writers, artists and critics be given a central role in education and more recognition by the academies and arts funders.

Since the late 1960s feminists have been reconstructing new women's traditions, particularly in literature, film and the visual arts. Much primary work has been done uncovering lost and forgotten texts and making them available to wider audiences. Nowhere is this more marked than in the field of women's writing. Writing has always been an area in which women have been active. Whereas they were long excluded from art and music schools, upper- and middle-class women, at least, had access to literacy, books, pens and paper. They could use male pseudonyms where necessary and they mostly found a large and appreciative (often female) reading public.

One important example of this work of recovery is the Virago series of 'modern classics' which prints contemporary women's writing and reprints of texts by women long out of print. The reprints are accompanied by introductions which give information about authors and place the texts historically. A similar work of recovery is to be found in the Dale Spender series 'Mothers of the Novel'. Dale Spender has done considerable historical work presenting forgotten women writers and 'Women of Ideas' to a wider audience in an accessible style.[8] In the area of Black women's writing, the Schomburg Center for Research in Black Culture, part of the New York Public Library, in collaboration with Oxford University Press, is currently reprinting the work of nineteenth-century Black women writers.

The 1980s and 1990s have seen an increasing number of academic studies of women's writing and women's literary history together with the publication of a range of reference books such as *The Feminist Companion to Literature in English* (Blain et al., 1990). Much of this research and publishing focuses on the work of White women. This point has not been lost on Black women who have repeatedly pointed to the implicit racism of many White feminist projects.[9]

Black feminists are recovering the work of Black women. Alice Walker's two volumes of essays, *In Search of Our Mothers' Garden: Womanist Prose* (1984) and *Living by the Word* (1988), are exemplary here. These texts combine political essays about the Black American experience, essays on Black culture and essays dedicated to the recovery of Black women's writing. They are part of a growing body of work by Black American women.[10]

Black feminist critical and historical work is both lively and diverse. The

anthology edited by Joanne M. Braxton and Andree Nicola McLaughlin, *Wild Women in the Whirlwind: Afra-American Culture and the Contemporary Literary Renaissance* (1990) illustrates some of the main concerns and approaches. Whether writers are recovering lost work or interpreting it, the emphasis is on tradition. In the introduction to the volume, Joanne Braxton argues that Black women writers draw on their foremothers and on the oral tradition and that 'the current flowering of Black women's writing must be viewed as part of a cultural continuum and an evolving consciousness' (p. xxii). The anthology presents the work of writers and musicians, and attempts to identify what is specific to Black women's use of language in oral and written traditions and in autobiography. It focuses on key themes in the work of contemporary American Black women writers taking examples such as the 'outraged mother', history and spirituality, themes which are located in a long tradition of African-American culture. History and tradition are crucial to developing a positive sense of culture and identity.

The Role of Women's Studies

The absence of women from dominant cultural traditions and from most academic disciplines was the key motivating factor in the development of Women's Studies. In looking to traditional education for a greater understanding of their lives, women found little of use to them. Whether we looked at the social sciences, history or the humanities we were confronted by an absence of material that dealt with women's lives or cultural production. For women of Colour the absence was twofold.

In Britain, Women's Studies was from its inception closely connected to the Women's Liberation Movement and it found an initial foothold outside formal education. It developed in the context of women's groups and adult education, for example in extra-mural and WEA classes run by feminists. It was innovative in both its content and teaching methods.

Women's Studies places emphasis on collective learning, on transforming the hierarchical relations of the traditional classroom and on the centrality of women's own experience to the learning process. These aims challenge many of the assumptions and practices of traditional education and they became controversial once Women's Studies moved into the realm of formal higher education. In Britain this move involved hard-fought battles. While liberal education offered a space which women could occupy, they found themselves in need of powerful male allies who were willing to testify to the academic respectability of Women's Studies. Moreover, the political impetus behind Women's Studies and its commitment to the centrality of feminist perpectives was sometimes attacked by liberals who argued that anything about women could be included in

Women's Studies regardless of perspective. In one case, male staff at one Welsh university, who wanted to teach Women's Studies, argued that a course on 'Women and Psychology' should focus on traditional psychology. Their syllabus privileged psychological theories that confirmed traditional assumptions about women's nature and blamed the victim for domestic violence and sexual abuse. Insistence by the course organizers on feminist perspectives on these issues brought the charge of illiberal ideological policing. Given the limited space on the syllabus in question, choice of material for inclusion was necessarily political. When it was taught, the students, some of whom were confronted by 'blame the victim theories' repeatedly in their professional lives as social workers, were both unhappy and disappointed. They had expected something different from Women's Studies.

The role of men both as teachers and students is a difficult question for feminist supporters of Women's Studies. Women's Studies courses tend to contain a strong consciousness-raising component. In the women's movement, consciousness-raising is always conducted in intimate woman-only groups. Consciousness-raising in the educational context also demands a supportive group who can be trusted with revelations of a personal nature. Practical experience in mixed groups has taught many women that the social relations of groups change radically when men are included. For many women the question of including men or not has become one of priorities and objectives. Where the emphasis is on empowering women, men tend to be excluded.

The tension between liberalism and separatism runs through the heart of Women's Studies and is related to questions of subjectivity, lived experience, knowledge and power. Whatever the nature of individual men, their position in patriarchal societies is structurally different from that of women. Moreover, the more self-effacing and masochistic aspects of contemporary femininity relate directly to male–female relations. For these reasons, many feminists argue for Women's Studies as a separate space in which women can develop both new understanding of society and new senses of self. Against this, however, are the arguments that gender is of concern to both women and men and that Women's Studies should help to change men as well as empower women. It is here, perhaps, that 'Gender Studies' comes in. It provides a space in which men and masculinity necessarily figure both in their own right and in relation to women and femininity.

Men and Masculinity

Whose responsibility is it to change men? Is it men's responsibility, women's responsibility or a joint issue? Most feminists would agree that

there can be no fundamental transformation of gender relations without fundamental changes in men and masculinity. Men have to change and such changes would involve a transformation and redistribution of power. The question of changing men is related to a second controversial question, namely: Can men be feminists?

The relation of men to feminism has always been controversial. It has become so increasingly as feminism has gained a degree of academic respectability and marketability. While most feminists welcome male support, they see men and masculinity as the area to which men should turn a critical eye, rather than to women and femininity. Moreover, they insist that real support involves a redistribution of power.

Current concern with masculinity has produced a growing number of books on the subject, as well as men's groups and therapeutic weekends in which men are encouraged, among other things, to recover their suppressed emotions.[11] In the USA it has also given rise to Men's Studies. These developments are in part a response to issues raised by feminism. Many men have realized that traditional forms of masculinity can be oppressive to men as well as women. Attention to masculinity has taken various forms ranging from attempts to understand and challenge the social construction of masculinity to the wish to reclaim for men the right to so-called 'feminine' qualities. Changes in conceptions of masculinity have rarely, however, been accompanied by real shifts in power relations between women and men.

Racism, Men and Masculinity

Much more powerful is the critique by some Black writers and artists of the way in which, since slavery, racism has colonized Black bodies, male and female. As we argue in detail in chapter 9, male sexuality remains a key factor in racist discourse.[12] Black British artist Keith Piper has produced a powerful series of six panels, *Go West, Young Man,* which document the exploitation of Black bodies since slavery. This photomontage traces the different treatment of Black women and men showing how Black male bodies became 'objects of fear and fantasy'. The four panels reproduced in plate 6.2 tell of the experience of slavery. A male voice speaks:

> They prized me for my stamina
> As beast of burden
> And raw unit of labour.
>
> They bred me at stud
> Cultivating my body
> Through unnatural selection

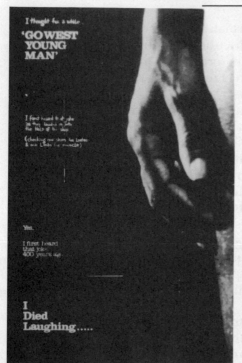
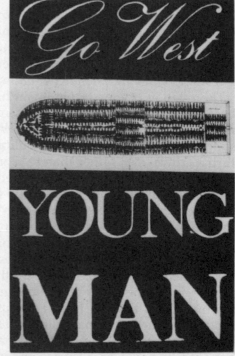

Plate 6.2 Go West, Young Man, Keith Piper.
Reproduced by kind permission of the artist.

> Mutating my physique
> Into an object of fantasy
> They feared me for my potency
> As a nexus of sex and savagery
> Brute force personified
> I remember how they pruned me with shackles
> And purged me with ritual castration.

Keith Piper's panels illustrate how the racist definition of Black male bodies as a 'nexus of sex and savagery' – Whites' 'worst fear and their best fantasy' – persists into the present. It shapes contemporary views of desirable male sexuality:

> I have begun to grow into the role, into a personification of their image of me. I have begun to carve my body into an object of awe. To cultivate my physique thru unnatural selection into a figment of their fantasies.

The body beautiful has become the body brutal.

It is not surprising that such a radical critique of the cult of the masculine body – a cult which permeates Hollywood cinema and numerous popular men's magazines – should come from a Black man. Racism does not allow an unproblematic identification with images of Black masculinity which most often have their roots in White society.

Contesting Dominant Images

Since the late 1960s, the question of representation has been a key issue in feminist politics. The images of femininity which we find all around us are often experienced by women as constricting and repressive. The legendary demonstrations at the Miss World contest in New York, which entered the public imagination via the myth of 'bra burning', symbolized a widely felt frustration with the trappings of conventional femininity. Moreover, images of sexualized women, found in a broad spectrum of practices from advertising to pornography, were seen as degrading and linked to sexual violence. Feminist responses have included picketing sex shops and violent and mysogynist films and campaigning against sexist advertising.

Take, for example, the representation of women in mainstream Western painting. Whether virgin or nude, subject of family portraits or of scenes of domestic life, women are most often defined by a male gaze. They are depicted as objects to be consumed by a male spectator. Look, for example, at plate 9.2, *The Babylonian Marriage Market*, which we discuss in more detail in chapter 9. Here women are not only the sexualized objects of a male gaze but are actually waiting to be auctioned in marriage. Alternative representations, in particular, the work of women artists, are missing from Western traditions.[13]

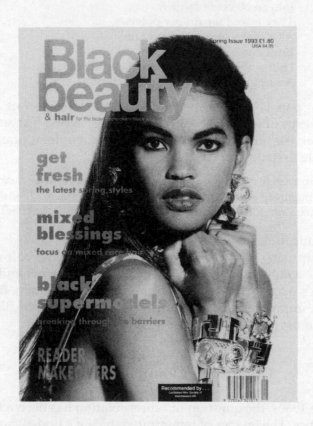

Plate 6.3 Cover of *Black Beauty and Hair*, Spring issue, 1993.
Courtesy of Hawker Consumer Publications. Photograph: Hannah Justice-Mills.

Similar arguments can be made about the representation of women in popular culture. The cover of the women's magazine reproduced in plate 6.3 is a typical example of fashion photography, in this case aimed at Black women. Taken from the cover of *Black Beauty and Hair*, it is explicitly directed at the 'beauty conscious black woman'. The image is of a highly made-up, exotic-looking Black woman (full of 'Eastern promise') gazing directly at the camera, glossy lips slightly apart and heavily braceleted arms, as if shackled, held tensely under the chin. She signifies both highly developed sexuality and vulnerability. Moreover, with her straight hair and light skin, she offers an image of desirable femininity to Black women which denies African features. This image is typical of the representation of women in magazines, fashion and advertising. It reinforces the idea that what matters about a woman is how she looks and how sexually attractive she can appear to men. With its shackles and vulnerable pose,

it also suggests that female sexuality is essentially masochistic. Who the woman is and what she can do beyond attracting men become insignificant.

Creating New Images

The Case of Feminist Film and Video

1. In all areas of the media, women are to a large extent ignored or shown in a negative way; we aim to improve the portrayal of women by exposing the reasons for women's oppression in the past and present, and by showing women in a positive and self-determining way.

2. The language of film and television derives from a male point of view and we recognise the need to construct a new language which is informed by a feminist perspective.

Thus, we aim:

3. To work against the discrimination in employment policies in film, television and video, and to build and maintain a national network of women working in the media.

4. To develop and run an effective advisory and information service in order to encourage access and participation of women – at all levels – in film, television and video production.

5. To research and produce a regularly updated folder of information and contacts covering all aspects of film, television and video productions. This will include hitherto unrecognised areas of women's labour in television.

6. To pressure for, and advertise training schemes in which women can learn necessary skills in film, television and video.

7. To actively encourage the involvement of women in making programmes for Channel 4 and other television companies.

8. To be informed by the demands of the Women's Liberation Movement.

(*The Aims of the Women's Film, Television and Video Network* (WFTVN), 1983)

Feminist film and video groups have been active in Britain since the early 1970s. Here is an account from 1971 by the Belsize Lane Women's Group, based in London, of their Feminist Film Workshop:

Some of our group when in the original Tufnell Park Group had made a ten-minute silent film, *Women, Are You Satisfied With Your Life?* Using stills from magazines it showed the complicity of advertising in idealizing woman as housewife. We all recognised the power of media images and the potential of film for radical organizing. Many women, even in the movement, had never seen the films available on feminism, so we organized the Workshop to show as many of these films as we could (in those days still

most films were from the US) and teach anyone who wanted to learn how to project films for themselves.

We showed rushes from *A Woman's Place*, the documentary about the Oxford Conference and the 1971 women's march which two of our group were editing. And proceeds from the film workshop went to Sue towards making *One, Two, Three* about the Children's Community Centre. (Rowe, 1982, pp. 564–5)

By the early 1980s women's film and video groups had become part of a broad-based move to change the representation of women in the media. At the time of the First National Feminist Film and Video Conference, held in Cardiff in April 1983, there were active groups in many larger towns and cities, for example, Norwich, Liverpool, Bristol, Cardiff and London. These groups shared a range of common objectives:

- to develop new forms of working practice which were collective, non-hierarchical and non-exploitative;
- to acquire and share the skills necessary for film and video production;
- to develop new ways of representing women through a study of film theory and films themselves;
- to make feminist films and videos more widely available by organizing screenings and discussions.

Their focus was twofold: (a) to increase awareness and challenge how women are represented in the media, and (b) to help women obtain the skills and resources to produce alternatives.

The South Wales Women's Film Group, for example, of which one of us was a member, first came together in November 1981 and met regularly for several years. Women in the group had various skills in 16 mm, 8 mm and video production and in teaching film. To begin with, the group was financed by subscriptions from members. It subsequently received small grants from the Welsh Arts Council and a larger grant from Channel 4 Television. It gradually developed a code of practice and a political identity as a feminist group which resulted from the process of working together on funding applications, training courses, small group projects and the screening and discussion of films.

Work began with a set of small group projects around the theme 'Age and Identity' which were designed to further skill-sharing and develop practical skills. The group's first public project was the organization of a Women's Film Event in Chapter Arts Centre in Cardiff in May 1982. This was part of the national 'Women Live' festival. The films shown were a selection of mainstream films, feminist shorts and documentaries. They encompassed European, 'Third World', Australian and North American films made by women, and British women's cinema of the previous ten years, including work by women made in the Chapter Film Workshop.

In April 1983, the South Wales Women's Film Group organized the First National Feminist Film and Video Conference. By July 1983, six films were being made by women involved in the group and some members had gained representation on the local funding body, the Film Panel of the Welsh Arts Council. Although the group did not survive into the 1990s, it raised the profile of women's film and video in Cardiff and was an important stepping-stone for many of its members who went on to found new production groups or to work full-time in the mainstream media.

Perhaps more than film, video has become a crucial area of feminist cultural politics. As we suggested in chapter 5, the 1980s saw a significant expansion in video-making in the community arts sector. Feminists have used video to document all aspects of women's lives. It has become an important form of recording both individual life histories and histories of communities. For example, during the miners' strike of 1984–5, miners' wives support groups made videos in collaboration with women's video groups, documenting their involvement in the strike. Organizations such as Women's Aid, which runs refuges for battered women, use their own videos for training and fund-raising. Women's health groups use video for health education and Black women's groups for exploring Black women's experience.

If making feminist films and videos is important, they can only be effective if they are widely distributed. Distribution is an important aspect of feminist media practice. Two organizations, COW (Cinema of Women) and Circles, were particularly important in promoting the development of a feminist film and video culture in Britain. COW's statement on 'Why a Feminist Distribution?', presented at the First National Feminist Film and Video Conference in 1983, summarizes some of the most important issues:

(a) We need to control our own culture. If we don't, films and videos made by women can be co-opted by men. For example, *Not a Love Story* (a film about pornography which includes pornography) was distributed by a non-feminist distribution agency and shown in porn cinemas for men;

(b) Feminist film and video needs to be named as such from within the Women's Movement not by the distribution establishment. For example, *Girl Friends* was presented and advertised as 'feminist' simply because it was about a woman despite the fact that it was anti-lesbian and negative about women;

(c) We can use money which comes from more 'popular' feminist films and videos to subsidise other feminist films and videos which do not have such a wide audience and also prevent this money being used to support sexist and pornographical work;

(d) We can help encourage the exchange of feminist film and video ideas within Britain and with other countries;

(e) We can try to get feminist film and video onto mainstream television and cinema.

The key issue here is control of cultural production. This control enables women to claim the power to define meanings. Yet equally important are the resources to disseminate them. The development of feminist distribution agencies has played an important support role for women in a wide range of areas. Their resources are used not only by independent cinemas and regional film theatres but by educational institutions, trade unions, women's groups and community groups.

The Double Burden of Sexism and Racism

Representation of desirable femininity is a doubly complex issue for Black women. In both High and 'popular' culture, the sexist representation of Black women is compounded by racist stereotypes. They include the mammy (immortalized, for example, in the film *Gone with the Wind*), the dominant maternal figure of American television comedy, and the exotic or voraciously sexual Black woman of fashion magazines and pornography.

Plate 6.4 What Are You Looking At?, Lesley Sanderson.
Reproduced by kind permission of the artist.

Black women have criticized existing culture both for its White supremacist and sexist dimensions, producing directly political paintings. An example of this is Tam Joseph's 'Native Woman with a Fetish'. This painting shows a Black woman lying down, reading *Elle* under an image of the Pope. The magazine in question is one which features predominantly White women and White ideals of beauty. 'Native Woman with a Fetish' points to the power not only of the images of femininity marketed by White women's magazines. It highlights the role of White patriarchal religion in the cultural construction of femininity.

In addition to critiquing the White supremacist and sexist nature of most images offered to Black women by popular culture, Artists of Colour have produced new images of Black women which challenge male-defined representations. Plate 6.4, for example, *What Are You Looking At?* by Lesley Sanderson, takes a major subject of the 'High Art' tradition, the female nude, and challenges conventional representations both through its choice of subject matter and mode of representation. The women in question do not conform to conventional norms of beauty, nor do they appear as passive objects for male consumption. They confront the viewer as active subjects in their own right. The semi-nakedness of the woman facing the camera does not define her as a 'sex object'. It becomes part of her individual identity celebrating a non-White female body which is different from conventional norms of beauty.

The Question of Female Aesthetics

In feminist cultural politics, the construction of new images and alternative female traditions – whether Black or White – are seen not only as a necessary balance to cultural canons which are biased towards male authors/artists and male views of the world, but as fundamental to identifying possible female aesthetics.

The idea that women might have intrinsically different modes of expression is particularly important in woman-centred feminism. Interest has focused on three related questions:

1 Do women *naturally* have languages and modes of expression that are different from men?
2 Do women use different modes of representation for social and historical reasons?
3 How can women use existing language to resist patriarchal forms of subjectivity?

In addressing these questions, writers and artists fall into two main

groups: (a) those concerned with history and social change, and (b) those concerned with essentially female modes of expression.

The first group tends to concentrate on historically specific forms of writing and visual representation by women and the constructions of femininity that go with them. In producing new representations, they work with existing language and forms while attempting to subvert them. They see differences in women's and men's language as historically produced.

The second group seeks to identify essentially feminine modes of representation. They assume the existence of a naturally different female or feminine language. This language is often rooted in female biology or libido, and it is thought to enable women to articulate their true identity. In psychoanalytic feminist writing, for example, attempts have been made to ground a female language in a different female libido. In the work of the influential French psychoanalytic theorist, Luce Irigaray, female sexuality and a female unconscious, defined outside the parameters of patriarchal society, is seen as the basis for authentic female language and expression.[14] In the work of French cultural theorist Hélène Cixous feminine writing – *écriture féminine* – offers a challenge to the patriarchal symbolic order.[15]

Many Black feminist critics are also concerned with the question of female aesthetics. Their approach is predominantly historical. They look to the history of Black women since slavery and the influence of transplanted and partially transformed West African cultural forms in their work. Here difference – positively valued and historically produced – is central. Yet the specificity of Black female culture can also be seen in essentialist ways. This happens in some Afrocentric Black feminist criticism which sees Black culture as determined by a given African cosmology. For Afrocentric feminists, it is this African cosmology that makes a work 'Black'. For example, writing in the Braxton and MacLaughlin volume *Wild Women in the Whirlwind*, Gloria I. Joseph argues that the nineteenth-century Black feminist and abolitionist Sojourner Truth is best understood within the framework of African cosmology and epistemology. This:

> provides a deeper understanding of her activism, her thinking, and the legacy she left for Black feminists. In addition to her life setting forth the parameters of activism exercised by Black women today, her radical ideas remain a part of Black people's collective consciousness. Her words and deeds were wholly consistent with an Afrocentric perspective that African-American women activists assert in these times, distinguishing themselves as *Black* feminists. (Braxton and McLaughlin, 1990, pp. 38–9)

Similarly, in reading Toni Morrison's *Sula*, Vashti Crutcher Lewis claims that Morrison writes from 'an African point of view – an African aes-

thetic'. Lewis suggests that the characters 'Sula and Shadrack represent Black sons and daughters of America who would be more at home in Africa. In traditional African cultures, they would be neither pariahs nor mysteries, since both represent tradition and a profound rootedness in African cosmology' (Braxton and McLaughlin, 1990, p. 317). This appeal to an Afrocentric conception of 'African cosmology' tends to deny both historical and cultural difference. It suggests an understanding of Black women's culture and of Black feminism which threatens to reduce its historical and cultural diversity to a single ahistorical source.

Femininity and the Politics of Subjectivity

At the heart of feminism is the question of how women understand and live their femininity. This is, for example, the central concern of consciousness-raising which seeks, above all, to understand the internalization of oppressive modes of femininity. There are two main approaches to subjectivity: those that posit an essential, 'true' femaleness and those that see feminine identity as always socially constructed.

Discovering True Womanhood

An important response to the patriarchal colonization of women's subjectivity has been a search for authentic forms of femininity. This can be found in humanist Marxist feminism which uses the concept of alienation to describe women's relation to their true selves under patriarchy.[16] It is more fully realized, however, in cultural politics influenced by radical feminism.

In celebrating women's difference from men, radical feminist cultural production tends to fix certain culturally specific qualities as naturally female, locating their origins in biological difference. The American radical feminist writer, Susan Griffin, for example, celebrates woman's affinity with nature, her 'wildness', arguing that women have been treated by men in ways similar to male exploitation of the natural world – subordinated, ravaged, deformed. Griffin's writing rejects rationalist modes of language. It creates a pastiche of different ways of writing which questions authoritative patriarchal discourse:

We heard of this woman who was out of control. We heard that she was led by her feelings. That her emotions were violent. That she was impetuous. That she violated tradition and overrode convention. That certainly her life should not be an example to us. (The life of the plankton, she read in this book on the life of the earth,

depends on the turbulence of the sea) *We were told that she moved too hastily. Placed her life in the stream of ideas just born. For instance, had a child out of wedlock, we were told. For instance, refused to be married. For instance, walked the streets alone, where ladies never did, and we should have little regard for her, even despite the brilliance of her words.* (She read that the plankton are slightly denser than water) *For she had no respect for boundaries, we were told. And when her father threatened her mother, she placed her body between them.* (That because of this greater heaviness, the plankton sink into deeper waters) *And she went where she should not have gone, even into her sister's marriage.* (And that these deeper waters provide new sources of nourishment) *That she moved from passion. From unconscious feeling, allowing deep and troubled emotions to control her soul.* (But if the plankton sinks deeper, as it would in calm waters, she read) *But we say that to her passion she brought lucidity* (it sinks out of the light, and it is only the turbulence of the sea, she read) *and to her vision, she gave the substance of her life* (which throws the plankton back to the light). *For the way her words illuminated her life we say we have great regard. We say we have listened to her voice asking, 'Of what materials can that heart be composed which can melt when insulted and instead of revolting at injustice, kiss the rod?'* (And she understood that without light, the plankton cannot live and from the pages of this book she also read that the animal life of the oceans, and hence our life, depend on the plankton and thus the turbulence of the sea for survival.) *By her words we are brought to our own lives, and are overwhelmed by our feelings which we had held beneath the surface for so long. And from what is dark and deep within us, we say, tyranny revolts us; we will not kiss the rod.* (Griffin, 1984, pp. 182–3)

Other radical feminists look to lesbian sexuality for women's essential nature, arguing that women are naturally homoerotic. They argue that heterosexuality is a powerful patriarchal institution which harnesses women's sexuality to male pleasure and prevents women from realizing either their own true selves or their sexual potential.[17]

In fictional texts, the visual arts and criticism, radical feminist ideas encourage writers, artists and critics to explore female sexuality, motherhood and lesbian identity. Such works often search for a biologically grounded essence of femaleness and a female language and aesthetics. Recent feminist art, film-making and fiction explore these ideas by concentrating on images connected with female biology, for example, female genital organs, menstruation and the process of pregnancy and childbirth.[18]

Radical feminist ideas tend to be founded on absolute differences. They reverse the patriarchal tendency to value the male above the female and celebrate a womanhood which is defined as nurturing, emotional, maternal, homoerotic and anti-rational. The masculine–feminine opposition is often seen as exclusive in the sense that the qualities ascribed to one side of the opposition are thought to be absent from the other. Natural differences from men are seen as the basis of woman's cultural production

which, once freed from the constraints of patriarchy, can give expression to the true femininity which patriarchal social relations repress.

The tendency to locate alternative female identities in sexuality and motherhood has failed to engage many women. Few women want to see themselves in terms of their natural bodily functions. These are, after all, precisely the area to which patriarchal thinking has long sought to restrict women. Another problem with feminist cultural politics that concentrate on finding true forms of femininity is that they fail to address most women's emotional investment in existing patriarchal forms of subjectivity.[19]

Postmodern Femininity

The other major site of feminist engagement with the question of femininity and subjectivity is postmodernism. In contrast to radical feminism, postmodern feminisms reject all versions of essential femininity or masculinity. Postmodern theory suggests that there is no singular, true femininity which women should attempt to reclaim. It highlights the ways in which subjectivity is fractured, contradictory and produced within social practices. Not only is subjectivity a site of conflicting ways of being and feeling, there is no one true reality to which women can have access in order to guarantee feminist politics. 'Reality' is only ever accessible in competing versions.

As early as the 1970s poststructuralist approaches to femininity and subjectivity came under attack. In Britain, the journal *M/F* aroused hostility among feminists for what was seen as its anti-humanist dissolution of the concept 'woman'.[20] How, it was asked, could women organize together and develop new positive identities if there were no essence of womanhood on the basis of which women could come together in the spirit of sisterhood. Since the 1970s, the concerns underlying this question have surfaced in new but related ways. For example, in claims that universal ideas of shared oppression and emancipation are fundamental to feminism.

Many feminist critics of postmodern theory claim that the Enlightenment discourse of emancipation is essential to feminism. They argue that postmodernism 'expresses the claims and needs' of White, privileged Western men who have had their Enlightenment and can afford to be critical (Di Stefano, in Nicholson, 1990, p. 86). In the volume of essays edited by Linda Nicholson, *Feminism/Postmodernism*, Nancy Hartsock argues that:

Somehow it seems highly suspicious that it is at the precise moment when so many groups have been engaged in 'nationalisms' which involve

redefinitions of the marginalized Others that suspicions emerge about the
nature of the 'subject' about the possibilities for a general theory which can
describe the world, about historical 'progress'. Why is it that just at the
moment when so many of us who have been silenced begin to demand the
right to name ourselves, to act as subjects rather than objects of history, that
just then the concept of subjecthood becomes problematic? Just when we are
forming our own theories about the world, uncertainty emerges about
whether the world can be theorized. Just when we are talking about the
changes we want, ideas of progress and the possibility of systematically
and rationally organizing human society become dubious and suspect?
(Hartsock, 1990, p. 164)

These objections to postmodernist theory are shared by many feminists
committed to identity politics. They raise a fundamental question in
poststructuralism about the relationship between a deconstructive ap-
proach to subjectivity and the question of agency.

 While some versions of poststructuralism show no interest in the ques-
tion of lived subjectivity or agency, this is not the case in feminist ap-
proriations of Foucauldian and Derridean theory. Here agency is seen as
discursively produced in the social interactions between culturally pro-
duced, contradictory subjects. It is not necessarily a question of rejecting
identity politics altogether. We need to recognize the nature and limita-
tions of the essentialist foundations of many forms of identity politics,
seeing identity as necessary but always contingent and strategic. More-
over, a particular identity is rarely the central issue in cultural struggle.
People most often come together on specific issues to resist and transform
practices which they find oppressive. This may well involve the rejection
of dominant definitions of women's nature and modes of femininity,
however, it rarely relies on the endorsement of any one alternative.

 To question the Western Enlightenment category of the Subject is not
necessarily to undermine the possibility of subjecthood. Poststructuralist
theories of subjectivity suggest that it is socially constructed and contra-
dictory rather than essential and unified. In an argument analogous to
that about subjectivity, feminist critics of postmodernism often assume
that to question general theories (metanarratives) is to undermine the
possibility of knowledge. Yet, rather than dispensing with knowledge
altogether, poststructuralism suggests that both subjects and knowledges
are provisional and differentiated according to the social and discursive
location of the 'knowing' subject.

 Postmodern feminists would ask of Enlightenment narratives of eman-
cipation: 'the emancipation of whom and from what?' They would insist
on consciously limited and located narratives and struggles. As Gayatri
Spivak has argued, 'we cannot but narrate' but 'when a narrative is con-
structed, something is left out. When an end is defined, other ends are
rejected, and one might not know what those ends are' (1990, pp. 18–9).

Thus, the invoking of Western feminist theories, for example, emancipatory liberal feminism or Marxist feminism, as general theories of historical progress often leads to a denial of Black and 'Third World' women's interests.

Postmodern feminists argue that to reject all essences and relativize claims to truth is to create a space for political perspectives and interests that have hitherto been marginalized. Speaking from the perspective of a radical Black feminist critic, bell hooks suggests that while the poststructuralist critique of subjectivity causes problems for Black identity politics, it can also be liberating and enabling:

> Criticisms of directions in postmodern thinking should not obscure insights it may offer that open up our understanding of African-American experience. The critique of essentialism encouraged by postmodern thought is useful for African-Americans concerned with reformulating outmoded notions of identity. We have too long had imposed upon us from both the outside and the inside a narrow constricting notion of blackness. Postmodern critiques of essentialism which challenge notions of universality and static overdetermined identity within mass culture and mass consciousness can open up new possibilities for the construction of self and the assertion of agency. (hooks, 1991, p. 28)

However, bell hooks is ever mindful of the ways in which the postmodern intellectual concern with difference may become a substitute for a committed practical politics (ibid., pp. 23–31). She argues that 'postmodern theory that is not seeking simply to appropriate the experience of "Otherness" to enhance the discourse or to be radically chic should not separate the "politics of difference" from the politics of racism' (p. 26). Difference in patriarchal, racist, capitalist societies always involves oppressive power relations.

Racism, Feminism and Cultural Politics

Bus Stop
Waiting at the bus stop,
Good day,
Work,
Play,
Bus come,
Not mine.

What's that land pon my face,
Warm,

Wet,
Gooey,
Ahhh,
them spit at me.

Blood rise,
Blood boil,
From toe to heel,
through calf and thigh,
through belly,
through heart,
Arms and brain,
Blood burning red,
Anger flow,
Ah who spit at me so!!!

Bus move
And gone,
Look up,
Shiny glass,
No face to see,
Who hate me?
who humiliate me?

All alone,
Anger have no place to go,
Turn to tears,
and spill, and flow.
— Carmen Tunde, *Black Womantalk*
Poetry, 1987, pp. 18–19

Racism is part of the everyday experience of Black women – of all women of Colour. Most White feminists, despite ideas of sisterhood, have failed to confront the reality of racism and its role either within the women's movement or the wider society. This has long been clear to Black women, both feminists and non-feminists. Writing in 1977, American critic Barbara Smith pointed out that 'Black women's existence, experience, and culture and the brutally complex systems of oppression which shape these are in the "real world" of White and/or male consciousness beneath consideration, invisible, unknown' (Smith, 1977; quoted in Showalter, 1986, p. 168). Many Black feminists have questioned the idea of 'sisterhood'. Audre Lorde, for example, wrote that 'By and large within the women's movement today, white women focus upon their oppression as women and ignore differences of race, sexual preference, class and age. There is a pretense to a homogeneity of experience covered by the word *sisterhood* that does not in fact exist' (Lorde, 1984, p. 116).

Reflecting on the absence of a Black feminism in 1977, Barbara Smith argued that there was:

> no political movement to give power or support to those who want to examine Black women's experience through studying our history, literature and culture. There is no political presence that demands a minimal level of consciousness and respect from those who write and talk about our lives. Finally there is not a developed body of Black feminist political theory whose assumptions could be used in the study of Black women's art. (Quoted in Showalter, 1986, p. 170)

Since 1977, the situation has changed dramatically. Black feminists have produced a wide-ranging body of theoretical and critical writing and have begun to reconstruct Black women's social and cultural history.

Challenging White Feminism

For most Black women and women of Colour, race remains the primary form of oppression, compounded by class and gender. While the issues which the White women's movement has taken up are relevant to Black women and other women of Colour, their interest in these issues is often different. Campaigns in the 1970s and 1980s about the rights to free abortion and contraception, for example, failed to take account of the different treatment often given to women of Colour. For Black women the right to choose often meant the right not to have abortions, injections of Depo-Provera or sterilization.

In the feminist cultural politics of the 1970s and 1980s, the absence of Black women from the rewritings of history and artistic and literary traditions confirmed Black feminists' suspicions of White racism. White feminist work on women's culture took little account of Black women's work. Black feminists played little part in redefining canons. At best they found themselves offered a token space in White-controlled anthologies. In consequence, Black women's relationship to a predominantly White and middle-class political movement has been at best problematic.

The anger that the White women's movement provokes in Black women interested in feminism was powerfully expressed in bell hooks' book *Ain't I a Woman: Black Women and Feminism*, first published in the USA in 1982. *Ain't I a Woman* offers a history of the interrelation of racism and sexism in the USA since slavery and a polemical attack on the racist practice of White feminists both in the nineteenth century and the present. bell hooks points to the exclusion of Black women from most White feminist scholarship, a tendency clearly visible in the analogies that White feminists draw between women and Blacks, and to the inadequacies of analyses that insist on separating racism and sexism.

The Question of Positive Identity

Ain't I a Woman touches on many of the issues central to Black feminism. Of key importance is the question of positive identity. bell hooks argues that Black women have always been defined negatively in relation to White women and Black men. They have been offered few, if any, positive forms of identity within American culture. Negative images which emerged under slavery, such as the image of Black women as sexually promiscuous and complicit in White male sexual assault, persist into the present. bell hooks argues that, in both slave and post-slave society, acceptable definitions of femininity and women's role drew and continue to draw on White middle-class norms of beauty, life-style and family organization, from which White society did its best to exclude Black women.

> During the years of Black Reconstruction, 1867–77, black women struggled to change negative images of black women perpetuated by whites. Trying to dispel the myth that all black women were sexually loose, they emulated the conduct and mannerisms of white women. But as manumitted black women and men struggled to change stereotypical images of black female sexuality, white society resisted. Everywhere black women went, on public streets, in shops or at their places of work, they were accosted and subject to obscene comments and even physical abuse at the hands of white men and women. (hooks, 1986, p. 55)

Furthermore, bell hooks argues, Black women were blamed for the state of the Black family and the feelings of inferiority of Black men. Long-established and widely accepted emasculation theories claimed that Black women trangress female roles and 'normal' forms of femininity by acting as bread-winners or as matriarchs within the family. Such theories are still used to explain the social position and behaviour of Black men and to blame Black women, rather than racist social structures and practices, for Black men's disadvantage. Positive images, bell hooks argues, have been limited to those of 'long suffering, religious, maternal figures' (p. 66).

Although parallels are often drawn between racism and sexism, the two are, we would argue, far from analogous. Most women can find some images and modes of femininity with which to identify. These may empower or they may perpetuate patriarchal relationships. Where they empower women at the expense of patriarchy, they offer active and positive forms of identity, valued at the very least by other feminists. Where they perpetuate patriarchal relations they will be positively valued by large sections of society. Nor is it clear that all the so-called 'feminine' qualities that patriarchal societies ascribe to women are bad in themselves. Even the contradictory subjectivity of feminist women will include patriarchal elements which are at once comforting and disturbing.

In contrast with patriarchy, racism does not offer its subjects positive forms of identity. As we argue in detail in Part IV, the forms of subjectivity that racism attributes to Black people and other people of Colour are defined in a negative relation of difference from being White. It is much less easy for Black people to have a contradictory relationship of partial accommodation to racist definitions of Black subjectivity.

How then does Black feminism go about offering alternatives to this long history of negative images of Black women? As we indicated earlier in this chapter, a key focus of Black feminist scholarship is the rewriting of what it means to be a Black woman through a recovery of history and culture. The last 20 years have seen the creation of a rich alternative to the negative history that bell hooks describes. Black feminists have produced a distinctive body of theoretical, critical and historical writing. They have begun to recover the work of lost writers and artists, to give voice to contemporary experience and to challenge the assumptions of White feminism. The major part of this critical work has been produced in the USA, where there is now a solid body of material in a wide range of disciplines written from Black feminist perspectives.

What Makes Feminism Black?

The question of what distinguishes Black feminism from other feminisms has been raised by Black women anxious to mark out a separate space for their work. Most feminists would subscribe to the idea that Black feminism must be produced by Black women, drawing on their own experience in racist societies. For some Black feminists it also implies adherence to an Afrocentric point of view.

Afrocentric Black feminism is part of a wider Afrocentric movement in Black cultural politics. In part, Black feminists have appropriated Afrocentrism in answer to a political need to produce positive alternatives to the ways in which Black women have been and are portrayed in mainstream American culture. Their work is concerned with documenting and analysing Black female experience understood in the context of an Afrocentric Black tradition.

Afrocentric approaches look for particular things within Black women's culture which unify it within an identifiable tradition. In her book *Black Feminist Thought* (1990), Patricia Hill Collins defines 'Afrocentrism' as a tradition that is rooted in an African-American culture that has retained many features of its African origins and has given rise to a shared world view:

> Every culture has a worldview that it uses to order and evaluate its own experiences (Sobel 1979). For African-Americans this worldview originates

in the Afrocentric ideas of classical African civilizations, ideas sustained by cultures and institutions of diverse West African ethnic groups (Diop 1974). By retaining significant elements of West African culture, communities of enslaved Africans offered their members alternative explanations for slavery than those advanced by slaveowners (Herskovits 1941; Gutman 1976; Webber 1978; Sobel 1979). Confining African-Americans to all-black areas in the rural South and the northern urban ghettos fostered the con-tinuation of certain dimensions of this Afrocentric worldview (Smitherman 1977; Sobel 1979; Sudarkasa 1981b; Asante 1987). While essential to the survival of African-Americans, the knowledge produced in Black com-munities was hidden from and suppressed by the dominant group and thus remined extant but subjugated. (p. 10)

Hill Collins argues that Black women have played a central role in retain-ing and transforming this Afrocentric world view:

Within African-American extended families and communities, Black women fashioned an independent standpoint about the meaning of Black womanhood. These self-definitions enabled Black women to use African-derived conceptions of self and community to resist negative evaluations of Black womanhood advanced by dominant groups. In all, Black women's grounding in traditional African-American culture fostered the develop-ment of a distinctive Afrocentric women's culture. (pp. 10–11)

This distinctive Afrocentric women's culture is seen as the basis for Black feminist cultural criticism.

To make a particular version of Afrocentric Black women's culture and identity the basis of Black feminism can be both empowering and restric-tive. It provides a positive sense of tradition, history and identity, but in doing so may not speak to all Black women. Black women's experience can never be one thing, although the social relations of racist and sexist societies will give it certain shared aspects.

Patricia Hill Collins advocates a meshing of theory and lived experience which can acknowledge and respect differences without fixing them out-side history or contemporary social relations. It allows for the construc-tion of Black women's cultural histories in ways that do not fix and essentialize the meanings of Black femininity. Unproblematized appeals to Black women's experience can be dangerous when they do not pay due attention to differences between Black women. Accounts of experience need always to be historically and socially specific and to acknowledge that experience has no one singular meaning.

British Black Feminisms

Black feminism is recovering Black women's culture and experience in racist societies and asking: what are its defining features? In Britain, in

particular, where 'Black' is sometimes used to include women of Asian as well as African descent, a recurrent question on the cultural political agenda is whether it is indeed possible to speak of Black womanhood as if it were one thing? If its meanings are historical and cultural, what are the implications of this for cultural politics?

In Britain the history and experience of Afro-Caribbean and Asian women has been rather different from the USA. If slavery and its aftermath are central to African-American feminist writing, in Britain the impact of colonialism and migration have been perhaps more important. British Black feminist writing first made an impact in the early 1980s with the publication of essays in *Feminist Review*, *The Empire Strikes Back* and the anthology *No Turning Back*.[21]

1985 saw the publication of a book about Black women's lives in Britain since the war, *The Heart of the Race*, by Beverley Bryan, Stella Dadzie and Suzanne Scafe. This book adopts a style of writing in which the narrators use 'we' as if speaking on behalf of all Black women and invoke numerous Black women's voices. The descriptions by Black women of their experience are not attributed to named individuals and the overall effect of this strategy is to create a unified Black women's voice. *The Heart of the Race* ties its accounts of contemporary Black women's experience, understood from a broadly Marxist perspective, to an Afrocentric perspective, creating a history that links Black women in Britain today with an African heritage stretching back through slavery to Ancient Egypt. In writing this history, the use of 'we' creates a sense of unity that tends to mask cultural and historical difference. The effect is to create a positive history that stresses Black achievement and resistance to racism and imperialism.

The Heart of the Race locates traditions of Black female resistance in history and myth and constructs a brief history of organized resistance in Britain since the Second World War. The authors argue that this began with the self-help, church and welfare groups which developed in the 1950s and 1960s. The 1970s saw the effects in Britain of the civil rights movement and the rise of Black Power in the USA in the late 1960s. It inspired Black political organizations such as the United Coloured People's Association, the Marxist Black Unity and Freedom Party and the nationalist Black Power Movement. They argue further that the sexism of these organizations gave rise to Black women's groups, for example, the Brixton Black Women's Group and the Organisation of Women of Asian and African Descent (OWAAD) which was active from 1978 until 1983.

The Heart of the Race stresses the importance of culture in shaping and determining identity. Like much American Black feminist writing, it points to the African origins of Black culture found throughout the diaspora, and to the importance of Black women in transmitting this culture. It argues that hegemonic British culture negates non-European cultures in general, and Black culture in particular, and is critical of liberal attempts

to improve this situation. For example, it argues that the coverage of Black issues on TV tends to trivialize them and fails to address racism. Black people, the authors argue, need to control the media in order to produce real alternatives such as community-based Black radio or film and video.

Since the publication of *The Heart of the Race* Black British feminism has been most visible in journal articles, for example, in *Feminist Review*, and in the long-established and recently defunct monthly feminist magazine, *Spare Rib*. *Spare Rib* developed in the course of 20 years from a virtually all-White, feminist monthly into a magazine that focused mainly on Black, Asian and 'Third World' women. It carried articles on contemporary political issues, culture, and the traditional areas covered by the women's movement such as sexuality and women's health. It estimated a readership of some 90,000. In its later years, its primary focus was the lives, culture and political issues facing Black, Asian, 'Third World' and lesbian women.

Black or Anti-racist Feminism?

In Britain there is an on-going debate about whether Afro-Caribbean and Asian women need Black or anti-racist feminism or both. It is a debate which raises many of the same issues that feature in the current discussion of 'Black art' in Britain.[22] Black feminism implies a politics that challenges the effects of racism on Black women, affirms Blackness and reconstructs Black history and culture. Anti-racist feminism questions the meanings and social practices through which racist social relations are constituted and reproduced. Anti-racism requires a deconstruction and transformation of the hegemonic meanings of being of Colour or White and a struggle to transform racist social relations.

Gemma Tang Nain discusses many of these issues in an article in *Feminist Review* (Tang Nain, 1991). She raises the question of whether 'Black' should be understood as a skin colour or as a political category that implies particular understandings of race and forms of identity which all women of Colour can share. In practical political organization, Black has most often signified women of African decent. Attempts in Britain to unite Afro-Caribbean and Asian women under the heading 'Black' have been fraught with difficulties because many Black and Asian women identify 'Black' with African descent and because the situation and problems faced by Afro-Caribbean and Asian women in Britain are often different. Gemma Tang Nain suggests that being Black does not necessarily imply particular forms of identity. She endorses Pratibha Parmar's view that 'Racial identity, alone, cannot be a basis for

collective organising, as black communities are as beset with divisions around culture, sexuality and class as any other community' (Parmar, 1989, p. 59).

Gemma Tang Nain suggests that Black feminism helped to counter the alienation that Black women felt in both the male-dominated Black movement and the White-dominated women's movement. It also exposed the racism within the women's movement and raised the profile of racism as a feminist issue. She argues that 'black feminists . . . now need to decide whether they want to retain this narrow focus, i.e., catering specifically for black women, or whether they want to broaden their constituency' (p. 16).

These questions are in some ways analogous to the questions of feminism's relation to men which we discussed in the section on men and masculinity. The choice to work to empower women most often demands a separate space. Black feminism, too, in empowering Black women needs its own space. This is not to deny the importance of challenging sexism in men or racism in Whites. Both Black and anti-racist feminisms have important, if different, roles to play. A broader anti-racist feminism, as espoused, for example, by bell hooks, among others, is certainly a real political necessity.[23] Gemma Tang Nain calls for such an 'anti-racist/ socialist feminism', open to all women, but in which Black women would play a leading role. She stresses the need at a practical level, for different organizations – 'feminist, black/antiracist and socialist – to retain their autonomy, while ensuring mutual collaboration and co-operation' (p. 18).

'Third World' Feminism

'Third World' feminism brings together women from the so-called 'Third World' and minority peoples and peoples of Colour living in 'First World' countries. It has a dual focus: deconstructing the Eurocentrism of much writing about women in the 'Third World' and giving adequate representation to the concerns of 'Third World' women. For many writers, for example the contributors to the volume *Third World Women and the Politics of Feminism* (Mohanty et al., 1991), it is a political category. Chandra Talpade Mohanty writes in her introduction to the volume:

> Just as it is difficult to speak of a single entity called 'Western feminism', it is difficult to generalize about 'third world feminisms' . . . I want to recognize and analytically explore the links among the histories and struggles of third world women against racism, sexism, colonialism, imperialism and monopoly capital. I am suggesting, then, an 'imagined community' of third world oppositional struggles. 'Imagined' not because it is not 'real' but because it suggests political alliances and collaborations across divisive boundaries, and 'community' because in spite of internal hierarchies within

third world contexts, it nevertheless suggests a significant, deep commit-
ment to what Benedict Anderson, in referring to the idea of nation, calls
'horizontal comradeship'. (p. 4)

For Mohanty, 'Third World' women's writing on feminism is marked by
'the grounding of feminist politics in the histories of racism and imperial-
ism', a recognition of the role of the state, 'the significance of memory and
writing in the creation of oppositional agency' and a recognition of 'the
difference, conflicts and contradictions internal to third world women's
organizations and communities' (p. 10).

In a critique of feminist scholarship and colonial discourses, Mohanty
demonstrates how much White Western feminist writing about 'Third
World' women depicts them as a singular category defined by their
victim status. 'Colonialism', she argues, 'almost invariably implies a rela-
tion of structural domination, and a suppression – often violent – of the
heterogeneity of the subject(s) in question' (p. 51). In Western feminist
writing, this effect is achieved by the implicit assumption that White
Western feminism is 'the yardstick by which to encode and represent
cultural others' (p. 55).

The production of the 'Third World' woman as a subject, who is a victim
by virtue of her sex, suppresses differences, denies historical specificity
and renders the operations of power, both negative and positive, and the
potential for resistance invisible. Mohanty argues against starting with a
pre-given category, 'third world women'. What it means to be a woman
living in the 'Third world' depends on specific and localized class, gender
and ethnic relations. These do not constitute women merely as victims. A
feminism that refuses colonial modes of thinking must do justice to
women as acting subjects.

The Way Forward

Since the late 1960s feminism has given rise to a wide range of cultural
politics. They have been most marked in education, criticism, fiction,
drama, film-making and fine arts. The 1970s and 1980s saw an explosion
of feminist art, theatre groups, film- and video-making and writing. In
education, Women's Studies is gaining an increased institutional basis and
feminist perspectives are shifting the profile of traditional disciplines.

The role of women as consumers of education and culture has been
crucial to the growth of feminist educational and cultural practice. Pub-
lishers have recognized that women, who form a crucial segment of the
book-buying public, will often choose to buy books by other women.
While this has long been the case in the area of popular fiction, it is now
also recognized where feminist books are concerned. Moreover Women's

Studies has a large actual and potential audience. This has affected both institutions of higher education and publishing. More courses are being introduced to meet student demand and publishers have begun to produce a wealth of material, including reprints of texts long since lost from view.[24] This has enabled the development of accessible alternative women's traditions and played a role in expanding the boundaries of the male-dominated mainstream. Similarly theatre, cinema and television managers have realized that there are audiences for feminist drama and film and women are playing an increasing role in programming cultural events.

Theory is an integral part of feminist cultural politics. It helps to define perspectives and political objectives. Since the late 1960s a wealth of feminist theories have offered new ways of understanding women's position, subjectivity and possible strategies for change. In recent years feminist theory and cultural politics have been profoundly affected by questions of difference. These have been raised by women who do not identify their interests with those represented by hegemonic forms of Western liberal, radical and Marxist feminisms.

Critiques of heterosexism, and above all of the implicit and at times explicit racism and colonialism of much Western feminism, have produced a much broader and more differentiated field of feminist theory and cultural politics. It calls upon different groups of women to recognize both their own interests and those of other women, and to pursue what Adrienne Rich calls a *politics of location* rather than to claim to speak in the interests of all women.[25] Politics of location imply attention to where one is speaking from and a consciousness of the exclusions that one's politics perpetrate.

For a long time the politics of White feminists excluded the interests of Black and 'Third World' women. Racism and colonialism are now firmly on the feminist agenda, though White women's practice still has a long way to go. For the most part, the power to have one's voice heard and to change the practices of the cultural institutions, including funding bodies, still rests with men and to a lesser extent with White women, but the struggle to change this is on-going. Until there are radical changes in the priorities of funding bodies, however, the production and distribution of alternative forms of culture will remain an upward struggle.

Outside mainstream cultural institutions women continue to produce work, often against the odds. For example, 1987 saw the publication of *Black Woman Talk Poetry*. This is the first publication of the first Black women's publishing press in Britain:

> Black Womantalk was set up in 1983 by a group of unemployed Black women of African and Asian descent who felt strongly about creating the space and the means for our voices to be heard. (Da Choong et al., 1987, p. 7)

Setting up a press offered Black women control over the entire publishing process but it faced daunting economic problems. Exhausted by the prolonged search for funding, the group eventually decided to concentrate on publishing their first book without paid workers and using donated money.

In *Black Woman Talk Poetry*, the collective describe the demands made on them to appear at all sorts of cultural events: 'the First Feminist Book Fair, conferences, arts festivals, workshops'. They were also asked to write about their work. While this points to a widespread interest in autonomous Black feminist publishing, like all alternative ventures, it cannot flourish without funding. As we suggested in chapter 5, gaining funding is a difficult and time-consuming process. Moreover, it often means negotiating between the objectives of alternative autonomous cultural production and the demands of mainstream cultural institutions. Feminists are beginning to make inroads into the centres of cultural political power, where resources are allocated, but this is an area that needs more concentrated action if feminist culture, particularly the work of women of Colour, is to reach its potential audience.

7

Alternative Subjectivities: White Feminist Fiction

Jill Miller has never been one for books. She stopped reading them when, as an awkward child, she was made to look foolish by a teacher because she stumbled over some classic lines from Treasure Island. *For about twenty years she never opened a book, 'I read only the* Daily Mirror *and comic strips.' Then a friend gave her a copy of* The Women's Room *by Marilyn French. She is now a confident and persuasive feminist and, remarkably, an author herself. Her first novel,* Happy as a Dead Cat, *was published last week.*

— Aidan White, *Guardian*, 23 January 1983

The years since the late 1960s have seen a major expansion in the publishing of books by and about women. Small companies specializing in women's writing have flourished, most academic publishers have developed extensive Women's Studies lists, and a number of feminist books – both fiction and non-fiction – have become best-sellers. In Britain feminist fiction has been pioneered by small presses with explicitly feminist orientations: the Women's Press, Sheba, the Onlywoman Press, Virago and Black Womantalk.[1] Their publications have found outlets in women's bookshops in larger towns and cities and in women's sections in mainstream bookshops. This new market, which publishers have been keen to supply and develop, was a direct effect of the revival of the women's movement after 1968. As our examples in the previous chapter show, the women's movement inspired a feminist cultural and intellectual climate that encouraged both feminist art, cinema and literature and the growth of Women's Studies.

Fiction as Consciousness-raising

From the late 1960s onwards, fiction played an important role in changing women's consciousness both of themselves and of their place in the world. Reading groups became a feature of the women's movement and in Women's Studies much pioneering work was done in literary criticism. Since the late 1960s, feminist novels, drama and poetry have offered readers new ways of understanding women's lives. Feminist fiction has looked at women's place in society, heterosexuality and lesbianism, racism and ethnicity. Writers have attempted to imagine and depict new ways of living. Black and Asian women's writing has raised the profile of Black women's lives, challenging both White women and men to take racism seriously.

Why should fiction be so important?

It is not surprising that fiction has played so central a role in sexual politics. Telling and reading stories are key ways in which we make sense of our lives. Through them we imagine modes of living different from our own, explore emotions and begin to develop new forms of identity. Fiction is an important source of ways of understanding society. It is also a repository of social values.

Narrative – the telling of stories – is central to everyday communication between individuals. In narrating our experiences, we attribute meaning to them and in the process assume the position of knowing, apparently sovereign subjects. We become subjects both by speaking and by being addressed. Yet the discursive construction of subjectivity most often remains invisible. Similar processes are at work in fictional narratives. In realist narratives, for example, the narrator is positioned as knowing subject, able to communicate her interpretation of social life. We learn the conventions of narrative from an early age from the stories that we hear, read and watch. These conventions govern not only the structures of story-telling but our expectations about appropriate characterization and narrative resolutions.

To narrate is to assume the position of a speaking subject. It involves the exclusion or marginalization of other possible subject positions and other meanings. Whereas much fictional narrative speaks as if it were addressing the individual, the values that it represents position its narrator and reader as implicitly male, White, middle-class and heterosexual. The effect of this is to marginalize the perspectives and interests of the majority of readers, who are different from this assumed norm.

Feminist criticism has focused on how most fiction – both 'literary' and popular – privileges patriarchal versions of gender and marginalizes woman-centred perspectives. Feminist accounts of gender-bias in fiction

have pointed to the different degree of access that women have to educa-
tion, publishing and the cultural institutions which select and reproduce
cultural canons. This access is also affected by class and race. Women are
absent in any great numbers from powerful cultural institutions. More-
over, their spheres of activity, influence and responsibility in society more
generally have tended to be different from those of men. While women's
fiction has often reflected this difference, the gender of an author does not
guarantee the perspective of particular works of fiction.

Feminist criticism has shown how most narratives represent either par-
ticular male interests or, more broadly, patriarchal values. Perhaps the
classic text of this type was Kate Millett's best-selling analysis of a range
of male writers, *Sexual Politics* (1977; original edition 1970). Many feminist
critics have argued that women's writing incorporates a 'difference of
view' from that found in male-authored texts. Women's writing, they
argue, suggests that gender relations are more complex and contradictory
than most male-authored fiction or criticism might suggest.[2] Often, how-
ever, it none the less confirms the hegemony of the patriarchal social
order by reinserting female characters into traditional roles.

Feminist writing, as distinct from women's writing, consciously takes
issue with patriarchal modes of femininity and gender relations. It has
become an important site for the analysis of existing forms of subjectivity
and female desire. Often it attempts to articulate non-patriarchal modes
of subjectivity and new social positions for women.

Like all narratives, feminist narratives position readers in relation to the
meanings encouraged by the text. They suggest that particular meanings
and values, particular ways of making sense of a story, are more valid
than others. Engagement with a narrative offers the reading subject a
more substantial experience of being positioned and discursively pro-
duced as reader than the more fleeting engagement with the images we
see around us in daily life. We may recognize romantic images in adver-
tising. Yet, we understand the full import of the language of romance,
which give these images their meaning, from our more sustained en-
counter with romantic narratives in books, films and magazines.

Fiction is often thought to provoke an imaginative identification with
the narrator or characters by an already constituted, sovereign, rational
reader. This is the assumption which underpins the Marxist–Leninist
criticism, which we discussed in chapter 4, as well as Liberal Humanism.
Yet arguably fiction has a more complex role to play in the constitution of
subjectivity. Narrative forms address and attempt to shape the reader's
conscious and unconscious thoughts, values, emotions and desires. Fem-
inist narratives engage explicitly with patriarchal modes of subjectivity.
Often they deconstruct them and offer alternatives. Feminist fictions offer
modes of subjectivity no more or less 'real' than others. They may, how-
ever, be more or less familiar and more or less effective in shaping our

assumptions and values. This will depend, in part, on whether the modes of subjectivity which fictional texts propose are also found in other discursive practices.

The persuasiveness of many fictional narratives, particularly different forms of realism, lies in their apparently definitive interpretations of experience. Texts naturalize certain meanings and values and mask the ways in which the meaning of experience is constructed for the reader in textuality itself. Realism denies its own fictionality by presenting an apparently true and convincing picture of social life. Other forms of writing – most particularly poetry and postmodern writing – acknowledge the principle of the linguistic construction of meaning which, poststructuralism suggests, all language shares.

In postmodern fictions, subjectivity, meaning and singular narratives are themselves questioned.[3] In her book *The Poetics of Postmodernism* (1988), Linda Hutcheon argues that postmodern fictions problematize narrative representation, even as they invoke it (p. 40). Postmodern historical novels, for example, offer critical reworkings of the past rather than a nostalgic 'return' to it. They demonstrate that 'truths' are 'socially, ideologically and historically conditioned' and use parody both to incorporate and challenge what they parody (p. 18).

Fiction is a discrete form of signifying practice produced under specific conditions. It is validated and circulated by particular social institutions. These not only teach us how to read fiction but also where to locate it in the hierarchy of social practices. The political importance which fiction is thought to have varies from society to society. As we suggested in chapter 4, fiction was widely seen as directly political in Eastern Europe before the revolutions of 1989. It was accorded a great deal of importance in the formation of social and political values. The importance which the State ascribed to fiction – particularly to its control through censorship and the size of print runs – made it a significant locus for discussion of what socialism meant and how it should be realized. Fiction also functioned as a site for the articulation of the marginal. For example, in the German Democratic Republic, where the 'woman question' had officially been resolved by legislation and a small measure of positive discrimination in training and at work, many of the issues central to Western feminism surfaced in women's writing. They included the social construction of gender, the question of sexuality, the patriarchal nature of the family and the politics of the personal in everyday social interactions. These were issues which were officially seen in the GDR as 'bourgeois' concerns, of little relevance to GDR society. Yet their articulation in a fictive context affected State thinking, as well as the general level of awareness of sexual politics in society at large.[4]

In the West, where censorship is much less overt and is more likely to be an effect of the market than of government intervention, fiction tends

to be seen as less politically significant. The response to particular fic-
tions, for example Salman Rushdie's *The Satanic Verses*, which helped to
fire the cause of Islamic fundamentalism in Britain, may draw attention to
the relation between fiction and politics. But such cases are rare.[5]

Despite its apparent distance from politics, fiction has long played a role
in facilitating the articulation of marginal perspectives. These include
women and men who are critical of patriarchy, racism and heterosexism.
Moreover, while there is a market for such fiction – created to a large
extent by the political movements of Women's, Black and Gay Liberation
– publication and distribution are not only possible but positively encour-
aged.

The women's movement has created a large market for feminist fiction.
It is a fiction committed in different ways to contesting patriarchal, racist
and heterosexist relations and to redefining the meaning of gender, race
and sexual orientation. The power and attraction of this fiction lies, in
part, in the overlapping concern of feminist writing with female subjectiv-
ity. How female subjectivity is understood varies widely. Some texts
propose an *essential* female nature, often located in sexuality and mother-
hood. Others deconstruct apparently natural gender differences and ar-
ticulate possible new ways of being a woman. In all these texts, however,
the relationship of women to language is central.

The Women's Liberation Movement began much of its political activity
in consciousness-raising groups. Here women learned to reinterpret the
difficulties and feelings of inadequacy that they experienced in the family
and in society at large. Talking about experience revealed that how we
understand our lives depends on the discursive frameworks to which we
have access. Failings previously seen as individual were reinterpreted as
effects of contradictory patriarchal values and practices. Many women
learned to articulate new and different narratives of their own lives.
These new perspectives required new language with which to analyse
patriarchal power.

Feminist attempts to create a new language in fiction vary widely. For
many, it is a question of subverting and transforming existing meanings
and values. Others attempt to develop a female language that is often
anti-rational and stresses the poetic, the unconscious, the supernatural
and the mystical. The work of many recent feminist writers suggests
familiarity with feminist theory, psychoanalysis and the current debates
about postmodernism. Some feminist fiction is concerned with exploring
particular identities, for example, lesbian identity. Yet postmodern con-
cerns also surface in feminist fiction. For example, they are central to
much of Jeanette Winterson's highly successful writing, and they are
explored in detail in relation to Toni Morrison's *Beloved* in chapter 8.
Speaking out as a woman and articulating a difference of view means
assuming a form of subjectivity which challenges traditional patriarchal

definitions of femininity. The degree to which this challenge is realized depends on the politics of the narrative in question and the ways in which language is used to affirm or deconstruct particular modes of gendered subjectivity.

Expressive Realism

Early feminist fiction, for example, *The Women's Room* (Marilyn French, 1978) and *Kinflicks* (Lisa Alther, 1977), while apparently speaking for women in general, tended to reflect the dominant White, middle-class perspectives of the women's movement at that time. Both these influential first-person narratives became best-sellers and were important in the articulation of gender difference and the affirmation of particular forms of femininity within fiction. Their narratives reflected the confessional structures of consciousness-raising.

The appeal of confessional narratives lies in their simplicity, directness and claims to authenticity. Often, too, they offer a voyeuristic view of women's emotional and sexual lives. Both *The Women's Room* and *Kinflicks* work with an apparently transparent view of language which enlists the reader by presenting the narratives as true accounts of women's experience. *The Women's Room* tells the story of a woman's struggle to free herself from the oppressive structures of middle-class, White, American family life. *Kinflicks* records a woman's progression from heterosexual, male-identified adolescence to a lesbian, woman-identified and later maternal, family-orientated adulthood, characterized by patriarchal values.

Female identity in *Kinflicks* is defined in relation to sexual partners. The narrative offers women's marginalized side of the story of heterosexuality, claiming to express it without disguise, pretence or masks. The novel uses a first-person, expressive-realist narrative. It seems to deny its own figurality and to offer the reader direct access to the meanings and experiences which it constructs. The first-person address to the reader invites identification with the heroine's heterosexual experiences. These fix both her femininity and, by extension, that of the reader. We are offered a universal, essentialized mode of femininity which stresses similarities between women, locates difference in masculinity and renders differences of race, class, creed and sexual orientation invisible.

Attempts to present specific versions of femininity and particular social values as natural and transparent inevitably have political implications. In *Kinflicks*, the values in question are arguably White, liberal, heterosexual, middle-class and American. Yet *Kinflicks* has also served as a liberatory text for women from other class and cultural backgrounds. It is,

of course, part of the power of fiction that it allows for imaginary identi-fication with very different subject positions.

Expressive realism relies on a theory of language and subjectivity in which the narrator/author is the guarantor of the truth and authenticity of the narrative. It has remained an important form of feminist writing but has tended more recently to be linked to forms of identity politics in which the differences between women are central. For example, much recent feminist first-person narrative attempts to redefine what it means to be Black, 'Third World', working-class or lesbian. These texts challenge conventions of normality and offer access to social and cultural dif-ference. This difference is rendered accessible precisely by the use of familiar conventions of narrative. This development both reflects and has contributed to the painful process of recognizing and articulating dif-ference within the women's movement.

Jill Miller, the 'housewife and mother' from South Wales quoted in a newspaper article at the beginning of this chapter, published a first novel, *Happy as a Dead Cat* in 1983. It is an example of the use of expressive realism to depict working-class experience. The narrative relates the re-lentless grind of the everyday life of a poor, working-class housewife and mother of five. Jill Miller

> hopes her book will provoke a little optimism among working class women who find themselves trapped in the domestic treadmill, 'Frankly most feminists are middle class. There aren't many working class women who go into a library and pick a Simone de Beauvoir book off the shelves.' (*Guardian* 23 January 1983)

Narrated in the first person in a direct and colloquial style, the text uses apparently transparent language to voice the oppressions of a White working-class woman. The novel depicts female subjectivity governed by guilt and self-sacrifice. It describes how the narrator acquires self-respect and a degree of autonomy. This process involves leaving a traditional, oppressive marriage for life as a single parent.

In texts that articulate marginal voices, the use of first-person narrative often suppresses contradictions and ensures the greatest degree of nar-rative closure. This writing strategy is perhaps most effective in creating alternative, positive images, as in the case of lesbian writing over the last two decades. Lesbian novels and short stories have sought to naturalize lesbianism by making it in some cases central to the narrative, in other cases, incidental. Thus, recent lesbian novels range in theme from docu-menting the experience of 'coming out' to the creation of popular generic forms, like the detective novel, with lesbian protagonists. The latter texts both normalize lesbianism and transform the conventional values of popular fiction.

The range of approaches to lesbianism in feminist fiction is well illus-
trated by the anthology of short stories *Girls Next Door* (Bradshaw, 1985).
This collection provides examples of diverse narrative techniques which
offer a range of lesbian subject positions across a spectrum of different
moments, environments and situations. Lesbianism is variously defined
as a natural sexuality and identity and as a result of political choices.

Those stories which make 'natural' sexuality the basis of subjectivity,
and privilege it as the source of what it means to be a lesbian, tend to use
an expressive model of language. 'The Marina Trench', for example, by
Sigrid Nielsen, uses language not only as the transparent expression of
experience but also suggests that the female body is inscribed in writing.
The tripartite structure of the narrative includes a highly metaphoric
prologue and epilogue which contrast with an intersecting dialogue of
commonsense, realist, but nevertheless emotionally charged prose:

> That is part of the Marina Trench: silence. You cannot speak; if you open
> your mouth the water will rush into your jaws. No one has ever been able to
> explain to me why that silence falls between women. It is simply something
> that happens. It is a place on the map of the women's world, that silence. It
> is not a passive silence, but a tangible presence, like a wall of water which
> resists everywhere at once.
> I was nearly ready for it. If I protested, you never heard me. This story is
> not a protest, no more than the purple spots on the map, the sounding in feet
> and meters, the name in boldface type, the warning to proceed cautiously.
> (Bradshaw and Hemming, 1985, p. 88)

In the prologue, the deepest depths of the ocean come to symbolize a
peculiarly natural, feminine, lesbian mode of relating. These dark and
highly pressurized 'purple places' on the oceanic map, which are more
sexual than social, more symbolic than literal, offer an essentialist version
of femininity which, although tied to lesbian sexuality, is seen to define
all women. This 'woman's language' questions, even displaces, the ability
of the seemingly transparent expressive-realist prose of the middle sec-
tion to fully express female sexuality and subjectivity (Bradshaw, 1985,
pp. 86–90).

Subjectivity Within a Patriarchal Order

The question of women's relation to writing and to patriarchal culture is
foregrounded in much feminist writing. Many feminist novels explore the
limits of the possible subject positions open to women in patriarchal
cultures. They show the impossibility of unified full subjectivity and the

repression brought about by defining sexual difference as an opposition in which masculinity is the dominant pole.

Sara Maitland's *Virgin Territory* (1984) is a novel that critically explores the various female subject positions of mother, lesbian and nun. Each of these implies a particular relationship to a patriarchally defined sexuality. The Church and the family are depicted as the two most important institutions supporting patriarchy. They produce classically patriarchal subject positions: virgin daughter and patriarchal mother and a sexuality that is marked by repressive masochism.

The novel tells the story of Anna, an American woman in her thirties who, after 16 years as a nun, finds herself in a state of crisis following the rape of one of her sister nuns at their missionary convent in South America. After a brief spell at the 'Motherhouse', the convent in the United States where she trained, Anna is sent to London to 'recover'. She is to work on the history of Catholicism in South America and to resecure her vocation. During nine months in London she confronts her own anger and repressed sexuality in a devastating battle with the 'Fathers', the jealous and violently repressive voices of patriarchal power and control. Anna comes to terms with herself through painful and sometimes joyful engagement with other women and finally decides to leave the convent and return to South America in a search for maturity.

Female subject positions in the text are represented by particular characters. They range from nun (Anna) through patriarchal mother (Fiona) to separatist lesbian (Karen). They are set against the radical rejection of all subject positions open to women under patriarchy, a position represented by the brain-damaged, three-year-old Caro. Anna's subjectivity becomes a site of contest precipitated by Sister Kitty's rape. Until the rape, Anna's own virginity had been the anchor that secured her own sense of self. The rape triggers self-questioning and a questioning of the institutions which gave Anna a unified sense of identity founded on repression and denial of sexuality and autonomy. Moreover Anna's friendship with the lesbian Karen brings her repressed sexual needs to the surface:

> What she experienced now was a driving force of desire, a great fierce demanding thing which she did not like and could not control. She tried to keep hold of Karen in her heart, but the Fathers descended on her and took over her body and her fantasy and were without mercy. It was horrible. They beat her and they buggered her and that excited her and in the end she did not know, she could not tell, she did not care whether it was punishment or pleasure for it was both and she was humiliated. And in the humiliation she found relief, and she felt the needs of her own body taking over and she fought against that and she lost; so that the pounding orgasm at her own hands was not victory but shame and darkness and that shame was thrilling and she did not know what it all meant. (p. 125)

Both conscious and unconscious subjectivity are central to the narrative. In making virginity, motherhood and lesbianism the structuring supports for modes of subjectivity, the novel locates women's subjectivity in understandings of sexual difference. These are defined in relation to sexuality, either expressed or repressed. Heterosexual family life is focused on parenthood. For Fiona, motherhood guarantees a privileged place in the patriarchal order, but it is also, at least during pregnancy, a site of female power transcending patriarchal control. Positive images of female sexuality are tied to lesbianism which is defined against patriarchy and religious celibacy. Karen's lesbianism is political in its resistance to patriarchal values, but it is also natural, based on sexual desire, and it represents power – mental and physical – which Karen enjoys and which is contrasted with Anna's masochism.

Virgin Territory questions unitary, essential, female subjectivity. It articulates a range of conscious and unconscious feminine voices which are defined in relation to a repressive patriarchal culture. It creates a mythic representation of a cruelly repressive patriarchy in 'the Fathers', who voice the sexual and sexist repression on which the patriarchal Christian order is built. Their power over women depends on female fear and masochism. The way forward for women is seen to lie in a return to a non-patriarchal mother and rebirth.

Virgin Territory draws on various aspects of recent feminist theoretical debate about femininity, female sexuality and identity. It works with a concept of a patriarchal symbolic order, similar to that found in Lacanian psychoanalysis. This implies a social order where meaning is founded on an understanding of sexual difference which defines women in terms of lack. The phallus is seen as the primary signifier of difference, guaranteeing meaning and the Law of the Father. The implications of this theory for women is that they have positions within the symbolic order only in relation to men – as mothers, wives and daughters – and no authentic voice of their own. The repression of the feminine is the prerequisite for the establishment of the patriarchal social order but the feminine returns in spaces beyond the 'Law of the Father'.

This theme is also explored in the work of Michèle Roberts, the author of poetry and several successful novels.[6] Her first novel, *A Piece of the Night* (1978), depicts female subjectivity as a site of complex contradictions which have their roots in immediate social relations. The novel tells the story of Julie, a French woman, married to an English academic, who realizes her 'true' identity in a lesbian commune. The novel is a formally experimental text which powerfully points out the impossibility of solving the contradictions that confront women in a society which is both patriarchal and capitalist.

In *A Piece of the Night*, femininity and masculinity are tied to biological difference. Masculinity is, in all cases, characterized by the exercise of

power, possession, authority and machismo. Women occupy the subordinate role in the female–male opposition, most clearly in the depictions of family life. But even the lesbian commune cannot escape the effects of a society where power and money are linked with masculinity. Thus, even though lesbian separatism may offer a warm, supportive environment for the development of new, stronger forms of female subjectivity, these are threatened by the material reality of an everyday life: Julie's ex-husband owns the property in which the commune is housed.

Female subjectivity in the novel is located exclusively in women's bodies. It is rooted in sexuality and motherhood which are defined either in terms of, or in opposition to, patriarchal heterosexuality:

> The night chuckles; the weeds in the garden clamber through the window to keep her company, throttle her. Julie ducks her head under the bedclothes, clutches with her hands. They meet a reassuring bush, a hillock covered with softly tangling hair. Sam and Bertha, she and Jenny, burying themselves that Saturday in the dead leaves around the hollow tree on Blackheath, solemn faces regarding each other, and then the mounds of leaves exploding as women and children roll towards each other, clasp each other's bodies in their arms. She breathes out, stretches her legs, redefines her place in her own garden. Her fingers slide between her wet and parted lips, isolate her clitoris, a sharp plump bud blossoming from beneath its daytime hood. As the waves of sweetness warm, constrict, and then dissolve her body, she is, as that first time, amazed and grateful. Jenny. That first time, she didn't need to call the other by her name, who was there, sharing her breath and her amazement. (p. 17)

The sinewy, tactile, sensuous quality of the text's prose is made peculiarly feminine and is not used to represent male characters. This, along with a background of feminine domesticity, works to support sexual difference as opposition. It fuses biology with culture. Positive images of female sexuality are located within a lesbian lifestyle which requires the exclusion of men. It is not possible for the text to offer women radically new, challenging subject positions beyond separatism because sexual difference itself is not deconstructed. Women can only take up subject positions which are either complicit with patriarchy or which oppose men.

Yet if *A Piece of the Night* does not offer new possibilities, it does suggest that further change is possible, given changes in social relations. Unlike much women's writing, the text does not attempt to unify the range of female subject positions that it constructs. These span childhood to adulthood and are always grounded in specific material relations, for example, conventional family life, convent school life, or a lesbian commune in South London.

While Julie is the unifying feature of the text at the level of narrative, she is not a fixed and organic subject. Different moments and different modes

of femininity are juxtaposed with one another. Moreover, the absence of a fully coherent, linear narrative – ruptured as it is by flashbacks and the juxtaposition of scenes within a section – forces the reader to question the forms of family and sexuality which are represented. The organization of material into progressively numbered sections simultaneously constructs and belies a linear narrative: a coherent numbering is contradicted by sections which present fragments of life. This formal technique reinforces Julie's struggle to make sense of her life as a journey from childhood to adulthood. But the trajectory is not straightforward – memories of childhood and other events intervene and fragment a unified sense of self.

Other textual strategies used in *A Piece of the Night*, which question rather than reassure, include repetition, juxtaposition, irony and the movement, without warning, from third-person to first-person stream-of-consciousness narrative. A positive reading of the novel's textual strategies and organization would be the location of an emergent subject in process. On the other hand, the fragmentary nature of the text and the slippage from third- to first-person narrative could be read as an indictment of the position of women in society. This position is depicted as inescapable and fractured by contradictions that cannot be solved within the binary opposition which structures the text, that is, lesbian sexuality/heterosexuality and the family.

The possibility of overcoming the male–female opposition is explored in Michèle Roberts's novel *The Wild Girl* (1985). This novel looks at the relationship between language, subjectivity and sexuality both within and outside the patriarchal symbolic order. It tells the story of Mary Magdalen and, unlike many earlier feminist novels, uses a first-person narrative of conscious and unconscious experiences to explore rather than to express gender subjectivity and language.

While the conscious narrative is written as if language were transparent, this transparency is undermined by the dreams and visions in the text which tell a history of the development of patriarchal religion from Adam and Eve onwards:

> In front of me were Adam and Eve, running and crying, chased by Ignorance, who wielded a great double-edged sword which he constantly thrust between them. When they turned their heads to look for one another, or tried to take hold of each other's hands, there was only emnity there, the glistening blade which whistled through the air and hurt them. . . . Each of them became aware of evil through the pain of desire and the loss they suffered, and each of them saw it in the other. They fled past me, through the gates of paradise, weeping and bleeding and hurling abuse, and were swallowed up in darkness. (p. 166)

The novel uses a juxtaposition of voices to suggest that fullness of subjectivity is impossible under patriarchy, not only for women, but also

song and as the longing for something once understood, and this has implications for masculinity. Fullness requires that the feminine and the masculine merge in a dissolution of subjectivity in a realm beyond language. Individual subjectivity implies boundaries. Yet, as a woman, Mary Magdalen can find no satisfactory subject position within patriarchy. There is only domesticity (Martha) or prostitution (Sybille). Freedom from either of these states means damnation. The lack of any alternative deprives her of a language from within which to contest the patriarchal definition of her self, a definition with which she does not identify.

In the novel, Jesus, as God, offers a new possibility which transcends the traditional male–female opposition. As companion of the saviour, Mary enjoys a measure of equality otherwise found only among women. The novel suggests that the physical side to Mary's relationship with Jesus is necessary to wholeness. The dissolution of the male–female opposition is the only route to a new unity. This is possible only if men are also willing to change. In the novel they are not. After Jesus leaves, Simon Peter lays down a law of celibacy for men and bans women from preaching. With Jesus's disappearance, Mary can only abandon desire, since its fulfilment is impossible under patriarchy.

Whole relationships between women and men, such as Mary achieves with Jesus, involve sexual and spiritual merging. *The Wild Girl* suggests that language is a barrier to this because it works with binary oppositions. However, these oppositions are not transparent expressions of a fixed social order. Truth cannot be fixed, it is plural. The text itself offers a new version of Christianity in which women are rewritten into the gospel stories. For example, they are centrally involved in tasks previously depicted as male miracles (the raising of Lazarus and the feeding of the 5,000). The text also creates a new Black creation myth and an account of the origins of patriarchy: the misrecognition by man of himself as God and the exclusion of the feminine from the Godhead.

The exclusion of women from the Godhead has important implications for their relation to language. The alternative to patriarchy in *The Wild Girl*, the repressed feminine (represented by Salomé), has no point of contact with the patriarchal order. It is voiced in dreams and visions. Language, as a patriarchal form, the text suggests, is not necessary in communication between women, here intuition is possible. However, Mary's visions show that all the repressed power of women cannot bring down patriarchy since it is a power to which most women have no access. Moreover, women have been burned as witches for establishing contact with it. While the implications of the text are effectively separatist, this separatism, imposed by men's unwillingness to change, is put into question by the characterization of Jesus and his appearance in the dock in Mary's vision of the trial of men for their crimes against women.

Beyond Patriarchy?

Moving beyond separatism which leaves patriarchy intact is a serious problem for feminist fiction. This is because sexual difference as a female–male opposition based on biological difference is the basis of most representations of both lesbianism and heterosexuality. Texts which create positive images of lesbianism in a separatist context, for example, often choose not to speak of contradictions within lesbianism or heterosexuality. They are concerned with creating strong lesbian subject positions and articulating lesbian voices.

It is in fictional depictions of future societies that positive (as well as negative) alternatives to patriarchy have been articulated most clearly. New ways of constructing sexual difference rest on the transformation of existing social relations and language. This assumes that gender identity for both women and men is non-essentialist, tied neither to forms of sexuality nor reproduction. Caroline Claxton's story in *Girls Next Door*, for example, 'The Strangers in the City', uses the device of a visitor from another planet to criticize the cultural organization of gender in contemporary London and to suggest future ways of constructing sexual difference.

The difficulty of articulating new forms of femininity rests in part on the patriarchal and heterosexist context in which women are writing. It would mean the transformation of existing heterosexuality and heterosexism. This is the perspective of one of the most powerful feminist novels of recent years, Marge Piercy's *Woman on the Edge of Time* (1979). This novel contrasts the oppressive class, race and gender relations of contemporary America with a future society where oppression and exploitation have been overcome. It uses realist techniques, but locates all forms of subjectivity historically, as cultural constructs. They are open to radical change given radically different social organization and language.

Western societies have as yet singularly failed to contest and transform the other term in the patriarchal oppositions which structures dominant norms of sexual difference – namely, men and masculinity. Recent feminist fiction suggests that sexual difference has no essential meaning, and need not necessarily rely on opposition. It is socially specific and can change. This can be seen as a positive starting point in the struggle for radical change.

8

Gender, Racism and Identity: Black Feminist Fiction

A Poem for Black Women

Rarely has a door opened and said welcome
never has a crack been big enough
but through the crack
we see an endless boundary of another place

we will not wait to be allowed entry
that, we will seek on our own
for we know where the light does not shine
our spirit will glow
and where mist moves on low ground
our spirit will take flight

The fire that burns on within us
is as strong as the wind on the eastern side
of the cliff
we know that the reflection will not move
when we come face to face with it
for we know that we must go where it is that
our soul desires

We will not be restricted
it is not a crime to say NO,
nor is it a crime to be in the presence
of self, taking control
and not being controlled
for what ever it is that we

black women desire
shall be ours to hold . . .
 — Patricia St Hilaire,
 Black Womantalk Poetry, 1987, p. 133

Since the late 1960s there has been a flowering of Black women's writing in the United States and the beginnings of Black and Asian women's writing in Britain and elsewhere in the Western world. The history and context of fiction by Black and Asian women in the two countries are different. If, in America, slavery and its aftermath continue to affect much contemporary writing, in Britain a long history of colonialism and the more immediate history of postwar immigration are the main points of reference. Moreover, there is a much longer tradition of Black women's writing in the United States.[1]

The themes and issue taken up in Black and Asian women's writing in both countries are many. This chapter takes four themes:

- affirming Black experience;
- negotiating difference;
- achieving positive identities;
- the importance of history.

For each theme we look at particular texts, drawing examples from Britain and the United States. The chapter does not offer an overview of Black feminist writing nor of the chosen themes. Rather, it selects examples that highlight some of the cultural political issues with which contemporary Black women's writing is concerned.

Affirming Black Experience: the Work of Joan Riley and Vernella Fuller

In Britain the realities of Black women's experience remain largely invisible. Sociological studies and government statistics may give some idea of the social position of Black women but they do not tell of the lived experience of racism or sexism. Fiction, whether poetry or prose, is better able to communicate what oppression feels like and its effects on subjectivity. Depicting this experience and the problems and contradictions that arise from it both affirms its importance and gives it visibility. For readers not subject to racism, it offers insight into what racism means – or, rather, how it feels.

Joan Riley's novels mark an important milestone in the struggle for a more plural and representative culture in Britain. As a Jamaican-born woman who lives in Britain, she writes a fiction committed to providing a testament to the experiences of the Afro-Caribbean people who migrated to Britain in the decades after the the Second World War. Her novels evoke the experience of Black women in Britain, an experience of White racism, patriarchy and class exploitation that is rarely visible in the mainstream media. Her stories highlight how a racist and sexist society prevents Black women from achieving a positive sense of self and a decent life.

Joan Riley's first three novels, published between 1985 and 1988, tell of Black, working class experience. *The Unbelonging* (1985) evokes the effects of leaving Jamaica as a child and growing up Black in Britain in an uncaring family and in children's homes. *Waiting in the Twilight* (1987) looks back on the life, in Britain and Jamaica, of a Jamaican woman, Adella, who, once full of hope and optimism, is now crippled, poor and lonely, abandoned by her husband and facing a premature death. *Romance* (1988) is the story of two sisters and their struggles to emancipate themselves from the worst effects of racism and patriarchy.

Joan Riley's novels are realist. They depict social relations through the eyes of their characters and have the rhetorical power of texts which appear to offer us access to authentic subjective experience. *The Unbelonging*, for example, presents an extremely bleak picture of paternal sexual abuse and White racism. An eleven-year-old girl, Hyacinth, leaves Jamaica to join a father she does not know. The narrative traces Hyacinth's life in Britain until her return to Jamaica as a grown woman. The novel is written exclusively from Hyacinth's perspective and shows how her experiences deny her the possibility of achieving a positive sense of identity other than one rooted in an imaginary Jamaica, derived from childhood memories.

Hyacinth's experience of home life instils in her a deep fear of Black men and a sense of guilt and shame at what has happened to her. In the White environments of school and the children's home, she comes to hate her blackness and to see herself as fundamentally different from other Afro-Caribbean people. Her university experience reintroduces her to Black people but threatens her sense of herself. This is anchored in the repression of her experience with her father and a child's innocent and romantic image of Jamaica that turns out to have nothing in common with the reality to which Hyacinth returns at the end of the novel. Her contact with other Black students and with Black nationalist thought offers her a framework from within which to make sense of her oppression. However, her experience of sexual abuse, which she is desperate to hide, and her fear of Black male sexuality make it impossible for her to identify with Black nationalism.

The Unbelonging is written with powerful and unrelenting realism:

> 'Hyacinth!'
> The sharpness in the voice brought her back to present reality and the fear she had been trying to suppress mingled with remembered horror.
> 'Yes sir?' she asked faintly.
> 'I think Joyce did give you too much freedom,' he said angrily.
> 'I not going to stand for none of this dumb insolence, you hear.'
> 'Yes sir,' she croaked hoarsely, desperately, swallowing hard.
> 'I hear you wet the bed again,' he said now, the eyes fixed unblinkingly on her.
> 'Y . . . yes sir,' she managed to get out in a frightened whisper, eyes falling, unable to stay averted.
> 'And you know what that means, don't you?'
> She nodded, swallowing hard to try to force the blockage from her throat. He wanted to frighten her and she could see that he was puzzled by the lack of tears. She knew she would suffer for it from the way his hand tightened on the wooden arms of the chair. She could feel the shaking that she could no longer control, the sting of salt tears in a fresh wave behind her eyes.
> 'You know what to do, don't you?' he asked now. And the hands released the arm of the chair as the tears she had been fighting back started to flow. He was getting to his feet, and sick fear made her legs weak as she saw the lump in his trousers. The confirmation she had tried so hard not to see. Her tongue was large in her mouth, swallowing jerky and painful, and the tears flooded faster as the lump of his anger increased. (p. 14)

The narrative juxtaposes two competing languages – Jamaican English and British English – which signify the escapist world of Hyacinth's dreams of her childhood in Jamaica, a world rich in metaphor and natural imagery, and the cold, prosaic reality of Hyacinth's life in England. Her dreams, however, are always liable to turn to nightmares as aspects of her real life impinge on them. Unable to take up a fully constituted subject position in either one of these languages, Hyacinth's sense of identity remains fragmented and unfixed throughout the novel. Even on her return to Jamaica as an adult, where she had hoped to rediscover a unified sense of self, she finds none. The Jamaica of her dreams is replaced by a reality of poverty, slum life and disease. Her position has become one in which she is marginal to both British and Jamaican cultures.

In her second novel, *Waiting in the Twilight*, Joan Riley picks up and develops the themes of identity and self-respect. The narrative tells the story of a Jamaican woman, Adella, a successful seamstress in Kingston, who follows her husband to Britain. There racism and ill-health reduce her to a crippled office cleaner living on low wages in a council flat.

> 'Johnson!'
> The insolence ran through her and she gripped the mop tighter with her

feeling hand, forcing back anger that still bubbled up after so many years. 'Thou shalt rise up before the hoary head,' she muttered under her breath, 'No wonda yu treat yu old people dem so bad.'

'Yes, mam . . .' she said aloud, turning to see a young white girl, not more than seventeen years old. Her feet had left a fresh trail of mud, and Adella's mouth thinned. This one had been working less than six months and already she had learnt how to treat the cleaning staff. Adella wanted to ask if this was how she was at home; bit back the words. Of course, this was how they all behaved: everybody knew what white people were like. (p. 2)

The narrative offers the reader Adella's perspective on her life and flashbacks to Jamaica which help to explain how she has become what she is. The depiction of Adella's Jamaican experience marks the cultural differences between the two societies and sets the scene for her subsequent life in Britain.

In Britain, class, gender, poverty, disablement and lack of family support magnify the effects of racism. Flashbacks tell of Adella's early life in Jamaica where she was seduced by a married man and forced to live as his mistress in return for support for herself and their children. These flashbacks help the reader to understand Adella's attitude to her life in Britain. Gender relations in Jamaica are depicted as patriarchal. Women have little power outside the structures of the family but the extended family offers an important material and emotional support network that is absent in Britain. On moving to Britain, the novel suggests, Afro-Caribbean women become exposed to much harsher patriarchal oppression within the isolation of the nuclear family and Black men are likely to become more emotionally and physically violent and less responsible because of their own experience of racism in the wider society. Moreover, cultural difference – the difference between the family, religion and codes of respectability in Jamaica and Britain – make it impossible for Adella to explain, even to her children, why she cannot return to live in Jamaica.

Yet cultural difference can be a source of strength offering positive forms of identity from which to resist racism. This is made clear in Joan Riley's third novel, *Romance*, which tells the story of two sisters who came to London from Guyana as small children. The novel traces the women's difficult paths to liberation based on the acquisition of a strong individual sense of identity and purpose. For Desirée, liberation means the transformation of her oppressive marriage and a redefinition of herself as something other than just wife and mother. For Verona liberation means the slow and painful process of coming to terms with sexual abuse, her fear of Black men and her flight from reality into romantic fiction and over-eating. In both cases the support of other Black women and the influence of Jamaican cultural values are crucial.

Joan Riley's novels suggest that subjectivity and Black identity are socially constructed. Predominantly White, racist societies offer no positive subject positions for Black people. They must look to each other and to Black cultural traditions for alternatives. Yet the very process of unmasking racist and patriarchal power relations and their implications for subjectivity – a major theme of the novels – helps to create conditions for developing positive forms of identity.

The themes of racism, identity and belonging are developed in a first novel by the Black British writer Vernella Fuller. First published in 1992, *Going Back Home* focuses on the lives of two sisters, born in Britain of Jamaican parents. Whereas Esmine claims a decent life in Britain as her birthright, Joy longs to return to Jamaica where, she believes, she will find a real sense of belonging. Unlike Joan Riley's heroines, both women become successful professionals: a solicitor and an interior designer.

Each of the sisters reflects the views of one of their parents. For Esmine and her mother, Black people have paid a high price and fought hard for the right to belong in British society:

> We had to fight to get our rightful place here. . . . It's *your* birthright! I had to do two jobs for years. Up at the crack of dawn to scrub their stinking dirty toilets, then to the factory to have machines wear down my ear drums. And if that wasn't enough, I struggled to night school for the piece of paper to get into nursing. I thought then the humiliation would stop. Stop? That was just the beginning. When I was working my guts out to change their old people nasty bedpan and wash their septic sores, they were scorning me, calling me black this and that. I suffered for this place! (p. 14)

In contrast, their father does not believe that they can ever belong in British society:

> 'White people will never accept us. We could be born and reborn a million times. So there is no point in staying in this God-forsaken place. They wring us dry already . . . we give everything we have to give. We punish enough dearheart!' (p. 50)

This, too, is Joy's experience. Living in England, she says, makes her life ugly and leaves a series of scars, psychological and emotional. These scars become physical after she is brutally assaulted by two White men. Unlike Esmine she feels that Black people are 'all just a colour' to Whites, that bigotry is fundamental to White culture, and that most Whites do not even try to overcome it. *Going Back Home* does not resolve the problems of racism, identity and belonging. It suggests that different ways are appropriate for different people.

The work of Joan Riley and Vernella Fuller marks a new departure in

British Black feminist writing in a context in which, unlike the USA, there is virtually no long-established tradition of Black culture. Their novels make visible the effects of racism on Black lives and suggest that what it means to be Black in Britain varies radically from individual to individual and community to community. There is no one obvious form of identity to which Black people subscribe.

Negotiating Difference: the Asian Women Writers' Workshop

Most women of Asian descent in Britain have links with communities where traditional cultural norms and practices, derived from the Indian subcontinent, flourish. Asian British women's writing raises questions of culture and identity in the context of immigration and, particularly, in relation to second-generation Asian Britons. Both fiction and poetry look at the experience of immigration, at the racism encountered in Britain, and the relationship of the younger British-born generation to traditional culture and family life. In novels, short stories and poems, writers look at family life and work in Britain and in the Indian subcontinent. They offer positive images of Asian culture and explore the problems that Asian women confront in Britain. They also examine negative aspects of traditional culture for women.

The difficult process of finding a voice as Asian women writers in Britain led a group of London-based women to found the Asian Women Writers' Workshop:

> The workshop was formed in 1984, originally the result of lone efforts by Ravi Randhawa, who had managed to get the support of Black Ink and funding from the Greater London Council. Now we are getting financial support from Greater London Arts and Lambeth Council. The workshop was the first of its kind for Asian women writers in Britain, and was meant to draw out any isolated woman who wanted to write but needed a supportive environment to achieve this. The need for this kind of group was poignantly expressed in one of our early meetings when a younger woman, born in Britain, confronted an older woman who had just finished reading a moving story with the question, 'Where were you when I was growing up?' Did it take that long for 'immigrants' to feel settled and strong enough to want to express, re-order and interpret their reality for themselves and society at large? We were also working in a vacuum; there seemed to be no precedents to which we could refer. A few Asian women had been published, but not enough to set up parameters which we could break or work within. Organising as a group gave us visibility, credibility and access to

institutions, publishers and other groups in the community. The workshop gave us the confidence to approach publishers, which as individuals we might never have done. It answered the vital question that haunted all of us: is my writing of any interest or use to anyone else? (Introduction to Asian Women Writers' Workshop, 1988, pp. 1–2)

The workshop's first beautifully written anthology, *Right of Way*, uses poetry and prose, realism, myth and fantasy, to explore the variety of Asian women's culture and experience.

A key theme of Asian women's writing is the conflicts that result from moving from the Indian subcontinent to Britain. The experience can be both harrowing and destructive, as it is, for example, for the central character in 'The Nightmare' by Ruhksana Ahmad. The story describes the fate of an Indian woman who comes to Britain with her children to join her husband from whom she has been separated for ten years. It opens in a mental hospital where Fariha has been taken by her husband, Salim. She has suffered a nervous breakdown after Salim forced her to have an abortion following contact with german measles.

Fariha's identity is grounded in traditional Indian attitudes to mother-hood and marriage. Like her mother before her, she sees a woman's value in her children and her duty in adapting to her husband. 'A man is like a vessel, hard and unchanging, and a good woman should be like water, flow and adapt herself to his shape' (ibid., p. 20). Fariha's relationship with her husband has not been happy. For ten years he worked in England before bringing his family over. He sent money home, but not regularly. By the time he sends for her his own expectations have been changed by his life in Britain:

It was a shock when he saw them arriving at the airport; talk about the reality betraying the dream. She looked . . . 'fat' . . . his mind had hesitated over the word then. And so much older than she ought. And the children, too. They looked so dark and, for some reason, poverty stricken. Much darker than he remembered them. Yes, the sun bakes, he reminded himself. They were toddlers when he'd left. (Ibid., p. 22)

The children adapt quickly, but Fariha does not. In the mental hospital she is given heavy drug treatment and at the end of six months she is released, only to be told by Salim that he has a job in America and she cannot come with him because of her history of mental illness. He plans to send her back to her family in India, taking the children with him. 'The Nightmare' shows the consequences of immigration for a woman whose husband has become assimilated to Western norms while she clings to her Indian cultural values in a foreign and hostile environment. It powerfully evokes the pain of her life in a loveless marriage away from family support and traditional values. For Fariha no negotiation is possible with her new life.

Conflicts of culture and identity arising from the experience of immigration are shown to affect not only first-generation immigrants but their British-born children. Generational differences are intensified for second generation Asian women by the experience of growing up in British society where gender norms and expectations are not only different, but also in conflict with parental values. Another story in *Right of Way*, 'Leaving Home' by Rahila Gupta, for example, looks at the problems of the younger generation of Pakistani women who are attempting to negotiate two cultures. Zara, 21 years old, unemployed and desperate to go to art school, lives a schizophrenic life. She dresses differently in and outside the home, transforming her public image – spiked hair with pink tips, skin-tight, shiny, black trousers and boots – into something more acceptable to her traditional family before returning home each day. To escape her dual life and to go to art college, she plans a marriage of convenience through a middle man, Pradeep, to a Muslim man (Ahmad) from the same tiny village in Pakistan. Ahmad has had two applications for political asylum rejected.

Zara's plans go wrong from the day of her marriage. She has saved to go to college and organized a housing association flat. After the wedding, however, Ahmad refuses to leave her flat and attempts to rape her. While she defends herself successfully, Ahmad continues to pursue her. Helped by a Black women's centre, she is reconciled with her family who respond supportively to her situation, asking only that she pretend still to be married. The problems of cultural difference and aspirations incompatible with traditional Muslim life are not resolved, but the story suggests that even traditional families can be tolerant.

Achieving Positive Identities: Alice Walker's *The Color Purple* and *Meridian*

In the USA, where Black communities and African-American culture go back to the beginnings of slavery, many writers have turned to history in their search for an answer to the question of where Black women and men might find positive identities in a racist society. Many women writers, including the best known such as Alice Walker and Toni Morrison, have looked to marginalized African-American cultural traditions in an attempt to authenticate a specifically Black women's language and cultural history.[2] Both writers have published novels that are among America's most acclaimed best-sellers. Unlike Black British women writers, they are often published by large mainstream publishing houses.

Achieving a positive sense of identity is a central theme of Alice Walker's prize-winning, best-selling novel *The Color Purple* (1983). It tells the story of two sisters, one heterosexual and one lesbian, and how they manage to assert positive identities in the face of both patriarchy and racism. The narrative describes how Celie is married by her stepfather to a man with a large family after the stepfather has sexually abused her and given away their two children. Nettie, her younger sister, is forced to run away from home to escape sexual abuse both from her stepfather and Celie's husband Albert. She becomes a missionary in Africa. The course of the sisters' lives apart is related through letters – until, at the end of the novel, they are not only reunited, but have become wealthy members of a Black middle class with an assured future (in the style of the American dream).

The Color Purple is written as a series of letters from Celie to God and to Nettie, together with Nettie's lost letters to Celie:

You better not never tell nobody but God. It'd kill your mammy.

Dear God,
 I am fourteen years old. I have always been a good girl. Maybe you can give me a sign letting me know what is happening to me.
 Last spring after little Lucious come I heard them fussing. He was pulling on her arm. She say It too soon, Fonso, I ain't well. Finally he leave her alone. A week go by, he pulling on her arm again. She say Naw, I ain't gonna. Can't you see I am already half dead, an all of these children.

 She went to visit her sister doctor over Macon. Left me to see after the others. He never had a kine word to say to me. Just say You gonna do what your mammy wouldn't. First he put his thing up gainst my hip and sort of wiggle it around. Then he grab hold my titties. Then he push his thing inside my pussy. When that hurt, I cry. He start to choke me, saying You better shut up and git used to it.
 But I don't never git used to it. And now I feels sick every time I be the one to cook. My mama she fuss at me an look at me. She happy, cause he good to her now. But too sick to last long. (p. 3)

The first-person address and seemingly transparent language of Celie's letters which reproduce her Southern American Black dialect are important in establishing a Black female voice which resists the assimilation of cultural and gender difference into the mainstream. Celie's voice, like the voices of other Black women in the text, is one not usually heard – silenced by patriarchy perhaps even more than by racism. Articulation of voice, the text suggests, requires material independence from men. This is something that the singer Shug Avery has and that Celie achieves in the course of the novel. Yet it also requires a positive position from which to

speak, something that racist, patriarchal society denies Black women. Celie gains this through a dual process of discovery of her own lesbian sexuality and of Black cultural history. Shug Avery is instrumental in the one, Celie's sister Nettie in the other.

Both processes are for a long time rendered impossible by the exercise of male power. This power, represented by Celie's stepfather and her husband Albert, denies the possibility of a legitimate lesbian sexuality and keeps Celie from Black history. At the beginning of the novel, Celie's sister Nettie promises that nothing but death can keep her from writing to Celie. But it is not Nettie's death that prevents Celie from receiving her letters, rather it is Albert, Celie's husband. Out of feelings of revenge, provoked by Nettie's refusal to grant him sexual favours, he hides her letters from Celie and in doing so not only attempts to weaken the threat that female support poses to male power, but also suppresses knowledge of his own historical roots. It is through Nettie's letters, in her account of life with the African Olinka tribe, that Black history is reclaimed as the basis for positive identity.

Significantly it is with the help of another woman, Shug Avery, who identifies with Celie's emotional and sexual needs over those of Albert, that Celie finally gains a positive sense of herself and the access to her sister's letters which also provide knowledge of her people's history. An understanding of the past is shown to be necessary for any positive transformation of the present and it is only when Albert relinquishes the rest of Nettie's letters that Celie accepts his company and is able to demand from him a non-sexual, non-sexist relationship.

The Color Purple's epistolary structure is a fictive attempt to articulate an authentic voice. We see the world through Celie's eyes, a technique which privileges one version of history and of meaning. This mode of writing can be read as radical in its retrieval of Black women's diaries and letters from the margins of a White male literary culture. They become important sources of knowledge which trace the process of achieving a positive sense of self.

A rather different approach to the question of identity is to be found in Alice Walker's novel *Meridian* (1976/1982). The text focuses on racism and gender oppression in the context of the civil rights movement. In contrast to those feminist fictions whose principal aim is to make women visible in writing and to do this by inviting the reader to identify with the individual experience of the text's heroine, *Meridian* offers an explanation of the historical and cultural specificity of different modes of identity – female and male, Black and White. Despite a title which privileges the named individual, Meridian, she is not the centre of the text since she is not a fully realized, unified character; rather, she is an emblematic figure who embodies the possibilities of personal and political change:

She was strong enough to go and owned nothing to pack. She had discarded her cap, and the soft wool of her new grown hair framed her thin, resolute face. His first thought was of Lazarus, but then he tried to recall someone less passive, who had raised himself without help. Meridian would return to the world cleansed of sickness. That was what he knew.

What he *felt* was that something in her was exactly the same as she had always been and as he had, finally, succeeded in knowing her. That was the part he might now sense but could not see. He would never see 'his' Meridian again. The new part had grown out of the old, though, and that was reassuring. This part of her, new, sure and ready, even eager, for the world, he knew he must meet again and recognise for its true value at some future time. (p. 227)

The third-person narrative works against the reader identifying with any single character. It is organized into short fragmented chapters which offer a spectrum of different subject positions across different historical moments. The thematic concerns linking these chapters are highlighted, not the plausibility of the events they describe. These are history, motherhood and racial and sexual difference. Each is treated in relation to its historical and political meanings. For example, although racism and gender oppression are seen to be intimately linked they are not collapsed. While the history of Black women's racist oppression, from the early days of slavery to the civil rights movement, reaches a kind of closure, sexual difference and gender and racist oppression are not resolved.

This is apparent in the consistent ambiguity which characterizes women's relation to writing. For example, early in the novel there is a description of women chopping down the Sojourner, a tree which has grown to immense proportions with the planting of a slave girl's severed tongue. As such it symbolizes both the silencing of women and women's resistance to that silencing. In one of the final images of the novel, it is suggested that women's language is beginning tentatively but not yet powerfully to speak. A single line of writing, small and partially erased is pinned to Meridian's wall, suggesting that women are still alienated from writing. But next to this is pinned an image of a gigantic tree stump with a tiny branch growing out of one side. The Sojourner has not died.

For Black women writers language is not just a gendered question but one of history and cultural tradition which involves reasserting Black cultural forms from the margins of a dominant White culture in which Black women have been defined in negative terms. Positive, oppositional identities are fundamental to resisting racism, sexism and heterosexism. They create a space for voices, marginalized by the dominant culture, to articulate a difference of view.

The Importance of History: Toni Morrison's *Beloved*

The rewriting of history is central to cultural politics which aim to produce new and positive forms of identity from which to challenge racism and sexism. While not 'history' in the usual sense of the word, fiction can offer new perspectives on the past and on the process of history writing itself. It can show how meanings and subjectivities are formed and suggest new ways of understanding racism which are relevant to the present. These are some of the achievements of Toni Morrison's novel *Beloved*.

Beloved is an historical novel, set in Kentucky and Ohio in the mid-1800s and based on an actual event.[3] It tells the story of slaves from an estate called Sweet Home in the period immediately before the Civil War and during the uneven transition from slavery to a post-slave society. The novel focuses on a household of now free women – grandmother, Baby Suggs, both before and after her death; her daughter-in-law, Sethe; her granddaughter, Denver; and Sethe's other, dead daughter, Beloved.

The story tells how an escape attempt is precipitated by the death of a liberal slave owner (Garner) at the Sweet Home estate and his replacement by a much harsher manager (Schoolteacher) with radically different racist views about the nature and role of slaves. This bid for freedom leads to the death of two male slaves, the selling of Paul D, the disappearance and assumed death of Halle and the escape of Halle's wife, Sethe, with her children. She is found by Schoolteacher and slave hunters at the home of her now free mother-in-law, Baby Suggs. Faced by the slave catchers and the prospect of a return to slavery, Sethe attempts to kill her children. She kills one of her daughters and is arrested. After a short spell in prison (her case is taken up by White abolitionists) she returns to Baby Suggs's house and lives there with the ghost of her dead baby daughter for the next 18 years.

After 18 years Paul D, one of the Sweet Home men, comes to live with Sethe. He has experienced both a brutal prison camp in Georgia and the Civil War. He exorcises the ghost of Sethe's daughter only to have it return as a young woman to wreak further havoc until it is finally driven out by the Black women of the neighbourhood. During her life with Sethe, her sister Denver and Paul D, the ghost, Beloved, like the return of the repressed, forces each of them to come to terms with their past.

Beloved offers a version of the meaning of slavery, racism and patriarchy in which subjectivity and voice are central. Mediated by an absent narrator who speaks from an African-American perspective and uses the language of the African-American community, the narrative consists mostly of a polyphony of voices of Black women slaves or former slaves.

The text presents competing narratives in which changing sets of meanings and values enable the characters to make sense of their lives. These meanings and values are formed in opposition to the racist and patriarchal ways of thinking which characterize dominant White discourse and provoke various forms of resistance.

The text offers a critique of both liberal and conservative approaches to slavery through the juxtaposition of Black and White perspectives. Liberal slave-owners, like Garner, are shown to respect the individual while failing to address the structural relations of oppression from which they benefit, a position which has parallels in present-day attitudes to race. Garner is shown to treat his male slaves as men who are responsible, thoughtful and who have a positive contribution to make to the running of the estate – treatment which belies the power structures of slavery which denied all forms of Black autonomy.

Gender relations at Sweet Home reflect White patriarchal society and deny liberal subject positions to both Black and White women. The liberal climate is, however, shown to be important to the men. Having a voice, being able to speak in one's own right, that is, being the subject rather than object of discourse, is central to resistance to slavery and to White definitions of Blackness. Crucial, too, is the question of respect. Remembering Sweet Home, Paul D reflects: 'In their relationship with Garner was true metal: they were believed and trusted, but most of all they were listened to' (p. 125). Yet the right to speak as a Black man under slavery was only at the whim of the White owners and subsequent experience of the full brutality of slavery, makes Paul D ask whether he was a man by 'Garner's gift or his own will' (p. 220).

Black subject positions in the novel are defined in a relation of difference from White definitions of Blackness and of gender. These are represented not as singular and unchanging but as a site of struggle in which Whites also battle over meanings which have direct bearing on their material interests. Extreme racist views are represented in *Beloved* by Schoolteacher's theories of race which find support among other White slave owners. Yet the contradictions and conflicts in White definitions of race are important in the process of articulating resistant forms of Black subjectivity and the right to define oneself rather than be defined is shown to be central to resistance to slavery.

Beloved suggests that language, subjectivity and power are integrally related. Both Sixo, the most perceptive of the Sweet Home slaves, and Schoolteacher, the harsh racist manager, recognize the importance of language and the power to define oneself and situations, a power which relies on being a speaking subject. Slavery is shown to deny identity at this most basic level. Slaves were not even recognized by their own names; to Whites they were all the same, distinguished only by the brands which marked ownership. The three brothers at Sweet Home are all called

Paul; Baby Suggs is called 'Jenny' by her owners; and, once a prisoner, Paul D has only a number.

Under slavery resistance to White definitions can only mean rejection of dominant forms of language. This language defines Black women and men as inhumanly other and the perpetuation of the system rests on this opposition between Black and White. Even the liberal Whites in the novel recognize the danger of letting Black men and women occupy subject positions reserved for Whites. Thus Garner does not allow his men off Sweet Home and Mrs Garner refuses Sethe a marriage ceremony which might blur differences between Sethe and herself in a world in which they are both subject to the power relations of a White patriarchy and find themselves working side by side in the kitchen.

Under Schoolteacher, Black attempts to control meaning are subject to violent physical repression. For example, Sixo attempts to use the dominant language to turn meaning around, but is beaten for it 'to show him that definitions belonged to the definers – not the defined' (p. 190). He gives up speaking just as he has previously refused the opportunity to learn to read and write: '[he] said it would change his mind – make him forget things he shouldn't and he didn't want his mind messed up' (p. 208). It is a doubly marginal Black ex-slave woman, Baby Suggs, who, rejecting the White, male order of meaning in which she has no place from which to speak, even when free, creates an alternative positive language based on self-love:

'Here,' she said, 'in this here place, we flesh; flesh that weeps, laughs; flesh that dances on bare feet in grass. Love it. Love it hard. Yonder they do not love your flesh. They despise it. They don't love your eyes; they'd just as soon pick em out. No more do they love the skin on your back. Yonder they flay it. And O my people they do not love your hands. Those they only use, tie, bind, chop off and leave empty. Love your hands! Love them. Raise them up and kiss them. Touch others with them, pat them together, stroke them on your face 'cause they don't love that either. *You* got to love it, *you*! (p. 88)

Beloved depicts subjectivity as both relative and socially produced. Sethe's killing of her child does not tell us anything essential about her nature but is shown to be produced by slavery itself. Sethe sees morality as context-bound – not only where killing her children is concerned but in lesser things. For example, she finds pilfering acceptable at Sweet Home under Schoolteacher but not once she is working. Similarly Paul D experiences shifting subjectivity: 'When he looks at himself through Garner's eyes, he sees one thing. Through Sixo's, another. One makes him feel righteous. One makes him feel ashamed' (p. 267). In the Civil War he feels a little ashamed at feeling 'pity for what he imagined were the sons of the guards in [the prison camp in] Alfred, Georgia' (p. 268).

Beloved is a novel very much concerned with resistance to slavery and racism. It suggests that resistance can take both negative and positive forms. It can result in violence, the violence of the White male oppressors that Paul D experiences in the prison camp in Georgia, or the violence of death, as in the case of Sixo, who is burned and shot because he refuses to be silenced, or of Sethe who, in response to violation of her integrity as woman and mother, attempts to kill all her children and kills one. Alternatively it can take the form of the self-love preached by Baby Suggs, Sethe's mother-in-law, a path which leads to a new identity. She preaches an independent Black identity, an alternative religion in which self-love and self-esteem are paramount. Yet even Baby Suggs's ability to love is finally broken by those Whites who provoke Sethe to kill her child, a choice Baby Suggs can neither approve nor condemn. Slavery, the novel suggests, undermines the possibility of any general standard of morality.

In *Beloved* self-love, love for one another and solidarity between women are shown as important forms of resistance to White racism and patriarchy. Sethe's escape and successful delivery of a baby daughter, Denver, are only possible with the help of a poor White girl. Her recovery is brought about by love and care of her mother-in-law, Baby Suggs. Her final rescue from fatal persecution by her daughter's ghost is the result of the collective action of the Black women of the neighbourhood, who are also important in reintegrating Sethe's daughter Denver into society. The double marginality of Black women forces them to develop new subject positions which resist both racism and patriarchy.

Beloved displays many features which might be described as 'postmodern'. It refuses to endorse a single account of the Black experience of slavery, articulating a range of Black voices including those of the dead. The realism of the narrative is set against a plot which challenges the authenticity of realism since the central catalyst for coming to terms with the past is the return of a dead baby daughter as a grown woman. History, in the novel, is depicted as a process in which forms of subjectivity and meanings change. It is not constituted by a single narrative but by many. Moreover, the oppositions between Black and White which underpin racism are shown to be constructed and are changeable.

Conclusion

Writing by women of Colour, in both Britain and the United States, contests the dominant orders in which racial oppression is naturalized or rendered invisible. The voices of women of Colour have been long marginalized within White racist culture. Dominant understandings of

cultural difference and cultural imperialism work against the assertion of visible, positive, oppositional subject positions for women of Colour. Although, in the United States, long-established African-American communities offered women valued status, these communities were fraught with problems of sexism. In Britain the lack, until recently, of outlets for Black cultural expression rendered Afro-Caribbean and Asian women's perspectives virtually invisible.

The project of much writing by women of Colour, both in Britain and the United States, has been, among other things, to make racial and sexual oppression visible and to depict its effects on the subjectivity of its subjects. Fiction by women of Colour addresses the multiple power relations which constitute femininity and make the problem of achieving a positive identity so complex. It has undermined any easy assumptions on the part of White feminist readers that women have either a shared experience of oppression or a simple, transparent relationship to language.

African-American, Afro-Caribbean and British Asian women's writing demonstrates that it is possible to raise important issues about racism and sexism using both realist and postmodern textual strategies. Realism has been central to the process of making Black experience visible and affirming its importance. Different forms of realism, particularly autobiographical narrative, are important tools for constructing positive forms of identity for women, especially in the case of doubly marginalized groups of women such as women of Colour. The strengths and limitations of realism lie in the ways in which its textual strategies construct singular subject positions and use language as if it were a transparent expression of Black female experience. In *The Color Purple*, for example, we are offered a version of what it means to be a Black lesbian woman and how such a woman becomes her own woman, achieving a positive identity where she had none. This technique of writing invites empathy rather than the mixture of empathy and questioning that results from the use of postmodern textual strategies such as are to be found in *Beloved*.

Postmodern writing strategies can offer new perspectives on racism and sexism because they highlight language as a site of struggle over meaning. They insist on the idea of narrative, including historical narrative, as plural and of subjectivity as a cultural construct. The self-conscious nature of postmodern writing, with its questioning of singular meaning does not mean that either meaning or subjectivity disappear. We still have narratives, meanings, values, subjects and social implications, but we also gain an insight into how these are produced and how they are not singular and true, but potentially plural, changing, changeable and above all political.

Part IV
The Cultural Politics of Race

On Blackness and Subjectivity

Being a Negro in America is not a comfortable existence. It means being a part of the company of the bruised, the battered, the scarred, and the defeated. Being a Negro in America means trying to smile when you want to cry. It means trying to hold on to physical life amid psychological death. It means the pain of watching your children grow up with clouds of inferiority in their mental skies. It means having your legs cut off, and then being condemned for being a cripple. It means seeing your mother and father spiritually murdered by the slings and arrows of daily exploitation, and then being hated for being an orphan. Being a Negro in America means listening to suburban politicians talk eloquently against open housing while arguing in the same breath that they are not racists. It means being harried by day and haunted by night by a nagging sense of nobodiness and constantly fighting to be saved from the poison of bitterness. It means the ache and anguish of living in so many situations where hopes unborn have died.

— Martin Luther King Jr

9

Marking Difference, Asserting Power: the Cultural Politics of Racism

The AA subway train to Harlem. I clutch my mother's sleeve, her arms full of shopping bags, Christmas heavy. The wet smell of winter clothes, the train's lurching. My mother spots an almost seat, pushes my little snow-suited body down. On one side of me a man reading a paper. On the other, a woman in a fur hat staring at me. Her mouth twitches as she stares and then her gaze drops down, pulling mine with it. Her leather-gloved hand plucks at the line where my new blue snow pants and her sleek fur coat meet. She jerks her coat closer to her. I look. I do not see whatever terrible thing she is seeing on the seat between us – probably a roach. But she has communicated her horror to me. It must be something very bad from the way she's looking, so I pull my snow suit closer to me away from it, too. When I look up the woman is still staring at me, her nose holes and eyes huge. And suddenly I realizé that there is nothing crawling up the seat between us; it is me she doesn't want her coat to touch. The fur brushes past my face as she stands with a shudder and holds on to a strap in the speeding train. Born and bred a New York City child, I quickly slide over to make room for my mother to sit down. No word has been spoken. I'm afraid to say anything to my mother because I don't know what I've done. I look at the sides of my snowpants, secretly. Is there something on them? Something's going on here I do not understand, but I will never forget it. Her eyes. The flared nostrils. The hate.
— Audre Lorde, *Sister Outsider*, 1984, pp. 147–8

As If She Had Seen a Roach . . .

Racism is insidious. It is not simply that it provides justification for economic exploitation and political domination. If that were all racism

did, its victims could live with it. The problem is that racism penetrates to the very core of who we are. It is one of the primary influences negating – or affirming – our sense of individual and group worth, passing final judgement on the value of one's history, culture and language, of one's intellect and physical appearance.

The problem is not that the woman sitting next to the young Audre *believes* that Black people are inferior to Whites, that she subscribes to an ideology of racism – although this would be bad enough. Rather, she *knows* that the brown child is repugnant – knows it in her bones, knows it before she thinks it.

> TRUTH: 'I learned . . . that to be a Negro meant, precisely, that one was never looked at but was simply at the mercy of the reflexes the colour of one's skin caused in other people.'
>
> — James Baldwin, *Notes of a Native Son*, 1964, p. 90

Her response is visceral, physiological: she stares, . . . her mouth twitches, . . . her hand plucks, . . . she jerks, . . . she communicates her horror, . . . her nostrils flare, . . . her eyes bulge, . . . she stands with a shudder Her whole body signifies defilement and hate. It is as if her space had been invaded by someone with a horrific, contagious disease. It is as if she had seen a roach.

The child, for her part, is shocked and hurt to discover that she is the object of such disdain. But her primary reaction is one of confusion, and creeping self-doubt: 'I don't know what I've done. I look at the sides of my snowpants, secretly. Is there something on them? Something's going on here I do not understand' Whatever it is I have done, I accept my guilt.

> TRUTH: 'I can conceive of no Negro native to this country who has not, by the age of puberty, been irreparably scarred by the conditions of his [or her] life.'
>
> — James Baldwin, *Notes of a Native Son*, 1964, p. 72

RACISM CREATES ITS SUBJECTS – on both sides of the divide. The subjectivity of the White woman in the fur coat – her sense of who she is in relation to other people – is fundamentally the product of a social and cultural system that magnifies differences of skin-colour and phenotype, and links these differences to notions of superiority and inferiority. Similarly, the young Audre's subjectivity will be largely the product of racially structured meanings, racial discrimination and other forms of racial domination and oppression. This brings us to FUNDAMENTAL QUESTIONS:

- What is this system that victimizes Audre and the woman passenger with whom she has shared a seat?
- How do racist cultural politics work?
- How and why do they affect our subjectivity?

In this chapter we suggest that, as cultural politics, racism makes certain claims about CULTURE, HISTORY, and INTELLECT – about who has them and who does not; that it makes certain claims about THE BODY – about beauty, ugliness, sexuality; and that it makes assertions about CHARACTER – about what different categories of people are like. These beliefs, attitudes, feelings are not individual: they are the property of collectivities, of groups, of society. The woman sitting next to the young Audre Lorde belongs to a social grouping – 'White Americans' – who largely define themselves in relation to 'non-White' people.

> TRUTH: 'The Afro-American encounter with the modern world has been shaped first and foremost by the doctrine of white supremacy, which is embodied in institutional practices and enacted in everyday folkways under varying circumstances and evolving conditions.'
> — Cornel West, 'A Genealogy of Modern Racism', 1982, p. 47

Racism is a cultural and institutional phenomenon, not fundamentally a matter of individual psychology, not of 'racists' or 'prejudiced individuals'. It is deeply ingrained within the dominant social structures and signification systems of contemporary Western societies.

We also suggest that racism, as a system of cultural power, has profound effects on SUBJECTIVITY. When a person of Colour says, 'Who Am I?' or 'Who Are We?' she or he has already posed a question about race. Issues of race and subjectivity recur in the following chapters, especially chapter 14, which is on the cultural politics of Australian Aboriginal writing.

It is fashionable these days to think of RACISM AS DISCOURSE ABOUT DIF-FERENCE. This is not false, but surely the more useful stance, certainly in the first instance, must be to think of RACISM AS BRUTALITY – as one of the most vicious, degrading practices in human history. The slave ships, the plantations, the colonial wars, Auschwitz – to forget this history is to abandon an understanding of racism.

One of the ways the cultural politics of racial domination works is through *terror* and *genocide* – physical and/or cultural. In these contexts and others, racism as a system of meaning and power often foregrounds THE BODY OF THE OTHER – as object of ridicule or admiration, as object for domination or commodification. This topic is pursued at some length in the present chapter.

Manly Sports

In the nineteenth century a favourite pastime of Australian settlers was *lobbing the distance*. This manly sport, perhaps inspired by European football (soccer), consisted of the following. Small Aboriginal children were buried up to their necks in sand. The colonists then competed to see who could kick off the children's heads and send them flying the greatest distance (see Gilbert, 1988b, p. xxii; Lippmann, 1981, p. 21). It seems a great time was had by all – except the Black children who were killed or maimed and their grieving relatives and friends, who often watched helplessly as this sick spectacle took place.

Another favourite pastime of those who brought civilization to Australia, apparently 'made popular by the close proximity of good dry firewood, was to cut the throats of Black women and men and let them run in terrified flapping circles', like chickens with their heads cut off, until they collapsed, whereupon their civilized friends threw their exhausted bodies on to the fire. 'Live children were thrown directly into the flames' (Gilbert, 1988b, p. xxii).

A third pastime was perhaps inspired by that very English, very gentlemanly game, the foxhunt. Or maybe it was inspired by the turkey shoot. In any event, this game, usually played on Sunday afternoons, presumably after the good Christians had attended church services, consisted of chasing down fleeing Aborigines and shooting them from behind.

A fourth manly sport was the raping of Aboriginal women. The rules of this particular sport varied. One innovation involved kidnapping these women and keeping them in conditions that varied somewhere between imprisonment and enslavement. Listen to the account in a letter submitted in 1897 to the Select Committee on the Aborigines Bill by R. C. Thorpe, a White policeman, regarding the situation of Aboriginal women on the Queensland–Northern Territory border:

> They were run down by station blackguards on horseback, and taken to the stations for licentious purposes, and there kept more like slaves than anything else. I have heard it said that these same lubras have been locked up for weeks at a time – anyway whilst their heartless persecutors have been mustering cattle on their respective runs. Some, I have heard, take these lubras with them, but take the precaution to tie them up securely for the night to prevent them escaping. (Quoted in Lippmann, 1981, p. 19)

A second innovation in this manly sport of rape involved 'tying the severed head of the husband around the neck of the raped spouse' (historian Rhys Jones, quoted in Lippmann, 1981, p. 21).

By the mid-1800s, most Aboriginal groups standing in the way of White colonization had been militarily defeated if not exterminated. From the early decades of the 1800s survivors of the defeated groups were herded into church missions and reserves – like the South African 'native reserves' and the American Indian reservations. On the reserves, physical genocide continued. (In the missions, the process might best be described as *cultural* genocide – a point to which we shall return.) As the land meted out as reserves was too poor to sustain human life, Aborigines living there were forced to rely on their conquerors for rations of the barest necessities – flour, salted beef, tea, sugar – which they received, instead of wages, for working for their White masters.

> TRUTH: 'All that the native has ever seen in his country is that they can freely arrest him, beat him, starve him; and no professor of ethics, no priest has ever come to be beaten in his place, nor to share their bread with him.'
> — Frantz Fanon, *The Wretched of the Earth*, 1967, p. 67

It was in the context of dependency relations that a fifth pastime occurred. It combined benevolence, entertainment and science. This pastime was perhaps inspired by traditions of gift-giving – or perhaps by traditions of rat-killing and the extermination of vermin. Thousands of Aboriginal people were poisoned by arsenic or strychnine in the bags of flour graciously given to them by the White colonists, or by cyanide in the meat. Even more were killed off by diseases kindly transmitted to them by their uninvited guests. Some of these diseases were deliberately transmitted through infected blankets.

Like the Nazis who sometimes made leather goods out of the skins of their victims, early White settlers in Australia sometimes made tobacco pouches from their victims' testicles. Good use was also made of skulls and skeletons of murdered Aborigines: many of these were given to science, to museums and laboratories concerned with the comparative study of human anatomy and culture.

> I drive past Mitchell, a suburb of Canberra, and glance towards the buildings that house some eight hundred Aboriginal skulls, including many of the Murray Black collection, skulls of my ancestors. This triggers my mind to dwell on many more Aboriginal skeletons lying disrespectfully in the State museums around the land, as well as in museums overseas . . . [and on] the bodies skinned for their cicatrice patterns and pickled in the South Australian Museum basement. (Gilbert, 1988b, p. xxi)

And Still You Hold Your Tongues . . .

It is not right, my fellow-countrymen, you who know very well all the crimes committed in our name, it's not at all right that you do not breathe a word about

them to anyone, not even to your own soul, for fear of having to stand in judgement
on yourself. I am willing to believe that at the beginning you did not realize what
was happening; later, you doubted whether such things could be true; but now you
know, and still you hold your tongues.

— Jean-Paul Sartre, Introduction to Fanon's *The Wretched of the*
Earth, 1967, p. 25

Black Bodies: the Politics of Representation

Mum said she didn't want the children growing up with people looking
down on them. I understood what she meant. Aboriginals were treated the
lowest of the low. It was like they were the one race on earth that had nothing
to offer.

When I was little, Mum had always pinched my nose and said, 'Pull your
nose, Gladdie, pull it hard. You don't want to end up with a big nose like
mine.' She was always pulling the kids' noses, too. She wanted them to grow
up to look like white people.

— Sally Morgan, *My Place*, 1987, p. 305

He did not fail to remind me that my child was an addition to his stock of
slaves.

— Harriet Jacobs, *Incidents in the Life of a Slave Girl*,
1861/1987, p. 61

Racism assumes a view of the world in which people are divided into
'races': it is based on a conception of differences among people as having
fundamentally to do with the traits they inherit, or supposedly inherit, by
virtue of being part of some gene pool. Throughout human history,
groups of people have found ways of emphasizing differences between
themselves and their neighbours. Such distinctions as Civilized/Barbar-
ian, Occident/Orient, Moslem/Christian, Christian/Jew are among those
that have been widely used over the last few thousand years. Moreover,
people in many societies and historical periods have made aesthetic and
sometimes moral judgements about different phenotypes: some facial
features have been considered more attractive than others, some ethnic or
racial groups have been viewed as more sensual than others, and so on.

But it has only been within the last few hundred years – since human
beings became so terribly enlightened – that people have definitively
determined the worth of other human beings on the basis of skin colour,
hair texture, lip size and other physical traits.

As discourse and as nondiscursive practice *racism and colour-prejudice*
operate in and through the body. Consider the following.[1]

Disposable Machines

It is said that packs of sharks used to follow the slave ships across the Atlantic from the west coast of Africa to the Americas, lying in wait to feast on disposable Black bodies. By conservative estimates, at least a million enslaved Africans failed to make it across the Middle Passage. Like sacks of rotten potatoes, the dead, and sometimes the dying, were tossed overboard by their new masters, the benevolent agents of White civilization. Smelling and tasting red blood and brown flesh, the sharks followed the slave ships.

On the cotton plantations of the American South, Black women were used as breeders to produce an ever-increasing supply of young, strong slave labourers. The Black slave woman's children did not belong to her: they were the property of the master – who could do with them as he chose. Having branded them like oxen, he could sell them or hire them to the highest bidder. He could use them as objects of ridicule or sadistic pleasure. He could beat them or murder them – without violating a single law.

On the sugar plantations of the British West Indies the life expectancy for a slave was seven years. Like a machine in a continually running factory, or a mule worked to death by its master, black bodies were consumed – literally used up – and then replaced by a fresh supply. It was an economically rational system, one that continued for several centuries.

One of the recurrent refrains in African-American slave narratives is this: *'I been treated like a mule'*

The practice of viciously exploiting the labour of people of Colour – Africans, Asians, American Indians . . . – in the European colonies of the Old World and the New, could not have continued without ideological justification: one cannot treat other human beings like animals without believing – eventually, at least – that they somehow belong to a lesser order.

> A HISTORY LESSON: 'There was a day, and not really a very distant day, when Americans were scarcely Americans at all but discontented Europeans, facing an unconquered continent and strolling, say, into a market-place and seeing black men [i.e., black people] for the first time. The shock this spectacle afforded is suggested, surely, by the promptness with which they decided that these black men were not really men but cattle. It is true that the necessity on the part of the settlers of the New World of reconciling their moral assumptions with the fact – and the necessity – of slavery enhanced immensely the charm of this idea. . . .' (Baldwin, 1964, p. 159)

Racism as discourse and imagery provides such ideological justification. Racist ideology says that 'THEY' ARE NOT LIKE 'US' – that, unlike us, they are

uncivilized, debased and lazy; that they are in need of strong discipline; that they can stand the heat, the dirt and hard manual labour; that they don't really have a bad life; that it is God's will for them to serve us; that they are no better than cockroaches . . .

QUESTION: What is racism?
ANSWER: In the first instance, it is ideological justification for some of the most cruel and barbaric practices in human history. In particular, it provides a cover-up for the brutal exercise of power over the bodies of Others.

The power of racist ideology has weakened somewhat over the last century. However, some of the practices that it justified continue, even if on a reduced scale. Today, in many Western countries people of Colour perform the least-desirable jobs – the dirty jobs, those requiring muscle-power, those which have no future in a technological society. This fact is an effect of racism: the belief that people of Colour *should* have such jobs, that their role should be that of a modern-day mule.

Everyone knows Black people are only physical. They are super-athletes (and super-studs): sprinters, leapers, boxers, football players, basketball players, baseball players, cricketers

THE BLACK = THE SUPER-ATHLETE

For generations in Australia there were travelling shows whose entertainment included boxers who would take on all challengers, one after another. The boxers were often Australian Aborigines; the challengers and audiences were generally Australian Whites. From the point of view of the audience, the object of this entertaining and money-making spectacle was for the local 'White hope' to beat his brown-skinned opponent. The Aboriginal boxers made little money compared to those who managed them and/or took the bets. None the less, boxing and other sports seemed to offer a degree of success to Aboriginal sportsmen and sportswomen, denied them in other areas of social life.

Similarly, in the USA sport has long seemed to promise success, fame and wealth to young Black people. For a few, indeed it does. However, for every successful Black athlete there are hundreds of thousands of failures, many of whom have been channelled into basketball, football, baseball and track-and-field at an early age by the often unconscious racism of schoolteachers, counsellors and coaches.

THE HELPFUL COUNSELLOR: Don't bother about mathematics, science and language skills. We have just the place for you – a place where you can be a star . . .
THE FRIENDLY TEACHER: We have nothing against our Coloured students. We seek only to do what is best for them . . .

COLLEAGUES: We subscribe to the deeply held belief that Black people are more physical than intellectual and that academic subjects are best reserved for Whites . . .

The Beautiful . . . and the Ugly

The recovery of classical antiquity in the modern West produced what I shall call a 'normative gaze', namely, an ideal from which to order and compare observations. This ideal was drawn primarily from classical aesthetic values of beauty, proportion, and human form and classical cultural standards of moderation, self-control, and harmony. The role of classical aesthetic and cultural norms in the emergence of the idea of white supremacy as an object of modern discourse cannot [i.e., must not] be underestimated.
— Cornel West, 'A Genealogy of Modern Racism', 1982, pp. 53–4

Who is beautiful? Who is ugly? On what basis do we decide? From where do our standards of physical beauty come?

Today many of our decisions about who is beautiful – or not-so-beautiful – are facilitated by Hollywood images of desirable women and men (who are overwhelmingly White), by fashion magazines and by other visual communications media. Thomas Jefferson, that great champion of human equality – who also happened to own several Virginia slave plantations – did not have Hollywood to help him choose an idealized image of WHITE WOMANHOOD as the universal standard of beauty. None the less, he had no problem coming to the following firm conclusion:

> Are not the fine mixtures of red and white, the expressions of every passion by greater or less suffusions of colour in the one, preferable to that eternal monotony, which reigns in the countenances, that immoveable veil of black which covers all the emotions of the other race? Add to these, flowing hair, a more elegant symmetry of form, and their own judgment in favour of the whites, declared by their preference of them, as uniformly as is the preference of the Oran-ootan for the black women over those of his own species.[!!] The circumstance of superior beauty, is thought worthy of attention in the propagation of our horses, dogs, and other domestic animals; why not in that of man? (Quoted in Jordan, 1969, p. 458)

Here we have THE WHITE WOMAN AS ANGEL – as in Renaissance oil paintings and the popular imagination of the old (White) American South. (Incidently, the 'fact' that Black women were beauty-wise inferior did not stop the Father of American democracy from having an extended sexual

relationship with one of his 'mixed-race' slaves, Sally Hemming, which resulted in a number of offspring)

The notion that the 'White angels' possess superior beauty is sometimes accepted by people of Colour. However, it is probably the case that what is most often admired is not the (assumed) *physical* beauty of White women – 'the fine mixtures of red and white', 'flowing hair', 'a more elegant symmetry of form', and so on – but the benefits that have accrued to them by virtue of their *social* status.

> I 'member my mother showing me a picture of a white woman, she was all fancied up in a long, white dress. 'Ooh, Daisy,' she said, 'if only I could have a dress like that.' All the native women wanted to look like the white women, with fancy hairdos and fancy dresses. (Morgan, 1987, p. 328)

As racism defines beauty so it defines ugliness. In the eighteenth and nineteenth centuries, as well as in the first half of the twentieth, a favourite preoccupation of some White cartoonists in Britain and the USA was drawing caricatures of people of African descent. Here, Black people were represented with exaggerated facial and bodily features. They were portrayed as grotesque figures with grossly over-sized lips and noses, rolling eyes, grinning faces, frizzled ('nappy') hair, and so on. Black males inevitably grinned and clowned, Black females were inevitably fat with kerchiefs tied about their heads. The speech of these miserable sub-humans revealed their utter stupidity and depravity, their childlike ignorance of the thoughts, customs and manners of civilized people.[2]

In the autumn of 1992, while on a sightseeing tour of Germany, we were surprised to find a version of the 'Black Sambo' caricature immortalized as a statuette outside a cafe-restaurant in Hamburg (see plate 9.1). This is the friendly version of Black caricature: the creature is intended to be lovable rather than grotesque. (Whatever the intent, most people of Colour find such images offensive.)

Whiter Than Snow

Thus, the African, exile, pagan, hurried off the auction block and into the fields, fell on his knees before that God in Whom he must now believe; who had made him, but not in His image. This tableau, this impossibility, is the heritage of the Negro in America: Wash me, *cried the slave to his Maker*, and I shall be whiter, whiter than snow! *For black is the colour of evil; only the robes of the saved are white.*
— James Baldwin, 1964, p. 26

Devilish Exotics

To appreciate fully what is pure, one must have tasted what is wicked

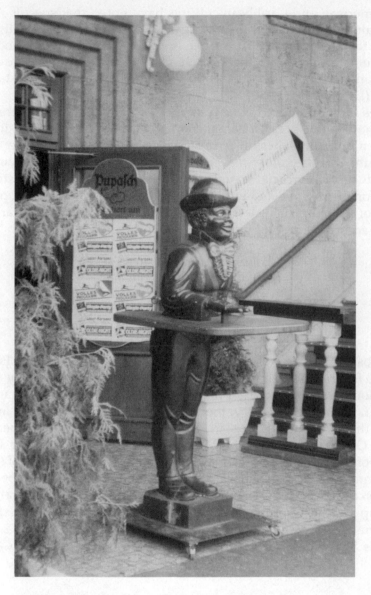

Plate 9.1 Statue of Black Waiter in Hamburg.
Photograph: Chris Weedon.

It would be wrong to assume that White standards of beauty allow no space for non-White beauty. Besides the attraction to 'White angels', there is a long tradition of fascination with EXOTIC WOMEN. These include both women of African descent – at least certain of them – and Women of the East.

Some such tastes were highly cultivated and very specific: 'Students of

Latin American and Caribbean cultures have noted that specific African tribes gained a reputation for having women who made attractive concubines for their masters during slavery' (for example Wolof and Mandingo female slaves in the French Caribbean). In these cases 'the Caucasian norm of physical beauty was not always the most highly valued' (Drake, 1987, p. 80).

Besides the preference for *specific* types of African women there was a much more widespread phenomenon. This phenomenon, again most prominent in Latin America (Spanish America and Brazil) and the French Caribbean, was the *cult of the mulatta.* 'Mixed-race' women, themselves the products of interracial sexual relationships, were – and often still are – prized for their exotic and erotic appeal. They occupy a central place as objects of (White) male desire in a system in which women are categorized according to their use-value:

> *White women are for marrying;*
> *Mulatto women are for fornicating;*
> *Black women are for service.*
>
> —Nineteenth-century Brazilian aphorism
> (quoted in Drake, 1987, p. 80)

Look back at plate 6.3 in the chapter on 'Feminist Cultural Politics'. Plate 6.3 is a reproduction of the magazine cover of *Black Beauty & Hair,* a London-based quarterly publication. Look at the eyes and the mouth. Look at the jewellery, the hair, the body language. The image is that of the EXOTIC ASIAN WOMAN. For hundreds of years the beautiful, sensual Oriental woman – the Middle Eastern, Indian and Far Eastern woman of the Western (male) imagination – has been the object of (White) male fantasy.[3] It is somewhat ironic that this imagery should be reproduced on the cover of a '*Black* magazine': the oppressor's images are often taken up by the oppressed; in this case, they are not even (slightly) transformed.

Here is Shakespeare's Mark Antony speaking, in *Antony and Cleopatra* (II. iii):

> *I will to Egypt:*
> *And though I make this marriage for my peace,*
> *I' the East my pleasure lies.*

For reasons of social convention, Antony marries a White Western woman. His preference, however, is for Cleopatra, a Woman of The East.

The portrayal of The East 'as a land that traded in voluptuousness, a land where sexual desires could be gratified to the hilt' dates from the European imagination of the Middle Ages:

To support the idea of a voluptuous East, the West inflated the Quranic idea of Paradise, arguing that Muslims were not only lewd in every day life, but had conceived of a heaven that would permit endless sensual gratification. . . . The notion of the carnal delights of Islamic heaven was sharply contrasted, in an effort to mock it, with the angelic society of the Christian paradise. Christians were morally refined and longed for a bodiless heaven; Muslims were spiritually coarse and could not envisage bliss that was not corporeal. (Kabbani, 1988, pp. 16–17)

The image of the Middle and Far East as places of fantastic wealth has been perpetuated since the ancient Greeks. By the Middle Ages and especially the Renaissance *the image of The East as a site of eroticism, decadence and sexual gratification* had come to the fore (as had the image of The East as a land of violence and fanaticism). Tantalizing descriptions of 'the harem', real or fictive, became a regular feature in the travel literature written by visitors – White, Western and male – to the East.

When The Eastern Woman appears in the literature of Renaissance and post-Renaissance Europe, it is often as the beguiling seducer of White Manhood. Confronted with overflowing sensuality, exotic beauty and passionate desire, they – poor things – could not help themselves: honourable men, through no fault of their own, were seduced.

As with many other things Oriental, The Western Gaze has historically viewed The Eastern Woman in both positive and negative terms: 'Europe's feelings about Oriental women were always ambivalent ones', fluctuating 'between desire, pity, contempt and outrage. Oriental women were painted as erotic victims and as scheming witches' (Kabbani, 1988, p. 26).

> TRUTH: In the Western imagination exotic beauty has always been linked with passionate sexuality.
> LOGICAL CONCLUSION: The Woman of Colour's position is not on a pedestal, but in the bed.

The history of Western racism and domination over people of Colour is *not* one in which Black, Brown, Red and Yellow people are simply despised. Rather, it is a history in which they – their bodies, their cultures – have served as a source of both ATTRACTION and REPULSION. The victims of racial domination can be admired as much as they are hated and denigrated.[4]

One of the more striking illustrations of this phenomenon is an early nineteenth-century painting by Edwin Long entitled *The Babylonian Marriage Market*. This painting, which sold for more than any other contemporary work of art in nineteenth-century London, 'has a special place in documenting the perception of the sexualized female' in *the great chain of female and racial being* (Gilman, 1992, p. 183).

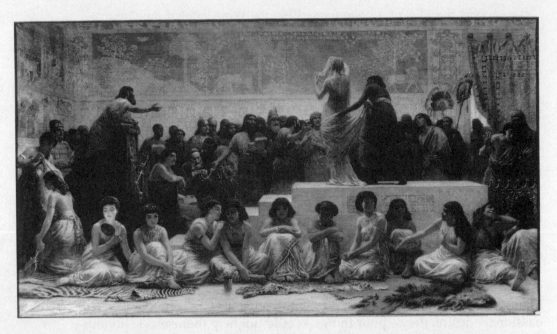

Plate 9.2 The Marriage Market, Babylon, Sir Edwin Long.
Reproduced by kind permission of the Bridgeman Art Library, London.

In an important article, 'Black Bodies, White Bodies: Toward an Iconography of Female Sexuality in Late Nineteenth-century Art, Medicine and Literature', Sander Gilman provides an insightful analysis of *The Babylonian Marriage Market*. Look at the plate 9.2 closely while reading the following:

> Long's painting is based on a specific text from Herodotus, who described the marriage auction in Babylon in which maidens were sold in order of comeliness. In the painting they are arranged in order of their attractiveness. Their physiognomies are clearly portrayed. Their features run from the most European and white (a fact emphasized by the light reflected from the mirror on to the figure at the far left) to the Negroid features (thick lips, broad nose, dark but not black skin) of the figure furthest to the observer's right. . . . This is . . . the Victorian scale of sexualized women acceptable within marriage, portrayed from the most to the least attractive, according to contemporary British standards. The only black female present is the servant-slave shown on the auction block, positioned so as to present her buttocks to the viewer (Gilman, 1992, p. 184)

It is generally the case that eighteenth- and nineteenth-century European and White American paintings (and engravings) which include both White female bodies and bodies of women of Colour are constructed in such a way that they reinforce the dominant iconography of the White female.[5]

Insatiable Appetites

Since the Middle Ages RACE and SEX have been overlapping discourses in the West, especially in those Western societies that have conquered non-Western peoples and/or have been inhabited by people of Colour. Although this linkage dates from before the trans-Atlantic slave trade, it was, of course, considerably strengthened as a result of it.

> TRUTH: 'The Negro gives off no aura of sensuality either through his skin of through his hair. It is just that over a series of long days and long nights the image of the biological-sexual-sensual-genital-nigger has imposed itself on you and you do not know how to get free of it.'
> — Frantz Fanon, *Black Skin, White Masks*, 1968, p. 143

What most distinguishes human beings from animals? Intellect, culture, language, the capacity to reason, the capacity to delay gratification. Now, it is precisely these qualities that, according to the cultural politics of racism, Black people lack. In the discourse and imagery of racism, Black people are but a rung above the apes on the ladder of evolution. Like the beasts of field and forest, Black people have a primitive, insatiable appetite for sexual activity. Here is Bryan Edwards, the liberal-minded Jamaican planter and English politician, writing in the 1790s:

> The Negroes in the West Indies, both men and women, would consider it as the great exertion of tyranny, and the most cruel of all hardships, to be compelled to confine themselves to a single connection with the other sex. Their passion is mere animal desire, implanted by the great Author of all things for the preservation of the species. This the Negroes, without doubt, possess in common with the rest of the animal creation, and they indulge it, as inclination prompts, in an almost promiscuous intercourse with the other sex. (Bryan Edwards, *The History, Civil and Commercial of the British Colonies in the West Indies*, London, 1793, vol. 2, pp. 82–3; quoted in Walvin, 1973, p. 163)

No one should be surprised that Black people, male and female, have immense sexual powers: 'What do you expect, with all the freedom they have in their jungles!' It is a well-known, a long-established truth, that *'They copulate at all times and in all places. They are really genital. They have so many children that they cannot even count them'* – which is a matter about which reasonable people should be concerned: 'Be careful, or they will flood us with little mulattoes' (Fanon, 1968, p. 111; emphasis added).

Everyone knows Africa is the land of licentiousness. Black people all over the world share this trait.

For the Negro is only biological. The Negroes are animals. They go about naked. And God alone knows . . .

—Frantz Fanon, 1968, p. 117

THE BLACK = AN ANIMAL

Large Tools

For hundreds of years the idea has been around that Black men have exceptionally large penises. Initially, this idea was given a degree of scientific legitimacy:

> That the PENIS of an African is larger than that of an European has, I believe, been shewn in every anatomical school in London. Preparations of them are preserved in most anatomical museums; and I have one [i.e., a pickled African penis] in mine. (Dr Charles White, *An Account of the Regular Gradation in Man, and in Different Animals and Vegetables; and from the Former to the Latter*, London, 1739, p. 61; quoted in Jordan, 1969, p. 501)

A century before Dr White, the Englishman Richard Jobson wrote (in 1623) that men of the West African Mandingo 'tribe' were 'furnisht with such members as are after a sort burdensome unto them' (quoted in Walvin, 1973, p. 162). Here, finally, is a twentieth-century version of the large-penis story. The source is a book called *Martinique*, published in 1948 by the French writer Michel Cournot:

> The black man's sword is a sword. When he has thrust it into your wife, she has really felt something. It is a revelation. In the chasm that it has left, your little toy is lost. Pump away until the room is awash with your sweat, you might as well just be singing. This is *good-bye*. . . . Four Negroes with their penises exposed would fill a cathedral. They would be unable to leave the building until their erections had subsided; and in such close quarters that would not be a simple matter. (Quoted in Fanon, 1968, p. 120)

As it turns out, the claim that Black males have larger penises than White males is false – but empirical falsification never stopped a good myth from continuing to be spread. (This is one racial myth that Black men themselves have never been particularly concerned to squash . . .)

The predominant myth regarding Black male bodies is not so much that they are endowed with exceptionally large penises, although this *is* part of it. Rather, it is that the Black man possesses a powerful body with a ravenous sexual appetite – an unquenchable drive for violent, aggressive sex – and that he/it lusts particularly after White women (who are, of course, innocent and helpless).

Things are indeed going to hell . . .
The government and the civil service are at the mercy of the Jews.
Our women are at the mercy of the Negroes.
 —Frantz Fanon, 1968, p. 112

The image of the strong, infinitely virile Black male body seeking to ravish White women is powerful indeed.

> There is something in the mere idea, one young woman confided to me, that makes the heart skip a beat. A prostitute told me once that in her early days the mere thought of going to bed with a Negro brought on an orgasm. She went in search of Negroes and never asked them for money. But, she added, 'going to bed with them was no more remarkable than going to bed with white men. It was before I did it that I had the orgasm. I used to think about (imagine) all the things they might do to me: and that was what was so terrific'. (Fanon, 1968, p. 112)

The mere thought brought on an orgasm . . .

THE BLACK MAN = THE PENIS

The sexualized imagery of the Black male is constantly exploited, by both Whites and Blacks. The BLACK STUD is a recurrent feature in Hollywood films, from the 'Blaxploitation' films of the 1970s to 'Miami Vice' and the films of Eddie Murphy and Spike Lee. Many Black male singers and entertainers, perhaps even most of them, exploit this imagery: Prince, Michael Jackson, James Brown, B. B. King. . . . The oversexed, singing and dancing Black male stands a good chance of making money, especially if he can manage to incorporate a gyrating pelvis into his act.

Besides the Black entertainer, there is The Black Athlete: 'There is one expression that through time has become singularly eroticized: the black athlete' (Fanon, 1968, p. 112). But the Black athlete may also pose a threat: he may overpower my sister, he may rape my wife. I must be diligent.

The Negro as Beast

> BRAVE *Keith Blakelock was killed by* FORTY-TWO *horrific wounds as the screaming mob hacked him to pieces.*
> *He had 14 in his back, eight on his head, 11 on his arms and nine on his face and neck.*
> *Worst was a gaping six-inch gash stretching from the constable's lips to the back of his head.*

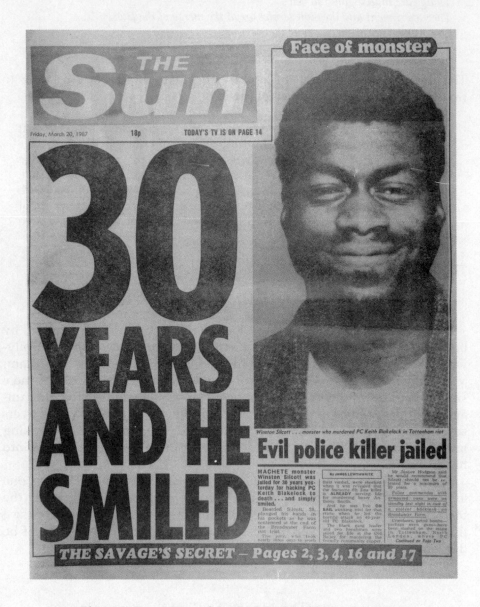

Plate 9.3 Front page of the *Sun*, Friday, 20 March 1987.
Courtesy of News International.

He had fallen to the ground with a bread knife sticking out of his neck and blood pouring from his injuries as the mob demanded his head be chopped off and paraded on a pole.

— *Sun*, 20 March 1987, p. 3

In October 1985, during a riot on Broadwater Farm, a working-class housing estate in London with a substantial Afro-Caribbean population, a White policeman, Keith Blakelock was knifed and hacked to death. Three 'ethnic' male residents of Broadwater Farm, Winston Silcott, Engin Raghip and Mark Braithwaite, were tried for Blakelock's murder. Silcott, a 'well-known criminal' with a long history of encounters with the police and court system, was alleged to be the group leader. On 19 March 1987 the three were found guilty. Winston Silcott – named after Winston Churchill by his Jamaican parents – received a prison sentence of 30 years for leading the murderous attack.

The killing of Police Constable Blakelock and the subsequent murder trial were widely reported in the British press, especially the popular press. On 20 March 1987, the morning after the convictions were handed down, two of Britain's tabloid newspapers, the *Sun* (the country's biggest-selling paper) and the *Star*, published almost identical front pages, one of which is reproduced in plate 9.3. Both papers devote five or six pages to the story.

What imagery is used in these articles? What system of meanings is invoked? First, consider the visual imagery, the pictures. Both papers feature the same large photograph of a smiling Silcott – contextualized in such a way that the viewer is strongly encouraged to read it as the face of a *'savage'* or *'monster'* with *'the smile of evil'*. This is a powerful representation of THE BLACK BRUTE, the fierce Black male – half-man, half-beast – who is an ever-present threat to civilization, that is, to White people. Other photographs are also used in the articles, the most prominent being one on the centre pages of the *Sun*. It is a photograph of Police Constable Blakelock's grieving widow seated in her home beneath a huge, life-size painting of her (brutally murdered) husband. The caption below it reads, 'Widow Elizabeth . . . the haunting portrait of her husband consoles her, recalling the happy times they shared.'

The dominant imagery in the articles is that of beasts, savages and evil-doers – uncivilized (read: *un-British*) aliens who pose a direct threat to our way of life. Here are some of the headlines and large-print captions used. From the *Sun*:

30 YEARS AND HE SMILED

Evil Police Killer Jailed

Face of Monster

THE SAVAGE'S SECRET

SILCOTT'S RECORD OF EVIL WAS KEPT SECRET

VICTIM OF THE SAVAGES

*WIDOW OPENS HER HEART ABOUT THE MURDER SHE
KNEW WAS GOING TO HAPPEN*

And from the *Star*:

SMILE OF EVIL

30 YEARS FOR BEAST WHO WAS FREED TO KILL AGAIN

30 YEARS FOR EVIL BEAST . . .

HOODED ANIMALS OUT FOR BLOOD

COUNTDOWN TO TERROR

A critical reading of these headlines and captions, together with the articles, provides some interesting insights into the politics of racial representation. Look back at the quotation from the *Sun* with which this section began. The first sentence establishes the crucial semantic opposition:

THE BRAVE LAW OFFICER vs. THE SCREAMING MOB

This relation is underpinned by a second semantic opposition:

GOOD vs. EVIL

Silcott in particular is the embodiment of evil, a central theme echoed in the *Star*:

> Silcott arrogantly believed . . . fear would save him from conviction in the killing of Pc Blakelock.
> For he ruled the lawless Broadwater Farm *jungle* with a *reign of terror*.
> Even his friends did not dare to look him in the eye.
> (*Star*, 20 March 1987, p. 2; emphasis added)

As for the screaming mob – the evil element within our midst – they are engaged in a SAVAGE RITUAL. Screaming, undoubtedly in delight as much as in rage, these jungle savages brutally hack the brave police constable to death. Among the 42 knife and machete wounds was 'a gaping six-inch gash stretching from the officer's lips to the back of his head'. No civilized person could engage in such an horrific attack. The six-inch gash – the mark of the beast? – was presumably inflicted in an attempt by the savages to behead the officer. Within our society we are faced now with an ongoing battle:

THE SAVAGES vs. THE CIVILIZED

The battle is not simply a result of the rise in criminality among the British population. It is also a result of immigration: the Blacks have come and, with their uncivilized behaviour, are posing a serious threat to 'our way of life', to the very fabric of British society.

THE IMMIGRANTS/THE BLACKS vs. SOCIETY AS WE KNOW IT

Not content simply to kill the officer, the frenzied mob, led by The King of Beasts (Silcott), 'demanded his head be chopped off and paraded on a pole' for all to see. In medieval Europe, for example, in France and Britain, criminals were often subjected to public punishment, to ritualized exercise of a precise and horrific technology of power directed on to the body. They were put on the rack; hung, drawn and quartered; covered in burning oil; hacked to pieces; or otherwise publicly tortured. After their public execution the heads of the villians were sometimes displayed on spiked poles, sometimes on castle gates, as a lesson to others who would dare to challenge monarchical law. The *'carnival of atrocity'* or crude *'ritual of power'* – the terms are borrowed from Michel Foucault's *Discipline and Punish* (1979a) – that took place on the Broadwater Farm housing estate was, the *Sun* appears to be suggesting, like those barbaric rituals of torture and display which took place in the Western past (that is, before we ourselves became fully civilized).

But the murder of Police Constable Blakelock, 'the friendly community copper' (*Star*), was not simply a ritual of power: it was also a carnivalesque *ritual of merriment*. The crowd of sadistic savages *enjoyed* this group murder. Most murderers would pursue every means to hide themselves and, if possible, also their victim. Not so with subhumans and other savages, because they lack conscience, a basic sense of morality. The animals, or rather beasts, monsters and savages, of Broadwater Farm wanted their deed publicly displayed – like the scalps proudly carried by 'savage' American Indian warriors or the shrunken heads proudly worn by 'primitive' headhunters in the South American jungle. This brings us to the smile.

MACHETTE monster Winston Silcott was jailed for 30 years yesterday for hacking PC Keith Blakelock to death . . . *and simply smiled.* (*Sun*, 20 March 1987, p.1)

THE monster who led the gang murder of Pc [Police Constable] Keith Blakelock swaggered from the dock yesterday *with a smile on his face.* (*Star*, 20 March 1987, p. 1)

Why so much emphasis on THE SMILE? This is not incidental but crucial

to the politics of representation employed. *The smile, or rather the evil grin, is the proof of savagery* – of Silcott's savagery in particular but also, it would appear, that of the mob he allegedly led. A brute or monster may kill, but only a savage smiles afterwards.[6]

> *Like the 'African cannibal' who, having eaten his victim, licked his lips and smiled an evil grin . . .*

Here the imagery is that of a sadistic killer – a Black beast, leader of a band of savages, perhaps as many as 40 of them, the articles tell us, who hacked a White law-enforcement officer to pieces for the pleasure of it. (For the record, it should be mentioned that, subsequent to Silcott's conviction together with two co-defendants, the confession statements presented in evidence at the trial were discredited. Electronic testing proved that they were not reliable and the conviction was quashed.)

Today, representations of non-White people as beasts and savages is not a routine feature of the popular Western media.

> A CONTESTING VOICE: *Ask Winston Silcott! Ask Mike Tyson![7] Ask Willie Horton – the Black rapist whose picture featured widely in 1988 campaign ads for President George Bush, as a warning about what the country would get should the Democrats be elected . . .*

However, it used to be, especially in White newspapers and popular books of the nineteenth and early twentieth centuries in the American South, Australia and South Africa, as well as in Hollywood films.

Such imagery also had SCIENTIFIC RESPECTABILITY. For example, in an essay entitled 'The Relation of the Whites to the Negroes', which was published in May 1902 in the *Publications of the American Economic Association*, George T. Winston, presumably an objective scholar, wrote of events preceding a lynching in the American South:

> when a knock is heard at the door, [the White woman] shudders with nameless horror. The black brute is lurking in the dark, a monstrous beast, crazed with lust. His ferocity is almost demoniacal. A mad bull or a tiger could scarcely be more brutal. A whole community is frenzied with horror, with the blind and furious rage for vengeance. (Quoted in Fredrickson, 1972, p. 278)

The (White) community, being good and honourable people, do the right thing: they lynch the Black brute. Actually, any old nigger will do: the important thing is to exact revenge and to teach the beasts a lesson.

Many readers will have seen or read of *Birth of a Nation* (1915) by W.C. Griffith. *Birth of a Nation* is widely discussed as a classic in the history of

Hollywood film. Most discussions manage to omit the fact that it is one of the most viciously racist films ever produced – cleverly linking Black images to hypersexuality, criminality and bestiality; and providing popular ideological justification for racist supremacy and the terror and lynching of the Ku Klux Klan.

IMMORALITY + CRIMINALITY + BESTIALITY = THE BLACK

Birth of a Nation is based on *The Clansman: An Historical Romance of the Ku Klux Klan* (1905), a novel by Thomas Dixon, a southern preacher and racist ideologue who was a close friend of Griffith. Dixon and Griffith collaborated not only on *Birth of a Nation* but also on several lesser films in celebration of southern White supremacist society and culture. The following is a typical line from Dixon's book:

> A single tiger spring, and the black claws of the beast sank into the soft white throat. (Dixon, 1905, p. 293)

The topic, of course, is a favourite one: Black male rape of a White woman.

NEGROPHOBIA, that is pathological fear of Black people, has been a recurrent theme in the history of the United States of America, as in several other racist countries (especially South Africa). For the most part, 'Black people' and 'White people' in the USA do not relate to one another as human beings, but as objects of mutual suspicion, fear and dislike. Today, many White Americans who own guns, own them as protection against potential Black rapists, brutalizers or murderers.

This brings us to 'MORAL PANICS'.

What are 'moral panics'? And what have they to do with the cultural politics of race and racism?

> When the official reaction to a person, groups of persons or series of events is *out of all proportion* to the actual threat offered, when 'experts', in the form of police chiefs, the judiciary, politicians and editors *perceive* the threat in all but identical terms, and appear to talk 'with one voice' of rates, diagnoses, prognoses and solutions, when the media representations universally stress 'sudden and dramatic' increases (in numbers involved or events) and 'novelty', above and beyond that which a sober, realistic appraisal could sustain, then we believe it is appropriate to speak of the beginnings of a *moral panic*. (Hall et al., 1978, p. 16)

'*Moral panics*' are public campaigns in which some person, group or series of events is perceived – experienced, represented, constructed – as an imminent threat to normal civilized society, to 'our way of life' if not 'our very lives'. The public is mobilized via the agencies of social control (the police, the courts), the 'moral guardians of society' (the religious establishment, politicians, the judiciary) and other orchestrators of public

opinion (newspapers, 'community leaders', educators, and so on) to stamp out this threat lest it bring catastrophe to us all.

Moral panics are commonplace in racist and xenophobic societies. Around the turn of the century (1900) in the American South, the main fear was of the over-sexed, Black male brute – that is, 'THE NEGRO AS BEAST'. We have already alluded to Dixon's book *The Clansman* and to Griffith's film *Birth of a Nation*. These works were part of a tradition, which included publications and films that we moderns would mostly find utterly bizarre. For example, in the nineteenth century there was the often-articulated argument that Black people belong to a separate creation: Adam and his descendants are White; God created Blacks – the sub-humans – separately. There was also the argument that Black people are closer to the apes than to civilization. There was the glorification of the new White saviours, the Ku Klux Klan.

> FACT: '*In 1900 a religious publishing house brought out* The Negro a Beast, *by Charles Carroll, a bizarre work that revived the pre-Adamite arguments . . . describing the Negro as literally an ape rather than a human being. According to Carroll, the apelike Negro was the actual "tempter of Eve", and miscegenation was the greatest of all sins – the true reason for God's destruction of slavery.*'
> — George M. Fredrickson, *The Black Image in the White Mind*, 1971, p. 277

From the abolition of slavery in the United States (1865) to the middle of the twentieth century, but especially around the turn of the century, racist imagery and discourse were mobilized in the context of moral panics in which Black people were the targets of campaigns of extreme violence and terror. Lynching Black men became a favourite White Southern pastime.

> QUESTION: What crime did one have to commit in order to get lynched?
> ANSWER: Looking at a White woman, or being accused of such, would do. 'Talking back' to a White person would do. Failing to know one's place would do . . .

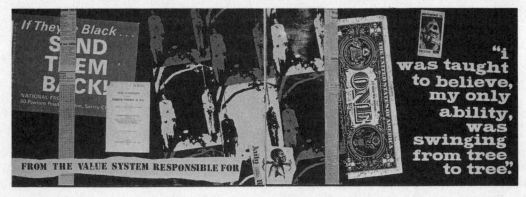

Plate 9.4 I Was Taught to Believe, Eddie Chambers.
Reproduced by kind permission of the artist. Photograph: Carolyn R. Reid.

Many families lost a father, brother or son because he was falsely accused of raping a White woman.

But here the Negro is the master. He is the specialist of this matter: whoever says RAPE *says* NEGRO.

—Fanon, 1968, p. 117; emphasis added

It is worth repeating this fact: *Racism is fundamentally to do with power – with domination, control and exploitation. Racist discourse and imagery is, quite literally, an afterthought.*

The idea of the barbaric Black is an ideological invention. But who wants to get rid of myths when they work so well?

Hot Black Females . . .

Included in the vast collection of the *Musée de l'homme* (Museum of Mankind), located near the Eiffel Tower in Paris, are the sexual parts – the genitalia and buttocks – of Sarah Bartmann.

Who is this woman and why is she so honoured?

In eighteenth- and nineteenth-century Western Europe, females from the continent of Africa were widely believed to possess a fierce, 'PRIMITIVE' SEXUAL APPETITE. They were also believed to display the external signs of this characteristic – namely, 'PRIMITIVE' GENITALIA.

> Eighteenth-century travellers to southern Africa, such as François Le Vaillant and John Barrow, had described the so-called Hottentot apron, a hypertrophy of the labia and nymphae caused by the manipulation of the genitalia and serving as a sign of beauty among certain tribes, including the Hottentots and Bushmen as well as tribes in Basutoland and Dahomey. (Gilman, 1992, p. 178)

The European public were fascinated by these (artificially) enlarged genital organs, and were prepared to pay good money to see those who possessed them.

This public (and certain scientists, such as pathologists Henri de Blainville and Georges Cuvier) were also shocked and fascinated by another physical characteristic which some 'primitive' females possessed: the steatopygia, or hugely PROTRUDING BUTTOCKS.

Sarah Bartmann (Saartjie Baartman), a woman of Colour and an indentured servant in the early 1800s, was blessed with both these anomalies, hypertrophy of the labia and steatopygia.[8] Which is why she, the 'HOTTENTOT VENUS', became so famous, the most famous Black woman of the nineteenth century.

The fact that Sarah Bartmann was a 'Hottentot' also contributed to her fame. The 'Hottentot' or Khoi-Khoi people of southern Africa had been regarded by European explorers and colonists since the seventeenth century as 'the most appallingly barbarous of men [*sic*] though other peoples were darker and lived in worse climates' (Jordan, 1969, p. 226).

> A SCIENTIFIC QUESTION: Can there be any race more primitive and bestial than the Negro?
>
> A SCIENTIFIC ANSWER: Yes, but only one: the Hottentot. 'If the question of savagery had come to a vote . . . the Hottentot would have won by a wide margin. Linnaeus even mulled over the possibility' – when he was refining his Great Chain of Being – 'that the Hottentots were not men but apes, though he rejected the idea.'
>
> — Winthrop Jordan, *White Over Black*, 1969, pp. 226–7.

During her short life – she died in 1815 at age 25 – Sarah Bartmann was exhibited over a five-year period in Paris and London. On display were not her genitalia (that would come later) but her buttocks, symbol of the widespread myth of the 'primitive' hypersexuality of African women. After her untimely death, Bartmann's body was dissected and her genitalia and buttocks – the crucial bits of her anatomy, which as we know contained her essence – were removed for observation and display. 'The audience which had paid to see her buttocks and had fantasized about the uniqueness of her genitalia when she was alive could, after her death and dissection, examine both' (Gilman, 1992, pp. 179–80). Indeed, the curious and the perverse can still view Sarah Bartmann's sexual parts: to this day, they are on display at the *Musée de l'homme* in Paris.

The body of the Hottentot Venus was an anatomist's dream. The first autopsy was performed by Henri de Blainville and published in 1816. But in 1817, de Blainville was outdone. Georges Cuvier, one of the most famous anatomists in the world, published *Extraits d'observations faites sur le cadavre d'une femme connue à Paris et à Londres sous le nom de Venus Hottentote* (Extracts from Observations Made on the Corpse of a Woman known in Paris and London by the Name 'Hottentot Venus'). These extracts included detailed descriptions and illustrations of Sarah Bartmann's body, especially her sexual parts. Cuvier, who knew a good thing when he saw one, did his duty to both science and the public . . .

> TRUTH: 'Sarah Bartmann's sexual parts, her genitalia and her buttocks, served as the central image for the black female throughout the nineteenth century'. They 'summarized her essence for the nineteenth century observer, or, indeed, for the twentieth century one, as they are still on display'.
>
> — Sander Gilman, 'Black Bodies, White Bodies', 1992, p.180.

The public display of images of 'primitive', Black female sexuality did

not disappear with slavery and the discrediting of nineteenth-century, racist biology. Such images became, instead, a mainstay of popular entertainment. The dancer Josephine Baker is a good case in point. Born in St Louis, Missouri, in 1906, the 'illegitimate' daughter of a Black mother and a Spanish father, Josephine Baker grew up in poverty. She left school at the age of eight to earn a living. At age fifteen, attracted by the local vaudeville theatre, Josephine Baker joined a travelling troupe and eventually became a chorus girl in New York. She went to Paris to appear in *La Revue nègre* – an American production where, at the age of nineteen, she was a sensational success:

> Paris 1925: the *Revue nègre* enjoys a smash season at the Theatre des Champs-Elysées, following on the heels of W. H. Wellmon's Southern Syncopated Orchestra. Spirituals and *le jazz* sweep the avant-garde bourgeoisie, which haunts Negro bars, sways to new rhythms in search of something primitive, *sauvage* . . . and completely modern. Stylish Paris is transported by the pulsing strum of banjos and by the sensuous Josephine Baker 'abandoning herself to the rhythm of the Charleston'. (Leiris, 1968, p. 33; quoted in Clifford, 1988a, p. 122)

Like Sarah Bartmann a century earlier, it was Josephine Baker's buttocks which captured the imagination of her public:

> She handled it as though it were an instrument, a rattle, something apart from herself that she could shake. One can hardly overemphasize the importance of the rear end. Baker herself declared that people had been hiding their asses too long. 'The rear end exists. I see no reason to be ashamed of it. It's true there are rear ends so stupid, so pretentious, so insignificant that they're good only for sitting on.' With Baker's triumph, the erotic gaze of a nation moved downward: she had uncovered a new region for desire. (From Rose, 1989; quoted in hooks, 1992, p. 63)

> AN OBSERVER: Shake it, baby. Shake that stuff!

In 1925 she caused a sensation on the Paris stage when she appeared naked except for a girdle of rubber bananas (see plate 9.5). Josephine Baker starred at the *Folies-Bergère* throughout the 1920s and 1930s.

During her life in Paris, Josephine Baker was admired and celebrated in a way that would never have happened in her racist, segregated homeland. (This was also true of a number of other Black American artists and intellectuals, such as Richard Wright, Charlie Parker and James Baldwin.) Always the flamboyant, Baker 'drove a Delage with snakeskin upholstery' and 'appeared everywhere with her pet leopard, Chiquita' (Thorpe, 1989, p. 108).

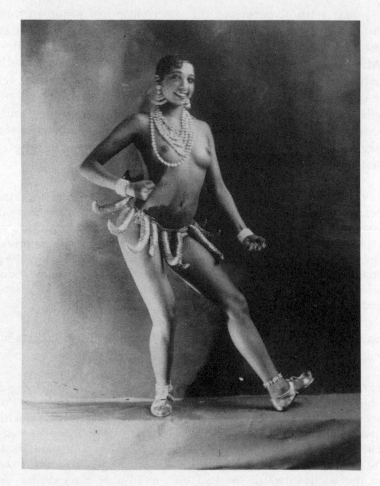

Plate 9.5 Josephine Baker, revue: *Folie du Jour*, Folies Bergère, 1926–7.
Reproduced courtesy of Roger-Viollet, Paris.

Throughout her career, Josephine Baker – 'La Bakaire', as they called her in Paris – cultivated an image of exoticism and primitive sexuality, appealing directly to European myths of Black bodies.

> The black body in Paris of the twenties was an ideological artifact. Archaic Africa (which came to Paris by way of the future – that is, America) was sexed, gendered, and invested with 'magic' in specific ways. Standard poses adopted by 'La Bakaire', like Leger's designs and costumes, evoked a recognizable 'Africanity' – the naked form emphasizing pelvis and buttocks, a segmented stylization suggesting a strangely mechanical vitality. (Clifford, 1988b, pp. 197–8).

It was an image that was very well received in Europe where, as we

discuss in chapters 10, 11 and 12, there has been a long tradition of fascination with the primitive and exotic – a fascination that does not automatically rule out the treatment of Black people as fully human beings. Baker's exotic – erotic – primitive image had less appeal on the other side of the Atlantic, in her homeland.

> TRUTH: In the United States of America, which we all know is, 'The Land of the Free', the legacy of slavery and racism is such that people of Colour are more likely to be seen as dangerous objects to be controlled than as fascinating objects to be admired.

The warmth of Josephine Baker's reception when she appeared on occasions in the USA was also much reduced by her support for the civil rights movement.

Have such images of Black female sexuality and the racist myths on which they draw lost their power in the wake of the civil rights, Black Power and women's movements? Even a cursory look at the popular music scene suggests they have not. A key recent example of the commodification of Black female sexuality as wild and primitive is Tina Turner. In her essay 'Selling Hot Pussy', bell hooks argues that 'the black female body gains attention only when it is synonymous with accessibility, availability, when it is sexually deviant' (1992, pp. 65–6).

Tina Turner is an extreme example of Black female sexuality sold as primitive, wild and abundant. To begin with, Turner's career was shaped by her husband Ike. He made her in the image of what bell hooks calls 'his pornographic misogynist imagination':

> Ike explained: As a kid back in Clarksdale [Mississippi], he'd become fixated on the white jungle goddess who romped through Saturday matinee movie serials – revealing rag-clad women with long flowing hair and names like Sheena, Queen of the Jungle, and Nyoka – particularly Nyoka. He still remembered *The Perils of Nyoka*, a fifteen-part Republic Picture serial from 1941, starring Kay Alridge in the title role and featuring a villainess named Vultura, an ape named Satan, and Clayton Moore (later to be TV's Lone Ranger). Nyoka, Sheena – Tina! Tina Turner – Ike's own personal Wild Woman. He loved it. (From Tina Turner, *I, Tina: My Life Story*, New York: Avon, 1987; quoted in hooks, 1992, p. 67)

During her marriage to Ike, Tina Turner suffered rape and physical abuse. She was caught in what bell hooks calls the 'sadomasochistic sexual iconography of black female in erotic war with her mate' (p. 68). After leaving Ike, Tina Turner appropriated this image of WILD-SEXUAL-SAVAGE-WOMAN for herself, successfully using it to promote her career. She has taken to wearing long blond wigs and clothes that emphasize her sexuality. The difference between her image before and after leaving Ike is that

now she comes across as in control, autonomous, even dominant. Instead of questioning the long-established imagery of Black female sexuality, her self-presentation suggests that Black women are as they have been defined by a White racist patriarchal tradition and must learn to beat men at their own game.

> TRUTH: 'Representations of black female bodies in contemporary popular culture rarely subvert or critique images of black female sexuality which were part of the cultural apparatus of 19th-century racism.'
>
> — bell hooks, *Black Looks*, 1992, p. 62

Forbidden Acts

In Britain there is a popular television programme called 'Blind Date', hosted by the sixties pop singer Cilla Black. 'Blind Date' is patterned on an old American show called 'The Dating Game'. On one side of a curtain sit three prospective 'dates' – male or female. On the other side sits the lucky person who gets to ask each of them three questions, and then, on the basis of their answers (that is without seeing the merchandise), has to pick one of them as her/his lucky date. The winners get an all-expenses-paid holiday together – on which they may find love.

There are American television programmes that are very similar to 'Blind Date': 'The Love Connection' is the most obvious case in point. But are they *really* similar? In terms of the cultural politics of race and sex, 'dating game' programmes in the United States and Britain are radically different. *In the USA, if one of the participants is Black, all of them are*: the game adheres strictly to the logic of apartheid – although hardly any Americans would notice this, so accustomed are they to the 'naturalness' of racial segregation. (Hitler would be pleased to discover that racist ideology has come to work so well in the land where 'all men are created equal . . .'.) In Britain, so far as race is concerned, the selection of participants appears to be random. On 'Blind Date' it is not at all uncommon to find a White male or female interviewing three prospective dates one of whom is Black or to find a Black male or female interviewing three prospective dates all of whom are White. Incidentally, this is not a question of 'liberalism' but of a fundamental difference in attitudes and culture: whereas most British people would find it extremely odd, if not offensive, for there to be only Blacks on the platform, most Americans, including Blacks, would see the matter in exactly the opposite way.[9]

Below is a poem published in the *Boston Gazette* and the Richmond, Virginia *Recorder* in 1802. The general topic, one that has been an obsession in American culture for longer than the United States has been an

officially constituted country, is 'the mixing of the races' – specifically, in this case, White men having sexual relations with Black women. The specific target is Thomas Jefferson (and his concubine Sally Hemmings):

> In glaring red, and chalky white,
> Let others beauty see;
> Me no such tawdry tints delight –
> No! *black's* the hue for me!
>
> Thick pouting lips! how sweet their grace!
> When passion fires to kiss them!
> Wide spreading over half the face,
> Impossible to miss them.
>
> Oh! Sally! hearken to my vows!
> Yield up thy sooty charms –
> My best belov'd! my more than spouse,
> Oh! take me to thy arms!
> (Quoted in Jordan, 1969, p. 468)

Historically, the enforcers of apartheid have been more concerned to police the activities of Black men and White women than those of White men and Black women.

To be most effective, racism depends on a clear demarcation between 'the races'. If the Blacks, the Jews or some other group are to be singled out for special treatment – slavery, segregation, lynching, the gas chamber – then one needs to be able to tell immediately who THEY are. If THE NATIVES, THE BLACKS, THE JEWS, THE ARABS, THE MEXICANS, THE ASIANS and all THE OTHERS are decidely inferior to us, then surely we do not want to mix with them.

'RACE MIXING' threatens the stability of the system: it must be banned. For much of the history of both the United States of America and South Africa sexual intercourse and/or marriage between Blacks and Whites – or rather between Black men and White women – was a criminal offence (punishable, in the case of Black men, by death). Similarly, in Nazi Germany 'race mixing' was absolutely forbidden. Below is a relevant order, signed by Adolf Hitler and some of his henchmen.

Law for the Protection of German Blood and German Honour
15 September 1935

Imbued with the realization that the purity of German blood is a prerequisite for the continued existence of the German people, and inspired by the inflexible will to protect the German Nation for all times to come, the Reichstag has unanimously passed the following law which is herewith promulgated:

I.
(1) Marriages between Jews and subjects of German or related [artverwandt] blood are forbidden. Marriages concluded in spite of it are null and void, even if concluded abroad to circumvent this law.
(2) Only the State Attorney may initiate an annulment claim.
II.
Extramarital sexual intercourse between Jews and subjects of German or related blood is forbidden.
III.
Jews may not employ in their households female subjects of German or related blood under 45 years of age.
IV.
(1) Jews are forbidden to fly the national flag of the Reich or display the national colours.
(2) They may, however, show the Jewish colours. The right to do so is protected by the State.
V.
(1) Anybody violating the injunction listed in Section I will be punished by detention in a penitentiary.
(2) Any male violating the injunction listed in Section II will be punished by either a prison term or a penitentiary term.
(3) Anybody violating any of the provisions listed in either Section III or IV will be punished by imprisonment up to one year and a fine, or by either of these penalties.
VI.
The Reich Minister of the Interior, in agreement with the Führer's Deputy and the Reich Minister of Justice, will issue the legal and administrative stipulations required to implement and supplement this law.
VII.
The law becomes effective the day after it is promulgated; Article 3, however, only as of 1st January 1936.

Nuremberg, 15th September 1935 at the Reich Party Rally of Liberty [Reichspartei-tag der Freiheit]

The Führer and Reich Chancellor
Adolf Hitler

Reich Minister of the Interior
Frick

Reich Minister of Justice
Dr Gurtner

The Führer's Deputy
R. Hess
Reich Minister without Portfolio

—Reinhard Rurup (ed.), *Topography of Terror, 1989,*
pp. 115–16; translation slightly amended

A reminder to those who would ban relationships between people of different 'races': although you may not realize it, the doctrine you follow is one of the cornerstones of the most viciously racist practices in human history. Hitler, as was said before, would be pleased to discover that he has attracted so many enthusiastic disciples.

Graceful Movers and Songbirds

As previously indicated, Black bodies are not always despised in the dominant discourses and imagery of race and racism. In hegemonic discourse on bodies, culture and character, people of African descent are not only smooth movers but soulful singers. Everyone knows Black people can sing. (And, many Black people would add, that White people can't . . .)

For centuries Black bodies, male and female, have been OBJECTS OF FASCINATION, if not envy, for many White people – on the dance floor, on the basketball court, on the athletic field, in the bedroom In an interesting essay entitled 'My Negro Problem – and Ours', which was published in 1963, Norman Podhoretz makes the following comment:

> Just as in childhood I envied Negroes for what seemed to me their superior masculinity, so I envy them today for what seems to be their superior physical grace and beauty. I have come to value physical grace very highly and *I am now capable of aching with all my being when I watch a Negro couple on the dance floor, or a Negro playing baseball or basketball.* They are on the kind of terms with their own bodies that I should like to be on with mine, and for that precious quality they seem blessed to me. (Quoted in hooks, 1992, p. 96; emphasis added)

White people have been known to spend hours on end trying to learn to dance like Black people, to move as they do on the basketball court or football field.

Perhaps the most spectacular current example of this fascination with Black bodies is the Michael Jordan phenomenon. As we write this book (in the early 1990s) Michael Jordan, basketball superstar with the Chicago Bulls, is the most famous athlete in the world – and thought by many to be the best. Nike markets Air-Jordan shoes, Chevrolet markets a Michael Jordan car (complete with his signature on the outside and on the dashboard), teenagers all over the world wear Michael Jordan tee-shirts, his restaurant is the most famous in Chicago, corporations pay millions of dollars to have his name associated with them . . . Michael Jordan's image is virtually everywhere.

In his essay 'Be Like Mike: Michael Jordan and the Pedagogy of Desire', Michael Dyson argues that Jordan 'has attained unparalleled cultural status because of his extraordinary physical gifts, his marketing as an icon of race-transcending American athletic and moral excellence and his mastery of a sport which has become the metaphoric centre of black cultural imagination' (Dyson, 1993, p. 64).

(One of us cannot resist saying that Michael Jordan is his cousin)

Over the last few decades, basketball has moved from its position as a largely Black American sport into the mainstream of American life (the position traditionally held by baseball) and its icons – foremost among them Michael Jordan – have become the heroes of White as well as Black America and beyond. Sport has long played an important affirmative role in the lives of Black Americans, offering the possibility of success and recognition denied them in other areas of life. It has served as what Dyson calls 'a way of ritualizing racial achievement against socially imposed barriers to cultural performance'.

> In short, black sport activity often acquired a heroic dimension, as viewed in the careers of figures such as Joe Louis, Jackie Robinson, Althea Gibson, Wilma Rudolph and Arthur Ashe. Black sports heroes transcended the narrow boundaries of specific sports activities and garnered importance as icons of cultural excellence, symbolic figures who embodied social possibilities of success denied to other people of color. But they also captured and catalyzed the black cultural fetishization of sport as a means of expressing black cultural style, as a means of pursuing social and economic mobility. (Dyson, 1993, p. 66)

For his Black fans, Jordan offers an image of a Black athlete who has achieved wealth, fame and respect beyond their wildest dreams.

Yet the emphasis on physique, style, performance and sporting prowess which characterize media representations of Michael Jordan, reaffirms long established MYTHS about Black bodies. Moreover, the importance of style and performance is part of a more general COMMODIFICATION of these aspects of Black culture.

Black Minds, Black Character

It has been said that the Negro is the link between monkey and man – meaning, of course, white man.

— Frantz Fanon, 1968, p. 22

Between Monkey and 'Man'

The European
↑
The Negro
↑
The Ape

Here is David Hume, the renowned Scottish philosopher, one of the leading Enlightenment thinkers, commenting at length on Black intellect and capacity for achievement:

> I am apt to suspect the negroes, and in general all the other species of men (for there are four or five different kinds) to be naturally inferior to the whites. There never was a civilized nation of any complexion than white, nor even any individual eminent either in action or speculation. No ingenious manufactures amongst them, no arts, no sciences. On the other hand, the most rude and barbarous of the whites, such as the ancient GERMANS, the present TARTARS, have still something eminent about them, in their valour, form of government, or some other particular. Such a uniform and constant difference could not happen, in so many countries and ages, if nature had not made an original distinction betwixt these breeds of men. Not to mention our colonies, there are NEGROE slaves dispersed all over EUROPE, of which none ever discovered any symptoms of ingenuity; tho' low people, without education, will start up amongst us, and distinguish themselves in every profession. In JAMAICA indeed they talk of one negro as a man of parts and learning; but 'tis likely he is admired for very slender accomplishments, like a parrot, who speaks a few words plainly. (Quoted in Jordan, 1969, p. 253; originally written in 1748)

Here is another enlightened voice. It is that of Thomas Jefferson, one of the principal architects of the enlightenment doctrine of human equality – of the doctrine that 'all men are created equal' and thus endowed with fundamental rights as human beings and citizens – offering his considered opinion on the widely held view 'that nature has been less bountiful to them [people of African descent] in the endowments of the head':

> Comparing them by their faculties of memory, reason, and imagination, it appears to me, that in memory they are equal to the whites; in reason much inferior, as I think one could scarcely be found capable of tracing and comprehending the investigations of Euclid; and that in imagination they are dull, tasteless, and anomalous. It would be unfair to follow them to Africa for this investigation. We will consider them here, on the same stage with the whites, and where the facts are not apocryphal on which a judgment is to be formed Some have been liberally educated, and all have lived in the countries where the arts and sciences are cultivated to a consid-

erable degree, and have had before their eyes samples of the best works from abroad ... *But never yet could I find a black had uttered a thought above the level of plain narration; never seen even an elementary trait of painting or sculpture.* (Thomas Jefferson, *Notes on Virginia*; quoted in Jordan, 1969, pp. 436–7; emphasis added)

Here is a third enlightened voice, that of Immanuel Kant: 'So fundamental is the difference between the two races of men [that is, "the whites" and "the negro"], and it appears to be as great in regard to mental capacities as in color' (quoted in West, 1982, pp. 62–3). Now, as is well known, Kant is one of the most clear-thinking philosophers of all time. Here is the great philosopher's response to some advice given to Father Labat by a person of Colour:

And it might be that there was something in this which perhaps deserved to be considered; *but in short, this fellow was quite black from head to foot, a clear proof that what he said was stupid.* (Immanuel Kant, quoted in West, 1982, p. 63; emphasis added)

Impeccable deductive reasoning! This is not Archie Bunker or Alf Garnett, but Immanuel Kant.[10] It seems that when it came to matters of 'race' the great philosopher's mental acuteness slipped somewhat.

Finally, we add the authoritative voice of the *Encyclopaedia Britannica*, in a passage written about 100 years after Jefferson's observations and 150 after Hume's:

No full-blooded Negro has ever been distinguished as a man [*sic*] of science, a poet, or as an artist, and the fundamental equality claimed for him by ignorant philanthropists is belied by the whole history of the race through the historic period. (*Encyclopaedia Britannica*, 1884, vol. XVII, p. 318)[11]

The above passages, written in the eighteenth and nineteenth centuries, would have been accepted as fact by many in the West until the last few decades.

In the eighteenth and nineteenth centuries the issue of THE RELATIVE ENDOWMENT OF 'NATURAL FACULTIES' between Black people and Whites was a recurrent topic in the writings of many intellectuals and scholars as well as in popular culture (for example, newspaper cartoons). Today, few people would make the sort of statements about race that were freely made by Hume, Kant, Jefferson and other wise men of their time – and any who did would be quickly branded 'racist'. The point, however, is that *the idea that Black people are intellectually inferior to Whites is very deeply embedded in Western culture(s)*. When schoolteachers decide their Black students 'are not university material', when Black scholars are not taken seriously by their colleagues, when 'dumb nigger' jokes are told in the

workplace, when White people go on at great length about how some particular Black person is 'absolutely brilliant' (unlike the other Blacks we know . . .) – when such actions occur (and they occur in millions of daily interactions), we should be forgiven for suspecting that racism is alive and well. There are still many people who hold that the sentiments of Hume, Kant, Jefferson and other such enlightened thinkers contain more than a grain of truth. For the most part, these are good and decent people, many of whom are far more likely to be identified as 'liberals' than as racists.

Our point, of course, is that 'liberal' and 'racist' are not mutually exclusive categories, as 'humanist' and 'racist' are not. Jean-Paul Sartre said once:

> *Humanism is the counterpart of racism: it is a practice of exclusion.*
> — Jean-Paul Sartre, *Critique of Dialectical Reason*, 1976, p. 752

Two Stories in Black and White

'I Could No Longer Laugh'

'Look, a Negro!' It was an external stimulus that flicked over me as I passed by. I made a tight smile.

'Look, a Negro!' It was true. It amused me.

'Look, a Negro!' The circle was drawing a bit tighter. I made no secret of my amusement.

'Mama, see the Negro! I'm frightened!' Frightened! Frightened! Now they were beginning to be afraid of me. I made up my mind to laugh myself to tears, but laughter had become impossible.

I could no longer laugh, because I knew that there were legends, stories, history, and above all historicity . . .

'Sho' Good Eatin'

Where shall I hide?

'Look at the nigger! . . . Mama, a Negro! . . . Hell, he's getting mad Take no notice, sir, he does not know that you are as civilized as we . . .

My body was given back to me sprawled out, distorted, recoloured, clad in mourning in that white winter day. The Negro is ugly; look a nigger, it's cold, the nigger is shivering, the nigger is shivering because it is cold, the little boy is trembling because he is afraid of the nigger, the nigger is shivering with cold, that cold that goes through your bones, the handsome little boy is trembling because he thinks the nigger is quivering with rage, the little white boy throws himself into his mother's arms: Mama, the nigger's going to eat me up.

—Frantz Fanon, 1968, pp. 79 and 80

People of a Different, Inferior Order

European. *White, sanguine, brawny. Hair abundantly flowing. Eyes blue. Gentle, acute, inventive. Covered with close vestments. Governed by customs.*

Asiatic. Yellow, melancholy, rigid. Hair black. Eyes dark. Severe, haughty, covetous. Covered with loose garments. Governed by opinions.
African. Black, phlegmatic, relaxed. Hair black, frizzled. Skin silky. Nose, flat. Lips tumid. Women's bosom a matter of modesty. Breasts give milk abundantly. Crafty, indolent, negligent. Anoints himself with grease. Governed by caprice.

 —From Linnaeus' 1758 categorization of *Homo sapiens*; quoted
 in Jordan, 1969, pp. 220–1.

'They' are naturally inferior in PHYSICAL APPEARANCE, in MENTAL CAPACITY and in CULTURAL ACHIEVEMENT – these are the truths revealed by classical racism. To these truths a fourth is added: in TEMPERAMENT AND CHARACTER they – the Blacks, the Arabs, the American Indians, the Jews, the family across the street – belong to a different and inferior order.

 Consider eighteenth and nineteenth century Anglo-American representations of THE BLACKS. Below is a poem published in 1701 by John Saffin, a Boston merchant:

The Negroes Character
Cowardly and cruel are those *Blacks* Innate,
Prone to Revenge, Imp of inveterate hate.
He that exasperates them, soon espies
Mischief and Murder in their very eyes,
Libidinous, Deceitful, False and Rude,
The spume Issue of Ingratitude.
The Premises consider'd all may tell,
How near good *Joseph* they are parallel.
 — Quoted in Jordan, 1969, pp. 199–200

In his classic *History of Jamaica* (1774) Edward Long wrote that Africans were a 'brutish, ignorant, idle, crafty, treacherous, thievish, mistrustful, and superstitious people'. He added that they were inferior in 'faculties of mind' and had a 'bestial and fetid smell' – which perhaps resulted from the fact that they had 'a covering of wool, like bestial fleece, instead of hair' (quoted in Drake, 1987, p. 27).

 Perhaps the merchant-poet and the planter-historian were simply vicious racists, offering views that were unrepresentative of Anglo-American sentiments at the time. Let us listen, then, to the more considered, objective view of the *Encyclopaedia Britannica*, a publication that has always been known for the rigorous ways in which it employs science and reason in pursuit of knowledge:

Vices the most notorious seem to be the portion of this unhappy race [people of African descent]; *idleness, treachery, revenge, cruelty, impudence, stealing, lying, profanity, debauchery, nastiness, and intemperance,* are said to have extin-

guished the principles of natural law, and to have silenced the reproofs of conscience. They are strangers to every sentiment of compassion, and are an awful example of the corruption of man left to himself. (*Encyclopaedia Britannica*, 1810 edition, vol. XIV, p. 750; emphasis added)[12]

The distinguished *Encyclopaedia* has not published such rubbish for a few generations. The point is that it used to do so.

> TRUTH: The history of racist ideology is not primarily a history of 'unrepresentative, ignorant racists', rather it is primarily a history of the beliefs and actions of PERFECTLY RESPECTABLE PEOPLE (such as enlightenment philosophers, architects of the doctrine of 'human equality', scientists and the *Encyclopaedia Britannica*). Racism is an integral part of the mainstream of Western culture.

Some of the specific traits attributed to Blacks in nineteenth-century editions of the famous *Encyclopaedia* are still widely held – by White police officers, politicians, social workers, teachers, shop assistants and other respectable people.

The Vicious Oriental

In classical racism, the counterpart to the exotic, Eastern women, enclosed in the harem, leading a life of sensuality dedicated to meeting every male sexual desire, is the fanatical, cruel, despotic Muslim or Arab man who keeps her there. During the recent war waged by the West and her allies against Iraq, following the Iraqi invasion of Kuwait, these classic racist representations of Muslims and Arabs, which can be traced back to the Crusades in the Middle Ages, resurfaced in press coverage of the war. In the popular press in Britain, links were made between early Eastern leaders, Genghis Khan and various sultans, who were depicted as cruel, despotic and warmongering, and Saddam Hussein. In the process, the East was once again removed from history. History as a process of change, development and transformations did not, it seems, apply to it.

In the propaganda surrounding the war, the West was portrayed as modern, enlightened and democratic, fighting to rescue a small independent state from annexation and dictatorship. Enlightened Western intervention had dire effects on the Iraqi people. In 1991, as a direct result of US bombings, some 200,000 Iraqis died. As an indirect consequence of the bombings – for example, through the destruction of sewerage systems, bridges, roads, and so on – thousands more died. Most of these people were poor. Many were young people. Most were more the victims of Saddam Hussein than his supporters.

But they had to die, sacrificed by the West in order to achieve its military and political aims: to humiliate Saddam Hussein, to drive him from power, to keep the price of petrol cheap in the United States of America. . . .

How was all this handled by the British press? On 23 January 1991 the *Guardian*, the British liberal-left daily newspaper, printed a comparison of the terms used to represent the two sides in the war (see Table 9.1). All the terms had appeared in the British press in the previous week.

Table 9.1 'Mad dogs and Englishmen'

We have	They have
Army, Navy and Air Force	A war machine
Reporting guidelines	Censorship
Press briefings	Propaganda

We	**They**
Take out	Destroy
Suppress	Destroy
Eliminate	Kill
Neutralise or decapitate	Kill
Decapitate	Kill
Dig in	Cower in their foxholes

We launch	**They launch**
First strikes	Sneak missile attacks
Pre-emptively	Without provocation

Our men are . . .	**Their men are . . .**
Boys	Troops
Lads	Hordes

Our boys are . . .	**Theirs are . . .**
Professional	Brainwashed
Lion-hearts	Paper tigers
Cautious	Cowardly
Confident	Desperate
Heroes	Cornered
Dare-devils	Cannon fodder
Young knights of the skies	Bastards of Baghdad
Loyal	Blindly obedient
Desert rats	Mad dogs
Resolute	Ruthless
Brave	Fanatical

Our boys are motivated by	**Their boys are motivated by**
An old fashioned sense of duty	Fear of Saddam

Our boys	**Their boys**
Fly into the jaws of hell	Cower in concrete bunkers

Our ships are . . .	**Iraqi ships are . . .**
An armada	A navy
Israeli non-retaliation is	**Iraqi non-retaliation is**
An act of great statesmanship	Blundering/Cowardly
The Belgians are . . .	**The Belgians are also . . .**
Yellow	Two-faced
Our missiles are . . .	**Their missiles are . . .**
Like Luke Skywalker zapping Darth Vader	Ageing duds *(rhymes with Scuds)*
Our missiles cause . . .	**Their missiles cause . . .**
Collateral damage	Civilian casualties
We . . .	**They . . .**
Precision bomb	Fire wildly at anything in the skies
Our PoWs are . . .	**Their PoWs are . . .**
Gallant boys	Overgrown schoolchildren
George Bush is . . .	**Saddam Hussein is . . .**
At peace with himself	Demented
Resolute	Defiant
Statesmanlike	An evil tyrant
Assured	A crackpot monster
Our planes . . .	**Their planes . . .**
Suffer a high rate of attrition	Are shot out of the sky
Fail to return from missions	Are Zapped

● *All the expressions above have been used by the British press in the past week*

Source: *Guardian*, 23 January 1991.

In the representations of the Iraqi war in the British press (which, as we all know, never fails to tell the truth) some very interesting 'facts' recur. The Western allies and their armies are modern, professional and brave. President Bush is a man who knows that he has both right and victory on his side. The Iraqis, in contrast, are led by a man who is evil, mad, defiant and monstrous – the quintessential vicious Oriental.[13] Lack of reason, lack of justice, ruthless cruelty and fanaticism govern the Iraqi leader and his troops. They kill and destroy using cowardly tactics. Unable to think for themselves, blindly obedient, cowardly, ruthless and fanatical – they are 'mad dogs'.

In contrast, our 'Gallant Boys' act out of 'an old-fashioned sense of duty'. They do not destroy or kill. Rather, they 'take out', 'suppress' and 'eliminate'. Brave, professional and resolute – they are heroes.

Earlier in this chapter, we discussed some of the classical racist imagery that the West has used to depict The Orient and The Oriental. Many of the features ascribed to Iraqis in the British press reproduce this ideological imagery. Like their forebears, the barbaric destroyers led by Genghis Khan, the Iraqis appear as 'hordes', as part of a killing-machine rather than a modern army.

One Small Step . . . to Auschwitz

Classical racism – the racist ideology of the nineteenth and early twentieth centuries – was predicated on the notion that people of Colour are literally *of lesser quality or value* than White people; that there is a *qualitative* difference in the character of White and non-White people. The notion is that some categories of people – because of the colour of their skin, the texture of their hair, the shape of their heads and so on – are worth more than others.

Once this stance is taken, extreme cruelty and even genocide become real possibilities. It is a small step from this idea to 'manly sports' or Auschwitz.

An old saying: *'The only good Injun is a dead Injun . . .'*.

People Without Culture

Misery is often the parent of the most affecting touches in poetry. – Among the blacks is misery enough, God knows, but no poetry.
 — Thomas Jefferson, quoted in Jordan, 1969, p. 437

On Being Brought from Africa to America

'Twas mercy brought me from my Pagan land,
Taught my benighted soul to understand
That there's a God, that there's a Saviour, too;
Once I redemption neither sought nor knew.
Some view our sable race with scornful eye,
'Their color is a diabolic die.'
Remember, Christians, Negroes, black as Cain,
May be refined, and join th'angelic train.
 — Phyllis Wheatley,
 a Contemporary of Jefferson[14]

In the introductory chapter, using impeccable logic, it was demonstrated that all the great figures in the history of civilization and culture – the great writers, artists and thinkers – have been White. Aside from a few odd contributions, like primitive sculpture, Black American soul music and Australian Aboriginal rock painting, non-White people have made no cultural achievements of which anyone can be proud.

> *The colonized is elevated above his jungle status in proportion to his adoption of the mother country's cultural standards. He becomes whiter as he renounces his blackness, his jungle.*
>
> —Frantz Fanon, 1968, p. 14

In racist discourse, Culture is the property of the West, primarily of White men. This Eurocentric view of Culture maintains an opposition between a modern, enlightened, progressive West and less-developed societies which are seen as quintessentially tradition-bound. The traditions in question are unenlightened, often irrational, untouched by modern technology and industrialisation.

> A DISSENTING VOICE: 'Of course, there remain a few small facts that resist this doctrine. To wit, the invention of arithmetic and geometry by the Egyptians. To wit, the discovery of astronomy by the Assyrians. To wit, the birth of chemistry among the Arabs. To wit, the appearance of rationality in Islam at a time when Western thought had a furiously pre-logical cast to it.'
>
> —Césaire, *Discourse on Colonialism*, 1972, p. 52

Enlightenment thought and the rhetoric underpinning Western colonialism made claims to moral, religious and scientific superiority. These claims have been used to justify a hierarchy of cultures, a ladder of civilization at one end of which stands the jungle and at the other (White) Western art and culture. The opposition PRIMITIVE:ADVANCED supports a number of further oppositions which underpin commonsense thinking and popular representations of cultural difference:

Primitive cultures		Advanced cultures
nakedness	:	clothes
the jungle	:	the city
spears	:	tanks
huts	:	houses
tribes	:	nations
magic	:	science
emotion	:	reason
sensual expression	:	disciplined will
ancestor worship	:	monotheisim
oral tradition	:	books and writing

| cannibalism | : | respect for the individual |
| savages | : | us |

On the scale of civilization, it is White people who are advanced and people of Colour who occupy lower positions. The Western assumption is that Western social forms, institutions and levels of development are desirable for all (despite the growing body of evidence to the contrary). The aspects of human culture which Western rationalism has banished as Other – sensuality, emotionality, intuition, bodily expression – are those associated with women and people of Colour.

If people of Colour are without progressive, enlightened Culture, the way forward for them is to become like their colonizers. This way of thinking has indeed been internalized by many people of Colour.

FACT: 'I have known, and I still know, Antilles Negroes who are annoyed when they are suspected of being Senegalese. This is because the Antilles Negro is more "civilized" than the African, that is, he is closer to the white man. . . .'
—Frantz Fanon, 1968, p. 19

A generation ago, in a very important book entitled *The Colonizer and the Colonized*, Albert Memmi wrote,

Just as the bourgeoisie proposes an image of the proletariat, the existence of the colonizer requires that an image of the colonized be suggested. These images become excuses without which the presence and conduct of a colonizer, and that of a bourgeois, would seem shocking. But the favored image becomes a myth precisely because it fits so well. (Memmi, 1965, p. 79)

Central to this image is the myth that the colonized, like the slave, has neither history nor culture.

Over the course of the past two or three generations some White people have become angry about how Western civilization is perceived and represented *vis-à-vis* The Others.

Why is this? 'Because of THE GREAT BETRAYAL of Western ethnography which, with a deplorable deterioration of its sense of responsibility, has been using all its ingenuity of late to cast doubt upon the overall superiority of Western civilization' (Césaire, 1972, p. 50). The anthropologist, who we thought would prove once and for all our superiority over the Blacks and other primitives, has returned only to tell us that cultures cannot be ranked, that Bantu witchcraft and Haitian voodoo are not inferior to Western science.

It is not only Western anthropologists who have questioned the nature and status of the Western cultural tradition and its relation to Other cultures. The multiracial and multiethnic nature of contemporary Britain and America, for example, has produced powerful critiques of the

dominant White traditions. We discuss challenges to one such tradition – twentieth-century Western art history – in the following two chapters. Here we would like, briefly, to give another example: the debate in American universities about courses in Western Civilization. We focus on a case with which one of us, a semi-retired activist, had some personal involvement.

Cultural Struggle in the Academy

Until the 1960s most American universities taught their first-year students (who are, unfortunately, called 'freshmen') a number of CORE CURRICULUM *courses. Among these was a course on Western Civilization, which obliged students to read* 'THE GREAT BOOKS' *from* 'THE GREAT AUTHORS' *of the traditional European – that is to say, White – canon.*

> TRUTH: *'More often treated as sacred monuments to be worshipped than as fellow humans to be engaged in dialogue, the great authors supposedly represented a grand tradition that stretched in a straight line from Homer through Shakespeare to Voltaire. Students were told that they must learn "our heritage" before going on. . . .'*
> —Renato Rosaldo, Preface to *Culture and Truth*, 1989a, p. x

Now, when Harlen, a Black American friend of ours from a working-class community in Sacramento, began his undergraduate studies at Stanford University in 1970, he was relieved to learn that the Western civilization requirement had been eliminated from the list of required courses. This achievement had only been accomplished as a result of a sustained struggle on the battlefield of cultural politics. Liberal and radical students – some of them organized as anti-war activists or as members of the Black American, Chicano, Native American and Asian American student associations – had played the leading role in this struggle. They had been joined by some faculty members.

Harlen left Stanford University in 1976 or 1977. A few years after that, he was surprised to learn that a Western Civilization requirement had been reinstated. Those academic reforms of the 1960s and 1970s which had led to increased student control over what they would be taught had produced a backlash, which led to the eventual reinstatement of a core course in Western Civilization. This, however, was not achieved without opposition.

In the 1980s the struggle over Western Civilization continued. At Stanford, the Black Students Union played an active role as did the Department of Anthropology. Three key questions were raised: (1) Should there be such core courses? (2) If there must be courses focused on the history of 'civilization', shouldn't 'Western Civilization' be replaced by world civilizations? (3) If there must be a course in Western Civilization, which themes and texts should be included?

The previously White elite universities in the USA were now racially and ethnically mixed and they included substantial numbers of women students. As a result a significant number of students and faculty continued to question the 'WE' defining 'OUR HERITAGE'. They point to the absence of works by women and by people

of Colour. They also pointed to an irony: given its elitist, classical European bias, the 'Western Civilization' course had virtually excluded books by American thinkers and writers.

'Western Civilization' at Stanford was eventually substantially modified, so as to include multiple voices and various perspectives. 'Our Heritage' has been reinscribed as plural.[15]

The assumption that the important cultural traditions are those of the (White) West still underpins the practice of most prestigious cultural institutions and continues to play an important role in legitimating THE IDEA OF WHITE SUPREMACY.

> The idea of white supremacy rests simply on the fact that white men are the creators of civilisation (the present civilisation, which is the only one that matters; all previous civilisations are simply 'contributions' to our own) and are therefore civilisation's guardians and defenders. Thus it is impossible for Americans to accept the black man as one of themselves, for to do so is to jeopardise their status as white men. (Baldwin, 1964, pp. 162–3)

In presenting the colonized, the natives, the Blacks as PEOPLE WITHOUT CULTURE it is forgotten that their cultures have been trampled under the boot of White power (slavery, colonialism and racism); that if any of 'their' culture remains, it is due to extreme tenacity and cultural reinvention on the part of the victim. Listen to our poet, Aimé Césaire:

> They talk to me about progress, about 'achievements', diseases cured, improved standards of living. *I* am talking about societies drained of their essence, cultures trampled underfoot, institutions undermined, lands confiscated, religions smashed, magnificent artistic creations destroyed, extraordinary *possibilities* wiped out. (Césaire, 1972, p. 21)

Here is Césaire again. Reflect upon the following passage, which our poet wrote in the 1950s. For the 'Third World' peoples Césaire names – the Vietnamese, the Madagascars, the Sudanese – substitute others who are today being dominated or oppressed by European and American power:

> Before the arrival of the French in their country, the Vietnamese were people of an old culture, exquisite and refined. To recall this fact upsets the digestion of the Banque d'Indochine. Start the forgetting machine!
> These Madagascars who are being tortured today, less than a century ago were poets, artists, administrators? Shhhhh! Keep your lips buttoned! And silence falls, silence as deep as a safe! Fortunately, there are still the Negroes. Ah! The Negroes! Let us talk about the Negroes!
> All right, let's talk about them.
> About the Sudanese empires? About the bronzes of Benin? Shango sculp-

ture? That's all right with me; it will give us a change from all the sensation-
ally bad art that adorns so many European capitals. About African music.
Why not?

And about what the first explorers said, what they saw. . . . Say, you know
who he was, Frobenius? And we read together: 'Civilized to the marrow of
their bones! The idea of the barbaric Negro is a European invention.'

The petty bourgeoise doesn't want to hear any more. With a twitch of his
ears he flicks the idea away.

The idea, an annoying fly. (Césaire, 1972, pp. 31–2)

A VOICE: Even if we concede that Coloured people have made a few contribu-
 tions to popular culture – I am White, but I like soul music and reggae – there
 is absolutely no reason to assume that they have made any real cultural
 achievements. Where are their painters? Their classical musicians? Their
 Shakespearean actors?
ANOTHER WHITE VOICE: There is a great deal that we can learn from the Blacks.
 They live closer to nature. They are in tune with their bodies. They com-
 municate with the supernatural. They know great mysteries.

This ALTERNATIVE WHITE VOICE is one we shall encounter on a number of
occasions – especially in chapter 10, but also in chapters 11 and 12. As you
can see, it reflects a consciousness that has nothing to do with racism . . .

People Without History

A BLACK VOICE: *'Perhaps the centrality and pivotal position of history in
our lives is due to the fact that our conquerors and colonisers have tried so
hard to take our history away from us.'*
 —Eddie Chambers, 'History and Identity', 1991a, p. 63

Racism is a cultural politics, producing its effects in the conjoined spaces
of culture, power and subjectivity. One of the ways in which racism
works is by distorting, discrediting and dismissing the past – the past,
that is, of the peoples, societies and cultures it subjugates. Listen to Fanon,
as he speaks truth:

Colonialism is not satisfied merely with holding a people in its grip and
emptying the native's brain of all form and content. By a kind of perverse
logic, it turns to the past of the oppressed people, and distorts, disfigures
and destroys it The effect consciously sought by colonialism was to
drive into the natives' heads the idea that if the settlers were to leave, they
would at once fall back into barbarism, degradation and bestiality. (Fanon,
1967, p. 169)

As it turns out, many of the interventions in cultural politics by people of Colour are precisely aimed at combating this idea – but that is a story to be pursued later.

The Subject of History? Or Its Object?

> [We] *must transcend the customary ways of depicting Western history, and must take account of the conjoint participation of Western and non-Western peoples in this worldwide process We can no longer be content with writing only the history of victorious elites, or with detailing the subjugation of dominated ethnic groups . . . [C]ommon people were as much agents in the historical process as they were its victims and silent witnesses. We thus need to uncover the history of 'the people without history' – the active histories of 'primitives', peasantries, laborers, immigrants, and besieged minorities.*
> —Eric Wolf, *Europe and the People without History*, 1982, pp. ix–x

Eric Wolf's challenge should be taken seriously. However, uncovering and foregrounding THE HISTORY OF THE PEOPLE WITHOUT HISTORY – that is, those groups, societies and cultures whose history has been marginalized, trivialized and ignored – is no small job.

Walk into virtually any museum in the Western world, turn on your television, go to the cinema or theatre, visit your local bookshop, re-read old textbooks about 'The British Empire' that you had in school – engage in any such activity and you are likely to encounter the glorification of (White) Western history at the expense of Others:

> The settler makes history and is conscious of making it. And because he constantly refers to the history of his mother country, he clearly indicates that he himself is the extension of that mother country. Thus the history which he writes is not the history of the country which he plunders but the history of his own nation in regard to all that she skims off, all that she violates and starves. (Fanon, 1967, p. 40)

The point is not that people of Colour – people whose natural skin-colour is 'black', 'brown', 'red' or 'yellow' – do not appear in dominant narratives of the past. Rather, it is that, like the Black servants, 'African savages' or 'Red Indians' in earlier generations of Hollywood films, *they appear not as subjects of history but as its objects.* This point requires some explanation.

> AN INFORMED VOICE: 'He is out of the game. He is in no way a subject of history. Of course, he carries its burden, often more cruelly than others, but always as an object.'
> —Albert Memmi, *The Colonizer and the Colonized*, 1965, p. 92.

What exactly is being claimed here? Here are two versions of how Black slaves in the British West Indies and North America came to be emancipated:

Version 1. Thanks to the long and difficult work of the great abolitionists such as Wilberforce the slave trade and subsequently the institution of slavery came to an end.

Version 2. Following the slave revolt in St Domingo of the 1790s (i.e., the Haitian revolution), slaveholders and other White settlers became fearful that slave rebellions would spread to their doorsteps. This was a very important factor contributing to the ending of the slave trade and the institution of slavery in the British colonies of the New World.

The difference between these two stories has to do with the respective roles of Black people and White people in the historical process. In Version 1, White people – Wilberforce and other (White) abolitionists – are the ones who act, who make things happen, who initiate change on the stage of history: it is they who are the agents or subjects. Black people are *given* freedom; they are the recipients of a gift; they do not *cause* history to be made but are *affected* by the actions of others.

> *Come on, you know how it is. These Negroes can't even imagine what freedom is. They don't want it, they don't demand it. It's the white agitators who put that into theiráheads. And if you gave it to them, they wouldn't know what to do with it.* (Aimé Césaire, 1972, p. 41)

In Version 2 it is Black people who act, who make history. Their freedom is the result of their own actions. They are actors on the historical stage (*Subjects of History*), not a passive audience (*Objects of History*).[16] Much of the work of Black historians, and other anti-racist scholars who share their concerns, has been to inscribe Black people as the subjects of history.

Condemned to Lose Their Memory . . .

So, there is the problem of how subjugated races, and other long-oppressed groups, are represented in history, that is, the problem of THE SUBJECT OF HISTORY. There is also a second one: THE PROBLEM OF MEMORY. Colonialism and racism, as physical and cultural domination, force their victims to – literally – lose their memory:

> The memory which is assigned him [in the schools] is certainly not that of his people. The history which is taught him is not his own. He knows who

Colbert or Cromwell was, but he learns nothing of Khaznadar; he knows about Joan of Arc, but not about El Kahena. Everything seems to have taken place out of his country. He and his land are nonentities or exist only with reference to the Gauls, the Franks or the Marne. In other words *with reference to what he is not*: to Christianity, although he is not a Christian; to the West . . . (Memmi, 1965, p. 105)

Albert Memmi, the North African Jewish philosopher who taught for some years at the Sorbonne and belonged both to the colonizer and the colonized, explains:

We should add that he draws less and less from his past. The colonizer never even recognized that he had one; everyone knows that the commoner whose origins are unknown has no history. Let us ask the colonized himself: who are his folk heroes? his popular leaders? his sages? At most, he may be able to give us a few names, in complete disorder, and fewer and fewer as one goes down the generations. *The colonized seems condemned to lose his memory.* (Memmi, 1965, pp. 102–3; emphasis added)

As Memmi says, 'Memory is not a purely mental phenomenon.' Just as individual memory is the fruit of one's history and physiology, the history of a people 'rests upon its institutions' – its language, its family and kinship system, its religion, its political structure, its artistic traditions and so on. *But it is precisely the institutions of subjugated people that are killed off, sabotaged or rendered largely ineffective by the dominators*. In any event, over time, the average member of dominated groups 'scarcely believes in those [institutions] which continue to show some signs of life and daily confirms their ineffectiveness'. She or he 'often becomes ashamed of these institutions, as of a ridiculous and overaged monument' (Memmi, 1965, p. 103). Why? Because they are so obviously powerless. Anyone can see that the institutions that matter are the (White) police, the (White) educational system, the (White) government, the (White) media, etc., etc. It is these institutions that people of Colour must somehow negotiate.

Material Traces of the Past . . .

History – or rather HIS STORY – is carefully preserved and displayed in official places. For the White elite in Western societies – or rather the White *male* elite – history is materially inscribed in museums, archives and monuments, in the names of towns and cities, streets and squares.

Suppose one travels through the United States in search of Black history? Suppose one looked for names on the map, for monuments in the landscape. In the American South, one easily finds material traces

(besides the people) of the Black presence – but virtually all of these are traces left by the slave masters: large plantation houses, statues erected to slave masters and lovers of American-style apartheid, streets named after apostles of hate, . . . the old Slave Market in Charleston, South Carolina. Not only has the built environment erased Black history, it has insulted us – with one exception: the Martin Luther King Boulevards and Avenues which are a feature of many American cities.

In some places Black people have attempted to inscribe a memory of Black history in the built environment. In Harlem, for example, there are some streets named after prominent Black people. In Northern California, 40 miles south of San Francisco, East Palo Alto offers another example. Members of the Black community there made several attempts to have the name 'East Palo Alto' changed to 'Nairobi' (as in Nairobi, Kenya). In a referendum in the 1970s they almost succeeded. Meanwhile, the area's Black nationalists renamed various local public institutions and set up an independent education system. The local shopping centre became the Nairobi Shopping Centre, the health centre became the Charles Drew Health Centre (after the famous Black doctor who did pioneering work on blood plasma). A Nairobi Children's Centre (nursery school), Nairobi Primary School, Nairobi High School and a Nairobi College (a two-year community college) offered an alternative to mainstream, State education.

In the United States, the official recognition of the history of the indigenous peoples is particularly bizarre. Many cities, towns and counties, many rivers, lakes and creeks have Native American names. More interestingly, a number of states have American Indian names: Iowa, Dakota, Utah, Delaware and Illinois are all the named after indigenous nations (so-called 'tribes'); the names of various other states, among them Minnesota, Kansas, Kentucky, Tennessee, Mississippi and Arizona, also derive from American Indian words.

Native American names are used for football, basketball and baseball teams, for mascots, products and buildings. Native American names and imagery produce millions of dollars each year for the tourist industry. But, for the most part, these names and images have been appropriated by the colonizers – while the colonized themselves continue to be denied space for their own cultural expression.

TRUTH: 'Today Indian people must still struggle in order to survive in America. We must battle against forces that have dealt us among the lowest educational opportunities, lowest income levels, lowest standards of health, lowest housing conditions, lowest political representation and highest mortality rates in America.

Even as these grave hardships exist for the living Indian people, a mockery is made of us by reducing our tribal names and images to the level of

insulting sports team mascots, brand name automobiles, camping equipment, city and state names, and various other commercial products produced by the dominant white culture.

—Edgar Heap of Birds, 'Born from Sharp Rocks', 1991, p. 341

Colonialism, racism and other forms of insidious domination have consistently renamed places, countries, peoples. The struggle against colonialism necessarily involves cultural politics. It involves renaming. It entails the reclaiming and rewriting of history.

A VOICE: Our task is to replace His-Story with our stories, His memories with ours.

Removed from History

In dominant Western conceptions of 'history', 'culture' and 'civilization', White people appear as subjects; people of Colour are either absent or objects. WHITE PEOPLE 'HAVE' CULTURE – Christianity, science, technology, education – which they may give to 'the Natives' or 'the ethnic minorities'. WHITE PEOPLE 'MAKE HISTORY' – they 'do things', they make progress – while people of Colour sit on the sidelines. When it comes time to stand up and fight for freedom, 'people without agency' search for the coward's escape.

TRUTH: 'The disaster of People of Colour lies in the fact that they were enslaved.'

—Frantz Fanon, 1968, p. 164.[17]

In racist societies and cultures, White people act while non-White people are acted upon. Now, this representation is somewhat simplistic, but it is not altogether false: it is, in part, an accurate reflection of much that has happened in the world over the past few centuries. As Albert Memmi says, 'The most serious blow suffered' by colonized and racially dominated people 'is being removed from history and from the community', that is, from the nation's affairs (Memmi, 1965, pp. 91–2). The victim of colonialism and racism is, as Memmi puts it, 'out of the game'. She or he 'is in no way a subject of history'. However cruelly the burden of history is borne, it is borne 'always as an object' (p. 92).

One has come to subscribe to a cultural politics of racism when one assumes that people of Colour are inherently incapable of agency – when one believes that 'the poor things can't help themselves', that 'we (the Blacks) will always be on the bottom' that 'niggers are too dumb to do anything about their circumstances'.

On Race and Subjectivity: People Without Worth

The ways in which black people, black experiences, were positioned and subject-ed in the dominant regimes of representation were the effects of a critical exercise of cultural power and normalisation. Not only, in Said's 'Orientalist' sense, were we constructed as different and other within the categories of knowledge of the West by those regimes. They had the power to make us see and experience ourselves as 'Other'. Every regime of representation is a regime of power formed, as Foucault reminds us, by the fatal couplet, 'power/knowledge'. But this kind of knowledge is internal, not [i.e., not simply] external. It is one thing to position a subject or set of peoples as Other in a dominant discourse. It is quite another thing to subject them to that 'knowledge', not only as a matter of imposed will and domination, by the power of inner compulsion and subjective con-formation to the norm. This is the lesson – the sombre majesty – of Fanon's insight into the colonising experience in Black Skin, White Masks.
— Stuart Hall, 'Cultural Identity and Diaspora', 1990, pp. 225–6

I was responsible at the same time for my body, for my race, for my ancestors. I subjected myself to an objective examination, I discovered my blackness, my ethnic characteristics; and I was battered down by tom-toms, cannibalism, intellectual deficiency, fetishism, racial defects, slave-ships, and above all else, above all: 'Sho' good eatin'.
— Frantz Fanon, *Black Skin, White Masks*, 1968, p. 79.

The Burden of Degradation

One cannot be a person of Colour or a Racial Other in a racist society without coming to experience oneself as a member of a devalued group. In this regard, as in many others, one cannot escape the burden of race. Let the following stories serve as a reminder of the daily experience of people who belong to racially subordinated groups. Both are from *My Place*, a powerful text combining autobiography and life histories by Sally Morgan, an Australian author of Aboriginal descent. Here is Sally's mother, Gladys, speaking about childhood experience:

I remember, one Sunday, waiting at a bus stop for a bus to my girlfriend's house, when a lady came along. She was catching the same bus as me, so we started to chat.
'You're very beautiful, dear', she said, 'what nationality are you, Indian?'
'No,' I smiled, 'I'm Aboriginal.'
She looked at me in shock. 'You can't be', she said.

'I am.'

'Oh, you poor thing,' she said, putting her arm around me, 'what on earth are you going to do?'

She looked at me with such pity, I felt really embarrassed. I wondered what was wrong with being Aboriginal. I wondered what she expected me to do about it.

I talked to Mum about it She made me feel really frightened. I think that was when I started wishing I was something different. (Morgan, 1987, pp. 278–9).

Here is her grandmother, Daisy, speaking about her experience as a servant in the home of an upper-class White family:

I 'member the beautiful cups and saucers. They were very fine, you thought they'd break with you just lookin' at them. Ooh, I loved them. Some of them were so fine, they were like a seashell, you could see through them. I only ever had a tin mug (Ibid., p. 335)

Everything tells me that I am a member of a devalued group. There is, first of all, the physical and social conditions in which most of my people live, as compared to the conditions in which my oppressors live:

The zone where the natives live is not complementary to the zone inhabited by the settlers. The two zones are opposed The settler's town is a strongly-built town, all made of stone and steel. It is a brightly-lit town; the streets are covered with asphalt, and the garbage-cans swallow all the leavings, unseen, unknown and hardly thought about The settler's town is a well-fed town, an easy-going town; its belly is always full of good things. The settler's town is a town of white people, of foreigners.

The town belonging to the colonial people, or at least the native town, the Negro village, the medina, the reservation, [the ghetto, the *favela*, the coloured quarter, the bantustan . . . l is a place of ill fame, peopled by men of evil repute. They are born there, it matters little where or how; they die there, it matters not where, nor how. It is a world without spaciousness; men live there on top of each other, and their huts are built one on top of the other. The native's town is a hungry town, starved of bread, of meat, of shoes, of coal, of light. The native town is a crouching village, a town on its knees, a town wallowing in the mire. It is a town of niggers and dirty arabs (Fanon, 1967, p. 30)

How could I not feel that I am despised? How could I not be angry? How could I not look at the oppressor's possessions with a look of envy?

The point is not that all people of Colour wish they could change their racial or ethnic identity. Rather, it is that, in Western societies at least, none – literally none – can escape THE BURDEN OF DEGRADATION.

TRUTH: If one wishes to understand racism, one might as well start here.

The Rage of the Oppressed

And there is, I should think, no Negro living in America who has not felt, briefly or for long periods, with anguish sharp or dull, in varying degrees and to varying effect, simple, naked and unanswerable hatred; who has not wanted to smash any white face he may encounter in a day . . . to break the bodies of all white people and bring them low, as low as that dust into which he himself has been and is being trampled.
— James Baldwin, *Notes of a Native Son*, 1964, p. 41

It is not possible to be a Black American without being angry – angry because of the pervasiveness and brutality of racism, angry because one cannot free one's soul from the burden of race. To repeat, one does not have the luxury of not being angry: 'one has the choice, merely, of living with it consciously or surrendering to it' (Baldwin, 1964, p. 92).

TRUTH: 'As for me, this fever had recurred in me, and does, and will until the day I die.'
— James Baldwin, 1964, p. 92

This experience is not limited to Black Americans – though they probably suffer this illness more than any other Black people: to varying degrees, people of Colour in other racist societies are also permanently enraged. Moreover, it is not simply an individual but a collective rage:

To smash something is the ghetto's chronic need. Most of the time it is the members of the ghetto who smash each other, and themselves. But as long as the ghetto walls are standing there will always come a moment when these outlets do not work. (Ibid., p. 107)

That moment, which does sometimes come, is one of urban rebellion.

Further Reflections

Come now! The Indians massacred, the Moslem world drained of itself, the Chinese world defiled and perverted for a good century; the Negro world disqualified; mighty voices stilled forever; homes scattered to the wind; all this wreckage, all this waste, humanity reduced to a monologue, and you think that all that does not have its price?
— Aimé Césaire, 1972, p. 57

But Surely It's All in the Past

Joyce is right about history being a nightmare – but it may be the nightmare
from which no one can awaken. People are trapped in history and history is
trapped in them.

— James Baldwin, 1964, p. 154

The picture of classical racism and its effects on its subjects which we have drawn in this chapter is bleak indeed. Of course, one might say, racists are like that. You would expect them to think and feel the sorts of things about Black people that we have been discussing. We modern, enlightened White people are not so narrow-minded – many of us have positive relations with people of Colour.

Yet, as we have argued throughout the chapter, racism is not (primarily) the province of individuals but of structures, institutions, narratives of history and culture (or lack of it). While many of the most vicious and degrading aspects of racism have diminished over the past few generations – for example, 'Manly Sports' in the Commonwealth of Australia and lynchings in the Land of the Free – the history of racism as brutality is deeply inscribed in the culture and subjects of racist societies. History is not simply 'in the past', in memory, in institutions and in 'residual' patterns of everyday interaction, it is very much alive in the present.

Like a Detested Nickname . . .

People of Colour cannot ignore images of themselves in the dominant culture. Why not? Because 'their portrait' is embedded in all, or virtually all, of society's dominant institutions – in the newspapers, magazines, paperback books, television programmes and radio broadcasts of the media, in the lessons, books and verbal discourse of the education system, in the speech and actions of the police and the courts. Because it is embedded in a myriad daily human interactions. One cannot escape. As Memmi says, Black and colonized people come to recognize their image in the dominant society 'as one would a detested nickname which has become a familiar description'.

People of Colour hate the degrading images and the subject positions that they offer, but they cannot simply dismiss them. One would like simply to say: 'IT ISN'T ME! IT ISN'T US!' But because these representations are everywhere, and because anyone can see that Blacks *are* inferior in terms of their position in the modern world, it is extremely difficult to avoid the

conclusion that the negative images of people of Colour must contain at least a grain of truth.

'Is he not partially right?' he mutters. 'Are we not all a little guilty after all? Lazy, because we have so many idlers? Timid, because we let ourselves be oppressed?'
— Albert Memmi, 1965, p. 87

Anyone who has lived in a Black American household has probably heard the expression, 'Stop acting like a Nigger!' This expression implicitly recognizes a crucial fact: that oppressed people of Colour are, to a certain extent, complicit in the reproduction of mythical, degrading images. This is a disturbing fact – a topic many people of Colour seek to avoid.

The Boomerang

In our discussions of the profound effects of colonialism and racism we focus primarily on people of Colour. But it must never be forgotten that *it is not possible to brutalize others without brutalizing oneself*. Listen as the Martinican poet Aimé Césaire comments on how, in situations of racial dominance and subordination, chickens come home to roost:

Colonization, I repeat, dehumanizes even the most civilized man; . . . colonial activity, colonial enterprise, colonial conquest, which is based on contempt for the native and justified by that contempt, inevitably tends to change him who undertakes it; . . . the colonizer, who in order to ease his conscience gets into the habit of seeing the other . . . as *an animal*, accustoms himself to treating him like an animal, and tends objectively to transform *himself* into an animal. It is this result, this boomerang effect of colonization, that I wanted to point out. (Césaire, 1972, p. 20)

The dehumanizer becomes another of the dehumanized.

The Invention of Black People . . . and the Reality of Race

BLACK PEOPLE WERE ONLY RECENTLY INVENTED. Before the trans-Atlantic slave trade, 'Black people' did not exist. There were people from specific ethnic and linguistic groups – Mandingo, Wolof, Ashanti, Fanti, Ga, Ewe, Ibo, Yoruba, Hausa, Kru, Mende, Fon, Kongo, Bantu, and so on. There were people from specific locales – from specific villages, towns, cities, regions. There were people of different religious communities. But there

were no Black people – no people who were collectively called 'Black', no people who accepted this designation as their identity.

The first stage in the invention of Black people was the Middle Passage. The slave ships transported people of different 'tribes' and nations from the African continent to the New World. Here they were deliberately mixed up on New World plantations, especially in North America, and collectively called 'African', 'negroes', 'blacks', 'niggers', 'Sambo', and so on, by their masters. That is, they were called such names as though they were one people, despite the fact that surely their identities, initially, were many – as that of Germans (or Prussians, Bavarians, Saxons, Swabians and so on), British or French.

> TRUTH: 'BLACK PEOPLE' were created – literally invented – in the Middle Passage and on the plantation. THE BLACK is not a fact but an effect of power.

In the New World the basis on which people are racially classified varies considerably. The three variables are ANCESTRY, APPEARANCE and SOCIO-CULTURAL STATUS. Whereas former British colonies tend to look to ancestry (race is 'in the blood'), former Spanish and Portuguese colonies privilege appearance and sociocultural status. French ex-colonies tend to come somewhere between the two, but are closer to the Iberian variant. Take, for example, two polar cases: the United States and Brazil. In the United States ancestry is the crucial factor in determining whether or not a person is 'Black'. Many Black people are very light-skinned and may even look White. Yet it is how their ancestors were classified that determines an individual's race. Only in situations far removed from the family, where the family is not known, could such a person pass for White.

The most extreme example of racial categorization by ancestry was, of course, Nazi Germany. Here 'White' people were reconstructed as a racial Other – even though many had been long since assimilated into German society and culture. Indeed, the State found it necessary to mark them out as Other. Here, TRUTH was an effect of POWER.

> TRUTH: You are a Jew!
> POWER: You are a Jew because we have the power to so define you. You will register as a Jew. You will wear the Star of David on your sleeve. Death through the Holocaust shall be your fate . . .

In Spanish America and Brazil, the situation is radically different. Here, the key determinants are appearance (physiognomy) and sociocultural status. Ancestry is not the key to race. How you look determines your racial position in a continuum which categorizes different gradations of skin colour, hair texture, and size and shape of nose and lips. As a result

of this, siblings with different appearances can be classified as belonging to different races.

Yet sociocultural factors also play a role. While lighter-skinned people tend to have higher social status than darker-skinned people, poor light-skinned people might find themselves classified together with darker-skinned people. Similarly, professional, middle-class, dark-skinned people might find themselves put with lighter-skinned people.

The point here is that classification by race is not natural but arbitrary. Yet the fact that it is arbitrary does not make it any less real in terms of the way it affects people's every day lives. Race is a reality.

> A VOICE: And this is a point those POSTMODERNISTS – with all their quotation marks ('race', 'ethnicity', and so on), all their emphasis on the constructed and the arbitrary – miss.

The REALITY OF RACE is the most elemental, inescapable fact that every Black person – that is to say, every person of Colour living in a society profoundly structured by racism – knows. The arbitrary and constructed nature of race has not affected lynchings and discriminations in all areas of life.

Yet 'Black People' are not the only invention: 'The Orient' and 'The Oriental' are also inventions, as are 'The European' and 'White People'. Listen to the cultural and literary critic Edward Said commenting on 'The Orient' and 'The Oriental':

> The Orient was almost a European invention, and had been since antiquity a place of romance, exotic beings, haunting memories and landscapes, re-markable experiences . . .
>
> The Orient is not only adjacent to Europe: it is also the place of Europe's greatest and richest and oldest colonies, the source of its civilizations and languages, its cultural contestant, and one of its deepest and most recurring images of the Other. In addition, the Orient has helped to define Europe (or the West) as its contrasting image, idea, personality, experience. Yet none of this Orient is merely imaginative. The Orient is an integral part of European *material* civilization and culture. Orientalism expresses and represents that part culturally and even ideologically as a mode of discourse with support-ing institutions, vocabulary, scholarship, imagery, doctrines, even colonial bureaucracies and colonial styles. (Said, 1978, pp. 1–2)

From its very beginnings Orientalism perpetrated racist myths and stereo-types which persist through to the present. This is evident, for example, in the scholarship of the founding fathers of Orientalism as a body of theory, writing and research about the East. In his study of this phenome-non, *Orientalism*, Edward Said identifies Silvestre de Sacy and Ernest Renan as two such founding fathers. Sacy was the first president of the

Société asiatique (founded in 1822) and his work was widely used in Europe for several generations. Renan, a philologist writing from the 1840s onwards, consolidated Sacy's work. Writing of Renan, Said comments:

> Everywhere Renan treats of normal human facts – language, history, culture, mind, imagination – as transformed into something else, as something peculiarly deviant, because they are Semitic and Oriental, and because they end up for analysis in the laboratory. Thus the Semites are rabid monotheists who produced no mythology, no art, no commerce, no civilization; their consciousness is a narrow and rigid one; all in all they represent 'une combinaison inférieure de la nature humaine'. (Said, 1978, pp. 141–2)

The racist content of language, imagery and practices of the institutions responsible for Orientalism are the basis for the kind of racist stereotyping of people from the East that we discussed earlier in this chapter.

The Commodification of Difference

It has rarely been the case that White people, even the most racist, simply regarded people of Colour in negative terms. There has always been, as we suggested in the discussion of the Black body, a degree of White Western fascination with Otherness – in travel literature, in film, in modern art, in anthropology. The following passage, written by one of Britain's most popular writers of the mid-1900s, is the most famous narrative of life in Tiger Bay, Cardiff's famous multiethnic seaport community (which had – and still has – a large 'Coloured' population):

> There was a fascination in the walk through Tiger Bay. Chinks and Dagos, Lascars and Levantines, slippered about the faintly evil by-ways that ran off from Bute Street. The whole place was a warren of seamen's boarding houses, dubious hotels, ships' chandlers smelling of rope and tarpaulin, shops full of hard, flat ship's biscuit, dingy chemists' shops stored with doubtful looking pills, herbs and the works of Aristotle. Children of the strangest colours, fruit of frightful misalliances, staggered half-naked about the streets; and the shop windows were decorated with names that were the epitome of all the clans and classes under the sun. The flags of all nations fluttered on the house fronts; and ever and anon the long bellowing moan of a ship coming into the docks or outward bound seemed the very voice of the meeting place of the seven seas. It was a dirty, rotten and romantic district, an offence and an inspiration, and I loved it. (Spring, 1939, pp. 43–4)

The author is 'SLUMMING' – among the lower classes and the ethnics, among 'mixed-race' children, poor seamen and prostitutes. And he loves it! . . . [18]

This is a peculiarly White male form of voyeurism. We shall later suggest that this sort of gaze lies at the heart of some of the most important movements of twentieth-century Western art, and that it helps to explain the ambiguous relations many Artists of Colour have with the dominant artistic establishment.

Seeking Encounters with the Body of The Other

If, in the sixteenth, seventeenth, eighteenth or nineteenth centuries, one – say, a White male – wanted to encounter Black bodies, one simply went to the auction-block, examined the creatures being sold and made a purchase.

> TRUTH: For most of the time that people of African descent have been in the Western hemisphere, their bodies have been for sale to the highest White bidder (who usually turned out to be a slave master).

Times have definitely changed. Witness the following story, which concerns everyday life in an American Ivy League university town.

Seeking a Bit of the Other

While teaching at Yale, I walked one bright spring day in the downtown area of New Haven, which is close to campus and invariably brings one into contact with many of the poor black people who live nearby, and found myself walking behind a group of very blond, very white, jock type boys Seemingly unaware of my presence, these young men talked about their plans to fuck as many girls from other racial/ethnic groups as they could 'catch' before graduation. They 'ran' it down. Black girls were high on the list, Native American girls hard to find, Asian girls (all lumped into the same category), deemed easier to entice, were considered 'prime targets'. Talking about this overheard conversation to my students, I found that it was commonly accepted that one 'shopped' for sexual partners in the same way one 'shopped' for courses at Yale, and that race and ethnicity was a serious category on which selections were based.

—bell hooks, 'Eating the Other: Desire and Resistance',
in *Black Looks*, 1992, p. 23

This story merits further discussion. What is going on? In her discussion of this incident (in 'Eating the Other', an insightful essay on the cultural and sexual politics of race and racism), bell hooks points out that the expression of open desire on the part of White men for sex with women of Colour breaks a long-established, rigorously enforced taboo. While White men in the USA have a long history of sexual relations with women

of Colour – including the violations of Black women's bodies which were part of everyday life under American apartheid and slavery – it was not a publicly acceptable practice. Today, among the privileged, highly educated young White men of America's elite colleges, *racial difference has been reinscribed as cultural diversity and pluralism.*

But does this mark a real change in attitudes? Arguably not.

The desire to experience sex with women from a large number of racial and ethnic backgrounds marks a reformulation of a perversely racist, if unconscious, set of assumptions about women of Colour that draw on the classic racist patterns of belief about Black and Asian bodies which we outlined above. They include assumptions about higher levels of sensuality, superior sexual knowledge and exotic sex:

> To these young males and their buddies, fucking was a way to encounter the Other, as well as a way to make themselves over, to leave behind white 'innocence' and enter the world of 'experience'. As is often the case in this society [the USA, the West], they were confident that non-white people had more life experience, were more worldly, sensual and sexual because they were different. Getting a bit of the Other, in this case engaging in sexual encounters with non-white females, was considered a ritual of transcendence, a movement out into a world of difference that would transform, an acceptable rite of passage. The direct objective was not simply to sexually possess the Other; it was to be changed in some way by the encounter. 'Naturally', the presence of the Other, the body of the Other, was seen as existing to serve the ends of white male desires. (hooks, 1992, pp. 23–4)

This also, of course, manifests a profoundly sexist attitude to women and sexuality. Female sexuality is a source of knowledge of the world. Women are objects in a male game of conquest. Masculinity is measured in terms of the number of women taken to bed.

Postmodern Enjoyment

> *To make one's self vulnerable to the seduction of difference, to seek an encounter with the Other, does not require that one relinquish forever one's mainstream positionality. When race and ethnicity become commodified as resources for pleasure, the culture of specific groups, as well as the bodies of individuals, can be seen as constituting an alternative playground where members of dominating races, genders, sexual practices affirm their power-over in intimate relations with the Other.*
> — bell hooks, *Black Looks*, 1992, p. 23

In contemporary youth culture – an international phenomenon linking

the 'wants' of young people to modern capitalism's capacity to 'deliver the goods' – Black bodies, especially Black male bodies, have obtained a kind of mythical status. *In the sixteenth, seventeenth, eighteenth and nineteenth centuries 'it was this black body that was most "desired" for its labor in slavery'. Today, 'it is this body that is most represented in contemporary popular culture as the body to be watched, imitated, desired, possessed'* (bell hooks, 1992, p. 34; emphasis added).

> TRUTH: Although they are not exactly the same, these White racial desires are
> related ...

Why is the Black body, especially the young, athletic Black male body, so highly regarded and imitated? The answer has to do both with the cultural politics of race and with the marketing abilities of modern capitalism. 'Blackness' – Black culture, Black bodies – stands as a primitive sign of wildness.

> It is the young black male body that is seen as epitomizing this promise of
> wildness, of unlimited physical prowess and unbridled eroticism. (hooks,
> 1992, p. 34)

It is well known 'that black people have secret access to intense pleasure, particularly pleasures of the body' (ibid.). If one is in search of the path to pleasure, one must seek an encounter with those who are its guardians.

The cultural construction of Black bodies and experience as a zone of PLEASURE is, in America, Britain, France and other racist societies, somewhat ironic.

> TRUTH: 'Regarded fetishistically in the psycho-sexual racial imagination of
> youth culture, the real bodies of young black men are daily viciously as-
> saulted by white racist violence, black on black violence, the violence of
> overwork, and the violence of disease and addiction.'
> — hooks, 1992, p. 34

The commodification of racial difference – the new ways of consuming Black bodies and culture – appears to offer White people alternatives to crises of identity in contemporary Western societies. bell hooks argues that these crises, 'especially as experienced by white youth, are eased when the "primitive" is recouped *via* a focus on diversity and pluralism': 'the Other can provide life-sustaining alternatives' (hooks, 1992, pp. 25–6).

But does this 'postmodern' fascination with the Other mark a real change, an end to the binary opposition White-Other? Does it signal the development of real respect for Others which might herald an end to racism? Don't hold your breath ...

Obsession with different and 'primitive' Others is a long-established feature of Western culture. It has not always had happy consequences. In the next two chapters we look in detail at examples of the Western fascination with 'its primitive Others'. The cases involve twentieth-century avant-garde movements in the visual arts – movements of people who proclaim themselves to be the enemies of oppression. The question we ask is: Are they?

THE LAST WORD: *'The conclusion is inescapable: compared to the cannibals, the dismemberers, and other lesser breeds, Europe and the West are the incarnation of respect for human dignity.'*

— Aimé Césaire, 1972, p. 53.

10

Primitives, Politics and the Avant-garde: Modern Art and its Others

What a right little, tight little, round little world it was when Greece was the only source of culture . . .

— Roger Fry, *Vision and Design*, 1961, p. 85

It is a striking characteristic of several movements within both modernism and the avant-garde that rejection of the existing order and its culture was supported and even directly expressed by the recourse to simpler [sic] art: either the primitive or the exotic, as in the interest in African and Chinese objects and forms, or the 'folk' or 'popular' elements of their own cultures. As in the earlier case of the 'medievalism' of the Romantic Movement, this reach back beyond the existing cultural order was to have very diverse political results.

— Raymond Williams, 'The Politics of the Avant-garde', 1989, p. 58

As Western modernity and progress has been made possible through the exploitation of the colonized, so Modernism . . . developed through a disaffection with the societal effects of modernity and turned for creative rejuvenation to the so-called 'primitive' cultures of others. In other words, the non-European has never been outside the modernist enterprise; he and she have always been its invisible and unacknowledged centre.

— Jean Fisher, Editorial in *Third Text*, 1989, pp. 3–4

How has modern Western art related to art and culture from the non-White world? How have dominant cultural institutions conceptualized

316 The Cultural Politics of Race

'Art' and 'The Artist'? How they have used these categories as a basis for
drawing boundaries and reproducing relations of power? These are some
of the questions with which we are concerned in chapters 10 and 11. We
explore how artistic products, aesthetic principles and cultural values
from Africa, the Pacific and Native America – from the so-called 'prim-
itive' and 'tribal' societies of the 'Third World' – have been received and
valued within the Euro-American art world.

In chapter 12 we ask: How has the history of the engagement between
modern Euro-American art and art from the non-White/non-Western
world affected the reception and valuation of Artists of Colour (non-
White artists) living and working in the West? Our particular focus in the
discussion of the lives and work of Artists of Colour is on Britain.

'Modern art' is not simply specific artistic products – paintings by
Picasso, sculptures by Moore, montages by Heartfield, and so on. It is
also, crucially, a nexus of social groupings and institutions – artists,
patrons, schools, galleries and the rest – and thus an arena in which
power is (re)produced and contested. We wish to explore *histories of
relations of power*, histories that have been rendered invisible.

The questions indicated above link issues of ART HISTORY, ART CRITICISM
and THE PRACTICES OF CULTURAL INSTITUTIONS to a broader context of society
and power. To explore them, we draw on a wide range of sources, with
some particular focus on the following three:

- *'Primitivism' in 20th Century Art: Affinity of the Tribal and the Modern* –
 a lengthy, two-volume catalogue published in conjunction with a
 major exhibition in 1984 at the Museum of Modern Art (MOMA) in
 New York which explored encounters between Western (White) mod-
 ernist artists and arts and cultures of the non-Western (non-White)
 world.
- *The Other Story* – a catalogue for an exhibition at the Hayward Gallery
 in London in winter 1989–90 which explored encounters between
 African, Asian, Caribbean and Black British artists and the modernist
 establishment in postwar Britain.
- *Third Text* – a quarterly journal, launched in Britain in 1987, which
 provides a forum for 'Third World perspectives on contemporary art &
 culture'. While *'Primitivism' in 20th Century Art* and *The Other Story* are
 interventions in art history, *Third Text* is intervention in art history, art
 criticism and cultural theory. It is an important journal – one which
 mainstream scholars would do well to read.[1]

'Primitivism' in 20th Century Art – and critical responses to it, some of
them in *Third Text* – provides the starting point for some key areas of
discussion in the present chapter and the next.

A Hidden History

No pivotal topic in twentieth-century art has received less serious attention than primitivism.
— William Rubin, 'Modern Primitivism', 1984, p. 2

Primitive adj. & n. **1.** *of or existing in the beginning or the earliest times or ages; ancient; original* **2.** a) *characteristic or imitative of the earliest ages* b) *crude, simple, rough, uncivilized, etc.* **3.** *not derivative; primary; basic.*
— *Webster's New World Dictionary of American English,* 1988

'Primitivism' in 20th Century Art: Affinity of the Tribal and the Modern, a 700-page study with more than 1,000 illustrations, is the most comprehensive scholarly treatment to date of the crucial influence of the arts of so-called 'primitive' societies on modern Western painting, sculpture and other visual art. It is also the first book to illustrate and discuss the art from non-Western 'tribal' cultures collected by Western vanguard artists. It is a major intervention in art history, exploring a too easily forgotten history of modern art.

> TRUTH: 'Primitivism has been virtually the "invisible man" of art scholarship . . .'
> — William Rubin (ed.), *'Primitivism' in 20th Century Art,* 1984, p. ix

'Primitivism' in 20th Century Art (note the quotation marks) includes nineteen essays by fifteen distinguished scholars. The study begins with a substantial essay entitled 'Modernist Primitivism: an Introduction' by William Rubin, Director of the Department of Painting and Sculpture (from 1973 to 1988) at the New York Museum of Modern Art and principal curator of the exhibition. Rubin's introductory essay is followed by three essays tracing the arrival and dissemination of non-Western 'primitive' art – American Indian, Oceanic, Eskimo and African – in the West (see Feest, 1984; Peltier, 1984; and Paudrat, 1984). Most of the two volumes consists of detailed studies of ways in which various (Western) modern artists and art movements – Gauguin, Fauvism, Picasso, Brancusi, German Expressionism, Dada, Lipschitz, Modigliani, Epstein, Klee, Giacometti, Surrealism, Henry Moore, Abstract Expressionism and certain postmodernisms – have been influenced by the arts of non-Western 'primitive' and 'tribal' cultures, especially African and Oceanic cultures. That is, the catalogue explores:

1 *direct borrowings* – for example, a specific image is appropriated by a modern artist from his or her invisible 'primitive' counterpart;

2 *formal or conceptual influences* – for example, ideas are assimilated about how to draw bodies and faces;
3 *philosophical influences* – for example, notions are incorporated about art as power or magic;
4 *other linkages*.

'Other linkages' include what Rubin calls *'elective affinities'*. This concept refers to the fact that artists, in different times and places (perhaps, ancient Africa and contemporary New York), have shared certain artistic problems and have sometimes arrived at remarkably similar solutions: 'The art-making process everywhere has certain common denominators' (Rubin, 1984a, p. 25). Thus, if you find, say, that one of Paul Klee's paintings looks remarkably like an Oceanic pictograph that you saw in an ethnographic museum in Berlin, Paris, London or New York, this could be a result of either influence (Klee nicked the design) or 'affinity' (Klee and his invisible – that is, historically erased – Oceanic colleague simply arrived at the same solution).[2]

Anyone interested in the history of modern art or in the impact of non-Western (or 'Third World') cultures on the West would do well to study these two volumes carefully.

What did the curators hope to achieve by this exhibition (and the scholarly volumes that accompanied it)? Here is Rubin's response, which occurs at the end of his introductory essay:

> It would be disingenuous ... to pretend that in proposing our exhibition I did not feel fairly certain that it would result in a significant correction of the received history of modern art, and draw to the attention of that art's very large public some unfamiliar but particularly relevant masterpieces from other cultures. There was also the thought that some modern works we know quite well might seem all the richer for being seen from a new perspective. However presumptuous it may seem, all this lies within the realm of my expectations.
>
> In the realm of my hopes, however, there is something less explicit, more difficult to verbalize. It is that the particular confrontation involved in our exhibition will not only help us better to understand our art, but in a very unique way, our humanity – if that is not saying the same thing. The vestiges of a discredited evolutionary myth still live in the recesses of our psyches. The vanguard modernists told us decades ago that the tribal peoples produced an art that often distilled great complexity into seemingly simple solutions. We should not therefore be surprised that anthropology has revealed a comparable complexity in their cultures. I hope our effort will demonstrate that at least insofar as it pertains to works of the human spirit, the evolutionary prejudice is clearly absurd. (Rubin, 1984a, p. 71)

As this statement suggests, the book and the exhibition were intended as AN ANTI-EUROCENTRIC, ANTI-RACIST INTERVENTION in the cultural politics

of art history. Whether they have succeeded is a question we shall have occasion to discuss, along with other questions of the racial politics of 'Primitivist' interventions in Western modern art.

The *'Primitivism' in 20th Century Art* exhibition was 'controversial'. So, as it turns out, was *The Other Story*. That is, both exhibitions were criticized by a larger than usual number of scholars and critics, and often in strong terms. This fact, however, is not of great interest to us, except in so far as the criticisms raised bear directly on the subject matter of these chapters. Also, as we all know, the critics are not always right. . . .

Modernism and Its Others:
Encounters with Non-Western Art

> STATUARY IN WOOD BY AFRICAN SAVAGES:
> THE ROOT OF MODERN ART
> *3rd Nov – 8th Dec 1914*
> *291 Fifth Avenue*
> *New York*
>
> *A Special Exhibition. From the collection of Paul Guillaume.*

When was African art invented? The date was November 1914. The place was Alfred Stieglitz's famous Little Gallery of the Photo-Session, located at 291 Fifth Avenue in New York City. The organizer was Marius de Zayas, Stieglitz's associate.

A DISSENTING VOICE: This is all wrong. African art was invented in 1906 or 1907 – when Picasso paid his first visit to the ethnographic museum in Paris. . . .

The 1914 exhibition was apparently the first exhibition in the world in which African wood carvings were shown solely from the point of view of art. Previous exhibitions, held in ethnographic museums, displayed such objects from the point of view of anthropology or ancient history. The exhibition at the gallery of the Photo-Session group, featuring objects belonging to Paul Guillaume, the famous Parisian art collector and dealer whose acquisitions would have a profound affect on modern art, was the first to emphasize the formal and aesthetic features of African sculpture. Eighteen objects were displayed, from Ivory Coast and Ghana.

The exhibition's title was an ironic play on contemporary conceptions of both African culture (which was viewed as 'primitive' or 'savage') and Western art and culture (which was viewed as 'advanced' and 'civilized').

The title emphasizes the link between 'US' and 'THEM', suggesting in effect that the so-called 'savages' invented modern art before we did.

Western Art and the Cult of 'Primitivism'

In an interview published in the *Echo de Paris* on 23 February 1891, the artist Paul Gauguin explained why he had decided to leave France and go away to distant Tahiti:

> I only desire to make a simple, very simple act. In order to do this it is necessary for me to immerse myself in virgin nature, see no one but savages, live their life, with no one other thought in mind but to render, the way a child would, the concepts formed in my brain, and to do this with nothing but the primitive means of art, the only means that are good and true. (Quoted in Varnedoe, 1984a, p. 187)

Gauguin's motives were those of the primitivist.

PRIMITIVISM is a search for origins and absolutes – for unspoilt nature and uncontaminated humanity, for the paradise we (modern Westerners) have lost. In some of its aspects 'Primitivism' is part of a long-established romantic tradition in Europe which found expression in the theoretical writings of Jean-Jacques Rousseau in the eighteenth century and in much subsequent art and literature. Daniel Miller describes the relationship between 'Primitivism' and ROMANTICISM as follows: 'Primitivism stands for that aspect of the Romantic movement which is based on the assumption that there exists a form of humanity which is integral, is cohesive, and works as a totality. Since this totality is always defined as a critical opposite to the present, it is always a representation of the primitive "other" ' (Miller, 1991, p. 55).

'Primitivism' is characterized by *a hungering for absolutes, a drive for universality* and *a powerful desire to escape from modern Western industrial, alienating society*. It has taken many forms, from the celebration of rural peasant life at home to an engagement with cultures that are radically Other.

TRUTH: 'The primitivist impulse in modern art is deep and widespread, and contact with the "ethnological arts" [i.e., so-called "primitive" and "tribal" arts] only furnishes one of the occasions for its expression.'
— Robert Goldwater, *Primitivism in Modern Art*, 1967, p. xvii

A VOICE: We think of ourselves as having progressed light years beyond the tribal peoples. But insofar as art is a concrete index of the spiritual accomplishments of civilizations, *the affinity of the tribal and the modern* should give us pause.
— William Rubin, 1984a, p. 73

In the late nineteenth century, interest in non-European cultures long shared by ethnologists and anthropologists spread rapidly throughout the art world. Listen as Kenneth Coutts-Smith, the British painter, art historian and critic, explains:

> the process of co-option and appropriation was extraordinarily rapid and complete, beginning jointly, and perhaps hesitantly, with Degas and Whistler staking out claims on the Japanese, and with Gauguin grasping first the 'primitive' of Breton folk art, then that of Melanesia, the pattern was set. Every artist, from the most significant members of the cenacle at Le Lapin Agile to the most obscure dauber in the Place du Tertre, attempted to secure for himself [they were virtually all men] some sort of cultural territory to exploit. *Within thirty to forty years not one corner of non-European culture remained untouched as a source of imagery* . . . (Coutts-Smith, 1991, p. 28; emphasis added)

And here, to a large degree (much larger than generally conceded), lie the origins of modern, twentieth-century Western art.

The Modernist Break . . . and the Primitivist Connection

Only the Africans and the Rumanians know how to carve wood.
— Constantin Brancusi

He recognises his brothers only in the primitives, the artists of the Gothic, and the Blacks.
— Benjamin Fonlane on Brancusi, his friend and fellow Romanian[3]

Modernism in the arts was motivated in part by a rejection of modern, Western society and culture. The deification of rationality and science, the rapid growth of industry and cities, the capitalist obsession with material values, the ideology of progress – many artists, especially those of younger generations, came to experience all of this as ALIENATION. Art, they felt, had lost contact with those basic human passions which were its source of inspiration. From the late nineteenth century onwards, many artists in the West looked increasingly beyond their own cultures and environments for new ideas about art. Above all they looked to so-called 'primitive' cultures.

TRUTH: 'The exotic became a primary court of appeal against the rational, the beautiful, the normal of the West.'
— James Clifford, 'On Ethnographic Surrealism', 1988a, p. 127

QUESTION: What was it about the art of Africa, Native America and Oceania that attracted modernist artists?

ANSWER: 'The demonic power, the overt sexuality, the extraordinary formal variety, and the inner logic often totally divorced from the representational considerations found in the European tradition – these were the characteristics of tribal art that had such a liberating and far-reaching influence on Picasso, Brancusi, Epstein, and Moore.'

— Alan Wilkinson, 'Henry Moore', 1984, p. 423

Yet 'primitive' and 'tribal' art has meant different things to different modern Western artists. For example, for Picasso and the Cubists, the major concern was with formal principles – together with direct emotional impact. Surrealism, on the other hand, was much more preoccu-

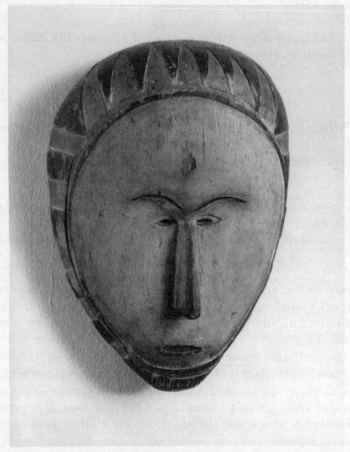

Plate 10.1 Fang Mask, Gabon, West Africa.
Reproduced by kind permission of the *Musée National d'Art Moderne, Centre Georges Pompidou*, Paris, Documentation Photographique. Formerly in the collection of the Fauvist painter Maurice de Vlaminck.

pied with the fantastic, demonic and imaginative qualities of 'primitive' art. Hence the Cubist preference for West African sculpture versus the Surrealist preference for Oceanic, Eskimo and Native American masks and totems (compare plates 10.1 and 10.4).

The modernist break in European art represents a fundamental shift from STYLES ROOTED IN VISUAL PERCEPTION to STYLES FUNDAMENTALLY BASED ON CONCEPTUALISATION, that is, an emancipation from the restrictions of a perceptually based art. For a great deal of its history, certainly since the Western European Renaissance, visual art had been derived from careful observation of the real world – nature, individuals, human activity. The idea had been to create art that was as close to the truth of visual observations/sensations as possible. (Perhaps it was photography that ultimately put an end to this, since, as we all know from common sense, there is no image more true to its referent than the photograph.)

In modernism the locus shifted FROM THE EYE TO THE MIND, from perception to conception. Perception had been dominant in the classical and realist traditions. In classical sculpture, for example, the goal was balance and proportion, and controlled emotion. In modernism conceptual modes of imaging became central. Modernism rejected the notion of the brain as slave to the senses, and, with a little help from 'the primitives', ushered in a new range of artistic practices.

The effect was profound. Take, for example, the impact of African art on modernist sculpture. African art legitimated:

- 'the rejection of the classical ideal of beauty'
- 'the freedom to create sculpture based on intense feelings and not to strive for anatomical accuracy'
- 'the dismissal of modelling [à la Rodin and the classical tradition] in favour of direct carving'
- 'identification with the emotional power of tribal art' (Wilkinson, 1984, p. 443).

CLASSICAL WESTERN SCULPTURE demands careful attention to realistic proportions and representation, the product of detailed knowledge of the muscle and bone structure of the body. In contrast, AFRICAN SCULPTURE often radically reinvents the human form. In the sculpture of West and Central Africa we find figures characterized by:

- a very large head
- a large, elongated torso
- prominent genitals
- relatively small limbs
- an elongated neck
- a characteristic bent-knee pose

- separated legs, each terminating in a foot (or footing), allowing the work to stand safely without attachment to a base.

Though most West and Central African sculptures tend to be anthropomorphic, that is, they often represent – or evoke? – human and human-like beings, they do not indicate an overwhelming concern with realism or (post-Renaissance European) perspective. (See plate 10.2, an ordinary but characteristic example showing many of the features indicated in the above.) Besides these general features, there are also a number of principles and techniques that are specific to specific African cultures – the Yoruba, the Fang, the Bambara, the Grebo, the Senufo and so on. For example, some traditional African artists place ridges on their sculpted faces, some make concave masks, some use rhomb-like shapes, some use a mélange of materials. Western modernist artists learned from *particular* traditions of African art.

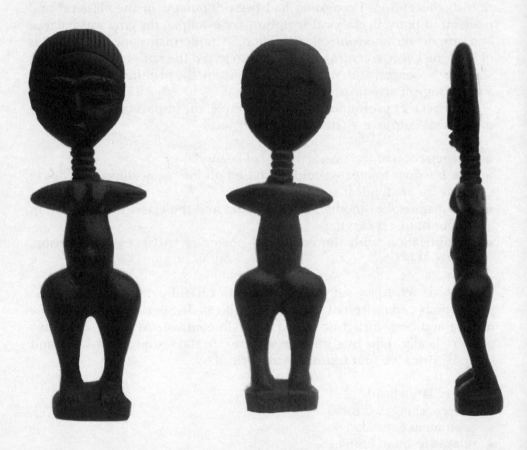

Plate 10.2 Akan 'Fertility Doll', Ghana or Ivory Coast.
From the authors' collection. Photograph: Hannah Justice-Mills.

Since the Renaissance, one of the main preoccupations of Western art had been to master PERSPECTIVE: objects in the painting are drawn as if viewed from a single perspective – from a point of view outside and in front of the frame. Another preoccupation had been to master the ILLUSION OF DEPTH: the good painting, in the traditional sense, is one in which objects intended to be seen as further away are reduced in size and distinctiveness, objects intended to be seen as near overlap those 'behind' them, and so on. One produces a painting that looks as though one were standing at a single point and looking through a window – that is, assuming one has got the perspective and depth 'right'.

Modern art breaks with both of these obsessions, as we shall see in our discussion of Picasso.

> A VOICE: 'The intrinsic emotional appeal of shapes – here in a nutshell is the potent alternative to the Greco-Roman tradition that tribal art offered. Tribal sculpture, with its astonishing freedom and variety of form invention, its intensity and directness of expression, and its own internal logic, suggested to twentieth-century painters and sculptors boundless formal sources on which to draw in order to reshape the human figure.'
>
> — Alan G. Wilkinson, 1984, p. 597

Here is Henry Moore, the renowned modernist sculptor, describing the effect of his encounter with African and other non-Western art:

> There was a period when I tried to avoid looking at Greek sculpture of any kind. And Renaissance. When I thought that the Greek and Renaissance were the enemy, that one had to throw all that over and start again from the beginning of primitive art. (Quoted in Wilkinson, 1984, p. 596)

And again:

> One room after another in the British Museum took my enthusiasm. The Royal College of Art meant nothing in comparison. (Moore, 1966, p. 33)

The Greeks, the Renaissance, the Royal College of Art – these were nothing compared to the objects in the British Museum.

Modernist artists appropriated a range of aspects of the art of Africa, Native America and Oceania. Sometimes they engaged in direct *visual borrowings*, the appropriation of icons and other images. Sometimes they took over adapted *forms and styles*. At other times, they sought to reproduce the *feeling*, the *purpose*, the general *emotional impact*. For many Western artists, the attractiveness had more to do with the POWER OF ART than with its specific appearance.

QUESTION: What was the precondition for Western artists' attractions to 'primitive' art at the beginning of the modern period?

ANSWER: It was a crisis – a rupture – in Western modes of representation.

> Primitivism was taken up as a means of challenging post-Renaissance techniques of illusionism.
>
> QUESTION: And what is 'illusionism'?
>
> ANSWER: It is a 'term used in painting of a style which exploits all the technical procedures of perspective, etc. not merely to represent 3-dimensional space in 2 dimensions but rather to give the impression that the pictorial space is an extension of real space; sculpted 3-dimensional figures are often integrated into paintings to heighten the fusion of real and artistic space.'
>
> — *Thames and Hudson Dictionary of Art and Artists*, 1988

The Power of Art

What is art for? What is its purpose? In their own context the magico-religious images of African, Native American and Oceanic art had a status radically different from art in the West. They were EMBODIMENTS OF SPIRIT ENTITIES which, during times of ritual, carry an enormous and immediate CHARGE OF SPIRITUAL POWER.

> During the religious ritual, the person who dons the mask in order to represent a specific entity LOSES FOR THAT TIME HIS [*sic*] INDIVIDUAL IDENTITY AND BECOMES THE SPIRIT ITSELF; in the Primitive view, man thus has the capacity to be temporarily transformed into some other spirit, whether of an ancestor, animal, or tree. The transformation is visual as well as psychological, for the mask costume usually totally alters the appearance of the ritual participant. (Maurer, 1984, p. 549; emphasis added)

It was this aspect of 'tribal' art that the Dadaists and Surrealists sought to capture. They looked to what they saw as its powerful, mysterious and transformative dimensions, its power to transform the SUBJECTIVITY of the individual. Art should be not just metaphor but METAMORPHOSIS.

Primitivists have taken a particular interest in the power of FETISHES, the use of MASKS in RITUAL, the role of the artist as MAGICIAN-SORCERER. They have been interested in worldviews in which THE SPIRITUAL is privileged over the non-spiritual, the supernatural over the world of daily life. *The challenge is to endow their works of art with the equivalent of 'primitive' fetish-power.*

fetish n. **1.** *an inanimate object worshipped by primitive peoples who believe it to have magical powers or to be inhabited by a spirit* **2.** *Psychol. an inanimate object that is abnormally stimulating or attracts sexual desire* **3.** *a thing to which irrationally excessive respect or attention is given.*

While some modern artists have been concerned to appropriate imagery and formal principles from 'primitive' art, others have been more interested in its power.

A Particular Pertinence Today

For many Western artists the attraction to 'primitive' art is part of a critical-political stance. They are convinced that the violence and alienation of the modern world can only be appropriately conveyed and addressed by an art that has the sort of power that one finds among the so-called 'primitives'. As Adolph Gottlieb, the American abstract expressionist painter, explains:

> If we profess kinship to the art of primitive man [*sic*], it is because the feelings expressed have a particular pertinence today. In times of violence, personal predilections for niceties of colour and form seem irrelevant. All primitive expression reveals the constant awareness of powerful forces, the immediate presence of terror and fear, a recognition of the terror of the animal world as well as the eternal insecurities of life. That these feelings are being experienced by many people throughout the world today is an unfortunate fact and to us an art that glosses over or evades these feelings is superficial and meaningless. (Quoted in Varnedoe, 1984b, p. 619)

'WE ARE THE PRIMITIVES OF A NEW AGE' – so numerous modernist manifestos have said.

Paintings by Savages, Spells against Civilization

People little know how near the truth they are when they jeer at these pictures and say they might be painted by savages. The bourgeois rule has turned us into savages. Barbarians . . . threaten; we ourselves have had to become barbarians to save the future of humanity from mankind as it now is. As primitive man, driven by fear of nature, sought refuge within himself, so we too have to adopt flight from a 'civilization' which is out to devour our souls. The Savage discovered in himself the courage to become greater than the threat of nature, and in honour of this mysterious inner redeeming power of his, which, through all the alarms and terrors of storm and of ravening beasts and of unknown dangers, never deserted him, never let him give in – in honour of this he drew a circle of guardian signs around him, signs of defiance against the threat of nature, obstinate signs of demarcation to protect his possessions against the intrusion of nature and to safeguard his belief in spirit. So, brought very near the edge of destruction by 'civilization', we discover in ourselves powers which cannot be destroyed. With the fear of death upon us, we muster these and use them as spells against 'civilization'. Expressionism is the symbol of the unknown in us in which we confide, hoping that it will save us. It is the token of the imprisoned spirit

that endeavours to break out of the dungeon – a tocsin of alarm given out by all
panic-stricken souls. This is what Expressionism is.
> — Hermann Bahr, *Expressionismus*, 1916, quoted in
> Harrison and Wood, 1992, p. 121

Focusing on the Politically Correct

In what follows, we probe more deeply into encounters between Western modern art and THE PRIMITIVE. After a discussion of Picasso's appropriation of the racial 'Other', we explore the 'primitivist' connection in three twentieth-century avant-garde art movements: Dada, Surrealism and German Expressionism. (As there is already a considerable literature on Picasso and African masks, we focus less on his art – or rather his cultural politics – than we would otherwise do.)

Why do we single out Picasso, Dada, Surrealism and German Expressionism? *Because we wish to focus in particular on the politics of race in Western art movements that specifically claim to be politically (not simply artistically) radical.*

> PICASSO: 'What do you think an artist is? An imbecile who, if he is a painter, has only eyes, if he is a musician has only ears, if he's a poet has a lyre in each chamber of his heart, or even, if he's a boxer, just his muscles? On the contrary, he is at the same time a political being, constantly alert to the heart-rending, stirring or pleasant events of the world, taking his own complexion from them. How would it be possible to dissociate yourself from other men; by virtue of what ivory nonchalance should you distance yourself from the life which they so abundantly bring before you? No, painting is not made to decorate apartments. It is an instrument for offensive and defensive war against the enemy.'
> — Pablo Picasso, in *Les Lettres françaises*, vol. V, no. 48, 24 March 1946;
> reprinted in Harrison and Wood, 1992, p. 640

We want to explore whether the most politically conscious radicals manage to escape the burden of racism.

The French Surrealists were the most politically committed of all, having been moved to action as a response to the horrors of the First World War, the success of the Russian Revolution (1917) and the brutality of French colonialism in North Africa and Indochina. The French Surrealists were also the only modern art movement to have substantial involvement with contemporary Black artists and intellectuals. Thus, it surely follows, the Surrealists, if no one else, were able to escape the burden of racism.

But did they? We shall explore this question later. We begin our quest with a well-known revolutionary artist from Spain, who in 1944 unashamedly proclaimed:

My membership in the Communist Party is the logical consequence of my whole life, of my whole work. For, I am proud to say, I have never considered painting as an art of simple amusement, of recreation; I have wished, by drawing and by colour, since those are my weapons, to reach ever further into an understanding of the world and of men, in order that this understanding might bring us each day an increase in liberation Yes, I am aware of having always struggled by means of my painting, like a genuine revolutionary. But I have come to understand, now, that that alone is not enough; these years of terrible oppression have shown me that I must fight not only through my art, but with all of myself. And so, I have come to the [French] Communist Party without the least hesitation, since in reality I was with it all along. Aragon, Eluard, Cassou, Fougeron, all my friends know well; if I have not joined officially until now, it was through 'innocence' of a sort, because I believed that my work and my membership at heart were sufficient; but it was already my Party (From an interview with Pablo Picasso published in *L'Humanité*, newspaper of the French Communist Party, 29–30 October 1944; reprinted in Barr, 1946, and extracted in Harrison and Wood, 1992, p. 639)

Thinking with the Other: Picasso and the Cubists

In no other artist's career has primitivism played so pivotal and historically consequential a role as in Picasso's.
— William Rubin, 1984b, p. 241

Primitive sculpture has never been surpassed.
— Pablo Picasso, quoted in Sebartés, 1949, p. 213

The African masks opened a new horizon to me. They made it possible for me to make contact with instinctive things, with uninhibited feeling that went against the fake tradition [late Western illusionism] which I hated.
— Georges Braque, quoted in Rubin, 1984b, p. 307

In the first two decades of the twentieth century, there was a fundamental shift in how masks, statues, totems and other objects from 'primitive' and 'tribal' cultures were perceived in the West. Objects from Africa and Oceania that had previously been viewed only as material embodiments of native customs and beliefs began to be perceived as objects of artistic importance. Thus (and this is no trivial point) 'primitive' art of the non-White world was INVENTED IN THE WEST – in Paris, in particular. 'Paris more than any other city became the point of convergence for the propagation of ideas and activities that bestowed on African art an essential role in the formation of Western sensibility' (Paudrat, 1984, p. 125).

Lessons from the Savages

Foremost among those artists influenced in the early years of the twen-
tieth century by African and other so-called 'primitive' art were Picasso
and the Cubists. What was the nature of this influence? What did the
Cubists learn from their new teachers? Here is the art historian John
Golding:

> Although cubist painting was from time to time to reflect the influence of
> CERTAIN STYLISTIC AFRICAN CONVENTIONS, it was the PRINCIPLES under-
> lying this so called 'primitive' art that were to condition the aesthetics of one
> of the most sophisticated and intellectually astringent styles of all times. *To
> begin with, as opposed to the western artist, the Negro [that is to say, the West
> African] sculptor approaches his subject in a much more conceptual way; ideas
> about his subject are more important for him than a naturalistic depiction of it, with
> the result that he is led to forms that are at once more abstract and stylized, and in
> a sense more symbolic.* Certainly Picasso seems to have realized almost at once
> that here was an art that was SIMULTANEOUSLY REPRESENTATIONAL AND
> ANTI-NATURALISTIC. This realization was to encourage the Cubists, in the
> years to come, to produce an art that was more purely abstract than anything
> which had preceded it, and which was at the same time a realistic art,
> dealing with the representation of the material world around them. Second-
> ly, Picasso saw that the RATIONAL, OFTEN GEOMETRIC BREAKDOWN OF THE
> HUMAN HEAD AND BODY employed by so many African artists could provide
> him with the starting point for hiw own re-appraisal of his subjects. (Gold-
> ing, 1981, pp. 52–3; emphasis added)

(We shall return to Picasso's fascination with African heads in
chapter 12.) Perhaps we can be more specific about the stylistic
conventions and principles which the Cubists learned from their savage
teachers:

> The cubists learned from the Africans HOW TO SHAPE EYES AND FACES with
> the help of RHOMB-LIKE FORMS and to accentuate different surfaces by mak-
> ing RIDGES. ROUND FORMS WERE REDUCED TO FLAT, FACETED PLANES, but
> above all they now understood the RHYTHMIC INTERRELATION BETWEEN
> SOLID MASS AND EMPTY SPACE in between. What this gave rise to are forms
> captivated in PICTURES WHICH APPEAR TO WEAR AFRICAN FACE MASKS.
> Sculptures of sitting or standing figures arrive at a mixture of components
> borrowed from the classical European tradition and the 'fetish' figures from
> Zaire. However, very soon the view prevailed that they COULD NOT TAKE
> OVER OUTER FORMS, because they could not be integrated, BUT RATHER THE
> PRINCIPLE. As is well-known, this contributed significantly to the triumphal
> march of expressionist art. (Koloss, 1993, pp. 228–9; translated by CW,
> emphasis added)[4]

Some Dictionary Definitions:
Faceted adj. *many-sided – like a cut stone or jewel.*
Rhombus n. *a geometric figure shaped like the diamond on playing-cards.*

Describing the influence of 'primitive art' on the work of the Surrealist painter André Masson, the art historian Evan Maurer says:

> As is the case with most artists who borrow forms or themes from Primitive sources, there are few one-to-one visual relationships between Masson's work and any specific example of Primitive art. Rather, the process of his incorporation of tribal forms or styles into his oeuvre is analogous to the phenomenon of *learning the vocabulary of a new language, but using the words or images within a personal syntactical structure.* (Maurer, 1984, p. 551; emphasis added)

This is exactly what Picasso does: (1) he observes and collects 'primitive' images; (2) he deduces the formal principles utilized (not necessarily consciously) in their construction; (3) he employs/transforms this vocabulary (their images) and grammar (principles) in his own productions.

While formal elements were extremely important, they were not all that the Cubists learned from the art of Africa and Oceania. They also learned a great deal about the (potential) power of art.

Les Demoiselles (or How Modern Art was Born – in a Brothel)

> What is left here of the traditional view of painting? Perspective is broken, shattered completely; colour has lost all atmosphere and become arid and lifeless; the figures are made up of angles fitted together. The revolt against the clichés of painting is complete.
> — Mario de Micheli, *Picasso*, 1967, p. 13

> PICASSO: 'A picture used to be a sum of additions. In my case a picture is a sum of destructions. I do a picture – then I destroy it. In the end, though, nothing is lost.
> — Pablo Picasso, quoted in Barr, 1946, p. 272[5]

Les Demoiselles d'Avignon (1907; plate 10.3) is a radical intervention in the history of art.[6] It is widely regarded as the twentieth-century's most important work of art. As his ideas for the painting were evolving, it seems Picasso realized that *Les Demoiselles* was to be no ordinary work of art. Measuring eight feet in height and nearly eight feet in width, 'It was

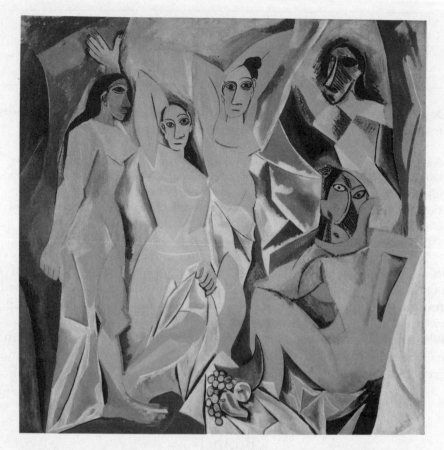

Plate 10.3 *Les Demoiselles d'Avignon*, Pablo Picasso, 1907, oil on canvas,
96" × 92", Museum of Modern Art, New York.
Acquired through the Lillie P. Bliss Bequest. Copyright DACS 1994.

the largest canvas that he had yet tackled, and he took the unprecedented
step of having it lined before he began it – a procedure usually reserved
for the conservation and restoration of the great works of the past' (Gold-
ing, 1981, p. 50). This monumental achievement owes a great deal to
Picasso's 'primitive' teachers.

A VOICE: But we, unfortunately, received neither prestige nor profit . . .

For thirty years – from 1907 to 1937 – *Les Demoiselles* was virtually
hidden from public view, known only to a small group of artists and
friends. Even Picasso's closest friends and 'fellow travellers' found the
painting shocking and disturbing. Here is Daniel-Henry Kahnweiler, the
famed art collector and dealer, commenting on how people, including
avant-garde artists in Paris, reacted at the time:

none of his painter friends followed him. The picture he had produced seemed to everybody an insane and monstrous thing. Braque [i.e., Georges Braque, who would become Picasso's closest ally and co-founder of Cubism] . . . said the impression it made on him was as if someone had drunk petroleum so as to spit fire, while Derain said to me privately that he would soon find Picasso hanging behind his large painting, so desperate did its mood seem to him. (Quoted in Micheli, 1967, p. 13)

Today, almost a century after the painting was made, many people still find it disturbing. (And if we do not, it is probably because so much of modern art, including commercial art, has built on Picasso's example. Art that was once revolutionary has begun to acquire an air of familiarity.)

As he was producing *Les Demoiselles d'Avignon*, Picasso himself seems to have found the painting disturbing. Here is André Salmon, Picasso's close friend at the time, commenting on the artist's state of mind:

Picasso was unsettled. He turned his canvases to the wall and abandoned his brushes . . . during long days and nights, he drew, giving concrete expression to the images which haunted him, and reducing these images to their essentials. Seldom has a task been harder, and it was without his former youthful exuberance that Picasso started on a great canvas that was to be the first fruit of his researches. (André Salmon, *La Jeune Peinture française*, Paris, 1912, p. 42; quoted in Golding, 1981, p. 50)

What is it that is so radical – so disturbingly radical – about *Les Demoiselles*? How does it encapsulate, as possibly no other painting does, the modernist break? And what does it owe to the 'primitives'?

The Abandonment of Story-telling There is a significant change in the content of *Les Demoiselles d'Avignon* as the painting evolved in Picasso's preparatory studies (hundreds of sketches and drawings). The early ensemble studies are clearly located in a brothel (a bordello). A sailor is seated in the middle of the picture, surrounded by five women prostitutes. Another male, a medical student (alternately shown carrying a book or a human skull), enters the scene from the left. Thus, *Les Demoiselles* began its life as a story of prostitution, sailors and, apparently, the threat of venereal disease. Later, there is a shift from a NARRATIVE to an ICONIC painting: the men are taken out, the association with a brothel is no longer obvious, the picture is removed from a narrative context. The completed version of *Les Demoiselles* is not a story about the world but a statement about art itself. (Changes in Picasso's vision as *Les Demoiselles* evolved from studies to completion are indicated in Rubin, 1984b.)

The move from *paintings-about-the-world* to *paintings-about-painting* is a widespread feature of twentieth-century art. This change is related to

334 The Cultural Politics of Race

certain other conceptual changes, for example, those involving perspective, space, the body and colour. *Les Demoiselles* signals a number of these changes.

A VOICE: We, the so-called primitives, must also be thanked . . .
FACT: 'Cubism emerges as a fusion of the conceptual or rational element in African art with Cézanne's principle of "realization" of the motif.'
— HerbeáRead, *A Concise History of Modern Painting*, 1974, p. 68

Perspective After years of tutoring and careful practice, the Western artist – thanks to the advances of the Renaissance – learns to make proper use of perspective. She learns those 'tricks' that give the ILLUSION of depth and make the painting look NATURAL. Specifically, she learns:

- *Scale perspective* – how to reduce the size of objects that are intended to be seen as farther away.
- *Overlapping* – how to cover part of an object with part of another so as to make one appear to be in front of (or behind) the other.
- *Atmospheric perspective* – how to decrease the detail and soften the focus to make distant objects appear less distinct.
- *Linear or geometric perspective* – how to emphasize depth by use of linear devices, that is, that illusion usually illustrated by train tracks which seem to converge as they recede into the distance.

Now, learning to execute properly these tricks of the trade takes hard work. Indeed one of the defining features of children's and bad amateur art is a failure to employ perspective properly. What is a bad drawing? It is one in which the houses, trees and people in the background look too big compared to those in the foreground; the fish on the hook looks half as big as the boat; the streets in the background fail to recede properly; and so on.

Or so the traditional view goes.

Modern artists break with precisely such assumptions about what makes a good picture. The radical, anti-perspectival interventions of Cézanne provides an initial impetus here. But the principal guides along this blasphemous route are the Primitives and Picasso.[7]

'For five hundred years, since the beginning of the Italian Renaissance', artists in the West had been guided by logical and mathematical principles, whereby the artist viewed her subject 'from a single, stationary viewpoint'. Picasso deliberately and powerfully breaks with this established practice. In the case of the seated figure in the right-hand corner of *Les Demoiselles* 'it is as if Picasso had walked 180 degrees around his subject and had synthesized his impressions into a single image.' This radical break with the traditional, Renaissance perspective was facilitated

by the Cubist engagement with African sculpture. It 'was to result, in the following years, in what contemporary critics called "SIMULTANEOUS" VISION – the fusion of various views of a figure or object into a single image' (Golding, 1981, pp. 53–4; emphasis added).

Privileging Space, Subordinating Colour So, Picasso plays with perspective and space. Notice that, besides being otherwise distorted, the human figures in *Les Demoiselles* have been almost entirely flattened. The painting lacks 'proper' – that is to say, traditional – depth of field: there is very little space either in front of the figures or behind them. Moreover, we are forced to be aware of the flatness of the picture plane, of the surface on which the artist painted. This sense of DEPTHLESSNESS and FLATNESS – a feature of much 'primitive' and 'tribal' art – is 'reinforced by the fact that the drapery around the figures has been treated in the same angular, faceted way as the figures themselves' (Golding, 1981, p. 54). Thus, the figures 'are thrust forward, and leave no polite distance between us and them' (Lambert, 1981, pp. 5–6).

The sensation Picasso has created is very much like that of an elaborately carved SCULPTURE IN LOW-RELIEF. Here, again, Picasso has an affinity with the primitives, for example, the court artists of the West African kingdoms of Benin and the Yoruba.

In *Les Demoiselles* and especially later in fully fledged Cubism, the emphasis is on form, use of space, perspective. Colour is relatively subordinated. For example, in *Les Demoiselles* blue and white are used to reinforce Picasso's use of space: 'We can see how determined Picasso was to keep everything at the picture surface if we look at the blue background at the right. The colour would normally recede, but by outlining it with white Picasso has brought it sharply forward' (Lambert, 1981, pp. 5–6). Picasso uses every trick to force us to see the painting as a flat surface, to prevent us from viewing it as through a window.

Broken Figures, Masked Faces and Ugly Prostitutes One of Picasso's intentions must surely have been to SHOCK the viewer. Take, for example, his attitude towards the Western aesthetic of THE BEAUTIFUL and our established conventions with regard to painting THE FEMALE NUDE.

'Anyone who examines the history of western art must be struck by the prevalence of images of the [White] female body. More than any other subject, the female nude connotes "Art" ' (Nead, 1992, p. 1). In countless Western paintings, from the Greeks onwards, the female nude is a symbol of beauty and, often, a symbol of nature. The task of the properly trained Western artist had been to reproduce the symmetry, grace and beauty of the human body, especially that of the (White) female.

Picasso shows total disregard for this time-honoured tradition. And this is no accident. Listen:

Academic training in BEAUTY IS A SHAM. We have been deceived, but so well deceived that we can scarcely get back even a shadow of the truth. The beauties of the Parthenon, Venuses, Nymphs, Narcisusses are so many lies. Art is not the application of a canon of beauty but what the instinct and the brain can conceive beyond any canon (Pablo Picasso, 1935, quoted in Harrison and Wood, 1992, p. 501; emphasis added)

The bodies on his canvas are DISTORTED: witness the angular bodies of all the figures, the twisted noses of the two central figures, the reversed head of the seated figure on the right, the fragmentation.

The women on his canvas are often UGLY: the figure on the left in *Les Demoiselles d'Avignon* recalls a face of ancient Egypt while the grimacing faces of the two on the right evoke 'primitive' masks, specifically, the elongated, ridged masks of some West African cultures.

The sensuality of the maids of Avignon, if they can be said to have any, is far from that of innocent maidens of the traditional Western oil painting: these women are PROSTITUTES.

> TRUTH: *Les Demoiselles* 'created new canons of aesthetic beauty, or, to put it differently, it destroyed traditional distinctions between the beautiful and the ugly.'
>
> — John Golding, 1981, pp. 50–1

The Savage Within

Listen to Picasso:

> They ['primitive' artists] were against everything – against unknown threatening spirits. . . . I, too, am against everything. I, too, believe that everything is unknown, that everything is an enemy! . . . women, children . . . the whole of it! I understood what the Negroes used their sculptures for All fetishes . . . were weapons. To help people avoid coming under the influence of spirits again, to help them become independent. Spirits, the unconscious . . . they are all the same thing. I understand why I was a painter. All alone in that awful museum [in 1907 at the Musée d'Ethnographie du Trocadéro in Paris] with the masks . . . the dusty mannikins. *Les Demoiselles d'Avignon* must have been born that day, but not at all because of the forms; because it was my first exorcism painting – yes absolutely! (Quoted in Foster, 1985, p. 182)

Picasso acknowledges a profound kinship with the 'primitive' artist – with the notion of art as spontaneity, as rooted in the unconscious, as fetish-power. What he seeks to capture in *Les Demoiselles*, and in many of his other works, is a primordial power. He seeks to create, as he puts it, an 'exorcism painting'.

Picasso is pleased to have digested the Savage.

Pasting Difference

The word 'collage' is often used for papiers collés as the gluing together of alien materials (oilcloth on canvas as in Picasso's Still Life with Chair Caning) and the assembling of diverse materials (the mariner's rope used as a frame in that same pioneer work). But papier collé, insofar as it maintains a unity of materials, is more classical than other forms of collage, and should be distinguished from them. It is characteristic for Braque's classicism and conservatism that he worked only in papier collé. Collage in all other forms – which are those with affinities to tribal art – is entirely the invention of Picasso.

—William Rubin 1984, p. 340, n. 173.

It is not simply Picasso's painting that is influenced by 'primitive' and 'tribal' art. His collages are influenced as well. For Picasso (as distinct from his colleague Georges Braque), collage involved the assembling of diverse, alien materials – of disparate elements with discontinuous textures.

Since classical Greece, the emphasis in Western art had been on symmetry and harmony. Many non-Western art traditions, perhaps especially in Oceania, emphasize RADICAL HETEROGENEITY – not the harmonious but the disharmonious, not continuity but unexpected juxtapositions, not wholeness but fragments. Picasso was attracted to this: the faces of the five women in *Les Demoiselles* echo the art of ancient Egypt (the figure on the left), early Iberian art (the two figures in the middle) and classical West African art (the two figures on the right). Picasso would undoubtedly have found the Sulka mask reproduced in plate 10.4 attractive. 'The MÉLANGE OF MATERIALS, so characteristic of tribal art . . . forms the background for Picasso's inventions of collage and construction' (Rubin, 1984b, pp. 307 and 309). See, for example, his *Bouteille de Bass, verre, pauet de tabac et carte de visite 'André Level'* ('Bottle of Bass, wineglass, packet of tobacco, and calling card "André Level" '), completed in early 1914 and now housed in the Musée Nationale d'Art Moderne of the Centre Georges Pompidou in Paris. This collage includes a calling card, tobacco label and pasted papers on paper.

Picasso, with a little help from his 'savage' teachers, brought radical interventions to modern art, including an artistic practice based on discontinuity and heterogeneity. This emphasis would be further developed by both Dadaists and Surrealists. (Today it is incorporated in some work that is referred to as 'postmodernist'.)

A VOICE: Collage in all other forms – which are those appropriated and adapted by Picasso – is entirely the invention of the 'primitives'.

Picasso and the Primitive

In the history of modern art, there is no Western artist who has been more influenced by non-Western sources than Picasso. In the preceding, we have detailed some of the conceptual principles which Picasso appropriated and developed from African and, to a lesser extent, Oceanic art. Interestingly, in his writings and interviews, Picasso downplayed the importance of the formal, logical dimensions of 'primitive' artforms. What he emphasized were their irrationality and apparent primordial power.

> A VOICE: Picasso was the first to say that 'Les Demoiselles d'Avignon must have been born that day' when he first visited the ethnographic museum. But he insists that it was 'NOT AT ALL BECAUSE OF THE FORMS' – not because of any conceptual or formal influences. It was, he disingenuously says, only the primitive fetish power that his 'FIRST EXORCISM PAINTING' appropriates.

The effect of this move was to reinforce stereotypes of 'primitive' cultures and, as we shall see in chapter 11, to elevate his own position (the White ARTIST-AS-HERO).

Become a Savage! But Hide the Details . . .

The echo of Rimbaud's cry 'BECOME SAVAGES!' can be heard behind these new images of Picasso [which he began to paint from 1905]. And it was not only in Picasso that this echo was resounding, but among a large group of other artists as well. This cry sums up the artists' rejection of both 'constituted society' and official art; in short, it represents a revolt against a situation which was now far removed from the ideas and sentiments that had nourished the greatest minds only fifty years before. The discovery of the 'primitive' is the direct consequence of this revolt, and without this discovery Picasso would not have painted The Maids of Avignon

The influences of archaic and Negro sculpture upon his style are obvious, although Picasso has attempted to deny that this is the case. However, for Picasso the discovery of the 'primitive' goes far beyond the simple acquisition of certain stylistic innovations or a mere delight in exoticism. In contrast to many artists for whom the primitive has been more an opportunity for cultural or social polemic, or a purely aesthetic exercise, for Picasso it was something which enabled him to discover his real nature and to express himself without the impediment of conventions or inhibitions. In his view, primitivism means above all spontaneity, reliance on impulses and passions, going beyond the rule or formula.
— Mario de Micheli, 1967, p. 15

A Journey Back . . . in Order to Go Forward Like most other modern Western artists who have gone for inspiration to non-Western art sources,

Picasso viewed African art as existing not simply across a cultural divide but across a time divide as well.

A VOICE: As is well known, we are those who do not belong to history. We are those who existed before time was. We are THE PRIMITIVES!

In actual fact, 'none of the African pieces Picasso saw in his first few years of fascination with "art nègre" were more than just decades old But old or new, the tribal works were associated by Picasso's generation with the earliest phases of civilization, in accordance with a highly simplistic model of world history' (Rubin, 1984b, p. 243; emphasis added).

Picasso also probably understood the path of his interests 'from Gauguin (whose own primitivist models were primarily in Archaic court art) to Archaic court art itself (Egyptian and Iberian sculpture) and then to Primitive art (African and Oceanic sculpture) . . . as A JOURNEY BACK IN TIME, to the beginnings of art' (Rubin, 1984b, p. 242; emphasis added).

This fallacy – that the Other exists in another time-zone, that the Other never belongs to modernity – is, unfortunately, one which the avant-garde artist shares with the racist.

Dancing with the Other: Dada

He who would be a creator . . . must be a destroyer first.
—Friedrich Nietzsche

Here is the Romanian artist Tristan Tzara, one of the leading figures of Dada, providing some helpful instructions on how to make a Dadaist poem:

Take a newspaper.
Take some scissors.
Choose from this paper an article of the length you want to make your
 poem.
Cut out the article.
Next carefully cut out each of the words that makes up this article and put
 them all in a bag.
Shake gently.
Next take out each cutting one after the other.
Copy conscientiously in the order in which they left the bag.
The poem will resemble you.
And there you are – an infinitely original author of charming sensibility,
 even though unappreciated by the vulgar herd.
 — Tristan Tzara, 'To Make a Dadaist Poem', in his
 Seven Dada Manifestos and Lampisteries, 1992, p. 39

After giving these instructions, Tzara illustrates by way of an example, which begins as follows:

> when dogs cross the air in a diamond like ideas and the appendix of the meninx tells the time of the alarm programme (the title is mine) prices they are yesterday suitable next pictures/appreciate the dream era of the eyes/pompously that to recite the gospel sort darkens/group apotheosis imagine said he fatality power of colours. . . . (Ibid.)

This model 'poem' goes on, but we think you've got the basic idea: the idea was to create a text that was utterly devoid of meaning – by wholly eliminating any conscious control by 'the author'.

Dada was more an attitude – political and artistic – than a style. Below is a second example of the Dada attitude, which we have quoted/reproduced at some length in order to convey a flavour of the Dadaist stance. The writer again is Tristan Tzara, the context another Dada manifesto.

Dadaist Disgust

Every product of disgust that is capable of becoming a negation of the family is *dada*; protest with the fists of one's whole being in destructive action: **DADA**; acquaintance with all the means hitherto rejected by the sexual prudishness of easy compromise and good manners: **DADA**; abolition of all logic, which is the dance of those impotent to create *DADA*; every hierarchy and social equation established for values by our valets: **DADA**; every object, all objects, feelings and obscurities, every apparition and the precise shock of parallel lines, are means for the battle of: **DADA**; the abolition of memory: *DADA*; the abolition of archaeology: **DADA**; the abolition of prophets: **DADA**; the abolition of the future: DADA; the absolute and indisputable belief in every god that is an immediate product of spontaneity: **DADA**; the elegant and unprejudiced leap from one harmony to another sphere; the trajectory of a word, a cry, thrown into the air like an acoustic disc; to respect all individualities in their folly of the moment, whether serious, fearful, timid, ardent, vigorous, decided or enthusiastic; to strip one's church of every useless and unwieldy accessory; to spew out like a luminous cascade any offensive or loving thought, or cherish it – with the lively satisfaction that it's all precisely the same for the blue-blooded, and gilded with the bodies of archangels, with one's soul. Liberty: DADA, DADA, DADA; a roaring of tense colours, and interlacing of opposites and of all contradictions, grotesques, inconsistencies: LIFE.

> — Tristan Tzara, *Dada Manifesto*, 1918; reprinted in Tzara, 1992, p. 13

There we have it, a good Dadaist might say, the entire Dada programme – complete with characteristic Dadaist sentence structure, punctuation, spacing and use of multiple typefaces. Whether in Zurich (1916–19),

Berlin (1917–20), Cologne (1919–20), Paris (1919–22), New York (1913–21) or Hanover (1923–32), Dada was a celebration of NEGATION, CONTRADICTION, SPONTANEITY and 'DESTRUCTIVE ACTION'.

TRUTH: Today, it would surely be called 'postmodernist'.

Defiling Golden Calves

Here is Tristan Tzara, the first Dada leader, speaking at the first Dada event: 'We demand the right to piss in different colours!' (Lewis, 1990, p. 4).

Dadaist rhetoric was bombastic, militant and utterly irreverent. As Tzara's manifesto of 1918 declares, Dada was AGAINST THE FAMILY, AGAINST LOGIC, AGAINST HISTORY, AGAINST RELIGION, AGAINST FAITH IN THE FUTURE – against everything that was the established social and cultural order, against the foundations of bourgeois society (including ART).

THE AUTHENTIC VOICE OF DADA: Everything must be demolished!

Against the Established Social Order

The bourgeois regarded the Dadaist as a dissolute monster, a revolutionary villain. . . . The Dadaist thought up tricks to rob the bourgeois of his sleep.
— Jean (Hans) Arp, quoted in Batchelor, 1993, p. 31

Dada was a child of the First World War. As millions of Europe's young men met untimely deaths in the trenches – from bullets, from gas, from bayonets – and as millions of others came home maimed and disorientated for life, DADA was born. The original birthplace was Zurich. (The founders were not Swiss but immigrant writers and artists from other European countries who had fled to Switzerland during the war because it was a neutral country.[8]) Arp, the bilingual and bi-cultural Alsatian Dada artist whose forename was Hans in Germanic circles and Jean in Francophone ones, explains:

In Zurich in 1915, losing interest in the slaughterhouses of the world war, we turned to the Fine Arts. While the thunder of the batteries [i.e., artillery units] rumbled in the distance [it was literally the case that only a few kilometres outside Zurich the cannon could be heard], we pasted, we recited, we versified, we sang with all our soul. *We searched for an elementary art*

that would, we thought, save mankind from the furious folly of these times. We aspired to a new order that might restore the balance between heaven and hell. (Hans (Jean) Arp, 'Dadaland', in *On My Way*, 1948, p. 39; quoted in Ades, 1981, p. 114, and Maurer, 1984, p. 536; emphasis added)

Here is the crucial point: the First World War 'confirmed a growing conviction . . . that the West's obsession with technological advance and the over-estimation of reason at the expense of feeling led straight to destructive megalomania' (Short, 1991, p. 292).

> FACT: 'Dada, in essence, was a revolt against war. None of these artists could bring themselves to work for the rebuilding of a society that had proven itself so morally bankrupt and they rebelled against the accepted values because these had all succumbed to rabid militarism.'
> — Helena Lewis, *Dada Turns Red*, 1990, p. 1

Dada was an international movement, and its political rhetoric and 'artistic' output varied somewhat from one metropolis to the next. (For example, Dada in Berlin was overtly leftist-political, while Dada in Zurich was more escapist and anarchist; Parisian Dada gave birth to Surrealism, while other Dadaists were engaging in 'anti-art' and 'non-art'.) None the less, 'the kinds of commentary produced through Dada publications do reveal some shared points of departure'. Chief among these was a vehement hostility 'towards the established social order, a hostility vindicated, they would have argued, by the carnage of world war'. *The Dadaists, wherever they were, 'regarded the war as irrefutable proof of the irredeemable corruption of bourgeois society. There was nothing to be salvaged'* (Batchelor, 1993, p. 31; emphasis added).

> DADA SPEAKING: 'Honour, Country, Morality, Family, Art, Religion, Liberty, Fraternity once answered human needs. Now nothing [remains] but the skeleton of convention'
> — Tristan Tzara, quoted in Rubin, 1969, p. 10

> DADA INTERPRETED: 'With its multiple meanings in a variety of languages – an enthusiastic affirmation in Slav, an obsessional preoccupation in French, a hobby-horse in baby-talk – Dada was ideally apt for infuriating the bourgeoisie. It was almost a manifesto in itself.'
> — Robert Short, 'Dada and Surrealism', 1991, p. 294

The challenge was to reject and subvert Western bourgeois society, its values and practices. Listen as Picabia speaks in his *Cannibal Manifesto*:

> You are all accused, stand up . . .
> What are you doing here, parked like serious oysters . . .

Dada feels nothing, it is nothing, nothing, nothing.
It is like your hopes, nothing.
Like your paradise, nothing.
Like your artists, nothing.
Like your religion, nothing.
— Francis Picabia, quoted in Ades, 1981, p. 122

The strategy of the new savages and cannibals was anarchist and nihilist. And it was directed against the sacred cows of Western bourgeois society.

Reflections on the Enlightenment and the Renaissance

Having finally succeeded in making parallel lines meet at infinity, and arrived at the sobriety of skilful superimpositions, he shook his art like a thousand-branched explosion . . .
— Hans Arp, 'Note on Art', 1917; reprinted in Tzara, 1992, p. 59

Here is a brief discussion of WESTERN LOGIC, a scholarly mediation on the truth of THE ENLIGHTENMENT. The author, we assure you, is serious:

There is no ultimate truth. Dialectics is an amusing machine that leads us (in banal fashion) to the opinions which we would have held in any case. Do people really think that, by the meticulous subtlety of logic, they have demonstrated the truth and established the accuracy of their opinions? Even if logic were confirmed by the senses it would still be an organic disease.... (From Tzara's 1918 *Dada Manifesto*; in Tzara, 1992, p. 9).

If this sounds amazingly like some of your postmodernist friends, perhaps you should encourage them to come out of the closet with their Dadaist pedigree
 Here is a considered Dadaist reflection on the development of Western ART as a result of THE RENAISSANCE:

The Renaissance was the infernal age of the cynic. For art it was a shambles, divided between anecdote and charm. Illusion became the goal, and man was trying to go one better than God. But the problems of an eventful life made him interesting and, unfortunately, productive.
 We want to continue the tradition of Negro, Egyptian, Byzantine and gothic art and destroy in ourselves the atavistic sensitivity bequeathed to us by the detestable era that followed the quattrocento. (Tzara, 1992, p. 63; emphasis added)[9]

Against Established Art

A work of art should not be beauty in itself, for BEAUTY IS DEAD.
— Tristan Tzara, 1918

> *'ART' – a parrot word – replaced by DADA,*
> *PLESIOSAURUS, or handkerchief*
>
> *MUSICIANS SMASH YOUR INSTRUMENTS*
> *BLIND MEN take the stage*
>
> *Art is a PRETENSION heated at the*
> *TIMIDITY of the urinary basin, the hysteria born*
> *in the Studio.*
>
> *IF EVERYONE SAYS THE OPPOSITE, IT'S BECAUSE HE'S*
> *RIGHT*
> — Tristan Tzara, 'Unpretentious Proclamation'
> (1924); reprinted in *Seven Dada*
> *Manifestos*, 1992, pp. 15–17

Dadaists believed in the unity of theory and practice – or rather thought and action, for their 'theory', they said, was NOTHING. They claimed to stand for nothing, except to undermine everything that was *something*. But actually, in addition to all the sacred cows that they were against, there were some things that they were *for*. One such was THE PRIMITIVE.

Dadaists wrote a number of essays on 'primitive art' – all of them positive, of course. One of these short essays is reproduced below. It is by the father of Zurich Dada.[10]

Note on Negro Art

by Tristan Tzara
Romanian artist and co-founder of Dada, 1917

The new art is first and foremost concentration, the lines from the base to the apex of a pyramid forming a cross; through purity we have first deformed and then decomposed the object, we have approached its surface, we have penetrated it. We want a clarity that is direct. Art is grouped into camps, each with its special skills, within its own frontiers. The influences of a foreign nature which were mixed up in it are the rags of a Renaissance lining still sticking to the souls of our fellow men, for my brother's soul has sharp branches, black with autumn.

My other brother is naive and good, and laughs. He eats in Africa or along the South Sea Islands. He concentrates his vision on the head, carves it out of wood that is as hard as iron, patiently, without bothering about the conventional relationships

between the head and the rest of the body. What he thinks is: man walks vertically, everything in nature is symmetrical. While working, new relationships organise themselves according to degree of necessity; that is how the expression of purity came into being.

From blackness, let us extract light. Simple, rich luminous naivety. Different materials, the scales of form. To construct in balanced hierarchy. EYE: button, open wide, round, and pointed, to penetrate my bones and my belief. Transform my country into a prayer of joy or anguish. Cotton wool eye, flow in my blood.

Art, in the infancy of time, was prayer. Wood and stone were truth. In man I see the moon, plants, blackness, metal, stars, fish. Let the cosmic elements glide symmetrically. Deform, boil. Hands are big and strong. Mouths contain the power of darkness, invisible substance, goodness, fear, wisdom, creation, fire.

No one has seen so clearly as I this dark grinding whiteness.

—Tristan Tzara, 'Note on Art', in Tzara, 1992, pp. 57–8; originally published as 'Note sur l'art nègre' in *Sic* (the Paris-based Futurist journal), September–October 1917

In 1917 the French painter Marcel Duchamp (1887–1968) submitted a urinal as a piece of sculpture for exhibition in the Independents Exhibition in New York. He called his contribution *Fountain* and signed it R. Mutt. When his submission was refused, Duchamp issued a statement saying that it did not matter whether Mr Mutt had actually made the fountain: what mattered was that he had chosen it.

The Richard Mutt Case

A letter from Marcel Duchamp, 1917

They say any artist paying six dollars can exhibit.

Mr Richard Mutt sent in a fountain. Without discussion this article disappeared and never was exhibited.

What were the grounds for refusing Mr Mutt's fountain:

1 *Some contended it was immoral, vulgar.*

2 *Others, it was plagiarism, a plain piece of plumbing.*

Now Mr Mutt's fountain is not immoral – that is absurd – no more than a bathtub is immoral. It is a fixture that you see every day in plumbers' show windows.

Whether Mr Mutt with his own hands made the fountain or not has no importance. He CHOSE it. He took an ordinary article of life, placed it so that its useful significance disappeared under the new title and point of view – created a new thought for that object.

As for plumbing, that is absurd. The only works of art America has given are her plumbing and her bridges.

— Marcel Duchamp, *The Blind Man*, New York, 1917; reprinted in Harrison and Wood, 1992, p. 248

Perhaps the most venerated painting in Western art is Leonardo's *Mona Lisa*. In 1919 Duchamp pencilled a moustache and beard on to a photograph of the *Mona Lisa* and entitled the new image *L.H.O.O.Q.* It was published in the Dadaist journal *391* in March 1920. When read aloud in French '*L.H.O.O.Q.*' becomes '*Elle a chaud a cul*' – which is a rather rude expression. (As the authors of this book are decent and respectable people, we shall not provide a translation . . .)

Hans Richter, the German-born painter and avant-garde film-maker who was part of the Zurich Dada group, says that he once witnessed fellow Dada artist Jean (Hans) Arp tearing up a drawing he had made and letting the pieces fall so as to form a new pattern. Arp introduced chance or randomness into his poems as well, 'tearing up' phrases and sentences in order to remove logical coherence.

> AN EXAMPLE: 'laughing animals froth by the iron pots the rolls of clouds bring out animals from their kernals.'
>
> — Quoted in Ades, 1981, p. 115

As for poetry, two types were preferred by Dadaists: '*the phonetic poem*' and '*the simultaneous poem*', as they called them. The former involved 'breaking language down' into a string of phonemes to form a nonsense text, which would then be publicly recited, apparently with the utmost seriousness:

> Early in 1917 a whole evening was devoted to Ball's reading of his phonetic poem at the Galerie Dada [which superseded the Cabaret Voltaire in Zurich]. Dressed in a kind of cylindrical pillar of shiny blue cardboard, so that he could not move, Ball had to be carried on to the platform, where he began to recite slowly and majestically 'gadji beri bimba glandridi laula lonni cadori . . .'. (Ades, 1981, p. 116)

The 'simultaneous poem' consisted of Tristan Tzara, Richard Hulsenbeck and Marcel Janco 'simultaneously reading three banal poems in German, French and English at the tops of their voices' (Ades, 1981, p. 116).

In 1920 in Cologne the Chief Constable tried to prosecute the Dadaists as a result of one of their 'exhibitions'. The circumstances were as follows:

> This exhibition, master-minded by Ernst, Johannes Baargeld and Arp, who was fresh from Zurich, was held in a small courtyard reached by going through the lavatory of the Brauhaus Winter. Visitors on the opening day were met by a small girl dressed in a white communion gown reciting obscene poems. The exhibition contained a large number of 'disposable' objects. A sculpture by Ernst had an axe attached with which the audience

was invited to destroy it. Baargeld's [sculpture], a foretaste of many sur-
realist objects, consisted of a small glass tank filled with water coloured red
(blood-stained?), with a fine head of hair floating on the surface, a human
hand (wooden) protruding from the water and an alarm clock at the bottom
of the tank. It [too] was smashed in the course of the exhibition. (Ades, 1981,
p. 118)

The show was closed while the authorities investigated complaints of
obscenity. (This closure was temporary, as it turned out.) The Chief
Constable sought to prosecute the Dadaist artists for criminal deception
– for fraudulently charging an entrance fee for an art exhibition
Max Ernst replied, 'We said quite plainly that it is a Dada exhibi-
tion. Dada has never claimed to have anything to do with art. If the
public confuses the two, that is no fault of ours' (quoted in Ades, 1981,
p. 118).

QUESTION: What was going on here? What were the Dadaists up to?
ANSWER: 'Experiment and improvisation which had been integral to Zurich
 entertainments was sacrificed to a single end: ASSAULT ON THE PUBLIC.
 The technique was to arouse expectations with tantalizing publicity and
 then to so disappoint these hopes that the audience would be forced on the
 rebound to realize the futility of its motive, to look over into an abyss of
 nothingness.'
 — Robert Short 1991, p. 300; emphasis added

Defiling enshrined images, performing 'phonetic' and 'simultaneous'
poems, producing 'chance' collages, staging fraudulent exhibitions –
these sorts of things were favourite activities for Dadaists. Why? Because,
by privileging change and arbitrariness, they deconstructed accepted
(bourgeois) notions of Art, The Artist and Taste.

JOHN BERGER ECHOING MARX: 'The art of any period tends to serve the ideo-
 logical interests of the ruling class.'
 — John Berger, *Ways of Seeing*, 1972, p. 86

Through TRANSGRESSION, INSULT and BLASPHEMY, through IRONY, PARA-
DOX and HUMOUR – through these and other techniques that today many
call 'postmodern', Dada sought to DISORIENTATE, SHOCK and PROVOKE
the public, to UNDERMINE traditional notions of 'good taste', to force re-
flection upon the nature of art (its objects, practices and institutions) and
society.

A DADA VOICE: What is our method? CULTURAL GUERRILLA WARFARE!
A DADA VOICE: What is our goal? SCANDAL, SUBVERSION and REVULSION.
 Which perhaps, like Duchamp's urinal, will result in REFLECTION.

Primitivism and the Cabaret Voltaire

What else did Dadaists do? As previously indicated, Dada took somewhat different forms in the different cities that were its major centres – Zurich, Berlin, Cologne, Paris, New York, Hanover. In Zurich, where the primitivist impulse was the greatest, they used to regularly hold 'NEGRO SOIRÉES' at the Cabaret Voltaire.

The Cabaret Voltaire, something between a nightclub and an arts centre, was founded in February 1916 by the German poet, pacifist and philosopher Hugo Ball. It was the central focus of early Dada activity in Zurich. There 'the social atmosphere of food and drink, noise and conversation, provided a lively context for performances, exhibitions, and the launchings of broadsides and publications'. The place was bursting with activity, much of it spontaneous and improvised. A 'riotous mixture of nonsense poems, sound poems, recitations in various languages, piano playing, drums, jazz, African music and poems, African-inspired masks, screams and laughter, pantomines, and insults' – this was 'the excitement and drama of the Dada evenings'. In particular, 'NEGRO' MUSIC, DANCE AND POETRY were 'frequently listed as major elements of the Zurich Dada performances.[11] Accompanied by the incessant drumming of Richard Huelsenbeck, who was obsessed with African music, Tzara [who was obsessed with African sculpture] and the others recited their own African-inspired songs.' Dada performances were all given 'with straightforward seriousness in a calculated effort to activate and involve the audience' (Maurer, 1984, p. 536).

A POSSIBLE CHANT: *DEATH TO THE BOURGEOISIE!*
LONG LIVE THE PRIMITIVIES!

Here is Tzara explaining later in life the attraction 'primitive' art and culture had for Dada:

> the art of primitive peoples was an integral part of their social and religious functions and appeared as the very expression of their life. DADA, which advocated 'dadaist spontaneity', meant to make of poetry a way of life much more than the incidental expression of intelligence and will. For DADA, art was one of the forms, common to all men, of that poetic activity whose profound roots mingle with the primitive structure of affective life. DADA tried to put that theory into practice, joining African Negro and Oceanic art with mental life and with its immediate expression . . . by organizing NEGRO SOIRÉES of improvised dance and music. It was for DADA a matter of recapturing in the depths of consciousness the exalting sources of the function of Poetry. (Quoted in Maurer, 1984, p. 540)

Elemental force, spontaneity, the privileging of emotion – this was the attraction of 'the Negroes' and 'the primitives'.

We Wear the Mask . . .

There is an important aspect of the Dadaist performance evenings (the 'NEGRO SOIRÉES') that we have yet to discuss: the masks. These were made by Marcel Janco and worn by participants in the course of the evening rituals. Writing in 1948, Jean (Hans) Arp said, 'I haven't forgotten the masks you [Janco] used to make for our Dada demonstrations. They were terrifying, most of them daubed with bloody red. Out of cardboard, paper, horsehair, wire and cloth' (quoted in Maurer, 1984, pp. 537 and 539). The radical use of different types of materials in Janco's masks, like the heterogeneous juxtapositions in the collages of Picasso and the Dadaists, was apparently inspired by certain 'primitive' masks – from Oceania, in particular.[12]

Janco's masks – his fellow Dadaists usually called them 'NEGRO MASKS' – were made in a way that was related to Dadaists' understanding of art in 'primitive' and 'tribal' societies, especially societies of the South Seas. In the West, the emphasis is on making art that is permanent (that is, that will last for generations if not centuries): hence, the importance of painting with oils and canvas, of carving into stone and casting in bronze. Many societies do not have this idea: rather than conceiving art as some kind of monument, they see it as an integral part of life, in particular, of ritual and religious ceremony. It was this notion of art – as IMPERMANENT, SPONTANEOUS and POWERFUL – that the Dadaists found so attractive. Thus, in describing how he made his own collages, Arp draws a comparison with the work of the artists of Oceania:

> Instead of cutting the paper, I tore it up with my hands, I made use of objects I found on the beach, and I composed natural collages and reliefs. I thus acted like the Oceanians, who never worry about the permanence of their materials when making masks, and use perishable materials like sea shell, blood, and feathers. (Arp, 1970; quoted in Maurer, 1984, p. 538)

(It would appear that it was not simply the encounter with 'primitive art' that encouraged the Dadaists to value the spontaneous and perishable over the durable and the permanent: the horrendous destructiveness of the First World War – made possible through technological advances that improved the killing-power of modern armies – exploded 'the myth of process'; and this 'encouraged the Dadaists' tendency to

identify life with the instantaneous and the ephemeral'. '[T]he ambition to make durable, classic works for posterity died' (Short, 1991, p. 293; emphasis added).)

In African societies, and in many other societies named 'primitive' by the White overlords, masks, as every anthropologist knows, are not simply worn. Rather, they serve, as *a means through which consciousness is transformed*.

> A VOICE: When I don the mask, I become a vessel for the supernatural. I may assume my deity's personal characteristics – her likes and dislikes, her body movement, her speech. The supernatural may take me over completely.

The experience (or that aimed for) was similar when Janco's masks were donned at Dadaist 'Negro soirées'. Here is Hugo Ball, founder of the Cabaret Voltaire, commenting on what happened:

> We were all there when Janco arrived with the masks, and each of us put one on. The effect was strange. Not only did each mask seem to demand the appropriate costume, it also called for a quite specific set of gestures, melodramatic and even close to madness. . . . The dynamism of the masks was irresistible. In one moment we became aware of the great importance of such masks in mime and drama. The masks simply demanded that their wearers should start up a tragico-absurd dance. . . . What fascinated us about these masks is that they represent . . . characters and emotions that are larger than life. (Quoted in Maurer, 1984, p. 539)

Of Cosmopolitans and Racists

The rejection by Dadaists of The Art Establishment and The Dominant Social Order of Western middle-class and elite society did not lead them to positive politics: theirs was a politics of nihilism – AGAINST a great deal but scarcely FOR anything. Unlike the Surrealists, the Dadaists (we exclude here the Berlin Dadaists like Hugo Ball and Hans Richter) were not attracted to socialist or communist politics.

> FACT: 'Even though Lenin was in Zurich, living on the same street as the Cabaret Voltaire, the group had virtually no contact with him. Obviously, the Russian revolutionaries at that time were as uninterested in art as the Dadaists in politics and, although both groups had in common a desire to destroy the system, the Bolsheviks, unlike the Dadaists, had a definite and positive goal and a whole system of theory and tactics for achieving it.'
>
> — Helena Lewis, 1990, p. 6[13]

They were, however, attracted to the art of non-Western Other and also to devalued and marginalized artistic practices of the West itself: folk art, naive art and children's art. Actually, they went even further: in an interview in the 1980s, Janco said, 'We not only thought of primitive art as the real art, but we also regarded the art of childhood as a real art. We even came to the idea of exhibiting the art of the insane' (quoted in Maurer, 1984, p. 538). For the Dadaists, all these arts – from 'primitive art' to 'children's art' to the art of the insane – were considered to be related. They (apparently, together with vulgarity) were all more or less the same thing: 'expressions of elemental feelings and ideas unspoiled by traditional Western values and utilizing alternative artistic means' (Maurer, 1984, p. 536).

> JEAN ARP: 'We searched for AN ELEMENTARY ART that would, we thought, save mankind . . .'
> ONE ORIGIN STORY: 'Let's take the word "dada", I said. It's just made for our purpose. The child's first sound expresses the primitiveness, the beginning at zero, the new in our art.'
> — Richard Huelsenbeck, *Dada Lives!*, 1936; quoted in Ades, 1981, p. 110

'PRIMITIVE' ART, CHILDREN'S ART and the ART OF THE INSANE – these would later become a preoccupation of Surrealism. But to lump together the varied artforms that are represented by these three categories is to ride down a slippery slope, on which the cosmopolitan artist joins the racist. We will have more to say about this later.

Dreaming with the Other: Surrealism

> The modern eye has gradually taken in the endless variety of those objects of so-called 'savage' origin . . . and aware of the incomparable resources of the primitive vision, has fallen so in love with this vision that it would wish to achieve the impossible and wed it.
> — André Breton, *Surrealism and Painting*, 1972, p. 171[14]

> TRUTH: *Modern art in Paris during the first half of the twentieth century was profoundly influenced by 'primitive' art, bodies and culture. Arguably, the Surrealists were influenced the most.*

In July 1931 at the Hotel Drouot in Paris one of the most important 'primitive art' auctions of the interwar years took place. 312 items were offered for sale: 134 from Oceania, 124 from the Americas, 30 from Africa,

14 from Malaysia, and 7 miscellaneous (Maurer, 1984, p. 546). The owners of these objects would have preferred not to sell, but extreme financial difficulties – it was in the depths of the depression years – left them no alternative. The objects on sale were from the combined collections of André Breton, chief spokesperson and organizer of the Surrealist group in Paris, and Paul Eluard, the Surrealist poet.

Art of the 'Primitive' Other was also included in various exhibitions, some of them major, which the Surrealists organized in the 1920s and 1930s. The first of these PRIMITIVE ART/SURREALIST ART exhibitions – Surrealists pride themselves on unexpected collections and juxtapositions – occurred in Paris on 16 March 1926. The occasion, the opening exhibition of the *Galeria Surréaliste*, featured the work of Man Ray and Oceanic objects selected from the collections of André Breton, Paul Eluard, Louis Aragon, and others.[15] Another such event was the May 1936 'Exhibition of Surrealist Objects', which was held at the Parisian gallery of Charles Ratton, the famed 'primitive art' dealer. The exhibition included an incredible *mélange* of objects, including many from Oceanic and North American Indian cultures: 'Primitive masks were juxtaposed with work by Picasso and with Surrealist objects, such as Alberto Giacometti's *Suspended Ball*; ready-mades by Marcel Duchamp were displayed along with Surrealist objects such as Meret Oppenheim's *Object: Fur Breakfast*' (Fer, 1993, p. 221). Objects created by Surrealist poets were included alongside those of 'proper' visual artists. Objects from the world of mathematics, science and logic were placed alongside objects from everyday life and from 'primitive' cultures.

Finally, there was the 'International Surrealist Exhibition' organized in London in 1936 'by a group of English artists with the support of Breton, Eluard and Man Ray'. On display at the London exhibition were 'over 400 paintings, sculptures, and objects, including a large number of pieces from Africa, Oceania, and the Americas'. As in the Paris exhibition of 1936, but on a larger scale, objects made by the Surrealists were placed – provocatively – beside 'primitive art' and natural and interpreted objects. Most of the objects in both the London and Paris exhibitions 'were borrowed from private collections of individual Surrealist visual artists and writers' (Maurer, 1984, p. 546).

Definitions

What is SURREALISM? And why have its artists and intellectuals been so interested in THE PRIMITIVE?

In the *Surrealist Manifesto*, written by André Breton and published in Paris in 1924, the following 'definition' is given:

Surrealism: Pure psychic automatism through which it is intended to express, either verbally or in writing, the true functioning of thought. Thought dictated in the absence of all control exerted by reason, and outside any aesthetic or moral preoccupation.

. . . Surrealism rests on the belief in the superior reality of certain forms of association neglected until now, in the omnipotence of the dream, and in the disinterested play of thought. It aims at the definitive ruin of all other psychic mechanisms and at its substitution for them in the resolution of the principal problems of life. (Quoted in Ades, 1981, p. 124)

Here is another definition, one that has the advantage of being rather easier to understand. It comes from James Clifford, the American cultural historian and theorist:

Surrealism: 'an aesthetic that values fragments, curious collections, unexpected juxtapositions – that works to provoke the manifestations of extraordinary realities drawn from the domains of the erotic, the exotic, and the unconscious.' (Clifford, 1988a, p. 118)

Breton's 'definition' reveals, even at a glance, a crucial point: surrealism is not simply an artistic practice but a PHILOSOPHY OF LIFE, a WORLD-VIEW. It is on this aspect – surrealism as a philosophy – that Breton focuses.

FACT: Surrealism seeks 'to transform the world, change life, remake from scratch human understanding'.

— André Breton[16]

Clifford's 'definition' is primarily a statement about SURREALISM AS AN ARTISTIC PRACTICE. Let us look more closely at these two 'definitions': they reveal principal characteristics of Surrealism. But first we provide some historical background.

Radicals, Great Minds and Elemental Forms

Surrealism is a child of the early 1920s, the creation of a group of French intellectuals and writers. Most of them were left-wing: all were anti-capitalists and anti-colonialists, some became members of the French Communist Party. Most of the Surrealists had been disciples of Dadaism. Dada, as we have seen, is Anti-Art and Anti-Philosophy – a de(con)structive, anarchistic and nihilist mode of thought and action, a practice of cultural guerrilla warfare whose *raison d'être* is transgression and negation. Surrealism is also a radical politics but it is not – that is, not usually – anarchistic; Surrealists involve themselves in radical political and cultural interventions but they maintain an allegiance to Art.

Surrealism was a movement of thinkers (activist-intellectuals) as much as of artists. 'Their interests, which were at first primarily literary, involved an intimate contact not only with contemporary trends in the verbal and visual arts, but with psychology, anthropology, philosophy, and politics.' As a result of this 'somewhat eclectic intellectual background', they were exposed to and affected by a wide range of influences. Many of these influences 'contained ideas about ELEMENTAL FORMS OF HUMAN CONSCIOUSNESS', while others 'followed from a direct interest in THE PRIMITIVE' (Maurer, 1984, p. 541). The Surrealists and others, such as Freud, Bergson and Frazer, who influenced them, saw 'The Primitive Mind' – to use that rather unfortunate phrase that Lévy-Bruhl and Lévi-Strauss would later make famous – as a route back to our basic humanity, to a *superior* mode of thought.

Surrealist philosophy is a movement in opposition to the rational and scientific viewpoint: it is against a social order that privileges logic, rationality and science. (It is also a movement against capitalism, the bourgeoisie and their moral code.) Whereas most of us, children of the Enlightenment, believe in the superiority of conscious and rational thought, 'Surrealism rests', as André Breton tells us, 'on the belief in the superior reality of certain forms of association neglected until now' – THE DREAM, THE UNCONSCIOUS and MYTH. To be more specific, three central elements of Surrealist philosophy are:

● 'a conviction that the dream is a valid and integral part of life experience';
● 'a belief in the creative power of the unconscious';
● 'an acceptance of the universal need for myth' – 'which arises from the common factor of human mentality and unites the peoples of all civilizations' (Maurer, 1984, p. 541).

For the Surrealists, as for the Dadaists, LOGICAL THOUGHT has failed: despite its ideology of progress and its claims for morality, the most outstanding gift from the West to humanity has proved to be exploitation, brutality and destructiveness on a scale never previously imagined.

Logical thought has brought us to the brink of destruction. The West has lost its way. The answers to our problems must lie outside Western modernity – outside capitalism, reason, Christianity; outside White arrogance. And here we reach a point at which Surrealism and Négritude converge.

NÉGRITUDE = SURREALISM + BLACK CULTURAL NATIONALISM (IN A FRANCOPHONE STYLE)

Listen to our poet Aimé Césaire. The extract is from his famous poem, *Notebook of a Return to the Native Land (Cahier d'un retour au pays natal)*:

Reason, I crown you evening wind.
Your name voice of order?
To me the whip's corolla.
Beauty I call you the false claim of the stone.
But ah! my raucous laughter
smuggled in
Ah! my saltpetre treasure!
Because we hate you
and your reason, we claim kinship
with dementia praecox with the flaming madness
of persistent cannibalism

Treasure, let's count:
the madness that remembers
the madness that howls
the madness that sees
the madness that is unleashed

And you know the rest

That 2 and 2 are 5
that the forest miaows
that the tree plucks the maroons from the fire
that the sky strokes its beard
etc. etc.

Who and what are we?
A most worthy question.
 — Césaire, 1983, pp. 49–51

Escaping Hell – By Turning Things Upside Down

Primitive society found answers to the questions of life in the spirit world and the realm of the dream. The Surrealists, in studying Primitive arts and cultures, followed a similar path.
 — Evan Maurer, 1984, p. 546

Surrealism is one of those philosophies that sees the modern world as alienating and oppressive, as a place in which women and men have lost their bearings. Surrealists contend that the modern world would cease to be such a hell if the non-rational, analogic, associative powers of the mind could be rediscovered and developed. Listen to this excerpt from André Breton's *Surrealist Manifesto of 1924:*

We are still living under the reign of logic: this, of course, is what I have been

> driving at. . . . Under the pretence of civilization and progress, we have
> managed to banish from the mind everything that may rightly or wrongly
> be termed superstition or fancy; forbidden is any kind of search after the
> truth which is not in conformance with accepted practices. It was, apparent-
> ly, by pure chance that a part of our mental world which we pretended not
> to be concerned with any longer – and, in my opinion by far the most
> important part – has been brought back to light. For this we must give our
> thanks to Sigmund Freud. On the basis of these discoveries a current of
> opinion is finally forming by means of which the human explorer will be
> able to carry his investigations much further, authorized as he will hence-
> forth be not to confine himself solely to the most summary realities. The
> imagination is perhaps on the point of reclaiming its rights. If the depths of
> our mind contain strange forces capable of augmenting those on the surface,
> or waging a victorious battle against them, there is every reason to seize
> them.　(Reprinted in Breton, 1969).

The Surrealist task becomes one of 'regaining the use of powers we once
possessed before they were emasculated by a materialistic civilization;
powers which CHILDREN, PRIMITIVE PEOPLES, WOMEN and THE INSANE' – note
the recurrent, unfortunate linkage – 'seem to be the last among us to
retain' (Short, 1991, p. 302; emphasis added). But Surrealists know that
this is a task at which they may not succeed: theirs is not an optimistic
philosophy; some of them are certain that the world is beyond hope, that
redemption is no longer a possibility.

Deeply suspicious of Modernity, Surrealism seeks to free THE IMAGINA-
TION from the strait-jacket of modern society and culture – to use dreams
and the unconscious to illuminate conscious experience and enhance
artistic experience, to find a creative alternative to the limited rationalism
of the modern West. The assumption is that we moderns have lost some-
thing basic, something that has been preserved by The Other. Listen to the
following passage from the preface to Freud's *Totem and Taboo*. It is a
statement with which most Surrealists agree:

> There are men still living who . . . stand very near to primitive man, far
> nearer than we do, and whom we therefore regard as his direct heirs and
> representatives. Such is our view of those whom we describe as savages
> [T]heir mental life must have a particular interest for us if we are right in
> seeing in it A WELL-PRESERVED PICTURE OF AN EARLY AGE OF OUR OWN
> DEVELOPMENT. If that supposition is correct, a comparison between the
> PSYCHOLOGY OF PRIMITIVE PEOPLES, as is taught in social anthropology, and
> the PSYCHOLOGY OF NEUROTICS, as has been revealed by psychoanalysis,
> will be bound to show numerous points of agreement and will throw new
> light upon familiar facts in both sciences.　(Freud, 1950, p. 1; emphasis added)

In order to recover, if we still can, the power and magic – the elemental
consciousness – that we once knew, we must commune with 'the prim-

itive', women and the insane. (The Surrealists had a particular – and, we must say, unhealthy – interest in female hysteria; see Fer, 1993, pp. 209–21.)

THE NOVICE: What is our task?
THE GUIDE: TO UNSHACKLE THE IMAGINATION! Thankfully, this is a task with which The Other can be of considerable assistance.

The main priority of Dada had been to destroy the foundations of established Art. Surrealism, a positive, tempered practice, is predominantly concerned to explore and illustrate the unconscious mind – with some assistance from The Other. In the case of Cubism and many other artistic movements, form, content and style are important. The situation is otherwise with Surrealism:

Content was again important, but the contents of a pictorial representation should now be the AN IMAGE OF THE WORKINGS OF THE ARTIST'S UNCONSCIOUS MIND The Surrealist artist sought to remake reality, so that it became the perfect expression of his [or her] own fantasies. (Lucie-Smith, 1991, p. 157; emphasis added)

Like Freud, the Surrealists regard THE UNCONSCIOUS as more important than the conscious mind. Again like Freud, they regard the dream as a direct expression of the unconscious. But unlike Freud, they believe, literally, in the superiority of the unconscious mind: it is the means through which we can increase our knowledge, insight and perception; it is the source through which our creative powers may be continually regenerated.

FACT: 'In their effort to expand insight and perception, and to regenerate creative powers, they [Surrealists] attempted to harness the common elemental resource of humanity: the unlimited potential of the unconscious, as manifest in dreams and myths.'
— Evan Maurer, 1984, p. 584

FACT: Unlike Freud, who spoke from the point of view of Reason, Surrealism attempts *to speak from the position of the irrational, to speak madness from the place of madness itself'*
— Briony Fer, 1993, p. 176; emphasis added

On this point – the assumption of the superiority of the unconscious mind – the Surrealists saw themselves as exactly in tune with 'the Primitives', which is to say, they were on firm ground indeed.

JACQUES LACAN: 'The unconscious is the discourse of the other'.

The authoritative source for their assumption was anthropology (especially nineteenth- and early twentieth-century ethnology). Later Surrealists would be attracted to French anthropologists, such as Lévy-Bruhl, Marcel Mauss, Michel Leiris and Marcel Griaule: the early Surrealists were particularly attracted to Sir James Frazer's *The Golden Bough*.[17] Through example and speculation, Frazer 'demonstrated' that a basic belief among 'primitive people' is that their dreams are an integral and essential part of everyday life. The 'primitives', apparently, do not simply regard their dreams as of *equal* importance to the thoughts and experiences of their waking hours. Rather, their dream life is of even *greater* importance in influencing their behaviour. Why? Because, as every 'Primitive' – and every Surrealist – knows, dreams convey a HIGHER LEVEL OF TRUTH than waking consciousness (Maurer, 1984, p. 542).

We, rational and modern creatures, assume that Reality is what we see, hear, touch, smell and feel in the course of everyday life. Surrealists, like their savage soul-mates and unlike positivists and dialectical materialists, hold that this is a superficial level of reality: the really important Reality is only discovered by probing the depths of the unconscious. If we wish to gain real knowledge, then we must move from logical thought to a higher level of perception and consciousness.

Given this view, what is the (Surrealist) artist to do? S/he must 'incorporate the resources of the unconscious into works of art in order to give them the deeply suggestive and consciousness-expanding power of the actual dream experience' (Maurer, 1984, p. 543).

In place of logical thought – that is to say, modern Western rationality – the Surrealists propose ANALOGICAL THINKING.

> **Logical thinking** n. **1.** *thinking that proceeds by inductive or deductive logic – that argues from empirical facts or logical principles* **2.** *characteristic of scientists and philosophers.*
> **Analogical thinking** n. **1.** *thinking that proceeds by metaphoric or metonymic analogy – that reclassifies experience in an emotional and intuitive way* **2.** *characteristic of dreamers and poets.*

Surrealism joins those great thinkers of the nineteenth and twentieth centuries – such as Sigmund Freud, Henri Bergson, Sir James Frazer, Lucien Lévy-Bruhl, Marcel Mauss and Claude Lévi-Strauss – who believe that there are fundamentally TWO KINDS OF MIND:

- **The rational, logical mind** – the mind of the scientist, the philosopher and other children of the enlightenment.
- **The irrational, analogical mind** – the mind of 'primitives' and the insane, the mind of children and, some great thinkers add, women.

In place of scientific rationality, the esteemed thought of modernity, Surrealists propose the associative powers of THE DREAMER, THE MAD and THE PRIMITIVE.

> TRUTH: 'the Primitive mentality directly embodied those very qualities the Surrealists were desperately trying to integrate into their own lives and art.'
> — Evan Maurer, 1984, p. 541

Surrealism reverses central assumptions of modern Western culture. We privilege: rationality over irrationality, consciousness over unconscious, logical thought over dreams, reality over myth, reason over emotion, mind over body, culture over nature. Surrealism stands all of this on its head:

$$\frac{\text{IRRATIONALITY}}{\text{RATIONALITY}} \qquad \frac{\text{UNCONSCIOUSNESS}}{\text{CONSCIOUSNESS}} \qquad \frac{\text{DREAMS}}{\text{LOGICAL THOUGHT}}$$

$$\frac{\text{MYTH}}{\text{LESSER REALITY}} \qquad \frac{\text{EMOTION}}{\text{REASON}} \qquad \frac{\text{BODY}}{\text{MIND}} \qquad \frac{\text{NATURE}}{\text{CULTURE}}$$

These reversals were made with the assistance of Romanticism, Symbolism, Freud and the Surrealist encounter with The Primitive.[18]

Through reversals and other techniques, Surrealism intends to jolt the viewer. To upset our normal expectations, to destabilize our basic assumptions and values, to call into question our sense of reality, to thrash commonsense knowledge – this is what Surrealism seeks to do to us.

SURREALISM = 'A Complete State of Distraction' (André Breton)

But what assumptions lie beneath these reversals? One of these assumptions, as the reader should have noticed, is that there exists such a thing as THE PRIMITIVE MIND – the term is singular, not plural – which is distinct from, indeed, is opposite to, THE WESTERN MIND. Presumably, if you find a proper Primitive, you will find an incarnation of The Primitive Mind. Otherwise, you can find it, more or less, in your dreams, in the depths of your unconscious.

THE PRIMITIVE MIND = (approx.) OUR UNCONSCIOUS

This is a dubious notion. (As is the related notion that there are two kinds of bodies: OUR BODIES and THE BODY OF THE OTHER.) Again, we find ourselves on a slippery slope, where the radical Western artist-intellectual and the racist meet. This is not the sort of occurrence that a proper discussion of the modern cultural politics of race can afford to ignore: we shall return to it.

The Artist's Stance

Surrealism proposes not so much the making of poems as the transformation of men into living poems.

— Octavio Paz[19]

In place of THE ARTIST as CREATOR and GENIUS, as careful and gifted maker of forms, Surrealism proposes an alternative view of the artist (the visual artist, the poet, the writer): the duty of the artist should be to put her or his 'whole sensitivity in direct contact with the universe in a STANCE OF COSMIC PASSIVITY' (Short, 1991, p. 292; emphasis added).

 FACT: Max Ernst and Salvador Dali explicitly compared themselves to spirit mediums.

The traditional view of The Artist as skilled, diligent and inspired is overturned: the best (Surrealist) artist is someone who, allegedly like the 'primitive', is governed by *chance* and by 'promptings of *the unconscious* and *internal impulses*'. S/he is one who seeks and welcomes *intuition, spontaneity* and *the irrational* (see Short, 1991, p. 292).

 Why? Because Surrealists believe that the best art, like the best truth, comes through such a stance – which is shared with 'the primitive artist' of the Surrealist imagination.

 Surrealism is a consistent philosophy and practice. From the 'stance of cosmic passivity', the Surrealists developed specific techniques for the creation of art objects. From the beginning they produced *'dream-paintings'*. Some Surrealist paintings are apparently actual records of dreams. Many others use illusionist techniques and have characteristics of what Freud called 'dream-work': 'for instance the existence of contrary elements side by side, the condensation of two or more objects or images, the use of objects which have a *symbolic* value (often masking a sexual meaning)' (Ades, 1981, p. 131).

 In the movement's formative period (1922–4), the Surrealist avant-garde experimented with hypnosis and drugs – to help their images along.[20] Later, two formal techniques were developed, *frottage* (rubbing) and *grattage* (scraping), both of which involved AUTOMATISM or 'SPONTANEOUS ACTS OF CREATIVITY'. The *frottage* technique, which is the better known of the two, was discovered by Max Ernst in 1925. It involves a process akin to 'automatic writing'. A sheet of paper is placed on a textured rough-grained surface – such as a wooden floor, a veined leaf, a piece of linen or a bit of string – and then a pencil or crayon is rubbed randomly over the paper. In the production that emerges the Surrealist artist may discover the basic contours of creatures or other images: 'There my eyes dis-

covered human heads, animals, a battle that ended with a kiss . . . rocks, the sea, the rain, earthquakes, the sphinx in her stable, the little tables around the earth' (Ernst, 1948, p. 7; quoted in Batchelor, 1993, pp. 52–3). S/he may then choose to enhance the imagery through highlighting and modelling, perhaps with the assistance of oil paint. (A famous example of the use of *frottage* is Ernst's 1927 painting *La Horde*.)

Thus, the Surrealist artist stands as 'SPECTATOR AT THE BIRTH OF THE WORK'. The methods are, as we have seen, fundamentally unplanned and random, 'by-passing conscious control and avoiding questions of taste or skill' (Ades, 1981, p. 128).

The 'stance of cosmic passivity' was, of course, a scandalous notion from the point of view of The Art Establishment, for its fundamental premiss is that of THE DEATH OF THE ARTIST. In the ideology of Modernism, it is only 'Primitive' and 'Ethnic' artists who produce works of art without conscious control, who are ruled by intuition and tradition.

If the artist must think, then, Surrealism maintains, the processes involved should not be Western rationality but analogical thought – the thought of 'primitives', poet and dreamers. For only such thought 'has the power to reveal the principle of identity between the human mind and the exterior universe' and thus to change our idea of our place in the world. 'The poetic or plastic image, especially when it brings together a pair of elements which reason would regard as having nothing in common, often generates a mysterious luminosity' (Short, 1991, pp. 302–3). Listen as André Breton explains (the statement is from *Les Vases communicants* ('Communicating Vessels'), published in 1932):

> The spirit is marvellously prompt to seize the faintest rapport that exists between two objects selected by chance and the poets know that they can always, without fear or deceit, say that the one is like the other: the only hierarchy that may be established among poets can rest solely upon the greater or lesser liberty which they demonstrate in this respect. (Quoted in Short, 1991, p. 303)

Surrealist art is rarely beautiful. On the contrary, it is a practice that privileges HETEROGENEITY and INCONGRUITY. Provocative juxtaposition, disruption without mediation, bricolage – these are its trademarks. Take, for example, Salvador Dali's *Scatological Object Functioning Symbolically* (1931):

> It included a shoe, a cup of lukewarm milk, paste the colour of excrement, a piece of sugar on a pulley painted with a small image of a shoe, pubic hair and a small erotic photograph. (Fer, 1993, p. 224)

As James Clifford said, Surrealist art 'values fragments, curious collections, unexpected juxtapositions'.

Caged Spirit-power

In a two-page spread commemorating the 'Fiftieth anniversary of hysteria',
in La Révolution Surréaliste *in 1928, Breton and Aragon had written:*
'Hysteria is by no means a pathological symptom and can in every way be
considered a supreme form of expression.' Their article was accompanied
by photographs of an hysteric studied by Charcot in 1878. The young
woman patient, 'Augustine', had been photographed in a series of involun-
tary states, subtitled 'attitudes passionnelles' *('postures of passion'). Un-*
like Charcot and his pupil Freud, the Surrealists tended to celebrate hysteria
as a passionate rather than a pathological condition. To Breton and Aragon,
the conditions of Charcot's hysteric exemplified the breaking down of re-
pressive laws.
 — Briony Fer, *Surrealism, Myth and Psychoanalysis*, 1993, p. 212[21]

As previously indicated, Surrealist thought was influenced by Freud –
although it drew conclusions that were rather more radical than any the
Father of Psychoanalysis would have dared to make. The discerning
reader will have noted by now that it was also profoundly influenced by
Romanticism and Symbolism. It shares all three of Romanticism's pref-
erences – for *subjectivity* and *emotion*, for *the mysterious* and *the exotic*, for
nature over (modern) culture.

> **Romanticism** n. *A profound revolution in the human spirit gathering*
> *momentum in the 18th c. and in full flood in the 19th The most*
> *important elements in Romanticism were:* **1.** *feeling for nature;* **2.** *em-*
> *phasis on subjective sensibility and emotion and on imagination, as opposed*
> *to reason;* **3.** *interest in the past, the mysterious and the exotic.*
> — *Dictionary of Art and Artists* (London: Thames & Hudson, 1985)

Similarly, Surrealism shares Symbolism's emphasis on the creative
power of the unconscious (as opposed to that of the rational mind): some
Surrealists were specifically attracted to Henri Bergson's notion of an *élan*
vital, the fluid creative life-force guided by intuition.

> Bergson's philosophy, which was entirely familiar to the Surrealists, posited
> a dualistic world in which the powers of reason and the abstract intellect are
> foreign to the ÉLAN VITAL, the CREATIVE LIFE FORCE which is guided by
> INTUITION. (Maurer, 1984, p. 544)

At least some of the Surrealist artists would have seen themselves as
utilizing the 'life force', as 'primitives' (allegedly) do.
 In particular, Surrealism holds the view, shared by all Romantics and

many Symbolists, that *modern civilization suppresses and imprisons the Imagination*. That is, Surrealism views Modernity not as an era of freedom but as a kind of IRON CAGE – here we appropriate Max Weber's term, for a somewhat different purpose than he intended – behind whose bars the Imagination, untamed and powerful, stalks like a wild animal.

Surrealists assume that this caged animal is free in the world of children, the insane and the 'primitives'.

Evocative Symbols

After Max Ernst, the German-born Surrealist painter, married Dorothea Tanning, the American Surrealist painter, in 1946, they moved to Arizona where they lived until 1953 in a house that they built.[22] The move was not incidental for Ernst: he had greatly admired the Southwest Indians – the Hopi, Navaho, Apache and Zuni – for many years. Now they, his teachers and soul-mates, would be his neighbours.

What did he share with them? Both artistic conventions and a world-view. We shall offer some comments about their 'common' world-view later. For the moment, let us consider artistic practice: the crucial point to note is that, like the art of the Southwest Indians whom he held in such high regard, Ernst's work is best seen as neither realist nor abstract but as EMBLEMATIC ART. In an article on 'Max Ernst in Arizona', Patrick Waldberg explains:

> With few exceptions, he never tried to capture the appearance of the human being (nor, for that matter, of things). Throughout his work, man [*sic*] is represented by some substitute, either an imaginary form, or a mark, usually by a bird, but often, too, by a schematized figure whose head may be a rectangle, a triangle or a disk. In a similar manner, the Indians use simple geometric forms in their paintings, figurines and masks. Here the head may be a circle, there a square and elsewhere a triangle, while the ornamental motifs surrounding it – quadrille patterns, wavy lines and parallel bands – may symbolize the sea, the clouds, the days or the seasons. Thus forms do not represent appearances, but ideas. (Waldberg, 1971, p. 57; quoted in Maurer, 1984, pp. 564–5)

'Emblematic art' is a form many other twentieth-century artists have employed, often after encountering some species of non-Western art. The brilliantly innovative work of Paul Klee provides many examples.

But it is not symbols *per se* that interest Surrealists. What they seek is imagery, whether representational or non-representational, that is *evocative* and *powerful*. Often such imagery is *sexual* in connotation (if not in denotation . . .).

Surrealism shares Symbolism's rejection of Art-as-Depiction-of-Objective-Reality in favour of ART-AS-EVOCATION-OF-SUBJECTIVE-REALITY.

> **Symbolism** n. *A movement in European literature and the visual arts c. 1885 – c.1910, based on the notion that the prime concern of art was not to depict, but that ideas were to be suggested by symbols, thus rejecting objectivity in favour of the subjective. It combined religious mysticism with an interest in the decadent and the erotic.*
> — Dictionary of Art and Artists (London: Thames & Hudson, 1985)

Much of Surrealist art consists of evocative symbols – images that evoke powerful mental pictures and emotions. Many of these are *private symbols*, a product of the artist's own dreams, fantasies and experience: for example, the grasshopper was a personal symbol for Dali, while the eagle was a symbol – a totemic symbol – for Ernst. (The fact that there are so many private symbols in Surrealist art is one of the main reasons why it is so difficult for most of us – the general public, including the educated but uninitiated – to understand.) Others are *shared symbols*, the product of images, myths and legends from Western and non-Western cultures. With regard to the latter, Sir James Frazer's *The Golden Bough* – a massive compendium of thousands of examples of myths and legends from the ancient world, the Orient, European folk culture, and non-Western 'primitive' and 'tribal' cultures (from Africa, Oceania and the Americas) – proved to be a gold mine for the Surrealists.

Nightmares and Juxtapositions

The Surrealists often represented the mind as a labyrinth – dark, intricate, unchartable, forbidding and intriguing . . .
— David Batchelor, ' "This Liberty and This Order" ', 1993, p. 54

Look at plate 10.4. Look at the eyes, the nose, the mouth. The colours are bright – mostly hot pink.

What is it? Surely, we (the initiated) say, it is a fine example of Surrealist art. Perhaps a painting by Max Ernst or one by a muted Salvador Dali. Or a mask by Marcel Janco, the Dada artist.

You, we, are mistaken. This fine example of an 'extraordinary reality' (we borrow the term from Clifford) is a Sulka mask – from New Britain, an island off the coast of Papua New Guinea. It is the kind of 'primitive' art that the Surrealists prefer.

Writing in a British Museum publication, Henry Moore, the highly acclaimed modernist sculptor, says,

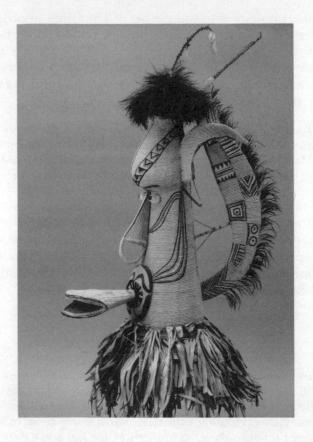

Plate 10.4 Sulka Mask, New Britain, Papua New Guinea, painted pith, wood and
feathers, 47 " high. Übersee Museum, Bremen.

> Whereas African Sculpture is bulky, powerful, and solid, seeming to reflect
> a down-to-earth attitude to life, the Oceanic peoples appear to me to have a
> more anxious, nervous, over-imaginative view of the world, expressing
> itself in fantastic, birdlike, beetlelike forms with a nightmarish quality about
> them. (Moore, 1981, p. 96; quoted in Wilkinson 1984, p. 604)

'Anxious, nervous, over-imaginative, . . . fantastic, . . . nightmarish' – it is
precisely these qualities that so attracted Surrealist artists to Oceanic (and
North American Indian) art and culture. The Africans, whose sculpture
had profoundly influenced Cubism, were apparently insufficiently primi-
tive for Surrealist tastes.

> They prized in the tribal object not its *raisonnable* form but its *bricole* hetero-
> geneity, not its mediatory possibilities but its transgressive value. In short,
> the primitive appeared less as a solution to western aesthetic problems than
> as a disruption of western solutions. (Foster, 1985, p. 200)

The Surrealist strategy is to use the art of The Other in order to disrupt our sense of reality, to challenge our commonsense assumptions, to wage war on 'Art' from within. The attempt is not to achieve some sort of synthesis between the Art of the West and that of its Others. Rather it is to maintain radical heterogeneity, incongruity. And this is facilitated via AN AESTHETIC OF THE UGLY, THE SHOCKING, THE NIGHTMARE.

> A VOICE: I say that the trademark of Surrealist art is the direct expression of nightmares. Not dreams and ordinary unconscious fantasies, but night-mares. Many Surrealist paintings are horrible, menacing and nightmarish. You have seen Salvador Dali's lovely contributions, haven't you?

Indeed, it is arguably the case that the Surrealists went beyond the Primitives. They produced not only frightening creatures but fragmented and dismembered bodies. Legs, arms, heads, penises, breasts – these may be cracked open, floating or attached in unexpected ways in Surrealist paintings. One could not be further away from 'the classical ideal', from Greek and Renaissance portrayals of the body.

From Culture to Nature

> *The nature he exalts is a timeless one, set in Oceania and with roots deep in a primordial past – a nature that transcends man [sic] and yet can lead him beyond the barriers and limitations of obviously daily realities. Breton saw in these primordial and evocative natural settings 'a dream world' (un pays de rêve) where the restrictions of society were broken and where there existed a state of natural harmony allowing man to exercise the deep, inborn desires of the dream and the unconscious.*
> — Evan Maurer, 1984, p. 548

Here is an ANIMIST VOICE: 'Spiritual forces animate all things in the universe – animals and trees, birds and fishes, rivers and streams, sun and moon, earth and stars, the living and the dead. All things are the dwelling places of souls, supernatural beings, spiritual forces. And these souls, spirits and forces have value and power equal to or greater than our own.'

For most of human history most people in most parts of the world would have agreed with the above – that is, they would have readily subscribed to a philosophy of ANIMISM. Now, since we have all – or nearly all – become civilized, the animist world-view is no longer very popular (having been replaced by the great religions, including that of modern science). In Surrealist thought, however, animism lives!

A major theme in the history of Surrealism is the attempt to reconnect with nature – with its mystery and its power. Now, the path to untram-melled nature is, as we all know (thanks to common sense), controlled by

the dark-skinned primitives. Hence, it was to them that the Surrealists went. Here is Clifford Browder, author of *André Breton: Arbiter of Surrealism*, discussing the 'primitive' connection in the philosophy of Breton and his Surrealist circle:

> It is not surprising that Breton developed an early interest in primitive art . . . and that he visited American Indian reservations and witnessed Haitian voodoo ceremonies providing living proof of the survival among savages of the very state of mind that Surrealism would cultivate. Insofar as they had escaped the 'contamination' of Christianity [and, presumably, capitalism], primitive societies for Breton offered the spectacle of man in harmony with nature, giving uninhibited expression to the exuberant desires repressed by Western culture. Consequently, hope for the latter lay not in the anthropological study of such societies, *but in the recreation of their modes of experience*. It was by exercising this bold imagination and systematic credulity common to the child and the savage alike that one recovered the lost paradise of the surreal. (Browder, 1967, p. 61; quoted in Maurer, 1984, p. 546)

'The evocation of the physical environment of Primitive cultures was . . . used by Breton as a theme in many of his works. The strange and enticing scenes of WILD, UNTRAMMELLED NATURE play a major role in *Martinique charmeuse de serpents*, written in 1948 with Masson.' In an earlier work, *L'Amour fou* (1937), Breton 'described EXOTIC PLANTS AND SETTINGS which were for him the embodiment of the MARVELOUS INCONGRUITIES and MYSTERIOUS WONDERS that only nature, unaffected by modern artifice, can produce' (Maurer, 1984, p. 548).

Perhaps the Surrealist artist most moved by the mysteries of nature and the powers of animism was Wifredo Lam.

Wifredo Lam in the Jungle

> Lam's work from 1942 onwards represents his definitive expression. . . . There is a Baroque rhythm of natural and fantastic elements which INTERPENETRATE, creating a weave of visual signs. Its message is the unity of life, a vision of Afro-Cuban traditions, where everything appears to be INTERCONNECTED because everything – gods, energies, human beings, animals, plants, minerals – is CHARGED WITH MYSTIC POWER and both depends and acts on everything else. In this sense, many paintings by Lam could be compared to *ngangas* of the *palo monte*, recipients of power where the sticks, leaves, earth, human and animal remains, iron, stones, signs, objects, spirits and deities are structured in one kingdom which summarizes the cosmos. (Mosquera, 1992, pp. 56–7; emphasis added)

Look at plate 10.5. *The Jungle* (1943), by Wilfredo Lam, is arguably one of the most interesting paintings produced by a twentieth-century

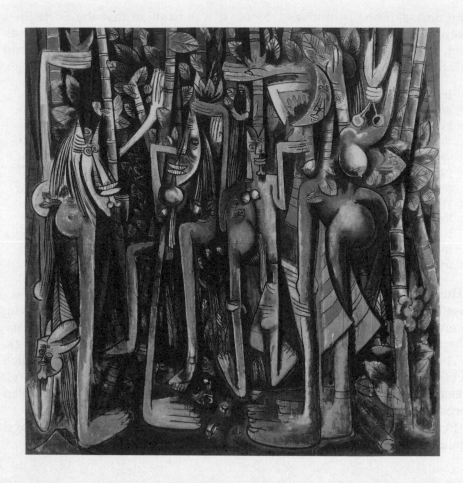

Plate 10.5 The Jungle, Wifredo Lam, 1943, gouache on paper mounted on canvas, 94" × 90". Museum of Modern Art, New York. Inter-American Fund. Copyright DACS 1984.

avant-garde artist. Lam's paintings and drawings are 'a visual incantation: he acclaimed the jungle as if it were a person, giving plants the appearance of animals, and animals a lapidary form'. In his work, 'plants have breasts like women, fruit is a round head with horns, bamboo has feet which look like hands, the insect blossoms, the wild beast has roots, and man is hewn from wood or from the rock of the earth which gave him birth' (Alexandrian, 1970, p. 170).

What is it that best symbolizes nature's power and mystery? For Lam, the quintessential symbols are the lush, primeval jungle and fantastic spirit-creatures. The horned spirit-creatures, some of which seem to float off the canvas, occur early in Lam's work and continue: see, for example, his illustrations for Aimé Césaire's *Notebook of a Return to the Native Land*

(*'Cahier d'un retour au pays natal'*). The lush, mysterious jungle theme occurs in a number of his works from the early 1940s onwards – for example, in *Malembo* (1943, New York, Pierre Matisse collection); *The Jungle* (1943, New York, Museum of Modern Art); *Jungle* (1944, Paris, private collection); *Song of the Osmoses* (1944, Indiana, J. Cantor collection); *Presente Eterno* (1945, Providence, Art Museum of Rhode Island); and *The Watching Spirit* (1946).

> A VOICE: From the penumbra of bamboo and palm frond forests that form Lam's PRIMAL LANDSCAPES, emerge HYBRID PERSONAGES whose presences seem to be discovered in the very defining of the flora.
> — William Rubin, *Dada, Surrealism, and their Heritage*, 1968, p. 71; emphasis added

A philosophy of animism animates *The Jungle*. For Lam, the 'primal landscapes' and 'hybrid personages' recall the Caribbean (the land of his birth) and Africa (a land of his ancestors).

> A VOICE: For me, they recall Tarzan the Ape Man – swinging through the trees and lording over the natives.

The Jungle is 'executed in gouache, a fast-drying medium that permitted Lam to apply many thin, transparent washes of color so that multiple images could be read through one another'. Given Lam's imagery, this technique was ideal, for it 'not only created highly evocative effects of transparency, but also suggested the "interpenetration" of phenomena that is so significant an aspect of the Primitive vision of nature'. *The Jungle*, with its colours of deep greens and blues, 'creates an impression of thick, impenetrable jungle vegetation'. In the midst of the lush foliage stand female figures 'whose tubular legs and rounded knees, buttocks, torsos, and breasts are conceived so as to be almost indistinguishable from the foliage surrounding them'. Do these beings belong to culture or nature, to humanity or the jungle? Camouflaged in deep green and blue, with feet, limbs, faces and breasts tempered by brown, orange, flesh and yellow, 'they are an integral element of the natural environment – a Primitive-inspired representation of humanity's union with nature' (Maurer, 1984, pp. 581 and 583).

In this painting, as in the animist cosmologies of West Africa (and elsewhere), everything – soil, leaves, branches, humans, animals, spirits – is inextricably linked. There is cosmic HARMONY.

There is also METAMORPHOSIS. In Lam's paintings, nature is caught in the act of transformation: people are seen as trees, vegetation as spirit-creatures.

> A VOICE: There is a 'sense of mutation' in Lam's paintings: 'everything seems to transform into something unexpected'.
> — Gerardo Mosquera, 1992, pp. 57–8

WIFREDO LAM: In my jungle scenes one can witness 'beings in their passage from the vegetal state to that of the animal still charged with the vestiges of the forest'.
— Wifredo Lam, 'Oeuvres recentes', p. 186; quoted in Maurer 1984, p. 583

Lam's paintings are 'an account of the genesis and proliferation of life, the *ache* or universal energy'. They allude to the *nature morte* genre of Western oil painting but at the same time he transfigures this, 'because in the cosmo-vision implicit in his art there is NO DEATH ONLY METAMORPHOSIS, because everything is full of energetic spiritual presence' (Mosquera, 1992, p. 57). Now, the continuity of spiritual energy and the frequent occurrence of cosmic metamorphosis are well-known phenomena in the metaphysics of 'primitive' cultures. We moderns are supposed to be well past this: Lam suggests that to move beyond animism is to make no advance at all.

It is not simply with this notion of metamorphosis that he abandons Western cosmology in favour of a 'primitive' one: 'Lam's art, with its mixture of the turbulent and the beautiful, the generative and the malign, the vital and the destructive, communicates a universe not ruled by the polarities of good/evil, light/dark, heaven/hell and God/devil of the Christian tradition' (Mosquera, 1992, p. 57). On the contrary, his work corresponds to the pluralistic polytheism of West African and African diaspora religions (like *shango* in Trinidad, *umbanda* and *candomble* in Brazil, *vodu* in Haiti and *santeria* in Cuba) – that is, to religions that do not accept that dualistic, Manichean universe that is so popular in the West.

From the Brothel to the Jungle

Look at Picasso's *Les Demoiselles d'Avignon* (plate 10.3) while looking at *The Jungle*. There are important differences between the two paintings: one is set in a brothel, the other in the jungle; one makes considerable use of colour, the other makes minimal use; one is of geometricized human beings, the other of geometricized mythological spirit-creatures.

But there are also a number of similarities. Lam and Picasso are kindred spirits. Indeed, *The Jungle* is, in part, a tribute to *Les Demoiselles*.

Of Wifredo Lam and Pablo Picasso

The Jungle *summarizes not only Lam's use of Primitive imagery but his debt to Picasso, whom he looked upon as both teacher and kindred spirit. Its dense foliage is peopled by four totemlike female figures who stand in the foreground of the typically shallow, nonillusionistic space, Lam's homage to both the common 'reductiveness' of Primitive art and Picasso's* Les Demoiselles d'Avignon. *In both pictures, a*

standing female with an arm raised above her head is placed at the left-hand border to direct the eye toward the other figures on the right. A similar compositional relationship exists between the two women immediately to the right of the first figure, both of whom face the viewer with right arms held high and elbows pointing upward. There is a further correspondence between the two paintings in the large female at the extreme right of The Jungle, *whose crescent-moon-shaped head Lam borrowed directly from the still life located at the lower centre of* Les Demoiselles. *Her body also recalls the figure in the upper right portion of Picasso's painting in that both have arms raised so that their elbows point back to the centre of the composition.*

Picasso's early response to Primitive sculpture is most clear in the faces of the two right-hand women of Les Demoiselles. *But, as Rubin has observed, these are not identifiable with any particular tribal works that Picasso could have seen, as are the stylistic elements of* SENUFO SCULPTURE *adapted by Lam. . . . The forward-curving head and decorative facial sacrification as well as the long nose and out-thrust mouth of the Senufo style are all reflected in the features of the seated and standing figures in the left section of* The Jungle. *The genital-like chin append-ages of these faces are also commonly found in Lam's work and can be related, in addition, to the stylized beards of styles such as the Dogon or the Teke. Other* FORMAL CHARACTERISTS OF AFRICAN STYLES UTILIZED *by Lam in* The Jungle *include the emphatic treatment of buttocks and breasts and the simplified limbs, hands, and feet.*

— Evan Maurer, 'Dada and Surrealism', 1984, p. 583

A VOICE: 'Lam can indeed be regarded as the only true continuer of Picasso's work; he was not an imitator, for he was able to re-create the Spanish master's freedom of form for his own use.'

— Sarane Alexandrian, 1970, pp. 169–70

ANOTHER VOICE: Wifredo Lam is Black, which is proof enough that his work is inferior.[23]

The Obsessive Gaze – or the Surrealist as Witchdoctor

People speak with justice of the 'magic of art' and compare ARTISTS *with* MAGICIANS. *But the comparison is perhaps more significant than it claims to be. There can be no doubt that art did not begin as art for art's sake. It worked originally in the service of impulses which are for the most part extinct today. And among them we may suspect many magical purposes.*

— Sigmund Freud, *Totem and Taboo*, 1950, p. 90

Like a number of other movements in twentieth-century Western art, Surrealism was not simply influenced by 'primitive art' but 'primitive in'as well. Surrealists, like Dadaists, were as attracted to the WORLD-VIEW of 'primitive' societies as to the objects they created.

Now, as mentioned earlier in this chapter, one of the most pronounced

differences between the art of so-called 'uncivilized' peoples and that of the well-civilized West is this: in 'primitive' cultures, masks, statues and other objects that we would classify as 'art' are not regarded primarily for their aesthetic qualities. Rather, they are, above all else, instruments of and dwelling places for the Supernatural. 'Primitive art' objects transmit CHARGES OF SPIRITUAL POWER, especially in ceremonies and rituals.

This power is something the Surrealists – like Picasso, the Dadaists and the Expressionists – sought to capture in their own artistic production. Their concern was to create works of art that, like Oceanic masks or voodoo dolls, produce a profound emotional – perhaps we should say metaphysical or spiritual – impact on their viewers.

The Surrealists were interested in FETISHISM, that practice the missionaries among the natives so depised. (See the definition of 'fetish' on p. 326, especially point 2.) 'For the Surrealists, the idea of the object as fetish could range from the examples of African and Oceanic art that they collected and exhibited, to "found" objects, to the art object itself – any object, in fact, on which their desiring gaze chose to fix' (Fer, 1993, p. 227).

In their own work, this fetishism reveals itself in two ways. On the one hand, in the work of a number of Surrealist painters (for example, Salvador Dali and Max Ernst), there is repeated – OBSESSIVELY RECURRENT – use of the same image or object. On the other hand, in the photography of Surrealists, 'the idea of THE ANGLED LOOK, which is at once obsessive and isolates the image from its familiar context, was characteristic' (Fer, 1993, p. 227). For example, there are photographs by Man Ray which 'focus on the form of the hat rather than on the hat as an accessory or an adjunct of the head'. These photographs – these FIXATIONS – are produced by a camera angle which skews the form of the hat in such a way that the viewer may be led to see in the image the form of the female genitals. Thus Man Ray's photographs not only give excessive attention to the part but also put 'a sexual connotation on an everyday object of clothing', 'concealing the face and symbolically invoking the female body without even depicting it' (Fer, 1993, p. 228). Here the Freudian conception of fetishism meets the anthropological one.

Because photography can employ unfamiliar angles, focus on a part of the whole and disconnect objects from other objects or their surrounding environment, it is in a particularly good position to be used for the purposes of fetishism. Our argument is not that Surrealism is the only artistic movement to use 'the angled look' in photography: indeed, by now (70 years after the Surrealists started doing it) the technique has become rather commonplace. Rather, it is that for the Surrealists the technique grew out of their philosophy: it was consistent with their view of the proper stance of the artist, their assault on (bourgeois) societal norms of morality and sexuality and their animistic worldview.

The Power of Art, Revolutionary Salvation and the Politics of the Jungle

We said at the beginning of this discussion that Surrealism was a move-ment of politically radical artists committed to anti-colonial struggle and to revolution at home. The questions we must now ask are: What precise-ly were the links between THEIR PRIMITIVISM and THEIR REVOLUTIONARY OUTLOOK? And what were the effects of that linkage?

Here is the first connection. Surrealists viewed art like the objects used by the shaman, sorcerer or witchdoctor. In the cosmology shared by the Surrealists and their 'primitive' friends, works of art are not simply pictures and sculptures but part of life. In particular, they are instruments of power, vehicles for the transformation of consciousness.

> From the start the Surrealists were aware that these powerful forces so permeate the very fabric of Primitive societies that they obliterate any bar-riers between life and art; this realization explains the particular seductive-ness for them of the Primitive model. (Maurer, 1984, p. 584)

For the Surrealists the transformation of consciousness included a PO-LITICAL dimension. Thus art becomes linked to REVOLUTION.

> QUESTION: What is a good work of art?
> ANSWER: The good work of art is powerful – like primitive fetishes, masks and rituals. It is both an expression of elemental consciousness and a conscious-ness-raising tool. 'The criterion that the Surrealists apply to a work of art is its susceptibility to provoke a real change in those who encounter it, to call forth an affective response'
> — Robert Short, 1991, p. 303

As Breton put it, their task was 'TO TRANSFORM THE WORLD, CHANGE LIFE, REMAKE FROM SCRATCH HUMAN UNDERSTANDING' (quoted in Maurer, 1984, p. 584). They wished, as Maurer says, to expand insight and perception, to regenerate human creative powers – through our common elemental resource, the unconscious (ibid.).[24]

Now, in pursuing their artistic and political aims, some Surrealists preferred some 'primitives' more than others. As we already noted, there was a strong attachment to Oceania, Africa and North American Indians. There was also the Eastern connection. Indeed, in early Surrealist writings an attachment to the East features strongly.

In a number of texts by Breton, Aragon, Artaud and others there are appeals to Asia ('the citadel of every hope'), to Buddhist religion and philosophy and to the Dalai Lama ('send us your illumination'). In some

passages from Surrealist texts THE ORIENT becomes the source of REVOLU-
TIONARY SALVATION (Batcor, 1993, p. 83). Listen to this extract from a
Surrealist manifesto:

> Western world, you are condemned to death. We are Europe's defeatists
> Let the Orient, your terror, answer our voice at last! We shall awaken
> everywhere the seeds of confusion and discomfort. We are the mind's agita-
> tors Rise, thousand-armed India, great lendary Brahma. It is your turn
> Egypt Rise, O world. (Quoted in Batchelor, 1993, p. 83)

(It must be said that not all Surrealists subscribed to this notion of The
East as salvation. For the more Marxist-orientated members, salvation
would only come through socialist revolution.)

In the work of Wifredo Lam it is the connection to AFRICA and the
Africanized Caribbean that predominates. His work has a two-fold aim.
First, it is *an act of recovery* – an attempt by Lam, an Afro-Cuban artist, to
reclaim his heritage. Secondly, it *a camouflaged act of revolution*.

Or so Lam conceives things.

Let us take the second point first. Lam's paintings – with their menacing
spirit-creatures, barbed wire, horns and sharp teeth – are intended, like so
many avant-garde works, to be an affront to bourgeois tastes:

> LAM: My intention is to create 'hallucinatory figures, capable of shocking and
> disrupting the sleep of the exploiters'.
>
> — Gerard Mosquera, 1992, p. 61

Now, one might ask: IS THIS SERIOUS? Perhaps if this were the voice
of Dada we might dismiss it as a bad joke or some sort of publicity
stunt. But Lam is a serious, politically committed artist and thinker. Sure-
ly he should know that the art he created was utterly capable of being
appropriated – without any loss of sleep . . . – by 'the enemy'. *The
Jungle* now hangs (downstairs, by the cloakroom) in New York's Museum
of Modern Art, one of the most prestigious bourgeois galleries in the
world.

> TRUTH: Ironically, many 'avant-garde' paintings now decorate the walls of the
> bourgeoisie. They may be an affront to the poor and working classes but the
> bourgeois 'enemy' has come to rather like them. . . .

We are not suggesting that it is easy to produce art that is a genuine,
effective political intervention. What we *are* saying is that, in this regard,
paintings like *The Jungle* will not do. *The Jungle*, like most avant-garde art,
fails to 'scare' the colonialists and the bourgeois. It also demonstrates a
central weakness in the Surrealist attempt to mobilize primitivism as a
tool in revolution.

The Jungle, implicitly and explicitly, makes a couple of unfortunate but fundamental assumptions. One of these is that the way back FROM CULTURE TO NATURE is through non-Western, so-called 'primitive' societies. Despite its deep roots in Western romanticism – from Rousseau to Gauguin to Picasso to the present – this is a dangerous assumption. It banishes people of Colour from the modern world. And it has overtones of classical, nineteenth-century racism.

Wifredo Lam takes his 'jungle' imagery to be an act of recovery (like Alex Haley's *Roots*). He takes it to be an instrument in the anti-colonialist, anti-racist, anti-bourgeois struggle for liberation. But one might legimately raise questions about the CULTURAL POLITICS OF 'JUNGLE' IMAGERY: Is it not more likely to reproduce bondage than to produce freedom? Is it not, whatever the artist's intent, at least as racist as it is anti-racist?

> A VOICE: I am certain that the slave-masters on the plantations of North America, the Caribbean and South America would have rather liked this painting
> WHITE POWER: The Blacks, as everybody knows, are only Animals. Their home, as everybody knows, is the Jungle.

The Cuban art critic Gerardo Mosquera (who was formerly Head of the Research Department at the Wifredo Lam Center in Havana) says that Lam's 'painting is a "primitive"-modern cosmogony, a re-creation of the world centred in the Caribbean, *appropriating the techniques of Western art, but with a space opened up by him*' (Mosquera, 1992, p. 57; emphasis added). Lam refers to his own interventions in modern art as that of a 'Trojan horse'. Perhaps he should have referred to himself as 'a sheep among wolves'.

Lam seems to assume, very naively, that the meanings he wishes to give to his paintings will be the meanings that come to be associated with them. But he is wrong: racial meanings are too deeply entrenched in the West for him to brush them aside by a few strokes on a canvas. Hardly anybody viewing *The Jungle* would think of it as a Black nationalist painting or a reclaiming of an African and Afro-Caribbean heritage. Indeed, many Black people would most probably view it as offensive, stereotyped imagery painted by an insensitive White artist.

Dominant cultural meanings are not easily overturned, certainly not by the politics of the jungle.

> A VOICE: And essentialist politics are a dangerous business, whether conducted by Black nationalists or radical feminists.

Bathing with the Other: German Expressionism

Echoes of Edvard Munch

I am alone.
Those people there, they do not know me.
I am the forgotten, forsaken and wretched.

I am lost.
My home is a labyrinth from which there is no escape.
I know no path but that of despair.

I suffer.
My pain is deep and unbearable.
My life is disillusionment, anguish and constant fear.

I am a slave.
Bound to the machine.
My lot I owe to reason, technology and good intentions.

I am imprisoned.
My chains we fashioned through science.
My cell we built through greed.

I would revolt.
My contempt for bourgeois society is utter.
But there is no possible escape.

I am alienated and utterly alone.
I live in a modern inferno.
I tremble with anxiety.
I sway with despair.

The end is madness.[25]

Private Misery . . . and Artistic Vision

Edvard Munch (1863–1944), the Norwegian painter and activist-intellectual, did not cover his eyes in the face of the modern inferno. In a series of paintings, the most famous of which is *The Scream* (1893), he sought to convey the *fin-de-siècle* condition. The context of his paintings is modern Western society – a world of the city, money, reason and technology. Munch's concern as an artist is not to reproduce the appearance of that

reality, although he does employ some Naturalist techniques, but to express the innermost feelings of the singular individual as he or she faces it. His task, through astute use of 'intense, expressive colour, often predominately dark in tone, undulating line and large areas of uniform colour' (Berg, 1974, p. 11), is to convey the agony of loneliness, alienation, fear and despair. The theme is human suffering, the inner turmoil of the modern individual.

QUESTION: What is art?
EDWARD MUNCH: 'Art is crystallization' – of the emotions.

The figure in the foreground of *The Scream* is the embodiment of naked terror – the eyes are large, blank and staring; the hands have sprung to the sides of the head; the dark body trembles, bends and sways under the force of terrifying emotions; the mouth, opened wide, *emits* an awful piercing scream . . .

'O-o-o-o, M-y-y-y God-d-d!!!'

Around the figure the blood-red sky and the blue-black sea swirl with hysterical, blood-curdling anxiety. 'There is no relief for the eye, no part of the background that is not agitated. The emphasis on strong lines and strong rhythms, and the agitation in the handling of the paint all make visible the artist's emotion. Munch . . . was obsessed with death and shows a condition that seems worse than death' (Lambert, 1981, p. 14).

The horror, the despair, is as personal as it is total.

There are two other figures in the picture, but they walk normally along a straight road. They are not terrified. The experience is not theirs to share. The foregrounded figure is all alone, in a state of profound alienation, pain and suffering, despite the objective presence of others.

It Is I That Suffers

On 22 January 1892, a year before The Scream *was completed, Edvard Munch wrote in his diary:*

> *I was walking along the road with two friends. The sun set. I felt a tinge of melancholy. Suddenly the sky became a bloody red.*
>
> *I stopped and leaned against the railing, dead-tired, and looked at the flaming clouds that hung like blood and a sword over the blue-black fjord and the city.*
>
> *My friends walked on. I stood there, trembling with fright. And I felt a loud, unending scream piercing nature.*[26]

Here is what Munch wrote in an epigraph which accompanied the picture when it appeared in Revue blanche *two years after it was completed:*

> *I stopped and leaned against the balustrade, almost dead with fatigue. Above the blue-black fjord hung in the clouds, red as blood and tongues of fire. My friends had left me, and alone, trembling with anguish I became aware of the vast, infinite cry of nature.* (Munch, 1895; quoted in Hamilton, 1987, p. 124)

Thus, the person in the foreground of the painting would appear to be the Norwegian artist himself. Munch was a deeply disturbed man, which is why he could see so clearly.

What is Expressionism? It is a twentieth-century art movement (more accurately, a series of movements), involving painters, film-makers, writers, architects and dramatists. It is that 'movement' in which external reality – the ordinary appearance of human beings, nature, the made-environment – is distorted in order to express with great power the artist's state of mind. Feelings, emotions, private miseries – these become the subject of the work of art. Individual emotions are depicted with such energy that realist and naturalist modes of representation must be abandoned for a more powerful means of expression. In painting, the emotions are conveyed through deliberate use of distorted forms, strong colours, heavy lines and agitated brushstrokes; through vitality, passion and wildness; . . . through primitivism.

> TRUTH: 'The romantic idea that art is the language of the emotions has a long and complex history reaching back to the belief in spells and incantations.'
> — E. H. Gombrich, *Meditations on a Hobby Horse*, 1971, p. 56.

On Origins

'Originally used in French in 1901 as a label for eight paintings exhibited by the dilettante painter Julien Auguste Hervé in the Salon des Indépendants in Paris', the term *Expressionism* seems to have made its first appearance in German 'in April 1911 in the Foreword to the catalogue of the twenty-second exhibition of the Berliner Sezession' in order 'to characterise a group of young French painters who included Picasso, Braque and Dufy'. The term caught on and 'by the end of 1911, it was being applied to any painter who was in reaction against Impressionism' (Sheppard, 1991, p. 274). Later, it evolved a more specific meaning, but this was from a retrospective perspective: there was never a group of artists in early twentieth-century Europe who referred to themselves as 'Expressionists'.

There were several different groups. The first and most important (certainly for the purposes of our discussion) was *Die Brücke*, the Dresden-based group founded in 1905 by four young architectural students, Ernst Ludwig Kirchner (1880–1938), Eric Heckel (1883–1970), Karl Schmidt-

Rottluff (1884–1976) and Fritz Bleyl. They were soon joined by Emil Nolde (1867–1956) and Max Pechstein (1881–1955), who had been part of the Berlin *Neue Sezession* group. 'Among the Brücke's founders, Erich Heckel and Karl Schmidt-Rottluff had been reading Nietzsche, while Whitman was Ernst Ludwig Kirchner's favourite author' (Gordon, 1984, p. 371). As we shall see, this little observation is not without powerful implications. For example, it goes some way towards explaining the fact that among the various Expressionists, it is *Die Brücke* artists who were most obsessed with sex. Arguably, it was also they who were most influenced by primitivism.

Die Brücke – the name comes from a passage in Nietzsche and translates as 'the Bridge' – was dissolved in 1912.

The second German Expressionist movement was *Der blaue Reiter* ('the Blue Rider'), the Munich-based group. Founded in 1909 by Kandinsky and some painters who had been associated with *Die Brücke*, *Der blaue Reiter* artists – their name comes from a painting by Kandinsky – were more concerned with actualizing Nietzsche's principle of renewal through destruction (discussed below) than with erotic art. The founder-artists of the Bavarian group were Auguste Macke (1887–1914), Wassily Kandinsky (1866–1944), the Russian-born painter, and Franz Marc (1880–1916). Both Marc and Macke died in the First World War.

Some of the Expressionists who were in Dresden and Munich, and in Vienna and Prague, ended up in Berlin by 1910 or 1911. There they formed *Neue Sezession*, a unified Expressionist movement.

What were the primary artistic influences on Expressionist style? Unlike many other art 'movements' Expressionism was unashamedly open to stylistic influences from a number of different sources. As the art historian Donald Gordon explains, in his brilliant study *Expressionism: Art and Idea*, these can be divided roughly into the following six classes:

1. Late Impressionism, Symbolism, Jugendstil
2. Fauvism, Cubism, Orphism, Futurism
3. German Gothic art, German Romanticism
4. Tribal art: both African and Oceanic
5. Folk art, naive art, children's art
6. Non-Western art: Islamic and Oriental. (Gordon, 1987, p. 70)

Now, these six classes can be usefully grouped as follows: Classes 1 and 2 are vanguard nineteenth- and early twentieth-century Western artistic formations. Class 3 includes national sources, including non-vanguard ones. Those three categories, taken together, are a source for various artistic techniques. Classes 4–6 are non-Western, 'primitive' and marginalized forms: they 'contained a more or less POWERFUL VITALIST IMPULSE' (Ibid.).

We shall return to the 'vitalist impulse' in Expressionist art – on more than one occasion.

Immediate Models

Gauguin's rejection of European civilization and his celebration of an alternative existence in emotional form and colour, Ensor's sudden revulsion from fine painting in favour of an intentionally shocking technique in which to present shocking subjects; Munch's use of hallucinatory images in which to give public form to his private miseries; Van Gogh's passionate yet controlled deformation of nature and intensification of natural colour in order to create a powerfully communicative art – these were the immediate models for twentieth-century painters seeking expressive means.

— Norbert Lynton, *The Story of Modern Art*, 1981,
pp. 32–3 (emphasis added)

Capitalism, Industry and Psychic Disorder

Expressionism was a reaction against the impoverishment and distortion of the human spirit brought about by rapid industrialization in turn-of-the-century Germany. It was vehemently hostile to the norms and values of bourgeois society:

> This violent hatred of bourgeois society, common to all the Expressionists, derived from their conviction that the institutions of industrial capitalism were maiming and distorting human nature by developing the intellect and the will in the service of material production and neglecting the spirit, feelings and imagination. The apparent purposefulness and technological order of contemporary society concealed, they claimed, an increasing psychic disorder. (Sheppard, 1976, p. 276)

Expressionist art, poetry and drama sought to express the effects of this distortion of the human spirit on the individual. Artists and writers rejected both Realism and Impressionism which they saw as concerned with the surface of life rather than its inner substance.

Of Machines, Nature and the Human Soul

This is the vital point – that man should find himself again. Schiller asks: 'Can man have been destined, for any purpose whatever, to lose himself?' It is the inhuman attempt of our time to force this loss upon him against his own nature. We would turn him into a mere instrument; he has become the tool of his own work, and he has no more sense, since he serves the machine. It has stolen him away from his soul. And now the soul demands his return. This is the vital point. All that we experience is but the strenuous battle between the soul and the machine for the possession of

man. We no longer live, we are lived; we have no freedom left, we may not decide for ourselves, we are finished, man is unsouled, Nature is unmanned. A moment ago we boasted of being her lords and masters and now she has opened her wide jaws and swallowed us up. Unless a miracle happens! That is the vital point – whether a miracle can still rescue this soulless, sunken, buried humanity. . . . Never yet has any period been so shaken by horror, by such fear of death. Never has the world been so silent, silent as the grave. Never has man been more insignificant. Never has he felt so nervous. Never was happiness so unattainable and freedom so dead. Distress cries aloud; man cries out for his soul; this whole pregnant time is one great cry of anguish. Art too joins in, into the great darkness she too calls for help, she cries to the spirit: THIS IS EXPRESSIONISM.*

— Hermann Bahr, *Expressionism*, 1920; quoted in Frascina and Harrison, 1982, p. 168 (emphasis added)

Now, none of this is to claim that the German Expressionists were REVOLUTIONARIES in any usual sense of the term. Many of those involved in the Surrealist movement were closely linked to communist and socialist tendencies – to movements for class revolution in Europe and anti-colonialist revolution in the 'Third World'. The Expressionists, by contrast, were almost all BOURGEOIS INDIVIDUALISTS – rebels in search of individual freedom. (This is why the cultural critic Georg Lukács, who knew a bourgeois rebel masquerading as a revolutionary when he saw one, so disliked them.[27]) They had no coherent political programme, which, given their stance, was perfectly logical. As it turned out, their ideas were later taken up by both fascist and left-wing German groups.

Expressionist artists and writers saw themselves as visionaries, exploding conventional reality in order to give expression to the psychic power and energy of individuals. This power and energy had been imprisoned by the machine (industrialism) and capitalist society. It had also been imprisoned by the bourgeois family.

The Ties that Bind

Max Beckman, in a triptych completed in 1949, the year before his death, 'still remembered a boy furtively drawing a nude in a classroom while another boy was forced to stand in a corner with arms raised'. Ludwig Meidner, as a teenage schooboy (who would later become an Expressionist with a strong commitment to social criticism), 'was so obsessed by punishment that he did a drawing, *Kill the Flesh* (1902) depicting Christian monks flagellating themselves'. In his autobiography George Grosz, the painter, graphic artist and political satirist, 'recalled the "Protestant officers" who were his teachers, and the "controlled fury" with which one of them would rap a heavy signet ring against the boy's head'. Oskar

Kokoschka, the Austrian painter and graphic artist whose Expressionist sensitivities were formed in Vienna, Berlin and Dresden, 'recorded in his autobiography a decision to commit suicide if he failed his *Realschule* exam and lost a scholarship'. Even Emil Nolde, who unlike the others was not born into the bourgeoisie or petty-bourgeoisie but into the class of peasants, 'remembered a religion class at school when the sexton confiscated his drawings and burned them in the oven'. Ernst Ludwig Kirchner, despite being the son of a well-educated chemical engineer, 'still smarted from "the dark heritage of fanaticism in the generation of Brandenburg ministers on my father's side" ' (Gordon, 1987, p. 27).

What are we to make of all of this?

Born in the 1880s and 1890s, the young men who created Expressionist art and culture were the products of 'respectable' – PIOUS, PRUDISH and REPRESSIVE – middle-class society and culture. The late nineteenth-century culture from which they came is best described as 'Victorian'. The term, of course, is usually used to describe that peculiar combination of 'middle-class respectability, prudery [and] bigotry' – the phrase comes from *Webster's New World Dictionary of the American English Language* (1960) – that obtained in Britain during the long reign of Queen Victoria (1837–1901). 'Yet Wilhelmian society was certainly Victorian in the sense that it was CLASS-CONSCIOUS, OSTENTATIOUSLY CHRISTIAN, and INTOLERANT of sexual mores not practised in the middle-class home'. Victorian values in late nineteenth-century Germany 'were enforced in the church, in the home, and above all in the school – in the *Gynasium* or *Realschule* where middle-class youngsters were prepared for the university.' In this climate there was a 'petty-bourgeois conspiracy to hush up matters sexual, especially when they concerned the young'. One of the features of this society was an alarmingly high incidence of adolescent suicides, especially among males – many of them surely due to the pressures of this oppressive and repressive society.

Expressionists were not simply opposed to capitalism and industrialization. It was the late nineteenth-century bourgeois family, with its bonds, that they found especially, and personally, abhorrent.

bond n. **1.** *a thing that ties us together* **2.** *a thing that ties us down* **3.** *a uniting force (as in* sisterly bonds*)* **4.** *a restraint* **5.** *a binding agreement* (his word is his bond) **6.** *imprisonment*.

This brings us to the crucial point: 'In becoming Expressionist artists, some of them at quite youthful an age, these men were to some degree reacting against an unusually repressive adolescent environment.' Expressionism was, in part, a kind of CULTURAL REVOLUTION, 'an inchoate or muddled rebellion against German bourgeois society'. '[B]efore the revolution was political it was familial; it was a protest by adolescents

[actually males in their early twenties] against the ignorance, intolerance, and materialism of their parents and teachers.' It was a struggle against the self-righteous, repressive mores of the bourgeois, 'Victorian' family. Expressionism is a post-Victorian art form – and, as we shall see, way of life (Gordon, 1987, pp. 26–7).

In waging this struggle two of their principal allies turned out to be a nineteenth-century German philosopher called Nietzsche and a nineteenth-century American poet called Whitman.

The Shadow of Nietzsche

It is with man as it is with the tree. The more he aspires to the height and light, the more strongly do his roots strive earthward, downward, into the dark, the deep – into evil.
— Nietzsche, *Thus Spoke Zarathustra*

What Nietzsche sowed, Expressionists reaped.
— Donald Gordon, *Expressionism*, 1987, p. 2

Here is Friedrich Nietzsche speaking, in section 440 of *The Will to Power* (1901):

> Genius resides in instinct; goodness likewise. One acts perfectly only when one acts instinctively. Even from the viewpoint of morality, all conscious thinking is merely tentative, usually the reverse of morality. . . . It could be proved that all conscious thinking would also show a far lower standard of morality than the thinking of the same man when it is directed by his instincts. (Quoted in Gordon, 1987, p. 33)

In this passage, the German philosopher, turning the tables on all his proper training, conceives instinct as a kind of unconscious intelligence and guide that supersedes both modern logic and modern morality. Such claims were not atypical: Nietzsche was a SCANDALOUS THINKER.

Summarized below are some of his startling claims – claims which, in some educated circles, have become rather popular today:

- **Objectivity and Truth are dead** – '*Every* belief, every taking-to-be true, is necessarily false' (*Will to Power*, 15). There are only perspectives, falsification and distortion. Truth is not a product of reason and logic but of power: 'Knowledge works as a *tool* of power. Thus it is obvious that it grows with every increase of power' (*Will to Power*, 480).
- **Facts are dead** – 'There are no facts, only interpretations.' There are only 'lies', 'errors', 'fictions' and 'illusions'.

- **Reason and Science are dead** – We now know that they are incapable of yielding anything like absolute knowledge, that they can guarantee neither the realisation of truth nor human progress. Science's concepts, laws and causes – these are all illusions (see *Will to Power*, 521).
- **Progress is dead** – Far from moving forward, modern society and culture have declined and decayed. Those who believe that we are destined to have a better world are seriously misguided. There are no guarantees. Our modern world is sick, sufficiently decrepit to warrant a mood of deep pessimism about the human condition.
- **Man is dead** – Here are two illusions: the humanist idea of Man as being a special creature with intrinsic value, the Christian-religious idea of man as being a spiritual being with a soul. Human beings (except for the *Übermenschen*) are only a species of the animal kingdom, and they are unequal.
- **God is dead!** – In philosophy, God no longer serves as the final guarantor of meaning, purpose and truth. In modern society, the Christian-moral interpretation of life and the universe no longer provides an anchor. There are neither spiritual values – they have been lost in our secular society – nor final guarantees. We are on our own.
- **Purpose and Meaning are dead** – We have not been placed on earth for a purpose. It is not 'God's will' that we do this or that. There is purpose neither in history nor in the universe. Nor are there final causes. What does life mean? With the death of the Christian-moral universe with all its guarantees, meaning has also died.
- **Morality is dead** – With the collapse of our traditional (Christian) values, human behaviour no longer has guides and sanctions. There are no grounds for saying that 'good' is better than 'bad', that 'good' is preferable to 'evil' (see *On the Genealogy of Morals*, 16 and 17). There are no grounds for asserting that we have a 'duty' to do this or that. Our world is a nihilist world.
- **Faith and Hope are dead** – With the demise of our moral structures and meanings, there is absolutely no grounds for hope or faith. Faith in reason is misguided, as is faith in society or mankind. There are only pessimism and hopelessness, which are the roots of nihilism.

What are we to conclude? Nietzsche's conclusion was: **Civilization is on the brink of collapse!** And this was a conclusion with which the Expressionists agreed. (They also agreed with the observations and assumptions that led to this conclusion.)

Nietzsche was an obsessed philosopher. 'Few philosophers have had a more impassioned driving concern than Nietzsche did; and few have felt that more depended on their philosophical enterprises. He believed that our entire civilization – and indeed humanity generally – is moving toward a profound and dangerous crisis' (Schacht, 1993, p. 7). The 'death

of God' – the collapse of the moral anchor of society, the demise of the final guarantor of truth and meaning – meant that fundamental assumptions about humanity, society and the universe could no longer be sustained. As a philosophical development, Nietzsche was not particularly alarmed by 'the death of God'. Indeed, it was 'his point of departure, which he took to call for a radical reconsideration of everything – from the world, human existence, and knowledge to value and morality' (ibid., p. 11). As a cultural event, however, he regarded it as profoundly alarming, as a source of deep concern.

He feared the cultural degeneration, the impending disaster, the 'nihilistic rebound' that was certain to follow as a result. Two thousand years of Western civilization are at stake. All of those core beliefs and assumptions that have given meaning and structure to our lives are rapidly disappearing. Nihilism – the wholesale rejection of truth, meaning and all religious and moral values – looms at the door. Nietzsche 'feared that unless something could be done, humanity would cease to flourish and develop and would instead sink into a degenerate and ultimately moribund condition' (ibid., p. 7).

Now, we must say Nietzsche does not always write as if he is fearful of these developments. On the contrary, he often seems to celebrate the nihilism of which he speaks – like those postmodernists, Baudrillard and friends, who seem to revel in the nihilism of today. Here is one example, selected more or less at random from the many that could be given:

> Every belief is a *taking-to-be-true*. The most extreme form of nihilism would be: that *every* belief, every taking-to-be-true, is necessarily false: *because there is absolutely no true world*. Thus: a *perspectival appearance*, whose origin lies in us (insofar as we continually have need of a narrower, abbreviated, simplified world).
>
> . . . that it is the *measure of strength* how far we are able to acknowledge *appearance* and the necessity of lies – without perishing.
>
> To that extent *nihilism*, as the *denial of a truthful world*, of being, *could be a divine way of thinking*. . . . (*Will to Power*, 15; original emphasis)

Long live pessimism!
Long live nihilism!
Long live the will to power!
So as to bring about renewal!

So as to bring about renewal?! Yes, as we shall see.

Nietzsche, when he was not revelling in nihilism, looked for an alternative to it – and his view was that a solution could only come out of the depths of nihilism itself. That is, he makes two crucial assumptions (in the preface to *Will to Power*): the first is 'that "nihilism" will generate its own

"countermovement" '; the second is 'that a revaluation of values will come not only after nihilism but "out of" it'. 'The very DESCENT INTO THE ABYSS OF NOTHINGNESS must precede the ASCENT UP to new values of self': it is only after we have '*lost* the illusory powers that state and religion had once seemed to give', that we – modern individuals, societies, cultures – can be regenerated (Gordon, 1987, p. 13; emphasis added).

> NIETZSCHE: *Apart from the fact that I am a decadent, I am also the opposite.*

Nietzsche would have agreed with Max Stirner who in *The Ego and His Own* (1845) wrote: '*I am not nothing in the sense of emptiness, but I am the creative nothing, the nothing out of which I myself as creator create everything.*'[28]

The German Expressionists would have agreed as well: in fact, Stirner's statement easily could have been their motto.

Indeed, the Expressionists shared many of Nietzsche's feelings, thoughts and assumptions: they were, on the whole, very good Nietzscheans. Take, for example, those two crucial notions (which have deep roots in German romanticist and dialectical thinking), the FEAR OF DEGENERATION and the HOPE OF RENEWAL:

> Expressionism was a cumulative reaction to many different intimations of decline: to an imagined decrepitude in society, a supposed running down of the cosmos, and an alleged decay in culture. It was a universal fear of degeneration that prompted a utopian hope for regeneration – that hope which is necessary if variably present in all art called Expressionist. Indeed the very magnitude of Expressionist optimism can only be measured against its starting point in despair. This tension creates ambivalence, and the two together describe the 'emotion' which viewers commonly observe. . . .
>
> Expressionism can be described more broadly and simply as a response to the fear of decline. Such a description permits otherwise disparate art forms to be unified, not according to some elusive quality of content or style, but by an underlying attitude of hoped-for-revitalization. Central to the Expressionist enterprise was reciprocity: HOPE AS ANSWER TO FEAR, DECLINE AS PREREQUISITE TO RENEWAL. . . . (Gordon, 1987, p. 3; emphasis added)

Unlike Dadaists, who were more consistent in their nihilism, German Expressionists always saw renewal as the outcome of degeneration, creation as the objective of destruction. At the core of the Expressionist programme is the Nietzschean, romanticist-dialectical assumption that you must go backwards in order to go forwards, under the bridge in order to cross it.

And thus, as all the other gods had failed, they went to Dionysius and the Primitive.

From the Bourgeois Family to a Cult of Dionysius

Through me forbidden voices,
Voices of sexes and lusts, voices veil'd and I remove the veil,
Voices indecent by me clarified and tranfigur'd.

I do not press my fingers across my mouth,
I keep as delicate around the bowels as around the head and heart,
Copulation is no more rank to me than death is.
— Walt Whitman, *Leaves of Grass*, 1947 (orig. 1855), p. 45

Given the sociocultural milieu out of which they came, the Expressionists created an art and culture that was liberating indeed. In many respects, certainly in the realm of sexuality, they turned proper Victorian conduct on its head – with a bit of help, as we said, from Nietzsche and Walt Whitman.

Here is a testimonial from Ernst Ludwig Kirchner, written towards the end of his life (in a letter dated 17 April 1937): 'That great poet, Walt Whitman, was responsible for my outlook on life. During my dismal days of want and hunger in Dresden, his *Leaves of Grass* was and still is my comfort and encouragement' (quoted in Gordon, 1987, p. 2). Kirchner was not the only one who felt under the spell of Whitman. The recurrent theme of *Leaves of Grass* is the insatiable appetite for sex. '[O]nce Schlaf's German translation became available in 1907, WHITMAN BECAME A MODEL for the entire Expressionist generation and a precedent for the "new pathos" in German Expressionist literature.' It was 'Whitman who first prompted the Brücke artists' public celebration of sexual activity'. The American poet who spoke from the repressive unconscious of Victorian society was the best friend not only to Kirchner but to a movement (Gordon, 1987, p. 29; emphasis added).

What was it about Whitman that so comforted and inspired them? It was the energy, the vitality, the unrestrained eroticism, the sexual urge.

Urge and urge and urge,
Always the procreant urge of the world.
Out of the dimness opposite equals advance, always substance and
 increase, always sex,
Always a knit of identity, always distinction, always a breed of life.
— Walt Whitman, *Leaves of Grass*, p. 25

Undrape! You are not guilty to me, nor stale nor discarded,
I see through the broadcloth and gingham whether or no,

And am around, tenacious, acquisitive, tireless, and can never be shaken
away.

— Walt Whitman, 1947, p. 29

'[W]hen Whitman writes that he sees through "broadcloth and ging-
ham" he evokes the erotic potential of *both* male and female bodies.
AUTO-EROTICISM, HETEROSEXUALITY, HOMOSEXUALITY – all are equally
possible and equally guiltless' (Gordon, 1987, p. 29). In the world accord-
ing to Whitman, the following is a prized assumption: 'In the beginning
was SEX!'

Listen, or if you must, cover your ears, as the untamed poet speaks:

Sex contains all, bodies, souls,
Meanings, proofs, purities, delicacies, results, promulgations,
Songs, commands, health, pride, the maternal mystery, the seminal
 milk,
All hopes, benefactors, bestowals, all the passions, loves, beauties,
 delights of the earth,
All the governments, judges, gods, follow'd persons of the earth,

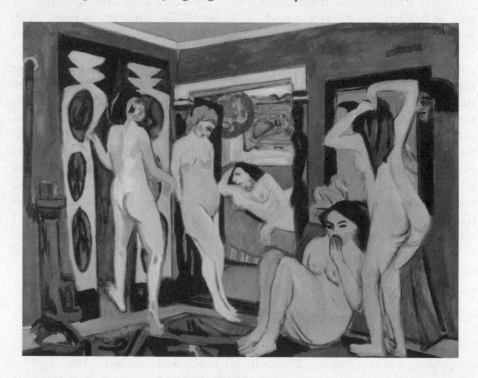

Plate 10.6 Bathers in a Room, Ernst Ludwig Kirchner, 1909, repainted 1920, oil on
canvas, 60" × 78".
Copyright Dr Wolfgang and Ingeborg Henze-Ketterer, Wichtracht, Bern. Photograph
supplied by Saarland Museum, Germany.

These are contain'd in sex as parts of itself and justifications of itself.

Without shame the man I like knows and avows the deliciousness of
 his sex,
Without shame the woman I like knows and avows hers.
 —Walt Whitman, 1947, pp. 88–9

When Dionysus Meets the Primitive

Look at plate 10.6. *Bathers in a Room* (1909) is a famous painting by the
Expressionist leader, Ernst Ludwig Kirchner. Five feet tall and six feet
wide – 151cm × 199 cm, to be precise – it is clearly intended as a statement
of some sort.

Now, nude female bodies and bathers are old themes in Western oil
painting. But this is no ordinary painting. Completed in late 1909, *Bathers
in a Room*

> depicts graceful and arfully posed 'bathers' in a stark and colorful 'prim-
> itive' interior. The nudes resemble those of Matisse's 1906 *Joy of Life*: They
> stand, recline, eat, or arrange their hair, all the while evoking a serene and
> idyllic arcadia. The interior, however, evokes the appearance of a space of a
> tribal house. Tall figures in black silhouette adorn the door-jambs to one side
> room while a pair of boldly painted curtains protect the entrance to another.
> The curtains have geometric designs: each field with a bright yellow, was
> framed in shapes of black, and contained green and black roundels depicting
> a seated king below and coupling lovers above. The bedroom within, appar-
> ently quite small, was also hung with painted wall-drapes in the course of
> 1910, drapes once again depicting couples making love – if now, more
> scenically, under tropical trees. (Gordon, 1984, p. 372)

The painting reflects the key concerns of the *Brücke* movement. It works
within and reinforces the fundamental binary oppositions celebrated by
German Expressionist artists. As Donald Gordon argues, 'The Raw'
confronts 'The Sophisticated', 'Nature' confronts 'Culture', Crude Sex con-
fronts Respectability and Romantic Love. The painting's imagery makes
links between a tropical island paradise and free love/sex. The figures of
the 'bathers' emphasize their mouths, breasts, genitalia and buttocks. The
curtains and drapes show copulating couples. Kirchner uses geometric
designs and vibrant colours and surrounds his bathers with tall, thin
'primitive' African or Oceanic sculptures. (The pseudo-'tribal' curtains
occur in other Kirchner works – for example, *Standing Nude with Hat*, 1910.)

With its explicitly erotic subject matter *Bathers in a Room* emphasizes a
Nietzschean DIONYSIAN OR VITALIST IMPULSE in art. This is a key theme of
Brücke paintings and woodcuts. It can be seen, for example, in Kirchner's

Girl under Japanese Umbrella (1909) which depicts a group of nudes, among them a woman bending over exposing her buttocks. To her right stands a male figure with an erect penis. 'The background screen shows raw "life", but the foreground nudes hold attributes of civilization. Where crude sex is suggested above, we find below the parasol of high fashion or the flower of romantic love' (Gordon, 1984, p. 372). Other Kirchner works from 1909 and 1910 'depict male and female nudes in sexually suggestive poses, most crudely in a ceramic tile *Love Scene* in which lovers physically arouse one another' (ibid., p. 371).

In their recourse to 'primitive' models, German Expressionists consciously took over formal as well as ideological/emotional aspects – linked to vitalist ideas of immediacy and authenticity – which they associated with Other cultures. The Primitivist impulse occurs in Expressionism in two ways: as a LIFE IDEA and an ART IDEA (ibid., p. 369).

In their use of form the *Brücke* group of painters emulated 'primitive' art by producing woodcuts in a 'primitive' style – or rather in a rough, crude style that gave the appearance of being untutored. Crucial here was that recurrent primitivist idea, especially pronounced among the Nietzschean Expressionists that in order to move forwards you must first go backwards – to cruder, less inhibited, less tutored ideas and forms. German Expressionist woodcuts are arguably among the outstanding contributions to twentieth-century art. (One notable example is Karl Schmidt-Rotluff's *Apostle* (1918) which is held at the *Brücke-Museum* in Berlin.)

Besides emulating the carving of 'primitive' and 'tribal' peoples, the German Expressionists also followed their dark-skinned teachers by using angular, geometric shapes and stubby proportions. Their 'prototypes ranged from the flat and silhouette-like painted reliefs of Palau to the powerful, three-dimensional forms of Cameroon sculpture'. Finally, true to their Nietzschean and Whitmanesque lineage, they sought to reproduce the VITALISM that they took to be a defining feature of 'primitive' art: in the work of the *Brücke* Expressionists, as in African and Oceanic sculpture, 'EYES, MOUTHS, BREASTS, GENITALIA were all given expressive prominence. Even in repose the expressionist face and figure seem packed with energy. *These are all German derivations from tribal art*' (Gordon, 1984, p. 370; emphasis added).[29]

Going Native . . . and Sleeping with the Other

The negro holds firmly the reins of his four horses, the block swags underneath
 on its tied-over chain,
The negro that drives the long dray of the stone-yard, steady and tall he stands
 pois'd on one leg on the string-piece,

His blue shirt exposes his ample neck and breast and loosens over his hip-band,

His glance is calm and commanding, he tosses the slouch of his hat away from
 his forehead,
The sun falls on his crispy hair and mustache, falls on the black of his polish'd
 and perfect limbs.
I behold the picturesque giant and love him, and I do not stop there,
I go with the team also.

— Walt Whitman, 1947, p. 33

German expressionism was not simply an artistic movement. It was also a way of life. In their revolt against both modern urban civilization and bourgeois sexual norms, German expressionist artists invoked the life-styles (as they imagined them) of agrarian and 'primitive' peoples. In their city studios – in Dresden, Berlin and Munich – they 're-created the imagined environment of tribal life. And in the countryside the life style of peasants was appreciated for its own sake.' Some German expressionist artists went futher: they 'WENT NATIVE' during the summer holidays, '*living in the nude with their models and practicing a sexual camaderie*

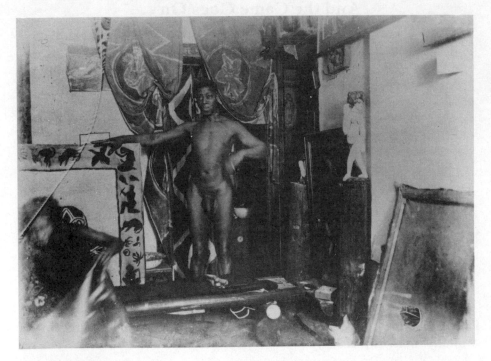

Plate 10.7 Sam and Milli in Kirchner's Dresden Studio, 1910. Photograph by Ernst Ludwig Kirchner.
Collection: Fotoarchiv Hans Bollinger and Roman Norbert Ketterer, Galleria Henze, Champione d'Italia.

that paraphrased – so they thought – the supposed instinctual freedom of tribal life' (Gordon, 1984, p. 370; emphasis added.)

Among their most prized models were Sam and Millie, two circus performers who were also, conveniently, Black. (See plate 10.7.)

A SERIOUS QUESTION: Why when they think about sex do they always think about us?

Kirchner's drawings of his two Black models include sexually explicit – most people would say, pornographic – scenes. (See, for example, the drawing called 'Sam and Millie' in Gordon, 1987.)

Two Black Voices

VOICE 1: I don't believe it! Look at Sam and Milli, their pet Negroes! I thought such objects of White pleasure went out of fashion after Elizabethan England . . .

VOICE 2: Oh, no. There are still some around. Come, I will show you . . .

And the Game Goes On . . .

I am Cubism
in search of new vision,
so I see the Blacks.

I am Surrealism
in search of the unconscious,
so I dream the Blacks.

I am Dada
in search of spontaneity,
and so I ape the Blacks.

I am Expressionism
in search of sexual power,
I must go purchase some Blacks!
— G.J.

Primitivism is still with us – in modern art, in popular culturel, in the capitalist market place.

MY QUESTION: Why have so many White people, including radical White artists been so interested in us – our art, our culture, our bodies?

The avant-garde art movements discussed in this chapter have been motivated by the concerns of (White) Western artists and intellectuals about modern Western societies. They have been reactions against capitalism, against industrialism, against the bourgeois family. In looking for alternatives and new ways forward they have turned to the West's Others – not to those colonized (and postcolonial) peoples who have been involved in the process of negotiating a 'modern' relation to the West but to 'primitive' and 'tribal' people, whom they see as existing outside of history.

> A VOICE: It should by now be known that Primitivism is a relation of power through which the colonial and racial Other is constructed.

In doing so Western avant-garde movements draw on long-established ideas about 'primitive' peoples, ideas that are both Eurocentric and racist. Their celebration of the 'primitive' helps to reproduce relations of White Power and Powerless Otherness. At best, they *reverse* rather than *transform* racist oppositions (irrationality becomes more desirable than rationality, spontaneity more valuable than thought, and so on). We investigate these issues fully in the next chapter.

The ideology of primitivism is no small thing. As we shall see in chapter 12, it has important, ongoing implications for the relationship of the modern art establishment to contemporary Artists of Colour working in the West.

Primitivism Lives – in Contemporary Art

The examples of 'primitivism' in modern art discussed in this chapter date from before the Second World War. One might well ask: What has this got to do with today?

Primitivism is definitely still with us. But this is not to suggest that it has remained the same in form. It is possible to think of the Second World War – or some time shortly thereafter – as a kind of divide.

In the first half of the twentieth century, it was frequently the case that Western artists directly appropriated artistic ideas from specific pieces or styles of 'tribal' art. Often they appropriated these ideas from objects in their own collections of non-Western art.

Contemporary modern artists in the West have not entirely stopped 'collecting tribal sculpture or looking to it for ideas. But this object-to-object relationship has been largely displaced', especially since the late 1960s, 'by a more tenuous, more elliptical, and above all, more intellectualized primitivism, which takes its inspirations primarily from *ideas*

about the way tribal objects functioned and about the societies from which they came' (Rubin, 1984a, p. 10).

Today's primitivism is mostly a 'CONCEPTUAL PRIMITIVISM'. Prepared in part by Surrealist attitudes towards non-Western Others, conceptual primitivism 'includes certain hybrid objects, Earthworks, Environments, Happenings (varieties of "shamanistic" theatre) and other activities'. It 'draws its inspiration more from texts than works of art, from the writing of Bataille and Leiris, among others, and especially from the structuralism of Lévi-Strauss' (ibid., p. 10).

In the next chapter we shall have something to say about the relationship between postmodernism and primitivism – that is, about the primitivist impulse in today's avant-garde art.[30] But our primary focus will be on the cultural politics of 'primitivism'. There are, as we shall see, serious issues involved here.

Primitivism Lives – in Popular Imagination, Popular Culture and Desire

It is not simply artists who have a general interest in racial and cultural difference and a specific interest in the 'primitive'. The Racial Other exists in the popular imagination, in culture, in desire. Why? Here, we think, is the real reason:

> The commodification of Otherness has been so successful because it is offered as a new delight, more intense, more satisfying than normal ways of doing and feeling. Within commodity culture, ethnicity becomes a spice, seasoning that can liven up the dull dish that is mainstream white culture. Cultural taboos around sexuality and desire are transgressed and made explicit as the media bombards folks with a message of difference no longer based on the white supremacist assumption that 'blondes have more fun'. The 'real fun' is to be had by bringing to the surface all those 'nasty' unconscious fantasies and longings about contact with the Other embedded in the secret (not so secret) deep structure of white supremacy. In many ways it is a contemporary revival of interest in the 'primitive' with a distinctly postmodern slant. (hooks, 1992, pp. 21–2)

The primitivist impulse is not dead. Racial and cultural difference is being sold like toothpaste – or rather like Malcolm X baseball caps . . .

11

Dialogues: Race and the Cultural Politics of the Avant-garde

Each of us is simultaneously the beneficiary and the victim of this heritage. Western artists, in particular, are the beneficiaries because it has enriched our store of visual knowledge, and added to our repertoire of formal means. But artists are also the victims of this legacy, because we have inherited an unconscious and ambivalent involvement with the colonial transaction of defining Europe's "others" as primitives, which, reciprocally, maintains an equally mythical "western" ethnic identity.
— Susan Hiller, Foreword to *The Myth of Primitivism*, 1991, p. 1

But lest this recovery of the other be a recuperation into a western narrative, a political genealogy of primitivism is also necessary.
— Hal Foster, 'The "Primitive" Unconscious of Modern Art', 1985, p. 200

This chapter consists of a series of dialogues – some of them real, others imagined. The attempt is to highlight central issues that relate to the preceding discussion. In particular, we wish to explore the cultural politics of primitivism, including its relationship to colonialism and racism.

We hope the reader will join us in these dialogues with authors and texts. We do not claim to have all the answers. We do claim, however, to have thought about some of the questions

Dialogue no. 1: Groundings . . .

A CONCERNED STUDENT: I have read all these pages, but what – in a nutshell – is this Western obsession with 'primitives' and 'primitivism' all about?

HAL FOSTER: 'Historically, the primitive is articulated by the west in deprivative or supplemental terms: as a spectacle of savagery or as a state of grace, as a socius without writing or the Word, history or cultural complexity or a site of originary unity, symbolic plenitude, natural vitality' (Foster, 1985, p. 196).

STUDENT: But why? This all sounds rather odd . . .

HAL FOSTER: 'There is nothing odd about this Eurocentric construction: the primitive has served as a coded other at least since the Enlightenment, usually as a subordinate term in its imaginary set of oppositions (light/dark, rational/irrational, civilized/savage)' (ibid.).

STUDENT: You are suggesting that 'primitivism' does not simply serve Western art but, in some basic sense, Western culture. How is this done? I mean, what role does primitivism play in relation to broader issues of Western culture and society? I thought the whole idea of primitivism was to deconstruct and overthrow dominant Western values, assumptions and practices?

HAL FOSTER: 'This domesticated primitive is constructive, not disruptive, of the binary *ratio* of the west; fixed as a structural opposite or a dialectical other to be incorporated, it assists in the establishment of a western identity, centre, norm and name' (ibid.).

STUDENT: So primitivism is less revolutionary than it may appear to be?

A FRIEND: You are beginning to get the picture . . .

Dialogue no. 2: Revelling in Difference

GLENN: I deliberately decided to include a substantial section on Dada in chapter 10. The main reason is because it is the modernist movement that seems to have most in common with *post*modernism. Dadaists and postmodernists employ some of the same strategies – irony, parody, transgression, subversion and so on. And both Dadaists and postmodernists revel in cultural difference.

CHRIS: Yes, I can see that. Perhaps we should explore this – what you call 'postmodern revelling in difference' – in some detail later. But first let me raise some issues that specifically concern Dadaism. I want to talk about the politics of Dada.

GLENN: Okay.

CHRIS: I suppose the best way to start is to ask this: What do you make of those 'Negro Soirées' that were so popular at Zurich's Cabaret Voltaire?

GLENN: That's a big question . . .

CHRIS: Well, let me start with a smaller one. It seems that these events, which most of us might view as totally bizarre, were very well attended. What do you make of that?

GLENN: It is very easy to dismiss the Dadaists as bizarre and eccentric. But I think we should give credit where credit is due. The anwer to your question is that Dadaists understood something about politics, especially *cultural* politics, that is absolutely fundamental: if you want people to be involved, you had better pay attention to questions of *pleasure* and *desire*. I think there are good grounds to argue that most of us political activists are too serious – I mean, too cerebral. It must be said that, from the perspective of the general public (the people we are seeking to engage), boredom is a central feature of the events we organize, the books we recommend, the materials we distribute, the posters we display . . .

Dada events – their 'Negro soirées', 'exhibitions' and other forms of cultural guerrilla warfare – attracted people. At minimum, people were bewildered, shocked or fascinated.

We may find them bizarre, but that should not prevent us from learning from them.

CHRIS: You used the term 'cultural guerrilla warfare' a minute ago. Are you suggesting that Dada was a politically progressive movement?

GLENN: I suppose it all depends on who you compare them with. The main point about their politics is that they were anarchist and nihilist (as compared, say, to their successors, the Surrealists, who were mostly socialists and communists). Today, they would be called deconstructionists or postmodernists.

CHRIS: What about their cultural politics of race?

GLENN: Let me begin by emphasizing the fact that the Dadaists were, in a profound sense, against modernity and also against racism. They believed, not unlike a number of romantic and utopian movements of the past few centuries, that there is some basic dimension of our humanity, having to do with emotions, spontaneity and power, that we modern Westerners – with our rationality, science, industrialization and bourgeois norms – have lost.

Those noisy evening rituals of spontaneous, free expression – aided by Janco's neo-primitive masks, alcohol, food, 'Negro music' and so on – were an attempt to recover, if only briefly, a repressed if not lost realm of our common humanity. Dada evenings were intended as a calculated assault on the norms and values of Western middle-class society and a celebration of cultural and racial difference. Viewed from the inside, Dadaists were anything but racists. Because the Blacks and the Primitives were in tune with their emotions and elemental power, and spontaneously expressed their feelings and desire, the Dadaists regarded them as *superior*.

CHRIS: You seem to have chosen your words carefully. You said, *'viewed from the inside'* the Dadaists can hardly be accused of racism. But what about 'viewed from the outside'? After all, most of us live outside of Dadaism.

GLENN: I think the evidence is very clear here: like a number of other 'primitivist' movements, their politics of race rest on A VERY SLIPPERY SLOPE.

CHRIS: For example?

GLENN: Take the terms rationality/irrationality, mind/body and thought/emotions, which in modern Western thought are viewed as binary oppositions. Much of Dadaist thought and action sought to invert the status given to these categories. That is, they wanted to privilege the irrational, the body, feelings, emotions, spontaneity and so on. They saw these attributes of humanity as extremely valuable.

Here comes the problem. In the larger context of Western society it is precisely this binary logic that underpins racist discourse and imagery. Racism employs a certain logical rigour. Thus:

'White' or 'The West' = rationality, logic, science, control, etc.
'Black' or 'The Primitive' = irrationality, emotions, elemental power, spontaneity and voodoo.

This is the sort of 'logic' that leads to statements like:

'Black people are natural musicians.'
'Black people have rhythm.'
'The Africans are natural athletes.'
'We don't think our Coloured colleague is up to teaching theory.'

No one ever says that Black people are 'natural' physicians, scientists or sociologists . . .

Now, in the 'equations' I mentioned a minute ago, the racist regards the 'White' traits as positive and the 'Black' traits as negative. Dadaists took the opposite view.

However, this is not enough – not enough for an anti-racist cultural politics.

Take the matter of dialectically revaluing oppositional terms – of assigning positive value to terms (like 'body' or 'emotion') that have negative value and negative value to terms (like 'mind' or 'logic') that have positive value. *This can be a dangerous strategy indeed.* For unless you can change the entire culture – not just the thinking of those who attend Cabaret Voltaire, but that of the society as a whole

– you are likely to end up *reinforcing* racial stereotypes and racist practices. By routinely portraying Black people as musical, physical, emotional and so on, you make it less likely that they are thought of as people like us.

The struggle, I would have thought, should be to get beyond these mythical, stereotypical and ideological oppositions: Black people have minds and bodies, so do White people. In any event, why constantly reduce people to categories like 'Black' and 'White'? One of the main reasons I left the United States in the mid-1980s is because of this obsession, which I myself could not avoid falling into when I was there . . .

Nothing in Dada, or for that matter in Surrealism, German Expressionism or most any other Western avant-garde movement you choose, addresses the problem of getting beyond these false oppositions. In fact, the opposite is the case: these movements thrive on such myths – and thus, presumably inadvertently, reproduce the BINARY LOGIC OF RACISM.

CHRIS: Glenn, I know you are very fond of jazz. So were the Dadaists. Why were they so interested in jazz? What did they make of it?

GLENN: Yes, I am a lover of jazz – much of it, anyway. And, as you know, my brother was for a time a professional jazz musician in San Francisco. But I'm not sure I'm attracted to jazz for the same reasons as the Dadaists.

Actually, their conception of jazz is very revealing. The Dadaists viewed jazz as a form of 'primitive' expression (like 'African drumming'). Now, as a matter of fact, it would be more plausible to read jazz as a classical music, as one of the few unique contributions from North America to modern 'High' Art. But Dadaists, like many White people today, seemed to think that playing jazz comes 'naturally' – that it simply involves spontaneous blowing and screaming. It is stupid enough to think this of African rituals and music. But to think this of jazz . . .

Dadaists had different links with the arts and cultures of the non-Western and non-White world. These included African languages, West African music, Aboriginal music, African-inspired masks, jazz and so on. The crucial point here is that, as in the *art nègre* craze in Paris of the 1920s, *Dadaists conceived all of these as essentially the same thing.*

CHRIS: They collapsed difference into sameness, in order to construct a racial and cultural Other.

GLENN: Precisely. The point I wish to make is that this sort of strategy has deadly serious effects. For example, in their attraction to 'Black' music, ceremonies and visual arts, Dadaists and other modern West-

ern avant-garde movements have virtually disallowed the poss-
ibility that Black people just might belong to the modern world.

In this context, I want to mention a case, which I regard as tell-
ing . . .

At the same time that Dada was flourishing in New York, so was
the Harlem Renaissance. That is, just across town there was an
unprecedented flowering of expression by Black American artists
(writers, musicians, painters, dancers, etc.) and intellectuals. But
Dada somehow missed them – despite being in the same city –
preferring to associate with the (mythic) NEGRO-IN-THE-BUSH.

As I said, this is a very slippery slope. And the Dadaists are not the
only avant-garde movement to ride down it.

CHRIS: You mentioned something in passing a minute or so ago that I
want to come back to. It concerns Paris in the first half of the twen-
tieth century and the business about *art nègre*.

As you know, I've just been reading about Josephine Baker in Paris
in the 1920s. Now, she made a lot of money masquerading as a
PRIMITIVE – with her pet leopard and shimmering buttocks. It is
interesting that at the same time in Paris jazz and 'primitive art' were
all the rage.

GLENN: Yes, in terms of the cultural politics of race, there is a deeply
rooted FRENCH PREFERENCE FOR PRIMITIVISM – which is, I want to em-
phasize, both racist and anti-racist at the same time. This point – that
primitivism is a double-edged sword – is what I was trying to say
about Dada

A VOICE: If these are the radicals and the anti-racists, God help us when
we encounter the liberals and the real racists

Dialogue no. 3: White Art

A VOICE: There is nothing more White than museums and galleries of mod-
ern art.

ANOTHER VOICE: You are wrong, my Black friend. We are there in every work
of Western modern art. It is just that ours is a history about which there have
been so many lies

Where are African, Caribbean and Asian cultures represented in the
'High Art' institutions of the West?

They are not to be found in the art galleries, not in the academies but in
the anthropological and historical museums. Not part of the living tradi-
tions of the modern world, they are represented as part of the non-

modern, 'primitive' world, the world of The Other. Above all, they are displayed through and defined by The Western Gaze – through the distorting lens of Eurocentrism.

It would appear to be the case that: *Europe is no longer White, but its dominant institutions of 'High Culture' – Art, Education, Literature . . . – are.* Actually, the situation is somewhat more complex than that.

Hardly anyone is still prepared to claim that the cultures of the non-White world have not profoundly influenced the West. THE USUAL VIEW – found, for example, in the press and in cultural studies textbooks since the 1970s – is that 'Black' culture is now at the centre of Western European and American popular youth culture and subcultures. That is, nearly everyone will concede that popular music, dance, language, style and sport have been profoundly influenced by the *Black presence*. In general, to participate in popular culture in the West is to participate, knowingly or unknowingly, to some degree or another, in 'the Black experience'.

We agree. But OUR ARGUMENT goes further, and makes a much more radical claim. We suggest, based on evidence such as that presented in chapters 10 and 12, that cross-fertilization between 'White' and 'Black' cultures is not simply a phenomenon that has occurred in the domain of the popular culture. It is also a phenomenon of modern Western 'High Culture' – painting, sculpture, 'classical music', and so on. As our discussion of primitivism has revealed, the Other is right at the heart of Western enterprise, including 'elite' or 'High' culture. That is to say, in terms of its cultural ideas and practices, *twentieth-century Western art is not 'White' but, to borrow a phrase, 'Mixed-Race'.*

However, none of this is to say that the 'White' and 'Black' parts of modern Western art are equal partners – in terms of acknowledgement, recognition and control. Listen:

> In borrowing or appropriating visual ideas which they found in the class of foreign objects that came to be labelled 'primitive art', and by articulating their own fantasies about the meaning of the objects and about the peoples who created them, artists [i.e., White Western artists] have been party to THE ERASURE OF THE SELF-REPRESENTATIONS of colonized peoples in favour of a western representation of their realities. (Hiller, 1991a, p. 2; emphasis added)

Dialogue no. 4: Where Art History Lies

To a large extent, this History has been a construction Made in the West, *one that has excluded, diminished, decontextualized or dismissed as*

bantustan a good part of the aesthetic-symbolic production of the rest of the world.
— Gerardo Mosquera, 'Modernidad y Africania', 1992, p. 48

There is a danger of reducing the history of 'primitivism' and modern art to a narrative of 'discoveries' and 'creations' by Great (White Male) Artists. To avoid such a distortion, and in order to raise certain political and theoretical points, most of the remaining discussion in this chapter is from the perspective of A POLITICAL GENEALOGY OF 'PRIMITIVISM'. That is, we locate Modern Art within a history of silences, marginalizations and exclusions, of domination, exploitation and brutality.

We begin with Art History, exploring issues of how modern Western art and its Other is represented in official discourse.

QUESTION: How do art historians proceed? What is the primary focus of their work?

ANSWER: 'It is not difficult to see that art historians take, as their main subject of enquiry, the life and works of certain individuals and the historical unfolding of distinct artistic movements. As with the history of music, of literature or of theatre, the history of art is seen as a mosaic of contributions made by individuals whose names we, know, whose works can be distinguished, and whose personal lives and the way they related to their age are worthy of our attention.' (Price, 1989a, p. 65)

QUESTION: Works of art, individual creators, artistic movements – a study of history based on historical chronology and individual creativity. Surely, this is not maximally informative, certainly not from the perspective of cultural politics?

ANSWER: But it *can* be very informative. The point is to study the marginalisations and omissions, the contradictions and silences.

QUESTION: For example?

ANSWER: I said a few moments ago that mainstream Art History focuses on the lives and works of individual artists and on historical chronology. 'There is, however, one single exception to this definition of the study of art. In this predominant Western conception, a work of art originating outside the "world traditions" is considered to be the product of a nameless person who is representative of his [or her] whole community and who unreflectively obeys the precepts of a time-honoured tradition.' (Price, 1989a, p. 65)

QUESTION: Do I understand you correctly? You are saying that in mainstream art history non-Western artists (the so-called 'Primitives') have a status exactly opposite that of Western artists? That in a field of study where there is a cult of the individual (The Artist), they remain nameless? That in a discipline where art is seen as individual creative expression, theirs is seen as the unreflective product of 'tradition'? That in a field where there is an obsession with dates and chronology, they and their cultures exist outside of history?

ANSWER: Yes – but this requires some explanation.

Dialogue no. 5: Art without Signature

Whatever its origins, ANONYMITY *plays an important role in the Western image of* 'PRIMITIVE ART'. *A Parisian art dealer with whom I have discussed this phenomenon summed it up neatly: 'If the artist isn't anonymous, then the art isn't primitive.'*
— Sally Price, 'Others' Art – Our Art', 1989, p. 67 (emphasis added)

Visit the art galleries and museums of the great metropolises of Europe and North America. There you will find works by the Great Masters – Michelangelo, Rubens, Monet, Picasso, Klee, Kandinsky, Pollock. . . . Visit the great museums of ethnography and 'primitive art'. There you will find Yoruba sculpture, Melanesian woodwork, Aboriginal bark painting, Eskimo totem poles, Fang masks, American Indian pottery. . . .
 We see works of art produced in the West as the products of individual creativity. On the other hand, although we are 'the product of a society which attaches great importance to names, to fame and to individual actions', when we modern Westerners see 'a collection of masks or other works of art from an exotic culture', we do 'not tend to think of an individualized human creator behind each object' (Bill Holm, quoted in Price, 1989a, p. 69). We see artworks made outside the West as IDENTITY-LESS, the products of cultures and 'traditions'. Or rather the identities they have – for us – are the identities they gain by virtue of their imprisonment in Western museums and galleries.

> TRUTH: 'The indigenous artists of the North-West coast have, like the "primitive artists" of other cultures, been RENDERED ANONYMOUS in our time.'
> — Bill Holm, quoted in Price 1989, p. 69 (emphasis added)

> TRUTH: 'In constructing itself as ideology art will always tend to control, as far as possible, the image of that it defines itself in opposition to.'
> — Daniel Miller, 'Primitive Art and the Necessity of Primitivism to Art', 1991, p. 60

It is a rare occasion when the labels we read help us to see personal characteristics in THE FACELESS ARTISTS. Sometimes an object is identified as coming from 'British Columbia', 'Benin', 'Easter Island' or 'the North-West coast'. At best a 'tribal' or 'ethnic' identification is suggested. In the case of non-Western art it is no wonder that:

> The idea that each object represents the creative activity of a specific human being, who lived and worked at a given place and time, whose artistic career had a beginning, a middle and an end, and whose work influenced and was influenced by the work of other artists, does not readily spring to mind. (Bill Holm, quoted in Price, 1989a, p. 69)

When proper names do appear in descriptions of non-Western art objects, they take the form of: 'From the collection of Paul Guillaume' or 'Collected by Colonel Dodds in the holy city of Kana in 1894' (at the end of the long and bloody French campaign to defeat the West African kingdom of Abomey).

A VOICE: These are not our names but the names of those who stole our culture.

'This replacement of a foreign passport by a domestic identity-card' – this DE-AUTHOR-IZING and RENAMING – has certain crucial effects. First, it 'serves to facilitate the introduction of the object into a system which centres around Western aesthetics and large sums of money'. Secondly, and more important for our purposes, 'When we erase the object's "signature" so that it might have a Western "pedigree", we transfer the responsibility of artistic paternity' (Price 1989a, p. 69). The Great White Men win again . . .

We concede that we usually do not know the names of the non-Western artists whose work we in the West have appropriated. But *why* do we not know their names? And why do we fail to look for signs of individual creativity? It is not always because the relevant information has not been available.

TRUTH: 'Individual hands are recognisable in Igbo sculpture, as in African art in general, and the artists have been, and continue to be, well-known in the areas in which they live.'
— Herbert Cole and Chike Aniakor, quoted in Price 1989a, p. 69

Now, some recent art history seeks to reverse this nonsense. That is, there is a small but increasing number of art historians who pay specific attention to individual biographies, creativity, stylistic variation and historical processes in 'primitive' and 'tribal' art and society.[1] But such work is definitely a minority tendency.

TWO REMINDERS: 1. 'If the artist isn't anonymous, then the art isn't primitive.'
2. If the source has a proper name, then the art is ours.
ANOTHER VOICE: We must make their individuality invisible, so as to exclude them from history.

Dialogue no. 6: Time and The Other

We are afraid to conceive of the Other *in the time of our own thought.*
— Michel Foucault, *The Archaeology of Knowledge*, 1972, p. 12

THE MODERATOR: We are grateful to our sponsors for funding this session. And we would like to extend a warm welcome to all of you in the audience. Our guests include: Sally Price, an American anthropologist and art historian; Susan Hiller, a British artist and theorist who also trained as an anthropologist; Rasheed Araeen, a London-based artist and Founding Editor of *Third Text*; James Clifford, an American cultural historian and leading figure in the new cultural anthropology; and Hal Foster, an American art critic and cultural theorist. Our topic, as you know, is 'Time and the Other'. We borrowed that title from Johannes Fabian's book.

Members of the audience have submitted questions in advance. I would like to turn to the first one now.

QUESTION: There are, obviously, different varieties of primitivism. However, underlying all of them there would seem to be the idea that there are societies existing today that have something we modern Westerners have lost. Isn't this an idea that is fraught with difficulties? Susan Hiller, as you have recently edited a book entitled *The Myth of Primitivism*, this question is initially addressed to you.

SUSAN HILLER: 'The concept of the "primitive" in European thought begins with an interest in discovering the origins of human society; this leads to proposals of evolutionary models of social development which position the west as the most advanced instance. To conform to this model, distant societies whose pasts are as long as our own are imagined to be unevolved, static, natural (organic), and simple. By making the assumption that the cultures of peoples designated "primitive", "marginal", or "underdeveloped" are virtually changeless, it becomes possible to see them as typical of what has been lost or superceded by "us" in our supposedly more rapid evolution at the centre. Societies geographically distant from Europe (located at the centre of its own myth) come to be seen as temporally distant, that is, typical of earlier stages in human development. In this way, *the far-away is transformed into the long-ago*' (Hiller, 1991c, p. 87).

THE PRIMITIVIST FANTASY: THE FAR-AWAY = THE LONG AGO

MODERATOR: Doesn't this view of Other cultures and societies have the effect of removing them from history, of turning them into what Eric Wolf calls *people without history*? Take that famous (or infamous) exhibition of 'primitive' and 'modern' art that was held at New York's Museum of Modern Art in 1984. One of the peculiar features of the exhibition was that none of the 'primitive' objects had dates on them, even when the dates were well known. What do you make of this problem of objects without dates, of peoples without histories?

JAMES CLIFFORD: 'Nothing on West Fifty-third Street [i.e., at the Museum of Modern Art] suggested that good tribal art is being produced today. The non-Western artifacts on display were located in a vague past . . . or in a purely conceptual space defined by "primitive" qualities: magic, ritualism, closeness to nature, mythic or cosmological aims. . . . In this relegation of the tribal or primitive to either a vanishing or an ahistorical, conceptual present, modernist appreciation reproduces common ethnographic categories' (Clifford, 1984c, pp. 201–2).

SALLY PRICE: I think that what really interests most of us here, on the panel and in the audience alike, is 'the proprietal roles that Westerners have bestowed upon themselves when it comes to others' art' (Price 1989a, p. 65). We have begun at what may seem to be an unlikely place – with a problem of Time. But I think issues of time and 'ownership' are crucially interconnected when it comes to primitivism.

HAL FOSTER: I wholeheartedly agree. 'Neither "dead" like the archaic nor "historical", the primitive is cast into a nebulous past and/or into an idealist realm of "primitive" essences. Thus the tribal objects, not dated in the Museum of Modern Art show, are still not entirely free of the old evolutionist association with primal or ancient artefacts (a confusion entertained by the moderns). In this way, the primitive/tribal is set adrift from specific referents and coordinates – which then makes it possible to define it in wholly Western terms' (Foster, 1985, p. 187).

A MODERNIST VOICE: Creative change is our essential quality, stasis is yours.

RASHEED ARAEEN: 'I do not question the necessity of recognising the importance of all cultural traditions, old and new, but I do worry when other cultures are reduced to stereotypical functions (myth and magic) and are prevented from entering and *critically* functioning within modern discourses. Is there any function for other cultures in Europe (or in the modern world, for that matter) beyond offering exotic entertainments?' (Araeen, 1991, p. 21).

A VOICE: Who are we?
AN-OTHER: We are those who have been banished from history and modernity.

MODERATOR: As I have been listening to the discussion today, I could not help recalling those rather unfortunate passages on the 'Oriental society' in Hegel and the 'Oriental Mode of Production' in Marx. The *myth of unchanging essences* seems to be alive and well, even among people who should definitely know better . . .

I should like now to shift the focus of the discussion slightly – to consider issues of how Western primitivist notions of Time and the Other affect our view of non-Western *artists*. Here is our next question from the audience.

QUESTION: What we are talking about is that curious, ideological notion that the societies of Others are incapable of historical movement – of change, progress, etc. – without the intervention of the West or, in the case of art, the Western Artist. In an article published in 1989 in *Third Text* Sally Price referred to this as a situation in which 'primitive' or 'tribal' artists are viewed as *'passive servants of time-honoured traditions'*. That is, they are viewed as people who produce art without reflection, creativity or innovation. They are slaves to tradition. Perhaps you could comment on this.

SALLY PRICE: 'This image of "primitive" artists as a mixture of people lacking both identity and artistic individuality, as passive servants of their time-honoured traditions, is derived from the use of "primitive" societies for legitimizing Western society . . .

COMMENT FROM THE FLOOR: Aren't we talking about racism here? These primitivists all sound like racists to me.

SALLY PRICE (continues): 'To characterize this use as "racist" or "patronizing" is probably an over-simplification, but we can quite categorically state that anonymity (and its corollary, the absence of historical development) attributed to "primitive art" owes much to the desire on the part of the commentators to believe their society is clearly superior to others, that their society represents a higher level in the unilinear evolution of civilization' (Price 1989a, pp. 67–8).

MODERATOR: Here is René Huyghe, member of the *Academie française*, offering his learned opinion on African and Oceanic art:

> There is no room for individual expression in art of this kind. Forms can be reduced to their primary geometric state, because they are governed by a psychological law, which is itself the reflection of the universal biological principle of the conservation of energy. Straight lines involve the least expenditure of energy, and the easiest way to remember any given feature of the real world is to reduce it to geometric shapes, which are basic and universal. African and Oceanic art is geometric because its creators are instinctively imitating the ways of nature. It is not in *any* way the result of sophisticated and concerted research, as modern Western art is, but of an innate way of looking at the world. (Quoted in Price, 1989a, p. 68)

QUESTION: When was this written? 1850? 1870? 1890? Surely, such statements of flagrant racism must belong to the nineteenth century, to the century when racism – including scientific racism – was at its height . . .

MODERATOR: In fact it was written in the 1970s. But my reason for quoting this passage is not to emphasize the fact that racist ideologues are still around: we should all know that. Rather, my point is to raise an issue about primitivism.

Obviously statements as absurd as that from Huyghe would never be voiced, or even thought, by most people who subscribe to a primitivist philosophy or artistic practice. But it seems to me, and to some members of our audience, that there is at least a little of this sort of viewpoint in some of the basic assumptions that underlie primitivism.

SALLY PRICE: 'For those who, like Huyghe think that African and Oceanic art is created by *anonymous* artists who are expressing *communal* thoughts by means of *instinctive* processes that take place in the *lower part of the brain*, it only requires one further step to arrive at the belief that this art has no history' (Price, 1989a, p. 68).

MODERATOR: This is a belief with which some people here are all too familiar.

A PANEL MEMBER: Amen to that!

A VOICE: Who are we?

AN-OTHER: We are the ones who have neither individuality nor creativity. We are those who do not require brains.

Dialogue no. 7: The View from the Modernist Summit

Art stands above social and economic realities of the time! It transcends racial barriers and conflicts and is really enlightened, with universal human values. Really!

— Rasheed Araeen, *Making Myself Visible*, 1984

We would like to invite an old friend, who is no longer flavour of the month, to join our dialogues. Our friend's name is Karl. We have asked him to read a passage from the *Grundrisse*, which he wrote some time ago (in the 1850s, to be precise).

KARL MARX: 'Bourgeois [i.e., capitalist] society is the most developed and the most complex historic organisation of production. The categories which express its relation, the comprehension of its structure, thereby allows insights into the structure and relations of production of all the vanished social formations out of whose ruins and elements it built itself up, whose partly

still unconquered remnants are carried along with it, whose mere nuances have developed explicit significance within it, etc. Human anatomy contains the key to the anatomy of the ape. The intimations of higher development among the subordinate species, however, can be understood only after the higher development is already known.' (Marx, 1973, p. 105)

Did you read it carefully? This is an important passage – one which, as it turns out, echoes precisely the relation between modern Western art and the art of the Others. Let me explain.

Marx argues: (1) that modern capitalist society is the most highly developed society in human history; (2) that it has been dialectically built up out of all the previous economic/social formations; and (3) that, therefore, the structure, trajectory and significance of all previous history can only be seen from this vantage point – from the perspective of modern capitalist (Western) society.[2]

Now, it is *precisely* this sort of argument that mainstream art history and criticism makes regarding the Modernist/Primitive encounter. The first point to note is this: as our Hegelian friend Karl assumed a singular, universal world history into which all the different societies since the genus Australopithecus can be placed, mainstream art history assumes a SINGULAR, UNIVERSAL ART HISTORY – 'of course, determined and realised by the West' (Araeen, 1987, p. 15).

A second crucial assumption made by mainstream art history is this: HISTORY proceeds by FORMAL INNOVATIONS and 'DISCOVERIES' (like Columbus 'discovered' America . . .) – all of them done by HIMSELF, the Modern (White Male) Artist. Creativity, innovation, agency – these all lie with modern Western artists. Now, this is dangerous ground: the second assumption, if not also the first, is a terribly Eurocentric, if not outright racist, notion. William Rubin and other mainstream theorists of the relation between 'modern' and 'primitive' art do not explicitly state these assumptions in such transparent language, but they are, without question, the logic of their position.

> THE SCEPTIC: What is going on here? You seem to be suggesting that our modern, twentieth-century liberal friends have become nineteenth-century evolutionists?
>
> THE AUTHORS: Not quite, but nearly. Our view here echoes that of Hal Foster . . .
>
> THE SCEPTIC: And what is *his* view?
>
> HAL FOSTER: 'That the modern work can reveal properties in the tribal is not necessarily evolutionist, but it does tend to pose the two as different stages and thus to encompass the tribal [sic] within our privileged historical consciousness' (Foster, 1985, p. 186).
>
> THE SCEPTIC: Surely the argument you are making is wrong . . .

THE MODERATOR: I see John Roberts, the art and cultural critic, in the audience. Perhaps you could come up and join us. I know that you have on occasion expressed some views on the vexed question we are currently considering.

JOHN ROBERTS: Yes, I have sought to analyse this issue, particularly with regard to how the art and cultures of the East have been understood and assimilated in the West. I suppose the main point I would like to make is this: 'if the history of Western art and culture from the early nineteenth century onwards has been a history of shifting identifications with, and disavowals of, the cultures of the East, it has also been a history of absences and silences insofar as the art of the East has had no value or identity until it has been "understood", mediated, trans-formed and circulated by the West' (Roberts, 1990a, p. 184).

THE MODERATOR: This is a strong statement – that it is Western culture, presumably the art establishment in particular, which has deter-mined the meaning, identity and value of art from the non-Western world; that we are the GATE-KEEPERS, the assessors of value and worth.

JOHN ROBERTS: 'Modernism's assimilation of the "primitive" from Gauguin to Abstract Expressionism certainly acknowledged the re-ality of cultural difference. But because of the nature of the process of assimilation – the idealised projection of non-Western cultures as free of the corruption of bourgeois rationalism – HEGEL'S HYPOSTA-TISATION of non-Western art as essentially undifferentiated in charac-ter was reproduced in a new form: the FETISHISATION OF THE EXOTIC AS OTHER. Moreover, assimilated to the imperialist ambitions of power-ful and emergent Western fine-art institutions such as the Museum of Modern Art, New York, the appropriated cultural materials were subordinated to the universally defining powers of Western pro-gress' (Roberts, 1990a, p. 184).

MODERATOR: Assuming this argument is correct, what is the effect of this absorption?

HAL FOSTER: 'This absorption allows the primitive to be read retro-actively almost as an effect of the modern tradition' (Foster, 1985, p. 192).

MODERATOR: Like Marx reads the anatomy of the ape retrospectively from the perspective of human anatomy? That is to say, like he reads the structure of previous modes of production from the perspective of the capitalist mode?

THE AUTHORS: Exactly!

HAL FOSTER: Modern Western art recoups The Other dialectically – 'as a moment in its own history' – and thus 'transforms the trans-gressive into continuity' (Foster, 1985, p. 191).

A VOICE: Not only have I been stolen by you, you have so transformed

me as to render me weak, harmless and totally assimilable to your project. Placed in the glass cages of your museums, I have been emasculated . . .

RASHEED ARAEEN: 'What is interesting is that within this concept of history there are peoples who are considered to be incapable of any *modern* progress by themselves, and this incapability is often attributed to racial differences' (Araeen, 1987, p. 15).

SALLY PRICE: 'According to the people that take this view, the Western connoisseur does for African masks (to take one example) what Marcel Duchamp did for urinals' (Price, 1989a, p. 70).

MODERATOR: What?

SALLY PRICE: By signing them and naming them 'ART', he allows them to enter (his) history.

RASHEED ARAEEN: 'The "primitive" can now be put on a pedestal of history (Modernism) and admired for what is missing in Western culture, as long as the "primitive" does not attempt to become an active subject to define or change the course of (modern) history' (Araeen, 1987, p. 8).

THE SCEPTIC: Just a minute. I've been wanting to raise this question for a long time: Are you all claiming that all those Western artists who have drawn upon 'primitive' iconography, styles and philosophy are RACISTS?

THE AUTHORS: That is a crude, reductionist, psychologistic rendering of the arguments we and others have been making.

JOHN ROBERTS: The argument is nothing to do with the racism of individuals. It is to do with power, institutions and ideology. 'In short, irrespective of how artists actually saw themselves utilising non-European sources, imperialism determined how such cultural relations would be used, what scale of values would be attached to such appropriations against their cultures of origin' (Roberts, 1990a, p. 184).

> So what do we behold here: a universality of form or an other rendered in our own image, an affinity with our own Imaginary primitive?
> — Hal Foster, 1985, p. 186

A GATE-KEEPER: As God made man in His own image, so we make the primitive in Ours.

On Visiting 'Primitivism in 20th Century Art': An Exhibition at the Museum of Modern Art in New York

I came out of the Museum with a mixed feeling of exhilaration (just seeing all those works together) and some anger. I talked to some people about this later, including some black artists, and the general feeling was lack of interest and cynicism. Some

*shrugged their shoulders, saying what else would one expect from MOMA, and
others denounced the whole thing as another imperialist enterprise, with which I
somehow agreed.*

 *Back in London, and going through the texts in the massive glossy catalogue of
about 700 pages, the denunciation of the exhibition as an imperialist enterprise . . .
became more clear. It is not that there were no informative or interesting texts, but
it seems that the purpose underlying all this scholarship was to perpetuate further
the idea of Primitivism, to remind the so-called 'primitives' how the West admires
(and protects and gives value to) their cultures and at the same time tell the modern
artist, who could only be a Western artist, the importance of this in his (masculine
gender here is deliberately used to emphasise the (white) male domination of mod-
ernist discourse) continuing role as an advancing force.*
 — Rasheed Araeen, 'From Primitivism to Ethnic Arts', 1987, p. 11

HAL FOSTER: 'However progressive once, this election to *our* humanity
 is now thoroughly ideological, for if evolutionism subordinated the
 primitive to western history, affinity-ism recoups it under the sign of
 western universality. . . . In this recognition, difference is discovered
 only to be fetishistically disallowed, and in the celebration of
 "human creativity" the dissolution of specific cultures is carried out:
 the Museum of Modern Art played host to the Musée de l'Homme
 indeed' (Foster, 1985, pp. 188–9).

Dialogue no. 8: The (White) Western Artist as Hero

QUESTION: What is the effect of such a history – of this 'universal' history that
 we have been discussing?
ANSWER: That all agency, intellect, artistic understanding and innovation lies
 with HIM.

In a statement that is now well-known, Pablo Picasso, the greatest of
twentieth-century Western artists, said that for him *African sculpture
'served more as witnesses than models'* – that is, rather than directly inspiring
his early artistic innovations, they served more to encourage and rein-
force what he had already begun to do. (It should be noted that Picasso
chose his words carefully. He does not say that the particular pieces of
African sculpture were never directly appropriated by him, but that this
was not the main way in which he was influenced.) This may well be a
historically accurate statement: Picasso was, it is a fact, more interested in
the underlying principles of African sculpture than in the particular
details of this or that piece; and it may be the case – the chronology is
unclear – that he had made his break with realist forms of repre-

sentations before he encountered 'primitive' art in the Paris ethnological museum.

The point we wish to make is that, given the ideology of modernism, he – the Western modernist artist – could never concede more than this. There is no space, within modernism, from which he – or rather HE, the ARTIST-AS-HERO – can concede more. The modernist truth is this: Agency always lies with us, never with the Other. Picasso, for example, never suggested that the 'primitive' artùist might actually think in formal/artistic terms. Rather, it was HE (Picasso) who, having examined the work of the Other, logically deduced the principles involved therein.

A VOICE: *Our* cultural achievements become *their* discoveries . . .

GENESIS 1. And out of the dust of the earth God made Man in his own image. And He blew into his nostrils and Man became a living soul.

GENESIS 2. And out of the dust of the ethnographic museum White Man claimed the works of Others. And He gave them the breath of life and they became Art – Primitive Art in the Modernist image.

Dialogue no. 9: Trophies for a Song

The early sea voyagers brought back only a few objects. Objects began to arrive in large quantities only when Europe embarked on its colonial expansion, and at that time they served as evidence of conquest. Displayed in museums, Expositions Universelles, and private collections, they demonstrated the lives and customs of the natives. They pointed to the existence of another world.

— Philippe Peltier, 'From Oceania', 1984, p. 115

Plate 11.1 or photographs similar to it *should be included in all books on the history of modern Western art*. The photograph is of objects from New Guinea about to be taken off to Europe.

AN OBSERVER: We see that 'the natives' are doing the work, while their master observes and directs. We have seen this pattern repeated in too many places.

The official story of modern art is a story of INNOVATION. The story we wish to tell here is a story of APPROPRIATION.

Now, as we indicated before, Western modern art is the product of contributions from peoples of many nations and cultures. Some statements providing brief details of this assistance (for which all contemporary artists should be extremely thankful), are provided below. We recommend that you read them with care.

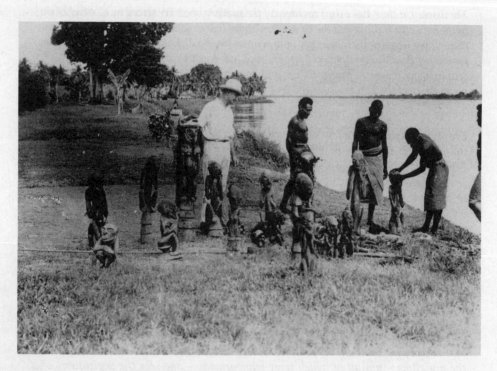

Plate 11.1 Objects from New Guinea about to be Taken Off to Europe, photographed
during the La Korrigane expedition, 1934–6, in New Guinea. Field photograph
by van den Broeck.
Collection photothèque du Musée de l'Homme, Paris.

Some Contributions to the Development of Modern Western
Art and Culture

From the Germans: *'Although Bismarck's Germany had been engaged in a policy
of colonial expansion for only two years, the Berlin Museum für Völkerkunde
[Ethnological Museum] housed almost ten thousand African objects when it was
opened to the public in 1886. The collections were based primarily on specimens
gathered on exploration expeditions led by such great German travellers as Barth to
the central Sudan (1850–55), Rohlfs between Tripoli and the Guinea Coast (1867),
and Schweinfurth in the Nile regions on the banks of the Uele (1868–71). Under the
firm direction of Adolf Bastian, the collections were later to be enriched by addi-
tional contributions'*

— Paudrat, 1984, pp. 133–4

From the French: *'The long and murderous campaign fought by France in Daho-
mey after 1877 to subjugate the kingdom of Abomey ended on January 25, 1894,
with the capitulation of its ruler. Behanzin's surrender marked for one part of the
French press the victory of faith, for the other of reason, over "degrading fetishism".*

The display at the Musée du Trocadero of the symbols of power seized by Colonel Dodds in the holy city of Kana and the palace of Abomey was in some way proof of the civilizing action over heresies that were not only religious but political as well: the royal throne, four relief doors with symbolic motifs, three allegorical statues said to be the repre-sentations of the ancestor, the father, and the king himself, to which were later added a metal effigy of the Fon thunder god and two monumental thrones'

— Paudrat, 1984, pp. 130–1

From the British: *'A few weeks after the pillage carried out by the British in the palace of the ruler of Benin (at the time of the punitive expedition sent in February 1897 to avenge the massacre of almost all the members of an apparently peaceful mission deemed unwelcome by the Oba's advisors), the official loot – close to one thousand bronze plaques that had originally adorned the wooden pillars of the palace – was put on sale in London by the Foreign Office. In addition, a large part of the spoils of war appropriated individually by soldiers in the expeditionary corps was soon put into circulation by enterprising dealers. For those who were its enthusiastic commentators and avid purchasers, however, this numerically consid-erable ensemble represented something other than a collection of curiosities. The technical mastery of rare, precious, or durable materials, along with the talent of craftsmen skilled in giving realistic material form to the legitimation of the royal powers, was recognized, not without amazement, as a sign of the incontestable presence of a great art in Africa. As proof, there are the numerous scholarly writings that already by 1900 offer a partial description of it At the same time, among the museums – not all of which were ethnographic – one sees the beginnings of a certain competition to obtain the most characteristic examples of this highly de-veloped court art.'*

— Paudrat, 1984, pp. 133 and 136

'PRIMITIVE ART' = TROPHIES OF COLONIAL EXPROPRIATION

A REMINDER: We must never forget 'the real affiliations (affinities?) between science and conquest, enlightenment and eradication, primitivist art and imperialist power.'

— Hal Foster, 1985, p. 197

A REASONABLE QUESTION: 'Why has it seemed obvious until recently that non-Western objects should be preserved in European museums, even when this means that no fine specimens are visible in their country of origin?'

— James Clifford, 1988d, p. 221

Colonialism, as reinvented by the White (that is to say, civilized) West, was extremely beneficial for the development of modernism. What would twentieth-century art be if it were not for that enlightened, benevolent regime of White power beneath whose heel the dark-skinned peoples of the world were subordinated?

TRUTH: '[L]et us remember that our National Museum of Modern Art, Tate

Gallery, bears the name of a benefactor whose wealth came from the sugar plantations of the West Indies.'
— Lynda Checketts 'British Art in a Century of Immigration',
1991, p. 10

What would twentieth century art be if it were not for the European and Euro-American settlers, soldiers, merchants, colonial officials, missionaries and anthropologists who stole – or 'purchased' for a song – the art, artefacts and sacred objects of people of Colour all over the world, who put the 'primitive' and 'tribal' cultures of the world on display in the museums of the great Western metropolises?

TRUTH: Behind the modernist revolution in art stand colonizers – murderers and thieves – with guns and trinkets.

Actually, it is not simply art objects – together with 'Third World' labour, resources and wealth – that have been appropriated by the West. Rather, there has been A DOUBLE APPROPRIATION. Western modern art is also a COLONIZATION OF THE OTHER'S SUBJECTIVITY AND MEANINGS.

A VOICE: While modern art got its first impetus through discovering the forms of primitive art, we feel that its true significance lies not merely in their formal arrangement, but in the spiritual meaning underlying all archaic works.
— Adolph Gottlieb, American abstract expressionist painter,
quoted in Varnedoe, 1984b, p. 616

Kenneth Coutts-Smith argues that Modern Art may be fruitfully viewed as 'an attempt to appropriate the whole twilight territory of the mind' of The Other – the preserves of psychology, psychiatry and anthropology. The terrain of the Other's unconscious and thoughts, the foreign lands of dreams and fantasies, the territories of superstition and magic, the domains of myth and folklore (Coutts-Smith, 1991, p. 24) – these phenomena, 'once located conceptually at the very margins of our known world, have been colonized, too'. '[A]s part of the process of European expansion', they have been 'absorbed into art, and brought inside the extended body of western culture for digestion' (Hiller, 1991b, p. 12).

This particular form of 'cultural colonisation' (Coutts-Smith, 1991) is, as we have seen, very apparent in the case of Surrealism. It is also a feature of some post-modernist artistic practices . . .

'What is singular about Western civilisation is its grotesque ambition to supersede every other culture or civilisation in its schizophrenic desire to expand, dominate, control and rule everything on earth' (Araeen, 1987, p. 15). IS MODERN ART NOT PART OF THIS IMPULSE? Surely, it is – certainly, from the point of view of a radical cultural politics.[3] Moreover, certainly

as far as museums and galleries go, the process continues (despite a certain amount of rhetoric to the contrary).

Dialogue no. 10: Masking Brutality and Theft

A VOICE: As Malcolm X used to say, walking into someone else's house and announcing, 'I discovered you!' is rather odd

As we have said, Modern Art in the West has been a major beneficiary of colonial brutality and exploitation. Allow us to put it bluntly: like the gold fillings extracted from Jewish victims on their way to the gas chambers, 'primitive art' and 'primitive minds' are trophies of conquest and theft. In the closets of modernism, especially primitivist modernism, are stacked the dead bones of peoples and cultures trampled underfoot by White Power.

TRUTH: This history is hidden in the official story of Modernism.

It is worth noting that it is precisely this genealogy – this hidden history of brutality, exploitation and racism – that the exhibition of *'Primitivism' in 20th Century Art* at the Museum of Modern Art in New York 'did not (could not?) attempt'. In the MOMA exhibition and catalogue, the issue of colonialism is barely raised at all. *And when it is raised, it is 'raised in colonialist terms, as a question of the accessibility of certain tribal objects in the west'* (Foster, 1985, p. 200; emphasis added). This sort of OMISSION and REPOSITIONING is common in mainstream histories of Modern Art.

The OFFICIAL STORY of primitivism is, as we have said, a story of the (White) Western artist as hero – a story of stylistic innovations based on internal creativity and external 'influences'. The ideological portrayal of primitivism in art history and criticism hides at least as much as it reveals. Listen to Hal Foster as he speaks the truth:

> Primitivism, then, not only ABSORBS THE POTENTIAL DISRUPTION of the tribal objects into western forms, ideas and commodities; it also SYMPTOMATICALLY MANAGES THE IDEOLOGICAL NIGHTMARE of a great art inspired by spoils. More, as an artistic coup founded on military conquest, primitivism CAMOU-FLAGES this historical event, DISGUISES the problem of imperialism in terms of art, affinity, dialogue, to the point (the point of the MOMA show) where the problem appears 'resolved'. (Foster, 1985, p. 199; emphasis added)

We should be honest. The hands of the West drip with the blood of Others. And we have been the beneficiaries.

Dialogue no. 11: Identifications and Awakenings

*Since meaning is defined through oppositions, dominant groups may often be
found not only to construct material representations of their own interests,
but also to project models of those which they define themselves in opposi-
tion to.*
— Daniel Miller, 'Primitive Art and the Necessity of
Primitivism to Art', 1991, p. 58

*Must the White Man's way of seeing remain the point of reference for ever
more, or will other ways of seeing be allowed?*
— Louis Perrois, 'Through the Eyes of the White Man', 1989, p. 51

QUESTION: Mr Brett, we simply could not pass up the opportunity to
converse with a radical, anti-racist member of the art establishment.
We would like to talk with you about 'primitivism' in modern West-
ern art. Given all the years you have worked as an art critic, writer
and curator, surely you have had opportunity to reflect on this issue.
So, what is your position on 'primitivism' in modern art? Do you
positively identify with it?

GUY BRETT: 'Having identified so strongly with the formation of mod-
ern art in this century, and the ongoing exploration of the avant-
garde, I have also identified with the "myth of primitivism": the two
are clearly connected at many points. I mean this identification not
only in terms of my continuing fascination with all those forms
which were once considered outside the canons of art, or beneath
notice, and which have influenced many twentieth century artists:
the masks, carvings, and other artefacts of "tribal" societies, prehis-
toric cave paintings, archaic art, popular, folk and peasant art, the
painting of children [and] psychotics, naive art, toys, graffiti, and so
on. As Robert Goldwater points out in his book *Primitivism in Mod-
ern Art*, the contact with "ethnographic arts" (and by implication
also with the other arts above) is only one occasion for the expression
of a "primitivist impulse" in modern art which is deep and wide-
spread.'

QUESTION: What, then, is the nature of this 'impulse'?

GUY BRETT: 'I saw it as a great and productive paradox: of looking
"back" in order to go forward, of an idea of the original, the primary,
the ancestral perhaps (though none of these words is quite right), as
a springboard for the modern and the radical' (Brett, 1991, p. 113).

QUESTION: It is reasonably clear why European artists in the late nine-
teenth century and early twentieth century were so fascinated by the
'Primitive' Other. But what is the continuing attraction? Why a

hundred years later are Western artists and intellectuals still driven by this 'impulse' of which you speak?

GUY BRETT: 'There were many ideological strands and deeply attractive ideas caught up in this, among them the desire to escape the restrictions of one's inherited and localized world-view, of ethnocentrism; to challenge official academic culture and bourgeois values; to look critically at spiritual needs in a corporate, technological civilization; to seek a kind of psychological renewal in the primary energies of materials, colours, forms, and so on' (ibid., pp. 113–14).

QUESTION: Yes, but is there no negative side to the Euro-American fascination with things 'primitive'? We find some of the assumptions and practices of 'primitivism' worrying . . .

GUY BRETT: 'It was in the late 1960s and early 1970s, with my growing awareness of the rise of liberation movements in the Third World and the black movement in the west, and the way they affected artists whose work I knew and admired, that I began to realize that the "myth of primitivism" in modern art is connected with the whole issue of imperialism' (ibid., p. 113).

QUESTION: I must say that we have read dozens of books and articles on 'primitivism' but there is very little serious discussion of this issue. Perhaps you could say a bit more about the connection between the 'primitivist impulse' and aspects of imperialism, colonialism and racism.

GUY BRETT: 'It is part of a Europe-centred ideology which looks out over the world and sees, not other autonomous peoples, but societies occupying levels in a hierarchy with Europe at the top; a schema confirmed by the economic, military and political power of the west, maintained directly at the expense, and by the deprivation, of most of the world's people' (ibid., p. 114).

QUESTION: Presumably this structure of dominance has profound effects. How, for example, has it affected how Western artists have seen 'the Other'?

GUY BRETT: 'When we thought we were looking at other cultures we were really looking at the west's version of them, not the self-representation of those peoples themselves. In the field of culture, it was exactly the rise of this self-representation in the context of the liberation movements which administered the shock: the inhumanity, low intelligence, and self-deception of ideas completely taken for granted in the west were grotesquely revealed' (ibid.).

QUESTION: But if our notions of the dark-skinned 'Other' are so grossly inaccurate, why do we maintain them?

GUY BRETT: One of the ways 'Western culture seems to have attained its *official* identity [is] by defining itself against its own version of other peoples . . .' (ibid.).

Dialogue no. 12: The Way We Were: Imperialist Nostalgia

A VOICE: I am the new, reinvented racist. I love you. I want you.
 So long as you stay in your place . . .

Gone are the days when the cultures of Others were conceived as inferior. The old racism is gone. . .

THE VICTIM: Do not lie to your readers. This issue is deadly serious.

but we do have a kind of longing for THE WAY WE WERE – for that glorious imperialist, colonial past when there were exotic primitives and everything had its natural place.

Innocent Yearning

Curiously enough, agents of colonialism – officials, constabulary officers, missionaries and other figures from whom anthropologists ritually dissociate themselves – often display nostalgia for the colonized culture as it was 'traditionally' (that is, when they first encountered it). The peculiarity of their yearning, of course, is that agents of colonialism long for the very forms of life they intentionally altered or destroyed. Therefore, my concern resides with a particular kind of nostalgia, often found under imperialism, where people mourn the passing of what they themselves have transformed.

Imperialist nostalgia revolves around a paradox: A person kills someone, and then mourns the victim. In more attenuated form, someone deliberately alters a form of life, and then regrets that things have not remained as they were prior to the intervention. At one more remove, people destroy their environment, and then they worship nature. In any of its versions, imperialist nostaligia uses a pose of 'innocent yearning' both to capture people's imaginations and to conceal its complicity with often brutal domination.

Imperialist nostalgia occurs alongside a peculiar sense of missing, 'the white man's burden', where civilized nations stand duty-bound to uplift so-called savage ones. In this ideologically constructed world of ongoing progressive change, putatively static savage societies become a stable reference point for defining (the felicitous progress of) civilized identity. 'We' (who believe in progress) valorize innovation, and then yearn for more stable worlds, whether these reside in our own past, in other cultures, or in the conflation of the two. Such forms of longing thus appear closely related to secular notions of progress. When the so-called civilizing process destabilizes forms of life, the agents of change experience transformations of other cultures as if they were personal losses.

Nostalgia is a particularly appropriate emotion to invoke in attempting to establish one's innocence and at the same time talk about what one has destroyed The

relatively benign character of most nostalgia facilitates imperialist nostalgia's capacity to transform the responsible colonial agent into an innocent bystander.
— Renato Rosaldo, 'Imperialist Nostalgia', 1989b, pp. 69–70

Contemporary primitivism seems to us to be, essentially, a kind of imperialist nostalgia – a longing for 'how things used to be', which restores the 'Native' to the status of exotic while forgetting that we have come to know and appropriate the Other through imperialism, colonialism and racism.

TRUTH: Do not be deceived, representations are not value-free!

Dialogue no. 13: Beyond Racism

A primitive people is not a backward or retarded people; in fact, it may possess, in some realm or another, a genius for invention or action that leaves the achievements of other peoples far behind.
— Claude Lévi-Strauss, *Structural Anthropology*, 1963, p. 102

We have intimated that culturally colonialist attitudes and assumptions permeate the whole domain of 'high' culture, and that this is nowhere more evident than across the spectrum of the fine arts.
— Kenneth Coutts-Smith, 1991, p. 17

GLENN: Modern Western art presents itself as the least ethnocentric art in human history – the first to be genuinely open to influences from all of the world's cultures, to welcome and assimilate influences that are distant and alien, to thrive on radical difference. Modernism presents itself as reflexive and disrespectful of dominant structures of authority. Modernist artists and thinkers tend to see themselves as engaged in a kind of (internal) guerrilla warfare against established traditions of Western art, if not against the larger culture and society in which they live. Postmodernists have also taken this stance.

CHRIS: Yes. Not all of them, but certainly many have done so.

GLENN: It is also the case that many of these artists have had strong credentials as political activists – from socialists and communists to left-liberals and anarchists. A number of the Surrealists were communists.

CHRIS: Here, for example, is a quote from André Breton, the leader of the group, declaring his allegiance to the red flag:

Our allegiance to the principle of historical materialism . . . there is no way to play on these words. So long as that depends solely on us – I

mean provided that communism does not look upon us merely as so many strange animals intended to be exhibited strolling about and gaping suspiciously in its ranks – we shall prove ourselves fully capable of doing our duty as revolutionaries.

The passage is from the *Second Manifesto of Surrealism*, published in Paris in 1929.[4] And there a number of such declarations in the writings of other avant-garde artists.

GLENN: Yes, but our concern is not so much with the rhetoric of the modern Western avant-garde but with their *practice*. Our question therefore must be: Have their 'borrowings' from so-called 'primitive' and 'tribal' art been used to challenge, decentre and overthrow dominant Western norms, values and practices? Or has the Other been appropriated in a way that actually *reaffirms* precisely those norms and values that the modern primitivists – in particular, those of the modernist avant-garde – set out to undermine?

And I want to pose a related question as well: Have their appropriations served the cause of racism or anti-racism? That is, I am not simply interested in Eurocentricism but also in racism.

CHRIS: So, to put it simply, the issue is: Whatever their intentions and rhetoric, just how radical, in terms of assumptions and practices, have the modern primitivists been?

GLENN: Exactly.

CHRIS: Perhaps the best way to pursue this point is to ask: What exactly did these radical avant-garde artists and movements *see* in the Other? What has the Other represented for avant-garde movements in twentieth-century Western art?

GLENN: I think I can answer that quite precisely. Let me start by discussing an image – *Sleeping Negress* [plate 11.2] by Erich Heckel, the German Expressionist painter and printmaker. Take a look at this.

CHRIS: Oh, God. That's gruesome!

GLENN: Tell me what you see.

CHRIS: I see a grotesque figure of a woman. The face, in particular, is grotesque – and the artist has used sharp lines and angles so as to force your attention on that face.

GLENN: What else do you see?

CHRIS: I see a woman who appears to be sexually stimulating herself. She's fondling her own breast. She's engaged in an act of auto-eroticism.

This is not the come-and-get-me posture that one usually finds in the paintings by Western men of female nudes. She is not looking out from the frame at the implied male viewer. She is not indicating desire for a man. No, this woman does not need a man. SHE IS ALL SEX.

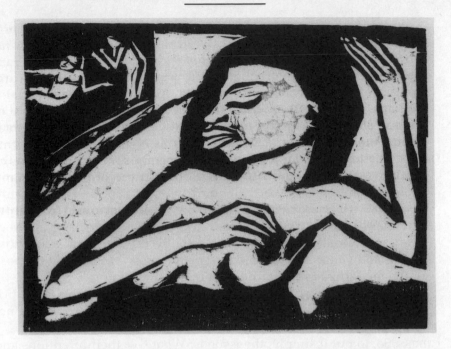

Plate 11.2 Sleeping Negress, Erich Heckel, 1908, New Haven, Connecticut, Yale University Gallery.

GLENN: Suppose we compare *Sleeping Negress* with images Western artists have created of The Oriental Woman. (I am thinking of Gauguin's *Hail Mary* (1891–2) and his other paintings of semi-naked Polynesian women, of Otto Pliny's *Oriental Dancer* (1909), of nineteenth-century paintings of Near Eastern women in hareems and Turkish baths and so on.) Now, in the Western artistic and cultural imagination, the Polynesian woman has an innocent beauty, exoticism and sensuality; and the Woman of the East is sensual, beautiful, exotic, a pleasure to look at. The former lives in a Garden of Eden, the latter in a hareem or Turkish bath.

Now, whereas the Eastern women are beautiful, exotic, sensuous and so on, the 'Negress' is ugly – ugly but powerfully sexual. The 'invitation' to the male viewer is not the possibility of making love with an exotic beauty but the possibility of raw sex – strong, power-ful, animal-like, overwhelming, primordial SEX! There is no question here of tenderness or closeness, of human bonding and cultivated pleasure.

CHRIS: Nor would there appear to be any question of a male control-ling *this* woman.

GLENN: That's right, here we have a construction that is well known: the POWERFUL BLACK WOMAN . . .

The more general point I wish to make is this. In their representations of Women of Colour, *Western avant-garde artists have too often simply reproduced the sterotypes of the dominant culture*. The 'radical' space they occupy frequently turns out, in so far as the cultural politics of race is concerned, to be a space of dominant racial – perhaps, I should say, rac*ist* – imagery. So, not only are people of Colour objectified – reduced to the exotic, the sexual, the spontaneous, the muscular and so on – but this objectification conforms precisely to, for example, traditional, unenlightened conceptions of THE EASTERN WOMAN and THE NEGRESS (the African or Black Woman).

A VOICE: Whenever White people show a special interest in NON-WHITE BODIES, I get nervous . . .

Dialogue no. 14: Of Dancers, Dreamers and Fornicators

We said earlier that COLONIALISM – exploitation, political domination, appropriation – has served modern Western art well. The truth is that RACISM has also been extremely beneficial. Take, for example, the notions of Black spontaneity, music, dance and spiritual power that were integral to Dadaism. Or the idea of the elemental power of African art which Picasso held. Or that concept of 'the primitive mind' which was uncritically exploited by Surrealism. Or assumptions about brown bodies, sexuality, eroticism and 'free love' in the perverted thought of German Expressionism.

And what about that bizarre equation, found (often explicitly) in twentieth-century Western avant-garde movements that links together the artistic production of 'primitives', women, children and the insane – that lumps them all together under the sign of irrationality? (Here, the 'cosmopolitan' racist joins the sexist.)

THE BLACK = THE WOMAN = THE CHILD = THE INSANE

And this from the West's most politically radical art movements of the twentieth century . . .

Spontaneity, rhythm, raw strength, primordial energy, powerful sexuality, irrationality – these notions ring with familiarity in the ears of those of us who have bothered to engage in serious study of racism. They are the stuff of racist discourse and imagery! It would be very difficult to find any concepts that are more central to RACIST IDEOLOGY.

TRUTH: Our avant-garde friends have, inadvertently, teamed up with the
 enemy.

Now, we are *not* claiming that various traditions of modern Western art
all appropriate 'The Primitive' in the same way. There are differences –
differences which reflect their respective artistic aims as well as their
respective political positions.

Take Picasso and the Cubists, for example. They were not interested in
black bodies (although, as we shall see, Picasso did have a fascination
with the head of a certain Black artist) but in the basic principles and
power of 'primitive', especially African, sculpture. The Cubists were
overwhelmingly concerned with questions of form – which is distinctly
different from the Expressionists and Surrealists, who sought to express
inner feelings, the unconscious, 'life-force' and so on.

Western artists who have engaged with 'primitive' and 'tribal' art on the
level of aesthetic principles and form have shown a certain respect for
Others as thinking, artistic beings. Those, like Expressionists, Surrealists
and Dadaists, who have been more concerned with 'primitive' elemental
forces, primordial rituals and so on have been more likely to reproduce
stereotypes of the Other.

It should perhaps be said that the way in which Dadaists and Surrealists
conceived Black people and culture has a counterpart in Black intellectual
and popular traditions: the idea that 'BLACK PEOPLE HAVE SOUL', held by
Négritude artists, Black cultural nationalists and many ordinary Black
people, is obviously a related concept.

Those who believe that people of Colour have special powers are on a
slippery slope – where, unfortunately, those who love Black people slide
next to those who despise us.

The issues here are complex: Wifredo Lam, the Surrealist painter who
painted *The Jungle*, was Black.[5] Now, that painting (see plate 10.5), what-
ever its artistic merits, reproduces imagery that is routinely drawn upon
by racists and racialist romantics. It, very unfortunately, equates Black
people with THE JUNGLE.

A VOICE: So, here we have a Black artist placing us in the make-believe land
 of 'Tarzan and the Apes' . . .

It reproduces the myth that Black people are a NATURE-PEOPLE, that we live
not in culture but in nature. Moreover, Lam's Nature-People are not
friendly but frightening: one reads them as the menacing Jungle-People
who trade in magic and sorcery, who transform themselves into plants
and animals in search of their victims. Given the powerful repre-
sentations of 'the Primitive' which exist in Western culture, one is likely
to see them as 'voodoo doctors' or cannibals.

Surely, this was not Wifredo Lam's intention. But meanings are not made of intentions alone ...

Dialogue no. 15: Colonialist Discourse

GLENN: Mr Araeen, you have said that *'primitivism has little to do with the actual conditions of the peoples and cultures it refers to'*. As we understand it, your argument has an affinity (if we can still use this term) with Edward Said's writings on 'Orientalism' as a terrain of knowledge and power. So, what is 'primitivism', fundamentally? Is it essentially a way of constructing, defining and containing Others while maintaining Western identity and power?

RASHEED ARAEEN: 'As a projection and representation of non-European peoples and their cultures in Western philosophy or discourse, it in turn justifies Western colonial expansion and domination. In other words, *Primitivism is a function of colonial discourse*, and it is therefore imperative that we try to look at the nature and complexity of this discourse' (Araeen, 1987, p. 8).

A Secret: PRIMITIVISM = A COLONIAL DISCOURSE

GLENN: Yes. This is precisely the issue we wish to explore. How would you begin to map the 'nature and complexity' of primitivism as a discourse, as a colonial discourse? Although you did not use the word, you seem clearly to be suggesting that primitivism is an *ideology*. Now, ideologies disguise and hide relations of domination and structural contradictions. What does primitivism hide?

RASHEED ARAEEN: 'We are confronted here by a discourse which is complex and ambivalent, for when the mask of its objectivity is lifted, what is revealed is not only a phoney rationalization but a structure which is mythical. It is this mythic structure that hides the contradictions of the bourgeois/imperial society by the invocation of the magical power of the modern artist (white, male, individual, heroic ...). Its ambivalence, expressed particularly in its fascination for the Other's traditions, does not hide its reaffirmation of the centrality of the Western/white artist in the paradigm of modernism' (Araeen, 1989a, p. 11).

CHRIS: I must admit to having found the extent of this 'reaffirmation' shocking. The Great White Men seem always to win the battle for artistic paternity, even if they were not even on the relevant continent at moment of conception or birth! Susan Hiller, in *The Myth of*

Primitivism, has put the issue well. She says there has been an 'erasure of the self-representations of colonized people' in favour of Western representations of their histories, cultures and arts. It is as if Picasso & Co. invented, rather than appropriated, African, Oceanic and American Indian arts . . .

GLENN: Exactly.

RASHEED ARAEEN: I would like to make a different but related point. 'The idea of the colonial Other as a group of racial stereotypes, with their equivalent cultural stereotypes, has played an important part in the development of Primitivism in colonial discourse. And it seems these stereotypes are still with us today and provide a source (though often unconsciously) for racist ideas in popular consciousness, institutions and scholarship' (Araeen, 1987, p. 14).

GLENN: We expect to raise issues like this in a chapter in a book we are currently writing on *Cultural Politics*. The chapter will be called something like 'Modernism and Its "Primitive" Others' . . .

Dialogue no. 16: They Should Be Grateful . . .

Because we are good liberals, with a long history of concern for the Coloured, we have decided to let two natives speak before we end this chapter. We are pleased to announce, as a special attraction, the following: the first of these voices is that of a self-confessed savage.

Listen and enjoy.

Of Cowboys, Artists and Savages

Everyone loves the lone cowboy. Free and independent, away from the law, he doesn't have to work. He has that really neat existential loneliness and penetrating gaze. He is a perceptive critic of those who live in the town, and he 'doesn't have to take no shit off nobody'. Sometimes he must kill evil savages, but the intelligent savages become his friends and he learns their ways, while always keeping to himself. What a perfect model for twentieth-century artists. What a perfect way for Jackson Pollock to get the draw on Picasso. But wait, these days artists like to think of themselves as 'shamans'. What if you could be the cowboy and the Indian, like Karl May's 'Winnetou'? A perfect set-up for profits both psychological and economical.

It becomes problematic for us savages, however, basically for two reasons: first, those cowboy-shaman-artist guys cannot seem to put themselves into even the slightest part of their analysis of a given situation (because they **do** *imagine themselves to be lone cowboys). The second reason has causes within the first: the guys believe art to be like an object, so when they think of 'art as a weapon' they imagine it to be like iron – an efficient poker and stabber. So the artist guys say they are 'challenging society' (to a duel?) and as cowboys and explorers and husbands*

they speak for us and about us. Now, in the first place, that is a bad situation because
I want to speak for myself; and in the second place, all Indians and Wives know that
Cowboys and Husbands don't know shit from Shinola.
 — Jimmie Durham (Cherokee artist, poet and political activist), 'The
 Search for Virginity', 1991, p. 291

The next voice is that of a primitive artist who refuses to accept his place
in the natural order of things. He has spent much of his life claiming that
he, and others like him, should be allowed to enter History. As we who
guard the spaces of History and Culture know, this is a patently ridicu-
lous request . . .

THE GATE-KEEPER: We shall ensure that he fails, that he is made to sound like
 a mad man out to destroy the temple of reason.

None the less, as proof that the academy, like the capitalist market place,
can absorb anything, we will let him speak.

A Primitive Replies to Primitivism

The 'primitive' has now learned how to draw, how to paint and how to sculpt;
also how to read and how to write and how to think consciously and rationally,
and has in fact read all those magical texts that gave the white man the power to
rule the world. The 'primitive' today has modern ambitions and enters into the
Museum of Modern Art, with all the intellectual power of a modern genius, and tells
William Rubin [then Director, Department of Painting and Sculpture, Museum of
Modern Art, New York] to fuck off with his Primitivism: you can no longer define,
Sir, classify or categorise me. I'm no longer your bloody objects in the British
museum. I'm here right in front of you, in the flesh and blood of a modern artist. If
you want to talk about me, let's talk. BUT NO MORE OF YOUR PRIMITIVIST
RUBBISH.
 —From a lecture presented at the Slade School of Art, University of
 London by Rasheed Araeen, in Araeen, 1987, p. 18

Liberal n. **1.** a *member of that White tribe known to welcome non-White*
people into their home **2.** a *person who wishes to be both cowboy* and
Indian at the same time.

Dialogue no. 17: Signs of Common Sense

How do we get beyond deeply engrained images of 'primitive' peoples
and cultures – images which Western 'primitivist' art sometimes inadver-
tently reinforces? Displaying non-Western objects solely as 'art', that is, on

their own, removed from their – or our version of 'their' – historical or cultural context is not sufficient to solve the problem. As Sally Price observes:

> Few are the visitors to a 'tribal arts' gallery that displays objects largely without ethnographic context, who do not in some way compensate for the absence of interpretation by calling on western 'common sense' misunderstandings about the life of 'primitives' – *including images of cannibalism, superstition, and rituals performed by flickering torchlight.* (Price, 1986; quoted in Hiller, 1991d, p. 187)

And as Susan Hiller observes:

> In the modern period, the arts of Europe's 'others' enlarged Western concepts of what art is, the many forms it can assume, and the diverse roles it can play. But however much or little ethnographic art [that is, so-called 'primitive' or 'tribal' art] truly has provided a source for western artists, and however much or little it still functions as a charter of difference and opposition, it always does so as a sign whose meanings are already in place before they are deciphered. (Hiller, 1991c, p. 88)

Dialogue no. 18: Postmodern Nomads and the End of Innocence

We know that we have got into serious matters of politics in this chapter. We are aware that, as respectable, objective scholars, we are supposed to avoid all questions of ethics and politics. But so it is . . .

If our study shows anything, it raises the question of whether, in some fundamental aspects, the practice of Modern Art is not precisely the opposite of how it represents itself.

> A VOICE: Is this not a dominant, authoritative force masquerading as marginal and radical? Is it not a case of Eurocentric institutions and practices masquerading as cosmopolitan anti-racists?

It is not a question of whether this or that modern artist or critic is 'racist'. It is rather a question of the historical and institutional context within which modern art – in particular, modernist primitivism – has functioned. Now, it is a fact that modernist primitivism was born during the heyday of Western imperialism – during the time when White Men ruled the world and the sun never set on the British empire.

The examples of 'primitivism' given in this book are virtually all from the first few decades of the twentieth century – a rather long time ago. None the less, they were quite deliberately chosen: we picked those

particular examples – Picasso, Dada, Surrealism, German Expressionism – because *we wanted to look at the cultural politics of race within the most politically radical primitivists*. It is easy to criticize the 'conservative art establishment' for being Eurocentric and, on occasion, racist. We wanted to look at the politics of the avant-garde, of those who proclaimed themselves anti-bourgeois, anti-racist and so on.

THE SCEPTIC: Okay, I can see that. I will even concede that it was a clever move. But my question remains: What evidence is there that primitivism lives today?

ANSWER: 'Since the mid-1970s art practices in the west which appropriate other cultures have proliferated on an unprecedented scale and questions around strategies of appropriation and meanings thus produced now occupy a central position in critical and non-critical writings alike. Celebrations of *post-modernism*, *transavantgardism*, *new subjectivity* and the like tend uncritically to embrace an AGE OF CULTURAL NOMADISM and "STYLISTIC ECLECTICISM".

TRUTH: Yes, precisely! An Age of Cultural Nomadism!

'Eclecticism seems to be the magic tool that allows the contemporary artist . . . unproblematically to traverse the cultural arena. HUNTING AND GATHERING FROM DIFFERENT TRADITIONS, western and non-western, become the very preoccupation of the artist-nomad moving across the debris of modernism' (Philippi and Howells, 1991, p. 249; emphasis added).

THE SCEPTIC: Earlier in this discussion it was said that one of the distinguishing features of 'primitivism' is that the Western artist remains Hero. That is, that the 'quoting' and 'borrowing' from the Other is done in such a way that any 'transgressive' potential this art might have is removed, rendering it tame and capable of being easily assimilated by the West. Now, surely, that sort of imperialistic stance is gone? Surely, postmodernists know better than that?

ANSWER: 'Quoting, appropriating, and borrowing, whether formal (the brushstroke, the material, etc.) or the iconic (the mask, African carving, sand-painting, etc.), have to be distinguished from other modes of enunciation because the image refers to, or comments on, something that always already exists in a different context' (Philippi and Howells, 1991, p. 249).

THE SCEPTIC: So, these days, Western art inspired by 'primitive' art and culture does acknowledge its source of inspiration.

ANSWER: No. 'Typically in primitivism the previous meaning and context are denied and the reference is thereby reduced to a signifier of purely western concerns.

As we have tried to argue, this is not surprising and could hardly be otherwise as historically *the process of primitivism is premissed on and reiterates the closure of (western) identity'* (Philippi and Howells, 1991, p. 249).

THE SCEPTIC: I would like to ask a final question. All artists appropriate ideas and imagery from the world around them. Surely it is wrong to accuse an artist of racism or indifference simply because she or he borrows from non-Western art and culture?

GLENN: Particular artists may well see themselves as using African, Eastern and/or Oceanic sources for artistically and politically progressive reasons. They may even view the imagery, styles and ideas they appropriated as *superior* to Western art. But 'primitivist' Western artists live in cultures which have hundreds of years of negative and romantic images and discourse about the histories, cultures and bodies of non-White Others. When they appropriate 'primitive' imagery, they enter an already existing web of meanings – meanings that they can not control.

LYNNE COOKE: *'Recourse to primitivist imagery can no longer be an innocent act*, its character as a social construct, as a manifestation of the 'other' must be taken into account, and the ramifications of the appropriation of such imagery – its consequent ubiquity and even banality – examined, or at least acknowledged' (Cooke, 1991, p. 43; emphasis added).

GLENN: Amen.

CODA: Beware of cosmopolitan eurocentrics and revolutionary racists . . .

12

Encounters: Postcolonial Artists and the Art Establishment

A VOICE: We are a sign whose meaning is already fixed before we speak, before we paint, before we write, . . . before we are born.

Guy Brett is an honest member of the Art Establishment who does not run from questions of race. As a critic, journalist and curator he has spent many years observing the British art scene. Let us invite him to probe into its hidden history.[1]

QUESTION: Mr Brett, what do you remember most about the London art scene of the 1960s and 1970s?

GUY BRETT: 'Artists from many different countries, of several generations, who had more or less settled in Britain as a place to work; foreign artists staying for shorter or longer periods; artists whose parents or grandparents had come to Britain in search of work; foreign students, political refugees, exiles – they and their relations and responses to the English artists and culture with which I grew up: this has in many ways been the London art world as I've encountered it' (Brett, 1992, p. 52).

QUESTION: The official story of twentieth-century art is that it has been, to put it sharply, the invention of White creative artists from Western Europe and the United States of America. Are you suggesting that there is another story? That the 'official story' is a distortion, an ideological construction?

GUY BRETT: 'I knew that the avant-garde of the 1960s and 70s – as a broad vector of experiment encompassed by such subsequent labels as kinetic art, process, minimal and environmental art, fluxus, happenings, conceptual and participation art – was an international movement created by artists who originated from [many] countriesAny association of this movement simply with a Europe/US axis was a distortion made by economic and

political power, *especially the implication that any non-European or non-North American artist was a late-comer and provincial imitator of the favoured nationalities'* (ibid., p. 53; emphasis added).

QUESTION: There is a real contrast between what you actually observed and what one reads in mainstream art history and criticism. This difference must have proved a real revelation for you?

GUY BRETT: 'In fact the experience gradually made me see the falsity of the hierarchy of mainstream and margins, of insiders and outsiders, which officially characterizes that art world (so assiduously maintained by the cultural institutions in defining the nature of "British Art")' (ibid., p. 52).

This chapter is a story about a liberal, enlightened institution, about a world inhabited by 'cosmopolitan' intellectuals, writers and artists. It is a polite world, a world of gentlemen and ladies. One could not be further away from parochialism, Eurocentricism and racism. Or so it is thought.

This chapter is a story of CENTRE and PERIPHERY, MAINSTREAM and MARGINS, INSIDERS and OUTSIDERS in the art world. It is an investigation of cultural politics in a space where, according to official common sense, politics do not exist. It is a story of the British Art Establishment, though many of the points we make could be made about the university, the literary establishment, the classical music world or the discipline of history.

DEAR READER: Do not think that this chapter is about somebody else. It is probably about you.

Our focus is on the institutional apparatuses of British Modern Art as they have been experienced by Artists of Colour (painters, sculptors, and so on). It is not the Official Story – not the sort of story you read in mainstream histories of twentieth-century art.[2]

Throughout the twentieth century artists – established and aspiring – have migrated and immigrated to the great metropolitan centres of Europe and America. Paris, New York, Berlin, London – these and other Western metropolises have exerted magnetic attractions for generations of artists from virtually all over the world. Thus it is that for more than 50 years artists have been coming from Asia, Africa and the Caribbean to Britain (mostly London) to be at the heart of the modern art scene.

Many of the Artists of Colour who came to Britain achieved both financial success and considerable critical acclaim, especially in the early 1960s. (To take the most obvious example: Francis Newton Souza was a dominant figure in the British art world from 1956 to 1966.[3]) The work produced by these artists is firmly grounded in modernism. They were serious, innovative artists whose work was a contribution to abstract painting, expressionism, kinetic sculpture and so on: 'They did not make

flower or animal paintings' for a popular market (Araeen, 1991, p. 21). As suggested in the above dialogue with Guy Brett, some of these artists were part of the modernist avant-garde, and pioneered some of the ideas and practices that are at the centre of contemporary modern art.

'*But what is amazing is that none of these artists managed to enter the history of British art* – leaving aside the recent case of Anish Kapoor about whose real position it would be premature to speculate now' (Araeen, 1991, pp. 21–2). Indeed, since the 1960s 'no national or international survey of post-war art in Britain has mentioned or included any non-European artist' (Araeen, 1989a, p. 15).

> A VOICE: We accept that all histories are selective. We know that all histories suppress certain events, names, dates and ideas. But we must ask: Why is it always *we* who are written out?

This brings us to the crucial question: What happened to these Artists of Colour? Why are their achievements trivialised and hidden? Why have they failed to enter history?

The Other Story

> MYTH: Modern Art is a European and American invention.
> REALITY: Modern Art is the achievement of many nations and cultures – but this history is hidden.

As we saw in chapter 10, '*Primitivism*' *in 20th Century Art* studies the reception and valuation of non-Western *art* by modern Western art. A few other exhibitions and catalogues have looked at the reception and valuation of non-Western – or non-White – *artists* by modern Western art. One superb example is *The Other Story: Afro-Asian Artists in Post War Britain*, an exhibition held in winter 1989–90 at the Hayward Gallery in London (and subsequently in two other cities). This major exhibition, together with the catalogue and supplement that accompanied it, probed a history that has been well hidden – hidden to an even greater degree than 'primitivism'.

The subject-matter of *The Other Story* is that part of the history of postwar British art which has been officially and institutionally suppressed. Focusing particularly on artists who migrated to Britain during the 1950s and 1960s, it is a retrospective portrait of the contributions of African, Asian and Caribbean artists to the mainstream of British modernist (and to a lesser extent postmodernist) art.[4] It is also a history of the struggles *vis-à-vis* this mainstream. That is, it is a story of both art objects and those who created them – both art history and a critical social history of the British art world. Artists included were: Rasheed Araeen, Saleem

Arif, Frank Bowling, Sonia Boyce, Eddie Chambers, Avinash Chandra, Avtarjeet Dhanjal, Uzo Egonu, Iqbal Geoffrey, Mona Hatoum, Lubaina Himid, Gavin Jantjes, Balraj Khanna, Donald Locke, David Medalla, Ronald Moody, Ahmed Parvez, Ivan Peries, Keith Piper, A. J. Shemza, Kumiko Shimizu, Francis Newton Souza, Aubrey Williams, Li Yuan Chia.[5] Five artists, objecting to the fact that ethnic origin was a major criterion for inclusion, refused to participate.

The Other Story was a controversial exhibition – certainly from the point of view of the Art Establishment. Later in this chapter, we shall return to a discussion of the issues of cultural politics raised by the exhibition – and by the responses to it. But first let us enter the world of Artists of Colour (in Britain). We begin by taking a series of close-up snapshots of their encounters with the Modern Art Establishment.

Modernism and its Others: Encounters Between Postcolonial Artists and the (White) Art Establishment

But there still exist assumptions and attitudes which consider other cultures/peoples outside modern history. These attitudes and assumptions are so pervasive, so intransient, that the very presence of others in the modern world is seen with suspicion. When it comes to the question of the modernity of other people, the whole citadel of modernism begins to fall . . .
— Rasheed Araeen, 'Introduction: when Chickens Come Home to Roost', 1989a, p. 10

In an important article entitled 'From Primitivism to Ethnic Arts', Rasheed Araeen, founding editor of *Third Text*, says: 'My main concern is with the question of the STATUS and REPRESENTATION of non-European cultures in Western scholarship and popular knowledge since the 18th century, and more importantly, the implication today of this history *vis-à-vis* the STATUS of non-European people in the modern world' (Araeen, 1987, p. 14; original emphasis). This is precisely the concern of the present discussion, focusing in particular on the relationship between PRIMITIVISM and the status of ARTISTS OF COLOUR in twentieth-century Britain.

Of Elephants and Tigers

Avinash Chandra was born in India in 1931. 'I was a painter', he says in a conversation with Rasheed Araeen, 'when I was born I was born to

paint' (Araeen, 1988, p. 72). His parents wanted him – their first son – to have a proper profession, such as engineering. He, however, was determined to be an artist, and so he lied to his father and mother, telling them that he was going to engineering school when he was in fact attending art classes. It was six months before they realized: 'They were paying my fees in the school office [at the Polytechnic of Delhi] which was on the ground floor, while all the other departments were upstairs. They did not bother to come upstairs to find out what I was doing' (Araeen, 1988, p. 72). Avinash Chandra received a first-class degree in art from the Polytechnic of Delhi and then became a teacher in the art school there – the first person to assume such a position immediately after graduation.

In 1956 this young, determined artist, schooled in the concepts and techniques of Western modern art, arrived in Britain.[6] In his early days in London, Avinash went to a West End gallery to show his work. The gallery owner, recognizing that the young artist was Indian, asked him if he could paint elephants and tigers! As he explains in a conversation with Rasheed Araeen of *Third Text*, this encounter proved to be one that he could never forget:

> We are talking about something which happened a long time ago, almost thirty years ago, but I still remember I was so hurt. There is nothing wrong with painting elephants and tigers . . . but to be asked to do these things because you are an Indian is insulting I had to actually borrow a few pounds to hire a cab to bring my work to the gallery, and the chap wouldn't even look at the work. All he wanted was elephants and tigers. (Chandra, in Araeen, 1988, p. 70)

Now, the gallery owner wants paintings that will sell: he, after all, is running a business. So it is not particularly surprising that he should try to get one of his prospective artists to pursue popular themes. The problem is that he cannot see Avinash Chandra as other than a stereotypical Indian artist. A modernist landscape artist, *because he happens to be an Indian*, is reduced to the stereotyped role of a 'traditional' Indian artist. By virtue of his skin colour, physical appearance and accent, the artist is hemmed in, assigned a place in the Western imagination that is reserved for 'ETHNIC ARTISTS' and 'INDIANS'.

Why Indian Artists Always Produce Indian Art

Perhaps we are making too much of a single incident? Let us return to the conversation between Avinash Chandra and Rasheed Araeen. Here, they are talking about how art critics, curators and historians in Britain and the USA have conceptualized Chandra's work:

RA: What interests me here is the way connections were made between your work and Tantra or perhaps also Khajuraho sculptures [i.e., with two styles of 'traditional' Indian art]. . . . How do you feel about this 'Tantra' and 'Khajuraho' business in your work?

AC: To tell you the truth I did not have the slightest idea about Tantra until I met a man called Ajit Mukherjee But by then I had become an over-night success.

RA: The other connection was perhaps with Khajuraho, because of the eroticism of sculpture there; and your work was seen as erotic.

AC: I didn't know anything about Khajuraho either. Valerie and I went there only recently, a few years ago, and I wasn't impressed [The] Khajuraho we all know is an imagination. It's our fantasy.

RA: But did you go to Khajuraho because of what people said about your work?

AC: No, no. We went to India because I wanted my wife to see my country. When we were on our way to Kathmandu, we also went to Khajuraho. Anyway I'm sick and fed up with these questions about Khajuraho. I never had the need to *go back* to whatever These guys who were making all those connections had their own problems and their own need to go to India. And I feel that I was used by these guys. (Araeen, 1988, p. 93)

Here is a rather typical statement from a review of Chandra's work in the British arts press of the 1960s:

All the work is very strongly related by consistent qualities of sensitive line, form and rhythm, born of an Indian normality which in this anaemic country would be termed as verging on erotomania. . . . The soft flowing, sensual forms pregnant with phallic symbolism dissolve and interpenetrate each other in searching fusions of almost liquid shapes. . . . His main debt is

Plate 12.1 Hills of Gold, Avinash Chandra, 1964, oil on board, 40″ × 95″.
Reproduced by kind permission of the Tate Gallery, London.

to the magnificent erotic sculptural decoration of Indian temples where sex plays an important part and is expressed beautifully by union of subject and form of the highest order. Chandra's work lacks to a degree this perfection of unity.[7]

'Born of an Indian normality, . . . verging on erotomania, . . . sensual forms pregnant with phallic shapes, . . . a debt to the magnificent erotic sculptural decoration of Indian temples' – what is going on here?

Let us concede at the outset that it is not unreasonable to describe Chandra's work as 'erotic'. But why claim that it derives from a hypersexuality that represents Indian 'normality'? The answer would appear to have deep roots in the Western imagination of The East. The portrayal of The East 'as a land that traded in voluptuousness, a land where sexual desires could be gratified to the hilt' dates from the European imagination of the Middle Ages (Kabbani, 1988, p. 16). The image of the Middle and Far East as a place of fantastic wealth has been perpetuated since the ancient Greeks. By the Middle Ages and especially the Renaissance *the image of The East as a site of overflowing sensuality, exotic beauty, passionate desire and sexual gratification* had come to the fore (as had the image of The East as a land of cruel violence and fanaticism). Tantalizing descriptions of 'the harem', real or fictive, have been a regular feature of Western travel writing and pornographic literature for hundreds of years. It is through this highly charged imagery – 'THE EAST' OF THE WESTERN IMAGINATION – that Chandra's work is read. And so it has been for many other Artists of Colour.

Let us make a second concession – that, although he has not done it consciously, there are likely to be traces of traditional Indian culture in Chandra's work. Indeed, all artists are likely to show traces of their origins in their work. If one wanted to, one could find Spanish culture in Picasso's Cubism, French culture in Matisse's Fauvism, Dutch culture in Mondrian's Abstractionism, Russian culture in Kandinsky's Expressionism, American culture in Andy Warhol's Pop Art

But discussions of modern (White) European and (White) American artists do not proceed in this way. No one says, 'Picasso was a great Spanish painter whose works reflect the intricate rhythms of flamenco' or 'Look at the brilliant use Kandinsky makes of patterns from traditional Russian floor tiles.'[8] So why do this when discussing the work of Avinash Chandra (and other Artists of Colour)? The reasons have to do with the cultural politics of modernism and the positioning of people of Colour and Eastern 'exoticism' within the Western imagination.

This point requires some elaboration. For the moment, let us simply note that in the case of (White) European and Euro-American modern artists their national origins are of no importance: 'They are considered as part of international modern movement in art which is the mainstream of

20th century art' (Araeen, 1988, p. 87). But when it comes to recognition of the work of non-White artists, things are usually otherwise: *'Their modernity is not recognised. Instead they are relegated to national or ethnic cultures'* (Araeen, 1988, p. 90; emphasis added) – like the 'tribal' artists 'discovered' and DE-AUTHOR-IZED by the primitivists. Listen as the conversation continues between Avinash Chandra and Rasheed Araeen:

RA: The way your work was recognised and promoted is an example. Your work was seen as specifically Indian, and you were promoted as an *Indian artist in Britain*, rather than as part of an international modern movement which in the post-war period had spread globally
AC: Yes, it's true that I was seen as an Indian artist. (Araeen, 1988, p. 90; original emphasis)

Defining Ourselves: a Muslim in Mecca

I, the bourgeois subject, am an INDIVIDUAL. Because I live in a free and democratic society, I can choose who or what I wish to be.

I, the bourgeois artist, am a SUPER-INDIVIDUAL. Because I work in an enlightened world where individual expression, creativity and innovation are deeply valued, I play the central role in defining the meaning of my work.

I live in – how can I put it? – a Mecca, a paradise of personal and artistic freedom.

A Muslim in Mecca

I was born in India, when India was under the British Raj. As a teenager I grew up, spent my early youth and was educated in Pakistan. At the age of 29, inspired by the West's achievement in art in the 20th century, and to fulfil my own aspirations to be a modern artist, I left my country to live in Europe. I have now lived and worked in London for 27 years. I often travel to Pakistan to see my mother, brothers and sisters, and also some friends. I can say I'm Asian, Indian, Pakistani, British, European, Muslim, Oriental, secular, modernist, postmodernist, and so on. . . . But what do these things mean? Do they define my identity? Can I accept all of them as part of my life, or must I choose one thing or another according to someone else's notion about my identity? I have no problem in saying that I'm all of these things, and perhaps none of these things at the same time.

Before leaving Pakistan I had never concerned myself with the importance of my own cultural identity, or its expression in my work. The question 'Who am I?' never bothered me until I arrived in Europe, and even then I entertained this question only occasionally when things were bad . . .

After living 27 years in the wilderness, I still feel at home wherever I am. How could I talk about uprootedness and diaspora when I consider myself a citizen of the world? What sometimes bothers me, however, is not that I have failed as an artist at

the market place – my failure is no different from many of the failures in history – but that for all these years I had to put up with the coldness and indifference . . .

My story seems to revolve around mistaken identities. But it does not bother me that people often mistake me for something other than my supposed self. In fact, there have been occasions when my mistaken identity provided me with moments of amazement, wonder and pleasure. I'm sure everyone of you have some story to tell in this respect. But there have also been other kinds of encounters with strangers, when I was asked to take my mask off and reveal my 'real' self in order that I could be recognised. This was painful.

After I had been in England for six years, I had the most unusual encounter with an Englishman whose admiration for my work still bothers me. I'm not being ironic, but the irony is there. It was as a result of this encounter that I discovered my 'original' self.

In the late 60s I had a studio which was part of a complex of studios in east London. In the summer of 1970 we had a grand party, to which hundreds of people from the art world were invited. It was during this party that the encounter I have mentioned took place. As I was having drinks and chatting with my friends in my studio, an elderly well-dressed gentleman moved towards us, and said hello to me. I returned the greeting and we shook hands. 'I like your work very much,' he said as we began to talk. I thanked him and we moved around together in the studio. As we were looking at various works something suddenly occurred to me, and I asked him: 'How did you know that this was my work?' 'Aren't you an Arab?' he replied looking at my face. 'No, I'm from Pakistan,' I said, becoming rather puzzled by all this: 'Oh, it's all the same. You are Muslim.' 'Yes,' I said reluctantly. 'You see, this kind of work could have been conceived only by a Muslim. I cannot imagine a European doing this work,' he began to explain politely. Instead of being happy with this interpretation of my work, I became irritated and annoyed. However, I kept my friendly posture and we parted with a good handshake and promised to meet again.

Next day somebody told me that the person I had met was the Professor of Fine Art at the Slade School of Art, and that he was an important member of the art establishment. I also came to know later that he was very helpful to artists who came to London from British Commonwealth countries. I myself found him very kind The only reason I have told you about my meeting with him is because it became a turning point in my life. It was the first time that I became aware that my work had something to do with Islamic tradition. It was a disturbing discovery, because I have never made any connection between my work and my being a Muslim. They were two different things. Moreover I was never interested in Islamic art, or concerned with the expression of my cultural identity. My interest was in modernism.

— Rasheed Araeen, 'How I Discovered My Oriental Soul in the Wilderness of the West', 1992, pp. 89–93.

One of the central claims of this book is that all signifying practices, that is, all human activities that have meaning, involve relations of authority and power. Rasheed's encounter with the well-dressed gentleman under-scores this fact. By virtue of his position as Professor-of-Fine-Art-at-a-Very-Prestigious-Art-College and Big-Chief-in-the-Art-Establishment,

Plate 12.2 8bs, Rasheed Araeen, painted wood, 183″ × 394″ × 38″.
Reproduced by kind permission of the artist.

the English gentleman has THE POWER TO NAME. It is irrelevant how well
the names he bestows – 'Arab', . . . 'Muslim', . . . 'Islamic Artist', . . .
'Traditional Art' – fit the object so designated.

> A VOICE: THE WHITE MAN IS MEDIATOR AND JUDGE. He determines what our
> work means, how it should be received and valued.

The encounter in the young artist's studio also serves to call attention to
the deeply rooted *binary logic* that supports White Western ethnocentrism
and racism. The encounter reveals an US/THEM logic – a perverse ration-
ality in which it is a contradiction in terms to be MUSLIM and WESTERN at the
same time. The fact that Rasheed thinks of himself as Indian and British,
Asian and European, and Muslim and secular at the same time is, quite
simply, irrelevant when he encounters White Power.

> TRUTH: In the end, we are judged, condemned, classified, determined in our
> undertakings, destined to a certain mode of living or dying, as a func-
> tion of the true discourses which are the bearers of the specific effects of
> power.
> — Michel Foucault, 'Two Lectures', 1980, p. 94

By this same logic, Artists of Colour are not viewed as contributing to
Western modern art, but to some tradition in their 'homelands' – the
Bantustans of modern art – about which they may, in fact, know very little
indeed. Again, from the point of view of those whose voices matter, the
artists' actual cultural background, education and interests are irrelevant.

An oriental soul can always be constructed through White Power and those who happen to look 'Oriental' can be encouraged, via a process of (properly guided) self-discovery, to find it.

Of Liberals and Traditionalists

Oh, East is East and West is West and never the twain shall meet . . .
— Rudyard Kipling, *The Ballad of East and West*[9]

Surely, you say, incidents like the one involving the well-dressed Professor of Fine Art must be rare indeed. The Art Establishment in Britain – enlightened, liberal, cosmopolitan (not an institution governed by the logic of White Power) – could never have been so narrow-minded and rude as a matter of course? Perhaps you are right. Here is the testimony of Balraj Khanna, who arrived in London in 1962 at the age of 22 after graduating from university in India:

> I vaguely knew that quite a number of young artists from India lived in London at that time [i.e., the early 1960s]. They lived closed, hermetically-sealed lives. Not from choice. It was how things were. . . . They continued to go about their business, unseen and unacknowledged. If they could paint fisherwomen on the Malabar Coast or tigers and elephants in the jungle of Mysore, they were all right.

But what if they chose to do otherwise, to pursue their work as artists belonging to the modern Western world? Khanna continues:

> They were not all right if they chose to address the world in the ever-expanding language of modernism, which, as if by some divine decree, was exclusively the white man's. It was silently, but generally, understood that modernism and *avant-gardism* were not for them; only traditionalism was: Indian traditionalism. The fault of these fellows was that they had chosen to turn their backs on it. (Khanna, 1989, p. 110)

This testimony raises several important issues having to do with the cultural politics of race in the Modern Art Establishment. Note that Khanna's comments depend on the observation that within the discourse and values of the mainstream art world, there is a distinction made between GENUINELY CREATIVE ARTISTS and ARTISTS WHO SIMPLY FOLLOW TRADITION. The true artist has the gift of individual creative expression. Those who simply follow tradition are barely artists at all: it makes more sense, in fact, to call them artisans or craftspersons. Now even if it is accepted that the

above distinction is useful (which is, of course, debatable), a crucial question arises: Why is it that *Indian* artists (Artists of Colour), whatever they actually produce, are seen to be the ones following tradition? Why is it that Indian artists can belong neither to the West nor to modernity? It is as if WE and THEY live in different time zones.

Balraj Khanna's testimony raises the question of how THE EAST – in this case, India specifically – has been perceived in the West.[10] And it poses the question of how Asian artists, whatever their actual links to 'traditional' Eastern cultures, are made part of that perception. As we have seen, the theory and practice of modernism have played an important role in the production of Western conceptions of The East.

We shall return to this point. First let us explore a few other encounters with modernism.

Jungle Rhythms . . .

In 1952, at the age of 26, Aubrey Williams came to Britain (where he has now lived most of his life). He was escaping political upheaval in his

Plate 12.3 Maya Confrontation (II), Aubrey Williams, 1982, oil on canvas, 122″ × 183″.
By kind permission of Eve Williams.

homeland, Guyana, where he had already established himself as an agricultural field officer and social realist painter. Settling down in London, he studied at St Martin's School of Art. By the end of the 1950s Williams had developed a personal style of abstract painting and become quite famous. Art critics hailed the brilliance of his work – but with a twist.

However much they praised his achievements, they always referred to his race. They always constructed him as Other. Below is an example. It is from an article entitled 'Portrait of the Artist: Aubrey Williams', published in *Art News and Review* in 1959:

> These paintings of Aubrey Williams, [combining] instinct with power, and informed with a passion that at times borders on terror . . . express in essence a sense of being which differs from that of the European in the same way that the music of a spinet differs from the rhythm of a drum. Williams comes out of a society where . . . forms range from the organic to the urbane. This painter has used the calligraphy of the South American Indian, the physical image of the Guyana earth, the dreams of a people who live in a womb of forest, the colours and confusion of his land to feed and enrich a new and original art. His art reflects the instinctive sense of rhythm of the Negro fused with the mytho-poetic imagination of the Indian-Voodoo and the image of gods and man, the dreams born in cradles of a forest and brought to the city where twentieth-century man paces the pavements of destruction . . . (Quoted in Araeen, 1989b, p. 32)

This sounds like the response of some of the turn-of-the-century Western artists and critics who first encountered 'primitive' and 'tribal' art. Perhaps it is not really an article on Aubrey Williams's work but a review of a piece of 'savage art' in an early avant-garde Surrealist publication of the 1920s . . .

White artists have creative genius. Black artists have instinct and natural rhythm. In the above passage, the abstract painter, intellectual and political activist has been reconstructed as jungle savage. Primitivism, in its racist variant, lives.

> A VOICE: Welcome, my Coloured friend. There *is* a space for you in the modern art world – as an Authentic Primitive(ist). You are, by birth, what we have been trying to get back to. We can learn a great deal from you. Show us how you achieve such power, such emotion, such jungle rhythms . . .

Come now, you say, Aubrey Williams – professional, middle-class, well-educated, etc., etc. – could not have been routinely mistaken for a jungle savage. This must have been a singular unfortunate incident. Perhaps you are right again. Here is a more enlightened commentary on Williams's work:

His first paintings . . . were full of hints of tangled forests and African rituals. England has tamed him, which reduces the strength of his impact, and refined him, which gives him more subtlety and more clarity than he had five years ago. On balance, he has become more acceptable to European eyes but less powerful, though some of the original primitive urgency remains. . . . Not many of his contemporaries in this country can produce an abstract painting that 'carries' across the width of a room without the overemphasis of form or the crudity of colour which is too often used as a substitute for genuine urgency. (Eric Newton, in the *Guardian*, 3 January 1963[11])

'Tangled forests, . . . African rituals, . . . original primitive urgency, . . . tamed, . . . refined' – this is the language of admiration and control, the vocabulary of romantic racism. It is a voice with which we have become familiar: the-White-Man-as-Primitivist.

Actually, it is a particular variant of that voice. Earlier we encountered the imagery of THE INDIAN and THE EAST. Here, we have a dominant construction of THE BLACK. That is, *we have in this chapter encountered two different sets of racial imagery, two different (but overlapping) racisms.* They are:

JUNGLE SAVAGES versus EASTERN EXOTICS.

Praised but simultaneously banished from the age of modernity to that of the primitive, it is no wonder that Williams became ambivalent towards the art establishment.

A DISTRAUGHT VOICE: 'Whatever these artists do, the status and value of their work is already predetermined.'
— Rasheed Araeen, 'The Other Immigrant', 1991, p. 19

The exclusion of Aubrey Williams from the mainstream of British art is both tragedy and farce. Guy Brett notes:

My feelings about Aubrey Williams' paintings are made up of a mixture of pleasure and anger. I can't help seeing the richness of his colours, the power and scale of his best paintings, without at the same time being aware of the narrow-mindedness and lack of discernment of the art establishment which has prevented Aubrey Williams' pictures from hanging alongside those other British artists who are his contemporaries at the Tate Gallery. For Williams is not an eccentric or obscure artist. He handles the large scale, and belongs to a generation of artists who gave abstract painting an epic quality able to convey a wide emotional range, from intense conflict to a feeling of peace. And yet the sensibility and dynamism of his work is quite distinct. Seen alongside the painting of Alan Davie or Peter Lanyon for example, or a younger painter like John Hoyland, it would create astonishment visually. For colours are being forged in London which are unknown to the 'keepers

of the modern collections' and would change our perception of art produced here. (Brett, quoted in Araeen, 1989b, pp. 32–3)

The question we would ask here has already been asked by Araeen: 'Why is it so difficult to accept that those artists who are not European or white could have also been inspired and influenced by modern movements, and in turn could have produced original works of art? What is it that makes the British art world so blind that it is unable to recognise its own import- ant achievement?' (Araeen, 1991, p. 27).

A Meeting with Picasso

In the mid-1950s, while spending some time in Paris, Aubrey Williams became friendly with Albert Camus. Camus introduced him to Picasso. Here is Williams's recollection of that occasion:

> There was nothing special about meeting Picasso. It was a meeting like many others, except that meeting Picasso was a big disappointment. It was a disappointment for stupid little things: I didn't like how he looked; I didn't like how he behaved. I never thought I would not like people like that. But the total of the whole thing is that *I did not like Picasso*. He was just an ordinary past-middle-aged man. I remember the first comment he made when we met. He said that I had a very fine African head and he would like me to pose for him. I felt terrible. In spite of the fact that I was introduced to him as an artist, he did not think of me as another artist. He thought of me only as something he could use for his own work. (Araeen, 1987–8, p. 32)

In this encounter the young artist, who had the misfortune of being born Black, has been transformed into EXOTIC OTHER. Denied all agency, he has become an Object to be examined, measured, catalogued, painted. The legacy of nineteenth-century racism and colonialism has not been fully erradicated.

> TRUTH: The black man insists, by whatever means he finds at his disposal, that the white man cease to regard him as an exotic rarity and recognise him as a human being.
> — James Baldwin, *Notes of a Native Son*, 1964, p. 164

It would be absurd to suggest that Aubrey Williams's encounter with Picasso is typical of the encounters Artists of Colour have had with the 'White' Art Establishment. However, one of the main problems facing 'Black' and 'Third World' artists and intellectuals in the West is THE PROBLEM OF RESPECT – the problem of being taken seriously, of feeling

acknowledged as a professional who might, just possibly, have an important contribution to make. This problem, which also affects women intellectuals and artists, is a longstanding one. It lies at the root of the alienation often felt by 'Black' and 'Third World' artists in relation to the mainstream 'White' establishment.

Of Pop Art, Fame and Politics

Here is a story about one of Britain's most gifted artists. Here is a narrative of fame and fortune.

One of the Boys

Frank Bowling is originally from Guyana. He came to England at the age of fourteen to complete his schooling. When it came to the National Service, he volunteered to join the Royal Air Force. After spending three years in the RAF he left and decided to be a writer. In 1953 he stayed in Paris for a year, and also visited Holland and Germany. It was after seeing the work of Goya, Rembrandt and Van Gogh that he also became interested in painting.

Back in London again, he moved around in the circle of artists and art students associated with the Chelsea School of Art and the Royal College, and while modelling for life classes, decided to be a painter himself. After attending the City and Guilds School, he joined the Royal College of Art in 1959, with a scholarship, and became from the very beginning one of the most brilliant students. But after the first year, as a result of marrying the registrar of the college, he was asked to leave. He was then taken up by William Coldstream at the Slade, but after a term there he returned to the Royal College, where he finished his MA degree in 1962.

Although he was excited by the work of Frank Auerbach when he first saw it, his main influence was Francis Bacon, whose name has often been linked with his . . .

He was on his way to a successful career when things began to go wrong. Although he shared an exhibition with Derek Boshier, Image in Revolt *at the Grabowski Gallery in 1962, and considered himself part of that Royal College group (Hockney, Boshier, Kitaj, Phillips) which represented the emergence of 'new figuration' in Britain, he found he was being left out of group exhibitions, on the basis that his work was different from theirs:*

> *'We were all painting from newspaper cuttings, photographs, films, etc., but I wasn't allowed to be a Pop artist because of their preoccupation with what was Pop. Mine was to do with political things in the Third World. I chose my own themes, such as the death of Patrice Lumumba, because this was where my feeling was. So I was isolated. It was a racist thing anyway, the whole thing I did not paint Marilyn Monroe because she did not interest me. Kitaj did not paint Marilyn Monroe either; he painted* The Murder of Rosa Luxemburg. *Kitaj was closest to me in political preoccupation, and he was leader of the Pop. But what I was doing was not considered as such'*

After his exclusion from the important 'New Generation' exhibition at the White-chapel Gallery in 1964, which featured all his friends who were later to become famous, he was shocked. He was confused because he had received critical acclaim from almost every art critic of note and there was tremendous enthusiasm for his work. When he tried to find out why he was turned down he was told 'England is not ready for a gifted artist of colour.'

— Rasheed Araeen, 'In the Citadel of Modernism', 1989, pp. 37–40

Bowling was, literally, *removed from history*. The core problem has to do with the binary logic of racism: the notion of a BLACK AVANT-GARDE ARTIST is a contradiction in terms. Artistic creativity is the province of White people. Artists of Colour are by definition ETHNIC ARTISTS, not innovators but followers of tradition. It all follows logically . . .

Fame . . . But Outside of History

However, despite all their success they remained the Other, in the sense that their Otherness was constantly evoked as part of the discussion of their work . . . [A]nd in spite of the success of some of these artists, many people knew that there was something not quite right.

— Rasheed Araeen, Introduction to *The Other Story*, 1989, p. 13

Many of the Afro-Caribbean and Asian artists who migrated to Britain from the Empire in the 1930s, 1940s, 1950s and 1960s achieved consider-able recognition – from both the art establishment (critics, galleries, and so on) and a larger public. The brilliance of Ronald Moody, Francis Newton Souza, Avinash Chandra, Aubrey Williams and several other artists from various parts of the British Empire was widely proclaimed. However, this was fame at a cost: the cost, for most of this generation, was that of being removed from history.

FACT: Since art, as cultural investment and heritage, is one of the West's primary historical narratives, it is hardly surprising that the work of its institutions should not simply be to conserve its own myths . . . – by way of individual catalogues, national and international exhibitions and art history books, and prestigious awards – but [also] to suppress any historical posi-tion outside this agenda.

— Jean Fisher, Editorial in *Third Text*, 1989, p. 4

Here are Avinash Chandra and Rasheed Araeen in conversation again. The topic is the perception of Chandra's work as fundamentally an ex-pression of traditional 'ethnic art'.

RA: Once your work was shifted back into India's past traditions it helped create a distance between your work and what is considered to be the mainstream of modern developments, so that India no longer posed a threat to the West's monopoly of modernism. You got your reward for supposedly playing the game (by becoming a king for the day) and they carried on with what they always wanted – to continue monopolising and dominating the modern art scene, nationally as well as internationallyWhat I am really saying is that your success was due to the promotion of your 'Indianess', to which you perhaps unknowingly contributed

AC: But you forget one thing: I'm *Indian*. I don't have to make apologies for that. I'm nothing but Indian. I don't want to be anything else

RA: I'm not saying that you are not Indian. All I'm saying is that you are not an Indian of Tantra or Khajuraho. For me you belong to 20th century India, the India of Nehru, a secular and modern India We didn't struggle to go back to archaic traditions, whether they were Hindu or Muslim, although all the traditions are part of our common heritage. I don't think you particularly represent any of these traditions.

AC: Of course I'm not part of Tantra or Khajuraho. People have not understood my work (Araeen, 1988, pp. 93–4)

Now, as we all know, ETHNIC ART does not – indeed cannot, by definition – belong to the modern world. Those who produce it – and we know logically that this is all that non-White artists *can* produce – deserve to be outside of history, marginalized and excluded from the main currents of modern art. Why should any of us shed any tears over the fact that the Jamaican artist Ronald Moody

lived for fifty-three years in England. He had some exhibitions, with favourable reviews in newspapers and art journals. He appeared to be successful and contended that he never complained about anything; and he was particularly honoured in his country of origin, Jamaica, by two of the highest official awards. But he died in England in 1984 without receiving any official recognition from the British art establishment. (Araeen, 1989b, p. 19)

Further Dilemmas of the Postcolonial Artist

I always thought people would be nice here, but I was shocked when I came here. There were notices all over, saying: No Blacks, No Indians, No Irish, No Dogs, etc. It made me so sad and angry. And it was so cold in those days. Everything was cold!
 — Avinash Chandra, in Araeen, 1988, p. 70

Think of all those artists who came from Africa, from Asia and from the Caribbean. They all thought [Britain] was their mother country. What

*happened to them? But I have not lost hope. This is why I find myself keeping
on painting.*
> — Aubrey Williams, in Araeen, 1987–8, p. 41

Always an Ethnic Artist?

AN HONEST STATEMENT: 'I can say I'm Asian, Indian, Pakistani, British, Euro-
pean, Muslim, Oriental, secular, modernist, postmodernist and so on . . . '
— Rasheed Araeen, 'How I Discovered My Oriental Soul . . . ', 1992, p. 90.

THE RESPONSE: We say you are an Ethnic Artist . . . And, as we thought you
knew by now, it is our view that matters.

In 'The Other Immigrant: the Experiences and Achievements of Afro-
Asian Artists in the Metropolis' (*Third Text*› no. 15, Summer 1991), Araeen
argues that, as a result of the CONFLATION OF 'RACE' AND CULTURE (which is
a classic racist move, whatever the 'liberal' intentions), Asian and Afro-
Caribbean artists are assumed to share the 'problems' of 'their com-
munities'. 'Their communities', in turn, are viewed as UNDIFFERENTIATED,
as SOCIALLY MONOLITHIC (which is a Eurocentric or racist stereotype, how-
ever kindlyáit is said): one hears talk of '*the* Black community', '*the* Mus-
lim community', and so on.

The effect of this is to fail completely to understand the actual motiva-
tions and achievements of Artists of Colour: 'It is often forgotten that
most of the artists . . . came from already westernised middle classes, and
the ambition behind their migration had been to establish themselves as
professional artists in the metropolis and within the context of contem-
porary art practice' (Araeen, 1991, p. 19). Often their knowledge of and
interest in so-called 'ethnic minority cultures' was very limited indeed.
But these facts had little bearing on how they were received within the
Modern Art Establishment: indeed, as they are reduced to 'Ethnic Artists',
success in the world of Western Modern Art was ruled out. Listen as one
of the marginalized and excluded explains:

> After being reduced to 'ethnic minority' artists, and being thus denied their
> own *individual* aspirations, perceptions and experiences, black or Afro-Asian
> artists are removed from the authentic space or experiences of the modern
> age. As a result, all signs of modernity in their work become *in*-authentic
> representations, making it almost impossible to understand the real signifi-
> cance of their work in their broad social and historical contexts. (Araeen,
> 1991, p. 19)

As the debates in *Third Text* illustrate, self-definition by Afro-Caribbean
and Asian artists include a range of positions in which 'race' or ethnicity
has different meanings and various degrees of importance. The role of the

artist varies from that of committed, politicized cultural worker working within 'the Black community' to 'universal' artists working at the cutting edge of contemporary artist practice. Whatever their personal identity and cultural politics, Artists of Colour wish to be taken seriously as artists. They do not wish to be reduced to some stereotyped category, whatever the label. But sometimes this problem is very difficult to avoid, as the following discussion makes clear.

A Double Bind

STATEMENT: We are Black Artists
RESPONSE: Yes, we agree. And we have just the place for you.

Thus far, the discussion of Artists of Colour has focused overwhelmingly on artists from Africa, Asia and the Caribbean who, in the 1930s, 1940s, 1950s and 1960s, migrated to Britain. There is now another generation of Artists of Colour in Britain. These artists, unlike the pioneers, are not immigrants but British-born – a fact which has major implications for their political consciousness and artistic strategies. (Some of this younger generation are unashamedly militant. See, for example, Keith Piper's *Go West Young Man*, reproduced as plate 6.2.) None the less, many of the issues that faced the pioneers remain in one form or another, profoundly affecting the lives and work of the later generation. Take, for instance, the policies and practices of 'ETHNIC ARTS' and 'MULTICULTURALISM'. Behind these can be discerned, if one looks closely enough, a legacy of PRIMITIVISM and RACISM. This requires some explanation.

The first issue of *Third Text* includes a conversation between John Roberts, a leftist writer and art critic, and Sonia Boyce, an important Afro-British artist of the later generation. The conversation between Roberts and Boyce raises some of the central issues with which this chapter is concerned – in particular, issues of the relationship between Artists of Colour and the Art Establishment and, relatedly, issues of the artist's identity, politics and aesthetic choices.

Roberts begins the conversation by noting that 'over the last few years' Black artists in Britain have made 'Enormous gains . . . in terms of self-organisation, exhibition spaces, consciousness-raising and individual recognition.' He then suggests that the contemporary Black British artist faces a profound dilemma – a *double-bind*. He says that whereas the art and culture of people of Colour was previously perceived, 'in classic imperialist terms', as *primitive*, this is no longer the case – due to 'deeper ideological shifts in the Western colonial discourse' (see Araeen, 1987). Today – in the postmodern world? – the work of Artists of Colour is simply considered as *different* (Boyce and Roberts, 1987, p. 55).

Now, the space of difference would appear to be a space in which Black artists can work with a degree of control and dignity. There is, however, the problem of the legacy of classical racism (discussed briefly in chapter 9) and primitivism (discussed in chapter 11). Given this legacy, for the artistic products and practices of people of Colour to be categorized as 'different' is, as Roberts says, for them to be 'ETHNICIZED' and 'EXOTICIZED' as Other (see Boyce and Roberts, 1987, p. 55): *the space of difference which the Artist of Colour enters is already structured by racism, including the (often liberal) racism of modernist primitivism.*

> TRUTH: 'The institutional space which is available to the non-European artist is necessarily predetermined by his or her cultural [racial?] difference, and the recent debate about cultural identity in the West seems to legitimise this predetermination.'
>
> — (Rasheed Araeen, 1992, pp. 87–8)

This brings us to the DOUBLE-BIND: Artists of Colour tell 'bourgeois culture that black art is different and bourgeois culture replies by ghettoising and marginalising this difference' (Boyce and Roberts, 1987, p. 55) – as it ghettoized and marginalized the work of an earlier generation.

The Black Artist is caught in a trap. As many articles in *Third Text* suggest, the potentially progressive recognition by the (White) Art Establishment of 'Black art' as 'different' is far from problem-free. If establishment critics and curators most often ignore or dismiss Black British art, its categorization as ethnically 'OTHER' often functions as another form of marginalization.

> TRUTH: 'It is therefore necessary to turn the table over and recognise that the problem here is not that of other cultures but of the dominant culture, which insists that the 'other' must always be recognised through racial or ethnic differences.'
>
> — Rasheed Araeen, 1992, p. 88

As we have already seen in the chapters on primitivism and modern art 'DIFFERENCE', in a racially structured society and culture, continues to imply 'of lesser value'. The logic is as follows:

BLACK ART = CULTURALLY/'RACIALLY' DIFFERENT ART =
DE-VALUED ART

The very definition of works of art in terms of the racial or ethnic origins of their producers becomes *a site of struggle over value*. Often Afro-Caribbean, Asian and other Artists of Colour find their work effectively restricted to the category of 'ETHNIC ART', a process of marginalization that makes many of them wish to escape beyond the strait-jacket of race.

A SERIOUS QUESTION: 'Why should one carry one's own culture on one's shoulder in order to be able to distinguish oneself? Why should the non-European [i.e., non-White] artist alone be burdened with what seems to be an essentialism?

— Rasheed Araeen, 1992, p. 86

For example, in July 1986 there was an exhibition called 'From Two Worlds' at the Whitechapel Gallery in London. The exhibition featured works by African, Asian, Caribbean, Middle Eastern, Far Eastern and South American artists working in Britain. In her conversation with John Roberts, Sonia Boyce tells of how, when their work was selected, a few of the artists 'had problems being in such a show'. They were worried that 'the context would restrict how their work could be viewed'. They were not pleased about being categorized as 'Black artists'. Why? Because the category 'Black Artist', like 'Ethnic Artist', *is associated with the derivative and provincial, lacking credibility or status* (Boyce and Roberts, 1987, p. 59, emphasis added).

QUESTION: Who is an artist? What is legitimate artistic practice?

The rejection by many Afro-Caribbean and Asian artists of the category 'ETHNIC ARTIST' or 'BLACK ARTIST' reflects the negativity and ambivalence generally associated with these terms in mainstream critical circles. Traditional art criticism in the West privileges THE INDIVIDUAL ARTIST, not the artist as product of some social group or culture. Moreover, traditional art criticism lays claim to UNIVERSAL AESTHETIC STANDARDS AND VALUES (but these, as the hidden history of modernism reveals, are based in practice on the exclusion or marginalization of everything that is not part of the Western – read: White and bourgeois – 'High Art' tradition). Actually, twentieth-century art criticism, despite its cosmopolitan trappings, privileges Euro-American modernism – as we saw in chapter 10.

TRUTH: 'Modernism . . . one of the principle ideologies of artistic privilege, has persistently denied others a creative space within it.'

— Jean Fisher, Editorial in *Third Text*, 1989, p. 4

The problem is that 'Modern Art' is assumed in practice to be White, just as 'Ethnic Art' is assumed to be non-White. That is, 'Ethnic Art' does not mean Greek, American, British, German, Italian or French art, but the art of the Africans, Asians, American Indians, Muslims, Chinese and so on.[12] Thus Afro-Caribbean and Asian artists who draw on European modernism tend to find themselves classified as inconsequential, 'derivative' and 'inauthentic': reduced to 'Ethnic Artists', their work is constructed as both

marginal and implicitly inferior to proper Modern Art. By definition the Ethnic/Black Artist, like the Primitive/Tribal Artist, does not – indeed cannot – belong to the modern age. It all follows, logically.

> ANOTHER SERIOUS QUESTION: 'What if the non-European artist is a modernist or an avantgarde artist, and has turned the whole thing upside down; that is, he or she has challenged the very notion of the Other by actually climbing all the heights of the modernist citadel and occupying one of its pinnacles? . . . Do we have a discourse or framework which can recognise the value of this kind of occurrence? If we do not, as seems to be the case, should we dismiss this historical achievement on the basis that it cannot be authentic, just because the origin of the artist is not [White] European?'
> — Rasheed Araeen, 1992, p. 86

The implications of the above discussion for White – that is, White-thinking – cultural critics and arts administrators are clear. They must work to transform the often implicit racist assumptions that still inform attitudes to the work of Afro-Caribbean and Asian artists in both critical writing and funding strategies. One key factor here is the awareness that neither race nor culture, neither ethnic origin nor identity, has a singular meaning. It is ridiculous to reduce the work of Afro-Caribbean and Asian artists to constructions based on ethnicity or race. It is patronizing and insulting to de-authorize their work and confine them within the chains of a new primitivism.

In part the issue here is the one foregrounded, in a particularly poignant way, in the recollection of the young Black artist's encounter with Picasso. It is the issue of PROFESSIONAL RESPECT.

Negotiating Identity

For many Asian and Afro-Caribbean artists and intellectuals in Britain, whether immigrants or British-born, a key issue is that of establishing an identity that engages with both their communities of origin (Afro-British, Caribbean, East African Asian, Pakistani, West African, and so on) and the dominant 'White' cultural mainstream. This relationship is worked out, sometimes painfully, in different ways by different people.

Sonia Boyce, who is British-born, says that her identity as a person and an artist has been defined against both the White mainstream (as represented by her experience of art college and the exhibition circuits) and a narrow pan-African Black nationalism (Boyce and Roberts, 1987). Black nationalist cultural politics suggest that there are appropriate forms of expression for Black artists and that these artists have a 'responsibility' to 'their communities'. Not all Afro-Caribbean and Asian artists subscribe to

such a notion. And even when they do, they do not necessarily have the same idea of what 'their community' is.

This point emerges clearly in articles and dialogues in *Third Text*. The second issue of the journal includes an interview with Aubrey Williams, the Afro-Guyanese painter. The interview is conducted by Rasheed Araeen, the journal editor. Part of their discussion concerns THE QUESTION OF IDENTITY. Listen in. The conversation is already in progress . . .

RASHEED ARAEEN: But why the Maya or Aztec? Why not Africa?
AUBREY WILLIAMS: Because this is my field of study. This is my subject. Now let me tell you something about the Maya. Let me tell you something vital about the Maya . . .
RA: No, no. You don't have to go into all this. The point I'm raising is different . . .
AW: It's very crucial what I'm saying, *Why the Maya?* like those people who say to me, *why Shostakovich?*[13] And I have to answer. I have all five races inside me, but the dominant one is West African – Ghanaian or Nigerian. Flowing through me are all these things, but the question is towards which pole I give my identity direction. I have to give it to Africa, because that's the predominant part of me. My history is the black history. By 'black' I mean those who have been persecuted as slaves: fifty million in the middle passage that nobody bloody well talks about. We hear of six millions and we hear this and that, but who talks about fifty millions? You know, around fifty millions were thrown into the middle of the Atlantic. Don't worry about the odd millions killed on the plantations. This is my black history But when a Guyanese or a Jamaican puts on that dashiki or fez and says 'I'm African', he's synthetic. He is so synthetic, it isn't true. You understand? It's fake. Africanness is put on with the dashiki and it is taken off with the dashiki . . .
RA: There is nothing wrong with 'synthetic' identity. And it is also understandable why so many people turn to their countries of origin for roots and identities. The problem with this kind of identity is that one gets trapped in what I call 'ethnicity'. Okay, you are not putting on an African dashiki. But it can be said that you are putting on a pre-Colombian dashiki. How would you answer to that?
AW: I don't have to answer to that. What else have I got? I have come out of South American earth, South American history and South American happening. I have drunk that water and I have eaten out of that earth. No, I'm just being myself. But nobody will accept that. Not even you: you question it, you see. But there is no other driving force in my art. (Araeen, 1987–8)

Williams's cultural identity is not fully 'consistent' with his 'racial' appearance. Are we to say that his identity is *inauthentic*? That he has *false consciousness*?

Only if the logic we employ is the logic of racism.

Beyond Western Influences?

The conversation between Williams and Araeen ends with Williams engaging in thoughtful discussion of the dilemma of the 'Black' or 'Third World' artist living in the West but seeking to create work that lies outside or beyond dominant Western artistic practices. Aubrey Williams's reflections, which at times seem to suggest a deep inner pain, grow out of his struggles over some 40 years as a professional artist.

> AUBREY WILLIAMS: Well, we use Western material. I can't go back to grinding pigments and using fats. It would be stupid. You have to use modern material.
>
> RASHEED ARAEEN: But, Aubrey, I don't see anything wrong with the European connection. It's not inauthentic. And I don't see that there is any compromise in terms of the work being related to Western culture whatsoever. . . . There is a European presence, of course.
>
> AW: There is. I can't get rid of it.
>
> RA: You don't have to. The significance of your work is in fact in the interrelationship between the European presence and what you call part of your own cultural history. It's a *critical* relationship.
>
> AW: I'm not interested in the European adherence. I'm not interested. I pay respect to European achievement in visual arts as I do to cultures such as Egyptian, Indian or Chinese.
>
> RA: Why do you find the 'adherence' to European art in your work disturbing?
>
> AW: Because of the historical background. [Presumably the reference here is to slavery, colonialism, cultural imperialism.]
>
> RA: Are you trying to get rid of it?
>
> AW: All my life I have been trying to get rid of it.
>
> RA: Can you really get rid of it?
>
> AW: I don't know. If we can get rid of it ourselves, it will be a great achievement. I don't think getting rid of economic structures or changing them is enough. We have to find new values, new directions, which we can now do only with the coming generations. Not so much with ourselves. We have to have the machinery to do this, a platform, you understand? (Araeen 1987–8, pp. 51–2)

It is worth contrasting Aubrey Williams's position with that of European 'primitivists'. Williams does not go to pre-Colombian art as a means to formal innovation in modern Western art but as a means to a positive identity in a racist world. He is not interested in exoticism or eroticism but in a radical cultural politics that speaks to problems of postcolonial societies. His concern is not with past 'Utopias' but to address the oppression and destructiveness of Western technological society.[14]

Can Artists of Colour living in the West create art that avoids or sur-

passes the European presence'? *Is such an art possible* (in the world in which we live)? *Is such an art desirable*, for example, for those artists concerned to produce art that helps to raise consciousness and assist in the struggle for racial justice and liberation? For Aubrey Williams, born in a multi-ethnic South American society, the struggle is to engage with pre-Colombian artefacts and imagery (in particular, Mayan iconography). For others, the quest is to raise 'Black Consciousness' and/or create a 'Black Aesthetics'.

The Problem of Society

As we have already seen, the dilemmas faced by Artists of Colour do not simply grow out of encounters they have with the Art Establishment and the practices of modern art.[15] Many of them have to do with daily life in an ethnocentric, Eurocentric and racist society.

Walking with Friends

Walking home from Kilburn to South Hampstead, I suddenly come across some skinheads on the other side of the road. As soon as they see me they start chanting together: 'Paki, Paki, Paki'. I stop. I try to show my anger. I'm actually holding in one hand a big spanner which I have just bought. They stop chanting. I resume my walk towards home. They start chanting again. But I ignore them, and carry on walking. I'm really shocked. It is the first time in eighteen years in Britain that anybody shouted 'Paki' at me (like shouting 'nigger' at an African). I thought it would not happen to me personally. I'm often told that I look more like a Greek or Spaniard [than an Indian or Pakistani]. I was really frightened when I was facing them, but I could have killed one of the bastards if they had come near me. . . .

A few weeks later I'm walking with a white liberal friend, going home from the pub. He is actually an important person in the art world. There are some white kids (age about 10 to 14) around the street corner. They laugh and shout 'Paki' as we pass by. One kid comes near and tries to touch me. My friend laughs as well. He thinks it is very amusing. But I feel terrible and walk in silence. They are only kids, he says to reassure me.

— From Rasheed Araeen, *Making Myself Visible*, 1984

The Other Story: A Hidden History of Artists and Modernism

The Other Story is not an attempt to rewrite history, but to present the simple fact that historiography has been an exclusive construct that has

written out of British art history the contributions, and existence even, of its 'Other' artists.

— Jean Fisher, 1989, p. 4

At a conference on 'British Art in a Century of Immigration', held in Norwich, England, in March 1991, Rasheed Araeen talked at some length about what he had hoped to achieve by *The Other Story* exhibition and how the art establishment, in particular the critics, had responded to it. Below are some extracts from that talk, together with some statements from Araeen's introduction and postscript to *The Other Story* catalogue. We present this material as a dialogue in order to foreground some central issues. We invite you to listen in:

ARAEEN: *'The Other Story* exhibition took me more than ten years to realise. It was a difficult struggle, and at times I almost gave up in desperation. But I'm now glad that the exhibition has taken place, whatever its merit, and ultimately it should be the responsibility of this society to respond to it in a manner which can uphold its humanist claims and intellectual integrity' (Araeen, 1991, p. 23).

QUESTION: What, in a word, was the main point of *The Other Story*?

ANSWER: 'To question the entrenched white nationalism of British art' (ibid., p. 25).

QUESTION: How did you propose to do that? What were your objectives for the exhibition?

ARAEEN: 'The main objectives of the exhibition were to give material evidence of the contribution of Afro-Asian artists to mainstream British culture in its postwar period; and to celebrate this achievement in a big way, not at the margins but in a major institution of this country. It was hoped that this would surprise those who are concerned with art and inform those who seek knowledge, and would also help to generate a debate in light of new information provided by the exhibition about the nature of postwar British art and what has been repressed by its official art history' (ibid., p. 23).

QUESTION: What is this 'repressed history'? Whose story is it? Why is it important?

ARAEEN: 'It is a unique story. It is a story that has never been told . . . a story of those men and women who defied their "otherness" and entered the modern space that was forbidden to them, not only to declare their historic claim on it but also to challenge the framework which defined and protected its boundaries. My attempt to tell this story pays homage to this defiance. My own struggle as an avant-garde artist (in the West) has been fundamental in my realization of the issues, and without this struggle it would not have been possible for me to recognize the importance of this story. However, it is not

the only story. There are many more, and I believe it is crucial, in our attempt to recover our place in history, to, as Edward Said says, "tell other stories than the offical sequential or ideological ones produced by institutions of power" ' (Araeen, 1989a, p. 9).

QUESTION: How would you classify the artists you have included? It is common these days to talk of 'Ethnic Art' or 'Black Art'. Are these categories you would use here?

ARAEEN: 'The uniqueness of Afro-Asian achievement is that it does not represent separate categories of "ethnic arts" or "black art" but is firmly located within or in relation to the mainstream; it reflects the complex articulation of modern developments in art that have taken place in post-war Britain' (Araeen, 1989e, pp. 105–6).

QUESTION: Well, if the struggles of African, Asian, Caribbean and Black British artists here have been struggles *within or in relation to* the mainstream' of modern Western art, why is this history so little known?

ARAEEN: 'It seems that the anomaly faced by black or AfroAsian artists is the ideology of Western culture, or modernism, which separates its historical formation from that of what it considers to be its racial Others. In so doing, it marginalises the "others" by relegating them to past histories' (Araeen, 1991, p. 23).

QUESTION: Are you saying that modern art and the British Art Establishment are Eurocentric and racist?

ARAEEN: 'There would have been no need for such an exclusive exhibition if it was not for the intransigence of those who still believe that British art is the exclusive domain of *white* artists. The exhibition clearly demonstrated that this was not so. AfroAsian artists have been participating within, and in relation to, the mainstream, and also have been bringing to it something which was otherwise missing from it: the black immigrant's [and Black British] experience of the metropolis and its modernity' (1991, p. 23).

QUESTION: Why weren't more women artists included in *The Other Story*?

ARAEEN: 'The issue of equal gender representation remains unresolved here. We have included only four women artists, which is regrettable. But this must be understood in terms of socio-historical factors, rather than through continually repeated rhetoric It seems that in the 50s and 60s 'black' women artists who had come here from Africa, Asia or the Caribbean returned home when they completed their education, unlike male artists who stayed on. On the other hand, black women artists who have recently emerged were either born and brought up in Britain, and they have no choice but to assert their presence here. They are an important part of our Story' (Araeen, 1989e, p. 106).

QUESTION: It is obvious that *The Other Story* revealed an important, hitherto hidden history of contributions to mainstream British culture – to its 'High Art'. How was this received? You said earlier that a main objective of the exhibition was to generate debate about the nature of modern, postwar British art. Did it in fact do so? Has it led to rethinking among art critics, historians and educators?

ARAEEN: 'What actually happened, as far as any debate was concerned, can only be described as pathetic. While about 25 thousand people visited the Hayward Gallery, and showed tremendous enthusiasm and admiration for what they saw in the exhibition, the media had a field day in renouncing and denouncing it. In one way this was seen to be good, because this controversy created some publicity; but beyond that it was the same old story. . . .

There was a total lack of critical and rational response, and an unprecedented hysteria and pettiness, not from the general public, but from those who have a highly respected place in the art world. Is this an indication of a bankruptcy of the established framework, or of something more serious? The irrational and outright dismissal of the exhibition by the critics was quite common. . . .

Most critics dismissed the exhibition on the basis that it represented mediocre, second-rate or derivative works, and that they were not surprised that these artists were not recognised, bla, bla, bla. . . . Some also used the success of Anish Kapoor to confuse the issue. It is difficult to mention every critic, but the general attitude was summed up by Brian Sewell whom I would like to quote here at some length. Writing in *The Sunday Times Magazine* [26th November 1989], he begins by asking the question: "Why have Afro-Asian artists failed to achieve critical notice and establish a London market for their work?" He then answers himself: " . . . they are not good enough. They borrow all and contribute nothing." He then continues to conclude:

The dilemma for the Afro-Asian artist is whether to cling to a native tradition that is either imaginary, long moribund, or from which he [*sic*] is parted by generations and geography, or to throw in his lot with an ancient tradition of white western art, from which he borrows, but with which he has scant intellectual or emotional sympathy. Whichever he chooses, he must not require praise, nor demand a prime place in the history of art, simply because he is not white. For the moment, the work of Afro-Asian artists in the West is no more than a curiousity, not yet worth even a footnote in any history of 20th-century western art.

What do you make of it? I don't have to tell you again what underlies this sort of attitude. It's clear that Mr Sewell was unable to understand or come to terms with what he saw. I have been told that I should not pay much attention to him, even though he was "Critic of the Year",

because he has an eccentric rightwing position. I take the point, but I have yet to encounter a debate in the mainstream art press which would contest Mr Sewell's views or put forward a sympathetic or different understanding of the exhibition' (Araeen, 1991, pp. 23–6).

QUESTION: What is this idea that Black artists 'borrow all and contribute nothing'? What do you make of the fact that so many White critics see the work of Black artists as 'derivative'? It sounds rather like nineteenth-century racism to me – you know, the idea that Black people have no original thoughts or contributions, that we can never be intellectually or culturally on the same level as Whites.

ARAEEN: 'Most critics used the word "derivative" to define the works in the exhibition. But what do we mean by this word? Aren't new ideas "derived" from old ones? Don't ideas travel from one place to another, from one individual to another, from one culture to another, to achieve their historical transformations? The word "derive" is not the word I would use, and I have therefore put it in quotation marks. What I'm really concerned with are inspirations and influences. There is nothing unusual or wrong in artists being inspired and influenced by others. . . .

Why is it so difficult to accept that those artists who are not European or white could have also been inspired and influenced by modern movements, and in turn could have produced original works of art? What is it that makes the British art world so blind that it is unable to recognise its own important achievement?' (Araeen, 1991, pp. 26–7).

QUESTION: What do *you* think it is?

ARAEEN: 'The simple answer to all this would perhaps be that British society has not yet accepted AfroAsian peoples as its equal citizens, and it then ignores their contributions on one pretext or another, because their achievement goes beyond the "ethnic" framework which this society has constructed to contain them as Others. Many AfroAsian artists have defied this framework, and it seems that this is seen as a threat to the established order' (ibid., p. 27).

QUESTION: But how good is their work? Was the point of the exhibition to put forth the thesis that they have produced great art?

ARAEEN: As for the artistic or aesthetic merits of the works, these were open to critical scrutiny. In fact, we made no extraordinary claims, except that what was being presented was a part of this society's postwar transformational processes, and therefore it belonged to its history. We did not expect our claim to be taken for granted or accepted without it being subjected to the critical processes by which all artistic or aesthetic qualities are evaluated . . .' (ibid., pp. 23–4).

QUESTION: The problem is that it was not subjected to such processes, that it was not taken seriously.

ARAEEN: Yes.

Reflections

TRUTH: The non-European – that is, the non-White – has never been outside modern art but its invisible and unacknowledged centre.

ANOTHER TRUTH: 'If the story of AfroAsian artists in Britain is a story of important achievement, it is also a story of failure. It is a story of the failure of this society to understand this achievement. It is a sad story of paternalism, indifference, complacency and cynicism on the part of those who think themselves to be enlightened . . .

It seems that the anomaly faced by black or AfroAsian artists is the ideology of Western culture, or modernism, which separates its historical formation from that of what it considers to be its racial Others. In so doing, it marginalizes the "others" by relegating them to past histories.'

— Rasheed Araeen, 1991, pp. 20 and 23

The arguments of this chapter are closely related to those of chapters 10 and 11. In this final section we would like to summarize and foreground some of the central issues that have emerged in the preceding discussions. These have to do with liberal institutions and their Others – in particular, the cultural politics of inclusion and exclusion, containment and resistance.

Our argument is *not* that the Modern Art Establishment is a segregationist institution that systematically bars Artists of Colour and/or art from the non-Western/non-White world. (Sometimes it does work like that, but such occasions are quite rare: the Modern Art Establishment is, after all, a network of *liberal* institutions.) Rather, our concern has primarily been with the terms on which they have been *included*. Far from always being excluded, Artists of Colour – like 'primitive' art, jazz and Josephine Baker in Paris in the 1920s – have often been WELCOMED.

We are interested in how they have been welcomed. Who has done the greetings and on what basis? What is at stake in having been invited to the party?

TRUTH: Racism does not work by prohibition alone.

Official Stories/Other Stories

[D]ominant narratives are units of power as well as meaning. The ability to tell one's story has a political component; indeed, one measure of the dominance of a narrative is the space allocated to it in discourse.

— Edward Bruner, Introduction to *The Anthropology of Experience*, 1986, p. 19

It is commonplace these days, due to the impact of poststructuralist and postmodernist thought on contemporary intellectual life, to hear assertions that meaning and 'truth' are always *'plural'*, that all accounts are *'partial'*, that there are only *'competing'* stories. We have seen from the discussion in this chapter (and before) that there is more than one story of the development of twentieth-century art: one story is that postwar modern art is a (White) Euro-American invention, another is that it is the invention of artists from many countries, including Artists of Colour. We have also seen competing constructions of identity: *I* see myself as modernist painter but *they* see me as Indian traditionalist or Islamic artist.

The point we wish to emphasize is not simply that there are always different meanings and stories but that *some accounts carry more weight than others. Meanings – representations, accounts, stories, histories – are products of power*. They reflect and reproduce different degrees of authority and legitimacy. Their tellers have different amounts of material resources and occupy a hierarchy of social positions. There are *dominant stories* and *subordinate stories, official histories* and *hidden histories, authoritative accounts* and *other accounts*. Stories are terrains of struggle – instruments of domination or weapons of resistance.[16]

But what exactly are dominant, 'official' or authoritative stories? How do they work? Drawing to some extent on Foucault and Bakhtin, the American anthropologist Edward Bruner has argued that within institutions and societies there are 'DOMINANT NARRATIVES' (or OFFICIAL STORIES) of particular historical eras. That is, there are stories that: (1) are 'most frequently told', (2) serve as 'guiding paradigms' and (3) are 'taken for granted' as 'the accepted wisdom of the time' (Bruner, 1986, p. 18).

Why are dominant narratives important? Because 'they become the major interpretive devices' by which experience is understood, organized and communicated (ibid.). They tell us what is right or wrong, beautiful or ugly, important or inconsequential, proper art or 'traditionalism'. They convince us, despite the evidence to the contrary, that Indian painters only produce 'Indian art', that Aubrey Williams's modernist paintings amount to jungle rhythms, that Rasheed Araeen's minimalist sculpture is 'Islamic art'.

Dominant narratives tend to be ideological: taken for granted as common sense, they remain largely unexamined. It is mostly irrelevant whether they are actually true: spoken from a position of power and authority they are uncritically accepted as true.

'Only in a later time period, in a different social space or in a new phase of history can we adopt the perspective that enables us to see these narratives for what they are – social constructions' (ibid). Thus, the stories this chapter tells are from 'a different social space': not from the mainstream of the Modern Art Establishment but from its margins, not from the perspective of the dominant social group (White, male, middle-

class . . .) but from that of society's Others. Our stories – our Narratives from The Others – are also mostly told from 'a later time period' or 'a new phase in history': most of the incidents recounted occurred in the 1960s (which is not to say that similar incidents do not still happen . . .).

A crucial point about OTHER STORIES, alternative, competing narratives, is that they 'are generally not allocated space in establishment channels' – in 'official' publications, in mainstream education, in prestigious exhibitions, in 'legitimate' criticism. Alternative stories must seek expression outside the mainstream – in marginalized and dissident groupings, in underground and radical media (ibid., p. 19). Thus, *Third Text*, to take one example, provides a context in which counter-hegemonic voices may be heard.

Actually, sometimes alternative stories *do* manage to get within the mainstream. – For example, after years of negotiation, *The Other Story* exhibition got into London's Hayward Gallery (one of the most prestigious modern art exhibition spaces in the Euro-American world). But once there, they may be vilified by The Critics . . .

A VOICE: Even when you win, you lose!

Marginalized, Excluded, Objectified . . .

What has happened to Artists of Colour? Why have they failed to enter history? By now you should know: they have been marginalized, excluded and objectified. Remember the ENCOUNTERS presented earlier.

A VOICE: Here, our history was lost. In the case of 'primitivism', it was stolen.
ANOTHER VOICE: 'I would have thought that you would have preferred to be outside history.'
— Rasheed Araeen, 1987, p. 24

• **Marginalized** Avinash Chandra, a young modern artist, goes to a gallery in London's West End to show his work. The owner welcomes him. Seeing that the young artist is Indian – and thus, by definition, an 'ethnic' or 'traditionalist' artist (it all follows logically . . .) – the gallery owner is well pleased. Traditional and 'primitive' ethnic art sells. Knowing a good find when he sees one, the gallery owner asks the young modernist (who happens to have brown skin) if he can paint tigers and elephants . . .

Balraj Khanna says he knew a number of young artists from India who were living in London in the 1960s. Some of them managed to make a living – 'If they could paint fisherwomen on the Malabar Coast or tigers and elephants in the jungle of Mysore' . . .

Avinash Chandra became famous in Britain – as a painter in the Tantra and Khajuraho traditions. The fact that he knew nothing about these traditional Indian forms did not stop the critics (who know about these things ...) from categorizing him as Britain's leading practitioner of them.

- **Excluded** By the early 1960s, Frank Bowling has a master's degree from England's Royal College of Art (having been one of their most gifted students) and is on his way to a successful career as an avant-garde artist. He is one of the boys, part of that Royal College Group – David Hockney, Derek Boshier, R.B. Kitaj, Peter Phillips – who became internationally acclaimed as Pop artists. In 1964 there is a major exhibition, the 'New Generation' exhibition at the Whitechapel Gallery, which featured all the boys who were later to be famous. Bowling is specifically excluded. He is told, 'England is not ready for a gifted artist of colour ... '.

 The art world, it would appear, is a club with a restricted membership. Without the correct membership card – Whiteness, Maleness, the Proper Art School – one may be excluded.

 Excluded from what? From exhibitions, from patronage, from reviews ... from history – like the artists of Africa, Oceania and Native America whose genius was simultaneously exploited and rendered invisible by the modernists.

- **Objectified** Albert Camus introduces Pablo Picasso to Aubrey Williams, a fellow artist, in Paris. The young Williams is very pleased, largely because he thinks of Picasso as a kindred soul: he, like Picasso, has been profoundly influenced by non-Western art; he, like Picasso, is an immigrant and cosmopolitan; he, like Picasso, is not adverse to mobilizing art in the struggle against fascism and racism; etc., etc. But Picasso does not see a fellow artist, only an object to be exploited – like a 'primitive' mask, statue or drawing. Here is Picasso's first comment to Williams: 'You have a very fine African head. I would like you to pose for me' ...

- **Ethnocized** The distinguished English gentleman, Professor of Fine Art at the University of London, looks around Rasheed Araeen's studio. The gentleman interprets the artist's minimalist sculpture as Arabic or Islamic: 'I cannot imagine a European doing this work' ...

QUESTION: Who is to be included in the identity parade of twentieth-century thinkers and artists?
RESPONSE: Not you, if your skin is brown.

Modern Art prides itself on its liberalism and cosmopolitan attitude. None the less, the testimonies of artists who happen to have brown skin indicate, in case after case, that they are pushed from the universal to the particular, from artist to 'ETHNIC ARTIST'. This is Avinash Chandra's story, Aubrey William's story, Rasheed Araeen's story, Sonia Boyce's story . . .

Arguably the most common feature in the biographies of Artists of Colour is this: they have been 'ETHNOCIZED'. Perhaps you are not familiar with this term. Here is a dictionary definition:

> **Ethnocize** v. (*ethnocized, ethnocizing*) **1.** *to exclude from universal humanity* **2.** *to reduce to an ethnic Other* **3.** *to categorize and confine through the exercise of White Power.*

The Conflation of 'Race' and Culture

We have encountered this sort of attitude before – in the discussion of the modernist stance *vis-à-vis* 'primitive' and 'tribal' art(ists). Whatever the intentions of those who hold it (many of them are 'liberals' on questions of race and pride themselves on being cosmopolitan), this is a racist attitude.

As we indicated in a previous chapter, one of the hallmarks of classical racism is a conflation of RACE and CULTURE.

> TRUTH: There is no more racist idea than the belief that one can determine the intelligence, character and cultural dispositions of another (An Other) simply by looking at him or her.

If you think that Gita should paint elephants and tigers because she is Indian, that is a racist assumption. If you see jungle rhythms in your Afro-Caribbean student's paintings, you are undoubtedly looking through racist blinkers. If you are absolutely certain that the world of avant-garde 'High Art' does not belong to people of Colour, you have been duped by racist logic.

> TRUTH: As C. L. R. James used to say, classical music belongs to West Indians too . . .

There is a long established tradition in Western art history and criticism which sees the work of art as the 'expression' of the Artist's inner being. In the EXPRESSIVE THEORY OF ART, the painting, sculpture, and so on is viewed as the unique expression of the artist's emotions, thought and character. Most of the encounters we have discussed in this chapter involve the use of an expressive theory of art – *but with a difference*. Instead of assuming that the work of art is the expression of the artist's INDIVIDU-

ALITY, it is assumed to be the expression of the artist's ETHNICITY or CULTURE.

The conflation of race and culture coupled with this modified expressive theory of art provides the ideological grounds for the removal of Artists of Colour from modernity. The logical reasoning involved, which is impeccable, can be formally expressed as follows:

AN EXPRESSIVE THEORY OF ART + A CONFLATION OF 'RACE' AND CULTURE	\longrightarrow	THE ARTIST OF COLOUR CONSTRUCTED AS 'ETHNIC ARTIST' OUTSIDE OF MODERNITY

It must be said that Artists of Colour, like other professionals who happen not to have been born White, resent being marginalized, excluded and objectified. They do not like being constructed as outside of history and modernity. Indeed, one issue that hounds them is THE PROBLEM OF RESPECT. They wish to be treated as you would – as a professional with something to offer.

Primitivism and the Artist of Colour

TRUTH: *'The 'primitive' can be put on a pedestal of history (Modernism) and admired for what is missing in Western culture, as long as the 'primitive' does not attempt to become an active subject ...'*
— Rasheed Araeen, 1987, p. 8

The main underlying argument of this chapter is that, although they may seem to be disconnected states of affairs, there is in fact a close connection between the history of 'Primitivism' in Modern Art and the experiences of Artists of Colour in the West. *Fundamentally Modern Art (Modernism) treats 'primitive art' and non-White artists in the same way – certainly this is the clear evidence from the British case.* Consider the following points.

1 **Artists without individuality** We noted in chapter 11 that Western art history focuses on INDIVIDUAL ARTISTS and their work (and on the historical unfolding of artistic movements) – with one exception: art from the 'primitive' and non-Western world is viewed not as the product of individual genius but 'of a nameless person who is representative of his [or her] whole community and who unreflectively obeys the precepts of a time-honoured tradition' (Price, 1989, p. 65).

Now obviously, the Artists of Colour working in the West are not literally NAMELESS. However, there is a certain disturbing pattern: instead of seeing Avinash Chandra, Saleem Arif or Balraj Khanna, the Art Establishment sees 'Indian Art'; instead of seeing Sonia Boyce, Lubaina Himid or Mona Hatoum, those who know see 'Ethnic Art'. How does this occur? How is the artist – that is to say, the Artist of Colour, denied the role of ACTIVE SUBJECT?

2 **Artists without creativity** As we have seen in case after case, the work of Artists of Colour tends to be seen as the product of TRADITION, for example, 'traditional Indian art', 'West African art' or 'Islamic art'. (Sometimes it is even seen as INTUITION, for example, the soul of the Jungle). The effect of this move, which treads dangerously close to classical racism, is to deny Artists of Colour proper status as *individual* artists. Reduced to ETHNIC ARTISTS and TRADITIONALISTS, they are constructed as creatures of habit rather than exemplars of genius. In a culture (the modern art world) where tremendous emphasis is placed on individuality, creativity and innovation, it is precisely these qualities which Artists of Colour, like the 'Primitives' before them, are denied. Their work is DE-AUTHOR-IZED.

AN ECHO: We must make their individuality invisible, so as to exclude them from history . . .

3 **Artists outside of History** Among the most deeply rooted notions in Western intellectual and popular culture is the notion that *history is divided in two* (the West is a culture in which binary logic reigns supreme). WE, modern Europeans and Americans, live in the MODERN AGE, while THEY, the 'Third World' and the Primitives, live in the TIMELESS AGE OF TRADITION. When the artwork of Artists of Colour is defined in terms of 'traditional' art forms and when they themselves are defined as 'representatives' of 'traditional' cultures, then they have been banished from the Age of Modernity to a mythic and timeless past. The Artist of Colour is constructed as Outside of History: rather than contributing to modern art, she or he, like the Primitive Artist, is merely the Passive Servant of Tradition (Price, 1989 and 1991).

A MUFFLED VOICE: We are those who, again, have been banished from history and modernity.

4 **Not dialogue but appropriation** Whatever its faults, Primitivism at least involved dialogue with The Other – Picasso critically engages with African art in order to understand its formal principles and power; Moore engages in dialogue with 'primitive' sculpture and changes his practice as a result; Gauguin goes to Polynesia and dis-

covers the meaning of life; Dada goes to a voodoo ceremony and learns the power of ritual . . . Obviously, this 'dialogue' with 'primitive' and 'tribal' art has been rather one-sided: it has been on the terms of The West. But in the case of the Artist of Colour in the Western metropolis, dialogue is absolutely minimal if not nonexistent: there is no attempt to learn from the Artist of Colour, only to categorize and contain her. The Artist of Colour has even less to offer 'Modern Art' than her 'primitive' sister.

Cultural Overseers . . . and the Problem of Respect

The story of 'Primitivism' (which was explored, in part, in chapters 10 and 11) is not a story simply of how the 'art' of Africa, Oceania and Native America has profoundly influenced the development of modern Western art. It is also a story about MEANING – about dominant and subordinate meanings. For the 'primitive' and 'tribal' art that the Western artist has encountered 'has had no value or identity until it has been "understood", mediated, transformed and circulated by the West' (Roberts, 1990a, p. 184). The question of what a given piece of art might mean in the cultural context out of which it arose is simply irrelevant. (Modern art is not anthropology.) The only question is what does it mean *to us*: the materials we appropriated are subordinated to the categories and assumptions – to the hierarchical judgements of worth – of Western culture and Modern Art. The art of Others is – always, it seems – mediated and judged by us.

AN ECHO: The White Man remains mediator and judge . . .

And so it is with the works of art produced by Artists of Colour in the West. In the case-studies of this chapter we have seen repeated examples of this phenomenon occurring within the institutional structures of modern art in Britain: abstract Expressionist painting (which happens to be produced by a person of Indian descent) is judged by Those Who Know to be 'traditional Indian'; minimalist sculpture (which happens to have been produced by a person born in Pakistan) is judged to be 'Islamic'; and so on. That is, the works of Artists of Colour are mediated by a cultural logic that is grounded in the ideology of primitivism. Indeed, it is arguably the case that the CULTURAL OVERSEERS (we borrow this term from bell hooks) construct most work by Artists of Colour as either substandard or a kind of exotic entertainment. Here, art history and criticism functions – inadvertently, no doubt – as an ideology of racial difference.

QUESTION: 'Is there any function for other cultures in the modern world beyond offering exotic entertainments?'

— Rasheed Araeen, 1991, p. 21

The Cultural Overseers – in our case, art critics, curators, patrons, art dealers, art historians and other GATE-KEEPERS – may *celebrate* difference, but they also *contain* it. They appropriate the Other – on their own terms. The Other is welcomed, so long as she keeps her place – as an exotic plaything, as an ingredient to spice up the lives and culture of the dominant group.

A GATE-KEEPER: God made man in His own image, but we will not make the Artist of Colour in Ours.

A New Art History? Perhaps There is Hope . . .

Art history is peculiar in its function as a master narrative, not only in that it is fundamental in the recognition and legitimation of Art with a capital A, but that it seems to be the only discourse . . . which protects its Western territory so rigidly that we can hardly find an exception to its Eurocentric rules.
— Rasheed Araeen, Introduction to *The Other Story*, 1989, p. 11

The history of art of the last hundred years, no less than other histories, has been selective and partial, in the interests on the whole of a progressive, developmental model, a linear or 'vertical' line from movement to movement, 'ism' to 'ism', in which certain names appear, and others do not. But art historians have begun to develop a critique of this kind of history . . .
— Dawn Ades, 'Reviewing Art History', 1986, p. 12

ART HISTORY = A SITE OF CONFLICT AND STRUGGLE

In recent years a new art history has emerged – feminist, Marxist, psycho-analytic, poststructuralist, postmodernist – challenging the conservatism of the established discipline of *Art History*.[17] The Old Art History emphasizes chronology and progressive development, quality and authenticity, individual genius ('Masters') and specific works of art ('masterpieces'), stylistic changes and artistic movements. It views art – or rather *Art* – as a direct expression of The Artist's personality and as containing eternal Truths. Here, Art floats above social divisions, power relations and societal conflict.

A VOICE: Art History develops by formal innovations and discoveries – all of them done by HIMSELF, the (White Male) Artist.

The New Art History insists that art – art objects, artists, art criticism, art history, art institutions – must be seen in its social and cultural context. The New Art Historians 'question the status of art, and the almost

automatic assumption that art means paintings and sculptures in certain styles'. They demystify art, asking 'how such objects and not others came to be called "art" in the first place, and why they alone are worthy of study.' They want to know what purposes art 'served for the people who owned it and for those who look at it today in books, stately homes, museums and galleries'. Linking the study of art to broader questions of culture and ideology, they pose questions 'as to why the poor, or land-scapes, or women look as they do in the "representations" art makes of them'. Linking the study of art to questions of contemporary politics and economics, they explore 'in particular the sometimes camouflaged links between scholarship and the market, and the uses made of art by states or corporations anxious to polish up their images'. Employing a reflexive stance, the New Art Historians question their own points of view as well as 'the claims of earlier historians to produce objective scholarship' (Rees and Borzello, 1986, p. 8). Some of the New Art Historians oppose the concept of a singular, universal art history ('of course, determined and realised by the West' (Araeen, 1987, p. 15)), arguing that history is always plural, that there is no History, only histor*ies*.

Perhaps the most interesting developments in the New Art History involve *feminist interventions* (see, for example, Rozsika Parker and Grisel-da Pollock, 1981, and Lynda Nead, 1992) and interventions influenced by *postmodernism*. We end by engaging in some related reflections.

Stage 1, Stage 2 In an essay on 'Feminism, Art History and Cultural Poli-tics', the art historian Lynda Nead suggests that feminist interventions in art history may be usefully conceptualized as consisting of two stages. *Stage 1* 'was characterized by the attempt to rediscover the names and work of women artists' who had been written out of history 'and to integrate them into the traditional discipline'. This was a process of discovery and addition. Though a crucial intervention in art history – at minimum it deconstructs the notion that there are only Great (White) Men – and an important phase in the formation of feminist cultural poli-tics, Stage 1 'did not seek to challenge the categories and values of art history'. *Stage 2*, on the other hand, 'may be defined in terms of a far more critical approach to the discipline itself'. In Stage 2, the categories, values and interests of mainstream art history are challenged, together with an exposure of the role of culture in the reproduction of (women's) oppres-sion (Nead, 1986, pp. 122–3).

In these terms, one can say that *The Other Story* is a Stage 1 intervention. It is not an attempt to overthrow the foundations of art history and theory, but simply to include within art history the names and contribu-tions of those racial Others who have been written out. Thus, for example, it does not pose the question that many would regard as crucial: *Who wants to be a modernist anyway?* We (the authors of this book) would tend

to agree that 'art in the 20th century' has become 'more or less an esoteric, elitist cult, developing within its own formalist framework but incomprehensible to the society at large'; and that 'often its real cultural significance is no more than that it provides a cult of sophisticated, private mysteries in which a very small group of petit-bourgeois intellectuals find some refuge from metropolitan alienation and the other horrors of the industrial society' (Bandaranayake, 1987–8, p. 88). However, it does not follow that any attempt to (re)discover the history of modernist Artists of Colour is a waste of time.

Aside from the question of morality (is it right that people's lives and struggles should be marginalized, trivialized or dismissed?), there is also the fact that art history plays an important role in producing and sustaining dominant ideas and cultural values. If you want to see the proof of Western civilization, you go to an art museum. If you want to deconstruct dominant notions of Western civilization or culture, then you would do well to explore those histories that have been marginalized and suppressed – the histories of women, the poor, our racial Others and other 'outsiders'.

Because Western art history is so profoundly Eurocentric, attempts to tell the Other Story constitute important movement towards a radical deconstruction of the racial politics of Western art history and criticism. Much of *Third Text* consists of Stage 2 interventions, posing profound questions about the theoretical and political foundations of Modern Art. Chapter 12 explores one such effort.

Enter Postmodernism It remains to be seen whether the New Art History will manage to seriously erode the Eurocentrism of modern Western art. To date, while there has been considerable work around questions of gender and class, questions of race have not received serious treatment (except in *Third Text* and in a few other writings by Artists of Colour). Perhaps the new postmodernist influence in art history and theory will be of help here – since, in its more self-reflexive moments, it is 'a project that has in a fundamental sense sought to decentre the imperialist and masculine assumptions of the Western tradition [P]ostmodernism so constituted advances the theoretical displacement of the Western fine-art tradition as the self-certifying domain of white men' (Roberts, 1990a, pp. 184–5).

But there are no guarantees. Perhaps no reason even to hope: demolishing White Power is no small task. Moreover, as it turns out, many of today's 'postmodernists' were yesterday's liberals.

A VOICE: We have seen them before – those who claim to be working on our behalf, those who claim to have rid themselves of Eurocentrism and racism.

13

From Primitivism to Ethnic Art: Neo-colonialism in the Metropolis?

The incoming African/Asian cultures have provided an opportunity for the development of a new Primitivism that goes under the official title of Ethnic Arts.
— Rasheed Araeen, 'From Primitivism to Ethnic Arts', 1987, p. 7

Let them eat cake!
— Marie-Antoinette, 1789

New Primitives in the Metropolis

Europe is no longer White, neither in demographic nor in cultural terms. Visit Paris, London, Marseilles, Amsterdam, Berlin, Antwerp, Copenhagen or any number of other European metropolises and you will find substantial populations of people of Colour. Hundreds of thousands of immigrants from Africa and the Middle East, from the Indian subcontinent, from the Far East and from the islands of the Caribbean – they and their descendants now live permanently in Western Europe. Although not everyone realizes it, Europe, as we said, is White no more.

Diversity of people means diversity of cultures. Take a walk through the central districts of Birmingham, England's second largest city. As in many European cities you will find streets where one Asian shop adjoins the next in a colourful display of 'exotic' food. You will discover clothing

stores with their windows full of brightly embroidered saris. Note the cinemas with their large advertising posters for contemporary Indian films. See the Islamic mosques and the Hindu temples.

Or take a stroll through the Kreuzberg district of Berlin, a cosmopolitan oasis in an officially White society. You will not be able to miss the Turkish businesses – from banks and travel agencies to food shops, cafés and restaurants – that are all around you.

The streets of Europe's cities are alive with 'ethnic' restaurants and shops where day-to-day business is conducted in Chinese, Arabic, Gujarati, Urdu, Turkish and a range of non-European languages. On the billboards one sees posters advertising musical events dominated by Black American singers and groups. Black American culture – from fashion and music to Michael Jordan – has shaped European youth cultures, advertising and our ideas of style. Newspaper stalls display 'Black' magazines alongside the familiar range of women's weeklies, special-interest monthlies and soft porn. *At the level of everyday life, multiculturalism is, quite simply, a reality.*

In June 1993, while we were living and conducting research in former East Germany, a new Afro-Caribbean cultural centre opened in West Berlin. Set up by Black people living in and around Kreuzberg, this centre is part of a broad struggle waged by immigrant and minority groups in a predominantly White and racist Europe to gain their own cultural space. The 'ethnic' quarters of most European cities now have Afro-Caribbean and Asian cultural centres – spaces more or less independent of the dominant society – where people come together to affirm a sense of community and shared culture. Such centres may focus on the cultivation of traditional cultural practices, such as classical Indian music and dance, or may be spaces for more militant community-based education and cultural expression. Through a wide range of initiatives at the level of community arts and culture, Afro-Caribbean and Asian people have created alternatives to White cultural institutions.

Not all of us are pleased that Europe is no longer White. For generations 'the primitives' lived elsewhere: now, tens of thousands of them live in our very midst. Formerly, they were part of our collective imagination of racial and cultural difference. Now, they are here.

And thus emerges a new 'primitive' within Western metropolises, no longer a Freudian Unconscious, but physically present within the dominant culture as AN EXOTIC, with all the paraphernalia of grotesque sensuality, vulgar entertainments . . .
— Rasheed Araeen, 'From Primitivism to Ethnic Arts', 1987, p. 24

For some of us, immigrant and minority communities make our cities more interesting, perhaps even fascinating. For others, the 'newcomers'

pose a threat. THE QUESTION is: What should be done about them? Perhaps our old ideas of primitivism and racial difference will help us to understand them . . . and keep them in their place.

We explore these issues by invoking the arguments of an important article published in the inaugural issue of *Third Text*. The article, a sharp political intervention by Rasheed Araeen, is entitled 'From Primitivism to Ethnic Arts'. We also draw upon some related insights from the writings of Michel Foucault.

Scholarly 'Truth' as Neo-colonial Surveillance

> *Orientals were rarely seen or looked at; they were seen through, analyzed not as citizens, or people, but as problems to be solved or confined or – as the colonial powers openly coveted their territory – taken over.*
> — Edward Said, *Orientalism*, 1978, p. 207

> *'Truth' is linked in a circular relation with systems of power which produce and sustain it, and to effects of power which it induces and which extend it.*
> — Michel Foucault, 'Truth and Power', 1980, p. 133

There have been people of Colour in Britain for centuries (see, for example, Fryer, 1984; Walvin, 1973; Shyllon, 1977; Drake, 1990). Since the Second World War the number of immigrants and minorities from Africa, the Caribbean and Asia has increased substantially. An interesting phenomenon of postwar Britain has been the fact that a whole official machinery – a Race Relations Industry – has been 'set in motion to deal with them' (Araeen, 1987, p. 19). That is, specific research units have been established – in universities and in other research and policy-orientated organizations – for the sole purpose of studying the social and cultural life of the so-called ethnic and racial minorities. (The cynic might say that their sole purpose is to provide employment for White liberal sociologists, anthropologists and other 'social scientists' . . .)

Much of the work of these research units is concerned with the study of such phenomena as racial patterns in employment, housing, education and health care – that is, with issues of racial discrimination and 'prejudice'. But this is not all they study. What interests Rasheed Araeen is another aspect of their work. In his important essay 'From Primitivism to Ethnic Arts', Araeen argues that, in their research on racial and ethnic minorities, a central concern of these units has been to study the '*traditional* customs, beliefs, behaviour, values and what not' of Britain's 'ethnic minorities' and also what are called 'ethnic cultural artefacts – all lumped

together and labelled ethnographic material'. This raises certain suspicions – which we shall pursue for most of this chapter.

> ARAEEN: 'I'm not an anthropologist or sociologist, but it is not difficult to see what this game is all about'
>
> — Rasheed Araeen, 1987, p. 19

What, then, is this 'game' all about?

Now, as we all know, social science is concerned with gathering empirical evidence and establishing facts – *the* facts – about human societies and cultures. Through rigorous collection and analysis of data about behaviour, institutions, social groups, beliefs, values, social change, and so on, social scientists provide us with objective knowledge about the ways human beings live their lives. Unlike the propagandist, ideologist or demagogue, the social scientist pursues Truth.

That, in any event, is the *traditional view of social science*, the view we have been taught to believe. But there are other views, one of the most challenging of which derives from the writings of Michel Foucault. Foucault argues that POWER (for example, the continued subjugation of Black people to White Power, although he does not explore this case) depends upon the constitution of fields of KNOWLEDGE (such as law, political science, sociology, psychology, social policy, anthropology, literary criticism and art history) – and vice versa:

> [W]e should admit . . . that power and knowledge directly imply one another; that there is no power relation without the correlative constitution of a field of knowledge, nor any knowledge that does not presuppose and constitute at the same time power relations. (Foucault, 1979a, p. 27)

> What I mean is this: in a society such as ours, but basically in any society, there are manifold relations of power which permeate, characterise and constitute the social body, and these relations of power cannot themselves be established, consolidated nor implemented without the production, accumulation, circulation and functioning of a discourse [e.g., the discourses of law, the various 'social sciences' and the race relations industry]. We are subjected to the production of truth through power and we cannot exercise power except through the production of truth. (Foucault 1980a, p. 93)

In any society, certain individuals and institutions are privileged with the power and authority 'to produce and transmit "true" discourse' (Tagg, 1988). For example, in Western societies anthropologists have the right to explain – usually unchallenged – the customs, rituals and everyday life of all the world's 'primitive societies'. Similarly, the scholars and policy analysts of the race relations industry have the right to 'speak the truth' about racial and ethnic minorities living in the West. Here, Araeen

reminds us, is part of the Truth they speak about the new Others in the Western metropolises:

> The problem is that these people are uprooted – say the experts of the Race Relations Industry – from their own cultures, from their own traditions, and as a result they are feeling alienated and frustrated in this highly complex technological society. We shall therefore provide them with all the facilities to bring here and practise their own traditional cultures; and let them properly enjoy themselves. After all they are no longer our colonial subjects. (Araeen, 1987, p. 19)

Drawing on such arguments, one response from the State and the liberal cultural establishment – from central government, local authorities and statutory arts funding bodies (for example, the Arts Councils of England, Scotland and Wales and the regional arts associations) – has been investment in 'Ethnic Arts', including Black, Afro-Caribbean and Asian arts and cultural centres. These establishments, which take various forms (community arts centres, centres for the performing arts, galleries, educational and cultural centres) can now be found in most of Britain's major cities – London, Birmingham, Manchester, Leicester, Liverpool, Bristol, and so on.

Let's look briefly at one example – the CAVE Arts Centre in Birmingham. Located in the inner-city area of Balsall Heath, CAVE attempts to meet the needs of both the Asian and Afro-Caribbean communities. It offers workshops in classical Indian dance, African dance and Caribbean dance-drama. It provides courses in choreography, direction and composition – skills that are necessary in the development and expansion of Afro-Caribbean and Asian arts – and it stages productions by touring companies producing African, Afro-Caribbean and Asian theatre. The CAVE is funded by a range of sponsors: West Midlands Arts, Birmingham Inner City Partnership, the West Midlands Probation Service and Birmingham City Council – who see cultural self-expression not only as good in itself but as a way of keeping young people off the streets and out of trouble. That is, CAVE's funders view the initiative as a good investment from the perspective of both cultural engagement and social control, that is, policing.

How does Araeen view such initiatives? He, of course, fully recognizes that there are real cultural differences in British society, and is the first to concede that 'The need for various peoples to have their own cultures, particularly when they find themselves in an alien and hostile environment, is not something we should dispute.' Like most funders and participants, Araeen acknowledges that:

ETHNIC ARTS AND CULTURE = A FORM OF PLEASURE AND
ASSERTION OF IDENTITY

His quarrel is with the way 'the need' for difference – for example, for 'Ethnic' Arts and Culture – 'is being approached and manipulated'.

> HIS QUESTION: 'It has been the function of [Liberal-Humanism and] Modern-
> ism since early in this century to "eliminate" the importance of these dif-
> ferences in its march towards an equal global society. Why are these
> differences so important now?'

Why indeed? Araeen argues that all this discussion of THE NEED FOR DIFFERENCE 'has taken us away from the basic question of equality for all peoples within a modern society' – from issues of ensuring basic human rights and equality of opportunity for all; from issues of jobs, education, housing, health care and policing; from the legitimate demands of the underprivileged and exploited. Echoing Foucault (on 'truth' and power) and Marx (on ideology and control), Araeen says:

> The establishment, if not this society in general, is surprised and amazed
> that these people, who have been given the *privilege* of coming to this
> country, should now demand more. The 'primitive' demanding equality and
> self-representation within a modern society is unthinkable. There must be
> something wrong with them. They don't know what they want. *We* know
> what they want. (Araeen, 1987, p. 19)

And further:

> Lies, distortions, ignorance, confusions, etc. are *rationalised* into 'truths' that
> give the system credibility and power. THE DISCONTENT AND RESISTANCE OF
> THE UNDERPRIVILEGED IS TURNED INTO ISSUES OF CULTURE, A SHIFT THAT IS
> MANAGEABLE within the prevailing ideology. (Ibid.; emphasis added)

The questions Araeen poses are both political and moral: Why do we not see 'the presence of various cultures within our modern society as our common asset'? 'Why are they being used to fulfil the specific needs of specific people? Does this not somehow echo the philosophy of Apartheid?' (ibid.).

ETHNIC ARTS = A WAY OF AVOIDING GENUINE EQUALITY

ETHNIC ARTS = A NEW AND CLEVER FORM OF POLICING

His argument is that, especially in their contribution to the deflecting of issues of basic human rights and equality of opportunity to questions of culture, the Race Relations Industry serves White Power:

> And thus a new conceptual and administrative framework is set up to deal
> with the demands of what the establishment calls ethnic minorities. This

seems to have all the hallmarks of NEO-COLONIALISM, with specific features specific to metropolitan conditions, rationalised by a body of scholarly work done under the Race Relations and Ethnic Studies [apparatus] within some British universities and polytechnics; and it does not seem unreasonable to call this scholarship neo-colonial discourse. (Araeen, 1987, p. 19; emphasis added)

White Power masquerades as Truth. Demands for genuine equality are turned into issues of ('ethnic') song and dance.

THE VOICE OF SCIENCE: What is Truth? It is the product of rigorous objective research and systematic argument.

THE VOICE OF FOUCAULT: What is the Truth about 'social science' knowledge? It is an effect of – and conduit for – Power.

THE VOICE OF ARAEEN: What is the Truth about Ethnic Art or the Ethnic Artist? Beware, the 'truths' about Black people are fundamentally effects of – and conduits for – Power.

ECHOES OF MARIE-ANTOINETTE: Forget the demands of the poor for basic human rights and a decent standard of living. Just find out what kind of cake they like.

'Let Them Eat Curry . . .'

If power were never anything but repressive, if it never did anything but to say no, do you really think one would be brought to obey it? What makes power hold good, what makes it accepted, is simply the fact that it doesn't only weigh on us as a force that says no, but that it traverses and produces things, it induces pleasure, forms knowledge, produces discourse. It needs to be considered as a productive network which runs through the whole social body, much more than as a negative instance whose function is repression.

— Michel Foucault, 'Truth and Power', 1980b, p. 119

There is a widely held, *traditional view of power*. In this conception power is 'that which lays down the law, which prohibits, which refuses, and which has a whole range of negative effects: exclusion, rejection, denial, obstruction, occultation, etc.' (Foucault, 1980c, p. 183). In this conception, power is coercion, brutality, domination, constraint, prohibition, suppression. It is a force, outside and over us, which controls us, making us do things against our will. Undoubtedly, in feudal and authoritarian societies power mostly works like that, but not in modern, liberal, democratic societies. To understand the workings of power in the modern West, we need an *alternative view of power*. In this view, which derives in

particular from the writings of Michel Foucault, power *enables* as much as (or even while) it prohibits; power is as much a source of *pleasure* as it is of pain. We are subjected – produced as subjects – not just through repression but also through pleasure.

> A VOICE: '*We shall therefore provide them with all the facilities to bring here and practise their own traditional cultures; and let them properly enjoy themselves. After all they are no longer our colonial subjects . . .*'

As we enjoy ourselves, as we feel happy and free, we may be REPRODUCING OUR OWN OPPRESSION – this is one of the crucial lessons from the work of Michel Foucault. And it is a lesson that Rasheed Araeen, like Marie-Antoinette, understands very well.

> A VOICE: 'Your culture still has spirituality, why bother with our sick and material world?'
>
> — Rasheed Araeen, 1987, p. 24

Araeen's argument is that as we enjoy our curry, Bengali dance, fufu and calypso, we are being excluded – once again – from benefits of the dominant culture. It is that *The Establishment's support for 'Ethnic Minority Arts' amounts to a confidence trick which ensures our continued marginalization – like its support for 'primitivism' ensured that an earlier generation of Black artists would soon be forgotten.* In his own words: 'ethnic minority arts' is a form of CULTURAL BANTUSTAN which has been imposed upon the AfroAsian minority in Europe in order to deny its presence and innovative roles within modernism (Araeen, 1991, p. 19).
That is:

ETHNIC ARTS = THE PERPETUATION OF MARGINALIZATION

Araeen is well aware that he is addressing 'a complex and difficult situation', that he is making the sort of statements that may anger both the White Liberal Establishment and many people of Colour. He knows that the ideology of difference 'is now being internalised by many people in the black community, and is seen as essential to their cultural survival' (Araeen, 1987, p. 19). But he still insists on making the point that:

> The cultural traditions that colonialism once wanted to suppress and destroy are allowed to 're-emerge' for 'the creation of space' [as Homi Bhabha puts it] that is essential for the surveillance of neo-colonial relations. The idea of 'Black Arts' is central to this development. (Araeen, 1987, p. 20)

And that:

The policy of 'Ethnic Arts' has been systematically and insidiously intro-
duced into the system, through the cultural management of the desires,
aspirations and demands of black people for equal status in this society.
(Ibid., p. 23).

He says that the idea of 'Ethnic Arts' was not 'something that was de-
manded by black artists or cultural workers themselves' (ibid., p. 23).
Rather, 'It is part of the emerging neo-colonialism within Britain.' And it
is regrettable that Black people and many of our well-meaning allies,
including socialists, are 'instrumental in its development' (ibid., p. 23).

> ARAEEN: 'There is a general lack of will to face up to the reality of post-War
> Britain. There is a lack of will to listen to those who had no voice during the
> colonial era but who are now part of a "free" and modern society and want
> to speak and establish a meaningful dialogue across racial and cultural
> boundaries.'
>
> — Rasheed Araeen, 1987, p. 18

'Cultural Difference': the New Racism?

Araeen argues, following Martin Barker (1981), that there is a NEW RACISM
in Britain. The old racism was based on the idea and practice of White
supremacy. The New Racism has apparently abandoned such crude,
out-moded notions. It operates with a 'postmodern' twist: 'Of course, it is
not claimed that these outsiders are degenerate, immoral, inferior; THEY
ARE JUST DIFFERENT . . .' (Barker, quoted in Araeen, 1987, p. 23; emphasis
added). The New Racism is not based on the idea of Black inferiors and
White superiors but, we are told, 'on the maintenance of a *separate* status
for black people based on cultural differences' (ibid.).

One of Araeen's central claims is that 'ETHNIC ARTS' is to the NEW RACISM
as 'PRIMITIVISM' was to the OLD RACISM. The point is not that 'Ethnic Arts'
or 'Primitivism' are *only* racism: the point is that they are *partially* racism,
that their liberal ideals conceal some unacknowledged racist beliefs and
practices. Listen carefully:

> The idea of 'difference' is fundamental to the idea of 'Ethnic Arts' which is
> being supported by both the Right and the Left. My argument is not against
> the presence and recognition of all the different cultures in Britain today.
> They can and should in fact play an extremely important critical role in the
> development of this society into an equal multiracial society. But the idea
> that the creative abilities of black people are 'fixed' or can only be realised
> today, within the limits of their own traditional cultures is based on the
> racist philosophy of 'ethnic determinism' in art developed during the late
> 19th century. (Araeen, 1987, p. 23)

There are two crucial points here. The first is this:

> A WARNING: When in a racist society – like the USA, Britain, France . . . Germany, Bosnia, South Africa – you hear talk of DIFFERENCE, beware.

The second point – that the idea of 'ethnic art' owes much to classical, nineteenth-century racism – requires some explanation.

One of hallmarks of classical racism is a conflation of RACE and CULTURE. As a system of beliefs, racism is precisely the idea that, on the basis of a few physical traits such as skin-colour, facial features and hair texture, one can determine a person's intelligence, character and cultural predispositions. The racist does not need to engage in dialogue with the Other in order to know what we are like: the racist knows in advance what we need, what we can do, what we should aspire to. If you assume that because a Black youngster is Black he is more likely to excel at football than at biochemistry, *that is a racist assumption*. Araeen is arguing that it is similarly racist to assume that, based on the colour of someone's skin, we know the kinds of arts and culture into which that person should be channelled.

As cultural policy, racism fixes – determines, limits, constrains – the creative abilities of people: it decides in advance what our cultural needs and aspirations are, what our cultural achievements will be. Racism is precisely A FIXING OF DIFFERENCE.

> A POINT TO BE REMEMBERED: 'C.L.R. James used to say that "Beethoven belongs as much to West Indians as he does to Germans, since his music is now part of human heritage".'
> — Edward Said, *Culture and Imperialism*, 1993, p. xxviii

> ANOTHER ANTI-RACIST VOICE: No one would have said that Picasso should have limited himself to Spanish materials – that his creative abilities should have been so fixed, limited. No one would say that western modernist artists should not have looked outside the West for artistic inspiration.

Why not teach Shakespeare to Indian kids and Indian dance to White kids? Why teach Black history only in Black arts and cultural centres rather than properly integrate it into the curriculum studied by all children? Why not realize when allocating major funding for the arts that Western classical music is not the only classical music? Why not teach Coltrane alongside Beethoven? Why assume that Black singers prefer rhythm & blues to Italian opera? Why assume that because someone is a Muslim he or she is not also Western? Why assume that only people of Colour are 'The Ethnics'? Why not assume that all the world's cultural traditions, especially those alive in our countries, are available to each of us? WHY GHETTOIZE?

The point is not that 'Ethnic Arts' and ethnically or racially based cultural centres do not provide real benefits for people of Colour in the West. Indeed, they provide spaces in which people may enjoy themselves, affirm their identity and develop artistic and other skills. The point is that when it is assumed (or even mandated) – usually inadvertently, by people of goodwill – that people of Colour should limit their participation in art and culture to such spheres, that is a racist practice. And its consequences can be offensive.

> A VOICE: I am an artist, not a *Black* artist.
> AVINDASH CHANDRA: Why must I (only) paint elephants and tigers?

People of Colour and liberals tend to see the positive features of initiatives in 'Ethnic Arts'. Araeen invites us to see that there are also unintended consequences – which, ironically, reproduce some of the ideas and practices of racism.

'ETHNIC ARTS' = PRIMITIVISM IN A NEW GUISE

'ETHNIC ARTS' = A CENTRAL COMPONENT OF THE
NEW RACISM

A Pragmatic View

So far the discussion has been conducted at the level of ideas, the level at which it is easy to take a purist position, to be 'ideologically correct'. But artists and cultural workers, unlike theorists, have to make practical, hard-headed decisions – about funding, work-space, promotion and so on. As previously suggested, many Afro-Caribbean and Asian artists and cultural workers are aware of the limitations and constraints of liberal 'Multiculturalism' – which in the arts virtually always takes the form of 'Ethnic Arts'.

> THE QUESTION: What is to be done?

If the only money available for you to exhibit, write or perform is in some 'Ethnic Arts' budget, can you seriously afford not to take it? If you are only invited to participate in exhibitions with other Artists of Colour, should you turn down the invitations? If the probation service or Home Office is offering funds for an arts centre in the local Black community, should the response be 'No, thank you'?

Arguably, given the need for resources and access, the most sensible, responsible position is to see liberal 'Multiculturalism' as having both

benefits and shortcomings and to use 'the system' while not being co-opted or corrupted by it. This is difficult terrain to negotiate. But what is one to do? Here is advice from one of Britain's Black artists. She is of the younger generation.

> SONIA BOYCE: 'I don't think we as black artists have resolved as yet where we want to go. In many ways it is easy to be damning about the outcome of some of the initiatives of those involved in the promotion of black visual culture and the motives of those mainstream institutions who have opened up possibilities for black artists. What is required is to distinguish the constructive elements from those areas which maintain a kind of tokenist, grant related (guilt-ridden) inclusionism.'
> — In Boyce and Roberts, 1987, p. 56

Sonia Boyce is concerned that Artists of Colour learn how to use the system – the institutions and programmes that fund and validate art and cultural work – to their advantage.

Some would agree with her. Others would hold that to adopt such a position is to abandon one's principles.

Genuine Multiculturalism versus 'Ethnic Minority Arts'

> *It is imperative to abandon models of binary oppositions which impose fixed ordering systems, and according to which cultural practices are classified in terms of Same or Other. And it is to this end that considerations of art cannot be separated from questions of politics.*
> — Editorial, *Third Text*, no. 1 (autumn 1987), p. 4

The idea that modern nation-states contain a number of different cultures and 'that in some sense the diversity of cultures is a good and positive thing and ought to be encouraged' is an idea that has deep roots in liberal Western societies. It is commonplace in plural democratic societies, Homi Bhaba reminds us, 'to say that they can encourage and accomodate cultural diversity'. Indeed, 'the sign of the "cultured" or "civilised" attitude is the ability to appreciate cultures in a kind of *musée imaginaire*; as though one should be able to collect and appreciate them' (Homi Bhaba, in Rutherford, 1990, pp. 207–8). Western societies have always been interested in cultural difference – even fascinated by it (as our discussions of primitivism and of the cultural politics of racism have shown). In Britain since the 1970s concern with cultural diversity and its implications for

education and the arts has been on the agenda of educators, arts funders and local and central government.

Interest in other cultures is not necessarily the same as real Multiculturalism: indeed, many a racist has been interested in the culture of The Other. What, then, would a genuine Multiculturalism be?

Firstly, no one group (for example, middle-class Englishmen) would have a monopoly on determining what cultures and traditions are of value. That is, *genuine multiculturalism could not be based on a hierarchy of cultures and traditions*. It would not be a sham universalism 'that paradoxically permits diversity' while it 'masks ethnocentric norms, values and interests' (Bhaba, in Rutherford, 1990, p. 208). There would be no hidden agenda of ethnocentric or racist notions of value. It could not assume, for example, that English culture is better than Jamaican culture or that Anglo-American culture is preferable to African-American culture. Rather, all the cultures represented would be seen as being of equal value, all as capable of making a substantial contribution. Caribbean literature would be taught as an integral part of English literature – Derek Walcott alongside Shakespeare, Edward Braithwaite alongside Chaucer, Joan Riley alongside Virginia Woolf.

Secondly, *there would have to be genuine dialogue between cultures*. It is not simply a question of providing resources for 'ethnic' activities but of putting different cultures in contact one with the other. In this model, an evening performance of music might include instruments from different cultures (in a single orchestra); songs drawing on different languages and musical traditions; and a multilingual audience. In this model, issues of cultural and racial identity are not simply the problem of immigrants and minorities. Rather, they are the concern of all of us. The need is for a critical, reflexive stance.

> I remembered a radio-performance tape I had heard by the Mexican-American artist Guillermo Gomez-Peña in which there is a mock interview. The artist is asked about his cultural identity by a cool, female, WASP-ish voice. *When he asks her the same question she sounds taken aback and says: 'No, I'll ask the questions.'* Exactly. This is the position. It is as if the 'other's' cultural identity is problematic, but never our own. In Britain 'cultural identity' is usually raised in relation to the 'problem' of so-called ethnic minorities (with formulations like 'living in two worlds', and so on), but the dominant culture presents itself as whole and beyond question. As assuredly living in one world, not two worlds. There is an enormous unwillingness to admit contradiction and confusion, since we have always been accustomed to rule, to decide, to explain, to define. This is our conception of knowledge. But this self-confidence today is actually hollow, like an empty suit of clothes, a kind of void. (Brett, 1992, pp. 51–2; emphasis added)

Much of what goes under the banner of 'Ethnic Arts' and 'multiculturalism' operates rather like the above interview. This sort of stance –

an authoritative monologue masquerading as a dialogue among equals – must be avoided.

Now, the achievement of meaningful and proper dialogue across ethnic and racial barriers is no small task in a society with a legacy of racism and colonialism. Thus, thirdly, a genuine Multiculturalism must be *thoroughly anti-racist* in its approach – deconstructing racist imagery, ideas, beliefs and practices.

> RASHEED ARAEEN: 'What is not fully realised, by either white or black, is that the ideas which are essential to the kind of "multiculturalism" [i.e., Ethnic Arts] which is being promoted in Britain today come from the racial theories of art discussed earlier.'
>
> — Rasheed Araeen, 1987, p. 17.

In particular, *it would rigorously avoid conflating 'race' with culture* – never assuming that because a person is of a certain racial or ethnic background she or he should be directed towards certain modes of cultural expression and not others. White people could choose to learn 'Indian' crafts, contemporary music of the Caribbean and 'Black' history. Black people could choose 'Irish' popular music, Spanish dance and Impressionist painting.

The 'Multiculturalism' that is practised in most Western societies is, at best, only partial. '[A]lthough there is always an entertainment and endorsement of cultural diversity, there is always also a corresponding containment of it' (Homi Bhaba, in Rutherford, 1990, p. 208). We are talking of cultural diversity without containment.

Fourthly, unlike 'Ethnic Arts' and 'Primitivism', *it would not privilege 'traditional' culture over popular culture, 'High Culture' over the new cultural technologies* (photography, video, computer graphics, desktop publishing, and so on). It would be neither narrow nor backward-looking. Its fundamental orientation would be towards the present and the future.

Fifthly, *a genuine Multiculturalism would necessitate full multiethnic (and multiracial) participation throughout all the structures of the cultural institutions.* The faces of those involved in all aspects of arts and culture – production, distribution, validation – would mirror the racial and ethnic diversity of the nation. Curator, gallery-owner, arts funder, arts critic, art historian, and so on – such positions would no longer be reserved for White middle- and upper-class men.

In Britain, as in many other Western countries, 'Multiculturalism' is usually understood as 'multicultural education' and 'ethnic minority arts'. *We wish to underscore the fact the 'Ethnic Arts' and genuine Multiculturalism are not the same.* On this point we are in full agreement with Rasheed Araeen:

The issue of MULTICULTURALISM is extremely complex . . . however, the

question of 'ETHNIC ARTS' is different and it should not be confused with the need for a multicultural society. (Araeen, 1987, p. 23; emphasis added)

'Ethnic Art' fixes difference, it conflates phenotype (presumed biological origins) and culture, and it ghettoizes. 'Ethnic Art' is not concerned to ensure meaningful dialogue between different races and cultures. And it fails to grasp one of the most important facts of life in the contemporary world: 'Partly because of empire, all cultures are involved in one another; none is single and pure, all are hybrid, heterogeneous, extraordinarily differentiated and unmonolithic' (Said, 1993, p. xxix).

TRUTH: THERE ARE NO PURE CULTURES, ALL ARE HYBRID.

Now, it is precisely this fact – of hybrid, heterogeneous cultures (and subjectivities) – that 'purist' notions like 'Ethnic Art' and 'Ethnic Artist' deny. Multiculturalism, properly conceived, makes no such errors.

ETHNIC ART = SHAM MULTICULTURALISM IN A RACIST SOCIETY

As we previously indicated, many Black British artists and thinkers, for example, a number of contributors to *Third Text*, feel that the current funding strategies, with their frequent conflation of race and culture, perpetuate a *marginalization* that has a long history in racist and colonial discourse. Hence, Rasheed Araeen's fierce attack on liberal 'Ethnic Arts' strategies in Britain, in which he argues: that the old category of 'primitivism', formerly routinely used to romanticize and dominate the art of The Other, has been replaced by a new, enlightened racism which inscribes Artists of Colour as 'Ethnic' Artists; that Western art history, permeated – unbeknownst to most of its practioners – by a philosophy of racial superiority, informs the kind of 'Multiculturalism' which is being promoted today; that 'Ethnic Arts' is as much a form of policing as it is a space for enjoyment (Araeen, 1987).

TRUTH: 'Ethnic Art', like the 'Ethnic Artist', is less a fact than an effect of power.

As for the last point, it is worth noting that 'Ethnic Arts' centres and initiatives are partly funded by the agencies of law and order. In Britain it is often the case that funds granted by the central government to 'Ethnic Arts' and 'Multiculturalism' come not from budgets for arts and culture but from the Home Office.

Conclusions

The discontent and resistance of the underprivileged is turned into issues of culture, a shift that is manageable within the prevailing ideology.
— Rasheed Araeen, 1987, p. 19

A VOICE: The historical record is clear: 'Ethnic Art' is a White invention.

There is a widespread assumption that liberalism – with its claims for universal human rights, the dignity of the individual, respect for cultural diversity and so on – belongs to the anti-racist camp; that racism is a phenomenon of the political right. This chapter, indeed this book, suggests otherwise: liberals and leftists can hardly claim innocence in so far as racism is concerned.

We are *not* making an argument about individual motivations, feelings or 'prejudices', but about several hundred years of social practices and representations.

The previous three chapters explored the primitivist idea in modern art. Many 'primitivists' have been politically radical and consciously anti-racist. None the less, 'primitivism' and racism are closely intertwined discourses and practices: fascination with the non-White Other is, as we have shown, a slippery slope. Primitivism is not inherently racist: indeed, it can on occasion be powerfully anti-racist. Rather, primitivism is a complex unity, in which many racist ideas and much racist imagery have found a welcome home. So it is with 'Ethnic Art'.

To state the matter in simple terms, let us say that there are TWO RACISMS in modern Western societies. One is the bigotry of the right. The other is the White liberal/left fascination with the Exotic and 'the Ethnic'. We have been exploring the latter.

14

Racism, Culture and Subjectivity: Australian Aboriginal Writing

Desolation
You have turned our land into a desolate place,
We stumble along with a half-white mind.
Where are we?
Who are we?
Not a recognized race . . .
There is desert ahead and desert behind.
　　The tribes are all gone,
　　The boundaries are broken:
　　Once we had bread here,
　　You gave us stone.
We are tired of the benches,
Our beds in the park,
We welcome the sundown
That heralds the dark.
White lady Methylate!
Hold back the hate
And hasten the dying.
　　The tribes are all gone,
　　The spears are all broken:
　　Once we had bread here,
　　You gave us stone.
　　　　　　— Jack Davis, *The First Born,*
　　　　　　and Other Poems, 1988, p. 36[1]

Most images in the West of Australian Aborigines are of a 'primitive', 'tribal' people – the uncivilized 'dying race' of the anthropologist,

National Geographic and documentary films; the dark-skinned savages of cultural evolutionist texts; the scary nature-people of 'Crocodile Dundee'; the 'stone age artists' of Australian travel brochures. The images are of naked primitives with their boomerangs, stone axes and spears, their ancestral sites and secret rituals, their traditional songs, dances and Dreamtime stories, their bark paintings and body decorations – living in harmony with nature, blending into the flora and fauna. The focus of this chapter is on THE OTHER ABORIGINES, those who have been 'through The Middle Passage' of White colonization, who have faced genocide, who have been subjected to brutal attempts at assimilation, denial of civil rights, denial of basic human rights. These people, who constitute the overwhelming majority of the Australian Aboriginal population, are *not* the exotic natives of the White Western imagination. They are not a people who live 'in harmony with nature' but an uprooted, demoralized people living in the urban slums, shanty towns and remote reserves of contemporary Australia. They do not belong to some distant past – to a mythical 'stone age' – but to the present. They are not some 'pure race' who have lived in isolation from other peoples and cultures for thousands of years, but a people who are overwhelmingly of 'mixed' racial and cultural background. They are a people whose everyday lives necessarily involve negotiation with structures of White power.

Generations of anthropologists and travel writers, in search of the authentic primitive, have failed to 'see' these Blackfellas (the term Aborigines use to describe themselves). It is an oversight produced by the Western gaze.

The writings foregrounded in our work on race, culture and identity in Australia are not those of the White middle-class ethnographer or travel writer but those of Aboriginal intellectuals and artists. The chapter is an intervention in cultural politics: it privileges voices that have been historically marginalized or silenced. And it is a discussion of cultural politics: it shows how oppositional, counter-hegemonic representations of Australian Aboriginal society and culture are being developed in the texts of Aboriginal writers.

Genocide and Other Forms of Domination

The First-born

Where are my first-born, said the brown land, sighing;
They came out of my womb long, long ago.
They were formed of my dust – why, why are they crying?
And the light of their being barely aglow?

I strain my ears for the sound of their laughter.
Where are the laws and the legends I gave?
Tell me what happened, you whom I bore after.
Now only their spirits dwell in the caves.

You are silent, you cringe from replying.
A question is there, like a blow on the face.
The answer is there when I look at the dying,
At the death and neglect of my dark proud race.
 — Jack Davis, 1983, p. 1

As suggested in chapter 9, the history of the Aboriginal people of Australia since White settlement has been predominately one of *genocide* and the *decimation* of indigenous peoples and cultures. The last 200 years have seen a range of destructive White policies and practices towards Aboriginal people: appropriation of land, indiscriminate shooting, rape, imprisonment on reservations and missions, forcible removal of children from their parents, denial of citizenship, institutionalization of pass laws and other infringements of basic human rights. These policies and practices have been part of an attempt to assert and maintain White dominance. And they are not simply 'in the past', things that happened a long time ago which we can now forget. As history and as present, they profoundly affect the lives of Aborigines – one is tempted to say, *every* Aborigine – living today.

Aboriginal Australia
to the others

You once smiled a friendly smile,
Said we were kin to one another,
Thus with guile for a short while
Became to me a brother.
Then you swamped my way of gladness,
Took my children from my side,
Snapped shut the lawbook, oh my sadness
At Yirrkala's plea denied.
So, I remember Lake George hills,
The thin stick bones of people.
Sudden death, and greed that kills,
That gave you church and steeple.
I cry again for Worrarra men,
Gone from kith and kind,
And I wondered when I would find a pen
To probe your freckled mind.
I mourned again for the Murray Tribe,
Gone too without a trace,

I thought of the soldiers' diatribe,
The smile on the Governor's face.
You murdered me with rope, with gun,
The massacre my enclave,
You buried me deep on McLarty's run
Flung into a common grave.
You propped me up with Christ, red tape,
Tobacco, grog and fears,
Then disease and lordly rape
Through the brutish years.
Now you primly say you're satisfied,
And sing of a nation's glory,
But I think of a people crucified –
The real Australian story.
 — Jack Davis, in Gilbert 1988b, p.58

Aborigines suffer from extremely high rates of alcohol abuse, which includes widespread drinking of methylated spirits – a substance which contains alcohol but is not for human consumption: the 'White Lady Methylate' referred to by the Aboriginal poet whose voice introduced this chapter. Aborigines are perhaps the most imprisoned people in the

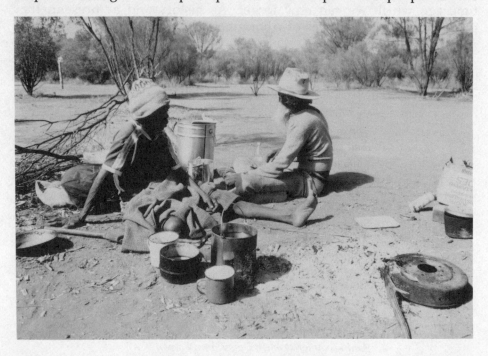

Plate 14.1 We are the Drifters, two elderly Aboriginals around a campfire, Alice Springs, Northern Territory, Australia.
Photograph: David Bowden Photographic Library.

world: Black Australians are ten times more likely to be in prison than Whites – mostly from alcohol-related offences, such as public drunkenness, disorderly conduct and fighting while drunk.

The legacy of colonialism, racism and poverty is starkly revealed in the health situation of Black Australia (i.e., Aborigines): it is worse than that of many 'Third World' countries. Life expectancy for Aborigines is about 50 years, while that for White Australians is about 75. Infant mortality rates are three or four times that of Whites. Aboriginal children suffer from malnutrition-related disorders, including low growth rate and brain damage. Aborigines suffer from a high incidence of blindness (especially trachoma), a rate similar to that of 'Third World' countries like Bangladesh. They suffer, like African-Americans and other colonized people, from stress-related conditions such as hypertension, alcoholism, diabetes, obesity and depression. Leprosy, a disease long eradicated in the developed world, is widespread in parts of Black Australia (Lippmann, 1981, pp. 106–20).

Commenting on this rather unpleasant side of the Australian legacy, the Aboriginal novelist, poet and political essayist Kevin Gilbert writes,

> For two hundred years we have been subjected to death, abuse and denial of dignity and basic human rights by the white usurpers of our land. Today, we are the products of the ravages of white settlement. History has moulded us, psychologically and physically. Our milestones are not splendid constitutions or Eureka stockades but massacres at Naomi River, Myall Creek, Slaughterhouse Gulley and, more recently, Skull Creek. They are records of defeat, victimization and persecution and they live in the memories of Aborigines even today. (Gilbert, 1978, p. 238)

A Cultural Politics of Domination

For generations the process of maintaining Black subordination in Australia has crucially involved cultural politics. White power in Australia does not simply depend upon physical domination – upon having militarily defeated the Aborigines, appropriated their land, restricted them to certain areas and so on. It also depends upon racial and cultural hegemony, upon a structure of widely accepted beliefs and values that helps to legitimate a system of racial difference and oppression.

White power and cultural imperialism in Australia has meant the forced imposition of Eurocentric – and sometimes racist – cultural forms, meanings and values on the indigenous people of Australia. Simultaneously, it has meant denial of the value of Aboriginal histories and cultures – the treating of their sacred sites as just another piece of

available land, the appropriation of their sacred rituals as material for the entertainment of tourists and so on. It has also meant denial of the value of Aboriginal languages. There are many statements by Aborigines concerning the active suppression of their traditional languages. Here is the renowned poet Oodgeroo Noonuccal (Kath Walker) commenting on why she does not write in Noonuccal, the language of the Aboriginal ethnic group to which she belongs:

> I do not know the Aboriginal – the Noonuccal language. It was flogged out of us at school. It was forbidden, it was classed as a pagan language. You get rid of that pagan language and you learn the king's English. Which is a *Christian* language. In the name of Christianity! Look at what they did to us. (Turcotte, 1988, p. 23).

Many Aboriginal life stories tell of how, in the schools and missions run by Whites, they were made to feel ashamed of Aboriginal culture – with its 'heathen' rituals, 'primitive' music and so on – and even told to avoid contact with other Aboriginal people.

A historically informed survey of Australian children's books provides many insights into the process of the degradation of Aboriginal history and culture. Here are a few selections from school textbooks of the 1950s:

- 'The picture shows you that they are rather ugly, have dark skins and wear very few clothes.'[2]

- 'Most of them draw pictures on their bodies by cutting themselves with sharp knives. At certain times of the year they paint themselves with great splashes of white, red and yellow. When painted like this they get very excited, and do many strange dances. I should not like to be the child of one of these people. Would you?'[3]

- 'They were . . . and many of them still are . . . among the most backward people on earth.'[4]

Today, textbooks rarely contain this sort of overtly racist language. Indeed, some children's textbooks obviously seek to deconstruct notions of Aboriginal inferiority (see, for example, Luling, 1979 and 1989; and Holdyn, 1985). However, the dominant imagery of Aboriginal people in Australian school textbooks remains deeply problematic:

> Most materials available in schools still show people running around naked in the bush. Nowadays people go hunting but they go hunting with a gun and a Toyota, once again adapting things to fit our needs. Many of these materials still concentrate on precontact Aboriginal society and don't show us as we are, namely Aboriginal people living in a contemporary way. (Osterhaus, 1988, p. 191)

Aboriginal people are condemned to exist only in the remote past, in some mythical, timeless period before real history began, that is, prior to the day when White settlers brought civilization to a backward land.

Travel books and brochures on Australia often mention Aborigines in the same context as descriptions of the natural world – Australia's land, plants and exotic animals. That is, in addition to viewing Aboriginal people as belonging not to HISTORY but to PRE-HISTORY ('the stone age'), they are also viewed as belonging not to CULTURE but to the world of NATURE. (Outside Australia, the best English-language examples of this reduction of 'traditional peoples' to nature are to be found in *National Geographic* magazine, especially issues before about 1970.)

In sum, the dominant representations of Aboriginal people are grounded in a Eurocentric cultural politics which works through a set of binary oppositions:

$$\frac{CULTURE}{NATURE} \qquad \frac{HISTORY}{PRE\text{-}HISTORY} \qquad \frac{CIVILIZED}{PRIMITIVE} \qquad \frac{AUSTRALIANS}{ABORIGINES}$$

The top and bottom elements in these binary formulations are not equal: the top terms are positive or highly valued, the bottom ones are negative or of lesser value. As in society, the bottom position is occupied by the Blacks, who, ironically, come to be constructed as outside 'the Australian nation'.

Resistance Through Cultural Struggle

The history of the Australian Aboriginal people from the early days of colonization has revolved around *a dialectic of domination and resistance*. On 26 January 1988, Australia – more accurately, White Australia – celebrated its 200th birthday. (Aborigines have been in Australia for at least 40,000 years.) The Australian bicentenary of White settlement in 1988 provided a focal point for much public debate about Australian history. Aboriginal activists spoke of making the bicentennial – Invasion Day – a time of remembering, an occasion for placing Aboriginal history and contemporary life and human rights on the mainstream political agenda.[5] The much-publicized activism of 1988 included the largest demonstration in the history of Australia. This demonstration, in which Aborigines were joined by thousands of anti-racist White Australians, was the culmination of years of protests, mostly initiated by Aborigines themselves, which have sought to give the original inhabitants of Australia full civil rights and self-determination.[6]

The political movements which have been fighting for Aboriginal rights

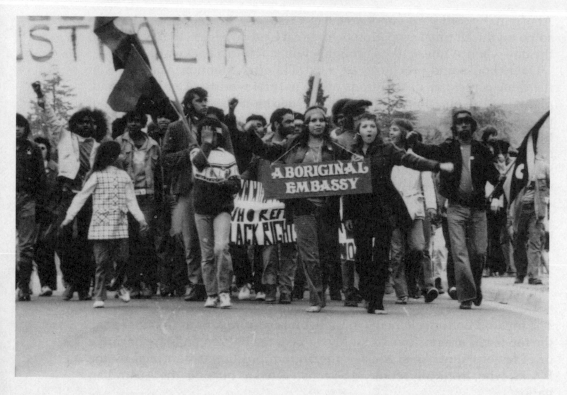

Plate 14.2 A Demonstration Against White Racism, National Library of Australia.
Photograph: Ken Middleton.

have had, directly and indirectly, important cultural dimensions. This
cultural struggle has been of great importance since one of the main
effects of white policies was to undermine traditional 'tribal' culture
while not offering any new positive sense of culture and identity to a
people displaced into camps and slum dwellings on the outskirts of
country towns. The 'Australian bicentenary' proved to be an occasion for
which a considerable amount of work by Aboriginal artists was produced
and/or marketed, from painting, pottery, sculpture and basketry to
drama, essays, poetry and novels. One contribution was a rewriting of the
Australian National Anthem by the Aboriginal writer Kevin Gilbert:

The New True Anthem
Despite what Dorothea has said
about the sun scorched land
you've never really loved her
nor sought to make her grand
you pollute all the rivers
and litter every road
your barbaric graffiti

cut scars where tall trees grow
the beaches and the mountains
are covered with your shame
injustice rules supremely
despite your claims to fame
the mud polluted rivers
are fenced off from the gaze
of travellers and the thirsty
for foreign hooves to graze
a tyranny now rules your soul
to your own image blind
a callousness and uncouth ways
now hallmarks of your kind.

Australia oh Australia
you could stand proud and free
we weep in bitter anguish
at your hate and tyranny
the scarred black bodies writhing
humanity locked in chains
land theft and racial murder
you boast on of your gains
in woodchip and uranium
the anguished death you spread
will leave the children of the land
a heritage that's dead
Australia oh Australia
you could stand tall and free
we weep in bitter anguish
at your hate and tyranny.
— Kevin Gilbert, *Inside Black
Australia*, 1988, pp. 197–8

The development of a new Aboriginal popular and artistic culture has
been helped by subsidies from central government. This has inevitably
proved controversial within Australian Black society since one of the key
themes of debate among Aboriginal artists and writers is the need for
cultural autonomy. For generations Aboriginal people have been arguing
for full land rights. In recent years they have also been demanding access
to and control of the means of cultural production – that is the mate-
rial and human resources to publish their own writings, to produce
and broadcast media programmes, to fundamentally influence public
opinion.

One of the most visible effects of attempts to resist the negative inscrip-
tion of Aboriginality within mainstream Australian culture has been
the publication of fiction, drama and poetry by Aboriginal people

themselves, both in English and in Aboriginal languages. Aboriginal writing has played a central role in the struggle for positive identity and self-determination.[7] It is an intervention in cultural politics, an ongoing struggle over meaning, power and subjectivity.

Dominant Themes in Aboriginal Fiction

> It is a curious fate to write for a people other than one's own, and even stranger to write to the conquerors of one's people.
> — Albert Memmi, *The Colonizer and the Colonized*, 1965, p. 109

The publication of fictional texts in English by Aboriginal writers is a fairly recent phenomenon. The first complete published work by an Aborigine, David Unaipon's Native Legends, appeared in the 1920s. But it was not until the 1960s that Aboriginal writing began to be published regularly. The first volume of Aboriginal poetry, *We are Going* by Kath Walker (Oodgeroo Noonuccal), was published in 1964; the first Aboriginal novel, *Wild Cat Falling* by Colin Johnson (Mudroogoo Narogin), appeared in 1965; and the first publication of an Aboriginal play, Robert Merritt's *The Cake Man* was in 1978. (Kevin Gilbert's *The Cherry Pickers*, composed in 1968, was possibly the first written Aboriginal play, that is, it was apparently written before Merritt's play, but it was not published until 1988.)[8] In addition to written texts, a number of traditional (oral) tales from 'tribal' cultures have been collected, translated and published.[9] Some Aboriginal writing is published by mainstream publishers. Yet even here it often relies on subsidies and is not widely available, even in Australia.[10]

English language Aboriginal writing is concerned with QUESTIONS OF DOMINATION: it explores the effects of *colonization*, *White racism* and *cultural imperialism* on Aboriginal people and culture(s). The majority of published texts deal with the experience of urban and camp life, often coupled with historical perspectives which offer accounts of why urban and fringe-dwelling Aborigines have come to be in the position in which they now find themselves.[11] English language Aboriginal writing is also concerned with ISSUES OF RESISTANCE – with how Aborigines can fight at the level of culture for a new sense of *value*, *history* and *identity*. Aboriginal writing is necessarily an intervention on the terrain of cultural politics, an attempt to create new meanings and values which challenge or subvert the dominant ('White') ones.

Recurrent themes in Australian Aboriginal novels, short stories, poetry and drama include the following:

- the brutality of racism;
- the quest for identity – which often means the recovery of history;
- the difficulties of growing up and living as a person of 'mixed race' in a racist society;
- the condition of spiritual and material poverty;
- the problem of links between the past and present – which is often conceived in terms of issues of knowledge and power.

Aboriginal fiction explores these themes in the context of representations of the different situations of Aboriginal tribal people against a backdrop of 200 years of oppression – on desolate reserves, in fringe dwellings on the outskirts of country towns, in poverty-ridden urban areas.

The remainder of this chapter is a detailed look at three books by writers of Aboriginal descent, followed by some concluding comments on the cultural politics of Aboriginal writing. The first book, a collection of short stories, is *Going Home* (1986) by Archie Weller. The second, an autobiography/life history, is *My Place* (1987) by Sally Morgan. The third, *Long Live Sandawara* (1979), is a novel by Colin Johnson (Mudroogoo Narogin).[12]

We ask: What insights does Aboriginal writing provide into the relationship between CULTURE, POWER and SUBJECTIVITY? Specifically, what insights are offered concerning the cultural politics of RACE?[13]

The Effects of Racism and Poverty: Degraded, 'Mixed Race' and Going Home . . .

> *We are the drifters, the faceless ones.*
> *Turn your heads as we walk by.*
> *We are the lost, forgotten sons,*
> *Bereft in a land of plenty.*
> — Jack Davis, 'The Drifters', in
> Davis, 1983, p. 35

Betwixt and Between . . .

What does it mean to be Aboriginal today – what does it mean socially, culturally or psychologically? Who, ethnically or 'racially' speaking, is an Aborigine? For some people such questions are important. They will find no easy answers.

Much Aboriginal writing emphasizes the importance of past cultural traditions and positive acceptance of oneself. The main concern of this

literature, however, is with diagonising the present condition of Aboriginal life. This is a strong feature of Archie Weller's writing.

> In his two books, *The Day of the Dog* and *Going Home*, Archie Weller has established himself as the leading chronicler of the lives of urban and fringe Aboriginals. His narratives are searing and depressing accounts of an existence which affords few gratifications and is irretrievably circumscribed by white power. (Tiffin, 1988, p. 222)

The theme of profound human degradation resulting from racist oppression occurs in the work of a number of Aboriginal writers. Archie Weller's fiction is a particularly powerful example. Weller's stories, through a 'relentless realism' (Tiffin, 1988), take up the theme of the lack of positive identity available to people of Aboriginal descent in a world dominated by White racism and Aboriginal poverty. This poverty is depicted as material, spiritual and cultural. Like a number of other Aboriginal writers, Weller suggests in many of his stories that colonialism has essentially destroyed Aboriginal culture and identity, forcing unsuitable White values and ways of living on people of Aboriginal descent, while at the same time further victimizing them for their ethnic origin and failure fully to conform.

This point is made forcefully, for example, in 'Cooley', the short story that concludes *Going Home* (Weller, 1986). 'Cooley' is the story of a 'mixed-race' boy who has come to Perth from the north and who has no place either in the local White world or in Aboriginal communities.

Weller traces the lack of positive identity experienced by Aboriginal people today to the effects of colonialism and their routine experiences under the heel of White power. Indeed, 'Cooley' suggests, it is no longer clear what it means to be Aboriginal beyond the negative definitions proposed by the dominant society:

> Cooley looked at their hybrid faces and strange thoughts churned in his mind. What were these people? Were they Aborigines? With clothes and boots, cigarettes and cars, radios and money? Greed and hate and jealousy? And a strange mongrel language, product of their mongrel breeding. (p. 196)

These words are harsh and uncompromising. In the modern world most cultures are impure – 'hybrid' and 'mongrel' – and this can be a source of strength. However, the world of the Colonized and the Colonizer is a world divided into Black and White. There is, in general, no middle ground: one either stands with the Colonized or against them – or so it is perceived. Those in the middle – 'racially mixed' people, culturally mixed people, 'liberals' – tend often to be despised. Hence Cooley's harsh words about the 'mongrel' fringe of Aboriginal society. Cooley is no postmodernist, no lover of plural identity, slippery meaning and 'impure' culture. Racism has a way of reducing plurality (for example, an infinitely diverse gene pool) to dichotomy ('White' versus 'Black').

'Cooley' explains the Aboriginal *crisis of identity* through a mythical history of the European/Aborigine encounter. The story (told in a male voice which has the unfortunate affect of excluding women from history) foregrounds the problem of *knowledge and power*:

> Once upon a time there had been a naked man on a red hill. Strong and healthy, with his spears and family and dogs – with his laws and religion. Then another man had come, white and weak and diseased, with his beer and smokes and clothes and hatreds. He said to the first man, 'Come with me and I'll teach you things you've never seen the likes of.'
> So the Aboriginal had followed – now he died of white man's pox and drowned in cheap wine and suffocated in prejudices and his laws were trampled by the white man's laws. They cried as all they had was turned to dust when they listened to the white man's lies. And the white man laughed and jeered at their plight and their efforts to mimic their masters. (p. 196)

For the colonized *it is as if history were divided into two: before the Whites came* and *after the Whites came*.

The tone of Weller's stories is often powerfully emotive. Listen to these words from the last page of *Going Home*:

> So everyone has forgotten Cooley. . . . Grass grows between the stones on Cooley's grave, and a wildflower or two. Here lies . . . only a small-town half-caste who tried to raise himself out of the dirt and who was kicked back down again
> Only a half-caste who had been pushed around and beaten, humiliated, made to eat dust from the dust of his degraded life. Who, on the first day at school, as a six year-old, had been pushed around the circle of grinning white boys
> He had leapt high for the mark on cold grey days, sent along graceful kicks in the air and listened to the shouts from the crowd as his thin, long fingers plucked the ball from the sky. He had dreamed of the day when big Cooley, Number One, main actor, ran out on the field in the state football team.
> Only a half-caste who had lived in a world of football and dreams. Who had hated with all his heart, who had had his soul eaten out by the white man's ways, but who had been killed by a black man.
> Only a half-caste Cooley lies here. (p. 213)

Weller's stories depict not only the harsh reality of Aboriginal life but also attempt to convey what it feels like to be Aboriginal in Australia today – the anger, the alienation, the despair. His stories depict a range of 'mixed-race' male protagonists – including 'Cooley, the dreamer'; 'Cooley, the hate-filled and hated half-caste'; 'Cooley, the dead boy' (*Going Home*, p. 212) – whose lives are destroyed by the society in which they live. Some become successful in the White world, usually in sports, but not even they can escape their primary definition as racially inferior.

Once they move outside the immediate sphere of their success, a success that virtually always means the denial of their own people, they become just another Black person, denied full humanity and abused.

Writing about Bigger Thomas, the character from Richard Wright's *Native Son*, the Black American novelist and cultural critic James Baldwin says,

> His lot is as ambiguous as a tableau by Kafka. To flee or not, to move or not, it is all the same; his doom is written on his forehead, it is carried in his heart. (Baldwin, 1964, p. 27)

He might well have been writing about Cooley, and thousands of others like him.

Weller, master of the realist text, is particularly fierce in his depiction of police treatment of Aboriginal people, suggesting that it is this, as much as anything, that drives them to crime. In the story that gives the volume its title, 'Going Home', the successful footballer and painter Billy Wood-ward – who has been living as if he were an Honorary White, spurning his own 'dark, silent, staring people, his rowdy, brawling, drunk people' (Weller, 1986, p. 2) – returns to the reserve where the rest of his family live.

Meeting his People . . .

Billy has become part of a White world. He has learned to deny and despise his origins. Billy considers himself White and has no time or sympathy for his Black relations whose world of poverty, alcohol and degradation he wants to forget:

> He was white now.
> Once in the middle of the night, one of his uncles had crept around to the house he rented and fallen asleep on the verandah. A dirty pitiful carcass, encased in a black greatcoat that smelt of stale drink and lonely, violent places. A withered black hand had clutched an almost-empty metho bottle.
> In the morning, Billy had shouted at the old man and pushed him down the steps, where he stumbled and fell without pride. The old man had limped out of the creaking gate not understanding (p. 2)

Who could love such creatures? Who could blame Billy for failing to accept them as 'his people'?

> He was walking home one night from a nightclub when a middle-aged Aboriginal woman stumbled out of a lane.

She grinned up at him like the Gorgon and her hands clutched at his body, like the lights from the nightclub.[14]

'Billy! Ya Billy Woodward, unna?'

'Yes. What of it?' he snapped.

'Ya dunno me? I'm ya Auntie Rose, from down Koodup.'

She cackled then. Ugly, oh, so ugly. Yellow and red eyes and broken teeth and a long, crocked, white scar across her temple. Dirty grey hair all awry.

His people.

His eyes clouded over in revulsion. He shoved her away and walked off quickly.

He remembered her face for many days afterwards whenever he tried to paint a picture. He felt ashamed to be related to a thing like that. He was bitter that she was of his blood. (p. 3)

Going Home . . .

On his return to the reserve Billy encounters the full force of hostile White attitudes to Aboriginals and police treatment of Blacks when he is violently arrested for a robbery, a crime of which he is innocent. The language of the story emphasizes the brutality of the world that Aboriginal people inhabit; it reminds us of the power of White over Black.

The title of the story – 'Going Home' – is ironic. Billy had hoped for a 'home' in the dominant White society. We (the readers of the story) might think that Billy is going to find a 'home' by reintegrating with his Aboriginal family. Neither option is available. 'The story ends with Billy and his brother in the back of the police van . . . [H]e is induced into his "real home" as society constructs it: police custody and jail' (Tiffin, 1988, p. 223). One is reminded of a joke Dick Gregory, the African-American comedian and activist, used to tell. The joke went approximately as follows:

QUESTION: What do you call a Black man walking down the street carrying a briefcase and all dressed up in a Brooks Brothers suit?

ANSWER: A Nigger.

THE EDUCATED, SUCCESSFUL BLACK PERSON = JUST ANOTHER NIGGER

Come listen all you Nungars,
Come listen to my tale
Of our poor downtrodden brothers,
Arotting there in jail.
They committed no real crime
Apart from being black;

> *Some don't know why they're in there*
> *And probably will go back*
>
> *But prison's nothing special*
> *To any Nungar I know,*
> *'Cause the white man makes it prison*
> *Most everyplace we go.*
> — Sung by Charly in
> Colin Johnson, *Long Live*
> *Sandawara*, 1979, p. 139

Other stories in *Going Home* focus on how the destruction of Aboriginal culture(s) has left people of Aboriginal descent with White Western models of living and success in a society that is bitterly racist. 'Mixed-race' people in this society are shown to lack both positive identity and self-respect. In 'Saturday Night and Sunday Morning' young Perry, who has committed robbery and murder, wants to explain his behaviour to the White girl he has taken as hostage. But he has no words for it, no position from which to speak:

> He would like to tell her how once everyone shared everything and no one was poor. How could anyone be poor with the silver songs of the birds raining down from the cool leaves, and honeyed flowers for jewels, and diamond-eyed children with hearts of gold? Now their hearts are stone and they are cracking up, with moss dragging them down into gentle destruction. He would like to tell her how the white man stole his soul and filled the empty husk with white man's thoughts and hate instead of love of his people. He would have told her how they stole him away from his mother when he was only young and adopted him to an ugly white brick mother called a reformatory. There he learned a new type of kinship. (p. 60)

The problem here is one of knowledge and power, history and identity. What Perry is said to lack is any knowledge of his Aboriginal heritage with its strong sense of alternative – that is, counter-hegemonic – values and identity. Here, as elsewhere in Aboriginal writing, the spiritual and material deprivation of the present is contrasted with an image of a very different past.

> A VOICE: 'No more boomerang
> No more spear;
> Now all civilized –
> Colour bar and beer.'
> — Oodergoo Noonuccal
> (Kath Walker), 'No More
> Boomerang', in Rutherford,
> 1988, pp. 34–5

Just Another Nigger . . .

A superficial reading of Weller's stories might suggest he is arguing that 'White' ways of living are fundamentally unsuitable for Aboriginal people: those who take this path are bound to fail, ending up living impoverished lives, dominated by alcohol abuse, subsisting on state welfare handouts. Actually, the argument is more sophisticated. It is that, given a racist society like Australia, there is no possible life strategy for Black people that has a strong likelihood of resulting in long-term success and happiness. One can 'play by the rules', acquiring a 'good' (White) education, a 'good' (White) job, middle-class (White) values, and so on. One can be SUCCESSFUL, for example, a famous personality, but the experience of 'success' is only momentary, really only an illusion. Because in a racist society no matter what position a Black person attains, he or she can always be reconstructed as JUST ANOTHER NIGGER – insulted by petty White police officers, beaten by a gang of racist thugs, exploited by the forces of White Power. A recurrent theme in Weller's stories is that even those young Aboriginals who achieve in White terms cannot escape the social attitudes and practices which define them negatively in terms of their 'race', which ensure that niggers are kept in their place. Here, the role of the police, as agents of White power, is crucial.

One of the most damaging effects of White racism, the stories argue, is the way in which it destroys self-respect. In some this provokes fear and compliance; in others it leads to violence – a violence often modelled, the stories suggest, on that of American gangster films and Westerns which are virtually the only source of entertainment for local Aboriginal youths. Crime, which usually begins as robbery, is shown to escalate quickly to violent assault and killing.

This theme is developed in Weller's best-selling novel *The Day of the Dog* (1981). The picture of Aboriginal violence in this novel is stark, but it is shown to be socially produced, a product of poverty and a racism which is itself often extremely violent. Those who turn to crime usually do so in order to escape the poverty of the reserves and camps where conditions are degrading.

Traces of Culture, Markers of Identity

Let no one say the past is dead.
The past is all about us and within.
Haunted by tribal memories, I know
This little now, this accidental present

> *Is not the all of me, whose long making*
> *Is so much of the past.*
> — Oodergoo Noonuccal (Kath
> Walker), 'The Past', in Walker,
> 1981, p. 93

It is not that colonialism totally destroys the culture(s) of the colonized. For eliminating all traces of a culture – all its ways of thinking and ways of being – is next to impossible. (The most certain method is probably wholesale genocide, and even that is not always sufficient.) Remnants of Aboriginal culture persist in the settlements and suburban slums. They include elements of traditional law and an affinity with the land, along with elements of religion and the arts. Thus for Reg Cooley, a 'mixed-race' youth from the north, and Snowy Jackson, a 'full-blood' Aboriginal from a rural area, it is not images taken from American cinema that legitimate killing, but 'tribal' law.

> An eye for an eye. That was the law from long ago, as ageless as the purple jagged ironstone mountains the boy could just remember. That was the law that kept people's pride aglow, like the fire that never went out. (Weller, 1986, p. 207)

More than 'tribal' law, affinity with the land is perhaps the key feature in Weller's stories that marks Aborigines as positively different from Whites. Sammy, the one expert Aboriginal surfer in the story 'Violet Crumble',

> is different from the other surfers, not just in his quietness and skin colour. He thinks differently from them about the ocean that was his ancestors' feeding ground for centuries. He can tell you where the hidden middens lie, holding the skeletons of shell-fish and stories going right back to where man's footprints first touched a truly virginal land. He can tell you where fish and crayfish reside in the nooks and crannies of a thousand jagged reefs. Unlike the white surfers, whose language is often inarticulate and sparse at the best of times . . . Sammy speaks of his ocean with a knowledge and love that no one . . . could hope to understand. (pp. 109–10)

For Reg Cooley the bush is the one place where he feels himself and is free from White persecution:

> After school. Cooley made his way through the dripping quiet bush. For a white person there were burnt slimy logs to trip over, hidden red rocks to stub toes on, prickle bushes to scratch the face. But Cooley's lithe brown form slipped silently through his bush. Tall, green, old trees with scratched scraggly bodies rustled to him from the grey drizzle and Cooley grew wet and cold. But he didn't mind. Away over the hill a kookaburra laughed. The green moss on the knobbly rocks caressed his big flat feet, while his boots danced a jig around his neck, Greeneyes flitted in amongst the moaning,

olive-coloured leaves and whistled to him. Parrots fled, shrieking over the hills at his approach. Cooley blended into the swirling shadows of the bush and the black cockatoo's cry echoed in his mind. Back, back to thousand years ago when a wild short full-blood had also fled into his sanctuary. Cooley's slouch and sullenness were gone, and a rare glint shone in his yellow, evasive eyes. Cooley was home. The wind that sang for him told him this, the leaves that brushed gently against his face told him; and Cooley was free, alone, a man again. (p. 180)

Like images of the past, affinity with the land figures in Aboriginal writing as a positive source of identity in opposition to the daily reality of Aboriginal life. Thus, even the most violent of Aboriginal youths (as depicted, for example, in Weller's *Day of the Dog*) find a peace and fulfilment outside the city, spending time on the land.

Where Are the Women?

Women, their experience and perspectives, are under-represented in Aboriginal texts.. Women do figure in texts about reserve and camp dwellers, which tend to take family and kinship groups rather than individuals as their subject.[15] They also appear in texts about urban youth, but rarely as central characters: rather, *women feature in relation to men*, often as sexual objects in extremely sexist social relations. Both types of text reproduce the patriarchal relations of Aboriginal life, relations which take an arguably more brutal form in representations of urban living. (Some of Archie Weller's short stories provide powerful insights into this theme.) And mothers – along with a White racist society – are blamed for the lack of belonging experienced by young male protagonists, for trying to integrate their 'mixed-race' children into White society by denying them access to their Aboriginal heritage.

A different perspective on these problems is to be found in the single best-selling book by a woman of Aboriginal descent, the autobiography and life history *My Place* by Sally Morgan (1987). The text explores the experience of growing up Aboriginal – more accurately, of growing up neither 'Black' nor 'White' – in the suburbs of Perth. It explores aspects of twentieth-century Aboriginal history and the value of recognizing and claiming an Aboriginal heritage.

In Search of My Place

At night I used to lie in bed and think 'bout my people. I could see their campfire and their faces. I could see my mother's face and Lily's. I really

missed them. I cried myself to sleep every night. Sometimes, in my dreams, I'd hear them wailing, 'Talahue! Talahue!, and I'd wake up, calling 'Mum! Mum!' You see, I needed my people, they made me feel important. I belonged to them. I thought 'bout the animals, too. The kangaroos and birds. And, of course, there was Lily . . . I missed her, I missed all of them.

— Sally Morgan, *My Place*, 1987, pp. 333–4

Yet we can see the start of some slight searching for 'Aboriginality'. But what is Aboriginality? Is it being tribal? Who is an Aboriginal? Is he or she someone who feels that other Aborigines are somehow dirty, lazy, drunken, bludging? Is an Aboriginal anyone who has some degree of Aboriginal blood in his or her veins and who has demonstrably been disadvantaged by that? Or is an Aboriginal someone who has had the reserve experience? Is Aboriginality institutionalized gutlessness, an acceptance of the label 'the most powerless people on earth'? Or is Aboriginality, when all the definitions have been exhausted, a yearning for a different way of being, a wholeness that was presumed to have existed before 1776?

— Kevin Gilbert, 'The Search for Identity', in Gilbert, 1978, p. 184

Taken Away . . .

Look at plate 14.3, a black and white reproduction of *Taken Away*, a silkscreen on paper by the author Sally Morgan. The print depicts two central themes in the history of Black–White relations in Australia, from the perspective of Black – Australian Aboriginal – women. In the bottom section of the print there are Aboriginal women with outstretched arms, desperately reaching upward. In the middle of the print there are Aboriginal children desperately reaching for their mothers, from whom they have been separated. But there is a massive, impassible barrier between the mothers and their children. However much they struggle to reconnect, they are prevented from doing so. Thus one theme – the dominant one – of *Taken Away* is the *'assimilationist' policy* which from around 1905 until the early 1970s dictated that the children of Aboriginal mothers and White fathers were to be taken away from the Aboriginal families and communities of their birth. Aboriginal mothers of 'mixed-race' children had no legal rights to these children (whose White father almost never acknowledged their existence). As a result of this policy 'mixed-race' children were forcibly taken away from their families and placed in White-run orphanages and missions – where use of Aboriginal languages and culture was prohibited, where outside contact with Aboriginal people was severely restricted or forbidden, where often they were cruelly treated, where they were to be 'assimilated' whatever the cost.

The second theme in *Taken Away* is that of the taking away of Aboriginal land by White power, that is, the military and legal processes through which White settlers and colonialists stole the continent from its original

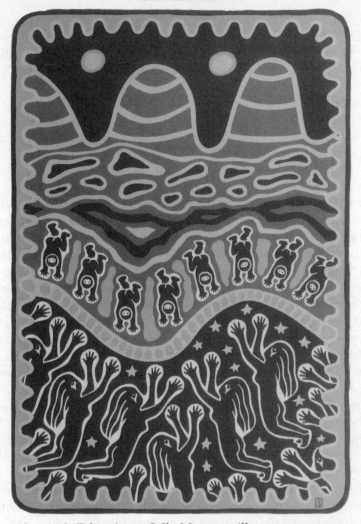

Plate 14.3 Taken Away, Sally Morgan, silkscreen on paper.
Reproduced by kind permission of the artist. From the collection of the National Gallery
of Australia, Canberra. Bicentennial Portfolio, commissioned 1988.

inhabitants, banishing them to marginal lands and slum dwellings. The
top part of the print includes a representation of Katatjuta (literally 'the
place of many heads'), a traditional Aboriginal sacred site populated by
mythical beings. Popularly known as the Olgas, this breathtaking group
of enormous rock domes is located in the barren, sandy desert of central
Australia. In recent years, as a result of the activities of feminist mystics
(White Australians and others), Mount Olga and the surrounding hills
have come to be constructed as a *women's* sacred site. 'The Olgas have
come to represent the new, feminine world. The rounded intimacy of the
Olgas is contrasted with the rigid, terrifying masculinity of Ayers Rock'

(Marcus, 1988, p. 270). The Aboriginal women in Sally Morgan's silk-screen are not only desperately reaching to reclaim their stolen children but also to reclaim the Olgas, that is, Aboriginal land, including their sacred places. Perhaps they are also striving to claim a woman's place in the universe.

In an interview a few years ago, Sally Morgan was asked whether she sees a relationship between her visual art and her writing. Part of her reply was, 'I'm also interested in not just writing oral histories, but painting oral histories, doing the same thing in a different form' (Wright, 1988, p. 105). The silkscreen *Taken Away* and the book *My Place* cover common ground.

My Place traces the history of three generations of the author's family, a 'mixed-race' Aboriginal family. Narrated by the eldest daughter of the third generation, Sally, who has grown up believing that she is ethnically Indian, the text encompasses the life histories of her mother, Gladys, her great-uncle Arthur and her grandmother, Daisy, known as Nan. It offers a picture of the profound effects on individual lives and identities of successive racist attitudes and policies towards Aboriginal people. 'It is a slow and very painful recovery of a past, full of humiliation and hurt, caused by white Australians' treatment of Aborigines' (Rutherford, 1988, p. 110). Although technically a mixture of autobiography and life history, *My Place* is written very much like a novel. Its plot is the search for a suppressed family history, for Aboriginal heritage and identity.

In chapter 9, we described some of the genocidal practices under which, especially in the nineteenth century, Aboriginal people suffered. *My Place* is fundamentally about CULTURAL GENOCIDE and THE DESTRUCTION OF A PEOPLE'S POSITIVE IDENTITY. The text is located in the context of twentieth-century Australia, a century during which Aboriginal people were no longer threatened by physical extermination but by brutal attempts by White power to destroy Aboriginal culture, languages and identity – for example, by taking away children from their families.

A Letter to my Mother

I not see you long time now, I not see you long time now
White fulla bin take me from you, I don't know why
Give me to Missionary to be God's child.
Give me new language, give me new name
All time I cry, they say – 'that shame'
I go to city down south, real cold
I forget all them stories, my mother you told
Gone is my spirit, my dreaming, my name
Gone to these people, our country to claim
They gave me white mother, she give me new name

All time I cry, she say – 'that shame'
I not see you long time now, I not see you long time now.

I grow as Woman now, not Piccaninny no more
I need you to teach me your wisdom, your lore
I am your Spirit, I'll stay alive
But in white fulla way, you won't survive
I'll fight for Your land, for your Sacred sites
To sing and to dance with the Brolga in flight
To continue to live in your own tradition
A culture for me was replaced by a mission
I not see you long time now, I not see you long time now.

One day your dancing, your dreaming, your song
Will take your Spirit back where I belong
My Mother, the earth, the land – I demand
Protection from aliens who rule, who command
For they do not know where our dreaming began
Our destiny lies in the laws of White Man
Two Women we stand, our story untold
But now as our spiritual bondage unfold
We will silence this Burden, this longing, this pain
When I hear you my Mother give me my Name
I not see you long time now, I not see you long time now.
— Eva Johnson, in Gilbert, 1988, pp. 24–5

If the social effects of racism and the search for a suppressed family history are the key themes of *My Place*, their location as part of the texture of the everyday lives of the characters and the concentration on how they affect people's sense of self-worth and emotional life engage the reader's sympathy. There are four different narrators in the text: Sally Morgan, her uncle (Arthur Corunna), her mother (Gladys Corunna) and her grandmother (Daisy Corunna). This mode of writing creates not simply an empathetic history but also a plural history, a text with different perspectives on past events.

Hiding the Past, Discovering the Truth

The nature and effects of White racism on Aboriginal people are made clear in the text through the attempt to explain why Sally Morgan's grandmother and mother hide their past – trying to pass for White, denying their Aboriginal origins. The answer is not that they really want to be White – the grandmother in particular despises White people for the pain they have inflicted on Aboriginal people[16] – but that they wish to

ensure that their children are not taken away from them (as it was against the law for an Aboriginal mother to keep a 'mixed-race' child). 'Passing for White' is a means, painful but successful, of preserving their family from the brutality of anti-Aboriginal policies, of ensuring that 'terrible things' do not happen to them. Here is Sally's mother (Gladys) talking about her attempts to talk to her mother (Daisy) about their family history:

> I tried for a while after that to talk to Mum and get her to explain things to me, especially about the past and where she'd come from. It was hopeless. . . She just kept saying, *'Terrible things will happen to you if you tell people who you are'*. I felt, for her sake as well as my own, that I'd better keep quiet. I was really scared of authority. I wasn't sure what could happen to me. (Morgan, 1987, p. 279; emphasis added)

Racial difference and the social stigma attached to Aboriginality is first brought home to the narrator at school:

> The kids at school had also begun asking us what country we came from. This puzzled me because, uptil then, I'd thought that we were the same as them. If we insisted that we came from Australia, they'd reply, 'Yeah, but what about your parents, bet they didn't come from Australia.' (p. 38)

Here, the country's original inhabitants are transformed into 'outsiders', immigrants, non-Australians. In this binary system of racial and cultural oppositions, being 'Australian' is assumed to mean being White: 'They could quite believe we were Indian, they just didn't want us pretending we were Aussies when we weren't' (p. 39). This implicit racism, the text suggests, has long been part of Australian experience and is central to Sally's family's attempt to hide their origins.

Sally's awareness of being DIFFERENT also emerges, bit by bit, from incidents that sometimes occur in the home. These incidents usually involve her grandmother:

> Towards the end of the school year, I arrived home early one day to find Nan [i.e., Grandmother] sitting at the kitchen table, crying. I froze in the doorway, I'd never seen her cry before.
> 'Nan . . . what's wrong?'
> 'Nothin'!'
> 'Then what are you crying for?'
> She lifted her arm and thumped her clenched fist on the kitchen table. 'You bloody kids don't want me, you want a bloody white grandmother. I'm black. Do you hear, black, black, black!' With that, Nan pushed back her chair and hurried out to her room. . . .
> For the first time in my fifteen years, I was conscious of Nan's colouring.

She was right, she wasn't white. Well, I thought logically, if she wasn't white, then neither were we. What did that make us, what did that make me? I'd never thought of myself as being black before.

That night, as Jill and I were lying quietly on our beds, looking at the poster of John, Paul, George and Ringo, I said, 'Jill . . . did you know Nan was black?'

'Course I did.'

'I didn't, I just found out.' . . .

'You know we're not Indian, don't you?' Jill mumbled.

'Mum said we're Indian.'

'Look at Nan, does she look Indian?'

'I've never really thought about how she looks. Maybe she comes from some Indian tribe we don't know about.'

'Ha! That'll be the day! You know what we are, don't you?'

'No, what?'

'Boongs, we're Boongs!' I could see Jill was unhappy with the idea.

I took a few minutes before I summoned up enough courage to say, 'What's a Boong?'

'A Boong. You know, Aboriginal. God, of all things, we're Aboriginal!'

'Oh.' I suddenly understood. There was a great deal of social stigma attached to being Aboriginal at our school. (pp. 97–8)

Were They Wrong to Hide Their Blackness?

My Place offers numerous examples of how racism affects identity. Sally's grandmother, Daisy, who has discernible Aboriginal features, hides when her grandchildren bring friends home from school. Her mother, Gladys, tells how her experience at a children's home taught her to be ashamed of her ethnic origins. Aboriginal people are shown to feel ashamed of speaking their language.[17]

The suppressed history of the Aboriginal people under White political, economic and cultural domination is central to *My Place*. Arthur, Gladys and Daisy tell of their experience of forced labour on the stations. They tell of police repression. They tell of women taken away from their communities and trained for domestic service. They tell of 'mixed-race' children taken from their mothers and brought up in homes on missions where darker children were separated from lighter children and all were forbidden to speak 'native' languages. Arthur remembers seeing people in chains and hearing of Whites shooting Blacks for sport. He recalls internment during the war and denial of citizenship. Gladys recounts how Aboriginals were under the control of the Native Welfare Department and made to carry permits in order to travel.

Because of the relatively powerless position of Aboriginal people in Australia Nan attempts to buy White friends and to convince them that

really she is White. Their refusal to accept a position beneath the heel of White power motivates her and Gladys's denial of their ethnic origins. Once they admit to being of Aboriginal descent, further questions are posed.

There is the problem of coming to grips with the fact that they had previously 'wanted to be White', which leads to guilt and embarrassment. Daisy reflects:

> I'm 'shamed of myself, now. I feel 'shamed for some of the things I done. I wanted to be white, you see. I'd lie in bed at night and think if God could make me white, it'd be the best thing. Then I could get on in the world, make somethin' of myself. Fancy, me thinkin' that. What's wrong with my own people? (p. 336)

What was wrong, of course, was that Daisy's 'own people' lacked respect, dignity and power; that being Aboriginal was a ticket to hell – the hell of racism, poverty and marginalization. To say, 'I wanted to be white' is to say, 'I wanted to be respected and to have a fair chance in life.'

There is also the matter of deciding what Aboriginality means. Sally reflects:

> What did it really mean to be Aboriginal? I'd never lived off the land and been a hunter and gatherer. I'd never participated in corroborees or heard stories of the Dreamtime. I'd lived all my life in suburbia and told everyone I was Indian. I hardly knew any Aboriginal people. What did it mean for someone like me? (p. 141)

Sally clearly has a *complex, non-unified identity*. The questions she poses lead to an emotional pilgrimage in search of her origins and of positive meanings of Aboriginality to set against the negative ones provided by White society.

Finding a Place

The importance of BELONGING, of HAVING A PLACE, is depicted as ultimately being a two-way process. Sally's family finally experiences this belonging on discovering their 'tribal' relations in the north. *My Place* suggests that people of mixed-race Aboriginal descent need to find their Aboriginal heritage and to experience a sense of belonging. On the other hand, the 'tribal' people on the reserves, whose 'mixed-race' children were taken away or have left, need to be recognized and accepted by them. Sally recounts how, when they visited the reserve, 'An old full-blood lady whispered to me "You don't know what it means, no one comes

back. You don't know what it means that you with light skins want to own us" ' (pp. 228–9).

On the dedication page of *My Place* there is an inscription. It reads:

> How deprived we would have been
> if we had been willing
> to let things stay as they were.
> We would have survived,
> but not as a whole people.
> We would never have known
> our place.

From Alienation and Degradation to Dignity and Resistance: *Long Live Sandawara*

The old man stares down into the fire and thinks about the death of Sandawara who died that all men should be free. He thinks of his own life: old Jacky Jacky taken far from his country to languish in a white man's prison, then ejected, old and broken, to live as best he could, bereft of land, hope and people. Far south, too far south and too broken in spirit to attempt the long trek back – until now since a boy has come asking him about the old days and the old ways, asking him about Sandawara and listening as he speaks of the warrior. His old voice murmurs: 'Sandawara, Sandawara,' and it is like a prayer.

'Yes,' Alan, the new Sandawara replies . . .

— Colin Johnson (Mudroogoo Narogin), *Long Live Sandawara*,
1979, p. 169

Aboriginal cultural heritage, denied in attempts to integrate Aboriginal people into the dominant, national culture, forms the basis in Aboriginal fiction for new contemporary forms of identity and resistance. *Long Live Sandawara*, published in 1979, is the second novel by Mudroogoo Narogin (then known as Colin Johnson). It draws directly on traditional material as a basis for exploring questions of identity and resistance. The novel contrasts the story of the Aboriginal resistance fighter Sandawara – as told by an old tribal leader, Noorak – with the aspirations and actions of a group of unemployed Noongar youth in the suburbs of Perth.

Writing is political. *Do Aboriginal texts provide an emancipatory cultural politics?* Or do they simply mimic the racism and romanticism of dominant representations? These are crucial questions. A close reading of *Long Live Sandawara* perhaps provides some answers.

The publisher's blurb on the cover of *Long Live Sandawara* reads as follows:

> Every revolution has a leader and there is no question in Alan's mind that he is that leader. For inspiration he goes to Noorak, the law holder of his people, and hears the heroic tale of Sandawara, the last of the warriors, who died defending his land and his people against the white man in the Kimberleys. So Alan names himself and becomes the new Sandawara and the rest of the unemployed teenage Aborigines of his mob take the names of Sandawara's followers. In his crash pad, a broken-down old house, the new Sandawara plots and schemes the revolution.
>
> The story of this mob of anti-heroes, of a farcical inefficient revolution, gives a vivid portrayal of a new and frightening world of rootless youth, who lack identity and purpose and shoot as easily as they love because neither act has meaning.

This 'official' account of *Long Live Sandawara*, apparently written for a 'respectable', middle-class White audience, manages to describe the book without alluding to the themes that are at its core: Australia's brutal history of racism, Aboriginal cultural and psychological degradation, the problem of struggling for positive forms of identity, the problem of struggling for a non-racist, multi-ethnic society. These and related issues, marginalized in the 'official' framing of the text, are the focus of the following discussion.

Taken Away . . . Again

As we have seen, the dominant theme of Sally Morgan's autobiography and life history, *My Place*, was the policy of removing the children of Aboriginal mothers and White fathers from their Aboriginal families and communities and placing them in White-run orphanages and missions.

The TAKING AWAY OF ABORIGINAL CHILDREN from their parents (with its traumatic effects on individuals and families) and the TAKING AWAY OF ABORIGINAL LAND are two dominant themes in the history of White–Black relations in Australia. The issue of White theft of things belonging to Aboriginal people – their children and their land but especially their dignity – recurs in *Long Live Sandawara*. In a moving passage, Charly, one of the aspiring musicians in the group, tunes his guitar and begins singing a song, 'Yawee, Yahaawee, My Brownskinned Baby They Takim Away'. Here are two of the four verses:

> Between her sobs I heard her say:
> Police been take my baby away,

From white man boss that baby I had,
Why he let them take baby away?

To a children's home, a baby came,
With new clothes on and a new name;
Day and night he would always say:
Mummy, mummy why they take me away?

The song, which ends by saying that the child and its mother will never meet again, resonates with the experience of Alan and his teenage friends. They have all felt the pain of familial separation. They are youngsters yearning for a home, for a place where they belong and are cared for (pp. 94–5).

Long Live Sandawara moves between two time-periods: a period of anti-colonial revolt (textually located probably in the 1880s or 1890s) and the present. The story of Alan and his mates is located in the present. Victims of the twentieth-century urban Australian Aboriginal condition, they exist as rootless exiles in an urban slum, as aliens on the land which their people have occupied since the beginning of time.

The legend of Sandawara dates from the colonization period. In the passage below, Ellewara, an 'outlaw' from the perspective of White colonial society, a revolutionary hero from the perspective of its Black victims, has been captured by the two Aboriginal trackers, 'Eaglehawk' (Sandawara) and 'Captain', who are in the employ of their White masters. As they bring him back from the bush to face White justice, Ellewara challenges them and other Aboriginal people within sound of his voice to reflect on what their colonial masters have done – on what they have killed, polluted and driven away, on how they have robbed Aboriginal people of their land, their way of life, their sense of dignity and self-respect:

'It's a pity,' he declares. . . . 'He's chopped down our sacred trees to pollute our holy dance grounds with his ugly houses. He takes the water and grass. He drives away the kangaroos and wallabies; he murders the ducks and geese. . . . He kills everything . . . He leaves us nothing . . . and what do we do? Slave and suffer.' (p. 23)

After letting his Aboriginal captors think for a while, Ellewara continues, emphasizing the complicity of Black people in their own oppression. He refers to them as 'gutless people' who have given the earth to the alien Whites – a gift that is not theirs to give as it is the land of their ancestors and children. Ellewara reminds his captors that without their help, the White enemy would die; without them he would be powerless. It is clear how the police use Aboriginal people against each other.

Personal and Cultural Degradation

Racism degrades human beings – not inevitably, but usually. This is one of its most profound, and sickening, effects. *Long Live Sandawara* is largely about the human degradation of racism's victims and the struggle for new forms of subjectivity, forms that facilitate dignity and self-respect. Some of the novel's principal characters have been reduced to a condition of psychological wretchedness, with only the lowest expectations for themselves and others like them. Tom tells Alan and his girlfriend Sue that *all he wants out of life is a bottle of alcohol and a place to crash. The dole's enough for him* (see p. 38). Elsewhere Tom, in a remarkable passage, declares his total lack of self-respect:

> 'I was born with a stone around my neck. I'm used to it, it keeps my eyes on the ground looking for butts. I ain't got any self respect. None of us has'
> (p. 124)

A central character in *Long Live Sandawara* is Noorak, the old Aborigine whose memory and stories allow Alan and his comrades to connect with 'their' (Aboriginal) history and culture. 'Jacky Jacky' was formerly Noorak, a powerful member of his tribe, the Keeper of the Law. As the physical embodiment of ancient knowledge and power, he was respected and feared by his people. But that was before his encounter with the repressive apparatuses of White power.

Now he lives beneath a railway bridge, 'Thin and wizened, doddering with age, cold in ugly second hand clothing he's never grown used to.' Noorak, or 'Jacky Jacky' as his White masters call him, lives without dignity or power, old, stiff and impoverished, thousands of miles away from his homeland. How has he come to such a state? For adhering to the ways of his ancestors, he was arrested by White men and taken away south to a prison far from his land and people. The five years he spends in prison changed him, leaving him a despairing, alcoholic living hundreds of miles from home. Formerly Noorak was the chief figure among his people. Now 'Jacky Jacky' lives in an alien, humiliating world where his only comforts are alcohol and his dreams:

> The fire flickers and the strands around his head grow heavier and heavier with the loss of his power. A band of iron fastens around his neck, a long chain drags him to the ground, pulling him away from his people to the deadland of the south – to the land of strangers, unknown and terrifying. *His power goes, his skin slackens and wrinkles, his almost sightless eyes turn blood red with drink. His power goes, leaving only a trembling old body, soulless and almost alone.* (p. 18; emphasis added)

This is a story not only about individual degradation but about the subordination, the *inferiorizing* of an entire people. It is a story about Aboriginal culture and society trampled under the heel of White power.

In this drama the police play a central, repressive role. Noorak was arrested and imprisoned for administering Aboriginal justice to an Aborigine who had broken one of their laws. It had been the law for centuries until the White policemen came. In their eyes Aboriginal laws and beliefs are nothing. Noorak, the Lawkeeper is transformed by White power into an outlaw, unable to defend his land and way of life against the White aliens with their different law and culture (see pp. 18–9).

The Lawkeeper becomes an outlaw . . . Noorak is reduced to the status of a common criminal. But the ultimate degradation is still to come.

The Aborigines are a defeated people, and their military and political subordination has its concomitance in the cultural sphere. There is, for example, the rather disdainful fact that, should the conquerors so desire, Aboriginal history and culture can be (re)constructed for their entertainment.

Since emerging from prison, the former leader of the Nungar people has become an impoverished alcoholic vagrant, living away from his people in conditions of urban squalor. He is, as the novel puts it, 'BLACK, LOST AND POWERLESS', 'BEREFT OF LAND AND HOPE' – without resources to acquire even the cheap warm red liquor he needs. Here, Noorak's personal history serves as a allegory of the collective experience of Australian Aborigines.

In this condition Noorak offers himself to his exploiters. Together with some other Nungars who, like him, have been robbed of their dignity, he becomes a parody of himself, a parody of his people, performing on stage for the amusement of Whites. As their way of assuaging their guilt and of showing their identification with the country's past, some White Australians have decided to preserve and display traditional Black Australian culture. But they have a problem since White power has almost totally wiped out the old ways: few Aboriginal people know their sacred dances and fewer still will display them before the White aliens. Jacky Jacky, 'picturesque with his rugged face and flowing grey beard' and regularly in need of resources for alcohol, allows the Whites to buy him. He lets himself and some other authentic-looking Aborigines be assembled together to stage a makeshift corroboree (p. 69).[18]

The performance is a nauseating spectacle, an exercise in personal and cultural degradation. Slouching before a chatting White audience, the old man waits to display his culture. He is gripped by TOTAL ALIENATION: his hair clad in a red bandana, his face covered with white ash, the old man is 'an actor, a performer – a monkey pantomiming for bananas'. Subjugated beneath the power of the aliens, the old man stands waiting for the performance to begin (p. 69).

Why does he do it? Like a monkey performing tricks for peanuts, the degraded former leader of the Nungar, 'Jacky Jacky', sings and dances for alcohol: a few old songs and dances will earn him enough money to pay for a dozen bottles of the sweet wine which is his only recurring desire (p. 69). Nothing is sacrosanct. As Aboriginal sacred lands have been transformed by the conquerors into cattle farms, building sites, motorways and cricket pitches, so the dancing black apes transform Nungar sacred rites into bizarre spectacles for the amusement of their masters:

> Another like himself drones out *a sacred tune turned blasphemous*; others like him join in, hands beating the flat earth. Pum, pum, *a passive rhythm without life – or hope.* Jacky Jacky hesitates, his dark brown body flabby and as soft as flour. . . . His shabby white man's clothing has been discarded – but it still imprisons his heart. *He feels a slave and wishes he didn't care.* (pp. 69–70; emphases added)

The White audience sit in the shade smiling at the antics of the Black entertainers.

It is rarely possible for the victims of racism to entertain their White masters in such a manner without profound effects on their subjectivity. Feeling isolation, guilt and shame, the 'Jacky Jacky' and the other Aboriginal performers ask themselves: What have we done to separate ourselves from our ancestors? What horrendous crime have we committed to offend the ancestral lawgivers and bring such a terrible punishment upon ourselves? (p. 70)

There is another dimension to this grotesque and pathetic spectacle. Included in the show is a performance of 'The Song of Sandawara', a musical and dramatic re-enactment of an Aboriginal armed revolt against White colonization. Sandawara (Noorak) is the leader. He stamps and leaps, in time to the powerful rhythm, landing with an earth-shaking jar. The hopes of his people are with him. The warriors clasp their war spears and 'shout with righteous anger'. Glowing with hope, they charge out to reclaim their land, their heritage from the White invaders. The great warrior Sandawara is in command.

> He stamps about the fire, his knees high, his feet hammering at the earth. . . .
> Three white outlaws die. The tempo quickens as Sandawara hunts down the police. Noorak runs and leaps, sways backwards and forwards in mortal combat with a many handed demon. (pp. 70–1)

But this is not revolution, it is only entertainment – entertainment which the aliens, having totally degraded the performers, their history and culture, do not even appreciate (p. 71).

What is going on here? The *real* domination/defeat of Australian Aboriginal peoples is so complete that White Australians and tourists can

even be entertained by dramatic reconstruction of Aboriginal revolt in which Whites were defeated, killed, and so on. It would be as if Whites in the Americas hired the descendants of Black slaves to perform for their entertainment songs and dances in which slave revolts featured prominently. More accurately, it would be as if, for the enjoyment of locals and tourists, Germans hired Jews who remember the concentration camps to dramatically reconstruct their history of resistance to extermination by the Nazis.

This is cultural appropriation at its most revolting. It is enough to make one sick. This sort of bizarre exploitation is only possible when a people have been utterly defeated, when real resistance is no longer a possibility.

But is Noorak *utterly* defeated? Although he has been reduced to despair by his arrest and imprisonment, Noorak remembers a different past, which he depicts as a time of dignity, power and honour. As the old man's 'sunken eyes, red with age and too much cheap wine, watch the flickers of his fire', he remembers/dreams a time when things were different. He sees himself standing tall and strong, grey mud caked in his hair, his initiation scars rubbed with white clay. He sees the old men of the tribe sitting on either side of him, with the others behind – all of them watching and waiting in terrible silence and dread for Noorak, the Keeper of the Law, to speak. As he sees himself and his people, the old man feels the power that was his flow through him again (p. 17).

This *positive image of the past* is contrasted with *a present that offers little* either to urban Aboriginal youths or to old 'tribal' Aborigines, like Jacky Jacky, who have been reduced to alcoholism and are dependent on selling their culture and identity for drink. Yet, the novel suggests, *even in such a context Aboriginal history can be a powerful force for positive self-image and dignity*. The image of Sandawara has the power to transform the old man, such that he becomes a CHANGED SUBJECT even as he performs for tourists: strength flows through his old, weakened body; he feels as if the old days have returned; his people acknowledge his presence; they are defending their earth; he is no longer Jacky Jacky but Noorak again – at least for the moment (p. 70).

Symbols of Resistance I: Whose Clothes Should I Wear?

One of the effects of colonialism, at least when the colonizers are not only politically and economically dominant but also culturally, is that the colonized come to *look* increasingly like the colonizer: the African-American woman comes to adopt the hairstyles and make-up of her White American counterpart, the North American Indian male comes to wear jeans and a cowboy hat, the South American Indian woman dons a full-length dress imported from Spain, the Bantu chief wears a

tailor-made English business suit – the slaves dress up in the costumes of their masters. During moments when the colonized come to gain consciousness of their 'true identity', that is, during periods of personal or collective revolt, the master's costume becomes a salient issue. Thus, in the 1960s during the Black power movement in the United States, many Black Americans came to don 'Afro' hairstyles and 'Afro' clothes (for example, dashikis). Similarly, and even more dramatically, in the 1980s and 1990s in the context of the worldwide 'Islamic revolution' there has been considerable emphasis on 'Islamic dress' – especially for women. (Such 'revolutions' can, of course, prove at least as repressive as the systems they replace.)

In *Long Live Sandawara* the issue of *clothes-as-symbols-of-oppression* and *clothes-as-symbols-of-resistance* surfaces on several occasions. For example, we are told that during the anti-colonial revolt led by Sandawara, all the warriors are naked except for the necessary White man's weapons. Their uniform is nakedness for, in an act of contempt and psychological liberation, *they have discarded the white man's clothing* and returned to their God-given state (p. 110). In a related act of defiance, Alan, the urban Aboriginal youth turned revolutionary, assumes the habit of posing in the style of Sandawara: 'Our national costume', Alan says grinning, as he poses nude in a spear-throwing stance. His eyes move to the painting of Sandawara that hangs on the wall and he wishes he had a full-length mirror to compare his pose with that of the great warrior (p. 30).

Symbols of Resistance II: What's in a Name?

If *Long Live Sandawara* is a novel about personal and cultural degradation in a White racist society, it is also, as we have begun to note, a novel about resistance to degradation. Such resistance, as articulated in the text, takes the form of both cultural and physical struggle.

Consider names. One of the powers of the colonizer is, as we pointed out in chapter 1, the power to name. The colonizer 'discovers', conquers and (re)names the colonized's homeland – for example, as 'Australia', 'Northern Territory' or 'Perth'; or 'America', 'Alabama' or 'New York'. *The colonizer even has the power to decide what the colonized shall be called*, by what name s/he shall be known:

'What's your name? . . . 'Captain,' he finally answers.
'That's a real old name,' the woman says 'Remember they used to give us names like that in the old days. *Captain* and *Pigeon*, *Blackie* and *Nigger*, *King Billy*
My name's *Mary*, good Catholic name. Named after a farmer's daughter, I am.' (pp. 125–6; emphases added; see also p. 76)

An analogy is usefully drawn here with the American plantation where it did not matter what position one had held, for example, as a political or religious leader, in the West or Central African society from which one came. The point was that on the plantation, in interactions with White power, one answered to 'Boy', 'Nigger', 'Auntie', 'Sam' or whatever other term, however inappropriate or degrading, the slave master chose to use.

Thus it is that many colonized people struggling for liberation come to change their 'names' – the personal names/terms by which they are called and/or the names by which their people or their country are called. In *Long Live Sandawara*, the colonizer's Aboriginal tracker, 'Eaglehawk', takes back his Nungar name; 'Sandawara', the degraded 'Jacky Jacky' eventually returns to his homeland as 'Noorak'; and in a dramatic moment Alan and his young comrades are all renamed. 'We should drop our white fellow names and have Nungar names', Alan declares. He then announces that henceforth he will be known as 'Sandawara', the great Aboriginal warrior who fought the Whites to a standstill up north. Asserting that Sandawara's struggle is now their struggle, the young leader renames each member of his group after the women and men of Sandawara's band. He begins by proclaiming Sue to be 'Kangawara' – that is, the new Sandawara's woman will assume the identity of the old Sandawara's wise and deeply loyal companion. The young leader continues by renaming Tom as 'Captain' (Sandawara's friend and right-hand man), Greg as 'Ellewara', Rob as 'Lillewara', Rita as 'Wawollu', Sally as 'Terwara' and Jane as 'Wandara'. This naming ceremony marks *a ritual of resistance, a reversal of power, an intervention in cultural politics*. Links made between past and present are crucial to the politics of representation in Aboriginal texts. In *Sandawara* the links are explicit.

From *Their* 'Official History' to *Our* Popular Memory

Alan and his group have had little in the way of formal education, and what they have had is, the text suggests, racially biased – an education from the perspective of the dominant (White Australian) society. The history they have learned provided little information about the Aboriginal past, and what it did provide could not offer a sense of pride or dignity for young Black people. The importance of their encounter with Noorak, that old Aborigine lost in Dreamtime visions of his lost culture, is that it allows them to connect, for the first time, with *their* history – with a history, routinely suppressed and marginalized, of which they can be proud. Through the oral tradition, that is, by drawing on personal and collective Aboriginal memory of Aboriginal experience, the old man provides the link between past and present: his memories, his dreams of

times past, serve as an alternative to the 'official history' taught in the institutions of the dominant society. Through the old man, his body warmed and dreams assisted by bottles of sweet wine, the youths come to see themselves as part of a tradition of Aboriginal struggle for liberation, as part of a just fight for what is rightfully theirs. They realize for the first time that their people have a history, a history of resistance to White domination. This knowledge creates a bond between the past, the present and the future which gives their own actions a new meaning as part of a tradition of resistance that goes back to the beginning of White colonization.

We were not always so degraded, not always cowards under the heel of White power. We have history, culture, dignity – this is the lesson they learn.

Changed Subjectivity

I am Proud

I am black of skin among whites,
And I am proud,
Proud of race and proud of skin.
I am broken and poor,
Dressed in rags from white man's back,
But do not think I am ashamed.
Spears could not contend against guns and we were mastered,
But there are things they could not plunder and destroy.
We were conquered but never subservient,
We were compelled but never servile.
Do not think I cringe as white men cringe to whites.
I am proud,
Though humble and poor and without a home . . .
So was Christ.

— Oodergoo Noonuncal (Kath Walker),
in Walker, 1981, p. 90

Alan and his group are CHANGED SUBJECTS. That is, as a result of coming to engage with 'their history' and exchanging their European names for Aboriginal ones, their lives gain a sense of purpose, self-concepts are improved. This loose band of alienated urban youth becomes a group, that is, individuals bound together by shared actions and meanings, by a sense of common purpose and destiny. When Captain (formerly Tom) asks Kangawara (formerly Sue) what she thinks of the fact that they have all changed their names, she answers that she likes it, that it makes her feel part of a special group. Whereas before she had felt like they were just a bunch of kids with big ideas and talk to match, now she feels different.

She wishes to facilitate her change of consciousness, her new subjectivity. She feels she has to get used to being Kangawara, to become her on the inside. Later in the same conversation Kangawara says that times have changed. As Sandawara said, they must learn to live together as one family and look after each other in the way the Nungars used to do prior to their subjugation by the aliens (p. 123).[19]

Both Alan and Sue, as transformed subjects, know that a crucial part of the Aboriginal struggle must be a struggle for self-respect, for pride in oneself and one's heritage. Hence, Alan/Sandawara repeatedly lectures on the need to avoid excessive drink and drugs: he tells his people that the White merchants and drug-pushers are pleased that Aboriginals are so stupid that they pay their oppressors for poison in order to harm themselves (p. 34). Similarly, Sue (Kangawara) lectures Tom on the virtues of self-respect and self-help. They can, she argues, create their own self-respect by acting to improve their situation. Sue's new subjectivity is even apparent in her walk: she now walks firmly and confidently, 'a symbol of the Aboriginal movement on the march towards equality and dignity' (p. 99). She is a proud warrior in the continuing Aboriginal struggle for freedom.

The Path to Freedom: Accommodation or Violent Revolt?

For all oppressed people there is the question: Wherein lies the path to liberation? What strategy offers the best prospect for achieving freedom? Accomodation? Assimilation? Separation? Violent revolution? How can we shake off the yoke of oppression? Or even live with it?

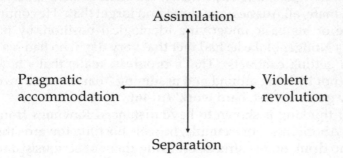

Assimilation

Pragmatic accommodation ←——————————→ Violent revolution

Separation

This issue is one of the main themes in *Long Live Sandawara*, and it is treated in a serious, sophisticated manner. The text assures us that there are no easy answers.

Alan and his group of Nungar youth are unemployed and alienated, separated from family and community, living in squalid urban conditions in Western Australia. Their situation is not unlike that of many other

Aboriginal (Nungar) youth in the area, that is, they have in common the fact that they are poor, aimless and often homeless. Alan and his group begin their involvement in Aboriginal politics by seeking to get the Establishment to provide resources for a youth centre and hostel which would be run by Nungar youth for Nungar youth. They decide, in the manner of good citizens in a fair, democratic society, to pay a visit to Mr Ken Rawlings, the local political leader – an Aboriginal politician, a Black man who has 'made it' – in order to deliver their petition. Painstakingly written, the letter, written 'on behalf of the Nungar youth', appeals for the establishment of a youth centre and hostel for the Nungar youth of Perth and Western Australia. The centre would include facilities for sleeping, cooking and dining as well as for sports and other events. It requests Rawlings to intervene with the proper government authority so as to procure a grant on their behalf.

How does 'THE BLACK LEADER' respond to this *politics of accommodation* from the grassroots? He decides to soothe the youngsters and then send them away (p. 47).

Long Live Sandawara presents a critical image of the Aboriginal politician, Rawlings, who is destined for a safe seat in parliament (p. 46). Rawlings is described as perhaps sincere but full of platitudes and already out of touch with his own people: to his political party he is an asset, a symbol of the new Australia, but to Aboriginal youth he is politically inert, a symbol of adult authority and perhaps a sellout. This Black man has made it and he knows it (p. 46). His aim is integration and acceptance in the mainstream of Australian society.

Rawlings subscribes to an individualist liberal ideology, a world view focused on individual rights and responsibilities. He tells the youngsters that 'we have our rights', like any other Australian citizen. 'Everyone's the same as us, mate, all Aussies, and don't you forget that.' He continues, revealing more of his basic underlying ideological position, by telling them about this Nungar bloke he had met that very day who had his own truck and was getting contracts: 'That's progress, mate; that's how we earn respect' – not by lying around and assuming 'that the state owes us a living, but by good, honest, hard work' (p. 46).

This mode of thinking is shown to have distanced Rawlings from the plight of other Aborigines. For example, he feels hostility towards the old Aborigines who drink on the streets, accusing them of seriously damaging the Aboriginal image, of disgracing the race: How can we demonstrate to White people that we should be treated as human beings, he asks, 'when they only have to go along certain Perth streets to see this disgrace?' His solution is to put them away in an old folks home – a nice one like those the White people have, 'but one with a bit more bush around it' (p. 47).

Many Black people, from America to Australia, would regard Rawlings

as an opportunist, a 'WHITE MAN'S NIGGER'. Tom, the oldest member of Alan's group, was certain about this all along. When Alan first indicated his intention to go and see Rawlings, Tom says that he is too straight, too much a traditional Black Leader, who wants to keep all the power in his own hands. Tom is certain that Black Leader will not be pleased to have a group of street kids coming to him with bright ideas. At the very most, he will pinch their ideas and take the credit. 'Just scratch him and it's all lilywhite under that black skin of his' (p. 37).

The attempt by Alan and his group to employ an accomodation strategy, that is, to appeal to government via a Black Leader, gets them nowhere. Having failed to acquire funds for their prospective youth centre by 'reasonable' means, they decide, under Alan's leadership, to 'liberate' some funds from the White establishment. There is no moral dilemma here. To paraphrase Alan: The white colonialists took everything from us – the land and wealth that is rightfully ours – and now we intend to get some of it back (pp. 92–3).

They decide to rob a bank.

First, they break into a gunshop – in order to arm themselves for the revolution. Alan has come to the same conclusion as Sandawara did several generations before – that Aboriginal freedom can never come through words but only through armed struggle. Victory requires weapons not words. Only guns can beat the White man at his own game, drive him away or destroy him.

Unfortunately, defeating White Power through armed struggle is no easy matter. There are, firstly, certain problems with regard to KNOWLEDGE AND POWER. For example, in the case of Sandawara's late nineteenth-century revolt, the leader has put together an army with which to challenge and defeat the Whites, but he does not possess some rather crucial information: Sandawara does not know of the British empire with its vast resources and thousands of soldiers. He is only a man defending his people's lives, land and dignity (p. 80). The latter-day Sandawara (Alan) faces even greater obstacles, in addition to the fact that he has no clear strategy.

Secondly, there is the problem of DISCIPLINE. The bank robbery fails because one member of Alan's group, while drunk, gives all the relevant details to Ron, a White sex pervert. The racist Ron, whom Tom takes for a friend, goes straight to inform the police (p. 129).

Sandawara and his small band manage to elude the enemy time after time. Their armed resistance achieves legendary status. None the less, at the moment when they have the greatest number of followers, when there is a real possibility of moving from a localized revolt to genuine revolution, a seemingly ever-present demon, the curse of alcohol, rears its ugly head. Sandawara knows better, but his better judgement submits to the curse: rather than feeding the poison to the earth, the leader allows the

liquor to be passed around among his people. He should intervene to stop this fiasco, 'but hell exists deep within his mind'. The result is that REVOLUTION is turned into CARNIVAL. Even Sandawara himself, the ever-disciplined and vigilant leader, joins in.

> He drinks deeply of the whisky, feeling the warmth spreading like a fever through his numb body. The ways of the white men begin to prevail in the gorge. The natural discipline, . . . passed down from the very dawn of humanity, disappears from the river flat.
> Scenes as riotous as in old England erupt in shrieks and cries of alcohol pain kicking out in spasmodic violence. . . . [H]uge fires like beacons are encouraged to blaze up out of control. The cliff faces dance maniacally in the flames and the shadows cast by the leaping intoxicated men and women. (p. 81)

The colonized, given an opportunity to struggle for freedom, may choose to PARTY instead. Ironically, this may be most true in the case of those who are most oppressed.

But is the problem here simply that poor people, or Black people, lack discipline? That they are a frivolous people who will always choose 'a good time' over disciplined activity? The novel suggests the matter is more complex than this.

Because he has been so victimized by racism and oppression, Sandawara is prepared to die in exchange for a few glorious moments – a few moments of intense freedom, a few moments of dignity, a few moments in which he can experience life in its fulness: '*He has known the viciousness of the white man – thus comes despair and the desire to experience to the full a moment or two of heightened life before death*' (p. 81).

> TRUTH: Racism tortures the soul. Under some conditions, a moment of freedom may be chosen over a lifetime of bondage.

So What Is the Answer?

> *As long as he tolerates colonization, the only possible alternatives for the colonized are assimilation or petrification. Assimilation being refused him . . . nothing is left for him but to live in isolation from his age.*
> — Albert Memmi, 1965, p. 102

> *We broke down the doors. The master's room was wide open. The master's room was brilliantly lighted, and the master was there, quite calm . . . and we stopped . . . He was the master . . . I entered. 'It is you,' he said to me, quite calmly. It was indeed I, I told him, the good slave, the faithful slave, the slavish*

slave, and suddenly his eyes were two cockroaches on a rainy day . . . I struck,
the blood flowed: That is the only baptism *that I remember today.*
 — Aimé Césaire, *Et les chiens se taisaient,*
 quoted in Fanon, 1968, p. 141

Earlier in this discussion we posed the question: What is the path to
liberation? By what means might the Australian Aborigines, and other
similarly subordinated and humiliated people, throw off the yoke of op-
pression – a yoke which has profound effects at the level of subjectivity?

The story of Sandawara, while one of pride, power and resistance, ends
badly. Sandawara and his army are up against White imperial power, the
military might of the British empire. In this context, armed struggle is not
successful in defeating the colonisers.

Nor, *Long Live Sandawara* suggests, does it offer a way forward today –
certainly not in a society where Whites are numerically, politically and
militarily dominant. All the members of Alan's group, except the leader,
are killed – slaughtered – by the police. The novel indicates that Alan's
future will be as an elected politician, a parliamentarian, that is, as an
individual pursuing an accommodationist strategy, but it is cautious
about the desirability of this way forward.

So, what is the answer? How can Black Australians rid their lives of
racism and oppression? PRAGMATIC ACCOMMODATION is one possible res-
ponse. You may play by the rules – as Alan and his group did with their
petition for an Aboriginal (Nungar) youth centre – but the dominant
powers may simply choose to ignore you. You may grin and bear it,
leading the overseers to think that all is well – as in the case of 'Jacky
Jacky' and his 'tribesmen' who performed for the entertainment of their
White masters. You may drink to hide the pain – like Noorak, Tom and so
many others. The Black pragmatist in a racist society neither assimilates
nor revolts, but adapts to the situation by not rocking the boat. This is
undoubtedly the path that millions of oppressed people have chosen to
take. It does have, however, a major disadvantage: those who take this
path often lead degraded, alienated lives. Like the old and drunken
Noorak sleeping beneath the bridge, they are a people without dignity, a
people without respect.

ASSIMILATION, the text suggests, is an even less viable option. Since the
dominant group continues to use 'race' as a barrier to complete accep-
tance, the odds on successfully assimilating are very small indeed. And
what if one succeeds? The 'assimilated' Black is often alienated, degraded
and confused.

Long Live Sandawara suggests that part of the answer lies in the 'cultural
nationalism' option. By gaining knowledge of their history and cultural
traditions oppressed people move down the road towards disalienation

and freedom. By creating a bond between past, present and future, historical and cultural knowledge can serve as a source of positive identity and encourage a spirit of resistance.

What remains open is how resistance – personal as well as collective – is best conducted: what form should it take? Armed struggle, it is suggested, whether in Sandawara's day or now, may inevitably lead to annihilation. But merely working within existing White structures, assimilating or accommodating, leads to a denial of self. Taking on a 'traditional' name and clothes, coming to terms with 'my people's' past – all this make me *feel* better. It allows me to accept myself/my people. But, as it turns out, this option – the 'CULTURAL NATIONALIST' PATH – usually leaves the dominant society essentially unchanged: despite my new African name, millions of Black people remain below the poverty level; despite my African clothes, millions of Black people continue to be brutally oppressed by racism; despite my fine collection of books on ancient African history, millions of Black children cannot read . . .

There are no easy answers to the problem of racism. Those who are quick to propose 'solutions' rarely grasp the magnitude of the problem.

Reflections: On the Cultural Politics of Aboriginal Writing

> *Much of the historical subject of this poetry has been carved indelibly in blood over the past 200 years and before the poets were born. That the psyches still quiver with the shock of these horrendous times can be directly attributed to the continuing brutality, the national lies, the callous indifference to Black human life and the continuing practices of institutionalised racism today.*
> — Kevin Gilbert, 1988, p. xix

> *Suppose that he has learned to manage his language to the point of re-creating it in written works: for whom shall he write, for what public? If he persists in writing in his language, he forces himself to speak before an audience of dead men. Most of the people are uncultured* [sic] *and do not read any language, while the bourgeoisie and scholars listen only to the colonizer. Only one natural solution is left: to write in the colonizer's language. In this case, of course, he is only changing dilemmas.*
> — Albert Memmi, 1965, pp. 108–9

Western colonialism of the 'Third World' is not simply economic and political – not simply the expropriation of people's land, the exploitation of their labour, the replacement of their political institutions by mecha-

nisms of White control. Colonialism is also an exercise in cultural politics: the colonizers rule through the educational system, religious institutions and the media as much as through the occupying army and police. The cultural politics of colonialism is CULTURAL IMPERIALISM: there is a forced imposition of European cultural forms, meanings and values on indigenous and other subordinated people. This cultural imposition asserts European – White – superiority while denying the value of 'native' and 'Black' cultures.

This chapter has looked at the relation between 'White' and 'Black' Australia in terms of the cultural politics of domination and resistance. Australian society, like South Africa or the United States of America, provides a particularly good case for studying this phenomenon.

Mainstream Australian culture – textbooks, novels, television programmes, travel brochures, and so on – usually inscribes Aboriginality negatively: the Aborigine is not quite human, not quite like us. Aboriginal history, society, culture and identity are all reduced in value. The Aborigine is frozen in an eternal relation of difference.

In response to this CULTURAL POLITICS OF DENIGRATION, Aboriginal people, including artists and intellectuals, have recurrently asserted their humanity. They have developed an alternative CULTURAL POLITICS OF RESISTANCE, a cultural politics that challenges and seeks to subvert – or invert – dominant meanings and values, if not dominant forms. This chapter has looked at this potentially powerful alternative cultural politics through an examination of Aboriginal novels and short stories from Western Australia, specifically, the Perth region.

What are some of the points that emerge from this examination? The crucial points have to do with SUBJECTIVITY, CULTURE, HISTORY, the POLITICS OF REPRESENTATION and ART/WRITING AS POLITICAL INTERVENTION.

Subjectivity

The Subject of Racism It is at the level of individual lives that racism has its most insidious effects. Aboriginal writing explores how racism leads its victims to deny their own heritage, to experience crises of identity, to lose self-respect, purpose and motivation. Racism is a product of histories, societies and cultures. But those of us who encounter racism encounter it directly at the level of lived experience – on the street, in the classroom, in relations with the petty gate-keepers of White power.

The 'classic' studies of race and racism tend to be works by sociologists. Perhaps they should be works by novelists, poets and dramatists. For it is in literature that the EFFECTS OF RACISM ON SUBJECTIVITY – on our sense of who we are, where we belong, what we can do – are most clearly

illustrated. It is the particular quality of fiction, drama and poetry to be able to combine images of social groups and social relations with an emotional dimension – an evocation of how people experience and feel about social relations. Aboriginal fiction is particularly insightful regarding the subject of racism.

Identity in Crisis This book has often emphasized the central role played by issues of subjectivity and identity in cultural politics. The cultural politics of Aboriginal writing is largely about issues of identity. These novels and short stories recurrently ask: Who are we? Where do we come from? Where are we going?

Aborigines are not bourgeois individualists. They are neither Cartesians, existentialists nor liberal humanists. The fundamental question they pose is not 'WHO AM I?' but 'WHO ARE WE?'. The crisis is not so much one of individual identity as one of *collective identity*. Obviously, crises of group identity can have profound implications for individual subjects, as some of the literature discussed in this chapter indicates. None the less, the problem of Aboriginal identity is more an *inter*subjective problem than an *intra*subjective one.

Aboriginal writing suggests that Black Australians need a knowledge of the past on which they can draw for a positive self-identity. It suggests that, if the crisis of identity is to end, Aboriginal people must create positive cultural and psychological links between past, present and future.

Contradictory Subjects

> The Negro is a sort of seventh son, born with a veil, and gifted with second-sight in this American world – a world which yields him no true self-consciousness, but only lets him see himself through the revelation of the other world. It is a peculiar sensation, this double-consciousness, this sense of always looking at one's self through the eyes of others, of measuring one's soul by the tape of a world that looks on in amused contempt and pity. One ever feels this twoness – an American, a Negro; two souls, two thoughts, two unreconciled strivings; two warring ideals in one dark body, whose dogged strength alone keeps it from being torn asunder.
>
> — W.E.B. DuBois, *The Souls of Black Folk*, 1961, (1903), p. 81

Written nearly a hundred years ago by W.E.B. DuBois, the twentieth century's most renowned Black American intellectual, this passage remains unsurpassed as an insight into the subjective experience of Racism's Subject-ed Victims. Here is one horrible truth: *members of dominated groups become visible to themselves largely through images constructed by and for the dominant group.*

For a person of Colour in a racially structured society – a Black person in the United States of America, an Aborigine in Australia, an Asian in Britain, an Arab in France, a person of Turkish descent in Germany – the phenomenon is that of seeing oneself through the eyes which deny one's humanity, one's culture, one's history, one's individuality. One looks at oneself and at one's people, and, to recall the story of the young Audre Lorde with which we began chapter 9, it is as if one had seen a roach. . . . Of course, one does not have to accept such a portrait as an accurate rendition. Indeed, many Black people struggle against it: within the breasts of most Black subjects in modern Western societies there are indeed, as DuBois eloquently puts it, two warring spirits. But such struggle is extremely difficult – and, so long as one lives in a racist society, there is no way that one can fully win the battle, that one can escape the racial prison of 'double-consciousness'.

Such consciousness, one of the most profound effects of colonialism on Australian people of Aboriginal descent, is a key theme in contemporary Aboriginal writing. Uncle Worru, a character in Jack Davis's play *The Dreamers*, expresses it succintly: 'We stumble along with a *half* white mind'

In each of the texts discussed in this chapter, there are central characters who experience divided consciousness: selves are divided, subjectivity is contradictory – because of the ways in which Aboriginal people are treated, perceived and defined by dominant White society. Archie Weller's Cooley, in *Going Home*, looks at Aboriginal people, as if through White eyes, and wonders who and what they are – these people with their 'strange mongrel language', a product of their 'mongrel breeding'. Although he does not know his people – his mother has tried to bring him up 'White' – Cooley is treated at school as a hated 'half-caste'. Only away from people, outside of society, in the bush, does he feel free, alone and a man.

Billy Woodward, in another of Weller's stories, 'Going Home', has rejected Aboriginal people completely, believing himself White now. Yet White society defines him as one of the very people he so despises.

For Sally Morgan in *My Place*, knowledge of her Aboriginal origins comes only at the age of 15, when she finally realizes that her grandmother is Black. She is at once aware of the stigma attached to being Black, but she is unsure of what it means to be Aboriginal. Told from early childhood that she is Indian, Sally knows nothing of 'tribal' culture. And she knows hardly any Aboriginal people. To accept her Aboriginal inheritance means coming to terms with negative White definitions. Eventually, she does.

For Noorak in *Long Live Sandawara*, living a degraded life as an alcoholic vagrant, his previous self – as tribal elder and Lawgiver – lives on at the margins of his consciousness and in his identification with Sandawara and the history of Aboriginal resistance.

Culture

Culture and Power Many popular and academic conceptions of 'culture'
see it as some autonomous realm of ideas, values, beliefs and so on.
Australian Aboriginal writing emphatically denies this. The novels and
short stories that have been the subject-matter of this chapter, and the
poetry that has been interwoven into the text, assert or show continually
that QUESTIONS OF MEANING are inextricably linked to QUESTIONS OF POWER.
(Whether all the authors do this consciously is not our concern.) The texts
show that traditional Aboriginal cultural forms, meanings and values
have been subverted and replaced through the exercise of White power.
For most Black Australian writers, writing is a political act: it is a struggle
against hegemonic representations of Aboriginality. Aboriginal writing
is, virtually unavoidably, an exercise in the POLITICS OF REPRESENTATION.
Most of these artists seem to know that it is so.

Culture and History One of the most striking features of Aboriginal writ-
ing is the degree to which Aboriginal texts view culture as fundamentally,
inextricably linked to history, power and subjectivity/identity. Much of
twentieth-century social and cultural theory, especially structuralism and
semiotics and their derivatives, denies or denigrates the role of history in
relation to culture, seeing culture as an atemporal structure of elements
defined by relations of difference. Aboriginal writing certainly accepts that
cultural meanings – for example, those characterizing 'White' Australians
and 'Black' Australians – are structured in difference. However, Aborig-
inal writing, like African-American or American Indian writing, asserts
precisely the CENTRALITY OF HISTORY. This includes arguing for ideas like
tradition and heritage, which some would regard as rather old-fashioned.
Culture, in this view, is profoundly linked to the past – to the period before
the Europeans came, and to the period of anti-colonial struggle.

Articulating Cultural Difference, Redefining Cultural Value The articulation of
cultural difference – of different Aboriginal perspectives both on various
forms of Aboriginal society and on the dominant White society – is crucial to
Aboriginal writing. This difference encompasses not only questions of social
and spiritual values and desirable ways of living, but also questions of
identity and history.
 It is not that Australian Aboriginal writers are concerned to any signifi-
cant extent with explaining 'what Aboriginal people are like' to the larger
(White) society. Theirs is not the traditional liberal preoccupation with
achieving 'understanding between the races'. The cultural politics of
Aboriginal writing is rather more radical than that.

FACT: Contemporary Aboriginal writing seeks to DECONSTRUCT those BINARY
OPPOSITIONS that ascribe negative value to Aboriginal history, society, cul-
ture and identity.

Whereas the dominant culture suggests that Aborigines belong to some
'PRE-HISTORY', these texts insist that Aborigines belong to THE PRESENT.
Whereas the dominant view is that Aboriginal beliefs and ways of life are
'primitive' and inferior to those of the West, these texts offer a sense of the
value of traditional Aboriginal society, in particular kinship networks
and material and spiritual values. They suggest that Aboriginal culture is
of equal value to European culture, if not superior to it. Whereas the
dominant politics of representation suggests that there is no reason to say
'I AM ABORIGINE' with pride, Aboriginal writing suggests that, except for
the devastating effects of White colonialism, there are plenty of reasons to
be proud.
 Whether Aboriginal fiction is addressed to the dominant society or not –
and much of it would appear to be – it will have effects there. Fiction,
because of its capacity to encourage the reader to see the world through
the eyes of its protagonists, may be a particularly good medium through
which to present the dominant society with issues of racism and cultural
difference. Effective consciousness-raising requires a degree of empathy,
perhaps especially where racial and cultural difference is at stake. Thus,
Aboriginal fiction may play the role of encouraging understanding across
racial and cultural barriers even when this is not the primary concern of
its authors.

History and the Present

Critiquing the Present Historically, there has been a tendency among cer-
tain socialist and communist intellectuals and activists to romanticize
working-class communities and lives, to see them as more 'real', interest-
ing, heroic, and so on, than those of the middle classes. *Aboriginal writing
strongly rejects this romantic tendency.*

 TRUTH: If one turns to Aboriginal fiction expecting to find a positive, em-
 pathetic portrait of contemporary Aboriginal life, one is likely to be dis-
 appointed.

These texts view contemporary Aboriginal urban and camp life as a
world of poverty, hopelessness, crime, violence and distorted human
relations, as an ugly, cruel and tragic world where self-respect is lost and
group life is profoundly degraded, as a world of the dispossessed and the
alcoholic.

TRUTH: Aboriginal writing is a relentless critique of the present.

Knowledge, Power and Appropriation of the Past WHY STUDY HISTORY? Aboriginal writing is profoundly concerned with Aboriginal history, but not simply for the sake of it. As previously indicated, Aboriginal writing views history, culture, politics and identity as necessarily intertwined. Aboriginal fiction, like Michel Foucault, sees an intimate link between knowledge and power. For Aboriginal fiction the key knowledge is historical and cultural knowledge, knowledge about Aboriginal history and tradition.

Aboriginal fiction, poetry and drama articulates an alternative to popular mainstream versions of history. Moreover, it demonstrates the importance of understanding the past for understanding the present and for thinking the possibility of a different future, for example, one in which Aboriginal people live dignified lives free of poverty and racism.

But, as part of its critique of the present and imagination of a better future, what is this past upon which Aboriginal writing draws?

Confronted with a present and future that appear to offer no hope ('a desert ahead') and a colonial past (the past 200 years) that leaves them little or nothing about which to be proud, Aboriginal writers often turn to a rather distant past, to a time before the European presence. Recall the story in 'Cooley' of the pre-colonial naked Aborigine who had his strength, health, spears, family and dogs, who was part of a vibrant culture with its own laws and religion – that is, who had all of this before he was lulled into adopting the ways of the White colonizer.

This is a Garden of Eden story, a mythical, romantic tale of a trouble-free past. It is similar to the stories told by American Indians about the past before the European conquest of the Americas or by African-Americans about the glories of ancient Africa before the trans-Atlantic slave trade. Ancient Egypt looks very appealing from Harlem, as does the Mayan empire from the Native American reservation.

Sometimes Aboriginal fiction engages with the more recent past, the past of colonialism and anti-colonial struggle, as is the case in *Long Live Sandawara*. But it seems to prefer pre-colonial history, a romantic retreat into a distant mythical past. With regard to the present, Aboriginal literature has a strong anti-romantic impulse. With regard to the past, the impulse is for romanticism. The preference for a mythical past, for an Aboriginal Garden of Eden, is not without consequences.

It is arguably unfortunate that Aboriginal cultural politics can find nothing – certainly virtually nothing – good in the present, that the only good is to be found in the distant past. Revolutions do not start from scratch: those who are likely to achieve real social and cultural transformation must not only grasp but also respect the patterns of everyday life of ordinary people. One needs to build on strengths of contemporary

everyday life – on existing practices, beliefs, institutions. Antonio Gram-
sci, the Italian Marxist theorist of hegemony, understood this well. So did
Margaret Thatcher.[20]

Writing/Art as Emancipatory Cultural Politics

The Way Forward: Integration or Respect for Difference? Aboriginal fiction,
poetry and drama point to the inadequacy of integrationist strategies
determined by the dominant society. The texts point out the resistance to
integration on the part of the dominant White structures, as well as the
Black communities, in Australia. A recurrent theme in this literature is the
profoundly negative effects of partial integration on the identity of
'mixed-race' children. Aboriginal writings also indicate the negative con-
sequences for Aboriginal people of attempting to 'live White' in a society
which still regards Aborigines as inferior.

These texts are emphatically *not* a plea for assimilation into the domi-
nant society. Perhaps if Australia were a society with genuine recognition
of its multi-ethnic heritage, with genuine respect for the original inhabi-
tants, then Aboriginal texts might argue otherwise. What they presently
argue for, implictly if not explicitly, is a profoundly transformed society
in which there is respect for racial and cultural difference.

The Question of Form Most of the radical artistic movements of the twen-
tieth century insist that art must challenge the viewer, reader or listener
not just by its 'content', for example, its subject-matter or rhetoric, but
also by its form. Thus, modernist and postmodern novels, with their
plural voices, non-linear narratives, blurring of conscious and non-
conscious experience and so on, violate our expectations, challenging us
to think, to read more carefully, to take up a position *vis-à-vis* the text –
assuming we derive enough pleasure from the experience to keep read-
ing. Similarly, modernist and postmodern visual arts challenge our ways
of seeing – again, assuming we are prepared to look.

*Aboriginal fiction is not part of this tendency in twentieth-century arts to-
wards revolution in form.* Rather than seeking to decentre the traditional
Western novel (the realist text), the formal structure found in these texts
is *realist* in form: from the point of view of the Western artistic avant-
garde, Aboriginal fiction is structurally conservative.

What are the implications of this 'structural conservatism' for cultural
politics of Aboriginal fiction? Would anyone wish to claim that Aborig-
inal literature does not have profound effects on its readers? Who
would wish to argue that its politics are not progressive? Who would
wish to assert that the cultural politics of Aboriginal literature are more

conservative than those of most modernist or postmodern literature? In sum, the question is this: Can one not have a RADICAL ART in a 'CONSERVA-TIVE' FORM? We leave that question to the reader.

Who Is Controlling the Means of Cultural Production? Class, racial and gender oppression in the modern world operate as much through the institutions of culture – the media, educational institutions, religious institutions, the family and so on – as through military and political might. Aboriginal writing recognizes this. Hence, struggle around the politics of representation – around how Aboriginal life past and present is portrayed – is a major preoccupation.

There is, first of all, the matter of who decides what is to be published. This is an issue about which Black Australian writers, like Writers of Colour elsewhere, are acutely aware. One of the more interesting discussions of this issue occurred in a dialogue involving the Aboriginal activists Bruce McGuinness and Denis Walker (Kath Walker's son) at the first Aboriginal Writers Conference (held in 1983 at Murdoch University). The topic was 'The Politics of Aboriginal Literature'. Here is McGuinness speaking:

> All of our artists in the field of writing are struggling. Some of their work gets printed and a hell of a lot of it doesn't, and the reason why it doesn't get printed is because Aboriginal people don't control it. We don't have control at the local level, we don't have control at the funding level, we don't have control at the policy-making level. Policies are determined about what is written about Aboriginal people by non-Aboriginal writers. In the past that has been anthropologists and sociologists.... (McGuinness and Walker, 1985, p. 48)

But even if Aboriginals *could* determine what is written about them there would still be the problem of getting this literature to an audience. For while Aboriginal artists and writers have very little control over the MEANS OF CULTURAL PRODUCTION, they have even less over the MEANS OF DISTRIBUTION. They do not own and/or control book publishing companies, newspapers, television stations, tourist venues, etc. In earlier generations, traditional Aboriginal societies at least controlled the means of cultural production and distribution for their respective 'tribes'. Today they do not. This has serious consequences. It is, for example, far easier for Aboriginal youth to watch Hollywood westerns on television or read dominant 'White' constructions of Aboriginal history and culture than it is for them to encounter the texts discussed in this chapter.

QUESTION: What is the significance of Australian Aboriginal writing?
ANSWER: Contemporary Black Australian literature marks an import-

ant cultural-political intervention. It is a vehicle for critiques of mainstream White Australian history, culture and politics. It provides a means for Aboriginal people to reappropriate their past, to understand their present, to imagine an alternative future. For Aborigines and non-Aborigines, it provides a means for exploring new ways of thinking about Australian culture and identity. It insists upon the importance of a respect for difference as the basis for positive social change. It suggests that there can be no alleviation of human suffering without the restoration of human dignity.

Part V
Concluding Reflections

On the Politics of Postmodernism

Postmodernist discourses are often exclusionary even as they call attention to, appropriate even, the experience of 'difference' and 'Otherness'.

Disturbed not so much by the 'sense' of postmodernism but by the conventional language used when it is written or talked about and by those who speak it, I find myself on the outside of the discourse looking in. As a discursive practice it is dominated primarily by the voices of white male intellectuals and/or academic elites who speak to and about one another with coded familiarity. Reading and studying their writing to understand postmodernism in its multiple manifestations, I appreciate it but feel little inclination to ally myself with the academic hierarchy and exclusivity pervasive in the movement today.

It is sadly ironic that the contemporary discourse which talks the most about heterogeneity, the decentred subject, declaring breakthroughs that allow recognition of Otherness, still directs its critical voice primarily to a specialized audience that shares a common language rooted in the master narratives it claims to challenge. If a radical postmodernist thinking is to have a transformative impact, then a critical break with the notion of 'authority' as 'mastery over' must not simply be a rhetorical device. It must be reflected in habits of being, including styles of writing as well as subject matter.

— bell hooks, *Yearning*, 1991

15

The Postmodernist Challenge/Challenging Postmodernism: a Cultural Politics for Today

When, in March 1991, the Los Angeles police beat up the Black American motorist, Rodney King, it was a case of raw racist brutality. Such attacks have occurred regularly for generations in the United States. Because this time someone saw it and recorded it on amateur video, the incident became a media event and a focus of struggle. The image of Rodney King being beaten has been shown repeatedly throughout the world both on television news and as the opening sequence of Spike Lee's film *Malcolm X*. The police felt constrained to legitimate their behaviour, the Black community wanted the incident recognized as an illegal, brutal racist act and punished accordingly. The failure to convict the policemen concerned led to serious urban rebellions in Los Angeles.

Racial oppression is a form of domination – physical, institutional, cultural. As the case of Rodney King clearly demonstrates, racism is not *reducible* to attitudes and meanings, to the sphere of subjectivity and culture. The Rodney King incident came to world attention by chance. His treatment at the hands of the police might easily have gone unrecorded, known only to his immediate family and community. Because it became a media event in which viewers were forced to judge what was going on, it also became a focus of cultural politics. There is no struggle against oppression without a cultural dimension.

One aim of cultural analysis is the documenting of the process of how things come to mean what they do. Another should be to explore meaning as a social product, enmeshed in webs of power. Cultural politics is the struggle to fix meanings in the interest of particular groups. This fixing at the same time defines, places and controls others.

In the course of this book, we have looked at case studies in the cultural politics of class, gender and race. While postmodernism has not been our central concern, our studies have drawn, in part, on radical, Foucauldian poststructuralist thinking about language, subjectivity and power. In this final chapter, we want to look at the issues raised by our case studies in relation to postmodernism. We ask: How does postmodernism respond to these issues? How useful is it? What are its limitations?

In previous chapters we looked at challenges to hegemonic constructions of Culture, Literature, History and Art. We analysed how, at different times and in different contexts, liberal, socialist, feminist, Black and 'Third World' activists, writers and artists have responded to the dominant constructions of Culture. We looked at examples of challenges to the dominant which take account of the interests of marginalized and oppressed groups.

We considered, for example, in chapter 3, socialist and working-class struggle for access to Culture in interwar Britain. We looked at how the Writers' International attempted both to develop new ways of reading dominant cultural traditions and to support the growth of working-class writing. This cultural politics recognized the relationship between culture, power relations and class interests. It assumed the centrality of Culture to human development, a development that could only be realized fully in a socialist world.

In chapter 4, we examined what happened to these ideas once they became rooted in a 'socialist' state organized on Marxist-Leninist principles. The experience of cultural politics in the German Democratic Republic raises questions of how one might achieve *cultural democracy*. While the cultural infrastructure in the GDR was extensive, conservative definitions of culture and of its social role, imposed from above, severely limited the democratic potential and effectivity of GDR cultural politics.

In the postwar West, the achievement of cultural democracy is an ongoing struggle which concerns all areas of cultural production, history and criticism. In their different ways, 'community arts', feminist, Black and 'Third World' cultural producers, critics and activists have put into question hegemonic definitions of valuable culture. They have used Literature, Art and History in the struggle against middle-class, White, sexist and racist cultural traditions, institutions and practices. They have taken up culture as a tool in the struggle against oppression. They have looked to it for new identities and histories that give people dignity and empower them.

QUESTION: What issues do our case studies raise?
ANSWER: They raise a range of important concerns which crystallize into questions of power, subjectivity and meaning.

Among the most striking issues to emerge from this book is the link between *culture, identity* and *self-respect*. This was an important issue for working-class people in Britain during the first half of this century, motivating the fight for education and access to Culture. It was a key impetus in early feminist critiques of femininity, particularly versions in which women are defined as purely domestic beings or sex objects. It is seen most clearly, however, in the case of Black people and other people of Colour. Here the racism of the dominant culture – a racism which both defines people of Colour as negatively different and denies self-worth – has given rise to strong attempts to redefine subjectivity, culture and history.

Our case studies suggest that Culture is a conduit of power. Power is exercised and secured in part through the constitution of meanings and subjectivities. Cultural politics involve a struggle over meaning – to fix meaning, to keep it fixed, to contest it, to redefine it, to change it. Meaning is both a channel for power and its legitimation. Cultural politics is also a struggle for subjectivities. Through culture identities and subjectivities are produced. Power exercised through culture relies to a large extent on consenting subjects.

In our concluding chapter we take up some of these issues. We focus on the question of *universals, truth, subjectivity, history, value* and *tradition*. We consider *cultural democracy, form, pleasure* and *audience* and we look at *cultural difference*. We discuss them in relation to the current debate about postmodernism and the postmodern world.

Cultural Politics and the Postmodern Challenge

The Question of Universals

In 1978 in the United States and 1979 in Britain, the American radical feminist writer and philosopher Mary Daly published a highly influential book *Gyn/Ecology: The Metaethics of Radical Feminism*. In this book she analysed a range of oppressive practices – Indian *Suttee*, Chinese footbinding, African genital mutilation, European witchburnings and American gynaecology – as examples of what she called 'planetary patriarchy', that is universal patriarchy. In her chapter on cliterodectomy, she commented in a footnote:

> I have chosen to name these practices for what they are: barbaric rituals/ atrocities. Critics from Western countries are constantly being intimidated by accusations of 'racism', to the point of misnaming, non-naming, and not

seeing these sado-rituals. The accusation of 'racism' may come from ignor-
ance, but they serve only the interests of males, not of women. This kind of
accusation and intimidation constitutes an astounding and damaging rever-
sal, for it is clearly in the interest of Black women that feminists of all races
should speak out. (Daly, 1979, p. 154)

Mary Daly's uncompromising position on cliterodectomy did indeed
provoke much debate within Western women's movements. At the heart
of the debate were two questions:

1 Should White Western women speak on behalf of African and other
 'Third World' women?
2 Was the failure to respect cultural difference, whatever its content, a
 form of racism?

For Mary Daly the issue was simplified by her own radical feminist
perspective. She saw all the atrocities she described as part of a planet-
wide patriarchy under which women of all races suffer and against which
all women must fight. For feminists of other persuasions, who lacked
radical feminist certainties, the issue was the legitimacy of applying
Western norms to other cultures as if they were unproblematically non-
racist and universally valid.

 In chapter 2, we suggested that there has never been anything unprob-
lematically non-racist about the liberal discourse of universal human
rights which became hegemonic in Western Europe in the centuries fol-
lowing the Enlightenment. Yet despite this political reality, the cultural
struggle to achieve new subjectivities, identities, meanings and values
which we have looked in this book have often relied on Enlightenment
ideas of the individual, human rights, justice and progress. In some cases,
these ideas have taken liberal, in others Marxist or feminist forms, but
they have shared the assumption that human rights should be universal.
Often cultural political struggle has focused on wresting universal human
rights from the control of privileged groups – in the first instance White,
middle- and upper-class men – and extending them to other classes, to
White women and to people of Colour.

 In the case of human rights, universals have most often functioned
positively in the interests of the groups who have fought for them. The
issue has been access to them. In other areas, particularly that of Culture,
norms and practices claimed as universal have more often functioned as
exclusive, denying value to the work of non-bourgeois, non-male, non-
White cultural producers. As our chapters on feminist cultural politics
and on modernism, 'primitivism' and the postcolonial artist show, one of
the key features of feminist, Black and 'Third World' critiques of the
dominant cultural orders is of the narrow and exclusive nature of the

traditions and aesthetic norms which they proclaim as universal. In opposition to these traditions, cultural activists have attempted to produce different traditions and new norms of aesthetic value which both challenge the sexism and racism of the dominant culture and pay attention to the particularity and difference of excluded groups.

The political concern to break with universals that have, for the most part, privileged White, middle-class and male interests is often seen as a feature of what has come to be known as the 'postmodern world'. Postmodern thought challenges many of the universalist assumptions which ground most liberal, Marxist, gay, feminist, and Black cultural politics. It puts into question approaches to language, culture, history and subjectivity which look for universality, authenticity and fixity. In postmodern theory, language – whether the everyday language of common sense or the language of theory – is neither the expression of a ready-constituted world nor false consciousness produced by class, gender or racial oppression. 'Universals' are discursive constructs with which particular groups seek to legitimate their own particular interests. While there can be no true universals, none the less they may have a strategic political usefulness.

In the postmodern world there is no single *truth*. There are, at best, more or less comprehensive and convincing versions which carry with them particular social implications. Truths are discursive constructs which differ across histories and cultures, as well as between different interest groups within the same culture. Whoever has the power to define Truth in any society also has the power to define Others. This is a message reaffirmed by our case studies.

Not all forms of postmodern thinking stress power, some focus on play. Where play becomes the key concept, power tends to disappear. Thus, for example, in the postmodern celebration of 'difference', race often slides into ethnicity, ethnicity into just another term in a familiar list of differences. The question then is: Which of the following should our cultural politics emphasize?

Carnival or Revolution?

In much postmodernist writing the emphasis is on the former: play and carnival. Yet for feminist and anti-racist critics and cultural workers involved in people's education, history or art, the emphasis is more on the latter: revolution, that is, fundamental transformations in power relations. In 'carnival' the world may be turned upside down – slaves may masquerade as masters, men as women, poor as rich, and so on – but it is, after all, only a masquerade. When the party is over, the world remains the same.

More useful in radical cultural politics are models that stress the power relations through which different versions of truth are articulated. Take,

for example, Michel Foucault's configuration of discourse/power/knowledge. Here language is not just plural, it exists as competing discourses which constitute meaning and individual subjectivities in different but hierarchized ways. These serve the interests of different groups. Competing versions of social life are structured by power relations of class, gender, race, ethnicity, nationality and so on. Responses from the margins may develop and use alternative metanarratives (that is, oppositional general 'theories' that lay claim to truth – for example, Marxism, radical feminism or Black nationalism). Yet, like the dominant narratives that they contest, these alternatives, which also seek to offer comprehensive explanations of the world, give partial accounts of social and cultural life.

Some versions of postmodernism imply that we are confronted by a plurality of competing narratives, none of which can be privileged. Our case studies suggest that different versions are *not* all the same, neither in their explanatory power nor in the power that they exercise in the wider society where they work on behalf of particular interests. In terms of power and effectivity they differ radically.

Metanarratives are inevitably partial – in a double sense: they are incomplete stories and they represent sectional interests. This raises an important question: namely, Do metanarratives have strategic value?

We would argue against critical and analytical practices that start from metanarratives. Social life is more complex and contradictory than any one metanarrative allows. In some versions of postmodernism, for example, the postmodern world itself assumes the status of metanarrative. Everything is seen in terms of plurality and play. Divisions such as class, gender and race, which have long histories in which oppression is paramount, become just another difference. Structuring power relations disappear and oppositional cultural struggle is contained within a convenient metanarrative of postmodernism which is both politically dangerous and of limited analytical value.

In the practical politics of everyday life, as distinct from the arena of analysis and scholarship, the question of the usefulness of metanarratives looks rather different. Metanarratives are often extremely powerful, functioning as belief systems and motivating political action. Marxist theories of class struggle, feminist theories of patriarchy, Black nationalist theories of race and history – these have all functioned as cohesive ideologies, producing alternative subject positions and identities. In classist, sexist, racist societies such alternative forms of subjectivity are crucial in the struggle for change.

In cultural analysis the postmodern challenge to universals is useful, as is its focus on openness to and respect for difference. Yet more important is an understanding of the oppressive power relations that produce difference. As our chapters on art demonstrate, the privileging of difference

in racist and sexist societies often tends to reproduce the very racist and sexist assumptions that artists and writers are keen to deconstruct and transform. We would argue for a more differentiated approach to the question of universals. While they are clearly constructs, they can function in both negative and positive ways, depending on context. We would reject 'universals' in cultural theory and analysis, while acknowledging that they may in some situations function as useful strategic tools in the political struggle to contest racism and sexism.

Ethics and Politics

Moral principles have lost their distinctiveness. For modern man, absolute right and absolute wrong are a matter of what the majority is doing. Right and wrong are relative to likes and dislikes and the customs of a particular community. We have unconsciously applied Einstein's theory of relativity, which properly described the physical universe, to the moral and ethical realm.

— Martin Luther King[1]

Universals – for example, universal human rights – are linked to questions of ethics: that is, to what is right or wrong, moral or immoral. Much of the struggle by women and men of Colour for civil rights has mobilized ethical language. Universal ethical standards, like universal human rights, have been a source of hope for oppressed peoples. Any postmodern rejection of such concepts can have severe effects.

> A VOICE: Are we to tell those who have been in chains for hundreds of years that everything is relative? Are we to tell them that there is no hope?

It is precisely hope that sustained generations of Black people in the 'Land of the Free' (the USA). Hope is in the slave narratives and the slave songs (along with despair); in the vision of Mahatma Ghandi and Martin Luther King; in civil rights movements and movements for national liberation; in the women's movement and feminist politics. Are we now to say that there is no hope? That there is no reason to persevere and struggle because the bright future is an illusion? Who dares to deliver this message in the ghettoes and reservations of North America, in the favelas of Brazil, in the shanty towns of South Africa and Australia . . .?

Here, too, we need to distinguish between cultural analysis and practical politics.

The postmodern critique of truth and scientificity is compelling, yet is postmodern theory able to address the question of ethical values? If we

cannot know what is true, can we know what is right? Implicit in this question is an assumption that ethical values are of a different order from questions of truth. Yet, while we have categories of the good and th'e bad, the just and the unjust, the moral and the immoral, their precise meaning is discursively produced and subject to change. Attitudes to sexuality and race over the last hundred years clearly demonstrate this.

Just as political struggle often mobilizes ideas of universal human rights, progress and so on, so it also looks to apparently universal standards of morality. In practice our sense of what is right and of what is just is formed by socialization and the infinite heterogeneity of discursive practices which engage and constitute our subjectivity – as, for example, mothers, fathers, daughters, sons, citizens, students, professionals, feminists, human rights activists, Christians or environmentalists. Moral values are not only discursively produced, they play a more or less direct role in legitimating or challenging institutional and other social practices.

Yet morality is a particularly powerful discursive construct. As such it is an important dimension of cultural politics since, like gender or race, it directly addresses the individual's sense of self. Much of the Black art and writing discussed in this book, like socialist, working-class culture before it, appeals directly to apparently universal standards of morality. It urges readers and viewers to recognize the immorality of Black oppression, to acknowledge the need for fundamental change.

In the struggle for hegemony most discursive practices lay claim to an ethical dimension in ways that suggest that their standards of morality are the only true ones. It is often tactically useful to lay claim to absolute ethical standards, even though these standards will always be necessarily historically and socially specific and subject to change.

The Politics of Subjectivity

In our discussion of the cultural politics of racism we sought to remind the reader that racism is deeply ingrained in Western culture. Moreover, racism penetrates to the very core of who we are. While it is not just a function of individuals – it inheres in social structures and practices – it has profound implications for individual subjectivity. This was one of the most powerful messages of the writing by Australians of Aboriginal descent which we analysed in the previous chapter. For the victims of racism, respect and positive identity are crucial.

The cultural politics of marginalized groups point to two important aspects of subjectivity:

1 the need for recognition;
2 the need for a feeling of agency.

The need for recognition includes both the need to speak and the need to be heard, that is, to have one's speech affirmed. To speak and be heard are empowering experiences. Culture plays a central role in recognizing and affirming the experience of oppressed groups. Writing – both fiction and history – has been important in the struggle of working-class people, women and people of Colour for recognition of the unjustness of their exploitation and oppression. It has also played a central role in the redefinition of their sense of self.

Yet both racism and sexism pose the need for a theory of subjectivity which can throw light on the relationship between subjectivity, power and pleasure. In both racism and sexism, the body is most often the guarantor of the cultural meanings ascribed to it. Here perhaps the type of postmodern theory represented by Michel Foucault's work is helpful. A wide range of discursive practices, often located in powerful institutions have attempted to fix the characteristics of women and people of Colour, defining their bodies, their intellects and, in the process, their subjectivity. In both cases subordinated groups been defined against a privileged other: White men.

In postmodern theory, humanist subjectivity – for example, that underpinning liberalism and much Marxism – is put into question. So, too, are essentialist ideas of female or Black subjectivity. Unified, essentially rational subjectivity is replaced by non-unified culturally constructed subjectivities which comprise not only the rational thinking individual but also her unconscious and emotional dimensions. This is undoubtedly a useful *analytical* move which allows for sophisticated analyses of subjectivity and agency, from which to develop complex challenges to dominant versions of subjectivity.

In the area of cultural analysis we would want to insist on the political usefulness of postmodern thinking with its imperative to see forms of identity as situationally produced – as, in principle, temporary and historical. We would also insist on the usefulness of postmodern theories of subjectivity which take account of its emotional and unconscious dimensions.

But what about in political struggle? In her essay 'Postmodern Blackness', bell hooks writes:

> The postmodern critiques of 'identity', though relevant for renewed black liberation struggle, is often posed in ways that are problematic. Given a pervasive politic of white supremacy which seeks to prevent the formation of radical black subjectivity, we cannot cavalierly dismiss a concern with identity politics. Any critic exploring the radical potential of postmodernism as it relates to racial difference and racial domination would need to consider the implications of a critique of identity for oppressed groups. Many of

us are struggling to find new strategies of resistance. We must engage
decolonization as a critical practice if we are to have meaningful chances of
survival even as we must simultaneously cope with the loss of political
grounding which made radical activism more possible. I am thinking here
about the postmodernist critique of essentialism as it pertains to the con-
struction of 'identity' as one example. (bell hooks, 1992, p. 26)

Postmodern writers often suggest that culture offers the individual
many different possible subjectivities from which we can *choose*, together
with the ever-present possibility of creating new meanings and identities
which we define against those which we already know.

But can we really choose? How does this theory look from the perspective
of the oppressed? The reality for oppressed groups is different. The
experience of living as a person of Colour in a racist society is not one of
choice. Racism defines what we are, constrains what we do.

In political struggle marginalized and oppressed groups often espouse
and mobilize alternative identities, defined in reaction against the dom-
inant. The importance of this to the groups in question should not be
underestimated. To move too quickly to a postmodern critique of at-
tempts to produce alternative positive identities – as for example in Black
nationalism – is to fail to recognize the full force of the effects of racism
on Black subjectivity. This failure will affect the ability of alternative,
non-essentialist, cultural politics to speak to many Black people.

> TRUTH: Often the construction of essentialist forms of identity is important and
> empowering.

History

*Within the work of African and Asian artists in Britain and around the world,
two themes can clearly be seen as central and recurring. These are the twin
themes of history and identity. This of course is hardly surprising. . . .*

*For black people, 'history' refuses to be a lifeless and dull conglomeration of
boring dates and events. Instead, it presents itself as earlier episodes of our
current existence. We are the latest chapters of history, and as such, we are
scarely able to deny or downgrade its centrality and its importance in our
lives. Similarly, 'identity' has an urgency and a relevance which is literally
worlds away from the self-indulgent individualism which many white people
take it to be. Who we are as black individuals becomes one and the same with
who we are as black people, and vice versa. This is an inevitable consequence
of how we are perceived and treated in this society. Racism fails, or refuses, to
acknowledge our individuality, though it constantly forces us to consider our
identity.* History refuses to let go of us.
 — Eddie Chambers, 'History and Identity', 1991, p. 96;
 emphasis added

Reclaiming and rewriting history are central issues in cultural politics. Not only are the histories of oppressed and marginalized peoples absent from much history writing, where they do appear there is the question of *how* they are represented. Are they merely objects or victims or do they figure as active, often resisting agents? To problematize dominant narratives of history and to write the histories of oppressed groups from perspectives that do not privilege a bourgeois, White, male, Eurocentric gaze is central to the struggle to redefine what it means to be working class, a woman, or a person of Colour. As in the area of subjectivity, so in history, too, actual cultural politics and postmodern theory show common concerns.

Postmodern thinking about history has put into question History with a capital 'H'. Singular narratives of the past, which largely excluded the experience of ordinary people, people of Colour and most women, have given way in much recent history writing to a plurality of competing narratives which are linked to different groups and interests. Radical historians have recognized the importance of history in the cultural struggle for emancipation and the need for new ways of history writing which emphasize how histories can fix and unfix meanings and reveal and question power relations.

Postmodern ideas of history writing do not, however, necessarily privilege the question of power. The idea that history is plural has been taken up by the heritage industry in Britain. Industrial museums (some of them located at former coal mines, iron foundries and the like) and agricultural and 'folk' museums have sought to construct the social and cultural history of groups who were formally invisible. Museums and reconstructions of working-class history have proliferated. Libraries and exhibitions are increasingly charting women's place in history, literature and cultural production; and they are beginning to address the cultural history of Britain's Afro-Caribbean and Asian populations.

Yet the content, mode of presentation and overall conceptions of the histories in question in these new developments vary greatly. Often they present sanitized images of the past. For all their interest and appeal, specialist museums like the London Museum of Childhood or the York Castle Museum present a history that is predominantly middle-class and relatively conflict-free. Moreover, however welcome these developments may be, in most cases they have left the hegemonic traditions of cultural history untransformed. Alternative histories which empower marginalized and oppressed groups have, to date, largely remained on the margins.

Value and Tradition

1993 saw the staging in Berlin and London of the exhibition 'American Art in the Twentieth Century'. One of a series of exhibitions of

twentieth-century art, organized by the Royal Academy and held in different countries, it repeated, yet again, the failings for which previous exhibitions had been criticized. It focused predominantly on modernist art by White men. Just as 'German Art in the Twentieth Century' had excluded the art of the Third Reich, the German Democratic Republic and virtually all women, so the American exhibition excluded the work of non-White Americans and most women.

If we look at current museum and gallery exhibition practice, we find that the prestigious museums and galleries continue to stage exhibitions of the work of individual White male artists or groups of artists, usually divorced from any serious consideration of the conditions under which their work was produced. Even where moves are made to widen the scope of exhibitions, their terms of reference are often arguably still those of mainstream art history and criticism. Attempts to break with them, as for instance in the 1987 Barbican exhibition in London, 'The Edwardian Era', which explicitly highlighted questions of gender, race and class as well as popular culture, are both rare and controversial.[2]

At issue here is the question of the constitution and reproduction of dominant conceptions of value and cultural traditions and their implications for those marginalized or excluded by them. In chapter 2 we outlined the key assumptions of the institutions and practices which define the dominant versions of Culture, Art, History and Value. We argued that Liberal Humanist cultural politics claim to be liberal while actually working with hierarchical notions of value. While subscribing to an ideology of cultural diversity, contemporary Liberal Humanism privileges, often in complex ways, particular art forms and artists. Nowhere is this clearer than in our discussion of the reception of work by Artists of Colour by the British art establishment in the postwar period. Whether we look at education, the academies, museums and galleries, arts funding or cultural history and criticism, we find a privileging of the culture, history and values of bourgeois, White men. From Western classical music, through the great tradition of English literature and drama to Western modernist painting and sculpture, the situation is the same. The responses from the margins which we have analysed share a concern with claiming, challenging and transforming these traditions and the institutional spaces which define and reproduce them.

Liberal Humanist claims to universality invite challenge from those who find themselves on the outside:

A VOICE: If you are universal, why do you exclude us?

Feminist, Black and 'Third World' writers, artists, scholars and cultural activists are attempting to change hegemonic traditions – to question the legitimacy of the dominant versions of Culture and to create alternative

and oppositional cultural traditions. They have drawn attention to how Liberal Humanism fails to take seriously the always–already existing social structures and relations of power. They have also called attention to how, when it allows others in, it often confines them to specific unequal spaces – such as 'women's fiction' or 'ethnic art'. This creation of alternative categories restricts such work to non-threatening domains which leave the mainstream intact. This form of liberalism no longer constitutes a fundamental ideology and practice of exclusion. It is a complex form of marginalization.

Questions of Cultural Democracy

QUESTION: What is Cultural Democracy?
ANSWER: The active engagement of all individuals and groups in cultural production, consumption and legitimation.

If there is one thing that our case study of Marxist-Leninist cultural politics in the German Democratic Republic suggests, it is that cultural democracy cannot be imposed from above. To stimulate participation in culture and the arts, we must start from people's needs and interests. Our case studies raise several important issues of cultural democracy. These include:

1 access to culture;
2 control of cultural production;
3 questions of form and audience.

Access to Culture

'The African woman writing fiction today has to be somehow exceptional', prefaces Unwinding Threads, the anthology of writing by women in Africa (1983), to which the present collection is a companion piece. The assertion holds, nonetheless, but now African women writers are no longer isolated voices crying from a 'wilderness'. They are reaching an audience at home and abroad. They are aware of each other. Those who published earlier and are still writing provide role models for others, new and as yet unheard. And their wilderness is no bleak desert nor isolated jungle. It can be the bulldozed shanty town of a Capetown coloured suburb, the work-a-day world of the exploited serving girl in a middle-class Kenyan neighbourhood, the horror strafed sidewalk of a war-torn Lebanese city, or the turmoil of frustration and inhibition in the inner world of the woman behind the veil. There is also joy: the comfort of enduring friendship, the satisfaction of academic achievement

and social power, the independence of thought, the affirmation of personal identity.

 — Charlotte H. Brunner (ed.), *The Heinemann Book of African Women's Writing*, 1993, p. vii

At the centre of cultural politics are questions of power. Power relations determine access to existing cultural practices, to the means of cultural production and distribution, and to the institutions that legitimate different cultural forms and practices. For example, it is only recently that much writing by Black African women has been taken up and published by Western publishing houses. The absence of African publishing houses able to market such writing internationally is itself a legacy of colonialism. Yet when African women writers are published who is selecting them? Who are the gate-keepers controlling what is published and distributed? Mostly it is White Western women and men, with established positions in universities and other cultural and educational institutions.

The Preface to the *Heinemann Book of African Women's Writing* – quoted above – was written by a White American literary scholar. Why should this be? Are there no African scholars who could undertake such a task? Or is it yet another example of cultural colonization? If you read the extract from the Preface closely, you can see how the question of editorship affects not only African women's access to cultural production and the shaping of traditions, but also how African writing is framed by a Western (benevolent yet none the less colonial) gaze.

The wider power to define meanings and subjectivities and to influence and change social relations is linked to the power to *create, make visible* and *legitimate* meanings and values different from those which are inherent in much mainstream culture. The creation of alternative and oppositional meanings – for example, of 'woman', or 'Black' or 'British Asian artist' – requires skills, resources and access to cultural institutions. It requires a basis from which to put dominant culture into question and force transformations.

Controlling the Means of Cultural Production

The ideas of the ruling class are in every epoch the ruling ideas, i.e. the class which is the ruling material force of society, is at the same time its ruling intellectual force. The class which has the means of material production at its disposal, has control at the same time over the means of mental production, so that thereby, generally speaking, the ideas of those who lack the means of mental production are subject to it.

 — Marx, *The German Ideology*, 1970 (ong. 1846), p. 64

We must recognise that art is a profession. It has an economic base. The only outlet available to the artist, whether you are white or black, is through the established structures. If you say that black art is something which is meant for and addresses only the black community, while the black community has no economic power to support its artists, then the black artist is lost. . . . The black community does not have economic power to support its artists. I may be repeating myself here, but I think it's important to emphasise. The only alternative, then, is to turn to the established system, whether one likes it or not, and to make demands within it. It has contradictions, particularly when one is engaged in a radical practice, but that's the way things are. I'm not suggesting that we should give in to the market forces, but it's an issue we cannot ignore.

— Rasheed Araeen and Eddie Chambers, 'Black Art:
a Discussion', 1988–9, p. 77

As we indicated in chapter 2, the main sources of finance for the arts in Britain today are the arts funding bodies, local government and to a lesser extent commercial sponsorship. Some books receive a small degree of Arts Council subsidy, but most writers have to sell their work to commercial publishers. To rewrite history and to produce new cultural forms, marginal groups need skills and especially material resources. To gain the funding to resource their work, they are forced to negotiate existing structures and pre-existing ideas of what merits public money.

In addition to funding production, there are also questions of control and distribution.

In the 1930s, *Left Review* was an example of an intervention, initially financed by a private donation, where only distributors were paid. This ensured editorial independence. In the 1990s, Britain's only Black women's press, Black Womantalk, also relies on donations in order to publish books. As a result of this, the collective, all of whom work on publishing projects in their spare time, have produced two books since 1987 with a third on the way in 1993. Their independence from commercial publishing has been at a great cost. Yet in both cases, financial independence – however limited and inadequate – is seen as the key to editorial independence.

Developments in new technology, such as home computers and video cameras, have made the means of cultural production more easily available to ordinary people. Desktop publishing has revolutionized the capacity of community groups and others to produce their own texts. Once a group has the computer equipment, the major cost is printing. Editorial freedom is not a problem. Yet in order to get their ideas across, cultural activists require the means of distribution with which to reach a broad audience. Without this access alternative meanings and values remain

marginal. In the new era of desktop publishing, distribution is perhaps the greatest problem facing small independent presses.

Changing dominant meanings and values is important not only for marginal groups themselves but as part of the struggle to change existing power relations in society. Any redistribution of power which is not imposed by force requires a mobilization of subjectivities in the creation of new consensual values that allow new meanings and values to achieve widespread acceptance.

The Politics of Form

Form is a crucial issue in cultural politics. In Britain in the 1930s, socialists were asking what form a popular, socialist, working-class literature should take. As we saw in chapter 6, matters of form are currently a key area of concern for many feminist artists, writers and critics who are anxious to develop or uncover specifically female aesthetics.

Among Afro-Caribbean and Asian artists in Britain today there is an on-going debate about the nature of 'Black Art' in which issues of form are directly related to authorship and audience. They include the following questions:

- Who should produce Black art?
- To whom should it be addressed?
- What forms should it use?

These practical questions are related to broader issues in cultural politics, questions which are also central to the practice of other marginalized groups:

- How do artists and cultural workers relate to the communities that they seek to represent or address?
- Should art have a directly consciousness-raising function?
- How should artists and cultural workers deal with questions of form and accessibility?[3]

We suggested in chapter 3 that, in the 1930s, radical activists united around a politics of *social realism*. This was seen as a form that could show how and why oppression functioned and make a moral case for social reform. Similar assumptions underpin much of the Black women's fiction and Aboriginal writing discussed in previous chapters.

Familiarity with the form, meanings and values of texts makes the reading process easier. It affirms the subjectivity of the reader/viewer, giving pleasure in the process. For example, television soap operas offer

a form of pleasure founded on the accessibility of television realism constructed through characterization and familiarity of setting and plot and transmitted directly into the viewer's living room.

But what of forms other than social realism? Much popular culture – from Hollywood cinema to generic fiction – breaks with social realism. For activists producing *Left Review* in the 1930s, the question of a revolutionary *popular* culture, which would engage working-class readers, was at least as important as developing social realism. In the 1990s, audiences are exposed to a wide repertoire of popular forms, many of which are non-realist. Take, for example, television advertising or pop videos.

The sophisticated and expensive TV advertising campaigns in Britain in the 1980s and 1990s around privatization and popular share-ownership helped to shift forms of popular consciousness and social values. If the government can successfully mobilize popular cultural forms to reach a large audience, so, too, can oppositional groups. Indeed in the 1980s and 1990s cultural phenomena ranging from 'Live Aid' and the Nelson Mandela concerts to the revival of 'Rock Against Racism' have linked the consumption of popular music to progressive causes.

But what of 'High Art' non-realist forms? These tend to challenge the conventions of form with which we are familiar. They involve new ways of reading and interpretation. Often they attempt to change how we see things. Because they require new and different reading skills, they are often experienced as difficult and elitist. Does this mean that they have no role to play in radical cultural production?

Surely a radical cultural politics should be able to draw on all available forms? Returning to the case of 'Black art', we would suggest, for example, that there are several possible approaches to the question of form. Black art might draw on:

1 a critical, deconstructive engagement with the artistic language(s) of the dominant Western cultures;
2 a critical engagement with traditional art forms from Africa, Asia, Native America and so on, such that these art forms are transformed and made to speak from and to our contemporary experiences;
3 a critical engagement with popular art forms of contemporary society, perhaps especially those syncretic, dynamic, ever-emerging traditions created out of black diaspora experience.

Audience

The politics of form are closely related to questions of audience. Audience has long been an important issue in cultural politics. In the nineteenth century, both liberals and socialists wanted to extend the audience for

'High' Culture to include the working classes. How do radical cultural activists today address the question of audience? In producing art for and on behalf of marginal groups, do artists, writers, musicians and film-makers privilege the cultural traditions of those groups or aim at a wider audience? Indeed, to what extent can we talk of cultural traditions specific to particular marginalized groups?

The consumption of culture may be an individual or collective experience. In either case, it involves the active construction of meanings in the process of interpretation. This process relies on learned models of reading or viewing and familiarity with the meanings on which texts draw. All signifying practices have their own historically specific forms of textuality with which the reader or viewer must engage in order to produce meaning. How signifying practices are interpreted will depend to a large extent on the position from which they are read and the repertoire of reading skills and cultural connotations to which the reader or viewer has access.

In an article entitled 'Cruciality and the Frog's Perspective', the cultural critic Paul Gilroy raises issues of form and audience in relation to the British Black Arts Movement. Gilroy asks who should be the target audience for Black art? If it is ordinary Black people, should this rule out wider audiences? Must success in a predominantly White, racist society be at the expense of a Black audience? Does 'Black culture' have its own forms and language which Black artists and film-makers abandon when they find themselves addressing their work to White audiences beyond their own communities?

Gilroy comes down clearly on the side of what he calls Black *'vernacular forms'*. He is critical of 'High Cultural' Black film practice and Black visual arts. His critique is class-based:

> Vernacular forms derive their conspicuous power and dynamism in part from the simple fact that they seek to avoid the prying eyes and ears of the white world whereas black film production in particular, is tightly shackled into a relationship of dependency on overgrown cultural institutions which are both capital and labour intensive. When then is it becoming illegitimate to ask how different are the black audiences for these forms from the white? This can be a polite way of formulating a deeper and more shocking question: namely is there *any* black audience for some of the most highly prized products of the black arts movement? Is there a non-literate, black working or non-working class audience eagerly anticipating these particular cultural products? Have 'our' film-makers given up the pursuit of an audience outside the immediate, symbiotic formation in which black 'filmic texts' originate? (Gilroy, 1988–9, p. 36)

Gilroy questions the *relevance* of much work by Black artists and film-makers to a Black community that is predominantly working-class and

often unemployed. He believes firmly in the artist's responsibility to the community from which she comes.

The claim that Black art should address a working-class Black audience using popular forms is, of course, a highly political one. It has its parallels in critiques of the middle-class nature of Western feminism. It puts particular responsibilities and constraints on Black artists and cultural workers which many would reject.

In a reply to Paul Gilroy, the cultural critic Kobena Mercer suggests that Black artists in Britain face an unwarranted 'burden of representation'. They are faced by a range of expectations – coming from both Black and White society – that the work of Black artists, writers and film-makers should in some sense represent either 'Black art' and/or the Afro-Caribbean and Asian communities in Britain. These communities are not homogeneous and to assume that they are leads to an undifferentiated construction of the Black audience (Mercer, 1990, pp. 61–78). One of the key factors determining the nature of Black audiences is class. But to privilege one class and the aesthetic forms thought appropriate to it is to replace aesthetic criteria by political ones.

Class is not the only difficult factor where 'Black arts' are concerned. Undifferentiated constructions of ethnicity, coming at least in part from Liberal Humanist funding policies which now work with a category 'ethnic minority arts', place difficult if not impossible expectations on Black cultural workers. Analysing the reception of the 1989 Hayward exhibition 'The Other Story: Afro-Asian Artists in Postwar Britain', Mercer describes how:

> Although it was never explicitly voiced, there was a widespread expectation that the exhibition would be 'representative' of black art as a whole. The concern about who was included and who was excluded turns around this desire to see something that is 'representative'. Moreover, as the first exhibition of its kind at the Hayward Gallery (a key site of the official national culture in the visual arts), the exhibition was burdened with the role of making present what had been rendered absent in the official version of modern art history. As a moment of corrective inclusion to counteract the historical exclusion of black arts from the official versions of the modernist narrative, 'The Other Story' had to carry an impossible burden of representation in the sense that a single exhibition had to 'stand for' the totality of everything that could fall within the category of black art. (Mercer 1990, p. 62)

The expectation that the exhibition should have been representative is, Mercer argues, symptomatic of the situation of Black artists who are 'expected to "speak for" the black communities from which they come' (p. 62). One solution to this problem would be much wider access to exhibition facilities of all sorts for Artists of Colour.

Cultural Diversity, Postmodernism and the Politics of Difference

As previous chapters have indicated, the postwar period in Britain and most other Western countries has seen the emergence of an official recognition of cultural diversity and the development of a less elitist and more pluralist conception of art and culture. This has been a response to pressures from marginalized and excluded groups.

A central part of the process of creating alternative, oppositional traditions is the redefinition of what it means to belong to a particular group – to be working-class, a woman, Welsh, Aboriginal, . . . Black. This redefinition may involve strategies of renegotiation, reversal or rejection of existing terms. Each of these strategies can be found in feminist and Black cultural politics. The alternative positive identities which they produce are different from those usually offered by societies and cultures that are structured by race, gender and class. In contrast they offer their subjects a positive sense of self and of history from which to engage in cultural and political struggle.

Now, the various alternative cultural formations, whether working-class, feminist, Black or 'Third World', do not have equal status either with each other or with the dominant. Nor do they have equal power to determine accepted meanings and values. While recognition and support of 'diversity' is an important step, it can leave the structurally dominant mainstream intact.

AN ELITE LIBERAL VOICE: That's the general idea – to give a bit in order to fundamentally preserve the status quo.

Cultural political interventions by and on behalf of oppressed and marginalized groups necessarily rest on definitions of group interest. Such interventions may also mobilize particular ideas about group identity. Alternatively, people may come together on the basis of what they are fighting against. Definitions of class, gender and race are not naturally given: they are historically and discursively produced. Cultural politics coming from the margins often seek to redefine the accepted meanings of these categories. People need *subject positions* and *identities* – however fixed or provisional – in order to speak and act in the world. We cannot act without becoming subjects. In the process we fix, however temporarily, what it means to be a 'man' or 'woman', to be of a particular 'class', 'race' or 'ethnic group'.

The deconstructive approach to subjectivity and meaning which poststructuralism offers allows us to analyse how subject positions and

identities are produced but it does not do away with the characteristic pre-postmodern need for fixing. When individuals and groups engage practically in cultural political struggle over meanings, values and structures of power, they attempt to fix and unfix meanings, values and interests.

The recognition that theories do not yield Truth but constitute different versions of reality which are tied to specific social interests is central to politically radical postmodern thinking. This recognition need not necessarily dissolve into a politically disabling relativism. Rather, it is a move that should allow for the political importance and effectivity of different ways of understanding the world. Theory becomes grounded not in absolute truth claims, but in the politics of historically specific situations. Its usefulness lies in the light it can throw on how power works in particular instances.

In the final analysis judgements about the validity or degree of effectivity of particular theories and practices must look to their effects. From this perspective particular theories of gender difference would be judged by the social practices that they legitimate – and these change historically. For example, in postmodern sexual politics, it is not a question of ascertaining the truth about women and men. Theory should rather enable us to understand the implications for women and men of different versions of femininity and femaleness, masculinity and maleness in their class, racial and ethnic specificity. Similarly 'Black subjectivity', whether female or male, is not an essence to be uncovered. It takes many forms which have different social and political implications.

As the various studies in this book have demonstrated, subjectivity, meaning, knowledge, truth and history are the material of cultural politics. How they are constituted and understood has profound implications for power relations in society. How we understand them helps determine what we can change.

Dangers in Postmodern Thinking

Of course, in so-called postmodern society, we feel overwhelmed by the diversity, the plurality of surfaces which it is possible to produce, and we have to recognise the rich technological bases of modern cultural production which enable us endlessly to simulate, reproduce, reiterate and recapitulate. But there is all the difference in the world between the assertion that there is no one final, absolute meaning – no ultimate signified, only the endless chain of signification, and, on the other hand, the assertion that meaning does not exist.
— Stuart Hall, 'On Postmodernism and Articulation', 1986, p. 49

The postmodern critique of universals, metanarratives, essential subjectivity and the fixing of meaning has much radical potential but it is not

without its dangers. Many postmodernist thinkers and writers decidedly privilege plurality and pleasure over power and effective resistance. The postmodern celebration of difference becomes dangerous once it is divorced from the structural power relations that produce it. Where postmodern difference is seen as pluralism without attention to the social location of difference, power and its effects become invisible. Here difference often appears as a form of radical chic, indifferent to the (often brutal) power relations that structure difference. The postmodern move from History to histories can be productive and empowering for groups usually absent from History. But here, too, not all histories are equal. To ignore power, for example by treating all histories as if they had equal status and power, leads to a denial of specificity of oppressions.

In the end, the question is whether we see cultural politics as serious business or cultural politics as play.

Notes

Chapter 1: Introduction: What Are Cultural Politics?

1 The pluralist, 'anthropological' conception of culture derives from the eighteenth-century German philosopher Johann Herder. Herder distinguished 'cultures' from the eighteenth- (and nineteenth-) century unilinear – and Eurocentric – notion of 'civilization', the notion that all societies are on a common conveyor belt of human development with some at lesser stages than others. Herder argued that each people – each society, each ethnic group, each linguistic community – could be distinguished by a 'whole way of life', by common customs, ways of thinking and ways of being. He argued that each way of life is informed by a 'common spirit': that the social activities, patterns of thought and ways of being of a given group are produced in and through what we might call today a kind of 'grammar' or 'syntax' of everyday life, that is, by general values, categories, and so on, that guide and make sense of specific activities.

2 There is a tradition of Black nationalist thought that argues that Beethoven – one of the Great White Men – was in fact 'Black', that is, of Moorish ancestry. See Rogers (1972).

3 These biases are currently being contested with the expansion of museums, galleries and the leisure industry and their diversification in the face of a growing class, gender and ethnically differentiated consuming public. This is discussed in more detail in chapters 2, 5 and 6.

4 Relevant texts by Foucault include *I, Pierre Rivière* (1978), *Discipline and Punish* (1979a) and *The History of Sexuality*, vols 1–3 (1981, 1986 and 1988). See also Weedon (1987), esp. pp. 107–125.

5 Most so-called 'guest workers' and their families, for example, who have lived in Germany for decades and whose children have been born and bred there, have no automatic right to citizenship and therefore no vote. To become a German citizen is a lengthy process which involves renouncing one's previous nationality.

6 See Gilroy (1987).

7 For more on nineteenth-century women's and abolitionist movements, see bell hooks (1986) and Vron Ware (1992).

8 The literature on postmodernism is massive. For an introduction to the key issues the reader could turn to Turner (1990) and Docherty (1993).
9 For an introduction to poststructuralism, see Weedon (1987). For discussions of postmodern culture and politics, see Connor (1989) and Grossberg (1992).

Chapter 2: Liberals, Humanists, Cosmopolitans and Eurocentrics: On the Development of Cultural Policy in Britain

1 For more on liberalism, see Gray (1989); John A. Hall (1988); and Kymlicka, (1989).
2 Liberalism works with a narrow conception of rationality which it privileges over other aspects of human life. Alison Jagger describes how:

> Contemporary liberalism . . . presuppose[s] what I have called normative dualism, namely, the view that what is especially valuable about human beings is their 'mental' capacity for rationality. . . . The [liberal] instrumental interpretation of rationality . . . holds that an individual can make a rational choice between a variety of means to a given end, but that one cannot give a rational justification for any particular rank ordering of ends. On this interpretation of rationality it is because each individual is the ultimate authority on her or his own needs and desires that political society must allow maximum freedom for individuals to define their own needs. (Alison Jagger, 1983, pp. 41–2)

This normative dualism devalues those aspects of human beings usually seen as feminine (and often also 'primitive'), such as emotions, intuition and the body. The legitimacy and the desirability of the emphasis on a narrowly defined conception of rationality, which, for a long time, excluded all women and men of Colour, has been questioned by many feminists.
3 See, for example, both nineteenth- and twentieth-century forms of sociobiology. Janet Sayers gives an account of these in her book *Biological Politics* (1982).
4 For an account of different types of feminism and their positions on biology and women's nature, see Jagger (1983).
5 Hedwig Dohm was a strong, if marginalized, liberal voice in the German feminist movement. From the 1870s onwards she wrote many powerful and persuasive political texts arguing for education, access to work, suffrage and a transformation of existing standards of morality. She also wrote fiction that was critical of the position of women in German society.
6 Cited in Loewenberg and Bogin (1976, pp. 330–1); quoted in Hill Collins (1990, p. 37).
7 Key advocates of English literature in the nineteenth and early twentieth centuries can be found in Farrar (1868) and in Mathieson (1975). More recently this has been a particularly strong feature of the Leavisite tradition of literary criticism which was developed in the journal *Scrutiny: A Quarterly Review* (1932–53). It is analysed in Mulhern (1979). For a discussion of the role of English in education, see Batsleer et al. (1985).
8 See, for example, the Newbolt Report (Newbolt, 1921).
9 *The Highway*, 17(5), (1934), 20.

10 See, for example, Leavis (1930).
11 From 1994 a new structure comes into being. The Arts Council of Great Britain is replaced by separate, autonomous arts councils for England, Scotland and Wales. Funding of the arts in Scotland and Wales now comes directly from the Scottish and Welsh Offices. The regional arts associations become regional arts boards integrated within the arts council structure. It is not yet clear what the implications of these structural changes will be.
12 See the exhibition catalogue *The Other Story* and the discussion in *Third Text*, nos 8/9, 1989. We discuss this exhibition and its reception in Part IV.
13 'The *National Eisteddfod* is a cultural fair which lasts for eight days at the beginning of August every year. It attracts over 150,000 visitors and some 6,000 competitors and costs approximately £2 million. It is, in fact, the largest popular festival of competitive music-making and poetry-writing in Europe Its purpose is simple. It is to promote the Welsh language, to encourage popular participation in artistic and cultural activities, and to provide enjoyment' (*Eisteddfod: An Introduction and Guide for Non-Welsh Speakers*, nd, Cardiff, Wales: Eisteddfod Office).
14 For approaches to multicultural education, see the publications of the Arts Education for a Multicultural Society, 105 Picadilly, London W1V OUA.
15 The Welsh Arts Council's policy statement *Arts in a Multicultural Society* (Cardiff: WAC, June 1989).
16 The Arts Council of Great Britain, too, embraced the new business language and, until 1991, it had an Incentive Funding Scheme which drew on additional government funding (£3.5 million in 1988–9 and £4 million in 1989–90). This scheme was used to provide money-making additions to existing arts facilities such as computerized box offices, attractive bars and restaurants.
17 See, in particular, Pollock (1992), and debates in the journal *Third Text* which are discussed in Part IV.
18 Various articles in the journal *Third Text* touch on the role of 'primitivism' in art history, for example, Araeen (1987). We discuss this at length in chapters 10 and 11.
19 An example of this was the reception of Walter Greenwood's *Love On the Dole* (1933) which subsequently became a Penguin 'modern classic'.

Chapter 3: Writing as a Weapon in Class Struggle: Radical Cultural Politics in Britain to the Second World War

1 For accounts of working-class struggle for access to education and culture from the late nineteenth century, see Simon (1965, 1974) and Weedon (1984).
2 For more on the history of working-class writing, see Ashraf (1979); Gustav-Klaus (1982); Jon Clark, Margot Heinemann, David Margolies and Carole Snee, (1979); Smith (1978); and Weedon (1984).
3 The 'mode of production' refers to the way in which economic production and reproduction is organized. Capitalism is a mode of production. Its distinguishing feature is the division between a capitalist class which owns the means of production and the working class which is obliged to sell its labour-power to the capitalists in order to survive.

4 For a history of conceptions of class, see Giddens and Held, eds (1982).

5 For more on the WEA, see Mansbridge (1920).

6 See, for example, Wilkinson (1927).

7 *The Plebs' Magazine* was renamed *The Plebs* from 1919 onwards, and from January 1928 it was published by the Plebs' League's successor, the National Council of Labour Colleges.

8 The International Union of Revolutionary Writers (Writers' International) was founded in Moscow in 1927 with branches in Germany, Austria and Poland. Gradually it spread to many other countries. The British Section was founded at a conference held in Conway Hall, London, in February 1934, and was based at Collet's Bookshop in Charing Cross Road.

9 The novels of Scottish miner James Welsh and Durham miner Harold Heslop, for example, exemplify both the ways in which working-class writing took up labour movement thinking of the day and testify to the importance of fiction in the education of working class intellectuals and activists. Welsh wrote *The Under-world* (1920); *The Morlocks* (1924); and *Norman Dale M.P.* (1928). Heslop wrote *The Gate of a Strange Field* (1929); *Journey Beyond* (1930); *Goaf* (1934); *The Crime of Peter Ropner* (1934); *Last Cage Down* (1935); and *The Earth Beneath* (1946).

10 At this time seven shillings represented a few pence more than the weekly wage of a nurse in her final year of training. As Chris's mother, Mrs Marguerite Weedon, recounts, seven shillings would buy 140 cigarettes, a hat or a pair of slippers or two pairs of cotton underwear or a pair of kid gloves. It would cover the cost of two good London cinema seats, half a bottle of whisky or a gift box of handkerchiefs. Shoes or a coat cost more, ten shillings and sixpence and twenty-one shillings respectively.

11 The International Association of Writers for the Defence of Culture, founded in 1935, also contained both liberal and socialist elements and maintained its commitment to attracting liberal writers and encouraging them to recognize the threat posed by fascism to their conceptions of art and the individual. The proceedings of the first congress, published in *Left Review* (1(11), (1935)), are a good example of liberal attitudes to the United Front.

12 This way of viewing popular culture has only recently been substantially revised by Marxists – in the light of Gramsci's political writing and postmodernism.

13 See chapter 2, note 8.

14 Socialist realism as a form of aesthetic and cultural policy first gained ascendency in the Soviet Union at the Soviet Writers' Congress in 1935. It effects can be seen in Soviet cinema and fiction of the 1930s, 1940s and 1950s. In the rest of Eastern Europe it determined cultural policy and practice in the first two decades after the war. See Gorky et al. (1977).

15 The criticism competition, which involved writing about two of the published stories from the previous competition, only attracted seven entries.

Chapter 4: Marxist Cultural Politics in Eastern Europe: The Case of the German Democratic Republic

We are grateful to Bernd Rosner, the East German art historian and critic, for his helpful comments on this chapter.

1 The original German reads: '*Wenn wir von Kultur und kulturellen Aufgaben in der entwickelten sozialistischen Gesellschaft sprechen, so meinen wir nicht irgendein eng begrenztes Gebiet. Es geht uns um die Gesamtheit der Lebensbedingungen, der materiellen und geistigen Werte, Ideen und Kenntnisse, durch deren Aneignung die Menschen in Gemeinschaft mit anderen zu fähigen, gebildeten und überzeugten Erbauern des Sozialismus, zu wahrhaft sozialistischen Persönlichkeiten reifen.*'

2 For an account of radical cultural politics in the Weimar Republic, see Bullivant (1977).

3 *Das Wort. Litterarische* [sic] *Monatsschrift*, July 1936–March 1939 (Moscow).

4 Becher's 'New German Folksongs' were set to music by the composer Hans Eisler and became available on the GDR record label Nova in 1971.

5 See, for example, Anna Seghers' novel *Die Entscheidung* (1959).

6 Classic GDR socialist realism included Erik Neutsch's novel *Spur der Steine* (1964) and Hermann Kant's *Die Aula* (1965).

7 For the theory of the 'all-round developed personality', see John (1973).

8 See Lukács (1963 and 1972).

9 The original German is as follows: '*Wer anders als die Literatur der Deutschen Demokratischen Republik kann heute in Deutschland vom ganzen deutschen Volk den sozialen und nationalen Auftrag übernehmen, dafür zu arbeiten, daß den Meisterwerken der Klassik und den bedeutendsten Werken des Realismus im letzten Jahrhundert ebenbürtige literarische Leistungen folgen, in denen die Gestaltung unseres neuen Lebens, seiner Probleme, Kämpfe und Konflikte, die Gestaltung der Schicksalsfragen aller deutschen Menschen dahin führen, daß sich das sozialistische und das Vaterländische zu der neuen Konzeption der Nationalliteratur unseres Zeitalters vereinen?*'

10 Along with Kafka, James Joyce and Robert Musil were often quoted as examples of decadent modernist literature.

11 These writers included Willi Bredel, Jan Petersen, Hans Marchwitza, Otto Gotsche, Friedrich Wolf, Erich Weinert, Karl Grünberg and Ludwig Turek.

12 Some of the better-known novels influenced by the *Bitterfelder Weg* include Neutsch's *Spur der Steine* (1964) and Christa Wolf's *Der geteilte Himmel* (1963).

13 See, for example the anthologies *Zwischenbericht* (Leipzig: Zentralhaus für Kulturarbeit der DDR, 1969) and *Du gefällst mir*, edited by Jochen Haufe, (Cottbus: Bezirkskabinett für Kulturarbeit, n.d.).

14 The original German is as follows: '*Beides sind Erscheinungen der kulturellen Fäulnis des Imperialismus – und beides versuchen die Imperialisten, im ideologischen Kampf der zwei Gesellschaftssyteme, auch in unsere Deutsche Demokratische Republik und in andere sozialistische Länder einzuschleusen.*'

15 The original German reads as follows: '*Zu den großen Erfolgen der Entwicklung der DDR gehört die Herausbildung einer eng mit den Kämpfen und den Siegen der Arbeiterklasse und aller Werktätigen verbundenen Kunst. Eine große Zahl von Werken der DDR-Kunst wurde zum ständigen Begleiter vieler Menschen, und sie haben oft deren Entscheidung und aktives Eintreten für den Sozialismus mit beeinflußt. Viele Bücher, Fernsehstücke, musikalische Werke und Bilder sind zum Bestandteil unseres Alltags geworden, sie veranlassen zum Nachdenken über wichtige Fragen der sozialistischen Gegenwart, sie bereichern unser Leben und helfen mit, eine schöpferische Lebenshaltung herauszubilden. Ihre Wirkung vollzieht sich immer wieder auf*

vielfältige Weise. Sie reicht von heftigen Auseinandersetzungen mit bestimmten Kunstwerken bis zu behutsamen und scheinbar unmerklichen Einflüssen auf den einzelnen.

 Die große gesellschaftliche Bedeutung der sozialistischen Kunst zeugt davon, daß die Künste für den Sozialismus eine lebensnotwendige Erscheinung sind, unentbehrlich und unersetzbar für das geistige Leben unserer Gesellschaft. Diese Tatsache ist Ausdruck einer historisch neuen Gesellschaftsfunktion der Kunst, die untrennbar mit dem Kampf der Arbeiterklasse verbunden ist. In der sozialistischen Kunst wird die relative Verselbstständigung der Kunst vom sozialem Lebensprozeß überwunden, wie sie für die bürgerliche Gesellschaft charakteristisch ist. Sie wird zum bewußten Mitgestalter des Sozialismus und verstärkt ihre Mitantwortung beim Aufbau einer neuen Gesellschaftsordnung in der DDR. Diese sozialen Funktion ist charakteristisch für die Kunst aller sozialistischen Länder und eine Ursache für ihre dynamische Entwicklung.'

16 Those most opposed to the establishment of a socialist state left for West Germany in the years between 1945 and 1961 when the border was sealed.

Chapter 5: Whose History Is It? Class, Cultural Democracy and Constructions of the Past

We are grateful to Mark O'Neill, Local History Curator, Glasgow Museums, for his assistance with part of this chapter.

 1 This quotation is from an information pack published in the early 1990s by Valley and Vale, South Wales's largest community arts organization. They are based in Blaengarw, Mid-Glamorgan, as well as in the town of Barry.
 2 The Greater London Council, for example, encouraged a range of cultural initiatives which were plural in nature and included those of specific marginalized social groups, for example, working-class people, African, Afro-Caribbean and Asian groups, women's groups and gay and lesbian organizations.
 3 The reference here is to Sheila Rowbotham (1973).
 4 The preceding was, as you may well have suspected, a 'mock interview', using published statements from the 'interviewees'. In most cases, the emphases added – the capitalized words and the italics – are our own.
 5 This is a stanza from a song, entitled 'The People's Palace' and written by Alec Jamieson. It is available on Corban Records, 1984. The words are reproduced in King (1991), p. 115.
 6 The London People's Palace eventually developed into an institute for technical education which later became Queen Mary College, a constituent college of the University of London.
 7 The national press is also guilty. See, for example, the *Independent*, 4 May 1993, which had an article about 'Girls Taking to the Hills' (prostitutes going on an outing) which mistakenly suggested the women were Butetown prostitutes. Or again the *Independent*, 14 June 1993, which linked the brutal murder of an Ely housing estate resident – an estate some miles from Butetown – to the fact that Butetown families were rehoused on this estate in the 1960s.

8 For a sampling of the 'social science' literature on Butetown/'Tiger Bay', see Nancie Sharpe (1932); Muriel Fletcher (1930); Kenneth Little (1942a, 1942b, 1942c, 1943 and 1948); Harriett Wilson (1948 and 1950); St Clair Drake (1954 and 1955); Sydney Collins (1957a and 1957b); Leonard Bloom (1971 and 1972); P. J. O'Connor (1973); Neil Evans (1980, 1983 and 1985); Harris Joshua et al. (1983, pp. 14–41); and Iain Tweedale (1986 and 1987). Also see Daunton (1977), Davies (1981), and Jordan (1988). For a sampling of the novels and short stories, see J. M. Walsh (1936, 1947 and 1952); David Martin (1946); Jack Jones (1979); Alexander Cordell (1986); and Tom Davies (1989). A photo-history is provided in Catherine Evans et al. (1983). Written accounts by indigenous researchers include Stephen Khaireh (1984), Olwen Blackman Watkins (1975), and Neil Sullivan (1990). There have also been a few autobiographical accounts/community histories written by people from the area. They include Bill Twamley (1984) and Neil Sinclair (1993). The last of these is the first in a new series called 'Life Stories from Tiger Bay', edited by Glenn Jordan and published by the Butetown History & Arts Centre.

9 BHAP workers include Jane Chamberlain, Phyllis Chappell, Marco Gil-Cervantes, Mavis Jackson, Robert Johnson, Glenn Jordan, Molly Maher, Bev Morgans, Jeff Paine and John Taylor. Most of them work as volunteers.

10 The views of Butetown residents on the redevelopment and incoming 'Yuppies' were aired in an HTV Wales television documentary, broadcast on 25 May 1989, in the 'Wales this Week' series

11 See Drake (1954).

Chapter 6: Feminism and the Cultural Politics of Gender

1 For discussion of the construction of Black women's sexuality under slavery, see hooks (1986). For constructions of working-class women's sexuality in Britain in the nineteenth century, see Mort (1987).

2 See Wollstonecraft (1982) and also Jaggar (1983).

3 For Black and 'Third World' challenges to Western Feminism, see Mohanty et al. (1991).

4 Radical feminism, for example, often locates woman's 'true nature' in her capacity for motherhood and in lesbian sexuality. Traditional female qualities are revalued and men are seen as different and inferior for reasons ranging from the nature of male hormones to the supposed psychological consequences of men's inability to bear children. In Afrocentric feminism, Black identity is sometimes located in an essentialist version of 'Africanness' that links the pre-slavery African, slave and contemporary diasporic experience of Black women. Examples of this can be found in Bryan et al. (1985).

5 An example of this work of recovery is to be found in Showalter (1977). Showalter developed her idea of *gynocriticism* in the essay 'Towards a Feminist Poetics' in Showalter (1986).

6 In opposition to White notions of feminism Alice Walker introduced the term *womanist*:

 Womanist 1. From *womanish*. (Opp. of 'girlish', i.e., frivolous, irresponsible, not serious.) A black feminist or feminist of colour. From the black folk expression of

mothers to female children, 'You acting womanish', i.e., like a woman. Usually referring to outrageous, audacious, courageous or *willful* behaviour. Wanting to know more and in greater depth than is considered 'good' for one. Interested in grown-up doings. Acting grown up. Being grown up. Interchangeable with another black folk expression: 'You trying to be grown'. Responsible. In charge. *Serious*. (Walker, 1984, p. xi)

Being 'womanist' includes loving and appreciating other women and women's culture. It is the basis for a recovery of Black women's history and culture which, Alice Walker argues, is necessary for the survival and wholeness of both men and women. It encompasses a love of sensual and spiritual things. 'Womanist is to feminist as purple to lavender.'

7 Examples of Marxist feminist criticism include Barratt, (1980); Newton and Rosenfelt (1985); Kaplan (1986); and Landry and MacLean (1993).

8 Dale Spender's popular works of recovery include, for example, *Mothers of the Novel: One Hundred Good Women Writers before Jane Austen* (1986) and *Women of Ideas And What Men Have Done to Them: From Aphra Benn to Adrienne Rich* (1982).

9 See, for example, Audre Lorde (1984); Alice Walker (1984 and 1988); bell hooks (1983, 1984, 1989 and 1991); and Barbara Smith (1977).

10 See, for example, Christian (1980); Braxton and McLaughlin (1990); Carby (1990); and Gates (1990).

11 The recent literature on masculinity is voluminous. For a feminist perspective on it, see Segal (1990).

12 We also look at the representation of female, Black bodies in chapter 9. For discussion of the racist colonization of Black female bodies, see Gilman (1992), hooks (1989 and 1991) and Wallace (1990).

13 The objectification of women's bodies is well illustrated in John Berger's classic essay on the nude (1972) and in subsequent feminist writings on art which also discuss women's absence from artistic canons. See, in particular, Nead (1992); Parker and Pollock (1986 and 1987); Pollock (1988); Robinson (1987); Betterton (1987); and Nochlin (1989 and 1991). For a more mainstream perspective on this topic, see Lucie-Smith (1991).

14 See, for example, the work of Irigaray (1985), and the study of her work in Whitford (1991).

15 See Cixous (1984, 1991 and 1992).

16 See, for example, Foreman (1977).

17 See, for example, the writing of Susan Griffin (1982, 1984) and Adrienne Rich. The key text on heterosexuality as a repressive institution is Rich (1981).

18 For more on woman-centred art practice, see Robinson (1987) and Pollock (1987a).

19 For an exploration of this area, see Coward (1984).

20 *M/F*, London, 1978.

21 See, in particular, *Feminist Review*, no. 17, Autumn 1984; Centre for Contemporary Cultural Studies (1982a); and Kanter et al. (1984).

22 For debates about Black art, see *Third Text*.

23 See particularly hooks (1989).

24 For example, Virago books in the UK and the Schomburg series of reprints in the USA (see chapter 8, note 1).
25 'Notes toward a Politics of Location', reprinted in Rich (1986).

Chapter 7: Alternative Subjectivities: White Feminist Fiction

1 Women's publishers are currently being hard hit by the recession. For an account of the situation of the small feminist presses, see *Spare Rib*, no. 223 (May 1991); 10–13.
2 See the essay 'The Difference of View', in Jacobus (1976).
3 See Hutcheon (1988) and McHale (1987).
4 Of particular importance is the prose of Irmtraud Morgner, Christa Wolf and Helga Königsdorf.
5 The social effects of the debate over *The Satanic Verses* has to be understood in the broader context of the situation of Muslims in Britain. The racist social relations under which many Muslims live have created a sense of betrayal and lack of positive identity which fundamentalism seems to answer.
6 In addition to the texts discussed in this chapter Michèle Roberts has published poetry and the following novels: *The Visitation* (1983); *The Book of Mrs Noah* (1988); *In the Red Kitchen* (1990) and *Daughters of the House* (1992).

Chapter 8: Gender, Race and Identity: Black Feminist Fiction

1 See, for example, the Schomburg Library of Nineteenth Century Black Women Writers, under the general editorship of Henry Louis Gates, Jr. This is a 30-volume series published by Oxford University Press drawing on material from the Schomburg Center for Research in Black Culture. 'A research unit of The New York Public Library, the Schomburg Center has been in the forefront of those institutions dedicated to collecting, preserving and providing access to the records of the black past. In the course of its two generations of acquisition and conservation activity, the Center has amassed collections totaling more than five million items' (Howard Dodson, 'A Note From the Schomburg Center', in the forward to the series).
2 This sense of tradition comes through very clearly in the essays of Alice Walker (1984 and 1988). Walker and Morrison are but two among a wealth of contemporary African-American women writers. Others include Maya Angelou, Toni Cade Bambara, Gayl Jones, June Jordan, Audre Lorde, Gloria Naylor and Ntozake Shange. For a much fuller list, see the bibliography in Braxton and McLaughlin (1990).
3 *Beloved* is based on the case of Margaret Garner, 'a runaway slave who attempted to kill herself and her children rather than be returned to slavery . . . Margaret Garner did not achieve freedom, as Morrison's Sethe does. Instead she was tried, not for attempting to kill her child, but for the "real crime" of attempting to escape, of stealing property, herself, from her master' (Christian, 1990, p. 336).

Chapter 9: Marking Difference, Asserting Power: the Cultural Politics of Racism

Some of the ideas in this chapter – in particular those derived from reflections on the writings of Frantz Fanon, Albert Memmi and Aimé Césaire – were developed in the context of a series of courses on racism which Glenn Jordan taught some years ago at Stanford University. Glenn is currently working on a book on *Racism and the Black Subject*, which explores in detail issues of race, language, culture and subjectivity that are raised in this chapter.

1 An excellent discussion of many of the issues raised in this section is contained in Winthrop Jordan, 'The Bodies of Men: the Negro's Physical Nature'. In *White over Black* (1969, pp. 216–65).
2 James Walvin's book *Black and White: The Negro and English Society, 1555–1945* (1973) contains a useful discussion of eighteenth- and nineteenth-century Black caricature. Unfortunately, it does not include pictures.
3 The actual model may be of Afro-Caribbean rather than Asian origin. The look, none the less, is indisputably 'Oriental'.
4 The word 'denigrate' is related in its etymology to the word 'nigger'.
5 The reader interested in exploring this theme would do well to study paintings such as the following: Edouard Manet's *Olympia* (Musée de l'Impressionisme, Paris); Jean Marc Nattier's *Mademoiselle de Clermont* (Wallace Collection, London); Nicolas de Largillierre's *Princess Rakoscki* (National Gallery, London); Jean-Auguste-Dominique Ingres's *Odalisque with a Slave* (Walters Art Gallery, Baltimore). Another interesting example is William Blake's famous engraving, *Europe Supported by Africa and America*.
6 As it turns out, the picture used on the front page of the *Sun* and the *Star* was simply a photo the police had of Silcott, i.e., it was *not* actually taken just after he learned that he had been convicted of murder and sentenced to 30 years in prison.
7 The point is not about Tyson's guilt or innocence, but about the way Black-male-rapist-stories are projected in the press. An interesting discussion of the Tyson rape incident, viewed within the context of American racist society, is contained in June Jordan, 'Requiem for the Champ' (Jordan, 1993, pp. 197–202). The theme she pursues is different from ours, but of at least equivalent importance.
8 QUESTION: What is an indentured servant? ANSWER: A slave on a fixed-term contract.
9 It is perhaps worth mentioning that Cilla Black, the host of the television show *Blind Date*, is a prominent member of Britain's Conservative Party. One could hardly imagine a leading light in the USA's Republican Party promoting 'race mixing' on television.
10 Alf Garnett was the central character in the long-running BBC situation comedy 'Till Death Us Do Part'. This featured a working-class family in East London and was watched by some 18 million viewers each week (that was about half of Britain's adult population). As Milton Shulman wrote in a review

article in the *London Evening Standard* (21 February 1968): 'The fascination of Alf Garnett . . . lay in his ability to act as a distorting mirror in which we could watch our meanest attributes reflected large and ugly.' Alf was controversial for his 'views on coons, kikes and wogs; his reflections on Labour Party politicians; his suspicion of anything new (like transplant operations); his ignorant superstitions, his insensitivity to beauty, his blatant hypocrisy. . . . Even his conventional virtues – his faith, his patriotism, his loyalties – have all been acquired for the wrong reasons. His religion is motivated by fear of a vengeful God; his admiration of the Queen, by snobbery; his passion for West Ham [football club] by a need for aggressive self-fulfilment.' (From 'Viewers, You Were Looking at Yourselves', reprinted in Daniels and Gerson, 1989, pp. 24–7.)

Archie Bunker was the central character in the American situation comedy series 'All in the Family'. He was a racist 'bigoted but loveable(?)' man 'whose wife, daughter, and son-in-law labored, by example and by cajolery and trickery when necessary, to change Bunker into a more tolerant person' (Dates, 1990).

11 Quoted in Walvin (1973, p. 173).
12 Ibid.
13 Whether aspects of Saddam Hussein's personality do in fact conform to the Orientalist stereotype is not germane to this argument.
14 From *Memoirs and Poems of Phyllis Wheatley*, 3rd edn (1838; reprinted 1969), p. 48. As some readers will know, Phyllis Wheatley was an eighteenth-century poet, one of the first Black writers to be published in North America. She was a White consciousness in a Black body.
15 This 'Western Civ' struggle is well documented in campus and local newspapers: e.g. the *Stanford Daily*, *Campus Report* and *Stanford Observer*. Also see *The Real News*, newspaper of Stanford's Black Students' Union.
16 The extent to which the specific content of these stories is accurate does not concern us here: slavery actually ended due to a number of different factors. Our concern here is the difference in form.
17 We have rendered this passage gender-neutral. The original sentence read, 'The disaster of the man of colour lies in the fact that he was enslaved.'
18 See Jordan (1988).

Chapter 10: Primitives, Politics and the Avant-garde: Modern Art and its Others

1 Our discussions of the journal *Third Text* in this and subsequent chapters draw on careful readings of all the issues published between Autumn 1987 and Spring 1993.
2 The concept of 'elective affinity' proved to be controversial – at the MOMA exhibition if not in the catalogue. See, for example, Foster (1985) and Clifford (1988c).
3 Fondane (1929), quoted in Geist (1984, p. 361).
4 The original German reads: '*Auch wenn die afrikanischen Skulpturen nicht als Auslöser der kubistischen Bewegung gelten können – nach Picasso waren sie "eher*

Zeugen als Modelle" –, kam es dennoch zu der Übernahme einer Reihe von formalen Elementen. Man lernte von den Afrikanern, mit Hilfe rautenartiger Formen Augen und Gesichter zu konturieren, durch Furchenbildung unterschiedliche Flächen zu markieren. Runde Formen wurden auf flache, facettierte Ebenen reduziert, vor allem aber begriff man jetzt die rhythmischen Wechselbeziehungen zwischen festen Massen und hohlen Zwischenräumen. Was dabei entstand, sind auf Bilder gebannte Gestalten, die afrikanische Gesichtsmasken zu tragen scheinen. Skulpturen von Sitzenden oder Stehenden geraten zu einem Gemisch von Bestandteilen, entliehen der klassisch-europäischen Tradition und den "Fetisch"-Figuren von Zaire. Doch schon bald setzte sich die Einsicht durch, daß man äußere Formen, weil unintegrierbar, nicht übernehmen kann, wohl aber das Prinzip. Es hat, wie bekannt, wesentlich zum Siegeszug der expressionistischen Kunst beigetragen.'

5 Originally published in 'Conversation avec Picasso', *Cahiers d'art*, vol. x, nos 7–10 (1935), pp. 173–8.

6 It is commonly believed, following a story told by the Parisian art dealer, Daniel-Henry Kahnweiler, that *Les Demoiselles* was painted between the end of 1906 and Spring 1907 – over a period of eight or nine months, during which it was modified to look more 'primitive' after Picasso's legendary visit to the ethnographic museum at the Trocadéro. But this chronology is disputed by other scholars – in particular, by William Rubin, Director, Department of Painting and Sculpture at New York's Museum of Modern Art (1973–88). MOMA has owned *Les Demoiselles* since 1939, and Rubin has done detailed study of its evolution. Rubin has convincingly demonstrated that the painting began in 1907 and was completed in the summer of that same year: Picasso's preparatory sketches and drawings for *Les Demoiselles* date only from spring 1907. (See Rubin, 1984b.)

7 That is, once Picasso had shaken off the mournful naturalism of the pink and blue periods.

8 A more or less autonomous development of Dada began in New York at the same time as in Zurich.

9 This is from Tzara's essay 'Pierra Reverdy *"Le Voleur de Talan"* ', originally published in *Dada 4 et 5*, Zurich, May 1919.

10 Tzara published a number of short articles on 'primitive art', including: 'Note sur l'art nègre', *Sic*, September–October 1917; 'Note sur la poésie nègre', *Sic*, November 1918; 'L'Art et l'Océanie', *Cahiers d'art*, 4, 1929. *Sic* was a radical Futurist journal published in Paris. An English translation of the two articles from it are in Tzara (1992).

11 The definition of 'Negro music' was very wide indeed. It included not only African and Black American music but even Australian Aboriginal music! Getting the fine details right was not a major Dadaist concern.

12 For a picture of one of Janco's 'Negro Masks', see Maurer (1984, p. 537). Or should you be visiting Paris take a look in person at the *Musée National d'Art Moderne*, which is housed in the *Georges Pompidou Centre National d'Art et de Culture*.

13 Unlike the Dadaist group in Zurich, the Berlin Dadists *were* explicitly connected with radical politics. This fact has more to do with the general political culture of Berlin at the time than with the specific nature of Dada. A useful

short discussion of the cultural politics of Berlin Dadaists is contained in Lewis (1990, pp. 7–11).

14 Quoted in Maurer (1984, pp. 578 and 580).

15 Man Ray, the American painter, photographer and film-maker, was one of the founders of the New York Dada movement. He worked in Paris in the 1920s and 1930s and had a long association with Surrealism.

16 Quoted in Maurer (1984, p. 584).

17 James Clifford has provided some insightful discussions of the links between ethnography and Surrealism in France. See Clifford (1988a and 1988b).

18 Anyone interested in seriously exploring the encounters/relationships between Surrealism and Primitivism would do well to begin with Maurer (1984 or 1969).

19 Quoted in Short (1991, p. 303).

20 This turned out not to be a particularly good idea: 'a series of disturbing incidents, such as the attempted mass suicide of a whole group of them while in a hypnotic trance, led to the abandonment of these experiments' (Ades, 1981, p. 123).

21 Pictures of 'Augustine' which appeared in issue no. 11 of *La Révolution Surrealiste* are reproduced in Fer (1993, p. 215).

22 It should be mentioned that there were, in fact, a number of women artists involved in the Surrealist movement: Dorothea Tanning, Meret Oppenheim, Leonardo Carrington, Dora Maar, Leonor Fini, Frida Kahlo, Remedios Varo, Toyen and others. However, their contribution has been almost totally excluded from studies of Surrealism and authoritative histories of twentieth-century art. For an attempt to set this history right, see Chadwick (1985); see also Suleiman (1990).

23 See Yau (1990) and Mosquera (1992) on Lam's stepchild status in the history of modern art.

24 Later in life (by the 1950s) Breton realized, in despair, that the West was not likely to rediscover/re-create the kind of spiritual power and integrity that is (apparently) characteristic of 'Primitive' societies. Thus, he 'ultimately counseled a return to early European roots' (Maurer, 1984, p. 584).

25 Written by Glenn Jordan, November 1993.

26 Quoted in Arts Council of Great Britain (1974, p. 12).

27 See the debate between Georg Lukács and Ernst Bloch, in Taylor (1980, pp. 16–59).

28 Quoted in Gordon (1987, p. 13).

29 There are numerous other examples in various histories and catalogues showing the influence on German Expressionist art of African and Oceanic wood-carving and sculpture. The following are some of those included in Rubin (1984):

1 Karl Schmidt-Rottluff. *Still Life with Negro Sculpture*. 1913. Oil on canvas. 29"× 26"(73 × 66 cm). Museum Ludwig, Cologne (p. 391).

2 Karl Schmidt-Rottluff. *Three Kings*. 1917. Woodcut. 19.5"× 15.5"(50 × 39 cm). Museum of Modern Art, New York City (p. 395).

3 Karl Schmidt-Rottluff. *Blue-Red Head (Fear)*. 1917. Painted wood. 12" (30 cm) high. Brücke-Museum, Berlin (p. 396).

4 Karl Schmidt-Rottluff. *Four Evangelists: Matthew, Mark, Luke and John.* 1912. Oil over brass relief, each panel 16.75"× 13"(42.5 × 33 cm). Brücke-Museum, Berlin.

5 Max Pechstein. Sculpture. 1919. Wood. Whereabouts unknown (p. 398).

6 Ernst Ludwig Kirchner. *Girl under Japanese Umbrella.* 1909. Oil on canvas. 36"× 31.5"(90 × 80 cm). Kunstsammlung Nordrhein-Westfahlen, Düsseldorf (p. 370).

7 Ernst Ludwig Kirchner. *Bathers in a Room.* 1909, repainted 1920. Oil on canvas. 59.5"× 78"(151 × 198 cm). Saarland-Museum, Saarbrücken (p. 371).

8 Eric Heckel. *Girl with Pineapple.* 1910. Oil on canvas. 31.5"×17.5" Whereabouts unknown (p. 372).

30 Useful discussions of this topic are contained in Varnedoe (1984c) and Cooke (1991).

Chapter 11: Dialogues: Race and the Cultural Politics of the Avant-garde

1 A few examples are mentioned in Price (1989). Perhaps the best examples are Sally Price's own work on the arts of the maroons of Surinam. See Sally and Richard Price (1981).

2 This, some readers will recognize, is a *teleological conception of history.* Aside from a few rather minor points, Hegel, the Grand Master of teleological conceptions of World History, would be well pleased.

3 We are not claiming that this is *all* modernism is. It is surely also a history of cross-cultural influences, artistic innovation, stylistic changes and so on.

4 Breton's *Second Manifesto of Surrealism* is reproduced, along with a number of other key Surrealist writings, in Maurice Nadeau's classic two-volume study *Histoire du surréalisme, documents surréalistes* (Paris: Editions du Seuil, 1948). Nadeau (1973), an abridged, English translation of the 1948 study, contains extracts from the *Second Manifesto.*

5 That is, Wilfredo Lam would be 'Black' in those countries such as the USA that do not bother with fine distinctions when it comes to matters of race. His mother was Afro-Cuban, his father was Chinese. Lam's career and his position in the history of modern art are very interesting topics. See Yau (1990) and Mosquera (1992).

Lam was a serious, intellectual, politically engaged artist, influenced by Marxism, Surrealism, Négritude and other major streams of twentieth-century thought. (A selection of his paintings and drawings appears in Césaire, 1983.) We use Lam's painting *The Jungle* deliberately, without at first calling attention to the fact that he was 'Black', to underscore the point that we are not talking about the race of the artist but the racial imagery she/he employs.

Chapter 12: Encounters: Postcolonial Artists and the Art Establishment

1 The questions in the 'interview' below are ours. The answers are from an article published by Guy Brett in the Spring 1992 issue of *Third Text*. (This was a special issue of the journal, in English and Dutch, on cultural identity.)

2 The relevant literature is voluminous, as one would expect. See, for example: Lambert (1981); Spalding (1986); Lucie-Smith (1984).

3 See Araeen (1989b, p. 23). Also see the excellent article on Souza in *Third Text* by the renowned Indian art historian and critic Geeta Kapur (1989).

4 In Britain, the term 'Asian' refers to people from the Indian sub-continent and their descendants – Pakistanis, Indians, Bangladeshis, etc. In North America, 'Asian' generally refers to people from the Far East and their descendants, that is, Chinese, Japanese, Vietnamese and so on. The British usage is employed in this book.

5 Essays and interviews on the achievements and struggles of these and other Artists of Colour in Britain are included in *The Other Story* catalogue and the Autumn/Winter 1989 issue of *Third Text* (special supplement to the exhibition). They are also routinely included in ordinary issues of *Third Text*.

6 Avinash's wife, whom he had recently married, had just received a scholarship (in 1955) to the Central School of the Arts. Not wishing to be separated, he followed her to Britain.

7 From Cecil McCartney, 'Chandra at the Whitla', *Gown*, Belfast, 18 October 1963. Quoted in Araeen (1989b, p. 27).

8 These examples are, of course, fictitious.

9 Kipling's poem continues:

> *Till Earth and Sky stand presently at God's great judgement seat:*
> *But there is neither East nor West, Border, nor Breed nor Birth,*
> *When two strong men stand face to face, though they come from the ends of the*
> *earth.*

However, do not let this liberal gesture fool you: Kipling was most assuredly a colonialist and racist. Here he is at his best:

> *Take up the White Man's burden –*
> *Send forth the best ye breed –*
> *Go, bind your sons to exile*
> *To serve your captives' need;*
> *To wait, in heavy harness,*
> *On fluttered folk and wild –*
> *Your new-caught, sullen peoples,*
> *Half devil and half child.—*

Kipling originally published *The White Man's Burden* in 1899. Extracts from it have been reproduced in various sources, including Fryer (1984, p. 187).

10 The classic study of this phenomenon – the construction of The East in Western imagination – is Edward Said's *Orientalism*, which was published in 1978.

More recently, there have been some other very useful studies. See, for example, Kabbani (1988) and Inden (1990).

11 Quoted in Araeen (1989b, p. 32).

12 It also sometimes refers to the art of smaller, lower-status nations and cultures of Europe: Wales, Ireland, Bavaria, Brittany, Catalonia, Lithuania . . .

13 In the early 1980s Aubrey Williams produced a series of paintings inspired by the music of the twentieth-century Russian composer Dmitri Shostakovich. The prize-winning series includes: *Portrait of Shostakovich* 1980 (oil on canvas, 46 × 61 cm), *First Symphony, Opus 10* 1981 (oil on canvas, 163 × 264 cm) and *Eleventh Symphony, Opus 103* 1981 (oil on canvas 155 × 264 cm). Williams views Shostakovich as a kindred spirit: 'My work on the music of Shostakovich was not due to my discovery of something new in Shostakovich's music. It was more a realisation of common concerns and perceptions in our work. I have always found myself in sympathy with his vision, which became a source of inspiration for me [T]here are parallel anxieties involved in both of our work' (Araeen, 1987–8).

14 Among Aubrey Williams's central concerns are environmental catastrophe and the threat of nuclear destruction. In the following quotation, he is talking about a tragedy, the horrific damage we moderns have done to the ecosystem: 'I know that the sea is now 38% polluted. We live off the sea and we can't turn the clock back. It's getting worse every day. Our resources of oxygen are shrinking, and it can't be reproduced. We have also punctured the last source of oxygen which is the South American Selvas by building that stupid road through the Amazonas. We have done colossal ecological damage: turtles are laying their eggs in the sea; whales are beaching themselves everywhere. Pollution is beyond our ability to reverse. Cosmic rays bombardment is growing and we have no shield against its harmful effects; so leukemia will be like the common cold. Already we have respirators in the biggest cities of the world. And we are only waiting to see the first one put down here: push in 25p and you get ten breaths of fresh oxygen' (Araeen, 1987–8, p. 51). Williams sees certain parallels with the decline of Mayan civilization. Thus he turns to pre-Colombian Mayan civilization not just for reasons of identity but because, as a society that basically self-destructed through ecological disaster, they can provide us with valuable lessons – if we bother to listen.

15 Some other dilemmas of Artists of Colour are discussed in the following chapter.

16 Glenn Jordan has pursued this topic in some detail elsewhere. See 'On Ethnography in an Intertextual Situation: Reading Narratives or Deconstructing Discourse?' (1991).

17 A useful, brief introduction to the New Art History is Rees and Borzello (1986). This anthology includes a range of positions, from enthusiast to sceptic.

Chapter 14: Racism, Culture and Identity: Australian Aboriginal Writings

1 This poem is spoken by Uncle Worru in Davis's play 'The Dreamers' (Davis, 1983). It is published as a poem in Davis (1988).

2 This passage is from E. C. T. Hornblow, *People and Children of Wonderful Lands* (Grant Education, 1953, p. 138), quoted in Lippmann (1981, p. 217).

3 From Hornblow, *People and Children of Wonderful Lands*, quoted in Lippmann (1981, p. 215).

4 From *Oxford Junior Encyclopedia*, 1952 edition, p. 46, quoted in Lippmann (1981, p. 215).

5 See, for example, discussion of the Australian bicentennial in Rutherford (1988). This volume also includes a useful bibliography of Aboriginal writing (as does Davis and Hodge, 1985).

6 For background material on contemporary Aboriginal life and political struggle, see Gilbert (1978), and Lippmann (1981).

7 For Aboriginal views of the role of writing in the struggle for self-determination, see Davis and Hodge (1985).

8 Writers of Aboriginal descent have increasingly assumed Aboriginal, rather than English, names. This is an instance of the cultural politics of naming, discussed in our earlier treatment of racism and language as well as in a later section of the present chapter.

9 It seems that traditional Aboriginal stories and poems are being published with ever-increasing rapidity. There are a number of sources for such publications. The interested reader could start with the publications list of the Australian Institute for Aboriginal Studies in Canberra, which began as a centre for anthropological research and publication but now regularly publishes material prepared by Aborigines themselves. Two examples of transcribed and translated Aboriginal texts are Roe (1985), and Roughsey (1984). Also see Gilbert (1988b).

10 Australian Aboriginal writing has been published by both small presses and mainstream publishers, but in both cases usually with assistance from central and state governments.

11 A few texts, for example Mudroogoo Narogin's (Colin Johnson's) *Doctor Wooreddy's Prescription for Enduring the End of the World* (1983) are concerned exclusively with Aboriginal history. This novel tells the story of the extermination of the Aboriginal people of Tasmania from an Aboriginal perspective in a way that throws light on social relations of the present.

12 Mudroogoo Narogin's (Colin Johnson's) first novel was *Wild Cat Falling* (1965), the story of a profoundly alienated Aboriginal youth, a 'cool cat' of the early 1960s, a product of a racist society and Aboriginal 'fringe' dwellings. Other publications by Johnson include *Doctor Wooreddy's Prescription for the Ending of the World* (1983) and *The Song Circle of Jacky and Selected Poems* (1986).

13 This discussion is part of a larger study (in progress) of Australian Aboriginal writing, which focuses, in particular, on the relationship between culture, history, 'race' and identity in novels, short stories and plays. One of our intentions is to foreground Aboriginal voices, voices long marginalized and silenced by anthopologists, travel writers and other mediators between 'First World' and 'Third World' cultures.

14 The Gorgon, a figure from Greek mythology, had a face so ugly that it turned those who looked at it to stone.

15 See, for example, Jack Davis's plays 'Kullark' and 'The Dreamers' (1983).

16 A recurrent theme in Daisy's story (pp. 325–58) is White cruelty and deceit.

17 Although she does not speak her native language with her immediate family, Daisy clearly remembers it. On one occasion Sally is startled to hear her grandmother speaking 'Blackfella' with her brother Arthur.

18 A 'Corroboree' is a traditional Aboriginal dance. Held at night, 'Corroborees' are important rituals of traditional Aboriginal groups. They are lively festivals of dance held in celebration of some achievement or event.

19 At least one member of Alan's group is not fully on board as regards their newly found Aboriginal pride and militancy. In response to Kangawara's comment, Tom, who is some years older than the others, says, 'You've learnt it all off by heart, haven't you?' (p. 123). Tom thinks the whole thing is rather ridiculous.

20 Thatcherism is a classic case of a hegemonic politics. It was grounded in popular, commonsense notions of 'Britishness', 'The Family', responsibility, respectability and so on. And it spoke – seemingly spoke back – to 'the people' in a language that 'we' could all understand. (See Hall, 1988, and Fairclough, 1989).

Chapter 15: The Postmodern Challenge/Challenging Postmodernism: A Cultural Politics for Today

1 King (1985, p. 21).

2 See the accompanying catalogue to this exhibition, *The Edwardian Era* (Beckett and Cherry, 1987).

3 For details of the debate around 'Black art', see Araeen (1987); Araeen and Chambers (1988–9); Bowling (1988–9); Chambers (1991b); Gilroy (1988–9); Maharaj (1991); Mercer (1990); Piper (1987–8); Roberts (1987); and Tawadros (1989). The journal *Third Text* is a major site of this debate.

Bibliography

Abusch, Alexander 1975: *Humanismus und Realismus in der Literatur*. Leipzig: Reclam.

Ades, Dawn 1981: 'Dada and Surrealism'. In Nikos Stangos (ed.), *Concepts of Modern Art*, London: Thames and Hudson, 110–37.

—— 1986: 'Reviewing art history.' In Rees and Borzello (1986), 11–18.

Adorno, Theodor, Walter Benjamin, Ernst Bloch, Bertolt Brecht and Georg Lukács 1980: *Aesthetics and Politics*. London and New York: Verso.

Alexandrian, Sarane 1970: *Surrealist Art*. London: Thames and Hudson (originally published 1969 as *L'Art surréaliste*.)

Alther, Lisa 1977: *Kinflicks*. Harmondsworth: Penguin.

Althusser, Louis 1971: 'Ideology and ideological state apparatuses: notes towards an investigation'. In *Lenin and Philosophy and Other Essays*, London: New Left Books.

Araeen, Rasheed 1984: *Making Myself Visible*. London: Kala Press.

—— 1987: 'From primitivism to ethnic arts'. *Third Text*, no. 1 (Autumn 1987), 6–25. Reprinted in Hiller (1991), 158–82.

—— 1987–8: 'Conversation with Aubrey Williams' *Third Text*, no. 2, 25–52.

—— 1988: 'Conversation with Avinash Chandra'. *Third Text*, nos 3/4, 69–95.

—— 1989: *The Other Story: Afro-Asian Artists in Post-War Britain*. London: South Bank Centre.

—— 1989a: 'Introduction: When chickens come home to roost'. In Araeen (1989), 9–15.

—— 1989b: 'In the citadel of Modernism'. In Araeen (1989), 16–49.

—— 1989c: 'Confronting the system'. In Araeen (1989), 64–81.

—— 1989d: 'Recovering cultural metaphors'. In Araeen (1989), 82–104.

—— 1989e: 'Postscript'. In Araeen (1989), 105–6.

—— 1991: 'The other immigrant: the experiences and achievements of Afro-Asian artists in the Metropolis'. *Third Text*, no. 15, 17–28.

—— 1992: 'How I discovered my Oriental soul in the wilderness of the West'. *Third Text*, no. 18, 85–102.

Araeen, Rasheed and Eddie Chambers 1988–9: 'Black art: a discussion'. *Third Text*, no. 5, 51–77.

Araeen, Rasheed et al. 1987: 'Editorial: Why *Third Text*?' *Third Text*, no. 1, 3–5.

Arnold, Matthew 1869: *Culture and Anarchy*. London: Smith, Elder.

Arp, Hans (also known as Jean Arp) 1992: 'Note on art – H. Arp'. English translation in Tzara (1992), 59–60. Originally published in *Dada* 2, Zurich, December 1917.

Arp, Jean (also known as Hans Arp) 1970: *Arp on Arp: Poems, Essays, Memories*, ed. Marcel Jean. New York: Viking Press.

Arts Council of Great Britain 1974: *Edvard Munch, 1863–1944*. London: Arts Council of Great Britain.

—— 1989: *Towards Cultural Diversity*. London: Arts Council of Great Britain.

—— 1991: *Annual Report, 1990–91*. London: Arts Council of Great Britain.

Asante, Moleti Kete 1987: *The Afrocentric Idea*. Philadelphia: Temple University Press.

Ashraf, Mary 1979: *Introduction to Working Class Literature in Great Britain*, 2 vols. Berlin: Humboldt University.

Asian Women Writers' Workshop 1988: *Right of Way*. London: The Women's Press.

Bahr, Hermann 1982: 'Expressionism'. In Francis Frascina and Charles Harrison (eds), *Modern Art and Modernism: A Critical Anthology*, London: Paul Chapman 165–9.

Baldwin, James 1964: *Notes of a Native Son*. London: Michael Joseph.

Bandaranayake, Senake 1987–8: 'Ivan Peries (Paintings 1939–1969): the predicament of the bourgeois artist in the societies of the Third World'. *Third Text*, no. 2, 77–92.

Barker, Martin 1981: *The New Racism: Conservatives and the Ideology of the Tribe*. London: Junction Books.

Barnes, Ron 1974: *A Licence to Live: Scenes from Post-war Working Life in Hackney*. London: Centreprise.

Barr, Alfred H. Jr 1946: *Picasso: Fifty Years of His Art*. New York: Museum of Modern Art.

Barrett, Michèle 1980: *Women's Oppression Today*. London: Verso.

—— 1982: 'Feminism and the definition of cultural politics'. In Rosalind Brunt and Caroline Rowan (eds), *Feminism, Culture and Politics*, London: Lawrence & Wishart, 37–58.

—— and Anne Phillips 1992: *Destabilizing Theory*. Cambridge: Polity Press.

Batchelor, David 1993: ' "This liberty and this order": art in France after the First World War'. In Briony Fer, David Batchelor and Paul Wood (eds), *Realism, Rationalism, Surrealism: Art between the Wars*, New Haven and London: Yale University Press in association with the Open University, 3–86.

Bates, Ralph 1934: *Lean Men*. London: Peter Davies.

Batsleer, Janet, Tony Davies, Rebecca O'Rourke and Chris Weedon 1985: *Rewriting English: The Cultural Politics of Gender and Class*. London and New York: Methuen.

Becher, Johannes R. 1948–50: '*Volks eigen*'. Berlin: Nova Records, 1971.

—— 1972: *Als namensloses Lied. Gedichte*. Leipzig: Reclam.

Beckett, Jane and Deborah Cherry (eds), 1987: *The Edwardian Era* (exhibition catalogue). London: Phaidon Press and Barbican Art Gallery.

Behr, Shulamith, David Fanning and Douglas Jarman (eds) 1993: *Expressionism Reassessed*. Manchester: Manchester University Press.

Behr, Shulamith, David Fanning and Douglas Jarman 1993a: 'Introduction: Expressionism reassessed'. In Behr et al. (1993), 1–7.

Berg, Knut 1974: 'Edvard Munch (1863–1944)'. In Arts Council of Great Britain (1974), 9–11.

Berger, John 1972: *Ways of Seeing*. London: BBC and Penguin Books.

Betterton, Rosemary (ed.) 1987: *Looking On: Images of Feminity in the Visual Arts and Media*. London: Pandora.

Blain, Virginia, Patricia Clements and Isobel Grundy 1990: *Feminist Companion to Literature: Women Writers from the Middle Ages to the Present*. London: Batsford.

Bloom, Leonard 1971: *The Psychology of Race Relations*. London: Allen & Unwin.

—— 1972: 'Introduction'. In Kenneth Little, *Negroes in Britain*, 2nd edn. London: Routledge & Kegan Paul.

Boden, Frederic 1927: *Pithead Poems*. London: Dent.

—— 1929: *Out of the Coalfields*. London: Dent.

—— 1933: *Miner*. London: Dent.

—— 1934: *Flo*. London: Dent.

—— 1935: *A Derbyshire Tragedy*. London: Dent.

Bowling, Frank 1988–9: 'Formalist art and the black experience'. *Third Text*, no. 5, 78–82.

Bowyer, Fran with Bethan Eames, Mali Evans, Tom Barrance and June Gridley 1993: *The Time of My Life: A BBC Wales Series on Welsh Women's Lives Produced by Red Flannel and Broadcast on BBC Wales on 1* (booklet). Cardiff: BBC Cymru Wales Education.

Boyce, Sonia and John Roberts 1987: 'Sonia Boyce in conversation with John Roberts'. *Third Text*, no. 1, 55–64.

Bradshaw, Jan and Mary Hemming (eds) 1985: *Girls Next Door*. London: The Women's Press.

Braxton, Joanne M. and Andree Nicola McLaughlin (eds) 1990: *Wild Women in the Whirlwind: Afro-American Culture and the Contemporary Literary Renaissance*. London: Serpent's Tail.

Brecht, Bertold 1964: *Brecht on Theatre*, trans. John Willett. London: Eyre Methuen.

—— 1977: 'Against Georg Lukács'. In Theodor Adorno et al., *Aesthetics and Politics*, London and New York: Verso, 1980, 68–85.

—— 1978: *On Theatre: The Development of an Aesthetic*, ed. and trans. John Willett. London: Eyre Methuen.

Breton, André 1937: *L'Amour fou*. Paris: Gallimard.

—— 1969: *Manifestos of Surrealism*, trans. from the French by R. Seaver and H. R. Lane. Ann Arbor, Mich.: University of Michigan Press.

—— 1972: *Surrealism and Painting*, trans. Simon Watson Taylor. London: MacDonald.

—— and André Masson 1948: *Martinique, charmeuse de serpents*. Paris: Sagittaire.

Brett, Guy 1991: 'Unofficial versions'. In Hiller (1991), 113–36.

—— 1992: 'The limits of imperviousness'. *Third Text*, no. 18, 51–64.

Broverman et al. 1972: 'Sex role stereotypes: a current appraisal'. *Journal of Social Issues*, 28, 59–78.

Browder, Clifford 1967: *André Breton: Arbiter of Surrealism*. Geneva: Droz.

Bryan, Beverley, Stella Dadzie and Suzanne Scafe 1985: *The Heart of the Race*. London: Virago.

Bullivant, Keith (ed.) 1977: *Culture and Society in the Weimar Republic*. Manchester: Manchester University Press.

Burchard, Przemyslaw 1990: *Die Australier: Geschichte, Konflikte, Brauche, Sitten*. Leipzig: Urania-Verlag.

Carby, Hazel 1982. 'White women listen! Black feminism and the boundaries of sisterhood'. In Centre for Contemporary Cultural Studies (1982a), 212–35.

—— 1990: *Reconstructing Womanhood: The Emergence of the Afro-American Woman Novelist*. Oxford: Oxford University Press.

Centre for Contemporary Cultural Studies (ed.) 1982a: *The Empire Strikes Back*. London: Hutchinson.

—— 1982b: *Making Histories: Studies in History-writing and Politics*. London: Hutchinson.

Centreprise 1975: *Annual Report, 1975*. London: Centreprise.

—— 1992: *Centreprise Publishing Catalogue*. London: Centreprise.

Césaire, Aimé 1972: *Discourse on Colonialism* trans. John Pinkham. New York: Monthly Review Press (originally published in 1955 as *Discours sur le colonialisme* by Presence Africaine).

—— 1983: *Aimé Césaire: The Collected Poetry*, trans. Clayton Eshleman and Annette Smith. Berkeley, Cal. and London: University of California Press, 1983.

Chadwick, Whitney 1985: *Women Artists and the Surrealist Movement*. Boston, Mass.: Little, Brown.

Chambers, Eddie 1991a: 'History and identity'. *Third Text*, no. 15, 63.

—— 1991b: 'Black art now'. *Third Text*, no. 15, 91–5.

Chaucer, Geoffrey 1951: *The Canterbury Tales*, trans. Nevill Coghill. Harmondsworth: Penguin.

Checketts, Linda 1991: 'British art in a century of immigration'. *Third Text*, no. 15, 5–10.

Chesneaux, Jean 1978: *Pasts and Futures – or, What Is History For?*, trans. from the French (*Du passe faisons table rase?*) Schofield Coryell. London: Thames & Hudson.

Christian, Barbara 1980: *Black Women Novelists: The Development of a Tradition, 1892–1976*. Westport, Conn.: Greenwood Press.

—— 1990: ' "Somebody forgot to tell somebody something": African-American women's historical novels'. In Braxton and McLaughlin (1990), 326–41.

Cixous, Hélène 1984: *Writing the Feminine*. Lincoln, Neb.: University of Nebraska Press.

—— 1991: *A Politics of Writing*. London: Routledge.

—— 1992: *Reading and Teaching: 'Body and Text'*. Hemel Hempstead, Herts.: Harvester.

Clark, Jon, Margot Heinemann, David Margolies and Carole Snee (eds) 1979: *Culture and Crisis in the Thirties*. London: Lawrence & Wishart.

Clark, Kenneth 1969: *Civilisation: A Personal View*. London: BBC.

Clifford, James. 1988a: 'On Ethnographic Surrealism'. In *The Predicament of Culture: Twentieth-century Ethnography, Literature and Art*, Cambridge, Mass., and London: Harvard University Press, 117–51.

Clifford, James 1988b: 'Tell me about your trip: Michel Leiris'. In *The Predicament of Culture*, Cambridge, Mass., and London: Harvard University Press, 165–74.

—— 1988c: 'Histories of the tribal and the modern'. In *The Predicament of Culture*, Cambridge, Mass., and London: Harvard University Press, 189–214.

—— 1988d: 'On collecting art and culture'. In *The Predicament of Culture*, Cambridge, Mass., and London: Harvard University Press, 215–51.

Collins, Sydney 1957a: 'A negro community in Wales'. In *Coloured Minorities in Britain*, London: Lutterworth Press.

—— 1957b: 'An Arab community in Wales'. In *Coloured Minorities in Britain*, London: Lutterworth Press.

Connor, Stephen 1989: *Postmodern Culture*. Oxford: Basil Blackwell.

Cooke, Lynne 1991: 'The resurgence of the night-mind: Primitivist revivals in recent art'. In Susan Hiller (ed.), *The Myth of Primitivism: Perspectives on Art*, London and New York: Routledge, 137–57.

Cordell, Alexander 1986: *Tales from Tiger Bay*. Abergavenny, Gwent: Blorenge Books.

Coutts-Smith, Kenneth 1991: 'Some general observations on the problem of cultural colonialism'. In Hiller (1991), 14–31.

Coward, Rosalind 1984: *Female Desire*. London: Paladin.

Da Choong, Olivette Cole Wilson, Bernadine Evaristo and Gabriela Pearse (eds). 1987: *Black Womantalk Poetry*. London: Black Womantalk.

Daly, Mary 1979: *Gyn/Ecology*. London: Women's Press.

Daniels, Therese and Jane Gerson (eds) 1989: *The Colour Black: Black Images in British Television*. London: BFI Publishing.

Dates, Jannette I. and William Barlow (eds) 1990: *Split Image: African Americans in the Mass Media*. Washington, D. C.: Howard University Press.

Daunton, Maurice J. 1977: *Coal Metropolis: Cardiff, 1870–1914*. Leicester: Leicester University Press.

Davies, John 1981: *Cardiff and the Marquesses of Bute*. Cardiff: University of Wales Press.

Davies, Tom 1989: *Fire in the Bay*. London: Collins.

Davin, Anna 1972: 'Women and history'. In Micheline Wandor (ed.), *The Body Politic: Writings from the Women's Liberation Movement in Britain, 1969–72*. London: Stage 1.

Davis, Jack 1988: *The First-born and Other Poems*. Melbourne: J. M. Dent (first published 1970).

—— 1983: *'Kullark' and 'The Dreamers'* (two plays). Sydney: Currency Press.

—— and Bob Hodge 1985: *Aboriginal Writing Today*. Canberra: Australian Institute of Aboriginal Studies.

Diop, Cheikh Anta 1974: *The African Origin of Civilization: Myth or Reality*. New York: Lawrence Hill.

—— 1991: *Civilization or Barbarism: An Authentic Anthropology*. New York: Lawrence Hill.

Dixon, Thomas 1905: *The Clansman: An Historical Romance of the Ku Klux Klan*. London: William Heinemann.

Docherty, Thomas (ed.) 1993: *Postmodernism: A Reader*. Hemel Hempstead, Herts.: Harvester.

Drake, St Clair 1954: *Values, Social Structure, and Race Relations in the British Isles*, PhD thesis, Department of Anthropology, University of Chicago.

Drake, St Clair 1955: 'The "colour problem" in Britain: a study in social definitions'. *Sociological Review* (new series), 197–217.

—— 1987: *Black Folk Here and There, Volume One*. Los Angeles, Cal.: Center for Afro-American Studies, University of California, Los Angeles.

—— 1990: *Black Folk Here and There, vol. 2*. Los Angeles, Cal.: Center for Afro-American Studies, University of California at Los Angeles.

Dreyfus, Hubert and Paul Rabinow 1982: *Michel Foucault: Beyond Structuralism and Hermeneutics*. Chicago: University of Chicago Press.

DuBois, W.E.B. 1961: *The Souls of Black Folk*. New York: Fawcett (first published 1903).

Durham, Jimmie 1991: 'The search for virginity'. In Hiller (1991), 286–91.

Dyson, Michael E. 1993: 'Be like Mike? Michael Jordan and the pedagogy of desire'. *Cultural Studies*, 7 (1), 64–72.

Eastman, Max 1934: *Artists in Uniform*. London: Allen & Unwin.

Edgar Heap of Birds 1991: 'Born from sharp rocks'. In Hiller (1991), 338–44.

Ernst, Max 1948: *Beyond Painting*, trans. Dorothea Tanning. New York: Wittenborn & Schultz.

Evans, Catherine, Steve Dodsworth and Julie Barnett 1983: *Below the Bridge: A Photo-historical Survey of Cardiff's Docklands to 1983*. Cardiff: National Museum of Wales (Amgueddfa Genedlaethol Cymru).

Evans, Neil 1980: 'The South Wales race riots of 1919'. *Llafur: Journal of the Society for the Study of Welsh Labour History*, 3 (1), 5–29.

—— 1983: 'The South Wales race riots of 1919: a documentary postscript'. *Llafur*, 3 (4), 76–87.

—— 1985: 'Regulating the reserve army: Arabs, blacks and the local state in Cardiff, 1919–1945'. *Immigrants and Minorities*, 4 (2), 68–115.

Fabian, Johannes 1983: *Time and the Other: How Anthropology Makes its Object*. New York: Columbia University Press.

Fairclough, Norman 1989: 'The discourse of Thatcherism', in *Language and Power*, London and New York: Longman, 169–96.

Fanon, Frantz 1967: *The Wretched of the Earth*, trans. Constance Farrington. Harmondsworth: Penguin Books. Originally published 1961 as *Les damnés de la terre*.

—— 1968: *Black Skin, White Masks*. trans. Charles Lam Markmann. New York: Grove Press. Originally published 1952 as *Peau noire, masques blancs*.

Farrar, Dean 1868: *Essays on Liberal Education*. London: Macmillan.

Feest, Christian F. 1984: 'From North America'. In Rubin (1984), 85–97.

Feminist Review 1979 onwards. London.

Fer, Briony 1993: 'Surrealism, myth and psychoanalysis'. In Briony Fer, David Batchelor and Paul Wood (eds), *Realism, Rationalism, Surrealism: Art Between the Wars*, New Haven, Conn., and London: Yale University Press in association with the Open University.

Fisher, Jean 1989: 'Editorial'. *Third Text* 8/9 3–4. (Special issue: 'The other story: AfroAsian artists in postwar Britain'.)

Fletcher, Muriel 1930: *Report on an Investigation into the Colour Problem in Liverpool and Other Ports*. Liverpool: Association for the Welfare of Half-caste Children.

Fondane, Benjamin 1929: 'Brancusi'. *Cahiers de l'étoile*, 708–25.

Foreman, Ann 1977: *Feminity as Alienation: Women and the Family in Marxism and Psychoanalysis*. London: Pluto Press.

Foster, Hal 1985: 'The "primitive" unconscious of modern art, or white skin black masks'. In *Recodings: Art, Spectacle, Cultural Politics*, Seattle, Washington: Bay Press, 181–208.

Foucault, Michel 1972: *The Archaeology of Knowledge*. London: Tavistock Books.

—— 1978: *I, Pierre Riviere*. Harmondsworth: Penguin.

—— 1979a: *Discipline and Punish*. Harmondsworth: Penguin.

—— 1979b: 'What is an author?' *Screen*, 20 (1), 13–33.

—— 1980a: 'Two lectures'. In *Power/Knowledge: Selected Interviews and Other Writings, 1972–1977*, ed. Colin Gordon, New York: Pantheon Books, 78–108.

—— 1980b: 'Truth and power'. In *Power/Knowledge: Selected Interviews and Other Writings, 1972–1977*, ed. Colin Gordon, New York: Pantheon Books, 109–33.

—— 1980c: 'The history of sexuality'. In *Power/Knowledge: Selected Interviews and Other Writings, 1972–1977*, ed. Colin Gordon, New York: Pantheon Books, 183–93.

—— 1981: *The History of Sexuality*, vol. 1: *An Introduction*. Harmondsworth: Penguin.

—— 1986: *The History of Sexuality*, vol. 2: *The Use of Pleasure*. Harmondsworth: Penguin.

—— 1988: *The History of Sexuality*, vol. 3: *The Care of the Self*. Harmondsworth: Penguin.

Fredrickson, George M. 1972: 'The negro as beast: southern negrophobia at the turn of the century'. In *The Black Image in the White Mind: The Debate on Afro-American Character and Destiny, 1817–1914*. New York: Harper & Row, 256–82.

French, Marilyn 1978: *The Women's Room*. London: Sphere.

Freud, Sigmund 1950: *Totem and Taboo*. New York: W. W. Norton.

Fry, Roger 1961: *Vision and Design*. Harmondsworth, Penguin. (First published 1920.)

Fryer, Peter 1984: *Staying Power: The History of Black People in Britain*. London and Sydney: Pluto Press.

Fuller, Vernella, 1992: *Going Back Home*. London: The Women's Press.

Gärtner, Hannelore 1979: *Die Künste in der Deutschen Demokratischen Republik*. Berlin: Henschelverlag.

Gates, Henry Louis (ed.) 1990: *Reading Black, Reading Feminism*. New York and London: Meridian.

Geist, Sidney 1983: *Brancusi: A Study of the Sculpture*. New York: Hacker.

—— 1984: 'Brancusi'. In Rubin (1984), 345–67.

Giddens, Anthony and David Held (eds) 1982: *Classes, Power and Conflict: Classical and Contemporary Debates*. London: Macmillan.

 Gilbert, Kevin 1978: *Living Black*. Ringwood: Penguin Books Australia.

—— 1988a: *The Cherry Pickers*. Canberra, Australia: Burrambinga Books.

—— (ed.) 1988b: *Inside Black Australia: An Anthology of Aboriginal Poetry*. Ringwood, Victoria: Penguin with the assistance of the Literature Board of the Australia Council.

Gilman, Sander L. 1992: 'Black bodies, white bodies: toward an iconography of female sexuality in late nineteenth-century art, medicine and literature'. In

James Donald and Ali Rattansi (eds), *'Race', Culture and Difference*. London: Sage in association with the Open University.

Gilroy, Paul 1987: *There Ain't No Black in the Union Jack*. London: Unwin Hyman.

—— 1988–9: 'Cruciality and the frog's perspective'. *Third Text*, 5, 33–44.

Golding, John 1981: 'Cubism'. In Nikos Stangos (ed.), *Concepts of Modern Art*. London: Thames & Hudson, 50–78.

Goldwater, Robert. 1967: *Primitivism in Modern Art*. New York: Vintage Books (First published 1938.)

Gombrich, Sir E. H. 1962: *The Story of Art*. London: Phaidon Press.

—— 1971: *Meditations on a Hobby Horse*. London: Phaidon Press.

Gooding, Mel 1989: 'Frank Bowling: soundings towards the definition of an individual talent'. In Araeen (1989), 119–21.

Gordon, Donald E. 1984: 'German Expressionism'. In Rubin (1984), 369–403.

—— 1987: *Expressionism: Art and Idea*. New Haven, Conn., and London: Yale University Press.

Gorky, Maxim et al. 1977: *Soviet Writers Congress, 1934: The Debate on Socialist Realism and Modernism in the Soviet Union*. London: Lawrence & Wishart.

Gramsci, Antonio 1971: *Selections from the Prison Notebooks*. London: Lawrence & Wishart.

Gray, John (ed.) 1989: *Liberalism: Essays in Political Philosophy*. London: Routledge.

Greenwood, Walter 1933: *Love on the Dole*. London: Jonathan Cape.

—— 1934: *His Worship the Mayor*. London: Jonathan Cape.

Griffin, Susan 1982: *Made from This Earth*. London: The Women's Press.

—— 1984: *Women and Nature: The Roaring Inside Her*. London: The Women's Press.

Grossberg, Lawrence 1992: *'We gotta get out of this place': popular conservatism and postmodern culture*. New York and London: Routledge.

Gustav-Klaus, H. 1982: *The Socialist Novel in Britain*. Brighton, Sussex: Harvester.

Gutman, Herbert 1976: *The Black Family in Slavery and Freedom, 1750–1925*. New York: Random House.

Hager, Kurt 1982: *Beiträge zur Kulturpolitik. Reden und Aufsätze 1972–81*. Berlin: Dietz Verlag.

Hall, Catherine 1992: *White, Male and Middle Class: Explorations in Feminism and History*. Cambridge: Polity Press in association with Blackwell Publishers.

Hall, John A. 1988: *Liberalism*. London: Paladin.

Hall, Stuart 1986: 'On Postmodernism and articulation: an interview with Stuart Hall', ed. Larry Grossberg. *Journal of Communication Inquiry*, 10(2) (special issue on Stuart Hall).

—— 1988: *The Hard Road to Renewal: Thatcherism and the Crisis of the Left*. London and New York: Verso Books.

—— 1990: 'Cultural identity and diaspora'. In Jonathan Rutherford (ed.), *Identity: Community, Culture, Difference*. London: Lawrence & Wishart, 222–37.

—— Chas Critcher, Tony Jefferson, John Clarke and Brian Roberts 1978: *Policing the Crisis: Mugging, the State and Law and Order*. London: Macmillan.

Halward, Leslie 1936: *To Tea on Sunday*. London: Methuen.

Hamilton, George Heard 1987: *Painting and Sculpture in Europe, 1880–1940*. Harmondsworth, Penguin Books.

Harrison, Charles and Paul Wood (eds) 1992: *Art in Theory, 1900–1990: An Anthol-*

ogy of Changing Ideas. Oxford, England and Cambridge, Mass.: Blackwell Publishers.

Harrison, Charles, Francis Frascina and Gill Perry 1993: *Primitivism, Cubism, Abstraction: the early twentieth century.* New Haven, Conn., and London: Yale University Press in association with the Open University.

Hartsock, Nancy 1990: 'Foucault on power: a theory for women?' In Linda J. Nicholson (ed.), *Feminism/Postmodernism*, New York and London: Routledge, 157–75.

Haufe, Jochen (ed.) n.d.: *Du gefällst mir.* Cottbus, Germany: Bezirkskabinett für Kulturarbeit.

Herskovits, Melville J. 1958: *The Myth of the Negro Past.* Boston, Mass.: Beacon Press. (First published 1941.)

Heslop, Harold 1929: *The Gate of a Strange Field.* London: Bretano.

—— 1930: *Journey Beyond.* London: Harold Shaylor.

—— 1934: *Goaf.* London: Fortune Press.

—— 1934: *The Crime of Peter Ropner.* London: Fortune Press.

—— 1935: *Last Cage Down.* London: Wishart Books.

—— 1946: *The Earth Beneath.* London: Boardman.

Hewison, Robert 1987: *The Heritage Industry.* London: Methuen.

The Highway 1908 onwards: London: Workers' Educational Association.

Hill Collins, Patricia 1990: *Black Feminist Thought.* London: Unwin Hyman.

Hiller, Susan (ed.) 1991: *The Myth of Primitivism: Perspectives on Art.* London and New York: Routledge.

—— 1991a: 'Editor's Forward'. In Hiller (1991), 1–4.

—— 1991b: 'Editor's Introduction to Part I'. In Hiller (1991), 11–13.

—— 1991c: 'Editor's Introduction to Part II'. In Hiller (1991), 87–9.

—— 1991d: 'Editor's Introduction to Part III'. In Hiller (1991), 185–8.

—— 1991e: 'Editor's Introduction to Part IV'. In Hiller (1991), 283–5.

Holdyn, Robyn 1985: *Aborigines of Australia.* Hore, East Sussex: Wayland.

hooks, bell (Gloria Watkins) 1984: *Feminist Theory: From Margin To Center.* Boston, Mass.: South End Press.

—— 1986: *Ain't I a Woman: Black Women and Feminism.* London: Pluto. (First published 1983.)

—— 1989: *Talking Back: Thinking Feminist, Thinking Black.* Boston, Mass.: South End Press.

—— 1991: *Yearning: Race, Gender and Cultural Politics.* London: Turnaround.

—— 1992: *Black Looks: Race and Representation.* London: Turnaround.

Hume, David 1748: *Essays, Moral and Political and Literary* London: A. Millar: (First published 1741.)

Humphries, Stephen 1984: *Oral History: Recording Life Stories.* London: Inter-Action Inprint.

Hutcheon, Linda 1988: *The Poetics of Postmodernism.* London: Methuen.

Hyndman, H. M. and William Morris 1884: *A Summary of the Principles of Socialism.* London: Modern Press.

Inden, Ronald 1990: *Imagining India.* Oxford, England, and Cambridge, Mass.: Blackwell Publishers.

International Literature 1932–45. Moscow: International Union of Revolutionary Writers.

Irigaray, Luce 1985: *This Sex Which is Not One*, trans. Catherine Porter and Carolyn Burke. Ithaca, N. Y.: Cornell University Press.

Jacobs, Harriet 1987: *Incidents in the Life of a Slave Girl, Written by Herself*. Cambridge, Mass. and London: Harvard University Press. (First published 1861.)

Jacobus, Mary (ed.) 1976: *Women Writing and Writing About Women*. London: Croom Helm.

Jaggar, Alison 1983: *Feminist Politics and Human Nature*. Brighton: Harvester.

Jefferson, Thomas 1787: *Notes on the State of Virginia*. London: J. Stockdale.

Johansson, Sheila 1976: ' "Herstory" as history: a new field or another fad?'. In Berenice Carroll (ed.), *Liberating Women's History*, Urbana, Ill.: University of Illinois Press.

John, Erhard 1973: *Arbeiter und Kunst*. Berlin: Verlag Tribune.

Johnson, Colin (Mudroogoo Narogin) 1979: *Wild Cat Falling*. Sydney: Angus & Robertson. (First published 1965.)

—— 1979: *Long Live Sandawara*. Melbourne: Quartet Books.

—— 1983: *Doctor Wooreddy's Prescription for Enduring the End of the World*. Melbourne: Hyland House Publications.

—— 1986: *The Song Circle of Jacky and Selected Poems*. Melbourne: Hyland House.

Jones, Jack 1979: *Rivers out of Eden*. London: Pan Books. (First published 1951.)

Jones, Lewis 1937: *Cwmardy*. London: Lawrence & Wishart.

Jordan, Glenn 1988: 'Images of Tiger Bay: did Howard Spring tell the truth?'. *Llafur: Journal of Welsh Labour History*, 5 (1), 53–9.

—— 1991: 'On ethnography in an intertextual situation: reading narratives or deconstructing discourse?'. In Faye Harrison (ed.), *Decolonizing Anthropology*, Washington, D. C.: American Anthropological Association, 42–66.

Jordan, June 1993: *Technical Difficulties: Selected Political Essays*. London: Virago Press.

Jordan, Winthrop 1969: *White over Black: American Attitudes toward the Negro, 1550–1812*. Baltimore, Md: Penguin Books.

Joseph, Gloria I. 1990: 'Sojourner Truth: Archetypal Black Feminist'. In Braxton and McLaughlin (1990), 35–47.

Joshua, Harris and Tina Wallace with the assistance of Heather Booth 1983: *To Ride the Storm: The 1980 'Bristol Riot' and the State*. London: Heinemann.

Kabbani, Rana 1988: *Europe's Myths of Orient*. London: Pandora Press.

Kant, Hermann 1965: *Die Aula*. Berlin: Rütten & Loening.

Kanter, Hannah, Sarah Lefanu, Shaila Shah and Carole Spedding (eds) 1984: *Sweeping Statements*. London: The Women's Press.

Kaplan, Cora 1986: *Sea Changes: Essays on Culture and Feminism*. London: Verso.

Kapur, Geeta 1989: 'Francis Newton Souza: devil in the flesh'. *Third Text*, nos 8/9, 25–64. (Special issue on *The Other Story* exhibition.)

Khaireh, Steven 1984: 'The Somali Community of Butetown'. Unpublished paper.

Khanna, Balraj 1989: 'England: my brave new world'. In Araeen (1989), 108–10.

King, Elspeth 1991: *The People's Palace and Glasgow Green*. Edinburgh: W. & R. Chambers.

King, Martin Luther 1985: *The Words of Martin Luther King*, sel. Coretta Scott King. London: Fount Paperbacks.

—— 1992: *I have a Dream: Writing and Speeches that Changed the World*, ed. James M. Washington. San Francisco: Harper Collins.

Koloss, Hans-Joachim 1993: 'Afrikanische Kunst'. In *Wege der Moderne*, 223–40.

Krauss, Rosalind 1984: 'Giacometti'. In Rubin (1984), 503–33.

Kristeva, Julia 1984a: *Revolution in Poetic Language*. New York: Columbia University Press.

—— 1984b: *The Kristeva Reader*, ed. Toril Moi. Oxford: Basil Blackwell.

Kymlicka, Will 1989: *Liberalism, Community and Culture*. Oxford: Oxford University Press.

Lacan, Jacques 1977: *Ecrits*. London: Tavistock Publications.

Lam, Wifredo 1951: 'Oeuvres recentes de Wifredo Lam', *Cahiers d'art*, 26.

Lambert, Rosemary 1981: *The Twentieth Century*. Cambridge: Cambridge University Press (*Introduction to Art* series).

Landry, Donna and Gerald MacLean 1993: *Materialist Feminisms*. Oxford, England, and Cambridge, Mass.: Basil Blackwell.

Leavis, F. R. 1930: *Mass Civilisation and Minority Culture*. Cambridge: Cambridge University Press.

—— 1983: *The Great Tradition*. Harmondsworth: Penguin.

—— 1984: *The Common Pursuit*. London: Hogarth.

Lee, Patrick C. and Robert Sussman Stewart 1976: *Sex Differences: Cultural and Developmental Dimensions*. New York: Urizen Books.

Left Review 1934–8. London: Writers' International.

Leiris, Michel 1968: 'The discovery of African art in the West'. In M. Leiris and J. Delange, *African Art*, New York: Golden Press.

Lévi-Strauss, Claude 1963: *Structural Anthropology*. New York: Basic Books.

Lewis, Helena 1990: *Dada Turns Red: The Politics of Surrealism*. Edinburgh: Edinburgh University Press.

Linnaeus, Carl 1792: *The Animal Kingdom, or Zoological System of the Celebrated Sir Charles Linnaeus*, trans. Robert Kerr from 10th edn (1758–9) of *Systema naturae per Regna tria naturae*. London: J. Murray & R. Faulder.

Lippard, Lucy R. (ed.) 1971: *Dadas on Art*, Englewood Cliffs, N. J.: Prentice-Hall.

Lippmann, Lorna 1981: *Generations of Resistance*. Melbourne, Australia: Longman Cheshire.

Literature of World Revolution 1931, continued as *International Literature* 1932–45. Moscow: International Union of Revolutionary Writers.

Little, Kenneth 1942a: 'Loudoun Square: a community survey I'. *Sociological Review*, 34, 12–33.

—— 1942b: 'Loudoun Square: a community survey II'. *Sociological Review*, 34, 119–46.

—— 1942c: 'The coloured folk of Cardiff: a challenge to reconstruction'. *New Statesman and Nation*, 19 December, 406.

—— 1943: 'The psychological background of white–coloured contacts in Britain'. *Sociological Review*, 35, 12–28.

—— 1948: *Negroes in Britain: A Study of Racial Relations in English [sic] Society*. London: Routledge & Kegan Paul.

—— 1972: *Negroes in Britain*, 2nd edn. London: Routledge & Kegan Paul.

Loewenberg, Bert J. and Ruth Bogin (eds) 1976: *Black Women in Nineteenth-century American Life*. University Park: Pennsylvania State University Press.

Long, Edward 1774: *The History of Jamaica*, 3 vols. London: J. T. Lowndes.

Lorde, Audre 1984: *Sister Outsider*. Freedom, Cal.: Crossing Press.

Lucie-Smith, Edward 1984: *Movements in Art since 1945*. London: Thames & Hudson.

Lucie-Smith, Edward 1991: *Sexuality in Western Art*. London: Thames & Hudson.

Lukács, Georg 1963: *The Meaning of Contemporary Realism*. London: Merlin.

—— 1972: *Studies in European Realism*. London: Merlin.

Luling, Virginia 1979: *Aborigines*. London: Macdonald Educational.

—— 1989: *Threatened Cultures*. Hove, East Sussex: Wayland.

Lummis, Trevor 1987: *Listening to History*. London: Hutchinson Education.

Lynton, Norbert 1981: 'Expressionism'. In Nikos Stangos (ed.), *Concepts of Modern Art*, London: Thames & Hudson, 30–49

—— 1989: *The Story of Modern Art*. London: Phaidon Press.

Macherey, Pierre 1978: *A Theory of Literary Production*, trans. Geoffrey Wall. London: Routledge & Kegan Paul.

Maharaj, Surat 1991: 'The Congo is flooding the Acropolis: art in Britain of the immigrants'. *Third Text*, no. 15, 77–90

Maitland, Sara 1984: *Virgin Territory*. London: Michael Joseph.

Mansbridge, Albert 1920: *An Adventure in Working Class Education*. London: Longman, Green.

Marcus, Julie 1988: 'The journey out to the centre: the cultural appropriation of Ayers Rock'. In Rutherford (1988), 254–74.

Martin, David 1946: *Tiger Bay*. London: Martin & Reid.

Marx, Karl 1951: *Theories of Surplus Value*. London: Lawrence & Wishart.

—— 1970: *The German Ideology*. London: Lawrence & Wishart.

—— 1970a: *Economic and Philosophical Manuscripts of 1844*. London: Lawrence & Wishart.

—— 1973: *Grundrisse: Outlines of a Critique of Political Economy*, trans. Martin Nicolaus. London: Penguin Books.

Mathieson, Margaret 1975: *Preachers of Culture*. London: Allen & Unwin.

Maurer, Evan 1969: *In Quest of the Myth: An Investigation of the Relationships between Surrealism and Primitivism*. Ph.D. thesis, University of Pennsylvania.

—— 1984: 'Dada and Surrealism'. In Rubin (1984), 535–93.

McGuinness, Bruce and Denis Walker 1985: 'The politics of Aboriginal literature'. In Davis and Hodge (1985), 43–54.

McHale, Brian 1987: *Postmodern Fiction*. London: Methuen, 1987.

Memmi, Albert 1965: *The Colonizer and the Colonized*. New York: Orion Press. Originally published 1957 as *Portrait du colonisé précédé du portrait du colonisateur*.)

Mercer, Kobena 1990: 'Black art and the burden of representation'. *Third Text*, no 10, 61–78.

Merritt, Robert 1978: *The Cake Man*. Sydney: Currency Press.

M/F 1978. London.

Micheli, Mario de 1967: *Picasso*, trans. from the Italian by Pearl Sanders. London: Thames & Hudson.

Miller, Daniel 1991: 'Primitive art and the necessity of primitivism to art'. In Hiller (1991), 50–71.

Miller, Jill 1983: *Happy as a Dead Cat*. London: The Women's Press.

Millett, Kate 1977: *Sexual Politics*. London: Virago.

Mitchell, Juliet 1975: *Psychoanalysis and Feminism*. Harmondsworth: Penguin.

Mohanty, Chandra Talpade, Ann Russo and Lourdes Torres (eds) 1991: *Third World Women and the Politics of Feminism*. Bloomington, Ind.: Indiana University Press.

Moore, Henry 1966: *Henry Moore on Sculpture*. London: MacDonald.

—— 1981: *Henry Moore at the British Museum*. London: British Museum Publications.

Morgan, Sally 1987: *My Place*. Fremantle, Western Australia: Fremantle Arts Centre Press. (Published in the UK by Virago.)

Morrison, Toni 1988: *Beloved*. London: Picador.

Mort, Frank 1987: *Dangerous Sexualities*. London: Routledge.

Mosquera, Gerardo 1992: 'Modernidad y Africania: Wilfredo Lam in his island'. *Third Text*, no. 20 (special bilingual issue on Cuba), 43–68.

Mulhern, Francis 1979: *The Moment of Scrutiny*. London: New Left Books.

Nadeau, Maurice 1973: *The History of Surrealism*. Harmondsworth: Penguin Books.

National Arts and Media Strategy Monitoring Group 1992: *Towards a National Arts and Media Strategy*. London: Arts Council of Great Britain.

Nead, Lynda 1986: 'Feminism, art history and cultural politics'. In Rees and Borzello (1986), 120–4.

—— 1992: *The Female Nude: Art, Obscenity and Sexuality*. London and New York: Routledge.

Neutsch, Erik 1964: *Spur der Steine*. Halle/Saale: Mitteldeutsher.

Newbolt Report 1921: *The Teaching of English in England*. London: HMSO.

Newton, Arthur 1974: *Introduction to Years of Change: Autobiography of a Hackney Shoemaker*. London: Centreprise.

Newton, Judith and Deborah Rosenfelt (eds) 1985: *Feminist Criticism and Social Change*. New York and London: Methuen.

Nicholson, Linda J. (ed.) 1990: *Feminism/Postmodernism*. London: Routledge.

Nochlin, Linda 1989: *Women, Art and Power and Other Essays*. London: Thames & Hudson.

—— 1991: *The Politics of Vision: Essays on Nineteenth-century Art and Society*. London: Thames & Hudson.

O'Connor, P. J. 1973: 'Butetown: a case study in social, economic, and physical malaise'. Unpublished diploma dissertation, Department of Town Planning, University of Wales Institute of Science and Technology.

O'Neill, Mark 1988: 'Real things and real people'. In *Scottish Museum News*, Edinburgh: Scottish Museums Council.

Osterhaus, Carolyn 1988: 'Writing for children', an interview with Pat Torres. In Rutherford (1988), 191–7.

Otto, Herbert 1970: *Zum Beispiel Josef*. Berlin: Aufbau Verlag.

Owusu, Kwesi, 1986: *The Struggle for Black Arts in Britain*. London: Comedia.

—— ed. 1988: *Storms of the Heart*. London: Camden Press.

Paine, Thomas 1791: *The Rights of Man, Part One*. London: J. S. Jordan.

Paine, Thomas 1792: *The Rights of Man, Part Two*. London: J. S. Jordan.

Parker, Rozsika and Griselda Pollock 1987a: 'Fifteen years of feminist action: from practical strategies to strategic practices'. In Parker and Pollock (1987), 3–78.

Parker, Rozsika and Griselda Pollock (eds) 1981: *Old Mistresses: Women, Art and Ideology*. London: Routledge & Kegan Paul.

Parker, Rozsika and Griselda Pollock 1987: *Framing Feminism: Art and the Women's Movement, 1970–1985*. London: Pandora Press.

Parmar, Pratibha 1987: 'Hateful contraries: media images of Asian women'. In Betterton (1987), 93–104.

—— 1989: 'Other kinds of dreams'. *Feminist Review*, no. 31, 55–65.

Paudrat, Jean-Louis 1984: 'From Africa'. In Rubin (1984), 125–75.

Peltier, Philippe 1984: 'From Oceania'. In Rubin (1984), 99–123.

Perrois, Louis 1989: 'Through the eyes of the white man: from 'negro art' to African arts'. *Third Text*, no. 6, 51–60.

Perry, Gill 1993a: 'Primitivism and the "modern" '. In Charles Harrison, Francis Frascina and Gill Perry, *Primitivism, Cubism, Abstraction: The Early Twentieth Century*. New Haven, Conn., and London: Yale University Press in association with the Open University, 3–85.

—— 1993b: ' "The ascent to nature" – some metaphors of "nature" in early Expressionist art'. In Behr et al. (1993), 53–64.

Philippi, Desa 1987: 'The conjunction of race and gender in anthropology and art history: a critical study of Nancy Spero's work'. *Third Text*, no. 1, 34–54.

—— and Anna Howells 1991: 'Dark continents explored by women'. In Hiller (1991), 238–60.

Picasso, Pablo 1935: 'Conversation avec Picasso', *Cahiers d'art*, 10 (7–10), 173–8.

Piper, Keith 1987–8: 'Body and text'. *Third Text*, no. 2, 53–61.

Piercy, Marge 1979: *Woman on the Edge of Time*. London: The Women's Press.

Plebs Magazine 1909 onwards. London: Plebs League.

Plenzdorf, Ulrich 1973: *Die neuen Leiden des jungen W*. Rostock: Hinstorff Verlag.

Pollock, Griselda 1982: 'Theory and pleasure'. In Parker and Pollock (1987).

—— 1987a: 'Feminism and modernism'. In Parker and Pollock (1987), 79–122.

—— 1987b: 'Women, art and ideology: questions for feminist art historians'. In Robinson (1987), 203–21.

—— 1988: *Vision and Difference: Femininity, Feminism and Histories of Art*. London: Routledge.

—— 1992: 'Painting, feminism, history'. In Barrett and Phillips (1992), 138–76.

Price, Sally 1986: 'Primitive art in civilized places'. *Art in America*, 13, 9–13.

—— 1989: 'Others' art – our art'. *Third Text*, no. 6, 65–72.

—— 1991: *Primitive Art in Civilized Places*. Chicago: University of Chicago Press.

—— and Price, Richard 1981: *Afro-American Arts of the Suriname Rain Forest*. Berkeley, Cal.: University of California Press.

Ranfft, Erich 1993: 'Expressionist sculpture c. 1910–30 and the significance of its dual architectural/ideological frame'. In Behr et al. (1993), 65–79.

Read, Herbert 1974: *A Concise History of Modern Painting*. London: Thames & Hudson.

Rees, A. L. and Frances Borzello (eds) 1986: *The New Art History*. London: Camden Press.

Rich, Adrienne 1981: *Compulsory Heterosexuality and Lesbian Experience*. London: Onlywomen Press.

—— 1986: *Blood, Bread and Poetry: Selected Prose, 1979–1985*. New York: W. W. Norton.

Riley, Joan 1985: *The Unbelonging*. London: The Women's Press.

Riley, Joan 1987: *Waiting In The Twilight*. London: The Women's Press.

—— 1988: *Romance*. London: The Women's Press.

Roberts, John 1987: 'Interview with Sonia Boyce'. *Third Text*, no. 1, 55–64.

—— 1990a: 'Postmodernism and the critique of ethnicity: the work of Rasheed Araeen'. In Roberts (1990b), 182–94.

—— 1990b: *Postmodernism, Politics and Art*. Manchester and New York: Manchester University Press.

Roberts, Michèle 1978: *A Piece of the Night*. London: The Women's Press.

—— 1983: *The Visitation*. London: The Women's Press.

—— 1985: *The Wild Girl*. London: Methuen.

—— 1988: *The Book of Mrs Noah*. London: Methuen.

—— 1990: *In the Red Kitchen*. London: Methuen.

—— 1992: *Daughters of the House*. London: Virago, 1992.

Robinson, Hilary 1987: *Visibly Female: Feminism and Art Today*. London: Camden Press.

Roe, Paddy 1985: *Gularabulu: Stories from the West Kimberley*, ed. Stephen Muecke. Fremantle, Western Australia: Fremantle Arts Centre Press.

Rogers, Joel A. 1957: *100 Amazing Facts about the Negro, with Complete Proof: A Short-cut to the World History of the Negro*, 23rd rev. and enl. edn. New York: H. M. Rogers.

—— 1972: *World's Great Men of Colour: 3000 B.C. to 1946 A.D*, vol. 1. New York: Macmillan.

Rosaldo, Rentato 1989a: 'Preface'. In *Culture and Truth: The Remaking of Social Analysis*. Boston, Mass.: Beacon Press.

—— 1989b: 'Imperialist nostalgia'. In *Culture and Truth: The Remaking of Social Analysis*. Boston, Mass.: Beacon Press, 68–87.

Rose, Phyllis 1989: *Jazz Cleopatra: Josephine Baker in her Time*. New York: Harper Collins.

Roughsey, Elsie 1984: *An Aboriginal Mother Tells of the Old and New*. Ringwood, Victoria: Penguin.

Rowbotham, Sheila. 1973: *Hidden from History*. London: Pluto Press.

Rowe, Marsha 1982: *Spare Rib Reader*. Harmondsworth: Penguin.

Rubin, William 1968: *Dada, Surrealism, and Their Heritage*. New York: Museum of Modern Art.

—— 1969: *Dada and Surrealist Art*. London: Thames & Hudson.

—— (ed.) 1984: *'Primitivism' in 20th Century Art: Affinity of the Tribal and the Modern*, 2 vols. New York: Museum of Modern Art.

—— 1984a: 'Modernist Primitivism: an introduction'. In Rubin (1984), 1–81.

—— 1984b: 'Picasso'. In Rubin (1984), 241–343.

Rurup, Reinhard 1989: *Topography of Terror: Gestapo, SS and Reichssicherheitshauptamt on the 'Prinz-Albrecht-Terrain': A Documentation*, trans. from the German by Werner T. Angress. Berlin: Verlag Willmuth Arenhovel.

Rushdie, Salman 1982: 'The New Empire within Britain'. *New Society*, 62 (1047).

—— 1988: *The Satanic Verses*. London: Viking.

Rutherford, Anna, (ed.) 1988: *Aboriginal Culture Today*. vol. X, nos 1 and 2 of *Kunapipi*, Sydney, Australia; Coventry, England; and Geding Sovej, Denmark: Dangaroo Press.

Rutherford, Jonathan 1990: 'The third space: interview with Homi Bhabha'. In Jonathan Rutherford (ed.), *Identity: Community, Culture, Difference*. London: Lawrence & Wishart, 207–21.

Sabartes, Jaim 1949: *Picasso: An Intimate Portrait*. London: W. H. Allen.

Said, Edward 1978: *Orientalism*. Harmondsworth: Penguin Books.

—— 1993: *Culture and Imperialism*. London: Chatto & Windus.

Sampson, George 1921: *English for the English*. Cambridge: Cambridge University Press.

Sartre, Jean-Paul 1948: Introduction to *Anthologie de la nouvelle poésie nègre et malgache de langue français*, trans. S. E. Allan. Paris: Gallimard.

—— 1967: 'Preface' to Frantz Fanon, *The Wretched of the Earth*, Harmondsworth: Penguin Books, 7–26.

—— 1976: *Critique of Dialectical Reason*, vol. 1. London: New Left Books.

Sayers, Janet 1982: *Biological Politics*. London: Tavistock Publications.

Scarman, The Rt Hon. Lord 1981: *The Brixton Disorders, 10–12 April 1981*. London: HMSO.

Schacht, Richard (ed.) 1993: *Nietzsche: Selections*. New York and Toronto: Macmillan.

Schindlbeck, Markus 1993: 'Kunst aus Ozeanien'. In *Wege der Moderne*, pp. 241–58.

Scrutiny: A Quarterly Review 1932–53. Cambridge.

Segal, Lynne 1990: *Slow Motion: Changing Masculinity, Changing Men*. London: Virago.

Seghers, Anna 1959: *Die Entscheidung*. Berlin: Aufbau Verlag.

Sewell, Brian 1989: 'Pride or prejudice?'. *The Sunday Times Magazine*, 26 November.

Sharpe, Nancie 1932: *Report on the Negro Population of London and Cardiff*. London: League of Coloured Peoples.

Sheppard, Richard 1991: 'German Expressionism'. In Malcom Bradbury and James McFarlane (eds), *Modernism: A Guide to European Literature, 1890–1930*. London: Penguin Books, 274–91.

Short, Robert 1991: 'Dada and Surrealism'. In Malcolm Bradbury and James McFarlane (eds), *Modernism: A Guide to European Literature, 1890–1930*. London: Penguin Books, 292–308.

Showalter, Elaine 1977: *A Literature of Their Own: Women Novelists from Brontë to Lessing*. Princeton, N. J.: Princeton University Press.

—— (ed.) 1986: *The New Feminist Criticism*. London: Virago.

Shulman, Milton 1968: 'Viewers, you were looking at yourselves'. In Daniels and Gerson (1989), 24–7.

Shyllon, Folarin 1977: *Black People in Britain, 1555–1833*. London: Oxford University Press.

Simon, Brian 1965: *Studies in the History of Education*, vol. 2. London: Lawrence & Wishart.

—— 1974: *Studies in the History of Education*, vol. 3. London: Lawrence & Wishart.

Sinclair, Neil 1993: *The Tiger Bay Story*. Cardiff: Butetown History & Arts Project (*Life Stories from Tiger Bay* series, ed. Glenn Jordan).

Smith, Barbara 1977: 'Towards a black feminist criticism'. In Showalter (1986), 168–85.

Smith, David 1978: *Socialist Propaganda in the Twentieth Century British Novel*. London: Macmillan.

Smitherman, Geneva 1977: *Talkin' and Testifyin': The Language of Black America*. Boston, Mass.: Houghton Mifflin.

Sobel, Mechal 1979: *Trabelin' On: The Slave Journey to an Afro-Baptist Faith*. Princeton, N.J.: Princeton University Press.

South-east Wales Arts Association 1989: *Annual Report, 1988–9*. Cwmbran: South-east Wales Arts Association

—— 1991: *Annual Report, 1990–1*. Cwmbran: South-east Wales Arts Association

Southern Arts 1989: *The Arts Business*. Winchester, Hants.: Southern Arts.

Spalding, Francis 1986: *British Art since 1900*. London: Thames & Hudson.

Spare Rib 1972–92. London.

Spender, Dale 1982: *Women of Ideas and What Men Have Done to Them: From Aphra Benn to Adrienne Rich*. London: Routledge & Kegan Paul.

—— 1986: *Mothers of the Novel: One Hundred Good Women Writers before Jane Austen*. London: Pandora.

Spender, Stephen 1934: *Vienna*. London: Faber & Faber.

Spivak, Gayatri 1990: *The Post-colonial Critic: Interviews, Strategies, Dialogues.*, ed. Sarah Harasym. New York and London: Routledge.

Spring, Howard 1939: *Heaven Lies about Us: A Fragment of Infancy*. London: Constable.

St Hilaire, Patricia 1987: 'A poem for black women'. In Da Choong et al. (1987).

Storm 1933 (4 issues). London.

Sudarkasa, Niara 1981b: 'Interpreting the African heritage in Afro-American family organization'. In Harriette Pipes McAdoo (ed.) *Black Families*. Beverley Hills, Cal.: Sage, 37–53.

Suleiman, Susan Rubin 1990: *Subversive Intent: Gender, Politics, and the Avant-garde*. Cambridge, Mass. and London: Harvard University Press.

Sullivan, Neil 1990: *Housing in Butetown: A Historical and Critical Study*. Dissertation for degree in Housing, University of Bristol.

Tagg, John 1986: 'Art history and difference'. In Rees and Borzello (1986), 164–71.

—— 1988: 'A means of surveillance: the photograph as property in law'. In *The Burden of Representation: Essays on Photographies and Histories*, London: Macmillan Education, 66–102.

Tang Nain, Gemma 1991: 'Black women, sexism and racism: black or antiracist feminism?' *Feminist Review*, no. 37, 1–22.

Tawadros, Gilane 1989: 'Beyond the boundary: the work of three black women artists in Britain'. *Third Text*, nos 8/9, 121–50.

Taylor, Ronald (ed.) 1980: *Aesthetics and Politics: Theodore Adorno, Walter Benjamin, Ernst Bloch, Bertolt Brecht, Georg Lukács*. London: Verso.

Third Text: Third World Perspectives on Contemporary Art and Culture 1987 onwards. London: Kala Press.

Thompson, Paul 1978: *The Voice of the Past: Oral History*. Oxford: Oxford University Press.

Thorpe, Edward 1989: *Black Dance*. London: Chatto & Windus.

Tiffin, Chris 1988: "Relentless realism": Archie Weller's *Going Home'*. In Rutherford (1988), 222–35.

Tosh, John 1984: *The Pursuit of History*. London and New York: Longman.

Tressell, Robert 1965: *The Ragged Trousered Philanthropists*. St Albans, Herts: Panther.

Tunde, Carmen 1987: 'Bus stop'. In Da Choong et al. (1987).

Turcotte, Gerry 1988: ' "Recording the cries of the people": interview with Oodgeroo Noonuccal (Kath Walker)'. In Rutherford (1988), 17–30.

Turner, Bryan 1990: *Theories of Modernity and Postmodernity*. London: Sage.

Twamley, Bill 1984: *Cardiff and Me 60 Years Ago*. Newport, Gwent: Starling Press.

Tweedale, Iain 1986: *Butetown Project Household Survey*. Cardiff: Priority Estates Project, Welsh Office.

—— 1987: 'From Tiger Bay to the inner city: one hundred years of black settlement in Cardiff'. *Radical Wales*, Spring 5–7.

Tzara, Tristan 1917: 'Note sur l'art nègre'. *Sic* (Paris-based Futurist journal), September–October. Republished as 'Note on negro art' in Tzara (1992), 57–8.

—— 1992: *Seven Dada Manifestos and Lampisteries*, trans. Barbara Wright, illus. Francis Picabia. London: Calder Publications and New York: Riverrun Press.

Tyler, Leona 1947: 'Sex difference in personality characteristics'. In Lee and Sussman Steward (1976), 395–409.

Unaipon, David n.d.: *Native Legends*. Adelaide, Australia: Hunken, Ellis & King.

Varnedoe, Kirk 1984a: 'Gauguin'. In Rubin (1984), 179–99.

—— 1984b: 'Abstract Expressionism'. In Rubin (1984), 615–59.

—— 1984c: 'Contemporary explorations'. In Rubin (1984), 661–85.

Vergo, Peter 1993: 'The origins of Expressionism and the notion of the *Gesamtkunstwerk*.' In Behr et al. (1993), 11–19.

Viewpoint: A Critical Review 1934 (2 issues). London.

Waldberg, Patrick 1971: 'Max Ernst in Arizona'. In G. di San Lazzaro (ed.), *Homage to Max Ernst*: Special issue of *XXᵉ Siècle Review*. New York: Tudor.

Walker, Alice 1982: *Meridian*. London: The Women's Press.

—— 1983: *The Color Purple*. London: The Women's Press.

—— 1984: *In Search of Our Mothers' Gardens*. London: The Women's Press.

—— 1988: *Living by the Word: Selected Writings 1973–87*. London: The Women's Press.

Walker, Kath (Oodgeroo Noonuccal) 1964: *We Are Going*. Brisbane, Australia: Jacaranda Press.

—— 1981: *My People – A Kath Walker Collection*. Milton, Queensland: Jacaranda Press. (First published 1970.)

Wallace, Michele 1990: *Invisibility Blues*. London: Verso.

Walsh, J. M. 1936: *Once in Tiger Bay*. London: Collins.

—— 1947: *Return to Tiger Bay*. London: Collins.

—— 1952: *King of Tiger Bay*. London: Collins.

Walvin, James 1973: *Black and White: The Negro and English Society, 1555–1945*. Harmondsworth: Allen Lane.

Wander, Maxie 1978: *Guten Morgen, du Schöne*. Darmstadt and Neuwied: Hermann Luchterhand Verlag.

Ware, Vron 1992: *Beyond the Pale: White Women, Racism and History*. London: Verso.

Watkins, Olwen Blackman 1975: 'The role of the school in the community'. Diploma dissertation, Cardiff College of Education.

Webber, Thomas L. 1978: *Deep Like the Rivers*. New York: W. W. Norton.

Weedon, Chris 1984: *Aspects of the Politics of Literature and Working-class Writing in Interwar Britain*. Ph.D.thesis, Centre for Contemporary Cultural Studies, University of Birmingham.

—— 1987: *Feminist Practice and Poststructuralist Theory*. Oxford: Basil Blackwell.

Wege der Moderne: Die Sammlung Beyeler 1993: Catalogue for the exhibition of the same title at the Nationalgalerie, Berlin. Berlin: Staatliche Museen zu Berlin – Preussischer Kulturbesitz.

Weller, Archie 1981: *The Day of the Dog*. Sydney: Allen & Unwin. (Reissued Pan Books, Sydney, 1982.)

—— 1986: *Going Home – Stories*. Sydney, London, and Boston, Mass.: Allen & Unwin.

Welsh, James 1917: *Songs of a Miner*. London: Herbert Jenkins.

—— 1920: *The Underworld*. London: Herbert Jenkins.

—— 1924: *The Morlocks*. London: Herbert Jenkins.

—— 1928: *Norman Dale M. P.* London: Herbert Jenkins.

Welsh Arts Council 1988: *Annual Report*. Cardiff: Welsh Arts Council.

—— 1989: *Arts in a Multicultural Society*. Cardiff: Welsh Arts Council.

West, Cornel 1982: 'A genealogy of modern racism'. In *Prophesy Deliverance! An Afro-American Revolutionary Christianity*, Philadelphia: Westminister Press, 47–65.

Wheatley, Phyllis 1838: *Memoirs and Poems of Phyllis Wheatley*, 3rd edn (first published Boston, Mass.; reprinted Miami, Fla: Mnemosyne Publishing Co., 1969).

White, Charles 1799: *An Account of the Regular Gradation in Man, and in Different Animals and Vegetables; and from the Former to the Latter*. London: C. Dilly.

Whitford, Margaret 1991: *Luce Irigaray: Philosophy in the Feminine*. London and New York: Routledge.

Whiteman, Walt 1947: *Leaves of Grass*. London: Dent; New York: Dutton.

Wilkinson, Alan G. 1984: 'Henry Moore'. In Rubin (1984), 595–613.

Wilkinson, George 1927: *How to Read Literature*. London: Workers' Educational Association.

Williams, Raymond 1961: *Culture and Society, 1780–1950*. Harmondsworth: Penguin.

—— 1976: *Keywords*. London: Fontana.

—— 1977: *Marxism and Literature*. Oxford: Oxford University Press.

—— 1981: *Culture*. Glasgow: Fontana. (Published in USA as *The Sociology of Culture*.)

Williams, Raymond 1989a: 'The politics of the avant-garde'. In *The Politics of Modernism: Against the New Conformists*, London and New York: Verso Books, 49–64.

—— 1989b: 'Politics and policies: the case of the Arts Council'. In *The Politics of Modernism: Against the New Conformists*, London and New York: Verso Books 141–50.

Wilson, Harriett 1948: Letter to the Editor. *New Statesman*, May.

Wilson, Harriett 1950: 'A housing survey of the dock area of Cardiff'. *Sociological Review*, 42 (2) 201–13.

Wolf, Christa 1963: *Der geteilte Himmel*. Halle/Saale: Mitteldeutscher Verlag.

—— 1982: *The Quest for Christa T*. London: Virago.

Wolf, Eric R. 1982: *Europe and the People without History*. Berkeley, Cal., and London: University of California Press.

Wollstonecraft, Mary 1982: *A Vindication of the Rights of Woman*. Harmondsworth: Penguin. (First published 1792.)

Wright, Mary 1988: 'A fundamental question of identity: an interview with Sally Morgan'. In Rutherford (1988), 92–109.

Yau, John 1990: 'Please wait by the coatroom'. In Russell Ferguson, Martha Gever, Trinh T. Minh-ha and Cornel West (eds), *Out There: Marginalization and Contemporary Cultures*, New York: New Museum for Contemporary Art; London: MIT Press, 133–9.

Young, Robert 1990: *White Mythologies: Writing, History and the West*. London and New York: Routledge.

Zentralhaus für Kulturarbeit der DDR 1969: *Zwischenbericht*. Leipzig: Zentralhaus für Kulturarbeit der DDR.

Index of Names and Voices

Subject Index